ARTISTIC ANATOMY

ARTISTIC ANATOMY

BY

Dr. Paul Richer

Professor of Anatomy at the Ecole des Beaux-Arts
and the Academy of Medicine, Paris

TRANSLATED AND EDITED BY

Robert Beverly Hale

Instructor of Drawing and Lecturer on Anatomy
at the Art Students League, New York
Adjunct Professor of Drawing at Columbia University
Curator Emeritus of American Paintings
at The Metropolitan Museum of Art

WATSON-GUPTILL PUBLICATIONS / NEW YORK

Contents

INTRODUCTION, 11
PREFACE, 13

Part One: Anatomy, 17-81

1. OSTEOLOGY AND ARTHROLOGY, 19

Classification of Bones, 19
Substance of Bones, 19
Articulation of Bones, 19
Ossification of Bones, 20
Influence of Bones on Form, 20

2. THE SKELETON OF THE HEAD, 21

Cranium and Upper Part of the Face, 21
Anterior Aspect, 21
Posterior Aspect, 22
Lateral Aspect, 22
Inferior Aspect, 22
Superior Aspect, 23
Mandible, 23
Temperomandibular Articulation, 23

3. THE SKELETON OF THE TRUNK, 24

Vertebral Column, 24
True Vertebrae, 24
Characteristics Common to All Vertebrae, 24
Distinctive Characteristics of Vertebrae, 24
Cervical Vertebrae, 24
Dorsal Vertebrae, 24
Lumbar Vertebrae, 24
Special Characteristics of Particular Vertebrae, 25
First Cervical Vertebra or Atlas, 25
Second Cervical Vertebra or Axis, 25
Sacral Vertebrae, or Sacrum, 25
Coccyx, 25
Articulations of the True Vertebrae, 25
Articulations of the False Vertebrae, 26
Articulations of the Atlas, the Axis,
 and the Occipital, 26
On the Vertebral Column in General, 26
Mechanism of the Vertebral Column, 27

4. THORAX, 29

Sternum, 29
Ribs, 29
General Characteristics of the Ribs, 29
Particular Characteristics of Certain Ribs, 30
Articulations of the Thorax, 30
The Thorax in General, 30
Anterior Aspect, 30
Posterior Aspect, 30
Lateral Aspect, 30
Mechanism of the Thorax, 31
Shoulder, 31
Clavicle, 31
Scapula, 31
Articulations of the Clavicle, 32
Sternoclavicular Articulation, 32
Acromioclavicular articulation, 32
Skeleton of the Shoulders in General, 32
Mechanism of the Articulation of
 the Clavicle and Scapula, 32
Pelvis, 32
Hip Bone, 32
Articulations and Ligaments of the Pelvis, 33
The Pelvis as a Whole, 33
Skeleton of the Trunk in General:
 Its influence on Exterior Form, 34

5. THE SKELETON OF THE UPPER LIMB, 36

Bone of the Upper Arm: Humerus, 36
Bones of the Forearm: Ulna, 36
Bones of the Forearm: Radius, 37
Bones of the Hand, 37
Carpus, 37
Metacarpus, 37
Phalanges, 37
Articulation of the Shoulder, 38
Articulation of the Bones of the Forearm, 38
Articulation of the Elbow, 38
Articulation of the Wrist and Hand, 38
Skeleton of the Arm in General:
 Its Influence on Exterior Form, 39

6. THE SKELETON OF THE LOWER LIMB, 41

Bone of the Thigh: Femur, 41
Bones of the Lower Leg: Tibia, 41
Bones of the Lower Leg: Fibula, 41
Patella, 41
Bones of the Foot, 41
Tarsus, 41
Metatarsus, 42
Phalanges, 42
Articulations of the Hip, 42
Articulations of the Knee, 43
Articulation of the Tibia and Fibula, 44
Articulation of the Ankle Joint, 44
Articulations of the Foot, 45
Skeleton of the Lower Limb in General:
 Its Influence on Exterior Form, 46

7. MYOLOGY, 47

Composition of Muscles, 47
Disposition of Muscle Fibers, 47
Fascia, 48
Muscular Contraction, 48
Muscular Force, 48
Muscle Groups, 49
Antagonistic Action of Muscles, 49
Relationship of Muscles to Exterior Form, 49

8. MUSCLES OF THE HEAD, 50

Epicranial Muscles, 50
Frontalis, 50
Occipitalis, 50
Auricularis, 50
Muscles of the Face, 50
Corrugator, 50
Orbicularis Palpebrarum, 50
Procerus, 51
Nasilis, 51
Depressor Septi, 51
Dilator Naris, 51
Caninus, 51
Levator Labii Superioris Alaeque Nasi, 51
Levator Labii Superioris, 51
Zygomaticus Minor, 51
Zygomaticus Major, 51
Orbicularis Oris, 51
Buccinator, 51
Depressor Labii Inferioris, 51
Depressor Anguli Oris, 52
Mentalis, 52
Muscles of the Jaw, 52
Masseter, 52
Temporalis, 52

9. MUSCLES OF THE TRUNK AND NECK, 53

Posterior Region, 53

Transversospinal Muscles, 53
Rectus Capitis Posterior Major, 53
Rectus Capitis Posterior Minor, 53
Obliquus Capitis Inferior, 53
Obliquus Capitis Superior, 53
Rectus Capitis Lateralis, 53
Longus Capitis, 53
Semispinalis Capitis, 54
Longissimus Capitis, 54
Splenius Capitis and Splenius Cervicis, 54
Sacrospinalis, 54
Serratus Posterior Superior, 55
Serratus Posterior Inferior, 55
Rhomboideus, 55
Levator Scapulae, 55
Latissimus Dorsi, 55
Trapezius, 56
Anterolateral Cervical Region, 56
Deep Layer, 56
Longus Colli, 56
Scalenus Anterior, 57
Scalenus Posterior, 57
Middle Layer, 57
Suprahyoid Muscles, 57
Geniohyoideus, 57
Mylohyoideus, 57
Infrahyoid Muscles, 57
Sternothyroideus, 57
Thyrohyoideus, 57
Omohyoideus, 57
Superficial Layer, 57
Sternocleidomastoideus, 57
Platysma, 58
Muscles of the Chest: Intercostalis, 58
Anterior and Lateral Regions of the Chest, 58
Subclavius, 58
Pectoralis Minor, 58
Pectoralis Major, 58
Serratus Anterior, 59
Muscles of the Shoulder, 59
Subscapularis, 59
Supraspinatus, 59
Infraspinatus, 59
Teres Minor, 59
Teres Major, 59
Deltoideus, 60
Muscles of the Abdomen, 60
Quadratus Lumborum, 60
Diaphragm, 60
Anterior Region, 60
Rectus Abdominis, 60
Pyramidalis, 61
Lateral Region, 61
Transversus Abdominis, 61
Obliquus Internus Abdominis, 61
Obliquus Externus Abdominis, 61
Muscles of the Pelvis, 61

Deep Muscles, 62
Psoas Major, Psoas Minor and Iliacus, 63
Piriformis, 63
Obturator Internus and Gemelli, 63
Quadratus Femoris, 63
Obturator Externus, 63
Middle Layer, 63
Gluteus Minimus, 63
Gluteus Medius, 63
Gluteus Maximus, 63

10. MUSCLES OF THE UPPER LIMB, 64

Muscles of the Upper Arm, 64
Coracobrachialis, 64
Brachialis, 64
Biceps Brachii, 64
Triceps Brachii, 65
Muscles of the Forearm, 65
Anteroexternal Region, 65
Deep Layer, 65
Supinator, 65
Pronator Quadratus, 65
Middle Layer, 65
Flexor Digitorum Profundus, Flexor Pollicis Longus, 65
Flexor Digitorum Superficialis, 66
Anterior Superficial Layer, 66
Pronator Teres, 66
Flexor Carpi Radialis, 66
Palmaris Longus, 66
Flexor Carpi Ulnaris, 66
External Superficial Layer, 66
Brachioradialis, 66
Extensor Carpi Radialis Longus, 67
Extensor Carpi Radialis Brevis, 67
Muscles of the Posterior Region, 67
Deep Layer, 67
Abductor Pollicis Longus, 67
Extensor Pollicis Brevis, 67
Extensor Pollicis Longus, 67
Superficial Layer, 67
Extensor Digitorum, 67
Extensor Digiti Minimi, 68
Extensor Carpi Ulnaris, 68
Anconeus, 68
Muscles of the Hand, 68
Middle Region, 68
Interossei Dorsales and Interossei Palmares, 68
Lumbricales, 68
Muscles of the Thenar Eminence, 68
Adductor Pollicis, 69
Opponens Pollicis, 69
Flexor Pollicis Brevis, 69
Abductor Pollicis Brevis, 69
Muscles of the Hypothenar Eminence, 69

11. MUSCLES OF THE LOWER LIMB, 70

Muscles of the Thigh, 70
Anterolateral Group, 70
Quadriceps Femoris, 70
Tensor Fasciae Latae, 71
Sartorius, 71
Internal Group, 71
Adductor Muscles, 71
Gracilis, 71
Posterior Group, 71
Biceps Femoris, 72
Semimembranosus, 72
Semitendinosus, 72
Muscles of the Lower Leg, 72
Anteroexternal Region, 72
Extensor Hallucis Longus, 72
Extensor Digitorum Longus, 72
Tibialis Anterior, 72
Peroneus Brevis, 73
Peroneus Longus, 73
Posterior Region, 73
Deep Layer, 73
Popliteus, 73
Tibialis Posterior, 73
Flexor Digitorum Longus, 73
Flexor Hallucis Longus, 73
Superficial Layer, 73
Plantaris, Soleus and Gastrocnemius, 73
Muscles of the Foot, 74
Dorsal Region, 74
Extensor Digitorum Brevis, 74
Plantar Region, 74
Middle Region, 74
Interossei, 74
Adductor Hallucis, 74
Lumbricales, 74
Quadratus Plantae, 74
Flexor Digitorum Brevis, 74
Internal Region, 75
Flexor Hallucis Brevis, 75
Abductor Hallucis, 75
External Region, 75
Flexor Digiti Minimi Brevis, 75
Abductor Digiti Minimi, 75

12. VEINS, 76

General Observations, 76
External Jugular Vein, 76
Superficial Epigastric Vein, 76
Superficial Veins, 76
Veins of the Lower Limb, 76

13. SKIN AND FATTY TISSUES, 78

Fatty Tissue, 78
Panniculus Adiposus, 78

Fatty Tissue of Interposition, 80
Skin, 80

Part Two: Morphology, 83-135

14. EXTERIOR FORM OF THE HEAD AND NECK, 85

Forehead, 85
Eye, 85
Nose, 86
Mouth, 86
Chin, 87
Temple, 87
Cheek, 87
Ear, 87
Exterior Forms of the Neck, 88
Anterior Region of the Neck and Throat, 88
Surface of the Sternocleidomastoideus, 88
Posterior Region of the Neck, 88
Posterior Triangle of the Neck, 89
Movements of the Head and Neck, 89
Articular Mechanism, 89
Muscular Action, 90
Modifications of Exterior Form:
 Movements of the Neck, 90

15. EXTERIOR FORM OF THE TRUNK, 92

Chest, 93
Sternal Region, 93
Mammary Region, 93
Inframammary Region, 94
Back, 95
Spinal Region, 96
Scapular Region, 96
Infrascapular Region, 97
Abdomen, 97
Belly, 97
Loins, 98
Flank, 98
Pelvis, 100
Pubic Region, 100
Groin, 100
Buttocks, 101
Movements of the Shoulder, 102
Articular Mechanism, 102
Muscular Action, 103
Normal Position of the Scapula, 103
Exterior Form of the Trunk
 during Movements of the Shoulder, 103
Movements of the Arm, 104
Mechanism and Muscular Action, 104
Exterior Form of the Trunk
 during Movements of the Arm, 105
Arm pit, 106

Movements of the Trunk, 106
Articular Mechanism, 106
Muscular Action, 107
Exterior Form during Movements of the Trunk, 107

16. EXTERIOR FORM OF THE UPPER LIMB, 110

Shoulder, 110
Upper Arm, 110
Elbow, 110
Bend of Arm, 110
Posterior Part of the Bend of the Arm, 111
Forearm, 111
Wrist, 112
Hand, 113
Rotation of the Arm, 114
Muscular Action, 115
Modification of Exterior Form, 115
Movements of the Elbow, 115
Muscular Action, 116
Modification of Exterior Form, 116
Movements of the Hand, 116
Muscular Action, 116
Modification of Exterior Form, 116
Movements of the Fingers, 117
Modification of Exterior Form, 117

17. EXTERIOR FORM OF THE LOWER LIMB, 118

Thigh, 118
Knee, 118
Lower Leg, 123
Ankle, 123
Foot, 124
Movements of the Hip, 125
Muscular Action, 125
Modification of Exterior Form, 125
Movements of the Knee, 127
Muscular Action, 127
Modification of Exterior Form, 127
Movements of the Foot, 127
Muscular Action, 128
Modification of Exterior Form, 128
Movements of the Toes, 128

18. PROPORTIONS, 129

Canons of Proportion, 129
Cousin's Canon of Proportions, 130
Gerdy's Canon of Proportions, 131
The Canon des Ateliers, 131
Artistic Canons in General, 131
Anthropology and Human Porportions, 131
Richer: Canon of Proportions, 132

PLATES, 137

INDEX, 251

Plates

Plate 1. Skeleton of the head, 139
Plate 2. Skeleton of the head, 140
Plate 3. Vertebrae, 141
Plate 4. Vertebrae, 142
Plate 5. Vertebral column, 143
Plate 6. Ligaments of the head and of the vertebral column, 144
Plate 7. Ligaments of the vertebral column, 145
Plate 8. Skeleton of the chest, 146
Plate 9. Thoracic cage, 147
Plate 10. Thoracic cage, 148
Plate 11. Skeleton of the shoulder, 149
Plate 12. Skeleton of the hip. Coccyx, 150
Plate 13. Male pelvis, 151
Plate 14. Female pelvis, 152
Plate 15. Ligaments of the pelvis, 153
Plate 16. Skeleton of the trunk, 154
Plate 17. Skeleton of the trunk, 155
Plate 18. Skeleton of the trunk, 156
Plate 19. Skeleton of the arm. Humerus, 157
Plate 20. Skeleton of the forearm, 158
Plate 21. Skeleton of the wrist and the hand, 159
Plate 22. Ligaments of the upper limb, 160
Plate 23. Skeleton of the upper limb, 161
Plate 24. Skeleton of the upper limb, 162
Plate 25. Skeleton of the upper limb, 163
Plate 26. Skeleton of the thigh. Femur, 164
Plate 27. Skeleton of the leg, 165
Plate 28. Skeleton of the leg and the foot, 166
Plate 29. Skeleton of the foot, 167
Plate 30. Ligaments of the lower limb. Knee, 168
Plate 31. Ligaments of the lower limb, 169
Plate 32. Skeleton of the lower limb, 170
Plate 33. Skeleton of the lower limb, 171
Plate 34. Skeleton of the lower limb, 172
Plate 35. Skeleton of the lower limb, 173
Plate 36. Myology. Muscles of the head, 174
Plate 37. Muscles of the head, 175
Plate 38. Muscles of the trunk and the neck (posterior region), 176
Plate 39. Muscles of the trunk and the neck (posterior region), 178
Plate 40. Muscles of the trunk and the neck (posterior region), 179
Plate 41. Muscles of the trunk and the neck (posterior region), 180
Plate 42. Muscles of the trunk and the neck (posterior region), 181
Plate 43. Muscles of the trunk and the neck (posterior region), 182
Plate 44. Muscles of the trunk and the neck (posterior region), 183
Plate 45. Muscles of the neck, 184
Plate 46. Muscles of the neck, 185
Plate 47. Muscles of the neck, 186
Plate 48. Muscles of the chest, 187

Plate 49. Muscles of the shoulder, 188
Plate 50. Muscles of the abdomen, 189
Plate 51. Muscles of the abdomen, 190
Plate 52. Muscles of the pelvis, 191
Plate 53. Muscles of the trunk and the head (flayed figure), 192
Plate 54. Muscles of the trunk and the head (flayed figure), 193
Plate 55. Muscles of the trunk and the head (flayed figure), 194
Plate 56. Muscles of the arm, 195
Plate 57. Muscles of the forearm (anterior region), 196
Plate 58. Muscles of the forearm and the hand, 197
Plate 59. Muscles of the upper limb (flayed figure), 198
Plate 60. Muscles of the upper limb (flayed figure), 199
Plate 61. Muscles of the upper limb (flayed figure), 200
Plate 62. Muscles of the upper limb (flayed figure), 201
Plate 63. Muscles of the thigh, 202
Plate 64. Muscles of the thigh, 203
Plate 65. Muscles of the leg, 204
Plate 66. Muscles of the leg, 205
Plate 67. Muscles of the foot, 206
Plate 68. Muscles of the lower limb (flayed figure), 207
Plate 69. Muscles of the lower limb (flayed figure), 208
Plate 70. Muscles of the lower limb (flayed figure), 209
Plate 71. Muscles of the lower limb (flayed figure), 210
Plate 72. Superficial veins, 211
Plate 73. Superficial veins, 212
Plate 74. Topographical morphology, 213
Plate 75. Topographical morphology, 214
Plate 76. Topographical morphology, 215
Plate 77. Exterior forms of the trunk, 216
Plate 78. Exterior forms of the trunk, 217
Plate 79. Exterior forms of the trunk, 218
Plate 80. Exterior forms of the upper limb, 219
Plate 81. Exterior forms of the upper limb, 220
Plate 82. Exterior forms of the upper limb, 221
Plate 83. Exterior forms of the lower limb, 222
Plate 84. Exterior forms of the lower limb, 223
Plate 85. Exterior forms of the lower limb, 224
Plate 86. Exterior forms of the lower limb, 225
Plate 87. Movements of the head and neck, 226
Plate 88. Movements of the head and neck, 227
Plate 89. Modifications of the exterior forms of the trunk during movements of the shoulder, 228
Plate 90. Modifications of the exterior forms of the trunk during movements of the shoulder, 229
Plate 91. Modifications of the exterior forms of the trunk during movements of the arm, 230
Plate 92. Modifications of the exterior forms of the trunk during movements of the arm, 231
Plate 93. Modifications of the exterior forms of the trunk during movements of the arm, 232
Plate 94. Movements of the trunk, 233
Plate 95. Movements of the trunk, 234
Plate 96. Movements of the trunk, 235
Plate 97. Movements of the trunk, 236
Plate 98. Movements of the trunk, 237
Plate 99. Movements of the trunk, 238
Plate 100. Movements of the trunk, 239
Plate 101. Movements of the upper limb, 240
Plate 102. Movements of the upper limb, 241
Plate 103. Movements of the upper limb (lateral aspect), 242
Plate 104. Movements of the upper limb (various degrees of flexion), 243
Plate 105. Movements of the lower limb, 244
Plate 106. Movements of the lower limb, 245
Plate 107. Movements of the lower limb, 246
Plate 108. Proportions of the human body, 247
Plate 109. Proportions of the human body, 248
Plate 110. Proportions of the human body, 249

Introduction

I am delighted to have the opportunity of offering an English translation of Dr. Paul Richer's *Anatomie tique* to artists and students of art. The term ic anatomy implies a delicate and dynamic balance b een the esthetic and the scientific. Very seldom are th ese two qualities combined in a single individual. Dr Richer, however, was a first rate artist as well as a dist iguished scientist. He was, furthermore, a man of t uly wide interests. He was familiar with the full flow of the history of art; he was even aware of the then budding science of anthropology. He was, indeed, the first to fully realize the importance of this discipline to the teaching of artistic anatomy.

Every work on the subject of anatomy that has appeared since this book was first published has been strongly influenced by Dr. Richer's approach. It is not only the most complete but the most accurate of contemporary works on artistic anatomy. It has, indeed, the accuracy of a medical anatomy. But it must be remembered that medical anatomies are not written with the selective and esthetic requirements of the artist in mind. This book, however, meets both these requirements.

It is selective in that if offers only such material as an artist-student needs. It provides information on bone, muscle, function, and proportion that will enable him to arrive at the precise shape of all bodily forms. Further, it describes how these forms change in shape as the body alters its position. In short, it offers the student the understanding necessary to become aware of the movements and meeting places of all bodily planes. Frankly, it is only through such understanding that a successful rendering may be completed.

The author is aware of the dangerous possibilities of esthetic misinterpretation and over-influence. He is conscious, for instance, of the confusing relationship between perspective and proportion. I know of no other contemporary work in this field where these elements remain constant from plate to plate. And in the plates themselves the style is deliberately subdued so that it may not prove infectious to the student. These, I feel, are matters of considerable importance. Students are deeply influenced by books on drawing, but they are seldom mature enough to judge the qualifications of the author, the accuracy of his statements, or the qualities of his style.

From the point of view of traditional drawing, it is assumed that an artist cannot draw a form successfully unless he can draw that form from his imagination alone. In other words, when an artist draws from a model, he does not att pt the impossible task of directly copying every detail ees before him. He already has in mind a full image of e human figure, its forms, planes, and proportions, decided upon according to his taste. He has patiently constructed this figure through study and observation. To a great extent, when the artist draws from the model, he visualizes and sets down the image he has long since created. Thus the artist's personal image of the human body, his secret figure, so to speak, becomes the implicit vehicle of his style.

Naturally, as the artist draws, he makes changes here and there in order to conform to certain obvious characteristics of the model. But I assure you, he makes fewer changes than you might think. This is because laymen, on the whole, are unaware of the majority of the forms which together make up the human body. Being unaware of the identity—or even the existence—of these forms, they can have no conception as to the shapes of these forms. Thus, they cannot be too critical of what the artist chooses to set down.

Let us take an example. Let us suppose that the inferior termination point of the fleshy mass of the tensor fasciae latae, on the artist's personal image of the human body, is precisely at the bottom level of the buttocks. Artists like to put this termination point at this level as a matter of convenience. (It is easy to remember.) Now the actual termination point *upon the model* may be a touch higher or a touch lower. The artist, however, will place the termination point on his drawing exactly where it is upon his personal image. And why not? The mental effort needed to determine the precise solution of such a trivial matter might well impede the flow of his style. And he is, of course, aware that hardly anyone has even heard of the tensor fasciae latae. He is also aware that among those who have, very few indeed will be concerned as to its exact shape or its proportional relationship to the rest of the body.

Or let us suppose that the navel on the artist's personal image is vertical. This may well be, because a vertical navel suggests very nicely the extent of the rotation of the pelvis. Now even though the model has a horizontal navel, the artist may follow his image and draw a vertical navel. Who cares? Who knows? Probably not even the model.

In another matter, a matter most mysterious to the layman, the artist follows his personal image almost exactly. The layman may notice that the artist places upon his drawing certain lines and passages of light and shade that he, the layman, cannot see at all upon the

model. As a matter of fact, the artist cannot see them either. What the artist is doing is this: he is visualizing his personal image in the same position as the model; he is illuminating this image with lights of his own choosing; he is transferring to his drawing the lines and tones he sees upon this image. His lines are indications of the meeting of planes; his varying tones are indications of the changing shapes of the planes on which these tones move.

In the creation of his conception of the figure, the student must realize that the shapes of its forms are essentially based upon the skeleton. Naturally, the shapes of the forms of all the hard parts of the body—the head, the hands, the feet, the joints—are dependent upon bone. But it must be understood that the shapes for all other bodily forms are basically dependent on bones as well. The neck, for instance, rises from the first two ribs. Together, these ribs create an almost perfect circle; hence the cylindrical shape of the neck. The palpable mass of obliquus externus moves from the pelvic crest to the lower ribs. An understanding of the shapes of these bony parts will lead to an understanding of the shape of this muscular mass.

Anatomical plates, no matter how excellent, are essentially two dimensional; they cannot suggest the full shape of the bones. They can, however, point out proportional relationships and salient areas to be studied. I therefore strongly urge any student who is studying this (or any other) work on artistic anatomy to make every effort to acquire some bones. Real bones are the best, though nowadays medical supply houses have excellent plastic reproductions that are not too expensive.

To a great extent, the creation of a personal image of the human body consists of the formulation of questions and the search for answers. Questions such as, what is a proper shape for the rib cage from all aspects? Where should the high points of the pelvis be placed? What is a convenient proportional relationship for the carpus and the rest of the hand? Most works on artistic anatomy will give you varying answers, but Richer will answer all your questions precisely. And you can always rely on his knowledge and his taste.

I should like to thank my dear friend Mary Lyon for the help and advice she gave me. And I should like to offer my appreciation to my brilliant student Heather Meredith-Owens. As my editor, she has had the difficult and detailed task of checking the anatomical nomenclature used in this book, of preparing the anatomical plates, and finally, of bringing this book to press.

Robert Beverly Hale

Preface

I feel sure that it is not necessary for me to explain here why studying anatomy is important for all painters or sculptors who have to recreate all the varied aspects of the human figure in their work. Although it used to be a debatable issue, it is no longer.

"Anatomy" Gerdy said, "increases the sensitivity of the artist's eyes and makes the skin transparent; it allows the artist to grasp the true form of the surface contours of the body because he knows the parts that lie hidden beneath a veil of flesh." It is as though anatomy were a magnifying glass, making forms visible in minute detail. Through this glass the artist is able to see more clearly, and more quickly. As a result, he can render forms with greater fidelity; they have become distinct to his eyes because they are clear in his mind.

In fact, this is only another way of stating the same principle that Montaigne formulated: "It is the mind that listens, the mind that sees." Peisse, too, made the same point when he said: "The eye sees in things only that which it has observed; it observes only that which is already an image in the mind."

When a knowledge of anatomy is applied in the plastic arts, it leads to an understanding of exterior form through the relationship that exists between it and the underlying forms. Studying anatomy teaches the artist why the exterior forms of the body appear as they do, in action and in repose.

I have undertaken this work with the object of easing the path of artists in these highly specialized studies; they are always long and arduous. Its aims may be summed up as follows. First, to place paramount importance on the drawings—almost literally replacing verbal description with graphic—so that the entire work is encompassed in the plates. The text is to be considered merely as an accompaniment to the plates. Second, to follow, in order of the plates, the same analytical method as in the development of the text; proceeding, that is, from the simple to the complex, from the known to the unknown, from the part to the whole.

To facilitate these studies, all necessary caption information has been inserted beside the figures rather than grouped remotely at the bottom of the page.

However, an effective, articulate treatise on anatomy should go further. It should not consist solely of a series of reasonably clear anatomical drawings with a written summary of descriptive anatomy. Such a work should establish relationships, down to the smallest detail—relationships between the deep forms and the surface con-tours, relationships between the artistic concept and the figure itself. This means that the nude subject should be studied exhaustively, and drawn repeatedly from life.

I have concluded, therefore, that there is room for another work on anatomy in addition to the books already available to artists. (The most highly esteemed of these, and for good reason, is that of Mathias Duval.) The work which I have undertaken contains more than the usual number of illustrations, and besides the anatomical description, it contains a quite separate study of exterior form.

This book, then, is divided into two parts: the first, *anatomy*, is devoted to detailed anatomical studies; the second, *morphology*, to the study of exterior form.

The first part examines the bones, the joints, and the muscles. It ends with a description of certain superficial veins and a most important study of the skin and the layer of fatty tissue which underlies it.

Throughout the anatomical part, man is shown standing erect and motionless, eyes front, arms alongside the trunk with forearms in supination, palms facing forward and feet together, touching. This attitude has become a convention used in anatomical study.

It is in this attitude that anatomists have always described the human figure, and it is this attitude that has created terms and a certain nomenclature that are universally accepted today. We can scarcely alter this now.

The plates, therefore, represent man in this conventional attitude. They are drawn from the two basic points of view: anterior or posterior, and in profile. For academic reasons, all intermediate points, such as a three-quarters view, have been avoided. Finally, the plates adhere as far as possible to what in descriptive geometry is called "orthogonal projection." All perspective is thus eliminated with the consequent inevitable distortions. If the drawing suffers from an artistic point of view, much has been gained in clarity, it seems to me, and clarity is our main objective.

In the osteological plates, the bones are first seen one by one, independently of their relationship to each other. The description of a joint follows the explanation of the bones that form it; this is accompanied by sufficient physiological information to make clear the mechanism of the articulation. Then the effect of bone structure on the outer form is explored. To this end, a special paragraph is devoted to each major region of the body.

Further, in the osteological plates, bones are recorded in full detail. This holds true also for the plates on the

muscles. On the whole, these studies are carried much further here than is customary in the works on anatomy for art students.

In the plates devoted to myology, the first drawings concern the deepest muscles, those resting directly on the skeleton. The middle layers follow, progressing logically outwards to the superficial muscles. The student will thus observe the skeleton "clothing" itself, so to speak, with the successive thicknesses of muscle, from the center to the periphery. This will fully reveal to the student all that constitutes the true mass of the body and will enable him to render its outer form with accuracy. The exterior shape can hold no mystery for one who has studied the underlying forms.

It is of the utmost importance to study the deeper muscles; at times these may influence the surface form more than the superficial muscles, especially in the performance of certain movements.

In the text which accompanies the plates on myology—and following the established plan—each muscle is described separately. Its precise origins and insertions are given, its shape, its volume. That part of the muscle which contributes to the exterior form is carefully indicated.

Thus understood, the anatomical section of this work already has supplied numerous hints as to the *raison d'etre* of certain exterior forms. But, as I have said, this constitutes only half of the task we have undertaken, namely, to present an analysis of form. It therefore becomes necessary, in the second section of the book, to reestablish a synthesis of form.

The second part of the book was conceived according to certain principles which I shall explain briefly. I am among those who think that science has nothing to teach the artist concerning the direction of line, or the aspect of a surface. An artist worthy of the name is uniquely endowed to grasp the form instantly, instinctively, to judge it and then to interpret it. I should add that, as with form, so with color. Each artist, according to his temperament, has a vision which is his alone. Thus the artist cannot demand of anatomy that it provide him with unique ideas, beautiful surfaces, majestic lines, and voluptuous contours.

On the contrary, the anatomist should avoid esthetic considerations as superfluous. With total detachment, in the interest of his art, he should confine himself to portraying nature, live, and exactly as it is in its exterior form and its deeper parts. He should seek not so much to describe as to demonstrate, to explain, showing cause and effect. For this he needs only two qualifications: clarity and precision.

With this in mind, and following the example of Gerdy, I have divided the human body into regions and defined these different areas in a special terminology which explains their morphological details, their planes and depressions. This was necessary in order to simplify and clarify this entire study. It allows the same part in different models to be compared, or the same part on one model in different positions. One can see how useful this plan is in defining the limits, for instance, of the several areas of the trunk.

In the plates depicting the nude, the first anatomical illustrations (Plate numbers 74, 74, 76), show the human body (male) in the conventional attitude. They present the entire body, from three points of view, providing a true topography, or "contour map," of the human form. In the other plates, large segments of the body are presented separately, facilitating the study of the different regions in minute detail. Furthermore, there are sketches in the text itself comparing the morphology of the human body in male and female.

In the second series, the plates demonstrate the changes in the exterior form brought about by different movements. This is an exceedingly important part of the work as a whole. In fact, it might be said that all the preceding plates have been leading up to them.

Since it is impossible to represent all the movements of the body in their almost infinite variety, it was necessary to make a choice and proceed through analysis. Combined movements may be broken down to movements of diverse parts. These last have been stressed. In short, the movements of each part, however varied they may be, can quite easily be reduced to a few. These constitute the basic, elementary movements of which the others are but combinations.

Thus only the elementary movements of each part of the body need be represented because it is always through one, or several, of these movements that the entire body is portrayed in action.

Accordingly, for the movements of the head and neck, there are four drawings showing flexion, extension, rotation, and rotation and lateral inclination.

For the trunk, I have first shown the effects of moving the shoulder and the arm; then the movements of the trunk on itself which resolve themselves into four principal motions: flexion, extension, rotation, and lateral inclination.

As for the arm, its movements have been studied in particular detail and shown in four different positions: in supination, in pronation, in semi-pronation, and in forced pronation. Flexion of the arm is shown in its various degrees.

The plates devoted to the leg show it in extreme flexion and moderate flexion, the foot lifted or on the ground.

In order to further the analytical process, the plates described above are supplemented by anatomical sketches in the text. Moreover, there is text corresponding to all the plates on exterior form. This text, besides explaining the morphology, includes a study of movement itself, detailing the displacement of various bones in action as well as the powerful musculature brought into play.

Finally, the work ends with a study of the proportions of the human body. In conclusion, I owe the reader a few words of explanation concerning the morphological drawings. But first I should like to assure him that I have never presumed to offer artists what purports to be the perfect model of exterior form.

The matter of the form itself is therefore entirely optional. I feel impelled here to define clearly the role which I have assumed: it is purely that of purveyor of information.

The drawings were made from life and, after careful research, from two models (one served for the torso, one for the limbs). They were chosen not according to any

esthetic formula, but for reasons of clarity and academic method. Their bodies provided fine skin, powerful musculature, an almost complete lack of fatty tissue. Their forms were not by any means simple, but they were very clear-cut, made to order, for study and demonstration. Once familiar with these forms, one should be able to recognize them in other models who may perhaps be younger, fatter, or simpler but more "difficult to read."

To sum up, my aim has been to put in the hands of artists a manual which is entirely technical, which will not attempt to tell them how to choose a model but will tell them how to read and understand a model when they have chosen one.

And now a few words to doctors for whom this book also is intended, even though it is primarily for artists.

Long ago Gerdy became aware that anatomical knowledge of the surface forms of the human body might well be of value to surgeons. "The exterior forms," he said, "show what is hidden within the depths of the body by what is visible on the surface."

However, there is another point I must bring out which should be of interest to physicians as well as surgeons. It is the incontestable value of a precise understanding of the normal exterior form. Only in this way, in the course of a diagnosis, can a doctor recognize any abnormality that results from disease. Dr. Jean-Martin Charcot, with all the authority attaching to his eminent position, recently told an audience at the Salpetriere:

"I must emphasize strongly the importance, in matters of neuropathology, of examining the patient in the *nude*, whenever the susceptibilities of the moral order do not oppose it.

"In fact, gentlemen, we doctors ought to know the nude as well as or even better than do the artists. If a sculptor or a painter makes a mistake in drawing it is a serious matter, no doubt, from the point of view of art. But from a practical standpoint it is of no consequence.

"But what about a doctor, a surgeon, who mistakes— and this happens often—a prominence, a normal contour, for a deformity? I hope this digression will serve once more to stress the need for medicosurgical study of the nude by both physician and surgeon."*

In order to profit from an examination of the pathological subject it is necessary to know the normal nude thoroughly. Nevertheless, this is a study somewhat neglected by doctors. Actually there exists, among us doctors, a sort of prejudice which allows us to consider the anatomy of forms as an elementary science which we gladly abandon to the artists; we assume the doctor already knows enough about it.

Indeed, the anatomist who has often visited the amphitheaters and watched the scalpel explore the cadaver in every possible way, inside and out, can convince himself, and with every appearance of reason, that he knows human morphology even though he has not studied it specifically. Having neglected not even the smallest organ or tissue, he believes that the knowledge of exterior form is implicit with this accumulation of anatomical insight. However, this is an illusion. I have seen distinguished anatomists show confusion in the presence of the living nude, searching memory in vain for the anatomical cause of a certain unexpected bulge or prominence which, in fact, was perfectly normal.

But this is easy to explain. The study of the corpse cannot offer what it does not have. Dissection, which reveals all the hidden areas of the human machine, does so at the cost of destroying the exterior form. Death itself, from the first hour, brings on the final dissolution. Through the subtle modifications that occur then, throughout all the tissues, the exterior appearance is profoundly altered. Finally, it is not from the inert corpse that one grasps the incessant changes with which life, in its infinite variety of movement, imbues the entire human body. It might even be desirable to arrange, in our anatomical amphitheaters, the study of the living model in conjunction with that of the cadaver. This could well prove useful.

As a matter of fact, the anatomy of exterior form can only be studied from the living model. It is true that it is based on ideas provided by the corpse and its dissection, but these must be supplemented by observation of the living model.

The procedure is synthesis; its method is observation. To observe is to discover the multiple causes of the forms that make up the living human body and to capture this in a description. The living form asks only to be studied in itself and for itself. It provides the awareness that conventional anatomy cannot.

It is fitting that I should record here my deep indebtedness to Dr. Jean-Martin Charcot, the great master, for his encouragement and advice given generously throughout the course of this work, which was carried on in the laboratory of the Salpêtrière.

I am also grateful to Monsieur Le Bas, director of the Salpêtrière, from whom I have, once again, received warm cooperation; also to my good friend, Dr. Paul Poirier, chief of anatomical studies of the Faculty of Medicine. Without reserve he has put at my disposal his anatomical knowledge and the incomparable facilities of the amphitheaters of which he is director.

Paul Richer

Paris, July, 1889

* *Leçons du Mardi*, Oct. 30, 1888.

Part One
ANATOMY

This section of the book comprises the study of the bones (osteology) and the joints (arthrology); the study of the muscles (myology) as well as some observations on the superficial veins; finally, a study of the skin and the fatty tissues lying beneath it.

1. Osteology and Arthrology

Of all the components of the body, the bones have the greatest solidity and stability. The bones are the means of support and protection for the softer parts of the body. In the living, a fibrous membrane called the *periosteum* adheres to the bones except at the points of attachment to the tendons and ligaments and to the articular surfaces where cartilage is substituted. All this has been removed from bones that have been prepared for study.

CLASSIFICATION OF BONES

Anatomists divide the bones into three classes, according to their shape. First, the long bones—those in which length surpasses other dimensions. These have a shaft and two extremities. Examples: the humerus, the femur. Second, the large or flat bones—those which have a considerable extent as compared with their thickness, such as the shoulder blade or coccyx. Third, the short or mixed bones, that is to say, those which are neither long nor large, such as the vertebrae and those of the carpus or the patella.

For easy description, the bones are compared to geometrical solids. One considers their surface, their angles, and their sides. The exterior configurations are comprised of the general shape, the projections, and the cavities. The projections take on the aspect of lines, crests, tuberosities, and spines. The cavities are simple depressions, holes, grooves, sunken curves and so forth. The projections, like the cavities, are articular or non-articular, depending upon whether they do or do not form a joint.

SUBSTANCE OF BONES

To the naked eye, the bone presents a compact and a spongy substance. The *compact substance* forms a sort of crust, more or less thick, on the exterior of all bones. In this compact mass of the bone, cavities are scarcely perceptible. The *spongy substance* is formed of reticular layers of spicules and lamellae surrounding the irregular cells which intercommunicate with each other. This osseous substance is found in the interiors of bones, especially the short bones and at the extremities of the long bones, although the bodies of the long bones are formed almost completely of compact tissue. At the center of the bones is a sort of cavity or canal for the marrow.

In the interior of the bones, filling the canal, is a soft substance which constitutes the *bone marrow*. Marrow is composed of cellular tissue and fat and is reached by blood vessels which pass through the wall of the bone.

On the outside, the bones are covered by a membrane of tendinous fibers called the *periosteum*, and by a layer of special tissue called *cartilage* which we shall study later. Cartilage covers those parts of the bones which come together to form articulations; the periosteum covers the rest.

Cartilage is much softer than bone and has great elasticity. When cartilages are fresh they have a bluish-white tint, when they are dry they become yellowish, transparent, and brittle. Free cartilage, such as the cartilage of the ribs, is covered by a membrane analagous to the periosteum called the *perichondrium*. Cartilage with an intermixture of fibrous elements is called *fibrocartilage*.

All the bones, supplemented by cartilage, are joined together to form the framework of the body. This is called the *skeleton*.

ARTICULATION OF THE BONES

The study of the joining, or articulation, of the bones, accomplished in various more or less complicated ways, is called *arthrology*. The degree of "give" or movement of the bones within an articulation, one against another, is highly variable. The several types of articulation fall into three categories: the *sutures* or *synarthroses*, the *symphyses* or *amphiarthroses*, and the *diarthroses*.

Sutures. In sutures, the bones are fastened together by an intermediate mass of fibrocartilage. The periosteum is continuous from one bone to another, rendering the articulation immovable.

Amphiarthroses. In the *amphiarthroses* or *symphyses*, the contiguous bony surfaces are covered with cartilage; the ligamentous mass between them is much thicker than in the sutures, allowing a certain mobility for the bones in contact. Sometimes this connecting mass is filled out, sometimes it is hollowed out to form one, or even two, cavities.

Diarthroses. The *diarthrodial* articulations are the most complex. The contiguous bony surfaces are covered with a thin layer of *articular cartilage*, at the periphery of which the periosteum stops. They are connected by a fibrous element, shaped like a sleeve, and reinforced on the exterior by peripheral ligaments. The inner surface of this is lined by the *synovial membrane*, composed of a

continuous layer of epithelial cells. The bony extremities are in close contact so that the articular cavity is reduced to almost nothing. It is filled with a fluid which is secreted by the synovial membrane to facilitate the sliding action. In the case of the articular bony surfaces which are not contiguous, they are separated by a fibrocartilaginous ligament fastened, in turn, to the peripheral ligaments whose purpose is to adjust this discrepancy, adapting each of its surfaces to the bony part they control. The articular cavity is thus divided in two, each half provided with a synovial membrane.

OSSIFICATION OF THE BONES

In the foetus, the skeleton is at first entirely cartilaginous. Ossification—that is, the transformation of cartilage into bony tissue—takes place progressively and starts at several points in each bone. The ossified portions spread and eventually merge so that all trace of their cartilaginous origin disappears.

In the new-born, the skeleton is still mostly cartilaginous and it is due to the cartilaginous nature of this tissue that the growth of the bones is possible. It is not until the age of about twenty-five that growth stops and ossification is complete.

INFLUENCE OF BONES ON FORM

The study of the bones is the basis of all anatomy. From the standpoint of the morphological approach, which is our principal objective, it is of no less fundamental importance. It is the bones and their rigidity that give the body its proportions. By the stability of their subcutaneous projections, they make possible exact measurements. Even when the bones are deeply situated, they often determine the general form of a particular region. When they are superficial, they play a direct part in creating the actual exterior form. The shape of the articular extremity of any particular bone indicates the direction and the limitation of the movements allowed by their articulation. Finally, their relationship to the muscles, whose extremities are almost all attached to bones, makes a profound knowledge of the bones necessary to understand myology.

In the study that follows, the bones are not separated from their joints; their articulations are described along with the parts of the skeleton that make them up.

2. The Skeleton of the Head

I shall not describe separately all the bones anatomists consider to be distinct pieces which, taken together, compose the skeleton of the cranium and the face. These bones, which number eight for the cranium, and fourteen for the face, are as follows:

Bones of the cranium: one frontal, two parietal, two temporal, one occipital, one sphenoid, one ethmoid.

Bones of the face: two maxillary, two palatine, two nasal, one vomer, two inferior nasal conchae, two lacrimal, two zygomatic, one mandible.

Except for the mandible, however, all these bony parts are so closely fused together that it would be impossible for any one of them to perform the slightest independent movement. The skeleton of the head is, therefore, a single bone structure; it can be considered as a whole complete form by itself, or even as a single bone artificially divided by anatomists for purposes of description.

Be that as it may, the anatomy of form need not go into the complex details of the head. It can quite simply consider the skull as two distinct pieces: one, the cranium and upper part of the face; two, the lower jaw or mandible.

CRANIUM AND UPPER PART OF THE FACE

The cranium is a sort of bony box, irregularly ovoid in shape. It stands at the top of the vertebral canal and opens into it. In fact, it has been quite correctly regarded as an enlargement of the vertebral canal. The cranium encloses the brain, just as the vertebral column encloses the spinal cord, which is itself but an extension of the brain. It forms the superior and posterior parts of the head. From its anterior part the bones of the face are suspended, crowned by the forehead, or frontal bone, which closes the front of the cranial cavity.

Behind the bones of the face, on the under side of the skull, a vast orifice (*foramen magnum*) opens up, connecting the cranial cavity with the vertebral canal; the cervical column reaches as far up as the cranium, behind the skeleton of the face.

To make description easy, let us consider the skeleton of the head from its various aspects: the anterior, the lateral, the posterior, the inferior, and the superior.

ANTERIOR ASPECT (PLATE 1, FIGURE 1)

The entire superior front part of the skull is formed by the frontal bone. From our special point of view, the following characteristics are important.

In very young subjects, the frontal bone is divided from top to bottom on the median line by a denticular suture which generally disappears toward the age of two years; at that period, a complete fusion of the two halves of the bone has taken place. It is not unusual, however, to find traces of this suture in individuals of a more advanced age.

On each side, toward the center of the bone, lie two symmetrical bumps (*frontal eminences*) marking the points of ossification of the two halves. These eminences, most noticeable in infancy, are exaggerated in craniums deformed by rickets.

Above the root of the nose there is a small median protuberance at the same level as, and corresponding with, the frontal sinus. This is the *nasal eminence* but, because of the shape of the surrounding muscles, it becomes a depression in the living. Two elongated protuberances which support the eyebrows (*superciliary arch*) extend laterally and obliquely upward from the nasal eminence. Below these are two curving borders, the *supraorbital margins*, which terminate the frontal bone in this region. These orbital margins are joined at their extremities with other bones of the face in the following manner: their external extremities (*external orbital apophyses*) unite with the superior angles of the *zygomatic bones*; their internal extremities unite with the ascending processes of the superior maxillary. Between the two internal orbital apophyses, or processes, are the nasal bones.

The nasal bones are two small osseous pieces which lie very close against the median line, forming the root of the nose. At their inferior borders they articulate with the lateral cartilages of the nose.

The *superior maxillary* bones form the entire median portion of the skeletal face. They are symmetrical, fused on the median line, and contribute to the formation of the orbital cavities, the nasal cavity, and the buccal, or oral, cavity.

The median portion of the superior maxillary provides for the insertion of a great many of the facial muscles; the body of the bone is hollowed so that a groove connects it with the nasal cavity fossae. Four processes extend from this central point: above, the rising frontal process which, with the nasal bones, surround the anterior orifice of the nasal cavity; on the outside, the zygomatic processes which are joined to the zygomatic bones; below, the alveolar process shaped like a horseshoe and containing sockets for the teeth. And last, inside and extending transversely toward the back, are the palatine processes which join medially to form the vault of the palate.

The zygomatic bones define the sides of the frontal aspect of the face. Shaped like a four-pointed star, they

complete the orbital orifices. The superior angle rises to the external orbital process of the frontal bone. The anterior angle runs along the orbital edge toward the superior maxillary. The inferior angle articulates with the zygomatic process of the superior maxillary. And the posterior angle supports the zygomatic process of the temporal, thus forming an arch which we find repeated on the lateral aspect.

The only independent bone of the skull, the inferior maxillary, or mandible, completes the skeleton of the face. More on this later.

The different bones of the head surround the cavities which hold several of the sensory organs. These are the nasal and the oral cavities. The orbits are the cavities which hold the eyes. They are situated on each side of the median line, separated by the nose, directly beneath the cranial cavity. Each one is cone-shaped, like a four-sided pyramid of which the base is pointing to the front.

This base, surrounded by the bones described above, is shaped like a square with rounded corners and four margins. The lateral margin is almost vertical and is situated on a plane behind the internal margin. The other two, superior and inferior, run at a slightly oblique angle from within to without, from above to below. The superior external angle shelters the lacrimal gland. At the inferior internal angle the superior orifice of the *nasal canal* is situated.

The four walls of the orbit correspond with the four margins. The walls are formed not only by the bones already described, but also by others which lie deeper in the skull and are of little importance to artists. I shall merely say that the internal wall is situated on the vertical anteroposterior plane, while the outer wall is obliquely inclined toward the outside.

The summit of the orbital cavity, directed upward and inward, has a number of small openings leading to other deeper cavities. Most important is the optic foramen, through which the optic nerve passes. The orbits are subject to marked differences in conformation depending on the individual subject.

The nasal cavities, lying between the orbits, are much more extensive than the anterior orifice suggests. Above, they rise as far as the frontal bone, below they descend as far as the root of the palate, in the back they open into the throat. In addition to these bones the nasal cavities are formed in large part by a bone deeply situated and called the *ethmoid*. They are separated by a vertical partition on the median line; this is a single bone: the *vomer*. The anterior opening of the nasal orifice has been compared to the heart on a playing card, in reverse. We have already named the bones which encircle it. On the median line of the inferior part the nasal spine is situated.

POSTERIOR ASPECT (PLATE 2, FIGURE 2)

The posterior view shows the back of the great ovoid of the cranium, formed by the junction of three bones: above by the two parietals, below by the occipital.

LATERAL ASPECT (PLATE 1, FIGURE 2)

On the side view all the features of the skull which we have been examining from the front are shown in profile. The prominence of the nasal bones and the inferior nasal spine are clearly defined. The orbital orifice becomes an irregular line. The zygomatic bone presents details merely glimpsed from the front view; its posterior angle articulates with a long process from the *temporal bone*. This forms a solid, bony arch, the *zygomatic arch*.

The temporal bone is at the center of this region. Toward the middle of the temporal bone the external orifice of the auditory canal can be seen and descends into the massive portion of the bone. In front and below, the *styloid process* descends in an oblique direction. The mastoid portion of the bone reaches behind to the occipital bone where it ends below in the rounded *mastoid process*, always clearly visible under the skin behind the ear. Immediately above and in front of the auditory orifice the zygomatic process begins and, with the zygomatic bone, it forms the zygomatic arch described above. All the superior part of the bone is thin and forms the *squama*. This is shaped like an oyster shell; it is joined to the parietal bone in an irregular curve.

Above the squama of the temporal bone, the parietal forms the roof of the cranium. Toward its center there is a considerable eminence, *parietal eminence*, and near its lower edge there is a curved line which, above and behind, delineates the *temporal fossa*. In the front on the profile, and at the back of the occipital, the frontal bone appears. This will be described in detail later.

Toward the middle of the lateral view of the cranium lies a hollow, shallow above and in back, deep below and in front. This is the *temporal fossa* which is bounded above by the curved temporal line of the parietal and the line of the frontal. The temporal fossa is limited in the front by the orbital process of the zygomatic bone; it is limited below by the zygomatic arch.

The temporal fossa is seamed in various directions by sutures which mark the points of juncture of those bones which combine to form it. Among these, at the anterior part, is the great wing of the sphenoid bone.

INFERIOR ASPECT (PLATE 2, FIGURE 3)

All the inferior part of the skeleton of the head (minus the lower jaw) is called the base of the cranium. Although it is quite hidden by the soft parts of the neck, its most important characteristics should be pointed out briefly. The occipital takes up half of the posterior and median part of the cranium. The bone presents a great orifice, *foramen magnum*, which enables the cranial cavity to communicate with the spinal canal. In front of this orifice is the *basilar part*, the thickest portion of the occipital, which is joined with other bones to form the base of the cranium. On the sides, in the anterior part, two oblong, protruding surfaces articulate with the atlas; these are the condyles. In the back, the bone is thinnest and it is marked on the outside by roughnesses for the insertion of the neck muscles. This sometimes shows as a depression on a model. On the median line, the *external occipital protuberance* is connected with the foramen magnum by the *median nuchal line*. At the sides there are two curved lines reaching to the extremities of the bone. One is the *superior nuchal line* which, on the flayed figure, marks the separation of cranium and neck; the other is the *inferior*

nuchal line which is surrounded and hidden by muscular insertions.

The occipital is wedged, so to speak, between the two temporal bones, of which the petrous portion converges on each side of the basilar part of the occipital. Further to the outside the mastoid process appears; it is marked, within and below, by the mastoid notch.

The anterior half of the base of the cranium is not situated at the same level as the posterior half which we have just described.

Finally, I should point out the zygomatic arch which appears completely detached. Its posterior extremity contains a depression, the *glenoid cavity*, which serves as the point of articulation for the mandible. The glenoid cavity is bordered in front and outside by a process from which the zygomatic arch originates. This process is transverse and rounded; it plays an important part in the temporomaxillary articulation.

SUPERIOR ASPECT (PLATE 2, FIGURE 1)

Viewed from above, the cranium manifests its ovoid shape, formed in front by the frontal, on each side by the parietals, and in back by the occipital. These diverse bones are finely and irregularly united at their borders in a most solid fashion. The places of junction form the sutures which are at times visible on the scalps of bald people. These sutures are three in number: in front, the *coronal suture*; in the middle, the *sagittal*; and in the back, the *lambdoidal*.

THE MANDIBLE (PLATE 1, FIGURE 1 and 2)

The mandible has the form of a horseshoe though its two ascending branches (*rami*) form a right angle with the body which is the middle part.

The body, flattened from the front to the back, carries the teeth on its superior border. Its inferior border, rounded, is prominent under the skin of thin subjects and its middle part supports the chin. Its anterior aspect shows the oblique external line, directed backwards as if to join the front border of the corresponding ramus. On its posterior surface one might note four little tubercles (*mental spines*) on the median line, and on the sides an oblique line (*mylohyoid line*).

The rami are quadrilateral and present two faces and four borders. On the internal surface near its middle is the *mandibular foramen*, limited on the outside by a bony projection. Its external surface is roughened for the insertion of the masseter muscle. The superior border is formed by two processes separated by the *mandibular notch*. The anterior process (*coronoid process*) thin and triangular, gives attachment to the temporalis muscle. The posterior process or *condyle* is an oblong projection, and its long axis is perpendicular to the plane of the ramus. It is supported by a thin neck which articulates with the glenoid cavity of the temporal at the base of the cranium. The anterior border is grooved; the rounded posterior border forms an obtuse angle with the inferior border (*inferior maxillary angle*). This angle varies strongly with age. In the foetus the rami are but prolongations of the body, the angle only appears toward the third month of intrauterine life. Children have a most open angle; in adults it is about 120° on the average, although at times it approaches a right angle.

TEMPOROMANDIBULAR ARTICULATION (PLATE 6, FIGURE 1 and 2)

The temporomandibular articulation is a double condyloid articulation and includes an articular disk.

The articular surfaces are, on one aspect, the condyles of the mandible and, on the other, the glenoid cavities of the temporal with the transverse eminence of the zygomatic process which takes equal part in the articulation.

The articular disk, thick at its borders and thin in the center, elliptical in shape, presents different curves on its two faces. Above, it is alternatively convex in the part corresponding to the glenoid cavity and concave in respect to the transverse eminence of the zygomatic process; below, it is concave where it is applied to the condyle of the mandible. The articular disk is not horizontal but strongly drawn down below and in front. Connected to the condyle by fibrous bonds, it is displaced from it in certain movements of the joint.

Ligaments. These are three in number. The *lateral ligament* designates those fibers which come from the periphery of the glenoid cavity and go to the neck of the condyle and the posterior border of the ramus. The *internal lateral ligament (sphenomandibular)* comes from the spine of the sphenoid and divides itself into two bundles; the shortest one, at the back, going to the internal part of the neck of the condyle, the other, to the lingula mandibulae. Finally, the *stylomandibular ligament* runs from the styloid process to the angle of the jaw. The synovial membranes are double, the upper thick, the lower more compact.

Mechanism. The movements of the lower jaw are of three types. First, the movement of lowering and raising (opening and closing of the mouth). This movement consists of a combined double action taking place above and below the articular disk. In the superior articulation, the disk with the condyles is displaced and carried ahead under the articular tubercle; from being oblique below, the disk is able to become transverse and even oblique above. In the inferior articulation, the condyle rolls in the cavity of the disk. The jaw is thus carried forward and completely lowered, the condyle turning about a fixed axis which passes through the mandibular foramen. In this movement, the relief formed by the condyle of the mandible in front of the ear can be seen moving backwards and forwards, leaving a strong depression in the place which it had occupied when the mouth was closed.

Second, movements forward and back. These movements, which may consist of the total movement of the jaw to the front, in such a fashion that the lower teeth may place themselves in front of the upper, take place only through the superior articulation and constitute the displacement described above.

Third, lateral movements. In this case the movements differ in the right and left articulations: one condyle rolls in its cavity while the other describes an arc of a circle around the first and places itself under the articular tubercle.

3. The Skeleton of the Trunk

We will study successively the vertebral column, the thorax, the bones of the shoulders and the pelvis.

VERTEBRAL COLUMN

The vertebral column is formed of the vertebrae, the sacrum, and the coccyx. The vertebrae, twenty-four in number, are called true vertebrae, as opposed to the false vertebrae which compose the sacrum and coccyx.

TRUE VERTEBRAE

According to their regions, the true vertebrae are divided as follows: seven cervical, twelve thoracic, and five lumbar. Besides common characteristics, they have characteristics peculiar to each region. Certain vertebrae have unique characteristics.

CHARACTERISTICS COMMON TO ALL VERTEBRAE

Each vertebra is a ring of which the anterior part, formed by a massive enlargement (*body*), communicates with the posterior part, usually thinner (*a vertebral arch*), thus forming an orifice (*vertebral foramen*), which contains the spinal cord.

From the vertebral arch originate several bony prolongations or processes, directed in various ways: in back and in the middle, the *spinous process*; on each side and somewhat transversal, the *transverse processes*; also on the sides, above and below, four *articular processes*. The *superior* and *inferior*, two on each side. Very near the body, the vertebral arch becomes narrower (*the pedicle*). The superior and inferior parts of the pedicle are depressed and form, with the depressions of the other pedicle above and below, a channel for the passage of nerves which emanate from the spinal cord. The parts of the arch immediately outside the spinous process are generally thin and are called *laminae*.

DISTINCTIVE CHARACTERISTICS OF VERTEBRAE

All the common characteristics previously described assume a particular disposition according to the region in which they are located, and we shall describe them briefly. The same order of description will be followed in each region to make comparison easier. The distinctive characteristics of vertebrae not encountered to the same degree in all the vertebrae of a similar region will thus be classified. However, the central vertebrae possess the common characteristics to the highest degree and these characteristics attenuate at the extremities of the vertebral column through a gradual transition from region to region.

CERVICAL VERTEBRAE (PLATE 3, FIGURE 1)

The *bodies* are small. They are enlarged in the transverse direction. On the sides and on the superior parts, they are furnished with little vertical ridges and on the inferior parts with corresponding depressions.

The *vertebral foramen* is triangular. The *spinous process* is horizontal, grooved below and double pointed at its extremity. The *articular processes*, inclined at a 45° angle, are situated behind the transverse processes. The superior face above and behind, the inferior below and in front. The articular facets are almost flat. The *transverse processes*, situated on the sides of the bodies, have a superior groove, are double pointed at their extremities, and pierced by a hole at their base. Their *superior notches* are deeper than the inferior ones.

DORSAL VERTEBRAE (PLATE 3, FIGURE 2)

The *bodies* present on their lateral aspects two demifacets for the articulation of the ribs, the one superior, the other inferior.

The *vertebral foramen* is small and oval. The *laminae* are high and straight. The *spinous process* approaches the vertical; it is long, triangular, with one tubercle at the end. The *articular processes* are vertical, flat. The articular facets are almost planes, the superior ones are directed backwards and without, the inferior ones forward and within. The *transverse processes*, very large, are twisted to the back and swollen at their ends. In front they present articular facets for the tuberosities of the ribs. The *superior notches* are scarcely present, while the inferior ones are very deep.

LUMBAR VERTEBRAE (PLATE 3, FIGURE 3)

The *body* is very large. The *vertebral foramen* is triangular. The *laminae* are thick and straight. The *spinous process* is strong, directed transversely, rectangular in shape, with one tubercle at the summit. The *articular processes* are vertical. The superior ones have concave facets directed backwards and within and are furnished in

back with a tubercle; the inferior ones have convex facets, looking out and forward. The *transverse processes* are rib-like and slender. The *inferior notches* are more pronounced than the superior.

SPECIAL CHARACTERISTICS OF PARTICULAR VERTEBRAE

In each region, vertebrae which are distinguished by particular characteristics are those which are situated close to a neighboring region. Examples are the seventh cervical vertebra, the first dorsal, the last dorsal, and the fifth lumbar. They are thus, in a sense, vertebrae in transition, possessing characteristics of both regions. We will not dwell on them here. But there are two other vertebrae which merit our attention. These are the first two cervical vertebrae, of which the conformation plays a special role both in the static and moving head.

FIRST CERVICAL VERTEBRA OR ATLAS (PLATE 4, FIGURE 1)

The body is replaced by a transverse arch (*anterior arch*) which presents in front a blunt tubercle (*anterior tubercle*), and in back a concave facet which articulates with the odontoid process of the axis.

The *foramen* is large, to be filled in front by the odontoid process of the axis. This process ought to be considered as the actual body of the first cervical vertebra although it is fixed to the second. The *spinous process* is lacking; it is replaced by a rudimentary tubercle, the *posterior tubercle* of the atlas. The *articular processes* are massive; they form what are called the lateral masses of the atlas. Their superior surfaces, long and concave, articulate with the condyles of the occipital; their inferior surfaces, oblique and somewhat flat, articulate with the axis. The *transverse processes* have but one tubercle at their ends; they are pierced by a hole at their bases and are situated outside of the lateral mass.

The superior *notch*, in back of the superior articular process, continues on the outside with a horizontal canal which leads to the base of the transverse process. There is no inferior notch.

SECOND CERVICAL VERTEBRA OR AXIS (PLATE 4, FIGURE 2)

The body of the axis is surmounted by a long process (*odontoid process*) narrowed at the base (neck of odontoid process) and offering two articular surfaces—the one in front for the arch of the atlas, the other in back for the transverse ligament.

The *vertebral foramen* has the form of a heart in a pack of cards. The *spinous process* is heavy and has the characteristics of its region. The *superior articular processes* are circular and their superior articular surfaces face above and without. The *transverse processes* are small and there is only one tubercle at their summit. They are hollowed by a groove. There are no superior notches.

SACRAL VERTEBRAE, OR SACRUM (PLATE 4, FIGURE 3)

The sacrum is formed by the joining together of five vertebrae, and although they are deformed to a certain degree, it is still possible to distinguish the parts we have pointed out. The sacrum is, therefore, a single bone, large, flattened, its surfaces curved, of triangular form.

Its *base*, or superior portion, turned up and to the front, suggests somewhat the superior aspect of a lumbar vertebra. One finds here, in front and at the center, the oval superior surface of the body of the first sacral vertebra; immediately behind, the triangular superior opening of the sacral canal; behind and on the sides, the superior articular processes and the notches; finally, completely to the outside of the oval surface, two smooth triangular surfaces.

The *inferior apex* is truncated and presents an oval facet which articulates with the coccyx.

The *anterior surface* is concave and looks down. It presents, across the median line, four transverse ridges whose length diminishes progressively from top to bottom. These trace the unions of the five false vertebrae whose fusion forms the sacrum. Laterally these transverse ridges lead into large openings, the *anterior sacral foramina*.

The *posterior aspect*, which is subcutaneous, is divided by the *sacral crest* formed by the spinous processes of the sacral vertebrae; it ends at the bottom with an opening (*sacral hiatus*) bordered by two little processes (*sacral cornua*). On each side are four *posterior sacral foramina*, limited on the outside by rough tubercles.

The *sacral canal*, which runs through the thickness of the bone, terminates the spinal column; it travels from the base of the sacrum to the inferior end (*sacral hiatus*). The sacrum is much larger in women than in men.

COCCYX (PLATE 4, FIGURE 3)

The coccyx (*os coccygis*) is usually formed of four rudimentary vertebrae diminishing in size from above to below and terminating in a bony nodule. The first vertebra presents a rudimentary transverse process and two small vertical prolongations (*cornua*) which articulate with the sacral cornua.

ARTICULATIONS OF THE TRUE VERTEBRAE (PLATE 6, FIGURE 6 and 7, and PLATE 7)

The vertebrae articulate together through their bodies and through their articular processes. The spinous processes and the laminae are, on the other hand, united by ligaments.

The vertebral bodies are separated from one another by a sort of fibrous and elastic pad (the intervertebral disk) to which they closely adhere. In back and in front this articulation is reinforced by the two great ligaments that reach from one end of the vertebral column to the other (*anterior longitudinal ligament* and *posterior longitudinal ligament*).

The articulations of the articular processes are provided by a *fibrous capsule*, thicker on the outside, which covers a synovial capsule that is quite loose at the neck and in the lumbar region. The space left in the back by the laminae of the two contiguous vertebrae is filled by a very tough ligament almost entirely composed of elastic tissue of which the fibers stretch directly from one vertebra to another. These ligaments, called *yellow ligaments* because of their color, enclose the spinal canal at the back.

The spinous processes are held together by a wall of

ligament, *interspinal ligament*, descending from one to another in the anteroposterior direction. Further, a long fibrous cord (*supraspinal ligament*) stretches along the top of the spinous processes throughout the whole length of the spinal column except for the cervical region. At the level of the seventh cervical vertebra the ligament is deflected from the spinous process toward the external occipital protuberance, although it sends out fibrous offshoots to the spinous processes. It is called the *ligamentum nuchae* or *posterior cervical ligament*.

ARTICULATIONS OF THE FALSE VERTEBRAE (PLATE 7)

Coccygeal articulations. The different segments of the coccyx are joined together by an intervertebral disk and by the anterior and posterior ligaments; the whole articulation has a rudimentary nature.

Articulation of the sacrum and coccyx. In addition to the intervertebral disk, frequently ossified, this articulation has the following ligaments: an anterior ligament; a posterior ligament which closes the sacral canal below; two lateral ligaments which link up the transverse processes of the last sacral vertebra to the first coccygeal vertebra.

ARTICULATIONS OF THE ATLAS, AXIS, AND OCCIPITAL (PLATE 6, FIGURE 3, 4, and 5)

The occipital, by means of its condyles, articulates with the superior articular facets of the lateral masses of the atlas.

The curvature of the condyles is less marked in the transverse than in the anteroposterior direction; they overlap in front and in back of the corresponding surfaces of the atlas, a fact that indicates the chief direction of movement. The outside edge of the facets of the atlas is higher than the inside edge. Both surfaces are encrusted with cartilage. The synovial membrane is lined with connective tissue, in layers, and reinforced by ligaments which we shall come to in a moment.

The atlas and the axis are joined by a double articulation. In fact, as the atlas moves around the odontoid process as though around a pivot, it slides on the superior articular facets of the axis (*atlantoaxial articulation*). The anterior convex surface of the odontoid process is in contact with a concave facet of the posterior surface of the anterior arch of the atlas.

The lateral masses of the atlas rest on the superior articular facets of the axis.

The two articulations are provided with synovials and reinforced by ligaments which we shall now describe.

Transverse ligaments. The odontoid process of the axis is received in an osteofibrous ring formed in front by the anterior arch of the atlas and in back by a transversely directed ligament which is inserted into the lateral masses of the atlas. This ring has the form of a half funnel so that the interior tightly squeezes the neck of the process. From the transverse ligaments, one above and one below, extend two weak vertical ligaments; the superior one goes to the anterior border of the foramen magnum, the inferior to the posterior surface of the axis.

Odontoid ligaments. These ligaments are arranged so that they firmly hold the odontoid process, from which they rise to attach themselves in the occipital. They are, first, two strong fascious fibers coming from the lateral and superior parts of the odontoid process. These fibers go a little obliquely up and outside and insert into the condyles of the occipital. Second, a weaker vertical median ligament runs from the summit of the odontoid process and inserts into the anterior border of the foramen magnum.

I should like to also point out the ligaments in the form of a membrane which serve to connect the anterior and posterior arches of the atlas to the borders of the foramen magnum (*anterior* and *posterior atlantooccipital membranes*); those of the same form which unite the anterior and posterior arch of the atlas to the body and to the posterior arch of the axis (*anterior* and *posterior atlantoaxial ligament*); and finally, the ligaments which go from the anterior border of the foramen magnum to the posterior part of the body of the axis, covering the transverse and odontoid ligaments (*occipitoaxial*).

ON THE VERTEBRAL COLUMN IN GENERAL (PLATE 5 and 7)

Placed vertically on the median line, the vertebral column plays a double role. It serves, so to speak, as a column of support for other parts of the skeleton to which it is attached directly or indirectly and it protects the spinal marrow or spinal cord.

Curves of the vertebral column. Viewed in profile the vertebral column presents, in the anteroposterior sense, several curves. These alternate differently according to their region. The cervical region, composed of seven vertebrae, offers an anterior convex curve, the most projecting part of this curve corresponds to the fourth vertebra. The dorsal region (twelve vertebrae) is curved in the other direction, and the posterior convexity projects most at about the dorsal spine of the seventh thoracic vertebra. The lumbar region repeats the convex anterior curve and the maximum convexity corresponds to the third vertebra in this region. These diverse curves follow each other gracefully until the level of the junction of the vertebral column with the sacrum where there is an abrupt change in angle, the *sacrovertebral angle*.

The curves of the vertebral column, which we have just described, are most strongly formed by the anterior part, that is to say by the succession of the vertebral bodies. It is important to note that the line formed in back by the spinous processes does not follow exactly the same direction. This fact is significant for artists, especially in relation to the lumbar region. At the neck and in the back, the curves described by the spinous processes repeat those formed by the bodies of the vertebrae (Figure 1). They are the same sort of curves but they are related to the circumferences of different radii. Thus, in the cervical region, the curve described by the spinous processes is more closed than that of the vertebral bodies. Inversely, in the dorsal region, the posterior curve is more open. This results in a flatness which contributes, together with the overlapping of the dorsal spines, to a reduction of the dorsal projection in this region. But in the lumbar region the difference is marked. Here the spinous processes only

Figure 1. Scheme showing the difference between the curves of the vertebral bodies (straight line) and the curves described by the spinous processes (dotted line).

approximate the direction of the vertebral bodies. A line, touching their summits, becomes a straight line which descends from the last dorsal vertebra to the sacrum. At times it bends in an inverse sense, becoming a contraposterior curve. This condition is in accord with the development of the sacrolumbar muscle masses; it explains the more or less pronounced projections that one observes in certain subjects in the lumbar furrow even in the upright position. In flexion of the trunk these bony projections show clearly.

Let us now consider the vertebral column from other points of view.

Anterior aspect. The series of vertebral bodies, separated by their fibrous "washers" (*intervertebral disks*), and growing progressively larger from top to bottom, assures the solidity of the supporting column. Behind them runs the spinal canal, formed by the succession of intervertebral foramina that contain the spinal cord.

Lateral aspect. The presence of the central canal is revealed by a series of openings which communicate with it and through which pass the nerves which come from the spinal cord. One sees on the sides of the vertebral bodies in the dorsal region, at the level of the intervertebral disks, the articular facets destined for the heads of the ribs. The line of the transverse processes in the thoracic region deviates strongly from the line of the spinous processes. The transverse processes of the lumbar region represent the ribs of the thoracic region; the tubercles of the superior articular processes can be considered as the analogues of the transverse processes.

The lateral prolongations of the vertebral column

should then be divided into two series. First, the anterior series consisting of the anterior half of the transverse processes of the cervical region, the ribs of the thoracic region, and the rib-like transverse processes of the lumbar region. Second, the posterior series, consisting of the posterior half of the transverse processes of the cervical vertebrae, the thoracic or dorsal transverse processes, and, in the lumbar region, the tubercles of the articular process.

Posterior aspect. The succession of the spinous processes surmounted by the supraspinal ligament create a long ridge called the *spinal crest.* On each side are the *vertebral grooves*, the bases of which are formed by the laminae of the vertebrae.

Dimensions. It is necessary to distinguish between the length and the height of the vertebral column. The length is measured by a line following the flexuosities of the column, the height by the distance of the diverse parts above the horizontal. The intervertebral disks form about a quarter of the total length. But the height is the sole dimension in which we are interested.

The vertebral column varies slightly in height according to the individual. M. Sappey has assigned it, on average, 61 centimeters, and divides it as follows: 13 centimeters for the cervical region; 30 centimeters for the thoracic region; and 18 centimeters for the lumbar region.

In height the proportions of the trunk are maintained by the vertebral column. Measured from the dorsal spine of the seventh vertebra to the summit (or bottom) of the sacrum, the trunk is about one third of the figure. Generally speaking it is longer in the yellow races, shorter in the Negroes, and intermediate in Caucasians. At least among European people, women have a longer trunk. Tall subjects tend to have a shorter trunk. The trunk triples its length from birth to maturity, growing until about the twenty-fifth or thirtieth year.

MECHANISM OF THE VERTEBRAL COLUMN

The spine is an elastic and mobile column. The elasticity is created by the thickness of the intervertebral disks, through them shocks are absorbed so that they are only transmitted in a diminished form to the head. This mobility is equally due to the compression and distension which the disks are able to undergo, as well as the sliding of the articular processes.

The cervical column is the most mobile part of the spine. It owes this mobility to the thickness of the intervertebral disks; to the oblique direction of the articulations; to the shortness and horizontal direction of the spinous processes of the average vertebrae of the region; and to the looseness of the vertebral ligaments.

In the thoracic region the spine is less mobile. This is because the ribs are like so many flying buttresses that maintain it laterally. The lack of mobility is also due to the vertical direction of the articular planes; to the tightness of the ligaments; and to the length of the spinous processes which overlap like the tiles of a roof.

In the lumbar region mobility becomes greater—the intervertebral disks are thicker, the ligaments laxer, and the spinous processes straight and short.

Equilibrium of the spinal column. The viscera, which one may regard as suspended from the anterior part of the vertebral column, seem to invite the spine to incline forward. It is maintained vertically by the yellow ligaments stretched between the vertebral laminae. The elastic force of these ligaments, continually in play, counterbalances the movement of weight. The muscles thus appear to be unnecessary for the maintenance of the column. They only intervene under particular circumstances.

The head is placed on the vertebral column so that it is almost in equilibrium, a condition which is peculiar to man. In animals, the center of gravity of the head lies well to the front, and requires the presence at the nape of the neck of a strong ligament to hold the head solidly against the vertebral column and prevent it from falling. This ligament exists in man only in a rudimentary state.

Movements of the vertebral column. The vertebral column is susceptible to three sorts of movement. Movements around a transverse axis (flexion and extension); movements around an anteroposterior axis (lateral inclination); and movements around a vertical axis (torsion or rotation).

Flexion is made possible by the compression of the anterior parts of the intervertebral disks. It is limited by the distension of the yellow ligaments and the supraspinal ligament. In this movement the spinous processes separate and project under the skin, especially if the flexion is extreme.

Extension is less extensive than flexion and it is limited by the distension of the intervertebral disks.

Lateral inclination depends on the articular processes impeding or favoring this movement according to the direction of their surfaces. At the neck where they are placed obliquely at 45°, this movement can be produced only when accompanied by a sliding of the articular surfaces which rotates the bodies of the vertebrae.

It is not the same in the lumbar region where the vertical direction of the articular surfaces allows complete separation of rotation and lateral inclination. Moreover, these two movements, disassociated for study, are almost always combined in nature.

Mechanism of the articulations of the atlas, axis, and occipital. The head is very movable on the vertebral column. Its movements, like those of the column itself, may be reduced to three. However, instead of taking place at the same time in all the articulations, these movements are divided between the two articulations which connect the head to the vertebral column. In consequence, movements of rotation take place between the atlas and the axis, and movements of flexion and lateral inclination take place in the articulation of the atlas and the occipital.

This last articulation is composed, as we have seen, of the two condyles of the occipital which are received exactly in the superior articular cavities of the lateral masses of the atlas. This articulation is designed so that only movements of flexion, extension, and lateral inclination are permitted. In rotation, on the contrary, the atlas and occipital act as one and turn together on the axis bone. The axis of this last movement passes through the odontoid process and the transverse ligament; at the same time a sliding movement takes place between the articular lateral masses of the atlas and the body of the axis.

4. The Thorax

The thorax is a vast cavity occupying the superior part of the trunk. It is composed of two median pieces, the *dorsal column* in the back and the *sternum* in front; these are connected to each other by the bony arches of the *ribs*. Supported in back by the vertebral column, the ribs move to the sternum in front by means of cartilaginous extensions, the *costal cartilages*. We have just studied the spinal column, let us now describe the sternum and the ribs.

STERNUM (PLATE 8, FIGURE 1)

A single and symmetrical bone situated in the front of the chest, the sternum is inclined obliquely from top to bottom and from back to front. In the child it is composed of four or five contiguous bony pieces which in the adult are reduced to two through the joining of three or four of the inferior pieces into a single bone. It is terminated by a cartilaginous extension. The ancients compared the sternum to the sword of a gladiator with its point turned downward. The superior part (manubrium) represented the handle, the second part (gladiolus) the body or blade, and the cartilaginous appendage the point, hence its name xiphoid (sword).

The anterior surface, almost entirely subcutaneous, offers an appreciable angle across the skin at the level of the junction of the first piece with the second. The posterior surface, in contact with the thoracic viscera, corresponds to the projecting angle of the anterior surface.

On the lateral surface there are hollows which correspond to the number of pieces of which the sternum is formed in the infant. They are eleven in number: seven articular facets for the costal cartilages, and four others which form the free borders of the first parts of the sternum.

The superior or clavicular extremity is marked by three hollows, one median and subcutaneous, forming the bottom of the pit of the neck, and two on each side which, in living subjects, are encrusted with cartilage and destined for articulation with the clavicles. Below, the sternum is terminated by the *xiphoid process*. This is most variable in form. Although it is ordinarily straight, sometimes it is projected in advance, its point lifting the skin in the region of the pit of the stomach.

The sternum, on the average, is 19 centimeters long and divided thus: first piece, 5 centimeters; second piece, 6 centimeters; appendage, 3 centimeters. It is 5 or 6 centimeters across at the widest part of the manubrium.

The narrowest part corresponds to the junction of the body with the manubrium.

RIBS (PLATE 8, FIGURE 2)

Numbering twelve on each side, the ribs are divided as follows: *true ribs*, numbering seven, from which the cartilages go directly to the sternum; *false ribs*, numbering five, of which only the first three join the sternum by means of the cartilage of the seventh rib. The two others do not attach to the sternum. Their anterior extremities rest free in the flesh, they are called *floating ribs*.

The ribs are designated by number from the first to the twelfth proceeding from top to bottom.

GENERAL CHARACTERISTICS OF THE RIBS

The ribs are flat bony arches which present two curves on their surfaces. The first curve may be seen easily from above or below. It is not completely regular; towards the back, at about the fourth or fifth rib, the curve bends abruptly, forming an angle called the *angle of the rib*. The other curve is called a curve of torsion. It is a more complex curve; the rib makes a complete twist, the external surface looks down in the back and up in the front. The inverse is true for the internal surface.

There is also a gentle curve that follows the borders of the ribs in the form of a very much elongated italic *S* (concave behind and in front). It can only be seen from the fifth to the tenth ribs.

The ribs are composed of a body and two extremities, the anterior and posterior.

The posterior extremity offers three parts for study: at the very end of the rib, the *head*, where there is a double articular facet; at the back of the rib, the *neck*, a rough contracted part of bone; and, finally, a bony projection or tuberosity, of which the rough superior part offers attachment to ligaments, and the inferior part carries a facet for articulation with the corresponding transverse process.

The *body* of the rib presents two surfaces and two borders. On the internal surface there is a *costal groove*. The external surface is convex and often shows under the muscles and skin which cover it. The superior border is very thick in back, where it is slightly grooved. The inferior border is sharp.

The *anterior extremity* of the rib is slightly enlarged and forms a sort of nodule which is sometimes visible under the skin. It articulates with the costal cartilage.

PARTICULAR CHARACTERISTICS OF CERTAIN RIBS

The first rib, broad and short, has curved edges and its surfaces lie almost horizontally. The most projecting part (projecting angle) corresponds to the tuberosity. The neck is narrow and rounded. There is one facet at the head.

The second rib also has a pronounced curve along its borders. The blunt angle is situated about one centimeter from the tuberosity. The anterior extremity is straighter than the body.

The two last ribs only have a single articular facet. On the eleventh, the angle is far from the head; there is no tuberosity.

The twelfth has no angle, tuberosity, or groove. The anterior extremity is more or less pointed.

ARTICULATIONS OF THE THORAX (PLATE 10, FIGURE 2 and 3)

Articulations of the ribs with the vertebral column. The head of the rib presents a jutting crest separating two demifacets. This crest corresponds to the intervertebral disk, to which it is joined by an *interarticular ligament* which separates the articulation into two secondary articulations. The two costal facets are in accord with the corresponding demifacets of the bodies of the vertebrae.

In front, a strong, fan-like ligament runs from the rib to the neighboring part of the body of the vertebra (*anterior costovertebral ligament*); this ligament consolidates the articulation.

The articular facet of the tuberosity of the rib connects with the articular facet of the summit of the transverse process. A short solid ligament holds the articular surfaces together. This ligament extends obliquely from the summit of the transverse process to the external part of the tuberosity of the rib; it is called the *costotransverse ligament.*

The ribs are also attached to the vertebrae by ligaments which run from the transverse processes to the neck of the rib. These ligaments are of two kinds. They both originate at the neck of the rib. The ones which go to the upper side of the transverse process are called the *superior costotransverse ligaments.* The others, which go to the lower side of the transverse process, are called the *inferior costotransverse ligaments.*

Articulations of the costal cartilages. The articulations of the ribs with the cartilages (*chondrocostal articulation*) are a simple continuation of the rib into the cartilage. They are marked by a swelling. The costal cartilages then unite with the sternum (*chondrosternal articulation*). The cartilage of the first rib is directly united with the sternum. Although the movements of the other ribs are very limited, they have an articular cavity and a synovial membrane. The second rib has, moreover, an interarticular membrane which divides the articulation into two secondary articulations. Finally, I should point out the *radiate sternocostal ligaments* (anterior and posterior).

THE THORAX IN GENERAL

The ribs are all directed obliquely from above to below and from back to front. The tip of the last rib is separated from the iliac crest by an interval of 4 or 5 centimeters.

The ribs are placed, in relation to the median axis of the chest, in the following manner: the first four withdraw progressively; the following five maintain about the same relationship (the eighth, however, projects the most); and the four last ones draw back, each further than the one preceding.

The ribs are separated by a space, called the intercostal space, which is occupied by small muscles which form a wall and close the thoracic cavity. The *intercostal spaces* toward the middle part of the thorax equal the width of the ribs; they are larger below and still larger above. The same intercostal space is larger both in the front and back.

ANTERIOR ASPECT (PLATE 9, FIGURE 1)

The sternum does not enter into direct relation with the ribs; it is separated by the costal cartilages, which are designated by number according to the particular rib which they prolong. The first is short and ascends slightly from the sternum. The second is transverse. The following costal cartilages are longer and progressively decline from the sternum as they descend. The fifth, sixth, and seventh cartilages at first continue the direction of the rib and then form a band as they mount to the sternum. The eighth, ninth and tenth terminate in points and are attached to the cartilage above. The eleventh and twelfth ribs terminate in a free, attenuated extremity.

On the borders of the sternum the articulations project and may be seen externally, if the pectoral muscles are but slightly developed, in a series of corresponding nodules. To the side are a second series of nodules and these follow an oblique line from above to below and from within to the outside. They correspond to the articulations where the ribs meet the cartilages.

The anterior surface of the thorax is not subcutaneous, except on the median line. The rest of its extent is covered by muscles; below it supports the breasts.

POSTERIOR ASPECT (PLATE 10, FIGURE 1)

The median part is occupied by the posterior aspect of the spinal column, which presents the spinal crest in the middle and the series of transverse processes laterally. Between these are the vertebral grooves. The ribs relate, through their tuberosities, to the transverse processes; the heads and necks of the ribs are concealed by the spinal column.

The angles of the ribs, situated further outside, follow an oblique line from above to below and from within to the outside. This line starts above from the transverse process of the first dorsal vertebra, the angle of the first being identical to its tuberosity. Between the line formed by the angles of the ribs and the jutting of the transverse processes one finds, on each side, a veritable groove which is filled by the spinal muscles. Above and to the outside of the line of the angle of the ribs the scapula is situated.

LATERAL ASPECT (PLATE 9, FIGURE 2)

The posterior profile is limited by the line of the angle of the ribs which is exceeded a little by the spinal crest,

especially in the upper half. It is regularly curved. The anterior profile is equally curved and is formed first by the sternum, oblique from above to below and from back to front, and by the cartilages of the false ribs which prolong the direction of the sternum.

This anterior curve descends down well below the sternum and gives to the whole of the thorax, in the profile view, the appearance of an accentuated ovoid. The jutting forth of the costal cartilage, which forms the inferior extremity of the ovoid, is generally misjudged. It is, however, from the point of view of morphology, of great importance, as we shall see later when we study the region below the breasts.*

The inclination of the sternum in relation to the vertical is about 20° to 21°.

The *superior circumference* of the thorax is circumscribed in the back by the body of the first dorsal vertebra, in front by the sternum, and on the sides by the first ribs and their cartilages. The circumference is an oblique plane from above to below and from front to back. In the standing position the median groove on the top of the manubrium is about on a level with the middle of the body of the second thoracic vertebra.

The *inferior circumference* presents a vast anterior hollow marked at the top by the xiphoid process and bounded laterally by a border formed by the cartilages of the seventh to the tenth ribs. This hollow, in the form of a pointed or Gothic arch, is expressed on the skin of thin subjects by a marked relief, dividing the chest from the abdomen in front. On more strongly developed subjects this anterior hollow of the thorax often takes the form of a simple or Roman arch, as it does so often in the antique. This is because the superior part of the rectus abdominus muscles are stressed rather than the superior angle of the hollow itself.

Dimensions. For the dimensions of the thorax, Sappey gives the following averages: transverse diameter, measured at the eighth rib, 28 centimeters; anteroposterior diameter, 20 centimeters; vertical anterior diameter, 13.5 centimeters; vertical posterior diameter, 31.5 centimeters.

MECHANISM OF THE THORAX

The thorax is able to undergo the changes of volume necessary for respiration. It is able to augment its capacity (*inspiration*) and diminish it (*expiration*).

Without mentioning here the muscular forces that enter into the movement of respiration, I should point out the mechanism by which the enlargement of the thorax takes place. It is the result of a double movement of the arches of the ribs which may be analyzed as follows. First, enlargement of the anteroposterior diameter of the thorax takes place through a movement of the elevation of the anterior extremity of the rib. The axis of rotation of this movement, nearly horizontal, passes through the head of the rib and through the tuberosity. Second, enlargement of the transverse diameter takes place at the

On almost all mounted skeletons the thorax is too short and too open in front. It is also much too far from the pelvis. This is even true in most anatomical drawings.

middle of the costal arc. The anterior posterior axis of rotation passes through the neck of the rib in back and through the chondrosternal articulation in front.

The diminution of the capacity of the thorax takes place by an inverse mechanism.

It is evident that all the ribs do not take an equally active part in these movements.

In a woman, the greater mobility of the first ribs permits, in the movement of respiration, a considerable amplification of all the upper parts of the thorax. This is *thoracic respiration* which compensates for the lack of action of the diaphram (*abdominal respiration*), when the movement of this muscle is impeded, for instance, in pregnancy.

SHOULDER

The skeleton of the shoulder consists of two bones—the clavicle in front and the scapula in back.

CLAVICLE (PLATE 11, FIGURE 1)

The clavicle is situated on the upper part of the chest. It is supported by the sternum at its inner end and it maintains contact with the scapula through its outer end. It is directed from within to without, slightly from the front to the back and slightly from below to above. It offers two curves in the form of an italic S. The internal curve is of anterior convexity, the exterior of posterior convexity.

The internal part of the bone is like a triangular prism. The middle part is rounded and the external portion flattened from above to below.

The upper surface is smooth and entirely subcutaneous. It stands out under the skin and the S shape is easily recognizable.

SCAPULA (PLATE 11, FIGURE 2)

The scapula, flat and triangular, is situated at the back and lateral part of the thorax. The base of the triangle of the scapula is turned above and the summit below. It is placed in an oblique plane from back to front, and from within to without. It extends from the first intercostal space as far as the seventh rib. Its internal border is nearly vertical.

Its anterior surface (*subscapular fossa*) is concave and filled by a single muscle. It is furrowed by oblique ridges for muscular insertions. The anterior surface rests on the thorax throughout its extent.

The posterior or cutaneous surface is divided into two unequal parts by the *spine*; above there is the *supraspinatous fossa*, below the *infraspinatous fossa*. The spine springs from the internal border by a small triangular surface which usually can be seen on the nude as a depression. From there the spine moves to the outside and above, forming a projection which becomes stronger and stronger. It terminates in a large process, flattened from above to below, the *acromion process*. The deep depression that the spine of the scapula leaves on the superior surface is increased by the muscles. The posterior surface of the spine is, with the acromion, the only part of the bone which is subcutaneous. It shows on the exterior either as a projection or as a depression.

The acromion forms the summit of the shoulder, where its superior surface is easily seen under the skin.

The superior border of the scapula, very thin toward the inside, terminates toward the outside in a process (*coracoid process*) which is curved in the form of a half-flexed finger.

The external angle is occupied by a concave oval hollow (*glenoid cavity*) of which the largest diameter is vertical. This articulates with the humerus and is supported by a narrow portion of the scapula (*neck of the scapula*). Above the cavity, there are the two processes mentioned; the acromion behind, and the coracoid in front.

ARTICULATION OF THE CLAVICLE

The clavicle articulates at its inner end with the sternum (*sternoclavicular articulation*) and at its outer end with the acromion process (*acromioclavicular articulation*). It is, besides, united to the coracoid process by ligaments (*coracoclavicular ligaments*).

STERNOCLAVICULAR ARTICULATION

The clavicle projects from the sternal facet with which it articulates. It forms, in consequence, an appreciable projection under the skin; moreover, the two articular facets are not in accord. They are separated by an articular disk which divides the articulation into two. The surfaces of the disk adapt themselves exactly to the facets with which they are in contact.

The synovial capsules are reinforced by the fibers of anterior and posterior ligaments.

Two other ligaments assure the solidity of the articulation. The *interclavicular ligament* runs from the sternal end of one clavicle to that of the other. The *costoclavicular ligament* runs from the superior part of the first costal cartilage to the internal part of the clavicle.

ACROMIOCLAVICULAR ARTICULATION

The articular surfaces, oval and almost flat planes, are maintained by short fibers. These fibers are very resistant at the superior part where they are called the superior *acromioclavicular ligament*.

Coracoclavicular ligaments. The coracoclavicular ligaments are very strong and are two in number. Their names indicate their form. The *trapezoid ligament*, anterior and external, goes from the base of the coracoid process to the interior surface of the clavicle. The *conoid ligament* (cone-like) is attached to the internal border of the coracoid process, near its base, and goes to the posterior border of the clavicle.

SKELETON OF THE SHOULDER IN GENERAL

The clavicle and the scapula join on the outside of the body forming an acute angle opening within. The bony demi-girdle thus formed embraces laterally the summit of the thorax to which it is firmly united by its anterior extremity (*sternoclavicular articulation*).

The scapula, in effect, does not articulate at all with the thorax; it simply rests upon it.

The bony girdle of the clavicle and the scapula considerably enlarges the superior transverse diameter of the chest. The arm hangs from its external angle and through it the arm is attached to the trunk.

The position of the scapula in relation to the rib cage shows much variation in individuals; this results in a great variety in the form of the shoulder, chest and neck.

In women, the shoulders are relatively lower, which gives the clavicle a slightly oblique inclination from within to without, and from above to below.

MECHANISM OF THE ARTICULATIONS OF THE CLAVICLE AND SCAPULA

Sternoclavicular articulation. The movements, of limited range, are of two types: movements of elevation and lowering; and movements forward and backward.

In all these movements, the internal extremity of the clavicle undergoes a movement which is in a sense the reverse of that of the external extremity. The bone acts as a sort of lever of two unequal parts, the fixed point being close to the attachment of the costoclavicular ligament. Therefore, the projection of the internal extermity of the clavicle should be less marked when the shoulder is moved forward, more marked when the shoulder is moved back.

Acromioclavicular articulation. The ligaments which join the clavicle to the coracoid process are long enough to permit the angle formed by the plane of the scapula and the clavicle to vary its opening, following the transverse sliding of the scapula on the posterior wall of the thorax. This results in the withdrawal or approach of the interior border of the scapula from or to the dorsal spine and in a movement forward or back of the end of the shoulder.

Further, the end of the shoulder may be moved up and down.

PELVIS

The pelvis is formed by the union of the sacrum, the coccyx, and the two hip bones. The sacrum and the coccyx having been described, we have only to study the hip bone.

HIP BONE (OS COXAE, INNOMINATE BONE) (PLATE 12)

The hip bone, paired, large, irregular, narrowed at its middle part, is twisted on itself in such a way that the superior half is not in the same plane as the inferior half. At the center, on the external surface, is a hemispheric cavity (*acetabulum*) articulating with the femur. The superior part of the bone is called the *ilium*. The inferior part of the bone is pierced by a large opening (*obturator foramen*) in front of which is the *pubis* and in back the *ischium*.

Descriptive anatomy should concern itself with the two surfaces and the four borders. On the external surface there is: above, the *external iliac fossa*, unequally divided by a curved line (the anterior gluteal line). From this fossa the gluteal muscles originate. At the middle, the *acetabulum*, surrounded by a lip. It is open below (*acetabular notch*), and has a central groove (*acetabular fossa*). Below is the *obturator foramen*, oval in men, triangular in women. It is surmounted by the obturator groove.

The internal surface is divided into two parts by an oblique crest (*iliopectineal* and *arcuate lines*) which contribute in the formation of the superior *circumference* of

the pelvis. Above this there is the *internal iliac fossa* from which the *iliacus* muscle originates. Behind it the *iliac tuberosity* is situated together with the articular surface for articulation with the sacrum. Below the arcuate line there is a quadrilateral surface containing both the base of the acetabulum and the obturator foramen which is surmounted by the obturator groove.

Of the four borders, two are convex: the superior and the inferior. The two other borders, the anterior and posterior, are profoundly and very irregularly notched.

Proceeding from above to below, the anterior border presents the following particulars (see Plate 12, Figure 2): the *anterior superior iliac spine*; the *anterior inferior iliac spine*; the *iliopectineal eminences*; the *pectineal surface*; and the *crest of the pubis*.

At the posterior border we note, proceeding from above to below: The *posterior superior iliac spine*; the *posterior inferior iliac spine*; the *greater sciatic notch*; the *ischial spine*; the *lesser sciatic notch*; and the *tuberosity of the ischium*.

The *inferior border* goes from the ischium to the pubis and forms, with that of the opposing side, the *pubic arch*.

The superior border, or the *iliac crest*, plays an important role from the point of view of exterior morphology. It is broad, thick and divided into an external lip, an interstice, and an internal lip. It describes, in a horizontal sense, a double curve in the form of an *S*, as can be seen from the superior aspect (Plate 12, Figure 1). The anterior curve occupies the greatest length; it is a great segment of a circle, its convexity turned within, its anterior extremity slightly turned down. The posterior curve is short, it contains a sharp angle (*the reentering angle*), and it is marked by a very consistent depression in the nude, as we will see later on.

ARTICULATIONS AND LIGAMENTS OF THE PELVIS (PLATE 15)

The two iliac bones unite in front forming with the sacrum, which is interposed between them in back, a true girdle.

We shall study the articulation of the iliac bones with the sacrum (*sacroiliac articulation*), the articulation of the two iliac bones between themselves (the *pubic symphysis*), and the ligaments of the pelvis which constitute remote articulations.

Sacroiliac articulation. The articular surface of the iliac bone presents a roughness which engages with the analogous articular surface of the sacrum. It is oblique from above to below, and from front to back, in such a fashion that the sacrum, enclosed by the two iliac bones, forms an angle at its inferior base.

There are two *anterior ligaments*, one superior and one inferior (*iliolumbar* and *anterior sacroiliac*).

In the back, the deep excavation left between the sacrum and the iliac tuberosity is filled by very strong ligamentary masses. The deep part of these masses forms the *short posterior sacroiliac ligament*, and the superficial part forms the *long posterior sacroiliac ligament*.

Symphysis pubis. The two articular surfaces are separated by a fibrous disk, the *interpubic disk*.

All around there are ligamentary fibers. The thickest are below and form the *arcuate pubic ligament*. It has a triangular form and occupies the summit of the pubic arch.

Ligaments of the pelvis. The *iliolumbar ligament*, formed of a thick horizontal fasciculus, extends from the transverse process of the fifth lumbar vertebra to the superior border of the iliac bone. The *sacrotuberous ligament* is attached through an enlarged base to the posterior iliac spines and to the sacrum; its other part is attached to the internal edge of the ischium. Fibers run from its anterior surface and they insert into the sciatic spine forming the *sacrospinous ligament*. The *obturator membrane* is formed of intersecting fibers which close the obturator foramen except for the superior part where the obturator groove becomes an orifice which allows for the passage of nerves and vessels. The *inguinal ligament (Poupart's ligament)* extends from the anterior superior iliac spine to the spine of the pubis. This ligament circumscribes, with the anterior border of the iliac bone, an elongated space.

The superior surface of the inguinal ligament gives insertion to the muscles of the abdomen. Its anterior surface is united to a deep layer of the skin which creates the constant crease of the groin.

THE PELVIS AS A WHOLE (PLATE 13, 14, and 15)

The pelvis is a vast bony girdle supporting the vertebral column in the back. The pelvis in turn is supported by the two heads of the femur bones.

The interior surface is divided in two by a circle which goes from the pubis in front to the base of the sacrum in back. Above is the greater or *false pelvis*, below the lesser, or *true pelvis*.

The opening of the false pelvis is large. It is composed in front of the iliac crest and the inguinal ligament.

The true pelvis is small and it is enclosed by the pubic arch, the tuberosities of the ischium, the sciatic ligaments, and the coccyx.

The pelvis, when the model is in an upright position, is inclined slightly forward. The acetabulum is directed downwards. A line running from the base of the sacrum to the superior part of the symphysis forms an angle of about 60° with the horizon.

In women, the pelvis undergoes notable modification due to childbearing. It is larger yet not so high as that of man. The dimensions of the two principal diameters are generally given as follows: transverse diameter, taken from the widest points of the iliac crest, 28 centimeters in men and 30 centimeters in woman; vertical diameter in the height of the pelvis, 20 centimeters in men and 18 in women.

The pelvic arch is more open in women, the ischia further apart, the sacrum and coccyx less elevated and flatter, and the great sciatic groove more open and not so deep.

Mechanism. The different parts of the pelvis do not move against each other; the pubic and sacroiliac articulations serve to soften any shocks received by the pelvis.

SKELETON OF THE TRUNK IN GENERAL: ITS INFLUENCE ON EXTERIOR FORM (PLATE 16, 17, and 18)

All the bony pieces which we have studied constitute, when united, the skeleton of the trunk. We should now

study them as assembled. The vertebral column forms the center; it rests on the pelvis and supports the head at its superior extremity. At its sides, toward the middle, it is attached to the rib cage, of which the inferior extremity is no further from the iliac crest than 4 or 5 centimeters.

The vertebral column determines the height of the torso, while the thorax, of which the width never reaches that of the pelvis, determines, following its degree of development, the width of the chest. The rib cage terminates in the form of a cone at its superior extremity. By the addition of the skeletal shoulder girdle upon the ribs, the torso acquires that superior lateral enlargement which we call the breadth of the shoulders. The scapula rests on the posterior part of the rib cage, just outside of the line formed by the angle of the ribs. It reaches from the second to the eighth rib and its spinal border is almost vertical. The distance which separates the shoulder blades is about equal to the length of the clavicle. Although these measurements are approximate, they have some practical utility. The skeleton of the trunk ends at the pelvis and the development of the pelvis determines both the size of the hips and the modifications which, in this region, differentiate the sexes.

The measures of the height of the trunk are determined by the dimensions of the vertebral column which have already been given (see page 27). As to the measures of width, they are reduced on the skeleton to the transverse diameter from shoulder point to shoulder point and to a diameter across the pelvis. The first extends from the extremity of the acromion process on one side to the same point on the other side. The second measures the distance between the two iliac crests. Among men the acromial measurement is usually 32 centimeters, and the iliac measurement is 28 centimeters. Among women the relationship is reversed because of the great width of the pelvis: the acromial measurement is 29 centimeters, the iliac 30 centimeters. These figures, however, do not have much academic interest, although they have their value as measures of width characteristic of the sexes. On the actual model it is difficult to think in terms of the trunk alone. Perhaps it is better to think of the measurement as going from the head of one humerus to another and from one great trochanter to another. The relationship of these two measurements is in a sense the same in the two sexes. In men, as well as in women, the superior diameter surpasses the inferior, though in different quantity, as the following figures show:

	Male	Female
Humeral measurement	39	35
Trochantic measurement	31	32

The role which the diverse bony pieces of the skeleton play in the morphology of the trunk is considerable.

The vertebral column, mostly buried in the soft parts, reveals but few anatomical details on the surface. Only the crest, formed by the series of spinal processes, is subcutaneous throughout most of its length along the posterior medial line of the trunk. The muscles rising on each side transform the crest into a groove of which the depth varies in different regions and in this groove one may discern certain details of the bony processes. However, although the processes are visible in the small of the back, they ordinarily disappear as we ascend. They reappear toward the base of the neck where the prominence of the spinous process of the seventh cervical vertebra is constant; in fact, it constitutes a landmark used in measurements of the trunk in the living. The spinal process of the sixth cervical often forms an eminence, though less appreciable. Above this the spinal column is more deeply buried; it disappears completely in the soft parts of the neck.

The curves of the spinal column express themselves in the general form of the posterior part of the trunk. The small of the back responds to the lumbar curve; the rounded back, to the convexity of the dorsal curve; at the neck the concavity of the curve is always mitigated, if not straightened, through the presence of the muscles of the nape.

The thoracic cage is the key to the general form despite the muscles disposed upon its surface. Here, more than in any other part of the body—the cranium always excepted—the skeleton plays a considerable morphological role in spite of the fact that it seldom appears immediately under the skin. The crest formed by the dorsal spines in the back plays a similar role. In front the sternum is subcutaneous throughout all its length, but not all its width. It should be pointed out that in back, toward the angle of the scapula, there is a small triangular space of which the dimension varies with the movements of the shoulder. Everywhere else the rib cage is covered with muscle.

The sternum underlies the somewhat profound median groove that extends from the pit of the neck to the epigastric hollow.

The epigastric hollow corresponds to the xiphoid cartilage which is always situated on a plane more drawn back than the body of the sternum. The point of the xiphoid cartilage, at times bent forward, raises the skin in that area.

On thin persons, the ribs may be seen. They are visible in front, on each side of the sternum; and in back, below the scapula. In front the costal cartilages, and their articulations with either the sternum or the ribs, may also be clearly seen. We shall return to study these bony forms in detail when we study the separate regions.

By their union, the cartilages of the ribs create, with those of the opposite sides, a pointed arch which forms the anterior opening of the chest. This arch projects in both erect and bent positions even in individuals with well developed muscles. It should also be noticed, as can be easily seen in the profile, that the cartilages of the false ribs protrude more in the area below the pectoral muscles and the sternum, than those above. Their projection continues the general oblique direction of the rib cage. Therefore, the most forward point of the rib cage is not approximately at the bottom of the sternum or fifth rib, but lower, at the level of the projection formed by the cartilages of the ninth and tenth ribs.

The last two ribs, the floating ribs, disappear in the soft parts of the flank. They may be felt by strongly pressing the integument in this region, and will be found to be close neighbors of the iliac crest as we have already noted.

The clavicle is a bone which reveals itself clearly under the skin. It is, actually, subcutaneous along its anterior and superior surface. It curves in the form of an italic S and may be easily seen. The interior half is convex, the exterior, concave.

In the position of a soldier at attention—the chest jutting forward, the shoulders thrown back, and the palms of the hands turned to the front—the direction of the clavicle is slightly oblique, rising to the outside. When the hands are turned naturally along the side of the trunk it is a little more horizontal. However, these directions vary with different subjects. The clavicle is often inclined slightly downwards from within to without. Its internal extremity, articulating with the sternum, makes a notable prominence which deepens the central notch of the manubrium. This projecting extremity goes completely beyond the articular facet of the sternum to which it is attached only through the intervention of a fibrocartilage.

Its external extremity, flat in the transverse sense, unites with the acromion and thus forms the summit of the shoulder.

The clavicle sometimes makes a distinct projection under the skin at the point of the shoulder. This should not be confused with the external extremity of the acromion, the relief of which is sometimes marked by the insertions of the deltoid.

The body of the scapula disappears in the midst of the muscles of the back. The spine and the acromion process, which, of course, is at the outer end of the spine, project on the surface.

On thin subjects, the spine forms a projection between two planes which correspond to the supraspinatous fossa and the infraspinatous fossa. These planes are filled, though not completely, by muscles. On well built models the spine becomes a groove created by the swelling of the neighboring muscles. The direction of this groove is naturally the same as that of the spine, rising obliquely from within to without. It starts from the inside, near the interior border of the bone, with a small triangular depression. This depression is caused by a special disposition of the fibers of the trapezius as we will see later. From there it rises as a sort of platform to terminate at the shoulder above.

The internal border of the scapula, when the arms fall naturally along the side of the body, forms a longitudinal ridge which is transformed into a depression by the contraction of muscles attached to it when the shoulders are moved forward or backward. The direction of the scapula when it is at rest is almost parallel to the center line of the back, from which it is separated by 7 or 8 centimeters. This distance is slightly more at the bottom of the scapula. The inferior angle of the scapula projects when the shoulders are lowered, but this projection is lessened by the muscular fibers of latissimus dorsi which pass over and around it.

Lower down, the skeleton of the trunk is terminated by the bony girdle of the pelvis. The pelvis is buried in powerful muscular masses and is subcutaneous only at points corresponding to the surface of the sacrum in the back, the pubis in front, and the iliac crests on the sides.

The depressions on the posterior surface of the sacrum are filled by muscle masses. These are the sacrolumbar muscle masses and they are maintained by a solid aponeurosis which is attached at each side to the lateral projections of the sacrum, and to the posterior iliac spine. In the middle the aponeurosis is attached to the spinal crest. The disposition of these muscles results in a medial groove above the crest of the sacrum. This groove continues the lumbar groove, which disappears below a little above the great crease of the buttocks. The groove is marked by a depression corresponding to the junction of the sacrum with the lumbar column which results from the angle formed by these two bony pieces.

The superior border of the iliac bone, or the iliac crest, receives numerous muscular insertions and is subcutaneous only along its external contour.

Toward its posterior third the iliac crest turns to the outside (reentering angle) and is marked on the outside by a depression (superior lateral lumbar fossa). The two anterior thirds of the crest only project in very thin subjects. In muscular subjects, the muscles which are attached above and below create a groove. However, this groove does not exactly follow the bony line, as we shall see further on. The superior anterior iliac spine is always a little projection at the anterior extremity of this groove.

In back, at the limits of the sacral region, the iliac tuberosity becomes a depression because of the muscles which surround it (*the inferior lumbar fossa*).

The pubic bone is covered by a thick fatty cushion which masks its form. It is fastened to the anterior superior iliac spine by a solid aponeurotic line (*inguinal ligament*). This ligament is attached to the two bony points and runs like a bridge between them. It creates a line which corresponds to the crease of the groin and marks the point of separation between the abdomen and thigh.

5. The Skeleton of the Upper Limb

The shoulder having been studied along with the trunk, we shall now describe the bones of the upper arm, the forearm and the hand. These bones are divided in the following fashion: in the upper arm, one bone—the humerus; in the forearm, two bones—the radius and ulna; in the hand, three bony segments.

The first segment of the hand is composed of the *carpus* which consists of eight bones: the scaphoid, the lunate, the triangular, the pisiform, the trapezium, the trapezoideum, the capitate, and the hamate. The second is the *metacarpus* which is composed of five bones: the five metacarpals. The third is the *fingers* which each have three bones: the three phalanges. The thumb is an exception—it only has two bones.

BONE OF THE UPPER ARM: HUMERUS (PLATE 13)

Situated in the middle of the soft parts of the arm, the humerus is a long bone which appears to be twisted on its axis. Anatomists, for purposes of description, think of it, like all bones, in terms of a body and two extremities.

The body, somewhat cylindrical above, is triangular below where it enlarges transversely; the superior extremity is rounded but the inferior extremity is enlarged transversely and flattened in front and in back.

Body. One notes three surfaces and three borders. The anterior border is more or less equally distinct down the whole length of the bone; above it blends into the anterior edge of the *intertubercular groove*, dividing below to embrace the coronoid fossa. The two lateral borders are most noticeable on the inferior part of the bone; they are sharper than the anterior border.

The external surface has a roughness toward its center in the form of a *V* for the insertion of the deltoid.

The *superior extremity* is separated from the body by the *surgical neck*. This extremity is divided into two parts by an *anatomical neck*. These parts are the articular part, directed up and within, in the form of a one third of a sphere; and the non-articular part, formed of two tubercles to which muscles are attached (in front, the *lesser tubercle*, and on the outside, the *greater tubercle*). The two tubercles are separated by a groove through which the tendon of the long head of the biceps passes. This groove (intertubercular groove) continues down toward the internal surface.

The *inferior extremity* has two distinct articular surfaces at its center for the bones of the forearm. On the outside, for the radius, the *capitulum* presents a rounded surface directed to the front. In the center, for the ulna, the trochlea has the form of a bony spool, with its internal border descending lower than the external. A bony eminence surmounts each one of these articular surfaces. On the outside, there is the *lateral condyle*, and on the inside, the *medial condyle*. We ought also to note the following depressions: in front, above the *trochlea* the *coronoid fossa*; in back, above the *trochea*, the *olecranon fossa*; and above the capitulum, in front, the *radial fossa*.

After Rollet,* for the average height of 1 meter, 66 centimeters, the humerus, in its greatest dimension, should be 32.08 centimeters.

BONES OF THE FOREARM: ULNA (PLATE 20)

The ulna is a long bone which is a triangle in cross section. It is situated on the internal part of the forearm.

The *body*, most voluminous above, has three surfaces and three borders. The anterior surface is concave and smooth. The posterior surface is unequally divided into two parts by a bony crest which runs down its whole length. The internal surface, convex, smooth and rounded, is subcutaneous.

Of the borders, the external one is the most prominent: it offers attachment to the interosseous ligaments. The anterior border is smoother; it starts at the medial edge of the coronoid process and ends at the styloid process. Finally, the posterior border, not visible on the inferior quarter of the bone, rises to the olecranon above.

The *superior extremity* has an articular cavity, the *trochlear notch*, which opens to the front and above. It is unequally divided by a bony longitudinal crest which articulates with the trochlea of the humerus. This cavity is formed, so to speak, by the anterior surface of the olecranon and the superior surface of the coronoid process.

The *olecranon* forms the point of the elbow and offers attachment to the muscle triceps brachii. It terminates, in front and above, in a curved beak which is received by the olecranon fossa of the humerus when the arm is in extension.

The coronoid process offers attachment, on its triangular anterior surface, to the brachialis muscle. Its external border is notched by an articular facet for the radius

* De la Mensuration des Os Longes des Membres by Dr. Étienne Rollet, 1889.

(*radial notch*), and its summit, also in the form of a beak, is received by the coronoid fossa of the humerus when the arm is flexed.

The *inferior extremity*, or *head of the ulna*, is surmounted by a *styloid process* and contains a shallow groove for the tendon of the *extensor carpi ulnaris*.

For the average height of 1 meter, 66 centimeters, the ulna is 25.9 centimeters long (Rollet).

BONES OF THE FOREARM: RADIUS (PLATE 20)

A long bone, triangular in cross section like the ulna, the radius is situated at the external part of the forearm.

The *body*, more voluminous at the inferior end, offers three surfaces and three borders. Their arrangement is symmetrical to the surfaces and borders of the ulna.

The external surface has an impression towards its middle for the insertion of the pronator teres.

The internal border is prominent and gives attachment to the interosseous ligament. The anterior border, starting at the *bicipital tuberosity*, terminates at the styloid process. The posterior border is only marked toward the middle of the bone.

The *superior extremity* is formed by a rounded articular part, the *head*, supported by a narrow portion, the *neck*. The head is hollowed out above for articulation with the humerus, and it is bordered by a periphery which rolls in the radial notch of the ulna.

The neck is united to the body in an obtuse angle opening to the outside. At the summit of this angle is the *radial tuberosity*, which offers insertion to the biceps.

The *inferior extremity*, large, flattened in front and in back, is hollowed out below by an articular surface divided by a crest from front to back.

In the back of the inferior extremity there are grooves for the following muscles. Reading from without to within: abductor pollicis longus and extensor pollicis brevis; extensor carpi radialis longus and brevis; extensor pollicis longus; extensor indicis and extensor digitorum. On the outside, there is a styloid process which extends lower than the styloid process of the ulna.

For the average height of 1 meter, 66 centimeters, the radius has a length of 24.02 centimeters (Rollet).

BONES OF THE HAND

The skeleton of the hand is composed of three segments: the carpus, the metacarpus and the phalanges.

THE CARPUS

The carpus is composed of eight bones arranged in two rows. From without to within they are: first row—scaphoid, lunate, triangular and pisiform; second row—trapezium, trapezoideum, capitate and hamate. These bones are juxtaposed in each row, except for the pisiform, which is somewhat outside the first row, in front of the triangular bone.

The carpus is composed of the following: a superior articular surface formed by the scaphoid, the lunate and the triangular (these articulate with the radius directly, and with the ulna through a triangular ligament) and an irregular inferior surface which articulates with the meta-

carpals. The posterior surface is convex and the concave anterior surface is converted into a groove by the presence of four bony processes on its sides; two processes are internal, the pisiform and the hook-like process of the hamate, and two external, the tubercle of the scaphoid and the ridge of the trapezium.

METACARPUS

The metacarpus is composed of five bones, the metacarpals. They are designated by number, counting from without to within. They are separated by interosseous spaces.

The first metacarpal is isolated, the others maintain a certain relationship with each other. Altogether they form, when seen from the front, a concave mass, which prolongs the hollow of the carpus. In back the metacarpals are convex.

Below, the heads of the four last metacarpals are disposed along a curved line. The third metacarpal projects the most.

Common characteristics of all the metacarpals are as follows. The *body*, triangular in cross section, has two sides and one dorsal surface. The *base*, or *superior extremity*, has articular facets for the carpal bones and the neighboring metacarpals. The *head*, or *inferior extremity* terminates in a spherical articular surface marked on the sides by rough depressions.

Distinctive characteristics occur particularly at the base and may be summed up as follows. The first metacarpal is short and large. The articular surface of the superior extremity, or base, is in the form of a saddle and is prolonged in front by a jutting point. The second metacarpal has at its base three articular facets for the bones of the carpus and one for the third metacarpal. On its dorsal surface there is a tubercle for the insertion of the extensor carpi radialis longus. The third metacarpal has a median articular surface for the capitate and two lateral ones for the neighboring metacarpals. The base is prolonged in back and on the outside by a *styloid process* which gives insertion to extensor carpi radialis brevis. The base of the fourth metacarpal has three articular facets—one median for the hamate and two lateral for the neighboring metacarpals. Finally, the base of the fifth metacarpal has one articular surface for the hamate and another for the fourth metacarpal; on the outside, there is a rough tuberosity for the attachment of extensor carpi ulnaris.

PHALANGES (PLATE 21, FIGURE 6)

The thumb has two phalanges, the four other fingers have three. These segments are called, going from top to bottom: the first, second, and third phalanges. The phalanges diminish in size from top to bottom.

The first phalanges each have their superior extremity hollowed by an articular cavity to fit one of the metacarpals; their inferior extremity has an articular surface in the form of a pulley for contact with the next phalange.

On each of the second phalanges the articular facet of the superior extremity is divided in two from front to back by a crest. The inferior facet is like that of the preceding phalange.

Finally, the third phalanges have a superior articular facet resembling that of the second phalange, and their bodies, thin and short, carry an elevation at each extremity which serves to support the nail.

ARTICULATION OF THE SHOULDER (PLATE 22, FIGURE 1)

Articular surfaces. The humerus is brought into contact with the glenoid cavity of the scapula through the spheroid portion of its upper extremity. The depth of the glenoid cavity is augmented by a rim of fibrocartilage (*labrum glenoidale*).

Above an osteofibrous vault completes this articulation. It is formed by the acromion and the coracoid process united by a strong ligament, the *coracoacromial ligament*.

Ligaments. The two bones (humerus and scapula) are united by a sort of sleeve, or fibrous capsule, which is attached to the anatomical neck of the humerus and to the periphery of the glenoid cavity. Their union is reinforced by the *coracohumeral ligament*, the suspensory ligament of the humerus, which arises from the internal border of the coracoid process at its posterior superior surface. It is also reinforced by all the tendons of the muscles which insert into the tuberosities and blend into the fibrous capsule.

The tendon of the long head of the biceps emerges from the interior of the articulation at the intertubercular groove; it originates at the upper part of the glenoid cavity from the labrum glenoidale.

Mechanism. The articulation is remarkable for its excessive mobility which is due to the shallow nature of the glenoid cavity and the flexibility of the articular capsule. It allows movement in three principal directions: adduction and abduction, movement front and back, and rotation.

ARTICULATION OF THE TWO BONES OF THE FOREARM (PLATE 22, FIGURE 3)

The two bones of the forearm articulate with each other at their extremities.

Superior radioulnar articulation. The cylindrical border of the head of the radius is received in an osteofibrous ring formed by the radial notch of the ulna and by a ligament, the *annular ligament*.

Inferior radioulnar articulation. The articular surfaces here are the inverse of the superior articulation. It is the radius that furnishes the sigmoid cavity (ulnar notch) against which the head of the ulna is applied. However, the head of the ulna is only articular throughout about two thirds of its circumference, and the bones are maintained in contact by the *triangular ligament*, disposed transversely below the head of the ulna. This ligament is attached at its base to the radius at the angle where the ulnar surface meets the carpal surface. At its summit it is attached to the external portion of the styloid process of the ulna.

An interosseous membrane fills the space between the two bones, except for the area above and below, and it is attached to the borders of the bones.

ARTICULATION OF THE ELBOW (PLATE 22, FIGURE 2)

Articular surfaces. The great trochlear notch of the ulna is molded to fit exactly the trochlea of the humerus of which it embraces about half. On the outside the capitulum is in contact with the head of the radius.

Ligaments. A somewhat loose capsule surrounds the articulation in front and in back. The bones are maintained in contact by solid lateral ligaments. The *ulnar collateral* ligament, in the form of a fan, goes from the medial condyle to the medial border of the olecranon and to the coronoid process. The *radial collateral ligament* goes from the external condyle to the annular ligament without any insertion into the radius.

Mechanisms of the elbow and of the forearm. The articulation of the elbow is a true hinge, and movements are only possible in a single direction.

Flexion, which brings the forearm toward the upper arm, is limited only by the meeting of the coronoid process with the coronoid fossa. Extension, in which the forearm directly prolongs the upper arm, is checked by the meeting of the point of the olecranon and the olecranon fossa.

The axis of rotation is transverse, and not perpendicular to the axis of the humerus; it is inclined from above to below and from without to within. The result is that in extension the hand withdraws from the median plane of the body and the forearm diverges from the upper arm creating an obtuse angle opening to the outside.

In flexion the hand approaches the median line and the forearm creates an extremely acute angle with the upper arm.

Pronation and supination. These are the terms used to designate the rotation of the forearm on its axis, and the movements are due to the displacement of the two bones, radius and ulna. In supination, the palm of the hand is directed forward; in pronation, the palm of the hand is directed to the rear.

These movements are not (as described by most authors) the result of a simple movement of rotation by the radius around the ulna, which remains fixed. Duchenne de Boulogne has demonstrated perfectly that, during pronation and supination, these two bones clearly move throughout their inferior quarter, above all at the inferior extremities, and each describes a circular arc in an opposite direction. He has also demonstrated that these two movements are interdependent. It is in the inferior radioulnar articulation that this double movement is, in a sense, inverse. In the superior articulation, the head of the radius rolls by itself, maintained by the annular ligament, while the ulna undergoes a very slight movement of flexion and extension.

ARTICULATION OF THE WRIST AND THE HAND (PLATE 22, FIGURE 4)

I shall first describe the articular surfaces of the diverse articulations of the hand, and then the ligaments which surround them.

Articulation of the radius and the carpus, or radiocarpal articulation. On one side the cavity created by the radius

receives a rounded eminence formed, on the other side, by the superior surfaces of the bones of the first row of the carpus—except for the pisiform. The first row of the carpus consists of the scaphoid, the lunate, and the triangular bones.

Articulation of the two rows of the carpal bones with each other. The *articular surfaces* are very complex, formed above by the inferior surfaces of the bones of the first row, except for the pisiform, and below by the superior surface of the second row.

Each of these surfaces is alternately concave and convex, the convexity of the one moving on the concavity of the other.

Articulation of the trapezium with the first metacarpal. The articulations are saddle shaped, and enjoy reciprocal reception.

Articulations of the metacarpals with the carpus. The line of articulation is most irregular. It is formed by the inferior surfaces of the bones of the second row of the carpus with the superior extremities of the last four metacarpals.

Ligaments of the articulations of the wrist and the carpus. First of all, it is necessary to draw attention to the *interosseous ligaments* which solidly unite between them the small bones constituting each row of the carpus, with the exception of the trapezium. There exists, besides, an interosseous ligament, extending from the capitate and the hamate to the third and fourth metacarpals.

The peripheral ligaments are divided into the dorsal, palmar, and lateral ligaments. They extend between neighboring bones. I shall point out the principal ones. In the back, there is an oblique fascia, going from the radius to the triangular bone, which is called the *dorsal radiocarpal*. In the front, two oblique fasciae go from the two bones of the forearm toward the capitate, which is in the center of the carpus: one, very large, the *palmar radiocarpal ligament*, and another, straighter, the *ulnacarpal ligament*. On the sides the lateral ligaments can be seen. On the outside, the lateral ligaments run from the styloid process of the radius to the scaphoid and from there to the trapezium (*radial collateral* or *external lateral ligament*). On the inside, they run from the styloid process of the ulna to the triangular bone. From there they run to the pisiform (*ulnar collateral* or *internal lateral ligament*.)

The pisiform is, moreover, solidly held by two ligaments of which one goes to the hamulus of the hamate bone and the other to the fifth metacarpal. The articulation of the trapezium and the first metacarpal is surrounded by a fibrous capsule.

Finally, the hollow of the carpus is transformed into a ring by a strong ligament, the *annular ligament*, which attaches on the outside to the scaphoid process and to the crest of the trapezium, and on the inside to the pisiform and to the hamulus of the hamate. Through this ring pass the tendons of the muscles that flex the fingers.

Mechanism of the articulations of the wrist and hand. The radiocarpal articulation and the intercarpal articulations are susceptible to considerable movement.

They do not (exactly) act alone and it is their combined action that gives rise to the movements of the hand on the forearm. These movements can take place in two principal directions: in the anteroposterior sense, flexion and extension; and in the lateral sense, adduction and abduction.

The extent of flexion and extension amounts to more than two right angles; that of the lateral inclinations, from 45° to 50°.

The articulations of the second and third metacarpals with the carpus are almost immobile. The fourth metacarpal is capable of considerable movement. The capacity for movement is even more pronounced in the fifth where the articulation with the hamate is a true saddle joint.

The articulation of the first metacarpal with the trapezium is the most mobile. These movements are in two principal directions. First, the thumb approaches or removes itself from the axis of the hand: adduction or abduction. This movement is limited within by the contact of the two metacarpals, and without by the tension of the articular capsule. Second, the thumb moves forward and back: flexion and extension. The obliquity of the trapezium is such that, in flexion, the first metacarpal places itself in front of the others and results in the movement of opposition.

Articulation of the metacarpus and the fingers, or metacarpophalangeal articulations. The head of the metacarpal rests in the cavity of the superior extremity of the phalange; this cavity is completed by a thick ligament, the *palmar ligament.* The *transverse metacarpal ligaments* unite the palmar ligaments of the four last fingers.

Very strong triangular lateral ligaments (*collateral ligaments*) run from the posterior tubercles at the head of the metacarpals to the lateral parts of the phalanges and to the palmar ligament.

Mechanism. The movements are of two types. First, flexion and extension. Limited by the resistance of the ligaments, flexion seldom exceeds a right angle. Second, adduction and abduction. The extent of this movement is limited by the resistance of the lateral ligaments.

There exists besides a slight movement of circumduction.

Articulations of the phalanges. These articulations are of little trochleas furnished with an anterior, or palmar ligament, and two lateral ligaments. They constitute true hinges of which the only two possible movements are flexion and extension.

SKELETON OF THE ARM IN GENERAL: ITS INFLUENCE ON EXTERIOR FORM (PLATES 23, 24 and 25)

The humerus supports the soft parts of the upper arm. The swelling of its superior extremity is reflected in an extension at the shoulder and it juts out beyond the bony arch formed by the acromion. Its inferior extremity on the inside (medial epicondyle) creates a pronounced prominence under the skin, while on the outside (lateral epicondyle) it disappers under the relief of the external muscles of the forearm.

The axis of the forearm forms with the axis of the upper arm an obtuse angle opening to the outside, as pointed out before. In the position of pronation this angle disappears and the forearm continues the direction of the

upper arm. Placed side by side, the two bones of the forearm, when in supination, contribute a flat quality to the forearm both in front and behind. In back and above, the olecranon forms the projection of the elbow. The whole posterior border of the ulna is subcutaneous and may be seen on the model as a furrow caused by the high relief of the surrounding muscles. Below, the two styloid processes make distinct projections: on the inside, that of the ulna; on the outside and lower, that of the radius.

The hand is, in its natural position, somewhat inclined medially from the ulna border. As a result its axis forms, with that of the forearm, an obtuse angle opening to the inside, which is, so to speak, the opposite of that formed by the forearm and the upper arm.

The anterior groove of the carpus, crossed by tendons and filled by ligaments, scarcely reveals itself on the surface. The heel of the hand is formed by the promi-nence of the trapezium outside and by the projection of the pisiform inside. The projection of the pisiform is much higher.

The hollow of the hand and the convexity of the back of the hand suggest the shape of the metacarpus. The phalanges may be discerned on the dorsal surfaces of the fingers.

The proportional length of the humerus and the radius are of great importance as they determine the proportions of the two great segments of the arm. These proportions vary somewhat according to race.

Broca has shown that if the humerus is equal to 100, the average radius of a European would be 73.8, while that of a Negro would be 79.4. The result is that Negroes have longer arms than Europeans and this difference in length is due to the longer dimensions of the forearm.

6. The Skeleton of the Lower Limb

The bones of the lower limb may be divided as follows. In the thigh, one bone: the femur. In the lower leg, two bones: the tibia and the fibula. In the foot there are the following three segments. First, the tarsus which is composed of seven bones: the talus, the calcaneus, the navicular, the three cuneiforms, and the cuboid; second, the metatarsus, composed of five bones: the five metatarsals; third, the toes, consisting of three bones each: the proximal, middle and distal phalanges. The big toe has only two phalanges: the proximal and the distal.

BONE OF THE THIGH: FEMUR (PLATE 26)

A long bone, the femur has an anterior convex curve; it is bent sharply above and directed obliquely from above to below and from without to within.

The *body*, a triangular prism, presents an anterior surface, two lateral surfaces, two lateral borders, and a posterior border.

The anterior surface is smooth, convex, and hollowed out below. The two lateral borders are rounded, but the posterior border, in contrast, is rough and prominent. The posterior border is called the *linea aspera*. The linea aspera has two superior origins. One part springs from the great trochanter and the other from the lesser trochanter. Below the linea aspera divides, forming a triangular space, the *popliteal surface*.

The superior extremity of the femur is composed of a rounded head supported by a neck which leads to a portion of the bone enlarged by the presence of two tuberosities, the *great trochanter* and the *lesser trochanter*.

The *head* represents about two thirds of a sphere directed within and above. It is marked by a depression on its median line for the attachment of a round ligament. This depression is somewhat nearer to the inferior than to the superior border.

The *neck* forms an obtuse angle with the body opening within. It is more closed on the female.

On the outside the *greater trochanter* occupies the summit of the angle we have mentioned. It presents a prominent superior border, and its internal surface is marked by a depression, the *trochanteric fossa*. The *lesser trochanter* is situated within and below. The *intertrochanteric line*, in front, and the *intertrochanteric crest*, in back, unite the two trochanters.

The *inferior extremity* is large and quadrilateral. It is formed by two condyles separated in the back by a large groove. The axis of this groove is directed from above to below and from without to within. Thus the femur, though resting on a horizontal surface, does not rise vertically. It inclines obliquely to the outside in the human body.

In front, the two condyles unite to form a true articular spool on which the patella rests. The external border rises higher and projects more than the internal. The two condyles, directed obliquely, deviate from the median plane. They are separated by a deep depression in the back (*intercondyloid fossa*) and their posterior extremity projects strongly. On their sides, the two condyles are surmounted by two bony prominences (the *medial* and *lateral epicondyles*). Above the medial epicondyle is the *adductor tubercle*.

For the average height of 1 meter, 66 centimeters, the femur is 45.03 centimeters long (Rollet).

BONES OF THE LOWER LEG: TIBIA (PLATE 27 and 28)

A long bone, directed vertically, the tibia presents three slight curves in relation to its length. The superior curve is an external concavity; the inferior, an internal concavity. The tibia is twisted upon itself, and the transverse axes of the superior and inferior articular surfaces make an angle between them of about 20°. The result of this twist is that the direction of the foot is to the outside.

The body is a triangular prism with two lateral surfaces and a posterior surface, an anterior border, and two lateral borders. The external surface, concave above, becomes convex and moves to the front below. The internal surface, smooth and slightly convex, is subcutaneous throughout its entire length. The posterior surface is divided into two unequal parts by an oblique line directed from above to below and from without to within. Above the oblique line is the *popliteal surface*.

The anterior border, or *crest of the tibia*, forms an elongated italic *S*, ending in front of the medial malleolus. The external border divides in order to receive the fibula.

The *superior extremity* is large and flattened above. It is in contact with the condyles of the femur. The superior surface presents, on the anteroposterior axis, two shallow articular cavities which are separated by the *intercondylar eminence*. These two cavities are of slightly different form: the external one is larger and longer than the internal. They rest upon an enlargement of the bone which is composed of condyles. On the lateral condyle, at the outside and in the back, there is an articular facet for the fibula. The medial condyle is crossed by a transverse

groove for the tendon of the semimembranosus. Finally, in front and lower down, there is the *anterior tuberosity of the tibia*. This tuberosity offers attachment to the lower patella ligament and surmounts the anterior border of the bone.

The *inferior extremity*, which is quadrangular, offers a trapezoidal excavation on its lower part which articulates with the talus.

On the inside, the surface is prolonged by a thick process which forms the medial malleolus.

On the outside, there is a triangular surface which articulates with the fibula. In back, there is a groove for *tibialis posterior*.

According to Rollet, for a figure of 1 meter, 66 centimeters, the tibia has a length of 36.06 centimeters.

BONES OF THE LOWER LEG: FIBULA (PLATE 27 and 28)

The fibula is long, slender, triangular in cross section, and twisted upon itself.

At the superior part of the bone two lateral surfaces and a posterior surface can be distinguished. As a result of the twisting of the bone, the exterior surface becomes, below, a posterior surface. The other surfaces and borders follow the same deviation.

The internal surface is divided by a longitudinal crest, the *interosseus border*.

The *superior extremity*, or head, has a flat articular surface. Outside of the head the bone forms a prominence, the *styloid process* of the *fibula*.

The *inferior extremity*, or *external malleolus,* triangular in form, is subcutaneous on its external surface. Its interior surface has a vertical facet which articulates with the talus. Below, it has a rough depression for the insertion of ligaments. On its posterior border there is a groove for the tendons of the lateral peroneal muscles. The fibula is the same length as the tibia, more or less.

For a height of 1 meter, 66 centimeters, the fibula has a length of 36.02 centimeters (Rollet).

PATELLA (PLATE 27)

A flat triangular bone, the patella is situated at the anterior part of the articulation of the knee, reposing on the femoral condyles. Its superior part is attached to the tendon of the quadriceps; its inferior part to the lower patellar ligament.

It presents two surfaces and a circumference. The anterior surface is rough and subcutaneous.

The posterior surface is the articular surface. It is separated into two unequal portions by a bony crest which corresponds to the groove on the patellar surface of the femur.

The circumference has the form of a triangle of which the base points upward. The patella give attachment to ligaments on all of its sides.

BONES OF THE FOOT

Like the hand, the skeleton of the foot is composed of three segments: the tarsus, the metatarsus, and the toes.

TARSUS (PLATES 28 and 29)

The tarsus is composed of seven bones, divided into two rows. The first row consists of the talus, the calcaneus and the navicular. The second row consists of the three cuneiforms and the cuboid.

Talus. The talus forms the summit of the skeleton of the foot. Its superior surface is in touch with the bones of the lower leg and it surmounts the calcaneus. It has a head, a body, and a neck. Without entering into a detailed description of each of these parts, let us examine the diverse surfaces of the bone as a whole.

Above, there is an articular surface in the form of a spool for the tibia, wider in front than behind, and separated from the head (which is in front) by a depression.

The external or lateral surface presents a triangular articular facet for the inferior extremity (*lateral malleolus*) of the fibula, below which the bone projects somewhat.

On the medial surface there is a *medial malleolar facet*, shaped like a crescent.

In back, the bone is grooved obliquely for the tendon of the flexor hallucis longus. In front, the head of the talus shows a rounded surface for articulation with the navicular.

Finally, on the inferior surface there are three facets (posterior, middle and anterior) which articulate with the calcaneus. The posterior calcaneal articular surface is separated from the middle and anterior surfaces by a groove (*sulcus tali*).

Calcaneus. The calcaneus is the bone of the heel. It is massive and somewhat cuboidal in form. In front, a large and a small process can be distinguished. The body forms all the posterior part of the bone.

Like the talus, we shall consider the various surfaces.

The superior surface, in back, is narrow and rough. In front, there are two articular surfaces, separated from the posterior articulated surface by a groove (*sulcus calcanei*). These surfaces articulate with the inferior surface of the talus.

Below, the bone forms three unequal prominences; one is anterior, the *calcaneal tuberosity*, and two posterior, the *lateral* and *medial processes*. The posterior prominences are situated side by side, the larger on the inside.

The lateral surface is flat, rough, and vertical; a tubercle (*trochlea process*) separates two grooves for the tendons of *peroneus longus* and *brevis*.

The medial surface, on the contrary, is smooth. It is completely transformed into a groove for the tendons of the deep posterior muscles of the lower leg, owing to the projection of the *sustentaculum tali*.

In back, the calcaneus carries an impression for the insertion of the Achilles tendon.

In front, the greater tuberosity presents an articular surface which is in contact with the cuboid.

Navicular. The navicular, of smaller size than the two preceding bones, has the form of an oval disk. It presents two surfaces and a circumference.

The two surfaces are articular. The anterior surface is divided into three facets for the cuneiforms; the posterior

surface has but a single facet which is hollowed out to receive the head of the talus.

The circumference is rough and convex above. On the inside it is prolonged into a considerable swelling. On the outside it usually has an articular facet for the cuboid.

Cuneiforms. The cuneiforms, three in number, articulate with the navicular in back, and the three first metatarsals in front. They owe their name to their shape and are designated by their number reading from the inside of the foot.

The first (medial) cuneiform is the largest; its base is rounded below, and its edge is directed above. The medial surface is rough and it is marked in front and below by an impression for the attachment of tibialis anterior. The lateral surface articulates along its *superior and posterior borders* with the second (intermediate) cuneiform and in the front with the second metatarsal.

The two other (intermediate and lateral) cuneiforms are smaller and their bases are turned to form their superior surfaces. They create the most projecting part of the dorsum of the foot. The third (lateral) cuneiform articulates at its medial surface with the second (intermediate) cuneiform, and with a part of the head of the second metatarsal. Its lateral surface articulates with the cuboid bone.

Cuboid. This bone is formed like an irregular cuboid, hence its name. It is situated at the external border of the foot, beyond the navicular and the cuneiforms. The dorsal surface is rough and is strongly inclined toward the external border of the foot.

The plantar surface of the cuboid is crossed by an oblique groove (*peroneal sulcus*), for the tendon of peroneus longus. This groove is separated from the rest of the bone by a blunt tuberosity. The posterior surface articulates with the calcaneus, the anterior surface with the last two metatarsals. The flat medial surface articulates with the navicular and the third cuneiform, and the lateral surface, which is reduced to a heavy border, has a slight hollow which is the point of departure for the groove (peroneal sulcus) of peroneus longus.

METATARSUS (PLATE 28 and 29)

The metatarsus consists of five bones which articulate in back with the bones of the second row of the tarsus. They are designated by number reading from within to without.

They are, like the metacarpals, small long bones each offering a body and two extremities. The body, triangular and prismatic in cross section, turns one of its surfaces toward the dorsum of the foot. The tarsal extremity is a thick irregular cuboid. The anterior extremity, or head, offers a rounded articular surface, most prominent on the plantar surface. This anterior articular surface terminates in two tubercles.

The distinctive characteristics of the metatarsals are as follows. The first metatarsal is short and voluminous and its proximal extremity terminates below in a very large tuberosity. The base of the second metatarsal enters as a sort of wedge into a recess formed by the three cuneiforms. Besides their articulations with the tarsus, the proximal extremities of the second, third, fourth, and fifth metatarsals articulate one with the other by their corresponding facets. The fifth metatarsal has at its proximal extremity in back and to the outside, a large tuberosity.

PHALANGES

I shall not describe the phalanges in detail since they are analogous to those of the fingers.

ARTICULATIONS OF THE HIP (PLATE 25)

The articular surface is the acetabulum which is situated on the side of the iliac bone. The depth of the acetabulum is augmented by a prismatic extension or lip analogous to that of the glenoid cavity at the shoulder. The base of the lip lies on the superior part of the cavity and its internal surface prolongs the articular surface. The whole lip rests like a bridge above the acetabular notch.

On the side of the femur, the articular surface is formed by the spherical head of the bone of which the radius is the same as the cavity which receives it.

Ligaments. A *fibrous capsule* surrounds the articulation in the form of a complete fibrous sleeve running from all around the acetabulum to the base of the neck of the femur.

There are also longitudinal fibers of which the most considerable go from the lower part of the anterior inferior iliac spine to the intertrochanteric line. They form the *iliofemoral ligament*. There exist, besides, circular fibers which form the inferior and posterior parts of the capsule.

Several of these ligamentary fibers, besides those which originate at the anterior inferior iliac spine, come from the pubis and the ischium.

The longitudinal fibers have a disposition to spiral around the neck of the femur, through which their tension is augmented in extension and diminished in flexion.

Ligamentum capitis femoris. Lodged in the depth of the acetabulum, this ligament has a vertical direction. It descends and expands from the depression of the femoral head toward the acetabular notch, to the border of which it is inserted. It attaches to either side of the bottom of the acetabulum and to the cross ligaments which traverse the notch. It is formed of extremely strong fibers. This intraarticular ligament (the importance of which has long remained unrecognized) does not maintain the contact of the two articular surfaces but supports a part of the weight of the pelvis which would otherwise fall on the femoral heads. It is, in fact, a true suspensory ligament of the trunk as my friend Paul Poirier has demonstrated.

Mechanism. The femoral head exactly fills the acetabular cavity augmented as it is by its lip. However, the acetabular lip, which is not flexible, cannot maintain the two surfaces in contact without assistance. The contact of the two surfaces is, therefore, also maintained by the resistance of the ligaments, the tonicity of the neighboring muscles, and above all by atmospheric pressure.

The movements of the femur, because of the spherical

nature of the articular surfaces of the bone, can take place in any direction, nevertheless these movements can be broken down into three principal types.

Flexion and extension take place around a transverse axis passing through the center of the femoral heads. Flexion is limited by the meeting of the thigh and the trunk, extension by the tension of the anterior ligament.

Inward and outward rotation are carried out around a vertical axis. It is limited by the opposition of the capsular ligaments.

Lateral movements or abduction and adduction pass around an anteroposterior axis. They are limited in adduction by the iliofemoral ligament and in abduction by the meeting of the acetabular border and the neck of the femur.

ARTICULATIONS OF THE KNEE (PLATE 30)

The articular surfaces belong to three bones. The first surface lies on the *femur*. The articular surface is divided into three parts: in front, there is the patella surface which is hollowed at its center by a vertical groove and in back there are two condyloid surfaces which are separated from the patellar surface by two small oblique grooves. The secondary surface lies on the *patella*. The posterior surface of this bone is entirely articular. The third surface is situated on the *tibia*. The glenoid cavities of the tibia, quite flat and separated by the spine of the tibia, present articular surfaces on which the condyles of the femur rest. These cavities are surmounted by two fibrocartilages which increase their depth, and supplement or reduce the concordance of the two surfaces in contact. These fibro-cartilages are crescent shaped and are called the *menisci*. The thick convex edge of each is attached to the periphery of the glenoid cavities. The concave borders are thin and turned toward the center of the cavity. The lateral meniscus is nearly circular. It is inserted by its two extremities into the spine of the tibia. The medial menis-cus, which is attached in front and in back of the insertions of the lateral, is crescent shaped.

In the movements of articulation, the ligaments move with the tibia.

Ligaments. At the center of the articulation the *cruciate ligaments* are situated. These are very strong ligaments which partially fill the intercondylar fossa of the tibia and pass to the medial surfaces of the femoral condyles. They cross each other in both an anteroposterior and a transver-sal direction. The anterior, which starts in front of the spine of the tibia, moves back and outwards to insert into the posterior part of the medial surface of the lateral condyle of the femur. The posterior, which moves in a contrary direction from back to front, goes from the posterior part of the tibia to the anterior part of the intercondylar fossa. From there it runs to the medial surface of the medial condyle of the femur.

All around the articulation there are the following ligaments. The *anterior ligaments* are formed at the center by a very strong ligament. This ligament goes from the anterior tubercle of the tibia to the patella and joins with the most anterior fibers of the tendon of the quadriceps muscle. On each side thinner membranous ligaments go from the edges of the patella and attach to the condyles.

Posterior ligaments do not really exist. They are re-placed by the neighboring muscles and their tendons.

The *collateral ligaments* are extremely distinct. The fibular collateral ligament, in the form of a strong resis-tant cord, goes from the lateral epicondyle of the femur to the head of the fibula. The tibial collateral ligament, on the contrary, is flat. It is attached above to the medial condyle of the femur, and below to the posterior and superior internal surface of the tibia.

Mechanism. The articulation of the knee is that of an imperfect hinge. It permits not only flexion and exten-sion, but also rotation. It is true that this latter movement is incompatible with extension; it only takes place in demiflexion. Flexion and extension take place through the sliding and the rolling of the condyles of the femur upon the medial and lateral menisci.

Extension is arrested, as soon as the tibia and the femur form a straight line, through the tension of the cruciate ligaments and the collateral ligaments. Flexion may be carried out until the lower leg muscles meet the thigh.

Rotation can only take place in the intermediate positions between extension and complete flexion. The movement is located, above all, at the lateral condyle of the tibia, and dies out, so to speak, around the medial condyle. This is partly because the fibular collateral ligament is more relaxed in flexion than the tibial collat-eral ligament. The latter ligament maintains a more solid contact between the tibia and the femur on the medial side. In rotation to the inside, the intersection of the cruciate ligaments is augmented and this very quickly limits the movement. These ligaments do not intersect in rotation to the outside so that this movement is only limited by the resistance of the collateral ligaments.

ARTICULATION OF THE TIBIA AND FIBULA

The fibula articulates with the tibia by its two extremities. The two bones are also united by an interosseous mem-brane which inserts medially to the external border of the tibia, laterally to the interosseous crest of the internal surface of the fibula, and along its inferior third to the anterior border of this bone.

The superior *tibiofibular articulation* is formed by two articular facets which are almost flat planes. They are surrounded by a fibrous capsule.

The inferior *tibiofibular articulation (tibiofibular syn-desmosis)* does not really have an articular surface. The two bones are solidly united at their inferior extremity by an interosseous ligament and by two exterior ligaments, the anterior and the posterior tibiofibular ligaments. These ligaments secure the tibiofibular mortise.

ARTICULATION OF THE ANKLE JOINT (PLATE 31)

This is a hinge-like articulation formed by the talus with the tibia and fibula.

Articular surfaces. On the talus bone the surfaces take on the form of a segment of a spool which is disposed in an anteroposterior direction. The hollow is above, larger in front than in back, and the external border projects more than the internal.

Laterally there are two facets which continue into the superior surface without interruption. They are somewhat different in shape: the external facet is triangular; the internal facet is sickle shaped.

On the fibula and the tibia the articular surfaces (tibiofibular syndesmosis) fit the spool-like surface of the talus, but not exactly. Since their articular surfaces are not as long from front to back, they only rest on a part of the surface of the talus.

Ligaments. The ligaments of this articulation are disposed on each side. In front and in back the synovial membrane is loose and sheathed with fibers.

The *internal lateral* or *deltoid ligament* is thick and triangular. It is attached at its summit to the medial malleolus from where it fans out and inserts on three ankle bones: on the navicular, on the lesser process of the calcaneus, and on the posterior part of the talus. Its deepest fibers, which are somewhat separate, all go to the medial surface of the talus.

There are three external lateral ligaments. In front, the *anterior talofibular ligament* goes from the anterior border of the fibular malleolus to the talus, in front of its lateral articular facet. In the middle, the *calcaneofibular ligament* transcends from the summit of the fibular malleolus and goes to the lateral surface of the calcaneus. In the back, the *posterior talofibular ligament*, running transversely, goes from the medial posterior surface of the fibular malleolus to the posterior border of the talus immediately to the outside of the groove for the flexor hallucis longus.

ARTICULATIONS OF THE FOOT (PLATE 31)

Articulations of the talus. The inferior articulation of the talus (subtalar articulation) is divided into two distinct articulations: the first, posterior, the body of the talus articulating with the calcaneus; the second, anterior, the head of the talus articulating with the calcaneus and the navicular. These two articulations are separated by extremely strong sheaths of fibers which fill the cavity of the tarsus and bind the talus and the calcaneus firmly together. These fibers form the *interosseous talocalcaneal ligament.*

Inferior posterior articulation of the talus. Articular surfaces. The head of the talus is received in a cavity formed in back by the concave anterior facet of the calcaneus, and in front by the concave posterior facet of the navicular. A fibrocartilaginous ligament unites the calcaneus and the navicular. It is called the *plantar calcaneonavicular ligament.*

There are two other ligaments reaching from the calcaneus to the external part of the navicular: on the outside, the medial branch of the *bifurcated ligament*; on the superior part, the dorsal *talonavicular ligament* reaching from the neck of the talus to the navicular.

Articulation of the calcaneus and the cuboid (calcaneocuboid articulation). This is a saddle joint. The articular surface of the calcaneus is convex from within to without and concave from above to below. The articular surface of the cuboid has inverse curves.

There are three ligaments: first, the *dorsal calcaneocuboid ligament*; second, the lateral branch of the *bifurcated ligament*; third, an inferior ligament, the *long plantar ligament*. The latter goes from the tuberosities of the calcaneus to the whole inferior surface of the cuboid. Some of its most superficial fibers reach as far as the third cuneiform and the bases of the four last metatarsals.

Articulations of the navicular, cuboid and cuneiforms. The three cuneiforms and the cuboid articulate with each other through flat surfaces, and the navicular articulates with the three cuneiforms through triangular surfaces which are almost flat. There is sometimes a fourth facet on the navicular in contact with the cuboid.

Ligaments. The cuneiforms and the cuboid are united by three types of ligaments: a dorsal ligament, a plantar ligament, and an interosseous ligament. Besides, all four bones are united to the navicular by a dorsal and a plantar ligament; there is, in addition, an interosseous ligament going from the navicular to the cuboid.

Tarsometatarsal articulations. The first metatarsal articulates with the first cuneiform, the second with the three cuneiforms, the third with the third cuneiform, and the last two with the cuboid. Moreover, the metatarsals, with the exception of the first, articulate between themselves through their lateral facets.

All these bony parts are maintained in contact by three types of ligaments: the dorsal ligaments, the plantar ligaments, and the interosseous ligaments.

Metatarsophalangeal articulations. These are condyloid articulations formed by the reception of the convex heads of the metatarsals by the concave facets of the phalanges. Below fibrocartilaginous ligaments (*plantar ligaments*) fill the phalangeal cavity. These ligaments are all united by a transverse plantar band, the *transverse metatarsal ligament*. On either side of each joint there are very resistant lateral ligaments.

Mechanism of the Foot. The foot forms a rising flattened vault held above the ground by several points of support: in back, by the calcaneus; in front, by all the heads of the metatarsals; and, on the outside, by the entire length of the external border. This vault, which supports the whole weight of the body, is maintained by the shape of the bones; by the resistance of the ligaments (above all the great plantar ligaments); and finally by the muscles and the aponeuroses.

The movements of the foot upon the lower leg are of two kinds. Both these movements may be divided into two different articulations.

Flexion and extension take place at the ankle joint proper (tibiotarsal articulation); adduction and abduction take place beneath the talus (subtalar articulation).

The tibiotarsal articulation is a true hinge of which the axis is horizontal and transversal. In virtue of the movements which take place through this joint, the point of the foot is lifted or lowered. In extension, because the articular surfaces are larger in front than behind, the narrowest part of the talus is placed in the largest part of the tibiofibular mortise. Certain lateral movements are thus possible which are not possible in flexion.

Flexion and extension are limited by the meeting of the bony surfaces.

During adduction (subtalar articulation) the point of the foot turns to the outside and the external border is lowered. This movement is the inverse of abduction. During these movements, the calcaneus and the navicular, and with them the rest of the foot, move upon the talus. At this point the talus becomes immobilized within the tibiofibular mortise. Adduction is greater than abduction.

The other tarsal articulations also come into play during these movements.

The *tarsometatarsal articulations* are limited; they permit very slight movements. In the *metatarsophalangeal articulations*, flexion is more extensive than extension.

SKELETON OF THE LOWER LIMB IN GENERAL: ITS ACTION ON EXTERIOR FORM (PLATES 32, 33, 34 and 35)

The femur does not occupy, as the humerus does, the center of the limb of which it forms the skeleton. However, it appears to be in the center on the side view (Plate 34), apparently situated in the center of the soft parts and parallel to the axis of the thigh. However, in considering the front view (Plate 32), it can be seen that it is obliquely directed and that, flush with the skin (through the great trochanter) at the superior and external part of the thigh, it only approaches the axis of the thigh at the bottom. Its inferior extremity occupies the center of the knee.

The bones of the lower limb are directed almost vertically and in such a manner that they form with the femur an extremely obtuse angle opening to the outside. The summit of the angle corresponds to the internal part of the knee.

In the standing position, the superior border of the patella juts forward. Its inferior extremity does not quite reach the line of articulation of the knee.

Besides maintaining proportions in height, the femur directly affects the surface in numerous places. Above the great trochanter it creates a strong hollow which is easily seen in the erect position. (This hollow becomes somewhat obscure in flexion of the thigh, and we shall see the reasons for this later.)

I should mention here that the anterior convexity of the femur contributes to the curve of the anterior exterior surface of the thigh.

At the knee, the skeleton strongly affects the exterior surface. Taking into account the projection of the patella in front, a cross section of the knee has a quadrangular appearance of which the bony extremities of the femur and the tibia form the framework. Among the many forms seen on the surface, a certain number are directly caused by bony prominences. In front is the well known projection of the patella, and some distance below the anterior tuberosity of the tibia. In extension the intercondyloid fossa of the femur is masked by the presence of the patella. However, in flexion of the knee conditions change; the external border of the intercondyloid fossa stands out in sharp relief while the internal border is masked by the vastus medialis muscle.

On the external surface, the superimposed lateral condyles of the femur and the tibia sustain the form by their projection. However, the muscular shapes above and below place this side of the knee at the bottom of a large depression.

It is not the same on the inside. The medial condyles fall at the summit of the angle formed by the skeleton of the thigh and the lower leg. The condyles are expressed on the outside by two projections between which a transverse furrow, sometimes visible, marks the line of articulation.

The head of the fibula may always be seen, although its projection, much diminished by the muscles which attach to it, is not very large.

At the knee, the whole interior surface of the tibia is subcutaneous. At the ankle, on the inside, the inferior extremities of the tibia, and, on the outside, those of the fibula, constitute the two malleoli. The internal or medial malleolus is larger, nearer to the anterior border, and more elevated. The external or lateral malleolus is narrower, situated more or less at an equal distance between the anterior and posterior surfaces, and lower.

The projection of the heel is due entirely to the volume of the calcaneus. The arch of the foot is sustained by the skeleton of this region; the bones are disposed with this end in view. Along the internal border one notes, toward the middle, the projection of the navicular, and, at the anterior extremity of the border, the outline of the first metatarsal. The external border rests entirely on the ground; at the middle part of its outline the tuberosity of the fifth metatarsal is visible.

Anthropologists have sought to establish relative dimensions for the femur and the tibia.

According to Topinard, if the femur is equal to 100, the tibia, for the European, has a length of 80.4, and for the Negro, 82.9. Thus the tibiofemoral relationship in the white and black races resembles that of the bones of the forearm.

7. Myology

Between the bones (which form the framework of the body) and the skin, there are muscles which fill almost all the intervening space. The volume of the vessels and the nerves is, in fact, so slight that it hardly counts as far as the mass of the body is concerned. The fat, which is mostly disposed at the undersurface of the skin, is also of morphological importance, but I shall discuss this later. Myology is primarily concerned with the nature, structure, and function of the muscles in the human body.

COMPOSITION OF MUSCLES

The total mass of the muscles may be evaluated as a little more than half of the total weight of the body. They are composed of a central red contractile part, called the *belly* or *body*, and of resistant extremities of a mother-of-pearl color, called *tendons* or *aponeurotic insertions*. The tendons consist of fibrous tissue and they attach themselves to the fleshy part of the muscles and to diverse parts of the skeleton. Certain muscles are attached by their extremities to the undersurface of the skin itself (*cutaneous muscles*). Others are disposed circularly around natural openings (*sphincter muscles, orbicular muscles*).

The fleshy body is made up of primitive muscular fibers which join to form primitive fasciculi. These fasciculi join to form in their turn the secondary and then tertiary fasciculi. An envelope of connective tissue surrounds the entire organ and sends prolongations between the diverse fasciculi of which it is fashioned.

The skeletal muscles are divided into the long muscles, the short muscles, and the large muscles. The first are mostly encountered in the arms and legs; the second near the spinal articulations; and the last on the trunk.

DISPOSITION OF MUSCLE FIBERS

It is most important to consider the direction of the fleshy fibers of muscles and the fashion in which they grow into the tendon. Sometimes the fleshy fibers continue in the direction of the tendon. Most often, however, the fleshy fibers are implanted obliquely on the tendons in such a manner that each tendinous fiber receives a considerable number of fleshy fibers, and the muscle, which takes on a fusiform or spindle-like shape, then terminates in a point toward the tendon.

Diagrams can be easily made to show the variable dispositions of the fleshy fibers in relation to the tendons between which they are usually placed (Figure 2).

(A) represents the case already mentioned in which the tendinous fibers follow the direction of the fleshy fibers. In the figure (B), the superior tendon, in the shape of a simple cone, receives the fleshy fibers on its surface. These fibers are inserted at their base into the interior of a

Figure 2.

hollow cone formed by the inferior tendon. This type of muscle is called *penniform*, because the disposition of the fibers resembles a feather. The type drawn in (C) is another type which is but a half of the preceding. It is called *semipenniform*.

This same disposition of fibers is accentuated in (D). In (E) it still exists, but an inverse relationship may be observed between the dimensions of the tendinous parts and the fleshy parts.

From this variable arrangement of fleshy fibers we are able to deduce several important facts. The fleshy fibers are of the same length on A, B, and C, but the fleshy body is longer on B and C than it is on A. The fleshy bodies are of equal size in D and E, but the muscular fibers are much shorter in D than in E. Therefore, in considering the length of a muscle, it is wise to consider the length of the tendons, the length of the fleshy body, and the length of the individual muscle fibers.

The first two of the preceding ideas have great morphological importance. If muscles are superficial the outline of the fleshy fibers and the manner in which they are implanted into the tendons is always apparent on the surface. The last idea is important in physiology, for the length of the different parts of a muscle indicates the amount of shortening of which the muscle is capable, as well as the amount of stretching. These amounts indicate the degree to which the muscles may move.

In the examples we have noted above, the fleshy fibers of the same muscle are of the same length. However, this is not always so. Particularly in the flat muscles one may observe differences in the length of the fibers of which the muscles are composed.

FASCIA

All muscles are enclosed in veritable scabbards or sheaths of fascia. As all the sheaths of the same region are intimately joined where their surfaces meet each other, a reciprocal relationship is maintained. This fascia or aponeurosis, coming from bony eminences, is at times reinforced by the expansion of tendons. Some muscles attach themselves directly to the fascia. They have, like the tensor of the fasciae latae, a tendon which fills the role of an aponeurosis in regard to other muscles. Finally, these aponeurotic envelopes vary in thickness depending on the regions which they occupy. They exercise a permanent compression on the muscles contained in their sheaths and thus augment the muscle's power of contraction.

MUSCULAR CONTRACTION

Without entering into great detail on a phenomenon so complex as muscular contraction, I will say a few words.

The red muscular fiber is the generator of mechanical work; the tendon is only an inert organ of transmission. Therefore, the capacity for contraction is located in the red fiber and consists of a shortening under the influence of an excitant. These fibers are, besides, endowed with elasticity; that is to say, they may be stretched by pulling. After extension they recover their original form.

When a muscle is free at its extremities, it is soft and malleable both in contraction and repose. It only becomes hard under the influence of the pull of its two extremities, with the result that the hardness of a muscle is not a sign of its degree of contraction. A muscle stretched by the action of an antagonistic muscle, or simply by the mechanical separation of its points of attachment, may be as hard as a contracted muscle. A muscle free of its extremities forms, in the moment of contraction, a somewhat globular mass which is about a third of its original length. The shortening does not extend beyond this length in the living.

The amount of work of which a muscle is capable is proportional to the amount of active substance of which it is made: that is to say, to the weight of the red fibers. But a muscle's capacity for work would have a different proportional relationship to weight, depending on whether the weight was due to a certain quantity of long fibers, or to a more considerable quantity of short fibers. Physiologists have, in fact, stated that the extent of movement which a muscle may produce is proportional to the length of its fibers, while its force is proportional to the transverse section, that is to say, to the sum of the elementary fibers which the muscle contains. As a result, there is a necessary relationship between the form of a muscle and its function. This shows that the morphogenic point of view is of considerable importance as Marey* has pointed out.

MUSCULAR FORCE

If a muscle is attached at both extremities to two bones which are united by an articulation, when it contracts it moves the mobile bone in a direction determined by the conformation of the articular surfaces. The power of the movement depends on the manner in which the muscle is inserted on the mobile bone.

From elementary mechanics we learn that a force is exerting its maximum action when it is held perpendicular to a moving lever; it exerts less and less action as it is held in a direction more parallel to the lever. Therefore, a muscle would have the greatest possible power when its fibers are disposed in a perpendicular direction to the bone which it must move.

This disposition is, however, rare in the organism. The muscles of the members are, for the most part, placed in a parallel fashion to the great axis of the bones which they are destined to put in motion. But the importance of articular projections should be noticed in this respect. They perform the function of pulleys for certain tendons and, in augmenting the angle at which the muscular insertion is made, to a certain extent correct the defective arrangement I have just pointed out.

It follows from the preceding that, because the angle of insertion of the same muscle varies with the displacement of the mobile bone, its power varies correspondingly; if this angle is a right angle, the muscle will have at that point the greatest power. This point is what is called the *moment* of a muscle.

In these movements, the mobile bone represents a lever of which the point of support is at the articulation, the

* "Des Lois de la Morphogénie chez les Animaux" by E. J. Marey, *Archives de Physiologie*, 1889, Numbers 1 and 2.

power at the insertion of the muscle, and the resistance toward the free extremity of the displaced bone. This resistance takes the form of the weight, of the resistance of the antagonists and, in short, of all the obstacles which are opposed to the displacement. Depending on the respective positions of the three points of resistance, the mobile bone is a lever of the first, second, or third degree.

MUSCLE GROUPS

Muscles may be thought of in groups that act in the same way. Thus there is the group of flexors, of extensors, of adductors, etc.

These muscular groups, disposed around the articulation, impel the mobile segment by rotations in opposite directions. When a movement is produced in one direction under a given muscular action, there is always a muscular force in the opposite direction which produces an inverse movement. This inverse movement is destined to replace the member in the position of its point of departure.

Muscles acting in a given direction (flexors, for example) are the *antagonists* of muscles acting in the opposing direction (extensors).

It is important to list here certain laws which control the complex play of the muscular system.

A muscle, even in a state of repose, is always in a certain degree of tension and if, in the living, a muscle was divided through its middle, the two fragments could be seen pulling away from each other. This tension has been named *tonicity*.

ANTAGONISTIC ACTION OF MUSCLES

A muscle never contracts alone. Its action is accompanied by that of one or several of the congenerous muscles which surround it, and also by the antagonistic muscles themselves which enter into contraction. The action of the antagonistic muscles has the effect of moderating or rendering more precise the movement provoked by the first, so much so that it is false to say that in flexion, for example, it is only the flexors that contract. Whatever movement is produced, the antagonistic groups enter into the same action at the same time, and the direction of the movement (flexion or extension) is only determined by the predominance of the action of one group over that of its antagonist. The flexors, for example, may predominate over the extensors, or vice versa. Finally, all segments of the skeleton have a certain mobility upon one another. Therefore, if a muscle is to displace with sureness and precision the bone attached to one of its extremities, it is necessary that its other extremity should be inserted in a fixed place, and that, in addition, this place be immobilized by the contraction of other muscles which are attached to it. This is why, in somewhat violent movements, this synergetic contraction takes place to some extent even in parts far away from the scene of the action.

RELATIONSHIP OF MUSCLES TO EXTERIOR FORM

Before terminating these general considerations, let us draw from them the principal points that relate particularly to exterior form.

First, at the place where they are attached to the aponeurotic fibers, the fleshy fibers form an outline clearly visible under the skin. Here muscular contraction, which enlarges the volume of the fleshy portion, can be clearly seen. The surface relief of a superficial muscle will show a depression at the level of its aponeurotic portions, leaving out the prominence caused by the tendon.

Second, the relative lengths of the fleshy body and the tendinous fibers within one muscle are not the same in all individuals. There is great variety. The fleshy part being the essential part of the muscle, I shall designate under the term *long muscle* those in which the fleshy part is relatively longer, and, in a like manner, by the term *short muscle* those in which the fleshy body is relatively shorter. If we imagine a flayed figure whose muscles are of the long type, we would see the red fibers descending lower on the pearly aponeuroses and, therefore, as a whole the flayed figure would be quite red.

If, on the contrary, the muscles were of the short type, the red parts would lose their importance and the aponeuroses would be longer. The flayed figure would seem more pearly. However, these differences of color, invisible under the skin of the model, may be discerned on the exterior form through a difference of shape. The red parts generally correspond to the prominences and the pearly parts to the depressions.

Nevertheless, subjects who have long muscles may be recognized by their general slenderness of shape (despite the muscular volume), by the absence of violent indentations at the level of muscular insertions, and by the fusiform aspect of the members. Classical forms, for the most part, belong to this type.

The short muscled subjects, on the contrary, are all bumps and hollows. The bellies of their muscles are short and projecting, and there are marked depressions at their extremities. The general form is abrupt in style; there is less harmony.

Third, some aponeuroses are composed of distinct and resistant fasciculi which bind the fleshy body of the muscle and in certain positions cause important modifications on the model. Their effect can be seen, for example, low on the thigh, at the level of vastus medialis, when the leg is extended, and at the buttock, at the level of gluteus medius, during flexion of the thigh. However, the influence of the aponeuroses is difficult to formulate.

Fourth, when muscles enter into action they become short and thick. The result is that their relief under the skin increases and becomes hard. The modeling of a contracted muscle is therefore considerably different from that of one in repose. However, I should point out here that the state of repose does not exist for a single muscle of a member in the movement. It is important not to exaggerate the modeling of antagonistic groups. The harmony of the muscular play should correspond to the harmony of the form. Remember too, that the synergetic action of muscles, even in limited movement, may have an effect in varied and distant parts of the body.

Fifth, a relaxed muscle is subject to gravity, a fact which will explain certain shapes we shall study later.

Finally, if the points of attachment, in approaching each other, surpass the limits of the elasticity of the muscle, the fleshy body forms wrinkles perpendicular to the direction of its fibers. This may often be observed in the spinal muscles at the small of the back.

8. Muscles of the Head

The muscles of the head (Plates 36 and 37) may be divided into three groups. The epicranial muscles; the muscles of the face; and the muscles which move the lower jaw.

Among the muscles of the head, one epicranial muscle, the *frontalis*, and all the muscles of the face have the function of moving the integument of the face. This allows our expressions to reflect our sentiments and passions. However, I do not wish to undertake a study of physiognomy. I shall reserve that for a special work. Here, I shall simply set down the movements and wrinkles each muscle causes on the skin according to the remarkable work of Duchenne de Boulogne.

EPICRANIAL MUSCLES (EPICRANIUS)

These muscles, all superficial, are disposed about an aponeurosis which covers the vault of the cranium much in the manner of a skull cap. They form four groups: in front the frontal, in back the occipital, and on the sides the auricular.

FRONTALIS

Attachments: origin, from the anterior border of the epicranial aponeurosis; *insertion*, into the skin in the region of the brow and the nose.

This flat muscle is separated from its opposite side by a straight triangular space opening above. Its superior border describes a superior convex curve which can often be seen on the skin of the forehead if the hair line is high.

Action. Besides being a tensor of the epicranial aponeurosis, this muscles wrinkles the skin of the forehead transversely and elevates it at the same time when its fixed point is taken from the occipital. It expresses astonishment or attention. The elevated eyebrow describes a curve of superior convexity, and the frontal wrinkles are concentric to the arc of the eyebrow.

OCCIPITALIS

Attachments: origin, from two thirds of the superior curved line of the occipital bone; *insertion*, into the posterior border of the epicranial aponeurosis.

Action. It stretches the epicranial aponeurosis.

AURICULARIS MUSCLES

These are divided into the anterior, posterior, and superior auricularis. The muscles arise from the epicranial aponeurosis and are inserted into the external cartilage of the ear. Their action is very limited, and movements of the ear by these muscles are possible in some individuals, but not in others.

MUSCLES OF THE FACE

These muscles are divided into three groups. They are placed about the orifices of the eyelids, the nostrils, and the lips.

CORRUGATOR (CORRUGATOR SUPERCILII)

Attachments: origin, from the medial end of the superciliary arch; *insertion*, into the skin of the eyebrow. Stretching transversely, covered by the orbicularis muscle, the corrugator is slightly oblique from the outside and above.

Action. This muscle expresses grief. The head of the eyebrow lifts and swells; the eyebrow itself is oblique from below to the outside. Vertical wrinkles appear in the middle part of the forehead and become smooth below the external half of the eyebrow.

ORBICULARIS PALPEBRARUM (ORBICULARIS OCULI)

Very thin, set in a circle around the palpebral orifice, this muscle is divided into two parts; the palpebral portion and the orbital portion. The palpebral portion is in the eyelids. Its action closes the eye by lowering the superior eyelid and raising the inferior eyelid.

The orbital part, eccentric to the preceding, lies on the bony portion of the orbit. This muscle has a tendon which goes from the internal angle of the eye to the lacrimal crest of the rising apophysis. The outline of this tendon, slightly oblique from without to within and from below to above, may be easily seen across the skin.

The orbicularis muscle is also attached to the internal border of the orbit. From there the fibers move outwards to describe a line around the eye which is an almost complete circle.

Action. The superior orbital part pulls down the eyebrow mass and erases the frontal wrinkles. The eyebrow becomes rectilinear and vertical wrinkles appear above it. It is the muscle of concentration. The inferior orbital portion lifts the inferior eyelid which swells slightly. This is the muscle of benevolence.

PROCERUS (PYRAMIDALIS NASI)

Attachments: origin, from the skin over the inferior part of the nasal bone; *insertion,* to the skin between the two eyebrows at the origin of the nose. Situated close to the median line, this little muscle is sometimes confused with the internal fascia of the frontalis. But, according to Duchenne, its action is most important.

Action. It pulls down the head of the eyebrow, of which the internal half is directed from above to below and from without to within. The skin of the middle part of the forehead is smooth and stretched, and the bridge of the nose is marked with several transverse wrinkles. These express aggressive sentiments.

NASALIS (COMPRESSOR NARIS)

Extending transversely on the lateral surface of the nose, this muscle meets the muscle on the other side along the median line through the intermediary of a fibrous strip. On the outside it is attached to the integuments above and behind the wing of the nose.

Action. It draws the wing of the nose up and to the front which creates wrinkles across the lateral parts of the organ.

NASALIS (DILATOR NARIS)

This little muscle is situated in the thickness of the nostril itself. In contracting, it enlarges the inferior orifice.

DEPRESSOR SEPTI

Attachments: origin, from the incisive fossa of the mandible, *insertion,* into the skin of the wing of the nose and into the division of the nostrils.

Action. It constricts the nostrils.

CANINUS (LEVATOR ANGULI ORIS)

This little muscle, deeply situated, rests directly upon the superior maxilla.

Attachments: origin, from this bone, directly beneath the infraorbital foramen; *insertion,* into the fibers of the upper lip.

Action. It lifts the lip and pulls it a little to the outside.

LEVATOR LABII SUPERIORIS ALAEQUE NASI

The levator labii superioris alaeque nasi is the deep elevator of the wing of the nose and the upper lip.

Attachments: origin, from the maxilla above the infra-orbital foramen; *insertion,* into the skin of the wing of the nose, and to the skin of the upper lip.

Action. The same as that of the following muscle.

LEVATOR LABII SUPERIORIS

Attachments: origin, from in front of the lower margin of the orbit, at the crest of the mounting branch of the superior maxilla; *insertion,* to muscular substance of the upper lip.

Action. It draws up the wing of the nose. The lengthened nasolabial furrow becomes straighter. The upper lip itself is drawn up. It contributes to the expression of disdain.

ZYGOMATICUS MINOR

Attachments: origin, from the cheekbone; *insertion,* into the skin of the upper lip.

Action. It draws up and to the outside the middle portion of half of the upper lip. The nasolabial furrow describes a curve of inferior convexity. It is a muscle of grief. The muscle that follows, although it has much the same name, is a muscle of laughter.

ZYGOMATICUS MAJOR

Attachments: origin, from the zygomatic process and from the skin at the angle where the upper and lower lips join each other.

Action. The angle of the mouth is drawn up and out. The nasolabial furrow describes a slight curve. The flesh over the cheekbone swells and slightly raises the lower eyelid. It is the smiling muscle.

ORBICULARIS ORIS

This muscle creates the thickness of the lips; it is disposed in the manner of a sphincter around the orifice of the mouth. The most internal fibers form a complete circle. The peripheral fibers commingle with the muscles that radiate from the mouth.

Action. Under the action of the central fibers, the lips pucker and are brought together. Under the influence of the contraction of the peripheral fibers, the lips are pulled back on the outside and projected forward. It contributes to the expression of doubt and to the expression of certain aggressive and evil feelings.

BUCCINATOR

Attachments: this muscle has three fixed insertions. It originates from the superior maxilla, above the alveolar border and from an aponeurotic band which comes from the internal wing of the pterygoid process to the inferior maxilla. It inserts toward the angle of the lips and continues in part into the orbicularis oris muscle.

Action. When the two buccinator muscles contract at the same time, they open the angles where the lips meet and elongate the lips transversely and thus compress them.

DEPRESSOR LABII INFERIORIS

Attachments: origin, from the oblique line of the mandible; *insertion*, into the skin of the lower lip.

Action. It draws the corresponding half of the lip below and to the outside. When the two muscles are contracted simultaneously, the lip stretches and turns over in front.

DEPRESSOR ANGULI ORIS

Attachments: origin, from the oblique line of the mandible; *insertion*, into the angle of the mouth.

Action. The angles of the mouth are pulled down and out. The lips describe a convex inferior curve, the lower lip is somewhat pushed to the front, the nasolabial furrow becomes straighter and longer. This muscle contributes to the expression of grief and disgust.

MENTALIS

Attachments: origin, from the incisive fossa of the mandible; *insertion*, into the integument of the chin.

Action. This muscle lifts the skin of the chin and wrinkles it. In doing so it protrudes the lower lip and turns it down a little on the outsides.

MUSCLES OF THE JAW

There are four muscles of the jaw; two superficial and two deep.

The two deep muscles are hidden by the branch of the inferior maxilla. They are both inserted to its internal surface. On the other side both muscles are attached to the pterygoid plate, hence their name. The internal one (pterygoideus medialis) is really a deep masseter. Like the masseter, it lifts the jaw. The external one (pterygoideus lateralis), moves the jaw to the front and to the sides.

The two superficial muscles, which merit a detailed description, are the masseter and the temporalis.

MASSETER

Attachments: origin, from the inferior border of the zygomatic arch; *insertion*, into the inferior part of the ramus of the mandible. This quadrilateral muscle, short and thick, occupies the posterior part of the face. Its contraction may be seen most clearly in movements of the jaw.

Action. It lifts the lower part of the jaw.

TEMPORALIS (PLATE 37, FIGURE 1)

Attachments: origin, from the whole length of the temporal fossa; *insertion*, into the summit of the coronoid process. Fan-like in form, this muscle is covered by a very strong aponeurosis which is attached all around the temporal fossa and to the zygomatic arch. It is thus contained in an osteofibrous box. Its considerable volume allows it to fill up the bony fossa in which it is placed and its relief may be clearly seen, especially under contraction.

Action. It lifts the lower jaw.

9. Muscles of the Trunk and Neck

The muscles of the trunk and neck are extremely complex. I will deal with them in detail in this chapter.

POSTERIOR REGION

Deep layer. I should like to point out the small *interspinales muscles* which exist both at the neck and in the lumbar region. Disposed in pairs, they unite the spinous processes of neighboring vertebrae.

Let me also describe the *intertransversarii muscles*, of which the name indicates their arrangement. They are again, only found in these same parts of the body. At the neck, they are disposed in pairs and divided into anterior and posterior muscles. They run from the two lips which limit the superior groove of the transverse process to the inferior border of the process which is immediately above. They do not strictly belong to the dorsal region, but the intercostales muscles, which we shall soon discuss, can be considered analogous to them, since the ribs are but a prolongation of the transverse processes.

TRANSVERSOSPINAL MUSCLES (PLATE 38)

Attachments: some, to the summit of the spinous processes (that of the axis is included); *others*, to the external tubercles of the sacral foramina, to various tubercles in the lumbar vertebrae, to the transverse processes of the dorsal region, and to the articular processes of the five last cervical vertebrae.

These muscles (*semispinalis thoracis, semispinalis cervicis, semispinalis capitis, multifidus, rotatores, interspinales, intertransversarii*) partially fill up the lateral groove of the spine. The foundations of these grooves are formed by the vertebral processes. They are limited within by the spinous processes and without by the transverse processes. The transversospinal muscles are formed by a series of small obliquely directed muscles.

Action. These muscles are extensors of the vertebral column. They incline it laterally when they only contract on one side. At the superior part of the vertebral column, the greater scope of the movement of the first two vertebrae necessitates a more complex disposition of muscles. Situated in the back we find rectus capitis posterior major, rectus capitis posterior minor, obliquus capitis inferior, and obliquus capitis superior. On the sides and in front we find rectus capitis lateralis, longus capitis, and rectus capitis anterior.

RECTUS CAPITIS POSTERIOR MAJOR (PLATE 38)

Attachments: origin, from the spinous process of the axis; *insertion*, into the lateral part of the inferior nuchal line of the occipital bone.

Action. Extends the head and rotates it toward the same side.

RECTUS CAPITIS POSTERIOR MINOR (PLATE 38)

The rectus capitis posterior minor is a muscle of triangular form.

Attachments: origin, from the posterior arch of the atlas; *insertion*, into the medial part of the inferior nuchal line of the occipital bone and the surface below and adjacent to it.

Action. Extends the head.

OBLIQUUS CAPITIS INFERIOR (PLATE 38)

Attachments: origin, from the spinous process of the axis; *insertion*, into the inferior and dorsal part of the transverse process of the atlas.

Action. Rotates the head to the side.

OBLIQUUS CAPITIS SUPERIOR (PLATE 38)

Attachments: origin, from the transverse process of the atlas; *insertion*, into the most lateral portion of the occipital bone.

Action. Extends the head and inclines it laterally.

RECTUS CAPITIS LATERALIS (PLATE 45, FIGURE 2)

Attachments: origin, from the transverse process of the atlas; *insertion*, into the jugular surface of the occipital.

Action. Inclines the head laterally.

LONGUS CAPITIS (PLATE 45, FIGURE 2)

Attachments: origin, from the anterior tubercle of the transverse processes of the third to sixth cervical vertebrae; *insertion*, into the inferior surface of the basilar part of the occipital bone.

Action. The action is the same as that of the preceding.

MIDDLE LAYER

The muscles which compose this layer have a considerable influence on the exterior form. I am placing them before the flat superficial muscles because the superficial muscles model themselves upon the deeper form. Starting with the most internal, these muscles are: at the neck, the semispinalis capitis, along the whole length of the trunk, the spinal muscles and the serratus, and finally, two muscles near the limits of the neck and torso, the rhomboids and the levator scapulae.

SEMISPINALIS CAPITIS (PLATE 39, FIGURE 1 and 2)

A long muscle, deeply situated in the neighborhood of the median line at the back of the neck where it is thickest, semispinalis capitis descends as far as the middle of the back.

Attachments: origin, from the cervical vertebrae, except the atlas (the articular and transverse processes), and from the dorsal vertebrae (the transverse processes of the first and second); *insertion,* into the occipital bone (from the roughness outside of the external occipital crest between the two nuchal lines).

Action. Extends the head and turns the face to the opposite side.

Semispinalis capitis plays a large role in the exterior form of the neck. Even though it is deeply situated, covered by the splenius and the superior part of the trapezius, its form reveals itself on the exterior surface by two longitudinal depressions along each side of the median line. In thin subjects this relief is exaggerated. It then takes the form of two cords separated by a depression which becomes deeper as it approaches the occipital.

In young, muscular subjects, these two cords become a sort of flat surface which is slightly indented along the median line and marked by a more accentuated depression near the attachment of the muscle to the occipital bone. This constant depression, usually hidden by the hair, corresponds to the external occipital protuberance.

The thick, stretched, posterior border of this muscle seems much like two ropes stretched between the back and the occipital. The median depression corresponds to the ligament of the neck.

LONGISSIMUS CAPITIS (PLATE 39, FIGURE 1 and 2)

Placed on the sides outside the preceding.

Attachments: origin, from the mastoid process (posterior margin and summit); *insertion,* to the transverse process of the last four cervical vertebrae (transverse processes).

Action. It inclines the head laterally.

SPLENIUS CAPITIS AND SPLENIUS CERVICIS (PLATE 39, FIGURE 3 and 4)

Attachments: origin, from the ligament of the neck, from the seventh cervical vertebra and from the first five dorsal (spinous processes). *Insertions, splenius capitis* to the mastoid process (posterior half of the external surface) and to the lateral third of the superior nuchal line;

splenius cervicis to the three first cervical vertebrae (posterior tubercles of the transverse processes).

Flat, triangular in form, these muscles are influenced by the deeper muscles we have described. They combine to fill up the empty space on the skeleton which exists between the cervical column and the inferior surface of the occipital. They soften the median longitudinal furrow created by the underlying muscles. Their forms maintain the thickness of volume above and on the outside of the neck.

Action. Extends the head, inclines it to the side and turns the face to the same side.

SACROSPINALIS: ILIOCOSTALIS, LONGISSIMUS, SPINALIS (PLATE 40)

Attachments: origin (for the common mass), from the deeper surface of a strong aponeurosis which runs up as far as the middle of the dorsal region (this aponeurosis is attached to the superior iliac spine and to the neighboring part of the iliac crest); from the posterior surface of the sacrum, from the sacral crest, and from the spinous processes of the lumbar and the last thoracic vertebrae.

Insertions, to the external part of the angle of all twelve ribs and by its fascia of reinforcement to the posterior tubercles of the transverse processes of the five last cervical vertebrae; (spinalis thoracis), to the transverse processes of the lumbar vertebrae and into all twelve of the ribs between their tubercles and angles (external fascia); and to the accessory processes of the lumbar vertebrae and to the transverse processes of the thoracic vertebrae (middle fascia).

These fasciculi are prolonged as far as the neck by a distinct muscle which stretches from the transverse processes of the second, third, fourth, fifth, and sixth thoracic vertebrae to the articular process of the five last cervical (longissimus capitis.).

Certain distinct fasciculi run from the lumbar spinous processes to the thoracic spinous processes (internal fascia).

These muscles (spinalis, iliocostalis, and longissimus dorsi), undivided below, as I have said, separate above into a considerable number of fasciculi. Anatomists have grouped these fasciculi according to their insertions. They should be combined, from the point of view of morphology, into the mass at the posterior part of the trunk which fills the large furrow limited on the inside by the spinal crest and on the outside by the angle of the ribs and the iliac tuberosity.

This fleshy mass, strong and powerful below, diminishes gradually and in proportion to its ascent towards the neck through the intermediary of its fibers of reinforcement. It can be divided into two regions, lumbar and dorsal.

This division, justified by morphology, is equally sanctioned by physiology, as Duchenne de Boulogne has demonstrated.

Lumbar part. Very thick, presenting an ovoid cross section, it fills the empty space between the thoracic cage and the pelvis posterior to quadratus lumborum. Its superficial surface is covered, below and within, by a large

aponeurosis the insertions of which I have already pointed out. On the outside, the fleshy fibers descend, more or less, to near the inferior insertion at the iliac crest (at the reentering angle), and attach themselves to the aponeurosis following a curved line. This line is convex on the inside and it is directed from below to above and from without to within. The fleshy body forms on the outside, in the region of the small of the back, an appreciable outline.

When the trunk is slightly flexed, this outline stands in clear relief. It is limited on the inside by an oblique depression which corresponds to the insertion of the fleshy fibers into the aponeurosis. This depression should not be confused with that formed by the line of insertion of the fleshy fibers of latissimus dorsi which is situated, in general, above and to the outside. Within this depression one can see, in certain movements of the trunk, a cord-like swelling. This swelling limits the lumbar depression at the center and is due to deep fleshy fibers held in place by the superficial aponeurosis.

Dorsal region. Here the muscles we are discussing do not influence the exterior form half as much as they do in the small of the back. Their rounded surface is limited on the outside by the line of the angle of the ribs which is most apparent when the arms are lifted. One often observes, at the level of the inferior angle of the trapezius, a rounded form created by the fleshy fibers of latissimus dorsi.

Action. Despite the diversity of their superior insertions, all the spinal muscles exercise the same action on the vertebral column. The action is that of oblique extension or lateral inflexion, depending on which side is stimulated.

Only the interspinous fasciculi of the spinalis muscle produce direct extension. Duchenne de Boulogne has demonstrated that the spinal muscles, in the lumbar region, have an action independent of the spinal muscles of the dorsal region. The first gives the vertebral column a dorsolumbar curve, the second a dorsocervical curve. These two curves may be produced simultaneously in an opposite direction on each side, giving to the whole column the form of an S. This occurs in certain physiological postures, which, when pathologically exaggerated, create the deformation known as scoliosis.

The principal function of the spinal muscles lies in producing an extension of the torso which they can do with force. In the standing position, they are ordinarily inactive, as the relief in this region clearly indicates. (This will be covered later in the morphological section, lumbar region.)

As soon as the equilibrium is disturbed by a slight forward inclination of the trunk, they contract with vigor.

Immediately above the spinal muscles there are the following two muscles.

SERRATUS POSTERIOR SUPERIOR (PLATE 41)

Attachments: origin, from the ligamentum nuchal and from the spinous processes of the seventh cervical and the three first thoracic vertebrae; *insertion,* through four fleshy digitations to the superior external surfaces of the second, third, fourth, and fifth ribs.

SERRATUS POSTERIOR INFERIOR (PLATE 41)

Attachments: origin, from the spinous processes of the last two thoracic vertebrae and from the first three lumbar the origin is in the middle of a large aponeurosis, fascia thoracolumbalis and it is connected to that of latissimus dorsi, *insertion,* into the inferior border of the last four ribs.

These two muscles are connected by an intermediary aponeurosis which helps to keep the spinal muscles in a fixed position. The serratus posterior inferior may influence the exterior form, when, in certain movements in which the back is rounded, the inferior and posterior part of the thoracic cage is uncovered. When this occurs the digitation of the muscle may be seen because the latissimus dorsi is relaxed.

Finally, I should like to describe certain muscles which, although they are attached to the scapula, contribute much to the modeling of the back.

RHOMBOIDEUS, MAJOR AND MINOR (PLATE 43)

Attachments: origin, from the interior part of the ligamentum nuchae, from the spinous processes of the seventh cervical and the first thoracic vertebrae (rhomboideus minor) and the first five thoracic vertebrae (rhomboideus major); *insertion,* to the spinal border of the scapula.

Action. They draw the scapula toward the median line and at the same time they elevate and rotate the scapula. The serratus anterior acts as their antagonist. These flat muscles, together forming a lozenge shape, are covered by the trapezius. They form a considerable mass between the median line of the back and the scapula. Their fleshy body grows thicker from below to above.

LEVATOR SCAPULAE

Attachments: origin, from the first four cervical vertebrae (posterior tubercle of the transverse process); *insertion,* to the internal angle of the scapula and to the vertebral border above the spine.

Action. It lifts the shoulder. This muscle, from which the scapula is, so to speak, suspended by its superior angle, contributes to the widening of the neck below and in back.

SUPERFICIAL LAYER

Two large muscles, stretched out over those we have just described, complete the myology of the posterior part of the neck and the trunk. They are latissimus dorsi on the lower part and the trapezius on the upper part.

LATISSIMUS DORSI (PLATE 43)

Attachments: origin, from the spinous process of the six last thoracic vertebrae and all the lumbar vertebrae; from the sacral vertebrae; from the iliac tuberosity; from the posterior third of the iliac crest; and from the external surface of the three last ribs; *insertion,* at the base of the intertubercular groove of the humerus.

A large muscle of unequal volume, it is thickest at the area surrounding its superior insertion. It forms there, at the place where it spirals around the teres major, a fleshy body which can be clearly seen when the arm is raised. Its anterior border creates a vertical bulge on the sides of the trunk. At that point its costal insertions form, on muscular subjects, digitations similar to those of the anterior serratus. Its superior border, which is almost horizontal, is covered in the middle of the back by the tail of the trapezius. Outside this point the latissimus dorsi runs over the inferior angle of the scapula and holds it against the rib cage. In certain movements, the outline of the superior border may be easily traced beneath the skin along almost its whole length.

The line of implantation of the fleshy fibers on the lower aponeurosis is in an irregular curve of internal convexity. This curve runs from below to above and from outside to within and goes from the inferior insertion in the crest of the ilium to the superior insertion in the thoracic vertebrae. This line is usually situated above and outside of the analogous line formed by the implantation of the fleshy fibers of the spinal muscles in their aponeurosis (see page 55). However, the nature of this line depends on the length of the fleshy fibers and these vary according to the individual subject. At times the line meets the line of the spinal muscles on which it is superimposed but it usually ends much higher. The spinal line itself is susceptible to variation. Gerdy has made the line of the latissimus dorsi the superior limit of the loins. I believe it would be better to take the limit at the line of the spinal muscles because of its consistency and because of its generally lower situation. (We shall discuss this later in the morphological section, region of the loins.)

The fleshy body of the muscle, of medium thickness, thinner inside than outside, reveals the form of the serratus anterior beneath it. This relief is limited below by an oblique depression of variable depth. When the arms are elevated, the forms of the spinal muscles and the ribs are revealed.

Action. When both sides are contracted simultaneously, the latissimus dorsi, by its superior third, brings the scapulae together, throws back the shoulders, and produces a strong extension of the trunk. Through the inferior two thirds, it pulls the shoulder down firmly.

TRAPEZIUS (PLATE 44)

Attachments: origin, from the spinous processes of the first ten thoracic vertebrae and the seventh cervical, from the ligamentum nuchae, and from the occipital bone (medial third of the superior nuchal line); *insertion,* to the clavicle (lateral third of the superior border), to the scapula (the superior border of the acromion process and on the spine).

For the most part these insertions are made by short aponeurotic fibers, but these fibers, long in three places, form small aponeuroses that should be described. Around the protuberance of the dorsal spine of the seventh cervical, an *oval* aponeurosis is formed by the union of each side of the trapezius. A *triangular* aponeurosis terminates the tail of the trapezius at its base. In the area

of its insertion into the spine of the scapula, there is a second *triangular* aponeurosis.

These three aponeuroses influence the exterior form. The first produces a little median flat plane at the limit of the neck in the spinal region. In the middle of this plane one finds the prominence of the *vertebra prominens.* The second aponeurosis truncates the inferior tail of the trapezius. The third is the cause of the depression which may be seen at the root of the spine of the scapula, near its vertebral border. These aponeuroses vary in different individuals.

The trapezius is a flat muscle of most unequal thickness. Thin above and below, it becomes very thick in the middle part which includes the whole area of the lateral angle which inserts at the clavicle and the acromion process of the scapula. This thick part of the muscle rests on the supraspinatus and the levator scapulae muscles.

Above, at the back of the neck, the muscle molds itself on the deeper layers; the anterior border alone shows clearly from the occipital to the clavicle. Below, the trapezius is raised by the powerful mass of the rhomboids. It then covers the spinal muscles and latissimus dorsi. The triangular form of its inferior extremity can generally be easily seen under the skin.

Action. By its occipital fascia, it extends the head, inclines it to the side and turns the face in the opposite direction. When the two sides of the trapezius contract simultaneously, the head is directly extended. By its middle part it lifts the shoulder. By its inferior third, it lowers the shoulder and brings the scapula toward the median line.

ANTEROLATERAL CERVICAL REGION

This region is composed of several layers—deep, middle, and superficial. I shall outline the muscles of each layer.

DEEP LAYER

This layer is composed of longus colli, scalenus anterior and posterior.

LONGUS COLLI (PLATE 45, FIGURE 1)

This muscle, directly applied to the cervicothoracic column, has three portions.

The superior oblique portion is inserted into the anterior tubercle of the atlas and arises from the anterior tubercles of the transverse processes of the third, fourth, and fifth cervical vertebrae.

The inferior oblique portion is inserted into the anterior tubercles of the transverse processes of the fifth and sixth cervical vertebrae, and arises from the bodies of the first three thoracic vertebrae.

The vertical portion is inserted into the bodies of the second and third cervical vertebrae and arises from the bodies of the last four cervical vertebrae and the first three thoracic.

Action. It inclines the vertebral column to the front, and it slightly rotates the cervical portion of the vertebral column. This muscle has no influence on the exterior form.

SCALENUS ANTERIOR (PLATE 45, FIGURE 3 and 4)

Attachments: origin, from the third, fourth, fifth, and sixth cervical vertebrae (anterior tubercles of the transverse processes); *insertion*, into the scalene tubercle of the first rib.

Action. It lifts the first rib (it is an inspiratory muscle) and bends and slightly rotates the neck.

SCALENUS POSTERIOR (PLATE 45, FIGURE 3 and 4)

Attachments: origin, from the transverse processes of the last two or three cervical vertebrae (posterior tubercles); *insertion*, to the outer surface of the second rib.

Action. It has much the same action as that of scalenus anterior. Stretched across the lateral part of the neck, from the cervical column to the thoracic cage, the scalenus muscles contribute to the lateral thickness of the neck at its lower part They are superficial along one portion of their length, in the triangle above the clavicle, and so is the splenius above them, and the omohyoideus below them.

MIDDLE LAYER (PLATE 46)

At the anterior part of the neck there are organs related to the digestive and respiratory apparatus. We should note them because they provide insertion points to certain muscles of the region.

The esophagus is in the deep middle part of the neck next to the vertebral column. In front of it is the trachea, terminating above in the larynx, which is surmounted by the hyoid bone. A gland of variable volume, the thyroid gland (more accentuated in women), covers the superior and lateral parts of the tube of the trachea (Plate 46, Figure 1).

The hyoid bone is situated at the edge of the region, beneath the chin. This region, morphologically, should pertain to the head, but anatomically it should be attached to the neck under the name of the region above the hyoid (suprahyoid region).

The muscles of the anterior part of the neck have been divided by anatomists into two groups because of their situation relative to the hyoid. These groups are the muscles above the hyoid and the muscles under the hyoid (suprahyoid and infrahyoid muscles).

SUPRAHYOID MUSCLES

The suprahyoid region forms the floor of the mouth. It is composed of muscles arranged in different directions which run from the hyoid bone to the lower jaw, to the mastoid process, and to the styloid process at the base of the cranium.

These muscles, from the point of view of exterior form, are of but secondary importance. They are, from deep to superficial, as follows.

GENIOHYIODEUS

Attachments: origin, from the inferior mental spine on the inner surface of the symphysis menti; *insertion*, to the anterior surface of the body of the hyoid bone.

MYLOHYOIDEUS (PLATE 47, FIGURE 2)

Attachments: origin, from the mylohyoid line of the mandible; *insertion*, close to the symphysis. The medial tendon of the muscle is attached to the hyoid bone by an aponeurotic expansion (suprahyoid aponeurosis).

INFRAHYOID MUSCLES

These muscles, numbering four, form two layers: a deep layer composed of the sternothyroideus and the thyrohyoideus; and a superficial layer composed of the sternohyoideus and the omohyoideus.

STERNOTHYROIDEUS (PLATE 46 and 47)

Attachments: origin, from the oblique line of the thyroid cartilage; *insertion*, into the inferior border of the greater cornu of the hyoid bone.

Action. It lowers the hyoid bone and elevates the thyroid cartilage.

THYROHYOIDEUS (PLATE 46 and 47)

Attachments: origin, from the oblique line of the thyroid cartilage, *insertion*, to the inferior border of the greater cornu of the hyoid bone.

Action. It lowers the hyoid bone and elevates the thyroid cartilage.

OMOHYOIDEUS (PLATE 46, FIGURE 2 and PLATE 47)

Attachments: origin, from the superior border of the clavicle; *insertion*, into the body of the hyoid bone.

Action. It lowers the hyoid bone. It is the tensor of an aponeurosis which unites the muscles on each side.

The two muscles which go to the sternum, the sternohyoideus and the sternothyroideus, are flat and ribbon-like. They are raised somewhat on the sides of the larynx by the thyroid gland.

The omohyoideus traverses the supraclavicular triangle where, in certain movements, it forms a noticeable cord.

SUPERFICIAL LAYER

This layer is composed of the sternocleidomastoideus and the platysma.

STERNOCLEIDOMASTOIDEUS (PLATE 47)

Attachments: origin, from the sternum (sternal portion) and from medial third of the superior surface of the clavicle (clavicular portion); *insertion*, to the mastoid process (lateral surface) and to the superior nuchal line of the occipital bone (lateral two thirds).

Flat and quadrilateral, subcutaneous along its full length, this muscle spirals down the neck from the sides toward the anterior median line.

Single above, it divides below into two portions: the medial, or sternal portion, is rounded above and terminates in a tendon which inserts on the sides of the jugular notch; the lateral, or clavicular portion, is very flat.

These two portions are separated from each other by a triangular space.

The anterior border of the muscle is thicker than the posterior border. This is due partly to a deep fascia which starts high on the mastoid process and crosses the general direction of the superficial fibers obliquely as it descends. It is inserted below, at the back of the attachment of the clavicular portion.

Action. The sternocleidomastoideus of either side may incline the head to that side and turn the face in the opposite direction; bilateral action flexes the vertebral column and elevates the chin.

PLATYSMA (PLATE 53)

This large, thin muscle mingles at its superior insertion with the muscles of the chin and the lower lip. From there its fibers run down and to the outside, covering all the lateral and anterior part of the neck. These fibers attach themselves below to the aponeurosis of pectoralis major and to the deltoid.

Its medial border, taken with that of the other side, forms a triangle elongated along its inferior base. Its irregular lateral border covers the anterior border of the trapezius.

When it is relaxed, it reveals clearly the parts which it covers. When it is contracted, it enlarges the neck and draws down the lower lip. It contributes to the expression of terror and fright.

MUSCLES OF THE CHEST: INTERCOSTALES (PLATE 38)

The intercostal muscles round out the thoracic cage by filling the intercostal spaces. They stretch between the ribs forming two layers of which the fibers have different directions.

The *external intercostals* (intercostales externi) arise from the inferior border of a rib and are inserted to the superior border of the rib beneath. They fill all the intercostal space in the back and on the sides. They extend in front as far as the region of the costal cartilages.

The direction of their fibers is oblique from above to below, and from back to front. At the posterior part of the thorax, the *subcostals* each arise from the inner surface of a rib near its angle and are inserted into the inner surface of the second or third rib beneath. Their fibers run in the same direction as those of the external intercostals.

The *internal intercostals* (intercostales interni) arise from the inner border of the inferior intercostal groove on one rib and are inserted into the superior border and the inner surface of the rib beneath.

They fill all the intercostal space in front and to the sides. In back they stop at the angle of the ribs.

Their fibers run obliquely, in an inverse direction to those of the external intercostals.

The intercostales muscles play an important part in the function of respiration.

ANTERIOR AND LATERAL REGIONS OF THE CHEST

This layer is composed of the subclavius, pectoralis minor and major, and serratus anterior.

SUBCLAVIUS (PLATE 48, FIGURE 2)

This is a small muscle hidden under the clavicle.

Attachments: origin, from the first rib and its cartilage at their junction; *insertion,* to the clavicle (inferior surface).

PECTORALIS MINOR (PLATE 48, FIGURE 2)

Attachments: origin, from the external surface of the third, fourth and fifth ribs; *insertion,* to the coracoid process (anterior border).

This muscle, triangular in form, is divided below into three sections. It maintains the exterior form of pectoralis major on the front plane which, in the ordinary position of the arms, covers it completely. In vertical elevation of the arm, the inferior part of the lateral border of pectoralis minor becomes visible and forms a distinct relief.

Action. This muscle pulls down the point of the shoulder.

PECTORALIS MAJOR (PLATE 48, FIGURE 1)

Attachments: origin, from the clavicle (medial two thirds of the anterior border), from the sternum (anterior surface), from the cartilages of the first six ribs, from the fourth and fifth ribs (lateral surface) and from the abdominal aponeurosis; *insertion,* into the humerus (anterior border of the intertubercular sulcus).

This muscle is formed of fasciculi converging toward the humeral insertion. The superior fasciculi are directed from above to below, the median transversely, and the inferior from below to above. These fasciculi cross before reaching the humerus, the superior ones passing in front of the inferior. The highest and thickest fasciculus comes from the clavicle. Its fleshy fibers flow to the anterior surface and inferior border of an aponeurosis of insertion which is distinct from the aponeurosis beneath. They contribute posterior and inferior fibers to the aponeurosis of insertion. The latter aponeurosis functions for the remainder of the muscle.

The crossing of the fleshy fibers creates a thickening of the muscle on the outside at the place where it leaves the thorax to form the front wall of an armpit.

Pectoralis major is most important from the point of view of the exterior form of the chest. The whole muscle is subcutaneous except for its tendon and a small triangular portion of the clavicular fibers which are covered by the deltoid. Resting on each side of the median line on the anterior and superior part of the thorax, this muscle widens the chest considerably although it still reveals the arched form of the thorax.

The whole surface of the muscle is more or less convex. It does not face directly to the front, but above and to the outside.

When pectoralis major is well developed, the diverse muscular bundles, converging toward the external angle, are separated by oblique grooves which can be clearly seen across the skin. The groove that is most consistently visible is the one that limits, below, the clavicular portion. From the point of view of the exterior form, the abdominal portion of pectoralis major attenuates the transition between the plane of the pectoral muscles and the convex surface beneath the breast.

If, on the other hand, the muscle is not developed, the costal protrusions may be seen running across the form. Also, at the medial part, two corresponding series of nodes are visible. One series is caused by the articulations of the costal cartilages with the sternum, and the other, to the outside, by the articulations of the ribs with those same cartilages.

Action. From the point of view of the action which it produces, pectoralis major should be divided into two parts. The superior part, corresponding to that part of the muscle which is attached both to the clavicle and the manubrium, and the inferior part, comprising the rest of the muscle.

The inferior part lowers the arm. It also pulls the point of the shoulder down when the arm is lowered.

The superior part acts in a different way according to the position of the arm. If the arm is well down, it lifts the point of the shoulder (as in the action of carrying a burden on the shoulder, or hunching the shoulders in an expression of fear or humiliation). If the arm is horizontal, it makes the arm describe a curve carrying it within and to the front. Finally, it lowers the arm if the arm is raised vertically, bringing it back toward the median line as in the action of striking something with a saber or cudgel.

SERRATUS ANTERIOR
(PLATE 48, FIGURE 3 and 4 and PLATE 49, FIGURE 2)

Attachments: origin, from the first eight or nine ribs (lateral surface); *insertion,* into the spinal border of the scapula.

This very large muscle (serratus magnus) is situated on the lateral parts of the thorax against which it is directly applied throughout its whole length. The ventral surface of the scapula rests on its most posterior part. Its insertions into the ribs consist of eight or nine digitations which follow a toothed line in a convex anterior curve. These digitations group together into fasciculi of which the most important is the fan-shaped mass which attaches to the inferior extremity of the vertebral border of the scapula.

The serratus anterior is subcutaneous only at its most anterior and most inferior parts. Here the four last digitations show clearly under the skin in front of the anterior border of latissimus dorsi and behind the costal insertions of the external oblique (obliquus externus abdominis) (see Plate 55).

The rest of the muscle, although it is deeply situated, has an important influence on the exterior form. The fan-shaped mass which inserts into the inferior angle of the shoulder blade creates a relief which can be seen clearly beneath the latissimus dorsi which covers it.

Action. The serratus anterior, together with the rhomboid muscles which extend as far as the spine, holds the vertebral border of the scapula against the thorax. It raises the whole mass of the shoulder. By enabling the scapula to rotate, it assists in the movement of raising the arm.

MUSCLES OF THE SHOULDER

The muscles of the shoulder may be divided into the following two groups. First, the muscles which surround the scapula: subscapularis, supraspinatus, infraspinatus, teres minor, and teres major; and second, a superficial muscle: deltoideus.

SUBSCAPULARIS (PLATE 49, FIGURE 1 and 2)

Attachments: origin, from the shoulder blade (subscapular fossa); *insertion,* into the lesser tubercle of the humerus. This muscle fills the subscapular fossa of the scapula. It rotates the humerus medially.

SUPRASPINATUS (PLATE 49, FIGURE 3)

Attachments: origin, from the scapula (supraspinatous fossa); *insertion,* into the greater tubercle of the humerus (superior impression). Covered by the trapezius, this muscle, depending on its development, fills the supraspinatous fossa to a greater or lesser extent. Its relief can be seen on the exterior form.

Action. Abducts the arm.

INFRASPINATUS (PLATE 49, FIGURE 3)

Attachments: origin, from the scapula (infraspinatous fossa); *insertion,* into the greater tubercle of the humerus (middle impression). This muscle is superficial throughout the greater part of its length. Maintained by a strong aponeurosis, it forms a flattened relief in the center of the scapular region.

Action. It rotates the arm laterally.

TERES MINOR (PLATE 49, FIGURE 3)

Attachments: origin, from the supraspinatous fossa of the scapula, near the axillary border; *insertion,* into the greater tubercle of the humerus (inferior impression). This muscle is of small volume and it is cylindrical and elongated in form. It should be combined with the preceding muscle in considering the exterior form.

Action. Rotates the arm laterally.

TERES MAJOR (PLATE 49, FIGURE 1 and 2)

Attachments: origin, from the supraspinatous fossa of the scapula (inferior and lateral part); *insertion,* into the humerus (medial lip of the intertubercular sulcus).

This muscle plays an important morphological role. It forms, together with latissimus dorsi, the back wall of the armpit. When the arm falls naturally alongside the body, it creates a rounded prominence outside the inferior angle of the scapula. This relief may be observed even in thin models.

Action. Adducts, extends, and rotates the arm medially.

DELTOIDEUS (PLATE 49, FIGURE 4 and 5, PLATE 55)

Attachments: origin, from the clavicle (lateral third of the anterior border) from the scapula (external border of the acromion process and from inferior border of the spine); *insertion,* into the humerus (deltoid prominence).

The deltoideus is entirely subcutaneous and it forms the projection of the shoulder. This muscle covers the scapulahumeral articulation on all its sides: in front, in back, and on the outside. It is composed of three principal fasciculi which divide the muscle approximately into thirds.

The middle third, or *acromion portion*, is composed of numerous secondary fasciculi which run obliquely in miscellaneous directions. This portion rises from the acromion process by very short aponeurotic fibers and goes to the region of its inferior insertion through several vertical aponeurotic dividing membranes to which the fleshy fibers are attached. The middle third, at its base, forms the point of the muscle. The other two portions, the anterior and posterior, plunge in beneath this point at their inferior extremity.

The *anterior portion* arises from the clavicle by very short aponeurotic fibers which are joined by the fleshy fibers, all running in a parallel direction. The *posterior portion* arises from the spine of the scapula by a triangular aponeurosis. This portion is composed of longitudinal fibers which describe a slight spiral movement as they run, below, to beneath the middle portion.

The deltoideus, detached from its places of insertion, is a flat muscle of triangular form. It is like the Greek letter delta, hence its name. It is thicker at the center than at its extremities. On the model the relief of the deltoideus muscle is not uniform. It is raised more in front because the head of the humerus makes a greater thrust in this area. In the back, on the contrary, its surface is flat. The superior border follows the projection of the bones. The anterior border is clearly outlined by a linear depression which separates it from pectoralis major. The posterior border is much less distinct. It is broken to a certain extent, toward its center, by an aponeurosis which comes up from the armpit and, in binding the muscle in this area, creates a smooth plane.

Its inferior insertion is marked on the outside by a depression at about the center of the arm.

Action. The deltoideus is an elevator of the humerus, and, according to its center of contraction, it lifts the arm to the front, to the back, or directly to the outside. When the deltoideus acts alone, the arm cannot be raised above the horizontal. The vertical elevation of the arm is made possible through the cooperation of other muscles (serratus anterior and trapezius).

MUSCLES OF THE ABDOMEN

Deep muscles. First, I shall briefly describe the muscle quadratus lumborum. It is deeply situated in the abdomen and forms part of its posterior wall. Then I shall discuss the diaphragm which closes off the abdominal cavity above and separates it from the thoracic cavity.

QUADRATUS LUMBORUM (PLATE 38 and 52, FIGURE 1)

Attachments: origin, from the iliolumbar ligament and the adjacent portion of the iliac crest; *insertion,* into the inferior border of the last rib and into the transverse processes of the first four lumbar vertebrae.

Action. It flexes the vertebral column and the trunk laterally.

DIAPHRAGM

This musculofibrous septum, in the form of a vault, stretches transversely to form the floor of the thoracic cavity and the roof of the abdominal cavity.

The convex surface of the vault faces the thoracic cavity. The muscular fibers only take up its periphery and the remaining or central part is formed of interlaced fibrous fasciculi.

From the center part, divergent muscular fibers spring and attach themselves by their other extremities to the periphery of the inferior aperture of the thorax. In front, they are very short and they are attached to the posterior surface of the sternum, level with the xiphoid appendage. At the sides, they descend as far as the costal cartilages of the last six ribs. In the back, they are prolonged as far as the lumbar region of the vertebral column (second, third, and fourth lumbar vertebrae).

Deeply hidden in the center of the organism, the diaphragm plays a most important physiological role in the action of respiration, but we shall not discuss this here.

ANTERIOR REGION

This region is composed of the rectus abdominis and the pyramidalis.

RECTUS ABDOMINIS (PLATE 51, FIGURE 2)

Attachments: origin, from the crest of the pubis; *insertion,* into the xiphoid process and into the cartilages of the seventh, sixth and fifth ribs. The superior insertions of rectus abdominis mingle with those of pectoralis major.

Situated on each side of the median line, the two parts of the muscle, slightly separated above, come together completely above the umbilicus. The division of the muscle gives rise to a groove which, continuing on from the epigastric furrow, becomes thinner and descends as far as the umbilicus before it disappears. The external border of rectus abdominis, limited by a second depression, rises from the aponeurosis of the external oblique.

The muscle is divided transversely by aponeurotic intersections which delimit quadrilateral areas of projecting fleshy fibers. In general these intersections are three in number; the lowest is situated at about the level of the umbilicus. Occasionally, below the umbilicus there is an indication of a fourth transverse furrow.

The highest transverse aponeurotic intersection is a continuation of the furrow which follows the cartilages of the false ribs on the sides. The superior extremity of the muscle thus fills up the angle formed by the opening of the thorax and transforms it, so to speak, from an ogival, or pointed arch, to a simple curve, convex above. Thus, on the nude the projecting line, formed on the sides by the edge of the cartilages of the false ribs, does not run (as on the skeleton) to the top of the epigastric hollow, but continues above and within along the outline of the relief formed by the superior extremity of rectus abdominis. At

his level, the superior extremity seems to belong much more to the chest than to the abdomen.

This form, resembling a concave arch, was well understood and even exaggerated in classical works of art.

Action. This muscle is a flexor of the trunk.

PYRAMIDALIS (PLATE 51, FIGURE 2)

A small triangular muscle; it is situated at the inferior extremity of rectus abdominis and stretches from the pubis to the linea alba.

LATERAL REGION

On the sides, the wall of the abdomen is formed by the superposition of three muscles. The two most profound, obliquus internus abdominis and transversus abdominis, stretch from the inferior costal border to the pelvis. The most superficial, obliquus externus, mounts much higher, thus covering the thoracic cage to a certain extent.

We shall study these three muscles successively, from the deepest to the most superficial.

TRANSVERSUS ABDOMINIS (PLATE 50, FIGURE 1)

Attachments: origin, from the last six ribs (internal surface), from the posterior abdominal aponeurosis and from the iliac crest (anterior three quarters of the inner lip); *insertion,* into the linea alba. The fleshy body is thin and the fibers are directed transversely.

Action. It constricts the abdominal cavity like a girdle and compresses it.

OBLIQUUS INTERNUS ABDOMINIS (PLATE 51, FIGURE 2)

Attachments: origin, from the posterior abdominal aponeurosis, from the anterior three quarters of the iliac crest, and from the lateral third of the inguinal ligament; *insertion,* into the three or four last ribs and into the linea alba.

This muscle is larger in front than in back, and its fibers fan out in three directions as they leave the iliac crest: the superior fibers go above and to the front, the middle ones transversely, and the inferior ones below and to the front.

Action. If these two muscles act together, they flex the trunk. When one side alone contracts, it bends the vertebral column laterally and rotates it, bringing the shoulder of the opposite side toward the front. It is thus the antagonist of obliquus externus abdominis.

OBLIQUUS EXTERNUS ABDOMINIS (PLATE 51)

Attachments: origin, from the external surface of the last eight ribs; *insertion,* into the iliac crest (anterior half of the outer lip), into the inguinal ligament, and into the anterior abdominal aponeurosis.

Its superior insertion is formed of digitations which create a toothed line running obliquely downward toward the back and the outside. This line interlaces with the digitations of the serratus anterior and latissimus dorsi.

From the line of digitations fibers descend obliquely toward the front and inside, crossing perpendicularly the superior fibers of obliquus internus. Obliquus externus is not much thicker than a centimeter where it is applied to the superior ribs, but in the part which corresponds with the abdomen its thickness is doubled by the two preceding muscles, obliquus internus and transversus.

Obliquus externus can be thought of as having two parts, the superior, or thoracic, and the inferior, or abdominal.

The relief of the whole thoracic part is created by the bones which it covers and the varied forms of the skeleton can be seen on the surface (the ribs, the intercostal furrows, the articulations of the costal cartilages, etc.). However, this may be modified by the degree of development of the obliquus externus muscle and the varying thickness of its digitations.

The abdominal portion corresponds to the flank and it forms a characteristic relief in the back which mingles with a fatty pad which I shall describe later. (See fatty skin and tissue, Chapter, 12.) The lower border of this portion ends in the furrow of the flank. However, the direction of this furrow is not the same as that of the iliac crest, as we shall see later. In front, the fleshy fibers stop a short distance from rectus abdominis in a descending line. This line swerves below and doubles back sharply toward the outside, going a little above the superior anterior iliac spine. The result is that the furrow, which separates obliquus externus from rectus abdominis above, terminates below in a triangular surface of which the base is at the wrinkle of the groin. This surface is slightly convex, and it contributes to the uniform curve of the hypogastric region. This region encompasses the inferior median portion of the abdomen.

Action. The two sides, acting together, flex the trunk. The isolated action of one side turns the anterior surface of the trunk to that side. It also bends the vertebral column laterally.

MUSCLES OF THE PELVIS

I shall divide the muscles of the pelvis into two groups. First, the deep muscles: psoas major, psoas minor, iliacus, piriformis, gemellus superior, gemellus inferior, obturator internus, and quadratus femoris. Second, the gluteal muscles: gluteus minimus, gluteus medius, and gluteus maximus.

DEEP MUSCLES

These are composed of psoas major and minor, iliacus, piriformis, obturator internus, gemelli, quadratus femoris and obturator externus.

PSOAS MAJOR, PSOAS MINOR AND ILIACUS (PLATE 52, FIGURE 1)

Attachments: origin (considered as one muscle), from the lateral part of the bodies of the vertebrae in the whole lumbar region, from the transverse processes of the lumbar vertebrae (psoas), and from the internal iliac fossa (iliacus); *insertion,* into the lesser trochanter.

These muscles are situated on the interior of the pelvis. They line the internal fossa by their lateral or iliac parts and extend down the sides of the lumbar column by their medial parts (psoas). They are directed toward the same inferior tendon. The fleshy fibers of the psoas muscles unite in a fusiform body which moves over across the anterior rim of the lesser pelvis before reaching the lesser trochanter.

Action. These muscles are flexors of the thigh.

PIRIFORMIS (PLATE 52, FIGURE 4)

This muscle and the following ones, deeply situated at the posterior surface of the pelvis, have no influence on the external form. I shall simply describe their attachments and their actions.

Attachments: origin, from the anterior surface of the sacrum and from the margin of the greater sciatic foramen; *insertion*, into the superior border of the greater trochanter behind gluteus minimus and above obturator internus.

Action. It is an abductor and, to some extent, an extensor of the thigh. It also rotates the thigh laterally.

OBTURATOR INTERNUS AND GEMELLI (PLATE 52, FIGURE 4)

Attachments: origin, from the interior surface of the lesser pelvis around the obturator foramen, from the pelvic surface of the obturator membrane (obturator internus), and from the spine of the ischium (gemellus inferior); *insertion*, into the superior border of the greater trochanter below piriformis.

Action. These muscles rotate the thigh laterally.

QUADRATUS FEMORIS (PLATE 52, FIGURE 4)

Attachments: origin, the external border of the ischium, in front of semimembranosus; *insertion*, into the proximal part of the linea quadrata, a line running between the greater and lesser trochanter.

Action. It is an outward rotator of the thigh.

OBTURATOR EXTERNUS (PLATE 63, FIGURE 2)

Attachments: origin, from the periphery of the obturator foramen, and from the obturator membrane; *insertion*, into the femur (trochanteric fossa).

Action. It rotates the thigh laterally.

MIDDLE LAYER

This layer is composed of gluteus minimus, medius, and maximus.

GLUTEUS MINIMUS (PLATE 52, FIGURE 3)

Attachments: origin, from the external surface of the ilium between the anterior and inferior gluteal lines; *insertion*, into the great trochanter (anterior border and anterior part of the superior border).

All the fleshy fibers are disposed in a fan-like form converging toward the inferior tendon. This muscle is entirely coverd by gluteus medius.

Action. It abducts the thigh, and rotates it to the inside through its anterior fibers and to the outside through its posterior fibers.

GLUTEUS MEDIUS (PLATE 52, FIGURE 2, 4, and 5)

Attachments: origin, from the outer surface of the ilium between the posterior and anterior gluteal lines, from the anterior three quarters of the external lip of the iliac crest, and from the anterior superior iliac spine by a fascia it shares with the tensor fasciae latae; *insertion*, into the external surface of the great trochanter following a ridge which is oblique from below to the front.

This is a radiating muscle. Its form is fan-shaped like the preceding one, and it is covered at its posterior part by gluteus maximus. It is maintained by a solid aponeurosis which is attached above to the iliac crest and mingles below with the tendon of gluteus maximus and the femoral aponeurosis. The morphological role of this aponeurosis is most important, as we shall see later (see Morphology: Region of the Buttock).

Action. It differs according to the portion of the muscle which comes into play. The middle portion abducts the thigh, the anterior portion rotates it medially and the posterior portion rotates it laterally.

Gluteus medius and minimus, as abductors, support and hold the pelvis on the thigh whenever the trunk rests on the inferior members, for example, when the body is in an upright position or as in the second step of a walk when the weight tends to incline the pelvis to the opposite side.

GLUTEUS MAXIMUS (PLATE 52, FIGURE 2 and 5)

Attachments: origin, from the most posterior part of the ilium, from the external part of the sacrum and the borders of the coccyx, and from the posterior part of the sacrotuberous ligament; *insertion*, into the external bifurcation of the linea aspera from the great trochanter as far as the middle third of the femur, and into the femoral aponeurosis.

Gluteus maximus is a thick muscle of almost equal thickness throughout its entire extent. It is composed of large and distinct fasciculi which together create an irregular quadrilateral shape. Its fleshy fibers, which are directed obliquely from above to below and from within to without, arise, at their origin, from very short tendinous fibers. At their inferior insertion, however, these fleshy fibers join a large aponeurosis which is inserted into the iliotibial band of the fascia lata. The deeper fibers are inserted into the linea aspera.

The fleshy fibers of the superior border are much shorter than the inferior ones. In contrast, the aponeurotic fibers of insertion diminish in length from above to below. A powerful fascia limits the inferior border of the muscle and it is partially inserted into the femoral aponeurosis.

Besides the direct insertion of the fleshy fibers into the femoral aponeurosis, the entire tendon closely adheres to

this same aponeurosis which rises as far as the iliac crest and mingles in front with the tensor of the fascia lata. Entirely subcutaneous, gluteus maximus covers the ischium and the muscles of the deeper layers. It contributes to about half of the size of the buttock and the great abundance of fatty tissue usually accumulated in this region contributes the rest.

Its inferior border, oblique from above to without, has little influence on the crease of the buttock, as we shall explain later.

Action. It extends the thigh powerfully against the pelvis. If the femur is in a fixed position, it extends the pelvis against the thigh. It does not exert much action in an upright stance or horizontal walking position. It only intervenes in action which requires an effort, such as climbing, jumping, running, rising from sitting, etc.

10. Muscles of the Upper Limb

The muscles of the shoulder have been studied together with those of the trunk so we do not have to review them here. We shall now study, in succession, the muscles of the upper arm, the forearm, and the hand.

MUSCLES OF THE UPPER ARM

In front of the humerus, the muscles which compose the fleshy mass of the arm are three in number and they are disposed in two layers. The deep layer is composed of the coracobrachialis and the brachialis; the superficial layer of the biceps brachii.

On the back of the arm there is only a single muscle, the triceps brachii, but it is extremely powerful. It is composed of three distinct fleshy bodies.

CORACOBRACHIALIS (PLATE 56, FIGURE 1)

Attachments: origin, from the summit of the coracoid process (together with the short head of the biceps); *insertion*, into the internal surface of the humerus, at the level of the middle third of the bone.

This small muscle, deeply situated, has little effect on the exterior form when the arm falls alongside the trunk. In vertical elevation of the arm, however, it creates a distinct eminence within the armpit.

Action. It flexes and adducts the arm.

BRACHIALIS (PLATE 56, FIGURE 2)

Attachments: origin, from the two sides and the anterior border of the humerus; *insertion*, into the coronoid process of the ulna.

This muscle, attached directly to the skeleton above the articulation of the ulna, underlies the inferior part of biceps brachii. It can be easily seen on each side of the forearm.

Action. It flexes the forearm against the upper arm.

BICEPS BRACHII (PLATE 56, FIGURE 2)

This is a long muscle divided above into two heads: the long head and the short head.

Attachments: origin, from the superior border of the glenoid cavity of the scapula (by its long head) and from the summit of the coracoid process (by its short head); *insertion*, into the posterior half of the bicipital tuberosity of the radius.

The arrangement of the fleshy fibers of this muscle is very simple. Rising from the interior of a hollow tendinous cone (the long head), and from the deep surface of an aponeurosis of insertion (the short head), the fleshy fibers run below to the two surfaces of a central aponeurosis of which the fibers are gathered into a strong and resistant tendon.

Running from the skeleton of the shoulder to that of the forearm, the biceps takes up most of the anterior surface of the upper arm. It is subcutaneous along the inferior two thirds of its length. The superior third is masked by deltoideus and by pectoralis major. The fleshy body of the biceps begins to appear below pectoralis major, at the place where the two heads of the biceps become fused. In some models one is able to see in certain movements of the arm the mark of this division on the superior part of biceps brachii.

The placement of biceps brachii makes it easy to see the changes of form that take place during different phases of the muscle's contraction. In general, it should be noted that the fleshy fibers fall a little lower on the inside than on the outside. At the elbow, its tendon can be seen under the skin, as far as the point where it plunges between brachialis and brachioradialis to reach the radial tuberosity. The tendon is even more visible when the muscle is in action. Its outline varies with the degree to which the arm is flexed. The aponeurotic extension, going toward the medial border of the forearm, leaves a clear outline beneath the skin (Plate 59).

The length of the fleshy body is extremely variable. Its extension takes place at the expense of the inferior tendon, which diminishes in proportion. The modeling of the muscle is considerably changed by the shortness or length of the body of the muscle. In the first case, the anterior part of the upper arm, even in relaxation, takes on a globular aspect, and the planes of brachialis seem to increase its length. In the second case, the arm takes on a much more elongated form. The muscle is fuller and its outline descends almost to the bend of the arm, giving the region more uniformity and harmony.

Action. Biceps brachii is a flexor of the forearm on the upper arm and, at the same time, it is a supinator of the forearm. The tendon of its long head holds the head of the humerus against the glenoid cavity, and thus contributes to the stability of the articulation.

TRICEPS BRACHII (PLATE 56, FIGURE 3 and 4)

This voluminous muscle is divided above into three heads.

Attachments: origin, from the outer border of the shoulder blade below the glenoid cavity (the long head), from the humerus above the groove for the radial nerve (medial head), and from the posterior border and lateral surface of the humerus (lateral head); *insertion*, into the posterior and superior part of the olecranon.

Rising from multiple origins, these fleshy fibers group themselves into three bodies. Their disposition is quite complicated so I will explain it. The fleshy fibers of the long portion and those of the lateral head are at the superior part of the upper arm; they give rise to a large tendon which inserts into the olecranon. The fleshy fibers of the medial head descend further than the lateral head; they are attached to the internal border of the common tendon along its entire deep surface, padding it out, so to speak. These fibers also appear at the exterior border, below the fibers of the lateral head, where they mingle with the most superior fibers of anconeus. The common tendon has an internal part which is attached to the summit of the olecranon and an external part which is prolonged below as far as the posterior border of the ulna. The external part covers the anconeus and blends with the deep fascia of the forearm.

Triceps brachii occupies the whole posterior region of the upper arm where it is subcutaneous, except for the superior part which disappears under the deltoid. A plane created by the tendon of triceps brachii may be easily seen beneath the skin. This plane rises to the middle part of the upper arm and is directed obliquely from below to above and from without to within. It is supported by the deep fleshy fibers of the medial head. The fleshy fibers of the lateral head limit its outline above and on the outside. Within, it is bordered by the much more voluminous swelling of the long and medial heads. The most considerable part of this swelling is due to the long head. The medial head is usually separated from the long head by a slight furrow and it only occupies the most inferior part of the form.

The plane of the common tendon, and the swelling of the muscles which surround it, becomes very clear when the muscle is contracted and the fleshy bodies of the three heads may be easily distinguished. Sometimes each of the three heads is divided into secondary reliefs. These run parallel to the direction of the muscular fibers which are due to distinct fasciculi.

Action. Duchenne de Boulogne has well explained the action of the long head. It somewhat feebly lowers the forearm, although, when the lowering of the forearm is made with an effort, it contracts forcefully. Its purpose is not to interfere with the lowering of the upper arm (an action performed mostly by latissimus dorsi and pectoralis major) and to counteract the tendency that these muscles might have of dislocating the inferior end of the humerus. When the arm is in repose, the long head lifts the humerus and holds the extremity of the bone firmly against the glenoid cavity. Coracobrachialis fulfills an analogous function. The medial and lateral heads extend the forearm on the upper arm.

MUSCLES OF THE FOREARM

The muscles of the forearm divide into two regions, the anteroexternal and the posterior region.

ANTEROEXTERNAL REGION

The anteroexternal region is made up of the following three layers. First, a deep layer—the supinator and the pronator quadratus; second, a middle layer—the flexors; and third, a superficial layer—pronator teres, palmaris longus, flexor carpi ulnaris, and in the external region, brachioradialis, extensor carpi radialis longus, and extensor carpi radialis brevis.

DEEP LAYER.

This layer is composed of the supinator and pronator quadratus.

SUPINATOR (PLATE 57, FIGURE 1)

This is a deep muscle (*supinator brevis*) which is curved around the proximal third of the radius.

Attachments: origin, from the lateral epicondyle of the humerus, from the radial collateral ligament of the elbow joint, from the annular ligament, and from the ulna beneath the radial notch; *insertion*, into the superior third of the radius above the oblique line. This muscle contributes to the superior swelling of the external border of the forearm.

Action. It is a supinator, conjointly with the biceps.

PRONATOR QUADRATUS (PLATE 57, FIGURE 1)

This is a deep, flat, quadrilateral muscle, extending transversely between the two bones of the forearm at their inferior quarter.

Attachments: origin, from the inferior quarter of the anterior surface and internal border of the ulna; *insertions*, into the inferior part of the external border and to the anterior surface of the radius. It accounts for the thickness of the inferior quarter of the forearm at the point where most of the superficial muscles which pass in front of it are reduced to tendons.

Action. It is a pronator.

MIDDLE LAYER

This layer is composed of flexor digitorum profundus, flexor pollicis longus, and flexor digitorum superficialis.

FLEXOR DIGITORUM PROFUNDUS AND FLEXOR POLLICIS LONGUS (PLATE 57, FIGURE 2)

These two muscles are joined together and they cover all the anterior and internal part of the skeleton of the forearm.

Attachments: origin, from the superior two thirds of the internal and anterior surface of the ulna and from the interosseous membrane (flexor digitorum profundus);

from the superior three quarters of the anterior surface of the radius and from the interosseous membrane (flexor pollicis longus). *Insertions*, into the bases of the last phalanges of the fingers, into the third phalange of the four last fingers (flexor digitorum profundus), and into the second phalange of the thumb (flexor pollicis longus). These muscles contribute to the median and anterior swelling of the forearm.

Action. These muscles are flexors of the fingers and especially of the last phalanges where they insert.

FLEXOR DIGITORUM SUPERIFICIALIS (PLATE 57, FIGURE 3)

This muscle is superimposed on the preceding ones.

Attachments: origin, from the median epicondyle (common tendon), from the internal part of the coronoid process of the ulna, from the oblique line of the anterior surface of the radius; *insertion*, into the middle phalanges (on the lateral parts of the anterior surface).

The flexor muscles of the fingers each give rise at their lower parts to four tendons. Each of these tendons goes to one of the four fingers of the hand. They pass together through the carpal canal and each finger receives two flexor tendons. These two tendons, one superimposed upon the other, have a unique arrangement in their inferior parts. The superficial tendon divides itself into two portions which twist about the deeper tendon and attach themselves to the sides of the middle phalange. The deeper tendon continues its course and is attached to the last phalange.

The flexor muscles of the fingers form a voluminous fleshy mass which occupies the whole anterior portion and internal border of the forearm. The fleshy fibers descend far down the tendons, much lower than the fibers of the superficial layer of muscles which we are about to study. When the flexor muscles enter into action, they form a relief which occupies the median internal part of the forearm.

ANTERIOR SUPERFICIAL LAYER

All the muscles of the anterior superficial layer have a common superior insertion at the medial epicondyle of the humerus. They number four: pronator teres, flexor carpi radialis, palmaris longus, and flexor carpi ulnaris.

PRONATOR TERES (PLATE 57, FIGURE 1)

Attachments: origin, from the medial epicondyle of the humerus and slightly from the internal border of the humerus and also from the medial side of the coronoid process of the ulna; *insertion*, into the impression situated toward the middle of the lateral surface of the radius.

The fleshy fibers go into a tendon which appears on the anterior surface of the muscle, and which twists its lower part around the radius before it is inserted.

Toward its inferior part, this muscle is covered by the muscles of the external region. However, its superior part creates a distinct relief on the model on the inside of the crease of the elbow.

Action. It is, above all, a pronator. It also contributes to the flexing of the forearm on the upper arm.

FLEXOR CARPI RADIALIS (PLATE 57, FIGURE 4)

Attachments: origin, from the medial epicondyle (common tendon); *insertion*, into the base of the second metacarpal. The fleshy body descends somewhat obliquely from above to below and produces a flat tendon toward the middle of the forearm. This tendon can be clearly seen under the skin as far as the wrist where it plunges into a special sheath in order to attain its insertion at the second metacarpal.

Action. It flexes and abducts the hand.

PALMARIS LONGUS (PLATE 57, FIGURE 4)

Attachments: origin, from the medial epicondyle of the humerus (common tendon); *insertion*, by a slender, flattened tendon into the palmar aponeurosis, passing over the flexor retinaculum.

This muscle is absent in about one out of ten subjects. Its tendon, clearly visible under the skin, occupies the middle of the anterior surface of the wrist. It is more oblique than the tendon of flexor carpi radialis which is found more to the outside.

Action. It flexes the hand and is a tensor of the palmar aponeurosis.

FLEXOR CARPI ULNARIS (PLATE 57, FIGURE 4)

Attachments: origin, from the common tendon of the medial epicondyle of the humerus, from the olecranon, and from the crest of the ulna by an aponeurosis (Plate 60); *insertion*, into the pisiform bone and into the fifth metacarpal.

This muscle is situated on the internal border of the forearm and it covers the deep flexors. Its anterior border, on which the powerful tendon which forms its inferior attachment appears, is separated from palmaris longus by a triangular space, very elongated along its inferior base. Flexor digitorum superficialis appears in this space.

Action. It is a flexor of the hand and helps to adduct it.

EXTERNAL SUPERFICIAL LAYER

This layer is composed of three muscles: brachioradialis, and the two radial extensors.

BRACHIORADIALIS (PLATE 58, FIGURE 3 and PLATE 61)

Attachments: origin, from the external border of the humerus (inferior third); *insertion*, into the base of the styloid process of the radius.

The fibers of this long muscle (*supinator longus*) undergo a torsion movement of about a quarter of a circle. It is thin above where its fibers go around brachialis but it becomes thicker below at the anterior surface of the forearm where its internal border extends as far as palmaris longus. Brachioradialis covers palmaris longus for a short distance (Plate 59).

It is flat in two different senses. Above, in the upper arm part, it is flattened laterally; at the forearm and lower part, it is flattened from front to back.

Action. It is a flexor of the forearm.

EXTENSOR CARPI RADIALIS LONGUS (PLATE 58, FIGURE 2, and PLATE 61)

Attachments: origin, from the inferior third of the external border of the humerus, below the preceding muscle; *insertion,* into the dorsal surface of the base of the second metacarpal.

The fleshy body, much shorter than that of the brachioradialis, is still much like it in shape. Above, it is flattened laterally, and below it is flat in an anteroposterior sense. The two muscles, superimposed, undergo the same movement of torsion. Above, they touch each other by their borders; below, by their surfaces. Extensor carpi radialis longus is covered by brachioradialis, and, in turn, it covers extensor carpi radialis brevis. On the flayed figure it only shows as a triangular surface of which the inferior summit is between brachioradialis and extensor carpi radialis brevis (Plate 61).

Its form, always distinct from extensor carpi radialis brevis, blends with brachioradialis. It is only under certain strong movements of flexion that the two fleshy bodies can be distinguished from each other under the skin (Plate 104, Figure 1).

Action. It extends and abducts the hand.

EXTENSOR CARPI RADIALIS BREVIS (PLATE 58, FIGURE 1, and PLATE 61)

Attachments: origin, from the lateral epicondyle of the humerus; from the common tendon of the superficial muscles of the posterior surface of the forearm; *insertion,* into the dorsal surface of the base of the third metacarpal on its radial side.

The thick, fleshy body is covered along its anterior half by the preceding muscles. Its posterior superficial part forms, on the external border of the forearm, an extremely distinct elongated relief. It gives rise to a single tendon which descends with that of extensor carpi radialis longus as far as the hand. This tendon passes under the muscles on the posterior surface which go to the thumb.

Action. It extends and may abduct the hand.

MUSCLES OF THE POSTERIOR REGION

These muscles are disposed in two layers, each composed of four muscles. The deep layer includes the extensor indicis and the three muscles of the thumb: abductor pollicis longus, extensor pollicis brevis, and extensor pollicis longus. The superifical layer includes the following: anconeus, extensor carpi ulnaris, extensor digiti minimi, and extensor digitorum.

DEEP LAYER

All the muscles of this layer are directed obliquely from above to below and from within to without. Their influence on the exterior form is apparent only at their inferior extremities.

ABDUCTOR POLLICIS LONGUS (PLATE 58, FIGURE 1)

Attachments: origin, from the posterior surfaces of the ulna and radius; *insertion,* into the superior extremity of the first metacarpal.

Action. It draws the metacarpal obliquely to the outside and to the front.

EXTENSOR POLLICIS BREVIS (PLATE 58, FIGURE 1)

Attachments: origin, from the radius; *insertion,* into the superior extremity of the first phalange of the thumb. This muscle and the preceding one are coupled together throughout their course and they cross the other tendons on the radius obliquely. Their fleshy bodies descend as far as the region of the wrist and form, at the inferior part of the external border of the forearm, an extremely distinct oblique relief.

Action. It extends the first phalanx of the thumb and by continued action abducts the hand.

EXTENSOR POLLICIS LONGUS (PLATE 58, FIGURE 1)

Attachments: origin, from the ulna; *insertion,* into the base of the second or last phalanx of the thumb. Its tendon, distinct from those of the preceding muscles, passes down an oblique groove on the radius and crosses the radial tendons. On the inside it forms the medial border of a depression (the anatomical "snuff box") which is limited on the outside by the two tendons of extensor pollicis longus and extensor pollicis brevis.

Action. It extends the second phalanx of the thumb and by continued action abducts the hand.

EXTENSOR INDICIS (PLATE 58, FIGURE 1)

This muscle, situated lower than the preceding one, is inserted above it on the ulna. Its tendon blends below with that of extensor digitorum. It has no effect on the exterior form.

SUPERFICIAL LAYER (PLATE 58, FIGURE 2)

This layer is composed of extensor digitorum, extensor digiti minimi, extensor carpi ulnaris, and anconeus.

EXTENSOR DIGITORUM

Attachments: origin, from the lateral epicondyle of the humerus (common tendon); *insertion,* into the bases of the second and third phalanges of the fingers.

The fleshy body is divided into several bundles which prolong themselves into the four tendons which pass under the annular ligament of the wrist and go toward the four corresponding fingers. The tendons form the oblique strips which are so often visible under the skin of the hand. Together with the radial muscles, the fleshy body of extensor digitorum forms a relief under the skin which

crosses the lower and inside part of the posterior surface of the forearm somewhat obliquely.

In contraction, the muscle forms a distinct relief on the superior part of the forearm. On the inferior quarter of the forearm it is no longer visible, but on thin subjects its tendons can be distinguished on the back of the hand.

Action. It extends the phalanges and, by continued action, extends the wrist.

EXTENSOR DIGITI MINIMI (PLATE 58, FIGURE 2)

This slender muscle shares its superior insertion with the other muscles which arise from the lateral epicondyle of the humerus; below its tendon unites with that of extensor digitorum. Its relief blends with the preceding muscle.

EXTENSOR CARPI ULNARIS

Attachments: origin, from the lateral epicondyle of the humerus (common tendon) and from the crest of the ulna (by an aponeurosis); *insertion,* into the head of the fifth metacarpal (ulna side).

On the nude this muscle forms a distinct elongated relief, bordered within by an oblique groove which corresponds to the crest of the ulna. Its prominent inferior tendon passes through a groove in the head of the ulna and adds to the projection of that bone.

Action. It is an extensor and abductor of the hand.

ANCONEUS (PLATE 58, FIGURE 2)

Attachments: origin, from the lateral epicondyle of the humerus by a distinct tendon; *insertion,* into the external part of the olecranon and to the posterior surface of the ulna (the most superior part). This very short muscle, of triangular aspect, forms a relief which can be clearly seen under the skin.

MUSCLES OF THE HAND

These muscles can be divided into three regions: first, the middle region, or hollow of the hand; second, the external region or thenar eminence; and third, the internal region or hypothenar eminence.

MIDDLE REGION

This region is composed of interossei dorsales and palmares, and lumbricales.

INTEROSSEI DORSALES AND INTEROSSEI PALMARES (PLATE 58, FIGURE 4 and 5)

Small muscles situated in the intermetacarpal spaces, two in each space, these muscles are divided into dorsal and palmar.

Their superior insertions are on the sides of the metacarpals; below they are attached to the sides of the superior extremities of the first phalanges. The interossei dorsales have a double fleshy body which prolongs itself

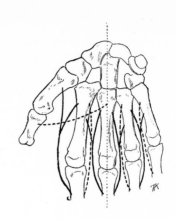

Figure 3. Schematic drawing showing the insertions of the interossei muscles. The dotted lines represent the palmar interossei and the continuous lines indicate the dorsal interossei.

below into a single tendon. The bodies are attached above to the two metacarpals which limit the interosseous space. The interossei dorsales can be seen on the dorsal surface of the metacarpus. In particular, the first dorsal interosseous should be studied since it forms the oblong swelling visible outside the second metacarpal on the back of the hand.

The palmar interossei muscles only have single fleshy bodies which are inserted into the metacarpals on the surfaces which are turned toward the palm of the hand. An exception must be made of the first palmar interosseous, which, because of its differences of insertion, should be separately described. It is actually flexor pollicis brevis and it will be described later. All the palmar interossei muscles are on the palmar surface of the metacarpus where parts of the dorsal interossei muscles may also be seen. The different anatomical details that I have described can be easily understood from Figure 3.

Figure 3 also indicates the action of these little muscles, which, because of their position in relation to the axis of the hand, are either adductors or abductors of the fingers. The abductors, which draw the fingers away from the median axis of the hand, are the dorsal interossei. The adductors, which bring them back in the opposite direction, are the palmar interossei.

LUMBRICALES (PLATE 57, FIGURE 2)

The lumbricales are small muscles situated in the region of the hollow of the hand. They run from the lateral side of the tendons of the flexor digitorum profundus, and they insert into the exterior tendons of each finger.

These small muscles do not influence the external form. Together with the tendons of the flexor muscles, they fill the hollow of the hand and the whole area is covered by a strong palmar aponeurosis.

MUSCLES OF THE THENAR EMINENCE

From the point of view of the exterior form we can divide these muscles into two groups: an external group which

forms the swelling at the base of the thumb, and an internal group, much deeper, which underlies the inferior group and raises the thenar eminence.

The first group is composed of three muscles: abductor pollicis brevis, flexor pollicis brevis, and opponens pollicis. The second group is composed of a single muscle, the adductor pollicis.

ADDUCTOR POLLICIS (PLATE 58, FIGURE 4)

Attachments: origin, from the capitate bone, the anterior part of the third metacarpal, and the superior part of the second metacarpal; *insertion,* into the internal tuberosity of the superior extremity of the first phalanx of the thumb.

This triangular muscle, deeply situated, is covered by the tendons of the flexor muscles and the lumbricales. It becomes superficial only at its external extremity where it forms the supporting and inferior part of the thenar eminence.

Action. It is an adductor of the first metacarpal.

OPPONENS POLLICIS (PLATE 58, FIGURE 4)

Attachments: origin, from the anterior part of the trapezium and the ligament of the wrist (flexor retinaculum); *insertion,* into the external border and the anterior surface of the first metacarpal.

Action. Deeply situated, this little triangular muscle abducts, flexes, and rotates the thumb.

FLEXOR POLLICIS BREVIS (PLATE 59)

Attachments: origin, from the trapezium and the ligament of the wrist; *insertion,* into the superior extremity of the first phalanx of the thumb. This thick muscle,

situated at the internal part of the thenar eminence, is divided into two bundles between which the tendon of flexor pollicis longus passes.

Action. It flexes the first phalanx of the thumb and carries the metacarpal in front and within.

ABDUCTOR POLLICIS BREVIS (PLATE 59)

Attachments: origin, from the tuberosity of the scaphoid, the transverse carpal ligament, and the ridge of the trapezium; *insertion,* into the superior extremity and radial side of the first phalanx. This flat muscle is the most superficial and the most external of the region.

Action. It abducts the thumb.

MUSCLES OF THE HYPOTHENAR EMINENCE (PLATE 59)

The muscles of the hypothenar eminence only need a brief description. They are, to a certain extent, analogous to those of the thenar eminence. They are, starting with the deepest, opponens digiti minimi, flexor digiti minimi brevis, and abductor digiti minimi.

They occupy the internal border of the hand and contribute to the diverse movements of the fifth metacarpal and the little finger. These movements are much more limited than those of the thumb. The muscles of the hypothenar eminence are also much less voluminous than those of the thenar eminence.

I should, however, call attention to the most superficial muscle of the region, palmaris brevis. This muscle is attached, on the outside, to the internal border of the palmar aponeurosis, and, within, to the deep surface of the skin at the ulnar border of the hand. When it contracts, it creates a longitudinal depression in this area which is traversed by extremely characteristic wrinkles over the skin.

11. Muscles of the Lower Limb

We shall study successively the muscles of the thigh, the leg, and the foot.

MUSCLES OF THE THIGH

The muscles of the thigh may be divided as follows: an anterolateral group composed of the quadriceps, the tensor of the fascia lata, and the sartorius; a medial group composed of the adductors and the gracilis; and a posterior group formed of the biceps femoris, of the semimembranosus and of the semitendinosus.

ANTEROLATERAL GROUP.

This group of muscles is composed of quadriceps femoris, tensor fasciae latae and sartorius.

QUADRICEPS FEMORIS (PLATE 63, FIGURE 1)

The quadriceps femoris is composed of four muscles: rectus femoris, vastus lateralis, vastus medialis, and vastus intermedius (crureus). They are united below by a single tendon.

Attachments: origin, for the rectus femoris, from the anterior *inferior* iliac spine (straight tendon) and from a groove above the brim of the acetabulum (reflected tendon); for the vastus lateralis, from the base of the great trochanter and the lateral lip of the linea aspera; for the vastus medialis, from the medial lip of the linea aspera; for the vastus intermedius, from the anterior and lateral surface of the femur, and from the distal part of the lateral intermuscular septum.

Insertion, into the base and the two borders and the anterior surface of the patella, then, through the patella tendon, to the anterior tuberosity of the tibia.

The *rectus femoris,* fusiform in shape, is the most superficial portion of the quadriceps. It occupies the center of the anterior surface of the thigh, and it follows the oblique direction of the femur. Its position makes the relief formed under the skin in contraction very distinct. This relief is marked, at its center, by a longitudinal furrow due to the disposition of the superior aponeurosis of the muscle.

The tendon of rectus femoris plunges above into an upside down V shape. This angle is formed by the sartorius and the tensor of the fascia lata. The rectus femoris runs into the angle in order to gain its insertion at the iliac bone. Because this insertion is made by a double tendon, the muscle is able to act efficiently in two different positions. In extension of the limb, for instance, the straight tendon is in play; in flexion of the thigh, on the contrary, all the strain is carried by the reflected tendon. Below, the tendon of rectus femoris goes to the base of the patella; its fleshy fibers cease almost a hand's breadth above this bone.

The two voluminous fleshy bodies of *vastus medialis* and *vastus lateralis* are situated on either side of the preceding muscle, and join together on the median line below it. Their inferior insertion is made by large aponeurotic surfaces which, closely joined to the tendon of rectus femoris, descend on each side and insert themselves onto the sides of the patella.

The vastus lateralis is the most voluminous of the quadriceps femoris muscles and it occupies almost all of the external surface of the thigh. It is supported on the outside by the band of the fascia lata, but the fibrous bundles of vastus lateralis may, in certain positions of the thigh, be seen running across this band. The fleshy fibers stop at a distance of several fingers' breadth from the patella.

The vastus medialis occupies the inferior and medial part of the thigh. It looks like an ovoid mass. The largest part is turned downwards and the superior point plunges into the angle formed by the rectus femoris and the sartorius. The fleshy body descends very low, as far as a line level with the middle of the patella. There is, therefore, a great difference between vastus lateralis and vastus medialis; this detail is of great importance in modeling the knee.

The *vastus intermedius (crureus)* is the deepest part of the quadriceps. It stretches along the femur and lies partly underneath the vastus medialis although the major part lies underneath the vastus lateralis. Nevertheless, its influence on the exterior form is marked. This is because it projects below the tendon of vastus lateralis and, at the external surface of the knee, it becomes superficial for a short distance. This superficial portion of vastus intermedius is covered by the fascia lata (Plate 70) when the lower leg is extended. When the leg is flexed it forms a distinctly ovoid swelling.

At a distance of three or four fingers' breadth above the patella, the transverse fibers of the aponeurosis become compressed and form a fibrous bundle or band of aponeurosis (*Richer's band,* Plate 68, 70 and 71). These fibers embrace in their curve the superior anterior and medial

part of the knee. The external extremity fans out and blends with the fasciae latae. Within, these fibers converge and cross vastus medialis in a direction perpendicular to the direction of its fleshy fibers. At about two fingers' breadth from its interior border, the band of fibers passes over the medial femoral tuberosity, descends in front of the sartorius, and intermingles with the tendon of this muscle as it turns down at an acute angle.

At the points where the band meets the dividing membranes of the internal and external aponeuroses some of its deep fibers detach themselves and, adhering to the dividing membranes, go to insertions on the divisions of the linea aspera. The band completes an osteofibrous ring around a transverse plane, inclined from above to below and from without to within. This ring may be thought of as enclosing the inferior part of the quadriceps.

Below, the band has a distinct border. The inferior extremities of the vastus lateralis and vastus medialis seem to be covered only by a loose aponeurotic network. The superior limits of the band are less sharp, and its fibers seem to blend almost imperceptibly with the transverse fibers of the femoral aponeurosis.

The band is important from the point of view of form in this region. When the muscles are relaxed, the fleshy extremities of vastus lateralis and vastus medialis swell boldly beneath the band and create distinct reliefs. We will study these forms later.

Action. The quadriceps femoris extends the lower leg. Also, through rectus femoris, it flexes the pelvis against the thigh.

TENSOR FASCIAE LATAE (PLATE 68 and 70)

Attachments: origin, from the outer lip of the iliac crest and from the outer surface of the anterior superior iliac spine; *insertion,* into the iliotibial tract and ultimately into the tibia.

The fleshy body is short and thick and it is situated at the superior and external part of the thigh. In the back it is placed against gluteus medius and its relief blends in with this muscle. It descends as far as the great trochanter to a point in front and somewhat slightly below it. The thick, fibrous band which constitutes its inferior tendon blends with the external investing fascia of the thigh, the *fascia lata.* The fascia lata is closely joined to the tendon of gluteus maximus and rises, passing over gluteus medius, as far as the iliac crest to which it is solidly attached.

Action This muscles is a flexor of the thigh. At the same time it rotates the thigh medially. The medial rotation is counterbalanced by the opposing rotative action of the psoas muscle.

SARTORIUS (PLATE 68 and 71)

Attachments: origin, from the anterior superior iliac spine; *insertion,* into the medial surface of the tibia, near the anterior crest.

This muscle, the longest in the human body, is flat and about two fingers' breadth wide. It descends obliquely across the anterior surface of the thigh and goes down around the internal part of the knee. It thus describes a sort of elongated spiral.

The fleshy fibers terminate below in a point at the posterior part of a flat tendon. These fibers are of various lengths in different individuals, but generally they descend beyond the articular interplane of the knee.

Action. Flexes the thigh and rotates it laterally. Flexes the leg, and, after it is flexed, rotates the lower leg slightly medially.

INTERNAL GROUP

This group is composed of the adductors and gracilis.

ADDUCTOR GROUP (PLATE 63, FIGURE 2 and 3 and PLATE 64, FIGURE 1)

Anatomists are not in agreement about the division of the adductor group into four distinct muscles: pectineus, adductor longus, adductor brevis, and adductor magnus. In fact, these muscles are often mingled together. However, the issue is of no importance to us. The united abductors form, on the living, a powerful mass at the superior and internal part of the thigh. This mass is never subdivided.

Attachments: origins, from the pectineal line and the triangular surface situated in front of this line (pectineus); from the crest of the pubis and below (adductor longus and adductor brevis); and from the tuberosity of the ischium and the ramus of the ischium (adductor magnus). *Insertions,* into the internal bifurcation of the linea aspera, into the whole interstice of the linea aspera, and into the projecting tubercle of the internal condyle of the femur (fascia of adductor magnus).

Action. The adductors are all, as their names imply, adductors of the thigh. The most superior ones are, at the same time, flexors and outward rotators. The lower part of the adductor magnus is an inward rotator.

GRACILIS (PLATE 71)

Attachments: origin, from the pubis and the pubic arch as far as the neighborhood of the ischium; *insertion,* to the crest of the tibia.

This thin, elongated muscle descend vertically down the internal side of the thigh; its relief blends with that of the adductors. The fleshy body, of varying length in different individuals, sometimes descends as far down as the inferior part of the thigh; the inferior tendon is, correspondingly, longer or shorter. Its lower portion follows the posterior border of the sartorius and contributes to the formation of the aponeurotic network which covers the superior part of the medial surface of the tibia and which has been called the *goose foot.*

Action. The gracilis adducts the thigh. It also flexes the lower leg, and, after it is flexed, assists in medial rotation. The first action is the most powerful.

POSTERIOR GROUP

This group is composed of biceps femoris, semimembranosus, and semitendinosus.

BICEPS FEMORIS (PLATE 64, FIGURE 2 and 3)

Attachments: origin, from the ischium by a common tendon with the semitendinosus (long head of the biceps), from the middle part of the linea aspera (short head of the biceps); *insertion,* into the lateral side of the head of the fibula outside, and the lateral condyle of the tibia further to the inside.

The fleshy body of the long head, elongated and fusiform in shape, gives rise at its inferior part to a tendon which rests upon the posterior surface of the muscle. This tendon receives, upon its external border, the fleshy fibers of the short head which come from the femur. The tendon is very strong and covers the fibular collateral ligament of the knee joint.

Action. See discussion of semimembranosus and semitendinosus.

SEMIMEMBRANOSUS (PLATE 64, FIGURE 2 and 3)

Attachments: origin, from the ischium, above and lateral to the semitendinosus and the biceps femoris; *insertion,* into the posterior part of the medial condyle of the tibia where the tendon divides into three fibrous expansions. These expansions are: first, an inferior, which is inserted into the inferior part of this same condyle; second, an external, which moves out and up to reinforce the oblique popliteal ligament; and third, an internal, which is inserted into the horizontal groove of the condyle.

This powerful muscle forms a vertical furrow which receives the semitendinosus. The inferior extremity of its fleshy body forms a rounded swelling above the superior part of the popliteal space. When the muscle contracts, the swelling becomes most pronounced. Its superior tendon arises from the external border of the muscle and it is hidden beneath the semitendinosus. Its inferior tendon, which shows itself on the internal border, is subcutaneous and may be seen behind the tendon of the gracilis (Plate 72).

SEMITENDINOSUS (PLATE 64, FIGURE 2 and 3)

Attachments: origin, from the ischium by a common tendon with the biceps; *insertion,* into the crest of the tibia.

This muscle is the most superficial of the muscles of the posterior region of the thigh. The fleshy body occupies the superior part of the thigh on the medial side of the biceps femoris. At its lower part it produces a slim, rounded tendon which descends to the medial surface of the tibia. This tendon forms, together with the tendons of the gracilis and the sartorius, the aponeurotic network called the *goose foot.*

Action. The semitendinosus and the biceps femoris produce three movements: flexion of the lower limb on the thigh; extension of the thigh on the pelvis; and rotation of the thigh on the pelvis (the first muscle produces medial rotation and the second lateral rotation). The semimembranosus, more powerful than the two preceding muscles, is not a rotator. It is an extensor of the thigh and a flexor of the lower leg.

MUSCLES OF THE LOWER LEG

The muscles of the lower leg are divided into two regions. The anteroexternal region includes five muscles: extensor hallucis longus, extensor digitorum longus, tibialis anterior, peroneus brevis, and peroneus longus. The posterior region also includes five: the popliteus, tibialis posterior, flexor digitorum longus, flexor hallucis longus, and triceps surae (glastrocnemius and soleus).

ANTEROEXTERNAL REGION

This region is composed of extensor hallucis longus, extensor digitorum longus, tibialis anterior, peroneus brevis and peroneus longus.

EXTENSOR HALLUCIS LONGUS (PLATE 65, FIGURE 1 and 2)

Attachments: origin, from the anterior surface of the fibula, from the interosseous membrane; *insertion,* into the base of the second phalanx of the big toe. Completely hidden above, this muscle appears at the inferior part of the leg between the two muscles described below. It passes under the inferior extensor retinaculum, and its tendon can be seen on the dorsum of the foot.

Action. It is an extensor of the big toe and flexes and supinates the foot.

EXTENSOR DIGITORUM LONGUS (PLATE 65, FIGURE 1 and 2)

Attachments: origin, from the lateral condyle of the tibia and from three fourths of the anterior surface of the fibula; *insertion,* into the second and third phalanges of the four lesser toes.

Throughout its length, this muscle occupies the anterior part of the lower leg. Its fleshy body is masked in its superior part by tibialis anterior which is situated medially to this muscle. Below, its four tendons pass together under the retinaculum, and only separate when they reach the dorsum of the foot in order to go to the toes.

The fleshy body is prolonged below by a small muscle called *peroneus tertius.* The tendon of this muscle attaches to the dorsal surface of the base of the metatarsal bone of the little toe.

Action. It extends the proximal phalanges of the four lesser toes. Dorsally it flexes and pronates the foot.

TIBIALIS ANTERIOR (PLATE 65, FIGURE 2)

Attachments: origin, from the lateral condyle of the tibia, and from the upper two thirds of the lateral surface of the body of the tibia; *insertion,* into the medial and plantar surface of the first cuneiform and to the base of the first metatarsal.

This thick muscle, fusiform in shape, creates a relief which projects beyond the crest of the tibia and blunts the sharp anterior border of this bone. Its fleshy body ends about halfway down the border and gives rise to a tendon. This tendon runs obliquely down and to the inside. The projection of the tendon can be easily traced as far as its inferior insertion.

The tendon of the tibialis anterior creates a much more considerable relief than those created by the tendons of

the extensor muscles which are situated to its outside. This is due to a special anatomical arrangement. The inferior extensor retinaculum passes completely above the extensor longus digitorum and the extensor hallucis longus, but it embraces the tendon of tibialis anterior in a sort of a loop. The result is that the tendon of tibialis anterior is less strongly held down to the foot and in contraction it forms a strong relief under the skin when it rises from the bony surfaces on which it otherwise rests.

Action. It flexes, adducts, and inverts the foot.

PERONEUS BREVIS (PLATE 66, FIGURE 1 and PLATE 70)

Attachments: origin, from the lower two thirds of the lateral surface of the fibula; *insertion,* into the tuberosity at the base of the metatarsal of the little toe.

Placed underneath the muscle described below, the fleshy fibers descend in the back as far as the level of the lateral malleolus. Its tendon runs in a groove behind this malleolus along with that of peroneus longus. On the lateral side of the foot, when the muscle is contracted, the tendon becomes clearly visible in the form of a cord. The tendon of peroneus longus, which goes to the bottom of the foot, remains invisible.

Action. It abducts the foot.

PERONEUS LONGUS (PLATE 66, FIGURE 1 and PLATE 70)

Attachments: origin, from the intermuscular septum which separates the neighboring muscles; *insertion,* into the external part of the base of the first metatarsal.

The elongated fleshy body of this muscle ends in a tendon toward the middle of the leg and this tendon covers that of peroneus brevis which lies beneath it. The tendons of these two muscles run together behind the lateral malleolus in a groove that contains the common synovial sheath. Their presence rounds off the lateral malleolus and increases its transverse diameter. At its inferior part, the tendon of peroneus longus leaves the tendon of peroneus brevis and crosses the plantar vault in an oblique line.

Action. It pronates and flexes the foot.

POSTERIOR REGION

The muscles of this region are five in number and they form two layers: a superficial layer composed of a single muscle, and a deep layer which consists of the four others.

DEEP LAYER

The muscles of the deep layer are the popliteus above and the tibialis posterior, the flexor digitorum longus, and the flexor hallucis longus below. The lower muscles descend as far as the foot.

These muscles, directly resting against the skeleton of the lower leg, do not show very much on the surface except behind the internal malleolus. Here, reduced to their tendinous extremities, they enter the groove of the calcaneus and move to the inferior surface of the foot.

Because of their slight influence on the surface form, I shall only point out their attachments and their actions.

POPLITEUS

Attachments: origin, from a depression of the lateral condyle of the femur; *insertion,* into the posterior surface of the tibia above the popliteal line.

Action. It flexes the leg and rotates it medially.

TIBIALIS POSTERIOR (PLATE 65, FIGURE 3 and PLATE 66, FIGURE 1)

Attachments; origin, from the popliteal line of the tibia and the most lateral part of the posterior surface of this bone, from that part of the internal surface of the fibula situated behind the interosseous ligament; *insertion,* into the tuberosity of the navicular bone.

Action. It adducts, inverts, and flexes the foot.

FLEXOR DIGITORUM LONGUS (PLATE 65, FIGURE 3 and PLATE 66, FIGURE 1)

Attachments: origin, from the popliteal line and from the middle third of the posterior surface of the tibia; *insertion,* into the bases of the distal phalanges of the four lesser toes.

Action. Flexor of the terminal phalanges of these toes.

FLEXOR HALLUCIS LONGUS (PLATE 65, FIGURE 1 and 2)

Attachments: origin, from the inferior two thirds of the posterior surface of the fibula; *insertion,* into the base of the terminal phalanx of the big toe.

Action. Flexor of the second phalanx of the big toe.

SUPERFICIAL LAYER

This layer is composed of the triceps surae.

PLANTARIS, SOLEUS, AND GASTROCNEMIUS (PLATE 66, FIGURE 2 and 3)

Attachments: origin, from above the medial condyle of the femur, from a depression on the internal surface and from the femur above (medial or larger head of gastrocnemius); from an impression on the side of the lateral condyle of the femur, and from the posterior part of the femur above the condyle (lateral head of gastrocnemius); from the head and from the superior third of the posterior surface of the fibula, from the popliteal line of the tibia, and from the middle third of its medial border (soleus); *insertion,* into the middle part of the posterior surface of the calcaneus (*Achilles tendon* or *tendo calcaneus*).

The plantaris is a very small and slender muscle. Its fleshy body rises above the lateral head of gastrocnemius. It terminates in a very long tendon which descends as far as the calcaneus, on the inside of the Achilles tendon.

The triceps surae, in its fleshy superior part, is composed of two layers: one deep, the soleus; the other superficial, the gastrocnemius.

The soleus has a flat, fleshy body composed of short muscular fibers. These fibers are obliquely directed and end in a dividing aponeurotic membrane. In the flayed figure only the borders of the muscle show on the corresponding sides of the lower limb. A very strong aponeurosis covers the inferior posterior surface of the muscle and joins onto the tendon of the gastrocnemius with which it forms Achilles tendon. The fleshy fibers of the soleus descend fairly low on each side of this tendon.

The two heads of gastrocnemius arise from each of the condyles of the femur and join each other along the median line. A strong aponeurosis descends from the tendon onto the middle of the posterior surface of each muscle and creates lateral furrows. The inferior extremities of the two heads of gastrocnemius descend more or less low depending on the individual. They terminate abruptly and thus form the well known outline of the calf. The medial head is the most voluminous. It encroaches upon the medial surface of the leg and descends lower than the lateral head. It terminates in a rounded extremity which marks the break in continuity of the calf. The lateral head has less volume and usually has a more pointed inferior extremity.

The common tendon, large above, becomes narrower as it approaches the calcaneus and slightly enlarges again at its point of attachment. The tendon is subcutaneous and its surface projects more in the middle than at the sides. It is joined laterally by the fibers of the soleus which descend more or less low depending on the individual. The fibers contribute to the size of this part of the leg.

Action. Soleus and gastrocnemius are powerful extensors of the foot and, at the same time, they draw the point of the foot to the inside. As flexors of the lower leg on the thigh, their influence is weak.

MUSCLES OF THE FOOT

These muscles are divided into two regions: plantar and dorsal.

DORSAL REGION

This region has a single muscle, extensor digitorum brevis.

EXTENSOR DIGITORUM BREVIS (PLATE 67, FIGURE 1)

Attachments: origin, from the anterior part of the calcaneus, in front of the groove for the tendon of peroneus brevis; *insertion,* this muscle terminates in four tendons. The most medial tendon is attached to the first phalanx of the great toe and the other three are inserted into the lateral sides of the tendons of the extensor digitorum longus of the second, third, and fourth toes.

This muscle is situated under the extensor tendons which cross the dorsum of the foot. The fleshy body of extensor digitorum brevis runs obliquely, and on the outside of the foot near its posterior insertion it forms a relief which is extremely important in modeling the superior surface of the foot.

Action. It is an extensor of the proximal phalanges of the big and adjacent three lesser toes.

PLANTAR REGION

The muscles of the plantar region are of little interest from the point of view of exterior form. They partly fill the bony arch which is principally responsible for the conformation of this region. However, the muscles on the side of the foot sometimes create distinct reliefs which can be seen under the skin.

It is only necessary to indicate the attachments of the muscles of this region. They may be divided, like the muscles of the hand, into three groups: the middle, the external, and the internal.

MIDDLE REGION

This region is composed of the interossei muscles, adductor hallucis, lumbricales, quadratus plantae, and flexor digitorum brevis.

INTEROSSEI

Divided, like the hand, into dorsal and plantar interossei, these muscles have the same disposition as in the hand with this exception: the axis of the foot, instead of passing through the third metatarsal, passes through the second.

ADDUCTOR HALLUCIS (PLATE 67, FIGURE 2)

Attachments: origin, from the bases of the second, third, and fourth metatarsal bones (oblique head), and, *from the outside,* from the transverse ligament of the metatarsus (transverse head); *insertion,* into the lateral side of the base of the first phalanx of the great toe (both heads).

Action. Adducts the big toe. The transverse head of adductor hallucis helps to maintain the vault of the foot in a transverse sense.

LUMBRICALES (PLATE 67, FIGURE 3)

Analogous to the lumbricales of the hand, these little muscles are attached to the internal sides of the tendons of flexor digitorum longus. They go to the first phalanges of the toes.

QUADRATUS PLANTAE (PLATE 67, FIGURE 3)

Attachments: origin, from the inferior surface of the calcaneus; *insertion,* into the lateral border of the tendon of flexor digitorum longus.

Action. Flexes the terminal phalanges of the four lesser toes.

FLEXOR DIGITORUM BREVIS (PLATE 67, FIGURE 4)

Attachments: origin, from the medial and inferior tuberosity of the calcaneus; *insertion,* into the sides of the second phalanges of the lesser toes. Its anterior tendon runs along with those of flexor digitorum longus. It is analogous to the tendons in the hand.

Action. Flexes the second phalange of the four lesser toes.

INTERNAL REGION

This region is composed of flexor hallucis brevis and abductor hallucis.

FLEXOR HALLUCIS BREVIS (PLATE 67, FIGURE 2)

Attachments: origin, from the third cuneiform and the cuboid bone; *insertion,* into the two sides of the base of the first phalange of the big toe.

Divided into two portions, this muscle forms a groove for the tendon of the flexor hallucis longus. It makes its double inferior insertion along with the tendons of the other muscles and its tendons give rise to small bones called the medial and lateral sesamoid bones. These bones augment the relief that the metatarsophalangeal articulation of the big toe forms on the sole of the foot.

The lateral sesamoid bone receives a portion of flexor hallucis brevis together with the two heads of adductor hallucis.

The medial sesamoid bone also receives a portion of the flexor hallucis brevis and it also receives a portion of abductor hallucis, a muscle which we are about to describe.

Action. Flexes the proximal phalange of the great toe.

ABDUCTOR HALLUCIS (PLATE 67, FIGURE 4)

Attachments: origin, from the medial process of the tuberosity of the calcaneus; *insertion,* into the base of the first phalanx of the big toe (medial sesamoid bone). It should be noted that the superior border of this muscle forms a longitudinal relief along the internal border of the foot.

Action. It is an abductor of the big toe.

EXTERNAL REGION

This region is composed of flexor digiti minimi brevis and abductor digiti minimi.

FLEXOR DIGITI MINIMI BREVIS (PLATE 67, FIGURE 3)

Attachments: origin, from the base of the fifth metatarsal; *insertion,* into the lateral side of the first phalange of the little toe.

Action. It is a flexor of the first phalange of the little toe.

ABDUCTOR DIGITI MINIMI (PLATE 67, FIGURE 4)

Attachments: origin, from the lateral process of the tuberosity of the calcaneus; *insertion,* into the base of the first phalange of the little toe (common tendon with the preceding muscle). The tendon of abductor digiti minimi glides over a smooth facet on the plantar surface of the base of the fifth metatarsal bone.

Action. It is an abductor of the little toe in relation to the axis of the foot.

12. Veins

The veins are canals designed to bring the blood that has been distributed to the organs by the arteries back to the heart. In the interior of the tissues the blood is not completely free—it is contained in an infinity of microscopic canals called capillaries. These capillaries are interposed between the veins and the arteries and they establish communication between the two systems. The cutaneous capillaries give the skin its roseate color. The veins contain dark blood which is unfit for nutrition, while the arteries contain red blood which is filled with nutritive qualities.

Veins are disposed both in the deep parts of the body and at the surface. The superficial veins, which alone interest us, arise within the skin. They travel along the cellular subcutaneous tissue and their origin and course are extremely variable. Only their termination, that is to say the place where they communicate with the deep veins, offers a certain consistency. The veins have an irregular cylindrical shape—they are dilated at certain places and contracted in others which gives them a knotty appearance. This knotty quality is due to the valves in their interior which are designed to facilitate the course of the blood. The veins are always of a bluish color because of the blood which they contain and, in people who have a fine and transparent skin, the color of the veins may be seen as they cross the integument.

The veins often communicate with each other and form a most irregular knotty network.

The arteries have resistant walls and are perfectly cylindrical in shape. As they are always deeply situated, I shall not deal with them here. However, the temporal artery is an exception. Its flexuosities may be easily seen under the skin of the temple, as well as its palpitations (arterial pulsations) when it is animated.

In the veins the blood circulates from the periphery to the center, in an inverse direction to that which it follows in the arteries. The blood in the limbs has to overcome the action of gravity, hence the utility of the valves we have just mentioned. Any obstacle in the course of the veinous blood swells the veins; they will show beneath the skin in great detail if the base of a limb is constricted with a band. An analogous result will take place from purely psychological conditions. For example, in the phenomenon of effort, the suspension of respiration and muscular contraction inhibits the course of the blood in the great veins of the neck. These swell and congest, even affecting the face itself. Exercise, by activating the circulation, increases the amount of blood which circulates in the veins.

Finally, muscular contraction compresses the deep veins and forces the blood to flow back into the superficial veins which then become more swollen.

I should like to point out certain superficial veins which artists are often called upon to portray.

EXTERNAL JUGULAR VEIN

When the neck is under muscular strain, a great vein appears which crosses the direction of the fibers of the sternocleidomastoideus obliquely (Plate 73, Figure 1). This is the *external jugular vein*. It arises from the reunion of the superficial veins of the cranium, among which the *temporal* is most apparent. The external jugular runs from the angle of the jaw down to the fossa above the clavicle which it penetrates immediately to the outside of the insertion of the sternocleidomastoideus. The tributaries of this vein are sometimes visible on the face. These tributaries are: the *frontal,* which descends the middle of the forehead; the angular vein, which runs down the outer wing of the nose; and the facial vein, which generally disappears in the tissues of the cheek.

SUPERFICIAL EPIGASTRIC VEIN

This is the only vein that should be noted on the torso. It is sometimes, though rarely, seen. It descends the lower abdomen, crosses the fold of the groin obliquely, and joins the great saphenous vein when the latter goes into the deep veins of the thigh.

SUPERFICIAL VEINS

These are most developed in the projecting limbs of the body. They may be seen, above all, in thin subjects, and in those who are used to violent bodily exercise. The reason for this is easy to see—if the subject is thin, there is no fat to mask the relief of the veins and if the veins are repeatedly congested in exercise, their superficial development becomes exaggerated. Congestion of the veins occurs because the blood is driven from the deeper veins to the superficial ones during muscular contraction, as I explained above.

In the upper limb (Plate 72), the superficial veins originate on a posterior plane at the back of the hand and fingers. They then run obliquely along the borders of the forearm and reach, at the level of the bend of the arm, the anterior plane. Their course is extremely irregular.

The collateral veins of the fingers unite and produce, on the back of the hand, a veinous network which has a form something like an arcade.

The external extremity of this arcade forms the *cephalic* vein of the thumb; the radial vein originates from it and mounts the lateral border of the forearm. From the internal extremity of the arcade the *basilic* vein develops; this vein is situated on the medial border of the forearm. At the anterior part of the wrist, several small veins originate at the thenar and hypothenar eminences. They join the cephalic and basilic veins which rise to the median veins at the middle part of the anterior surface of the forearm.

At the anterior part of the forearm, we find four veins: the basilic, the median antebrachial vein, the accessory cephalic, and the cephalic.

The cephalic and median antebrachial open into two branches which run toward the sides of the arm; the outside branch becomes the median cephalic and the inside branch, the median basilic. After a short path each of these two divisions unites with the veins on the sides of the forearm and gives rise to the two veinous trunks of the upper arm. The disposition of veins at the fold of the arm has been compared to a capital M.

There are two main veins in the upper arm. On the outside, the cephalic vein rises along the anterior border of biceps and the deltoideopectoral furrow, remaining subcutaneous until it reaches the level of the subclavicular depression. On the inside of the arm, the basilic vein rises up and disappears into the deep veins of the arm pit.

VEINS OF THE LOWER LIMB (PLATE 73, FIGURE 2 and 3)

Here two great veinous trunks are visible throughout the length of the leg, medially the *great saphenous vein* can be seen and, at the posterior part of the leg, the *small saphenous vein.*

As on the hand, the collateral veins of the toes join a vein disposed in a more or less transverse fashion, the *dorsal arcade* (dorsal veinous arch). On the inside, this vein passes along the internal border of the foot where it becomes the *medial marginal vein,* and forms the origin of the great saphenous vein. The *great saphenous vein* rises along the medial surface of the lower leg, crossing obliquely the swelling of soleus and the border of the medial head of gastrocnemius. It moves behind the medial condyles of the knee and reaches, following the plane of the sartorius, the internal and superior part of the thigh where it disappears among the deeper veins. At this level it is joined by the integument of the abdomen and the external veins which rise from the genital organs.

The *small saphenous vein* has two origins on each side of the foot. The internal branch comes from the medial border of the foot and the heel. The external branch comes from the external border and dorsum of the foot. Often some of the ramifications of this vein cut transversely across the external malleolus. The two branches converge and join each other at an acute angle on the Achilles tendon. The small saphenous vein then rises directly along the median line until it reaches the back of the knee, where it plunges into the deeper veins.

It must be added that all the principal venous trunks in the upper and lower limbs communicate between themselves by a network of branches. The larger divisions of this network are sometimes apparent. They are often accompanied by smaller branches which run in a parallel direction. At other times, instead of forming a single trunk, the divisions divide themselves into several branches which later unite.

13. Skin and Fatty Tissues

Although the skin and the fatty layer beneath it are really two separate subjects, because of their intimate union I shall treat the two subjects as one in this chapter. But, faithful to the method of moving from the deeper parts to the surface, I shall first describe the fatty tissue.

FATTY TISSUE

Fatty tissue may be found in the organism in two different places. First, it is disposed in a layer between the skin and the general enveloping aponeurosis; this is called the *panniculus adiposus*. Second, it is distributed in the spaces between the deep organs; this is the fatty tissue of interposition.

PANNICULUS ADIPOSUS

However important a role the muscles play in the exterior conformation of the body, we must not forget that between the surface of the muscles and the exterior form of the nude there is a difference, a greater difference, perhaps, than might be expected.

In reality, the skin does not lie directly over the muscles and their aponeurotic envelope. In other words, it is not enough to just cover the flayed form with skin, here and there smoothing out the rough places and not changing anything essential. There is, between the skin and the muscles, an additional layer of special tissue, the panniculus adiposus. Its presence in each region completely modifies the shape of the flayed figure. This is not only true in very plump subjects, whose forms drown in a sea of fat, but it is also true of young, robust, healthy subjects whose bodies seem devoid of superfluous fat.

This layer of fatty cells is throughout most of its extent actually as thick as the skin and adheres closely to it. When the skin is removed it is this layer which slides upon the aponeurosis and the external integument does not attach itself to this subcutaneous fatty layer.

Moreover, the panniculus adiposus varies considerably in thickness in different regions of the body, and on different individuals. It exists on all subjects, even those who are very thin, except in extreme and morbid cases of emaciation. It is important to understand just how much of an influence its greater or lesser development has on the external forms. The forms of the body are most masked in those subjects whose panniculus adiposus is most developed, whereas the exterior forms that seem withered, hard, or sharp appear in subjects who have a very thin fatty layer. Among women and children it is the abundance of the panniculus adiposus which causes the generally rounded form and often almost completely efface the muscular prominences.

The variations which occur in the fatty layer of different regions in one individual are even more interesting from the morphological point of view. From measurements made on a score of subjects of whom three fourths belonged to the lean category, and of whom none were very fat, we obtained the following results:

The panniculus adiposus is lacking in the skin of the nose, the eyelids, etc. It is very thin at the back of the hand, the foot, and at the level of the clavicles (1 to 2 millimeters). It is thickest on the torso where it is distributed most unequally. The layer of fat is thickest on the buttocks (1 centimeter on the average, and up to 2 centimeters); next in thickness is the fat on the posterior part of the flank (8 millimeters on the average, and up to 1 centimeter and a half); and next is the region of the breast at its inferior part, around the nipple (6 millimeters on the average, and up to 1 centimeter and a half). At the abdomen the fat is more abundant above than below the navel (6 millimeters and a half on the average above, and 4 millimeters below). Beneath the breast it is less abundant (on the average 3 or 4 millimeters). At the neck its thickest part is in the back, at the nape; this is almost double that which lies in the front at the level of Adam's apple. On the limbs, the fat diminishes in thickness from above to below. On the arms it is much thicker in the back than in front. On the lower limb, there are notable differences in the disposition of the fat; it becomes thickest in the middle going from above to below.

It is evident from these measurements that the panniculus adiposus plays a considerable part on the external form. It is not just a veil which attenuates the abrupt outlines of the flayed figure, it also directly influences the forms of the body. In fact it should be given the same status as the muscles and the bones with respect to its effect on exterior from. The panniculus adiposus accentuates certain prominences which already exist on the flayed figure, and at times it creates its own prominences. There are certain regions of the body where, through its persistence and abundance even in thin subjects, it acquires a sort of autonomy. Without anticipating the detailed descriptions of the different regions of the body which I shall give later, I should like to point out here certain regions where the fatty tissue plays a special morphological role.

First, let us consider the region of the buttocks. The fat is mostly accumulated around the center and the inferior border of this region and accounts for most of the volume especially in women. The panniculus adiposus gives the buttocks the firmness and elasticity that can be seen in young subjects. Its exaggerated development constitutes the steatopygia of the female Bushmen, which can also be seen, if I may say so, in different degrees of attenuation among European females (Figure 4).

Equally related to steatopygia is the fatty accumulation at the superior and external part of the thigh (Figure 5). The body of the female Bushman shows this at its maximum development. There is almost always a trace of this among European women, to a very variable degree, it is true (Figures 6 and 7).

On the back part of the flanks, above the small of the back there is always a sort of fatty cushion which fills an area which on the flayed figure is a void left between the

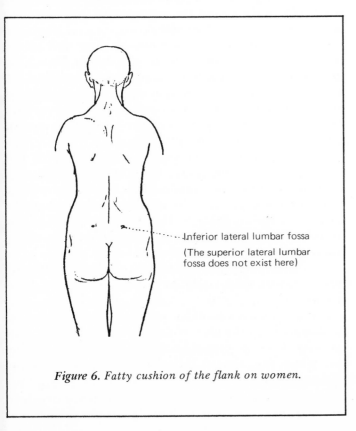

Figure 4. Steatopygia on the female bushman.

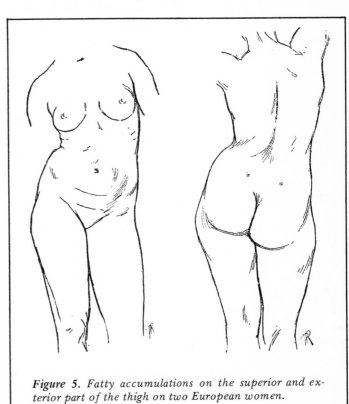

Figure 5. Fatty accumulations on the superior and exterior part of the thigh on two European women.

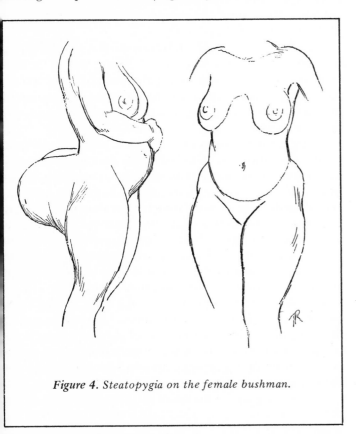

Inferior lateral lumbar fossa

(The superior lateral lumbar fossa does not exist here)

Figure 6. Fatty cushion of the flank on women.

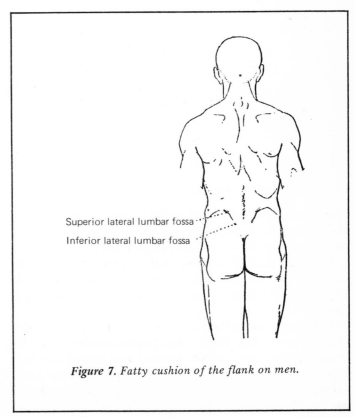

Superior lateral lumbar fossa

Inferior lateral lumbar fossa

Figure 7. Fatty cushion of the flank on men.

common mass of the spinal muscles and the posterior border of obliquus externus abdominis. This fatty cushion makes a most distinct swelling. As far as I know, its morphological role has not yet been pointed out. It has the effect of prolonging the surface of the flank in the back, and it creeps, diminishing, around to the side and front. The result of this is that the relief formed by the flank is muscular in front and fattish in the back. (This can be clearly seen in antique statues.) Among subjects who are just starting to put on weight, this cushion of fat all at once takes on a remarkable development. Among women it blends with the fatty tissue of the buttock behind the flank to such an extent that it seems to rise as far as the ribs which should limit the superior edge of the flank and mark the waist. The result of this disposition is that the furrow of the haunch, which can be seen so clearly in men, disappears almost completely in the back in women. However, this furrow remains visible in women along the whole anterior part, despite the enlargement of the iliac crest.

I should also mention the fatty tissue of the region of the chest. In women, besides the presence of the mammary glands, it is the fat which determines the volume and form of the breasts. Voluminous breasts are formed, above all, of fat; doctors know well that large breasts are but a poor indication of the quality of a wet nurse.

It is interesting to note that men only have rudimentary mammary glands but the fatty tissue still plays an important role in the morphology of the region. It augments the swelling of all the inferior part of the chest above the submammillary furrow. It is important to know that the relief in this region is due not only to the fleshy fibers of pectoralis major, but also to the fatty tissue. Even among the very lean, it plays a certain part. A considerable furrow can often be seen in subjects who are not at all muscular. This constitutes a favored place for the accumulation of fat on people who are just starting to put on weight.

Finally, let me bring to your attention the fatty tissue of the palm of the hand and especially that of the sole of the foot. On the sole of the foot there is a special disposition of cells in the elastic conjunctive tissue which confines the fatty tissue. This forms a sort of elastic cushion that adapts itself exactly to the surface of objects and withstands different pressures.

FATTY TISSUE OF INTERPOSITION

The fatty tissue of interposition is that tissue which is situated under the general enveloping aponeurosis. It is much less important than panniculus adiposus and, even in fat subjects, does not change their proportions. It fills the muscular interstices, accompanies the vessels, and fills the voids around the ligaments and the muscular insertions, etc.

From the point of view of exterior form, it has an effect in several regions. It fills the popliteal space and the armpit. Below the patella, it forms two lateral reliefs, a most important thing to know in understanding the morphology of the knee. Finally, on the face, it fills the void on the skeleton below the cheekbones.

SKIN

The skin, or external integument, is a solid, resistant, and elastic membranous envelope which stretches over the surface of the body. It is continuous and moves without interruption into the mucous membrane at the natural orifices.

The thickness of the skin varies, according to different regions. On most of the body, it is about 1 millimeter thick. It becomes about 3 millimeters thick on the palm of the hand, the sole of the foot, and toward the upper part of the back and the nape of the neck.

The skin is elastic and, in its normal state, it will spring back to the body if it is stretched. This is true of the skin even in cases of emaciation, if the emaciation is accompanied at the same time, as in old age, by a diminution of the skin's elasticity, the contraction of the skin will produce wrinkles.

Along most of its extent, the skin, together with the panniculus adiposus, is united to the parts it covers only by an extremely loose cellular tissue. Therefore, it can glide over the deeper parts of the body and undergo considerable displacement under the influence of outside action or simply because of the movement of various parts of the body. But the mobility of the skin is not the same in all regions. On the limbs, it is generally less mobile on the side of the flexion than on the side of extension; it is less mobile on the inside of the limbs than the outside.

The skin adheres completely to the body on the scalp, on the nape of the neck, on the palms of the hands, and on the soles of the feet. On the rest of the body there are a few places where the skin adheres more closely and causes certain wrinkles and depressions which are remarkable for their consistency.

In this category let me point out the depression of the skin on the anterior and the posterior median lines of the trunk; the depression around the dorsal spine of the seventh cervical vertebra; the depression at the level of the inferior tendon of the deltoid; etc.

The following wrinkles are among those due to the close adherence of the skin to the deeper parts. The flexion wrinkles at the wrist; the flexion wrinkles of the hand and the fingers; the fold of the groin; the wrinkle of the armpit; and the fold of the buttocks. I shall not go into details here as all these parts of the skin will be studied with the regions to which they belong.

Other wrinkles in regions where the skin does not adhere to the deeper parts are just as constant. For example, the extensor wrinkles of the fingers; the wrinkle of the bend of the arm; the wrinkle at the back of the knee; the flexion folds of the trunk; the semicircular wrinkle of the abdomen; and the flexion wrinkles of the anterior region of the neck (the necklace of Venus).

All the wrinkles just mentioned are due to articular deplacements; they could be called *wrinkles of locomotion.*

Other cutaneous wrinkles, especially on the face, are produced by muscular contraction. These are *skin wrinkles.* They are caused because the muscles of the face are, in fact, skin muscles. Attached to the skeleton by one of their extremities, they are inserted into the skin at their other extremity. When they draw the skin back, they create wrinkles on it perpendicular to the direction of

their fibers. By the changes they make on the character of the face, they contribute to the expression of different emotions.

Finally, we must mention the wrinkles of old age. They appear on all parts of the body. They result from the fact that the skin, having lost its elasticity, cannot contract itself enough to cover the tissues which have become atrophied by the progress of age. It doubles upon itself, therefore, and forms folds which are bordered by wrinkles of the most varied directions.

Besides the wrinkles which we have just studied, and which disappear when the skin is detached from its subjacent parts, there are others which are dependent upon the structure of the skin itself. First, there are the papillary wrinkles of the sole of the foot, and of the palm of the hand. Other parts of the skin, when viewed through a magnifying glass, show a multitude of small eminences separated by lozenge shaped wrinkles. These make the skin look like the rough grainy surface of an orange. There are also the little rounded swellings at the base of the hairs that become more prominent under the influence of strong emotion, and constitute the phenomena known as goose pimples.

It is this irregularity of the surface that gives the skin its matte quality. It is only when it is stretched that it becomes smooth and shiny.

The skin itself is composed of two superimposed layers. The epidermis, the most superficial layer, is very thin and does not have nerves or vessels. This layer adheres closely, and molds itself exactly, to the surface of the deeper dermis where there are small elevations caused by the nerves and the vessels. The sudoriferous and sebaceous glands open at the surface of the skin in microscopic orifices.

The color of the skin varies according to races, individuals, the different parts of the body and also with age. But on such a subject I have little to teach to artists.

Part Two
MORPHOLOGY

We have now reached a point of culmination in this work. All that preceded has been but a preparation for what is to follow. Now, we shall first explore each separate part of the body at rest in the attitude chosen for study. Then I shall point out the changes that occur in these forms during various specific movements. This study of exterior forms in action will be accompanied by information on the mechanism of the joints involved and of the musculature brought into play.

14. Exterior Forms of the Head and Neck

In this chapter I shall not go into the many different developments of the exterior forms on the head. I do not want to stray from the original plan of this book which was to discuss anatomy exclusively and its relation to the exterior form. For this reason I will not discuss the infinite morphological varieties that occur in individuals, as well as the differences which distinguish races. Nor shall I discuss the numerous expressions of the face, in movement or in repose. All these interesting issues deserve to be treated separately, and this is not the place. Moreover, the essential quality of the face is not, like the rest of the body, masked by the effects of certain climates or by social conventions. In fact, the overall problem of the face may be overcome in an instant by the penetrating observation of an artist. It is here, therefore, that personal observation must supercede scientific data, just as, in earlier civilizations, day by day observation of the nude athlete in a gymnasium supplied all the information needed for anatomical study.

At the superior and posterior part of the head, the oval shape of the cranium reveals its form under the hair, although the hair masks its details. On bald heads the marks of the diverse sutures which traverse the surface of the cranium may be observed (see Plate 2).

The whole anterior portion of the head makes up the face, which looks toward the front. Its summit, formed by the forehead, belongs to the cranium.

The head rests on the neck and projects beyond it, unequally, on all sides. The greatest projection is in front, so much so that, at the level of the chin, there is a small area below the head which is free (submaxillary region). This area is crescent shaped and its concavity embraces the superior part of the neck in its anterior half. Projecting from the median line, this region is hollowed out laterally into two depressions; these are extremely distinct in thin subjects (submaxillary depressions) (Gerdy). Although from the point of view of morphology I do not think this region should be separated from the head, anatomically it is part of the neck, and the reader will find the anatomical details concerning it in the chapter on the anatomy of the neck. It will be seen that the mylohyoideus muscle is inserted on the internal surface of the maxillary, well above its lower border. The submaxillary gland does not completely fill the space left void between the muscle and the bone and this results in the lateral depression I have just described.

In the description of the face, I shall study in succession the forehead, the eyes, the nose, the mouth, and the chin.

FOREHEAD

The forehead is delimited above by the hair, or by the line of its implantation when it has disappeared. On the sides, it is limited by the temples, and at its lower part, it is limited by the bridge of the nose and the eyebrows.

The form of the forehead is divided into two planes, joined at a more or less obtuse angle at the level of the frontal eminences. The forehead generally reproduces almost exactly the form of the frontal bone. However, if the lateral frontal eminences of the skeleton show clearly beneath the skin, the nasal eminence, in certain subjects, lies at the bottom of a depression caused by the lateral projection of the eyebrows. The skin of the forehead is furrowed by wrinkles which play a large part in the expression of emotions.

The superciliary arch should not be confused with the orbital arch. Although superimposed on the inside, they become separated on the outside in certain individuals. The reason for this is that the superciliary arch is directed obliquely upward and out, while the orbital arch, as we have seen in the skeleton, is directed outward and down.

EYE

The eyeball is lodged in the interior of the orbit and only its anterior segment, together with the muscular apparatus that moves it, shows on the exterior. It is framed by the eyelids and inserted into the quadrilateral bony frame which forms the circumference of the orbit. This part of the skeleton makes itself felt all around the eye and plays an essential role in the exterior form of the whole region. The superior border of the orbit is the most prominent; it belongs to the forehead and supports the eyebrow. The lower border, formed by the corresponding borders of the zygomatic and the maxillary bones, is depressed on the outside. The internal side blends with the lateral plane of the nose. The external border turns back to expose the eye which, less sheltered on this side, appears in full view on the profile.

It should be remembered in fact that on the skeleton the orbit does not open directly to the front, and that its base lies within a vertical plane which is inclined slightly downward and at the same time turns strongly to the outside. This last direction, to the outside, is followed to some extent by the transverse axis of the eye (meaning the straight line that passes through the two commissures of the eyelids). The internal angle of the eye, therefore, is very slightly in front of the external angle of the eye. The

transverse axis of the eye does not usually appear to be completely horizontal—it is usually raised a little on the outside. This disposition of the eyes, when exaggerated, constitutes one of the characteristics of the yellow races.

The eyeball, as I have said, only appears partially between the buttonhole created by the eyelids. When the eye shuts, the two free borders of the eyelids touch. The greatest part of the closing motion is performed by the superior lid which descends in front of the eyeball, molding itself over its form; the lower lid only rises very slightly. The surface of the upper lid is marked by two wrinkles which follow, more or less, the same curve as that of the free border. When the upper eyelid is lifted, it disappears under a fold of skin and leaves only a border of skin visible on the outside. This border varies in size according to the individual, and it is generally larger at the middle, above the pupils, than at the edges of the eyes at either side of the commissures. On the lower lid there are several light wrinkles which start at the internal angle of the eye and run obliquely below and to the outside.

The free borders of the eyelids are quite different from each other. The eyelashes on the upper border are longer than those on the lower border. Above, the down plane of the upper border disappears under the shadow of the lids; below, on the contrary, the upper plane of the lower border is inclined to the front and often the light falls on it in such a way that it seems like a luminous line between the eyeball and the dark line formed by its eyelashes. Finally, the border of the upper lid describes an arc which is much more extreme than that of the lower border.

Above the upper lid there is a depression which varies in depth, although it is always deeper on the inside than on the outside. This depression separates the eyelid from the prominence formed at the supraorbital margin. Below, the lower lid is separated from the inferior border of the orbit by the so called tear bag.

The two angles of the eye, whose direction and relative position we have described above, are also very different one from the other. The internal angle is marked by a sort of long indentation and at the interior of this there is a small pinkish mass, the *caruncula lacrimalis*. From this angle a small, elongated prominence departs and moves within and slightly upwards; it is the tendon of the orbicularis oculi muscle and it reflects light strongly. The external angle of the eye is marked by a wrinkle that travels down and to the outside; it appears to prolong the free border of the superior lid.

We still have to examine that part of the eyeball which is visible between the lids. At the center there is a segment of a sphere; it is transparent as glass, and its curve forms a prominence analogous to the crystal of a watch. This is the *cornea*. It is set within a white membrane which coats all the rest of the eyeball and is called the *sclera*. The projecting form of the cornea is clearly visible under the upper lid when the eyes are closed.

Only a small portion of the sclera can be seen because it is covered by a thin yellowish-white membrane called the *conjunctiva*. This membrane travels over the eye under the eyelids and reaches to the limits of the cornea. The white of the eye is more or less pure. Its whiteness depends on the conjunctiva which is sown with small blood vessels, more or less injected with blood. It is

bluish-white, as it is in children, when the sclera is thin and the conjunctiva is less vascular. This allows the black tint of the internal membrane of the eye to show through and contributes to the bluish color.

The cornea covers the colored iris and at the center of the iris there is a circular aperture called the pupil. The pupil appears to be dark because it opens into the eyeball, the interior of which is covered with a dark membrane, except among albinos.

NOSE

The nose, in its most superior part, directly continues down from the forehead. A hollow usually marks the root of the nose, although at times the transition on the profile is a straight line. The latter form was adopted by the sculptors of ancient Greece.

The base of the nose is free and turned downward; it is pierced by two openings separated by a medial partition which forms the nostrils. The openings swell on the sides and produce the *wings of the nose*; they also possess a anterior prominence (*lobes of the nose*).

The wings of the nose are circumscribed, above and in back, by a curvilinear wrinkle which separates them from the rest of the nose and the cheeks. The nostrils open below and also to the outside, which means that the medial partition descends lower than the inferior borders of the nostrils. This is why the opening of the nostril is apparent in profile.

The lobes are sometimes completely round, and sometimes they reveal the various planes which are created by the shapes of the cartilage with which they are partly constructed. It is not unusual therefore, on a lean subject, to see the end of the nose divided in two swellings, separated by a slight vertical groove. This groove is formed by the two cartilages which partly surround the openings of the nostrils on the insides. The line of the nose on the profile, which is usually either straight, convex, or concave, is at other times marked by a light break at the point where the nasal bones meet the cartilages.

MOUTH

The mouth is encircled by the two lips which lie on the convex projection of the dental arches. The meeting of the teeth above with those below maintains the height of the lips; thus, when a person loses his teeth, which often happens in old age, the height of the lips diminishes and at the same time they become gathered within the mouth.

The only teeth which actually meet together are the molars in the back. The teeth in front cross over each other like the two blades of a pair of scissors, the upper teeth descending in front of, and circumscribing, the lower teeth. When the mouth is closed, the upper and lower teeth contact each other in back, and cross each other in front. The interstice of the lips, when the lips are closed without effort, corresponds to about the middle part of the front upper teeth.

The red edges of the two lips have a sinuous form which is well known. They are composed of mucous membrane, and the place where they meet the skin is marked by a small lighter band which defines their shape. The commissures are protected on the outside by an oblique relief.

CHIN

The chin terminates the lower part of the face. Its protuberance varies considerably, depending on the individual. It is uniformly rounded on some, and marked by a median depression on others. The protuberance of the chin is due, on one hand, to the body of the inferior maxillary on which the chin rests, and on the other hand, to a dense accumulation of fatty tissue which doubles the thickness of the skin. This fatty tissue can, in certain individuals, considerably modify the forms of the skeleton and may well slightly change the proportions of the face, mostly from the point of view of height.

The chin is rounded below and it encroaches slightly upon the inferior surface of the jaw. It is separated from the submaxillary region by a transverse furrow of which the depth varies, but which is always visible. In fact, it is never effaced, regardless of the amount of the fat; it can even be seen on faces surcharged with fat. This line always neatly delineates the chin and it is absolutely distinct from the other transverse reliefs that develop at the expense of the inferior region of the face. These other reliefs are commonly known as the second or third chin.

On the sides of the head we will study the temples, the cheeks, and the ears.

TEMPLE

The temples prolong the forehead to the side. They correspond to the temporal fossae on the skeleton, but the excavated form of the bone can be seen only in exceptional cases and in subjects who are very thin. In fact, on the living, the temporal depression is filled by a powerful muscle which forms a considerable projection, especially when the lower jaw moves. In front, the temple blends into the forehead and the summit of the head. Sometimes there is a curved line separating these forms running from the superior insertions of the temporal muscle to the front of the external orbital process. At this place, and below, the limits of the temple are always quite distinct. In fact, the temple is separated from the eye by the relief of the external border of the orbit, the form of which, though depressed, can always be felt. At its lower part the temple is bordered by the transverse relief of the projection of the zygomatic arch which also serves as the superior limit of the cheek.

CHEEK

The cheek extends from the nose to the opening of the ear, and from the eyes and temples to the chin and the region beneath the chin; it blends completely into these different parts of the face. The cheekbone, or zygomatic bone, unites with the maxillary bone. On the line of their union the most prominent point of the cheek is situated, slightly below and sometimes a little to the outside of the orbit.

In front of this point the cheek rises obliquely underneath the eye to join the lateral surface of the nose. It is sometimes separated from the nose by a large shallow groove. In the back it becomes slightly depressed as it moves to the front of the ear and to the angle of the jaw where it meets the quadrilateral surface of the masseter muscle. The cheek is limited in front both by the lateral plane of the nose and the curvilinear line which separates it from the wing of the nostril and by another oblique line running downward and to the outside (*nasolabial fold*) which separates the cheek from the upper lip and the skin above. In back, the cheek touches the ear. Below, it runs into the submaxillary region and blends more or less with it, depending on the development of the subject's fat and the degree to which the inferior maxilla projects. Above, the cheek joins the temple from which it is separated by the transverse prominence of the zygomatic arch. This relief, very visible in thin subjects, merges into the cheekbone in front. In the back, the prominence of the zygomatic arch terminates at the base of the tragus of the ear. However, it is separated from the ear by a small hollow and by the slight prominence of the condyle of the inferior maxillary. When the mouth is open, this prominence moves to the front and below, leaving a marked cavity in its former place.

EAR

The funnel of the ear lies on the limits of the face, cranium, and neck. Altogether it is ovoid in form and its thickest extremity faces above, a little to the back and a little more to the outside. The funnel of the ear adheres to the surface of the head along about a third of its anterior part. The rest has an internal surface which generally lies about a centimeter and a half away from the cranium, although this distance is greater in certain individuals.

The ear resembles the flattened mouth of a trumpet of which the inner side is folded several times upon itself (Figure 8). It presents a number of individual forms. These forms vary according to the individual but in general they may be described as follows. At the center, there is a kind of anti-chamber for the external auditory passage which it introduces; this is the *concha*. At the periphery, a fold borders all the most superior and posterior part of the funnel; this is the *helix*. At its anterior extremity the helix rises from the bottom of the concha, above the external auditory passage. The posterior extremity of the helix terminates below in a fleshy ovoid mass (the *lobe*), of which the two surfaces are free. The lobe is attached to the cheek by the most elevated part of its anterior border.

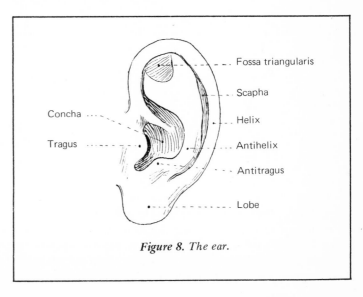

Figure 8. The ear.

The cavity of the concha is bordered in back by the *antihelix* which terminates above in two branches with a depression (*fossa triangularis*) between them. The helix and the antihelix are often separated by an elongated depression (the *scapha*). Finally, two projections, one below and one in front, restrict the entrance to the concha making it into a kind of opening which is extremely characteristic. In front there is the *tragus*, which shelters the entrance of the auditory passage, and in back and below, the *antitragus*, which prolongs the antihelix.

Beneath the ear, and behind the jaw, there is the *subauricular depression*, limited in the back by the mastoid process and by the anterior border of the sterno-cleidomastoideus muscle. The mastoid process is separated from the ear by a deep groove which limits the part of the ear which adheres there and leads it below to the subauricular fossa.

EXTERIOR FORM OF THE NECK

The neck is that part of the body which supports the head and unites it with the trunk.

Its limits are as follows. From the surface of the head, the neck starts, in the back, at the level of a curved horizontal line from one mastoid process to the other. This line follows the direction of the superior nuchal line of the occipital. In front, the neck is separated from the face by a line which, also running between the mastoid processes, descends below the lower jaw.

From the surface of the trunk, the limits of the neck which are extremely precise in front, are more indefinite in the back. In front, the neck ends naturally at the projections of the clavicles. On the sides, it stretches out to reach as far as the external extremities of the clavicles. In back, it is limited by a totally artificial line which runs from the points of the shoulders to the dorsal spine of the seventh cervical vertebra.

The cervical column, which forms the skeleton of the neck and maintains its proportions, is susceptible, depending on the individual, to only very slight changes in height. We have seen that the vertebral column as a whole is the part of the skeleton that presents the most fixed dimensions, and in fact any increase in height of the figure is due mostly to the development of the inferior members.

Therefore, the length of the neck, which seems so variable, depends almost always on its inferior limit, which is formed by the bony scapuloclavicular girdle. The long neck, in fact, is accompanied by low shoulders; the short neck, on the other hand, is formed by high shoulders. In the first case, the clavicle runs in an oblique line downward and to the outside; in the second case, it runs obliquely upward toward the outside.

I shall now describe successively the anterior region of the neck, or the throat; the anterolateral surface of the sternomastoid; the posterior region of the neck, or nape; and the supraclavicular hollow.

ANTERIOR REGION OF THE NECK AND THE THROAT (PLATE 74 AND 77)

On the front view, the anterior borders of the sterno-cleidomastoideus muscle (on the inside of which there is a slight linear depression) limit a triangular space of which the narrow point is at the sternum and the base at the mastoid processes. The superior part of this triangle is occupied by the inferior part of the face and the projection of the lower jaw. The angle of the jaw is a short distance in front of the anterior border of the sterno-cleidomastoideus. In its superior part this muscle is separated from the lower jaw by a depression situated below the ear, which we have discussed above (subauricular depression).

Below the chin, all the space included between the two sternocleidomastoideus muscles is filled by a rounded surface. This surface is separated from the submaxillary region above by a curved groove (hyoid depression), and ends below in an extremely narrow depression at the pit of the neck.

This surface is marked by the irregularities of the following forms. Above and on the median line, there is an angular projection formed by the thyroid cartilage of the larynx. Commonly called the *Adam's apple*, this projection varies considerably depending on the individual. The hyoid bone, situated above the larynx, at the level of the angle created by the meeting of the submaxillary region and the neck, cannot be seen except in extreme extension of the neck. However, there is a depression on each side of the hyoid bone at the center of which one can sense the projection of the greater cornu of the hyoid. Gerdy calls this the *hyoid fossa*. The depression is an equal distance from the body of the hyoid bone and the angle of the lower jaw. It becomes obvious in forced extension.

Below the Adam's apple the neck becomes rounder and owes its form not only to the thyroid gland, but also to the small flat muscles of the region.

Often, the thyroid gland, always more developed in women than in men, raises the interior extremity of sternocleidomastoideus and creates a marked enlargement at this point. Below the thyroid gland, the skin is depressed between the insertions of two inferior tendons of the sternocleidomastoideus into the manubrium and forms the hollow of the pit of the neck.

SURFACE OF THE STERNOCLEIDOMASTOIDEUS (PLATE 76 AND 79)

The sternocleidomastoideus is subcutaneous throughout its whole extent; the external surface betrays the same forms as the muscle itself (see page 57).

Above, this muscle is inserted into the mastoid process and the superior nuchal line of the occipital. From there it descends to the front, turning upon itself as it approaches the median line. It divides, at its inferior insertion, into two fasciae; the internal one rounded, and attached to the sternum; the exterior one flat, and attached to the clavicle. These two fasciae leave a triangular space between them which becomes a small depression (sternoclavicular fossa) on the outside.

The surface of sternomastoid is crossed obliquely by the anterior jugular vein.

POSTERIOR REGION OF THE NECK (PLATE 75 AND 76)

On the median line of the posterior surface of the body there is, at the junction of the neck and the cranium, a depression which corresponds to the external occipital protuberance on the skeleton. It is usually hidden by the

hair. A depressed line, caused by the meeting of two rounded planes, descends from this point toward a slightly depressed oval surface. In the middle of this oval depression there is a protuberance caused by the dorsal spine of the seventh cervical vertebra.

On the lateral sides of the neck there are two muscular reliefs which correspond to the superior part of the trapezius muscle. The trapezius is entirely subcutaneous, like the sternocleidomastoideus. It is a very flat muscle, moulding itself exactly on the deep parts. These deeper parts play a considerable role in the forms of the region. In other words, the two elongated longitudinal masses on each side of the neck are due to the deep muscles covered by splenius capitis and finally by the superior extremity of the trapezius. The form of the nape is created by the insertions of the deep muscles into the occipital bone. The depressed surface along the median line is due to the meeting of the rounded planes of these muscular masses and, above all, to the union of the two splenius muscles, the insertions of which meet each other on the median line. However, the oval depression, with the protuberance of the seventh cervical at its center, corresponds to the oval form of the aponeurosis of the trapezius.

Below and on the outside, the trapezius is raised, in the region above its clavicular insertion, both by the deeper muscles (*scalenus muscles*) and the *levator scapulae*. This produces that enlargement of the neck below and behind which on the front view can be seen outlined by two curved outlines descending from the middle of the neck towards the points of the shoulders. Also, I should point out that in this region there is a considerable, though varying, thickening of the trapezius, and in muscular subjects this causes certain accentuations of form (see page 56).

The thin anterior edge of the trapezius shows through the skin. Above, it allows the insertion of the muscle to be traced as far as the occipital, where it almost touches the posterior border of the sternocleidomastoideus. Towards the outside, this edge descends to the clavicle, to the point of the union of the external third of the clavicle with its internal two thirds.

POSTERIOR TRIANGLE OF THE NECK
(PLATE 77 and THE FOLLOWING)

Between the posterior border of the sternocleido-mastoideus and the internal border of the trapezius, there is an elongated space. The superior part of this space has a rounded surface; the inferior part, which is larger and descends to the clavicle, is depressed. The whole space is called the posterior triangle of the neck.

Above, the deep muscles of the neck completely fill the area between the sternocleidomastoideus and the trapezius. However, as these two muscles run toward their insertion at the clavicle, which moves away from the thoracic cage, they separate from the deeper muscles and occasionally alter the size of the depression itself. This depression is much more accentuated on the outside than on the inside, and more accentuated on the side of the trapezius than on the side of the sternocleidomastoideus.

The posterior triangle of the neck corresponds to the middle part of the clavicle which borders its lower portion. The hollow varies depending on the individual. It is pronounced in lean models, less so in fatter ones. The position of the shoulders also influences its degree of accentuation. It is deep when the shoulders are high and almost flat when they slope down. At its internal angle the anterior jugular vein rises and moves toward its insertion crossing the sternocleidomastoideus obliquely.

MOVEMENTS OF THE HEAD AND THE NECK

We have seen in the chapter on anatomy that the movements of the head on the vertebral column take place in the articulations of the first two cervical vertebrae (atlas and axis), and between them and the occipital bone (see Plate 24 and Plate 4). These movements are of three sorts. First, movements of rotation, which take place in the articulation of the atlas and axis; second, movements of flexion and extension; and third, movements of lateral inclination. The last two kinds of movement take place in the articulation between the atlas and the occipital.

We have seen, elsewhere, how the cervical column is the most movable part of the whole backbone, and how it is able to execute movements of three types: rotation, flexion and extension, and lateral inclination. I should point out that these movements are the same as those of the head.

I have already explained the mechanism of the diverse articulations described above. The movements of the head are rarely isolated from those of the neck; they work together as accomplices, almost always acting in the same way. Therefore, in the study which follows, we shall not separate the movements of the head and the neck.

ARTICULAR MECHANISM

In its movements around the transverse axis (flexion and extension), the head, on the condyles of the occipital bone, rolls upon the superior articular surfaces of the lateral masses of the atlas. From the side view, in flexion, the inferior maxillary bone can be seen meeting the anterior convexity of the cervical column; in extension, the occipital bone is lowered in the back. This movement is more extended.

When the cervical column enters into the same movements of flexion and extension these movements become considerably amplified. The head not only rolls upon itself but undergoes, at the same time, a movement of translation in the anteroposterior plane. In flexion, the chin approaches the sternum which it touches in front, and, in extension, the back of the head comes within a few centimeters of the dorsal spine of the seventh cervical vertebra.

In flexion, the cervical column, which is convex in front, straightens out and may even curve in the opposite direction. This takes place in such a manner that the cervical column continues the curve of the dorsal region, the two regions thus forming a single curve inclined toward the same direction. In extension, on the contrary, the normal curve of the cervical column is accentuated. In the movement of rotation the head and neck are entirely interdependent. The rotation of one cannot take place without the rotation of the other, however little the movement may be. At the limit of rotation, from a front view of the trunk, one may see the profile of the face.

Lateral inclination is hardly ever an isolated movement. When it is performed for purposes of study, the movement is restricted and looks forced. Usually, lateral inclination is accompanied by a movement of rotation which lifts the face upward and turns it toward the opposite side.

We have seen the anatomical reasons for this in the special disposition of the articular surfaces of the region (see page 28).

MUSCULAR ACTION

The movements of the head on the spine are reinforced, in every sense, by the small deep muscles which surround the articular surfaces of the occipital, the atlas, and the axis. However, they do not act alone, and other more powerful muscles whose more superficial disposition influences the exterior form, are also brought into play.

If we now consider the muscles whose contraction influences the exterior form, we have *for flexion*: the suprahyoid and the infrahyoid muscles, the scalenus muscles, and the sternocleidomastoideus; *for extension*: the large muscles of the neck, the trapezius, the splenius, the semispinalis capitis and the levator scapulae; *for lateral inclination*: the trapezius, the splenius capitis, the semispinalis capitis, and the sternocleidomastoideus; *for rotation*: the splenius capitis, the sternocleidomastoideus, the trapezius, and the semispinalis capitis.

However, one need not conclude from the above list that, in any given movement, all the muscles enumerated necessarily enter forcefully into the action, or reveal themselves on the exterior form.

First of all, slight movements can be performed exclusively by the action of the small deep muscles. The effect of gravity should also be considered since it plays a most important part in muscular interaction. Thus, for example, when the head is thrown forward, the displaced center of gravity tends to push it in that direction. This movement, which amounts to the movement of flexion, is thus produced by the influence of gravity alone. To prevent the complete descent of the head in front, the contraction of the extensor muscles becomes absolutely necessary. This results in a seeming paradox: the contraction of the extensors in a movement of flexion.

In fact, a general law might be formulated as follows. When the displacement of a part of the body is produced by the influence of its own weight, the muscles that ordinarily produce this displacement become unnecessary; it is their antagonists which contract to counterbalance and regulate the action of gravity.

MODIFICATIONS OF EXTERIOR FORMS: MOVEMENTS OF THE NECK (PLATE 87, FIGURE 2)

In the bending back of the neck into a forced position, the external occipital protuberance approaches within several centimeters of the seventh cervical vertebra and thus reduces the back of the neck to its shortest length.

At the same time, the anterior regions are extended and acquire their greatest dimensions in a vertical sense. The inframaxillary region tends to become a prolongation of the region beneath the hyoid, but the reentering angle which lies between these two areas is never completely erased. However, the hyoid depression becomes wider.

In this movement the mouth tends to open and at the same time the neck undergoes a lateral enlargement due to the displacement of the sternocleidomastoideus muscle.

The exterior forms become modified as follows. On the median line, the hyoid bone shows prominently at the bottom of the widened hyoid depression. On the sides, the hyoid fossae become hollowed out.

The angular form of the larynx projects under the skin and can be clearly seen. The superior border of the thyroid cartilage, with its anterior V-like angle, is also visible. Below the larynx the rounded form of the thyroid gland projects. The double prominence of the larynx and the thyroid gland shows great variety in form in different individuals.

The anterior border of the sternocleidomastoideus becomes clearly defined. The same is true of the sternal and clavicular attachments of the muscle and this augments the hollow of the pit of the neck.

The two spiral forms of sternocleidomastoideus muscle glide over the sides of the column of the neck while their posterior borders are lifted to the outside of the spinal attachments of the deep muscles. This causes the lateral enlargement of the neck which we have mentioned. The sternocleidomastoideus muscles, held within an aponeurotic covering which is attached by special fibers to the angle of the jaw, closely follow the curve of the neck. The posterior triangle is traversed obliquely by the cord of the omohyoideus.

During extension several strong cutaneous wrinkles, running transversely, appear at the nape of the neck.

Flexion (Plate 87, Figure 1). In flexion of the neck, the chin approaches the sternum and actually touches it in some individuals. The anterior regions of the neck disappear under transverse cutaneous wrinkles which are smaller and more numerous than those on the nape in extension. This is because of the difference in the thickness of the skin in the two regions.

The sternocleidomastoideus, pushed back by the angle of the jaw, forms a swelling in that area while the inferior extremities of the muscle disappear. The nape becomes rounded and elongated. The prominence of the dorsal spine of the seventh cervical vertebra is accentuated and surmounts the reliefs of the spinal processes of the first and second thoracic vertebrae.

On the sides, the distended anterior border of the trapezius can be seen, and the forms of the deep muscles become enlarged. The posterior triangle diminishes in height.

Rotation (Plate 88, Figure 1). If we examine the side of the neck which is most exposed, that is to say the part which is on the opposite side to that of the face, we will see that the oblique direction of the sternocleidomastoideus has become vertical. Its relief indicates the part which it plays in this movement. However, the relief is not due to an equal contraction in all the parts of the muscle. The relief created by the fleshy body is fusiform, and this shape is brought about mainly by the tendon of the muscle which projects strongly at the sternum, while the clavicular insertion almost disappears.

In front of the sternocleidomastoideus, the hyoid depression becomes hollowed out and it moves nearer to the angle of the jaw.

The posterior triangle tends to disappear. However, on the opposing side, that is to say the side towards which the face is turning, it becomes deeper. On this same side, the relaxed sternocleidomastoideus disappears under the wrinkles of the integument.

Lateral inclination (Plate 88, Figure 2). In this movement the ear is brought closer to the shoulder, without ever actually making contact with it (unless the shoulder is raised). In fact, the ear can be moved only within about four or five fingers' breadth of the shoulder.

On the side of the inclination, numerous cutaneous wrinkles are formed. On the other side, the integument is stretched. I should like to point out an extremely accentuated relief which has a cord-like form. It crosses the upper part of the posterior triangle, and it is due to the tension of the levator scapulae muscle. This cord becomes more and more apparent as the shoulder is lowered.

15. Exterior Forms of the Trunk

To make the description of the exterior forms of the trunk clear, I will divide each of these forms into several regions. On the whole, we shall follow the scheme adopted by Gerdy, with certain modifications for the sake of simplicity (Figure 9).

First, the trunk, or torso, may be divided into three large, natural segments determined by the skeleton: the thorax, which corresponds to the thoracic cage; the abdomen, which occupies all the space between the thoracic cage and the pelvis; and finally, the pelvis. Each of these segments is subdivided in the following way. The thoracic segment comprises: in front, the chest, which itself includes the sternal region, the mammary region, and the inframammary region; in back, the back, which subdivides itself into the spinal region, the scapular region, and the infrascapular region (Figure 10). The abdominal segment includes: in front, the belly; on the sides, the flanks; and in back, the loins. Finally, the pelvic segment includes: in front, the pubic region, the groin or the inguinal surface; in back, the buttocks.

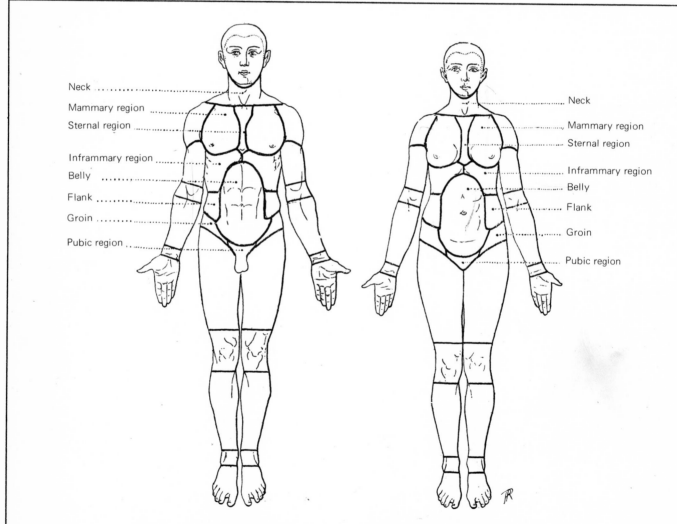

Neck
Mammary region
Sternal region
Inframmary region
Belly
Flank
Groin
Pubic region

Neck
Mammary region
Sternal region
Inframmary region
Belly
Flank
Groin
Pubic region

Figure 9. Comparative topographical morphology of man and woman
The designation of the different segments of the members is the same as in Plates 74, 75 and 76

The chest occupies the whole anterior part of the thorax. It can be subdivided into several natural regions. These regions are: in the middle, the sternal; and on the sides, the mammary region and the inframammary region.

STERNAL REGION (PLATE 77)

Situated on the median line, the sternal region rests on the sternum bone. It stretches from the pit of the neck to the epigastric depression. It is bordered on the sides by the muscular relief of pectoralis major which makes the region into a sort of furrow. The depth of this furrow varies according to the development of the pectoralis major. It is more depressed along its inferior half as pectoralis major contains more fat in its lower part.

The sternal region has two distinct planes: a superior one, shorter and wider than the inferior, which corresponds to the manubrium; and a narrower inferior one which is composed of the body of the sternum or gladiolus. At their articulation these two pieces are marked by a transverse meeting of planes which is called the sternal angle.

At its inferior part the sternal furrow becomes enlarged and forms a triangular plane which is caused by the increasing distance between the muscular fibers at this level. This disposition of the fibers can be understood easily if one remembers that the insertion of pectoralis major on the sides of the sternum follows a curved, not a straight, line and that the convex curve of this line is towards the median line of the body.

Finally, because the xiphoid process is so deeply situated it causes a depression, called the epigastric depression.

This depression is bordered, above, by an arch-like ligament which unites the cartilages of the last ribs in front of the xiphoid process. On the sides of the depression, the costal cartilages themselves project. Below, the borders of the depression are more indefinite. They are formed by the spreading fibers of the superior extremity of the rectus abdominis muscle. The epigastric depression is maintained by the disposition of the muscular fibers which border it; therefore, its form varies with the variations in the volume of the muscles.

The inferior extremity of the xiphoid process curves to the front and, at times, causes a small eminence at the inferior part of the epigastric depression which can be clearly seen under the skin.

Nape
Spinal region
Scapular region
Infrascapular region
Flank
Loins
Buttocks

Nape
Spinal region
Scapular region
Infrascapular region
Flank
Loins
Buttocks

Figure 10. Comparative topographical morphology of man and woman
The designation of the different segments of the members is the same as that in Plates 74, 75, and 76

The mammary region is bordered on the inside by the sternal region which we have just studied. Its upper border is formed by the clavicle, and the region extends from there to a deep groove which forms its inferior border. On the outside, it touches the shoulder. This region corresponds exactly to the pectoralis major, although the fascia of this muscle extends somewhat below it.

Its outline is thus more or less the same as that of pectoralis major, and it necessarily varies according to the degree of muscular emaciation or development.

Above and to the inside, the clavicle makes a strong projection on the surface of the region. This projection is caused by the thinness of the muscle at this point and by the strong forward curve of the bone to which the muscle is inserted, along the whole internal part of its anterior border. A triangular depression, the *infraclavicular fossa*, separates the insertions of pectoralis major and those of deltoideus. This depression is caused by the separation of these two muscles which were previously coupled together. They separate just before they reach upwards to the clavicle but the juxtaposition of these two muscles is in no sense a fusion. A slight groove (*deltoideopectoral line*) departs from the infraclavicular fossa and descends, towards the outside, as far as the inferior angle of the deltoideus. It fixes a line of demarcation between the two muscles, and at the same time establishes the limits of the pectoral region and the limits of the region of the shoulder. The cephalic vein, which comes from the arm, runs within this groove.

On all the other sides, the mammary region projects onto the areas next to it. Within, it swells slightly onto the sternal region; below, it swells strongly as it approaches the arm at the place where pectoralis major, leaving the thoracic cage to reach its insertion at the humerus, creates the anterior border of the armpit.

The anterior border of the armpit, which is very thick because of the disposition of the muscle fibers, which we have described (see page 58), does not run directly towards the outside. Even when the arm is lowered, it runs clearly upwards and disappears between the relief of the biceps brachii and the deltoideus. It forms an acute angle with the inferior extremity of the deltoideopectoral line. The inclination of the anterior border of the armpit is caused by the direction of the inferior fibers of pectoralis major. These fibers originate at the cartilages of the false ribs and the abdominal aponeurosis, and they are forced to rise upwards to reach their insertion at the humerus which lies on a much higher plane. The anterior border of the armpit also forms an angle with the inframammary furrow which borders the region below. But this angle is obtuse and rounded. At this level we find the nipple, which is always situated on the inside of a vertical line dropped from the infraclavicular fossa.

The inframammary furrow is not horizontal. It is oblique from below to above and from the outside to the inside. It usually follows a very slight curvilinear direction, but sometimes it is almost straight. It is large, shallow, and not very accentuated on the inside. It becomes much more definite as it approaches the armpit where it disappears. It is usually exaggerated on antique statues. Its situation corresponds to the cartilage of the fifth rib, across which it cuts in a very oblique direction. The crease is caused by the relief of the fleshy fibers upon the fibers of the aponeurosis of insertion, which themselves descend as far as the cartilage of the sixth or seventh rib. On the outside, the fleshy fibers of pectoralis major descend much lower to insert into the abdominal aponeurosis. The obliquus externus mounts as high as these fibers, which mask its superior digitation.

When pectoralis major is inactive, and the arms are falling naturally beside the body, its mass, provided that the muscle is somewhat developed, is drawn down below and to the outside by the action of gravity. This augments the anterior relief of the region and deepens the furrow which borders it.

The internal border of the pectoral region is marked by the projection of the fleshy fibers of pectoralis major which originate from the side of the sternum. These projections are usually slight and more marked below than above. They are irregularly disposed in groups along a curved line and the fibers of the muscle are gathered into several bundles which form about three or four digitations, all of which are reasonably distinct. On lean subjects the prominences caused by the chondrosternal and chondrocostal articulations can be seen near this internal border.

The arched surface of the whole region often presents linear depressions, which follow the direction of the muscular fibers of pectoralis major and separate its various muscular bundles. One of these lines is constant, the one which leaves the internal extremity of the clavicle and loses itself towards the external angle of the muscle. It separates the muscular bundle called the clavicular portion from the rest of the fleshy body of the muscle. These lines can be distinguished only on subjects with well developed muscles and a fine skin which is only slightly encumbered with fat. On the same type of subject, towards the external angle of the region one finds, at a slight distance from the deltoideopectoral line, a depression which is enlarged when the arm is extended to the outside and which corresponds to the crossing of the superior fibrous bundle over the inferior bundles.

Among subjects with slight muscular development, one can easily see, across pectoralis major, the prominences formed by the costal arches. These prominences are separated by depressions which correspond to the intercostal spaces. Finally, the forms on a subject who is not really fat but whose muscles are well developed are full and smooth due to a dense and firm fatty panniculus. Under these circumstances the pectoral surface takes on the simple and uniform quality which it has in antique statues. It is easy to demonstrate, therefore, that the fatty panniculus is not distributed in a layer of equal thickness throughout the region. It becomes thicker as it descends and its greatest thickness is at the level of the nipples and throughout the whole inferior part. Thus, the swelling of the mammary region is partly due to muscular development, and partly due to the accumulation of a certain amount of fat. The differences in thickness of the fatty panniculus are found even in thin subjects.

In women, the presence of the mammary gland gives the region its particular characteristics. I shall not discuss

in detail a form as variable as the female breast. Its relief is due both to the mammary gland, and to a considerable amount of fatty tissue. However, the exact position of the breast should be determined. It occupies the inferior and external part of the pectoral region, leaving the superior part free. The breast faces towards the front and slightly to the outside; the nipple lies on the most salient part, at the point where the upper and lower surfaces meet each other. The inferior border of the breast projects beyond the limits of pectoralis major and encroaches upon the inframammary region, which is narrow in women. In youth, when the breast is not very developed, its demi-globe seems clearly differentiated from the plane on which it rests. The anterior border of the armpit shows above it on the outside, and on the inside a space of several fingers' breadth separates the two breasts. However, when the breast is larger, because of the fat accumulated there, its limits are much less clear. Above, it blends with the pectoral region, which is also enlarged by fat. As it falls lower down under the influence of gravity, the crease which marks its lower border becomes much deeper. Finally, the two breasts almost join at the middle line.

INFRAMAMMARY REGION (PLATE 77 and PLATE 79)

The inframammary region is limited as follows: above, by the mammary region; on the outside and in back, by the somewhat vertical line of the anterior border of latissimus dorsi; below and on the side, by the superior line of the flank; below and in front, by the line which follows the border of the cartilages of the false ribs and by the line due to the first aponeurotic intersection of the rectus abdominis; and finally, within, by the epigastric depression and the median line which separates the two sides of the rectus abdominis.

This region, which seems to be circumscribed on the outside in such a manner, does not possess a single muscle which might be called its own. In fact, the region is composed of portions of three separate muscles: the anterior and inferior part of the serratus anterior, the superior half, more or less, of the obliquus externus, and the superior extremity of the rectus abdominis.

As a whole the region is convex because it is formed by muscular bundles which lie directly upon the ribs which form its skeleton. However, these bundles give it an undulating quality and a great number of small and differing planes. First of all, there is the series of digitations of the serratus anterior, created by the insertions of this muscle on the lower ribs. These digitations show on the exterior surface as a series of angular projections pointing towards the front, and they end along a curved line, convex below and to the front. Resting on the costal swelling and enlarging it, the muscle takes its origin on the external surface of the ribs. The visible digitations are four in number, and they differ in size. The first appears at the level of the inferior border of pectoralis major; the last seems to lose itself under the projection of latissimus dorsi. The digitations of the obliquus externus interlock with those of the serratus anterior, but these digitations are less prominent because they are formed of thinner muscular bundles. They are attached to the inferior borders of the ribs, resting on the depressed surface of the intercostal spaces.

The first visible digitation of the obliquus externus originates below the first visible digitation of the anterior serratus. Above this there is a muscular prominence which touches the inferior line of the mammary region, and which seems to be a new digitation of the obliquus externus. It is not. The prominence is created by the fasciculus of the pectoralis major which leaves the pectoral region to reach its insertion in the abdominal aponeurosis.

The obliquus externus arises from different muscular bundles and it follows the form of the part of the thoracic cage which it covers, until it detaches itself and descends to the flank. Because the muscle molds itself upon the thoracic cage, various forms arise. These vary, depending upon the thickness or thinness of the muscle. They also depend on the projections of the ribs, separated by the intercostal depressions, and on the series of tuberosities on the ends, formed by the chondrocostal articulations which are often confused with the muscular digitations. Finally, the forms are influenced by the unevenness of the cartilages of the false ribs along the costal border.

Among the forms of this region there are, therefore, three kinds of reliefs: the muscular reliefs, the digitations of the obliquus externus, the bony reliefs due to the ribs themselves or to their chondrocostal articulations, and the reliefs of the costal cartilages.

Of all these prominences, the most important is the one that forms the lower end of the costal border. Gerdy calls it the costoabdominal protuberance. It is due to the relief formed by the cartilage of the tenth rib. Usually, it can be easily seen. The lateral line of the belly begins beneath it.

The most internal part of the region has more uniformity. Moreover, it is much narrower and it is on a level with the first division of the rectus abdominis. The muscle is usually thick enough at this level to mask the relief of the cartilaginous border, and it fills the void which exists to the inside on the skeleton. Sometimes certain muscular bundles can be seen at the point of their superior insertions into the costal cartilages. The furrow which forms the lower edge of the costal border does not rise towards the epigastric depression (as it does in very lean subjects) but diverges at the external border of the rectus abdominis and continues transversely with the depression formed by the first aponeurotic intersection of the muscle. It thus cuts off the top of the anterior cartilaginous arch of the chest; this arch is always more or less angular in the skeleton.

BACK

The back consists of the whole posterior part of the thorax. Above, on the median line the limit of the back is formed by the prominence of the seventh cervical and the line which runs from this point to the external extremity of the clavicles (these are the inferior limits of the neck). Below, the back is limited by the two oblique lines which depart from the median line, run below and to the outside as far as the back of the flanks, and form the upper limits of the loins. Finally, on the outside, the oblique vertical line formed by the anterior border of latissimus dorsi separates the region of the back from the inframammary region.

The back may be subdivided into three regions. Within and near the vertebral column there is the spinal region; on the outside there is the scapular region and the infrascapular region.

SPINAL REGION (PLATE 78)

The back is traversed from top to bottom by a median vertical furrow which extends to the loins and disappears in the sacral region. The depth of this furrow, which corresponds to the projection of the spinal crest on the skeleton, depends on the development of the muscles which border it. It is the only place where the vertebral column is subcutaneous. By no means uniform, the regions of the vertebral column vary notably.

In the region of the back, the column follows the projections of the spinous processes of the first and second thoracic vertebrae which can be seen after that of the seventh cervical. The furrow, which is broad at the top, gets narrower and deeper as it descends. It also becomes more uniform and the dorsal spinal processes do not project except in very thin subjects and in flexion movements of the trunk. Of course, there are exceptions. At the lowest part of the back in some subjects the prominences of two or three spinous processes can be seen. This seems to be due to a special conformation of the spinal column, and an accentuation, in the dorsal region, of the normal curve.

At the loins, the median furrow offers interesting details which we will discuss later.

The spinal region, which occupies the entire extent of the part of the back closest to the vertebral column, is limited on the outside by the interior border of the scapula which separates the superior half of this region from the scapular region. Below, the lateral line of the back, which delimits the infrascapular region, forms the external border. The lateral line of the back corresponds to the angle of the ribs and it is not particularly accentuated in the upright position.

Superficially one sees only two muscles: the inferior extremity of the trapezius and the most internal part of latissimus dorsi. These two muscles are flat and not very thick and thus the general form of the region is due to the deeper muscles—the rhomboids above and the mass of the spinal muscles below.

The surface of the trapezius occupies the whole superior part of the region. One can easily see, even on lean subjects, the triangular form of the inferior extremity of the muscle. This muscle arises as far down as the last thoracic vertebra. However, the external relief of the muscle does not go as far as this. Its fleshy fibers stop at some distance from the inferior extremity in a small aponeurotic triangle, so thin that it is not visible under the skin. The result of this is that, on the nude, the inferior termination of the trapezius appears to be at the end of its fleshy fibers and looks like two points, just a little to each side of the median line.

There is another aponeurotic part of the muscle which greatly influences the exterior form. All the fleshy fibers of the inferior extremity of the trapezius (some of which cover the internal border of the scapula) insert into a small triangular aponeurosis and attach themselves to the inter-

nal extremity of the spine of the scapula. This aponeurosis is the cause, at this point, of a cutaneous depression which has a constant relationship with the skeleton on which it rests. I shall designate it, after Gerdy, the *scapular depression.*

Finally, let me refer again to the superior median limit of this region where there is an oval aponeurotic depression. In the center of this depression the dorsal spine of the seventh cervical vertebra projects.

The whole inferior extremity of the trapezius forms a clear triangle on the flayed figure. But the form of this triangle is raised by the powerful rhomboid muscles beneath. In fact, these are the muscles which create the ovoid relief which can be seen clearly on muscular subjects inside of the internal border of the scapula in the conventional attitude we are studying.

When persons of ordinary musculature stand with their shoulders in a normal position with their arms falling naturally beside the body, the lower part of the relief of the rhomboids is limited by an oblique linear depression. This depression ascends from the inferior angle of the scapula towards the vertebral column and corresponds to the inferior border of the lower rhomboid. I should also point out here a depression to the inside of the inferior angle of the scapula. It corresponds, on the flayed figure, to the only point where the posterior part of the thoracic cage is completely uncovered. This restricted space is triangular in form—it is limited by the latissimus dorsi below, the trapezius within, and the lower rhomboid without. Its size varies with the movements of the scapula and it disappears completely when the shoulder is pushed back. It is, however, accentuated by an opposite movement because its exterior limit, which is formed by the relief of the inferior extremity of the lower rhomboid muscle, becomes displaced.

The inferior part of the spinal region is occupied entirely by the relief of the fleshy bodies of the spinal muscles. They are very prominent here, although they are covered by the latissimus dorsi, and by the inferior extremity of the trapezius which lies on top of the most internal part of the latissimus dorsi. The external limit of the prominence due to the spinal muscles is usually not very distinct in the conventional attitude but it becomes clearer when the arms are raised vertically. During this action the slight linear depression, called the lateral line of the back, becomes most distinct. This depression corresponds, on the skeleton, to the internal angle of the ribs. On certain subjects, with well developed muscles, the external limits of the spinal region are different. They are pushed more towards the outside by the digitation of the serratus posterior muscle which inserts well to the outside of the angle of the ribs.

SCAPULAR REGION (PLATE 78)

The limits of the scapular region are: on the inside, the spinal region; above, the inferior limit of the neck; and below, the superior border of the latissimus dorsi (which also serves as the upper limit of the infrascapular region).

This region offers the following details. The projecting surface of the deltoideus divided by a strong aponeurosis that draws it in around the middle part; the surface of the infraspinatus, which does not project very much because

it is bound by a strong aponeurotic sheath; and the rounded surface of the teres major (projecting in a ball-like manner when the model is in the conventional attitude), of which the lower part is bound by latissimus dorsi.

The spine of the scapula, which projects in thin individuals, becomes a groove in muscular ones. This is due to the volume of the muscles which insert there. The superior muscle, the trapezius, projects the most.

The internal border of the scapula, covered by the rising fibers of the trapezius, forms a prominent blunt edge on thin subjects. In muscular individuals when the muscles attached to the edge are contracted, the internal border becomes a furrow.

When the arms fall naturally alongside the body, the inferior angle of the scapula forms a prominence blunted by the latissimus dorsi which passes over it.

The posterior border of the armpit, which does not really show in the conventional attitude, is formed by teres major and latissimus dorsi. The latter twists around the former in order to reach its insertion in the humerus.

INFRASCAPULAR REGION (PLATE 78)

The infrascapular region is limited by the following: above, by the scapular region; on the inside, by the lateral line of the back (which separates it from the spinal region); on the outside, by the projection of the anterior border of the latissimus dorsi; and below, by the superior line of the flank.

A single superficial muscle fills the whole region—the latissimus dorsi. This flat muscle follows the forms of the parts which it covers allowing them to appear on the surface. Above and to the outside, the serratus anterior lifts it and causes a large oblique furrow which runs from the inferior angle of the scapula, down and to the outside, towards the flank. This furrow is sometimes interrupted about halfway down. The lower half lies on a slightly lower plane because the last bundles of the serratus anterior are disposed in a different direction.

Between this furrow and the lateral line of the back, which is the internal limit of the infrascapular region, there is a small triangular space. Its summit is near the angle of the scapula and its base is turned down and to the outside. In this space the thoracic cage is covered only by the latissimus dorsi. The dimensions of this triangle vary in different individuals, and it usually quite small in the conventional attitude. However, it is worth pointing out because the triangle becomes much more developed when the arm is lifted and the serratus anterior is displaced. It allows that portion of the thoracic cage to which it corresponds to show under the latissimus dorsi.

On very thin subjects, the prominent form of the ribs and the depressed intercostal spaces are visible throughout the whole of the infrascapular region because of the thinness of the muscles.

ABDOMEN

The abdomen is that part of the trunk between the chest and the pelvis. It can be divided into three regions: in front, the *belly*; in back, the *loins*; and on the sides, the *flanks*.

BELLY (PLATE 77)

The belly is circumscribed by the following landmarks: above, by the anterior furrow of the chest; below, by the anterior line of the pelvis; and on the sides, by the vertical lines (lateral furrows of the belly) which separate it from the flanks.

It is traversed, on the median line, from top to bottom, by a groove of varying depth which disappears a few fingers' breadth below the navel. This groove is created by the relief of the rectus abdominis on either side. It disappears at the inferior part because the fleshy parts of the two sides of the muscle come together at this point.

The navel can be located at an equal distance between the xiphoid process and the pubis.

On each side of the median line one finds the surfaces of the rectus abdominis and its aponeurotic intersections may be easily seen on muscular subjects. The number of intersections varies in different subjects, although there are usually three. In classical times these intersections were given a regular form and the surface of the muscle was divided into quadrilateral planes.

The lowest intersection is at the level of the navel; the highest is just below the epigastric depression; and the middle intersection is at an equal distance between the two others. The highest intersection, the most important from the point of view of exterior form, reaches the level of the anterior furrow of the chest. The superior part of the rectus abdominis muscle thus fills the summit of the angle formed by the cartilaginous border of the ribs. The result is that on the model the anterior opening of the thoracic cage appears as a rounded arch, while on the skeleton it is clearly angular. However, the shape of the anterior opening varies, and on very thin individuals, the skeletal forms predominate.

Below, the line which limits the belly is curved, in an inverse direction to that of the anterior furrow of the chest. It extends laterally to the anterior border of the iliac bones and forms the superior line of the groin. In the middle, the line limits the upper part of the pubis. Its form is regularly rounded on subjects whose abdomens are very fat. However, on thinner subjects and adolescents, its form is angular with a truncated summit; it straightens out on each side and the line across the top of the pubic area becomes equally straight.

The lateral line, which separates the belly from the flanks, starts at the costoabdominal prominence of the cartilage of the tenth rib. As it descends towards the groin it becomes a furrow bordered laterally by the projecting form of the rectus abdominis on the inside, and by the fleshy fibers of obliquus externus on the outside. Below this line, it becomes larger and ends above the groin in a plane that follows the curve and separation of the two neighboring muscles. The rectus abdominis bends downward to the inside, while the line of insertion of the fleshy fibers of the obliquus abdominis bends upward to the outside towards the anterior superior iliac spine.

The volume and projection of the belly varies with the fatness of the subject. Even in thin subjects the maximum projection may be found above the navel. We have already pointed out that the fatty pannicule is usually thicker above the navel than below it.

A little above the navel, there is a transverse cutaneous

wrinkle caused by the forward flexion of the trunk.

The infraumbilical region is marked by a semicircular cutaneous line of which the concavity faces above. It is situated several fingers' breadth above the pubic region. The line is not necessarily due to the amount of fat in this region, as it is found on thin subjects.

LOINS (PLATE 78)

The region of the loins has the quality of a lozenge. The superior inverse V is formed by the union of the two superior lumbar lines which also form the lower border of the spinal region. The branches of the inferior V follow the exterior border of the sacrum and the posterior part of the bony projections of the iliac crest. These borders become transformed into linear depressions by the relief of the gluteal muscles which are attached to them. The inferior angle corresponds to the superior space between the buttocks, and the broader lateral angles approach the flanks.

The appearance of the region of the loins is extremely variable and its superior limits, often indefinite, differ a great deal from individual to individual.

The superior lumbar grooves, attributed by Gerdy to the relief formed by the fleshy fibers of the latissimus dorsi at its aponeurotic origin, are rarely accentuated. When they are evident, they run from the inferior angle of the trapezius, below and to the outside, towards the region of the flanks (Figure 11). In many subjects, they are not readily distinguishable. In some subjects, because their skin is slightly thicker, it is impossible to see them.

The spinal muscles give rise to another oblique line which goes in the same direction, but lower down. It is so often present that, in my opinion, it should fix the upper limit of the loins. This line is caused by the relief of the fleshy fibers of iliocostalis lumborum and longissimus dorsi upon their aponeurosis of insertion (see Plate 40). The situation of this line varies, depending on the length of these fibers. It is often the same as the line caused by the fleshy fibers of latissimus dorsi. The varying appearance of the upper limits of the lumbar region depends on whether the latissimus dorsi or the spinal muscles are of the short or long type. The different types of the two muscles create different lines and they may be near or far apart or they may fuse through superimposition.

On the other hand, the inferior limit of the loins is constant because it rests on the skeleton which varies so little. It is marked on each side by two small depressions, the *lateral lumbar fossets*, one superior and one inferior. Gerdy points out only one, the superior lateral lumbar fosset. This corresponds to a sinus opening towards the outside which exposes the iliac crest at the level of the posterior third of its length. It is near the external angle of the region and immediately below the origin of the iliocostalis lumborum at this part of the bone. The second notable fosset is situated a little lower, towards the middle of the inferior border of the region. It corresponds to the bony projection of the posterior superior iliac spine which is transformed into a depression by the relief of the fleshy masses which are attached to it. The superior fosset is sometimes erased by the presence of excess fat (we will discuss this later in relation to the flanks). Sometimes, for the same reason, the depression becomes slightly com-

pressed below. The inferior fosset is much more fixed. Moreover, it is the only one that can be seen on women.

In the middle of the lumbar region, one finds the lumbar furrow which prolongs the furrow of the back. This furrow is large and deep. It corresponds to the spinal crest on the skeleton, although it appears as a groove because of the powerful muscles which border it on each side. Nevertheless, the lumbar vertebrae often appear as a series of nodular prominences at the bottom of the furrow. Of these prominences, generally only three or four show. They are often irregular and hardly show at all in an upright position. When the trunk is forcibly flexed to the front, they are much more evident.

The lumbar furrow descends as far as the inferior half of the sacrum where it disappears completely. Near its termination, it is generally marked by a depression (*median lumbar fosset*), situated a little above the level of the inferior lateral fossets. It corresponds to the union of the lumbar column with the sacrum.

The whole surface of the lumbar region is filled by the powerful relief of the spinal muscles, covered at this point by their own aponeurosis and by that of the latissimus dorsi. I shall not describe again here the projection (in the superior part of the region) of the fleshy fibers on the aponeurotic part. Below the line of this projection (superior lumbar line), one can see in an upright position, when the lumbar curve is exaggerated, several transverse wrinkles. At first sight, they appear to be cutaneous wrinkles, but they are actually due to the wrinkling of the fleshy portion of the spinal mass under the aponeurosis. This occurs only when the spinal muscles are completely relaxed and the wrinkles disappear at once when they are contracted. By manipulating the skin of this region, it is easy to demonstrate that these wrinkles have nothing to do with the skin itself.

Outside the mass of the spinal muscles, there is a line which becomes visible during flexion of the trunk. It is the lateral lumbar line. Beyond this the region of the loins is depressed, and extends towards the flanks.

FLANK (PLATES 77, 78 and 79)

The flanks form the sides of the abdomen and they fill the space left between the base of the chest and the iliac crest. They correspond to the inferior half of the obliquus externus.

The superior limit of the flank (generally not very distinct) is marked by a superficial transverse line due to a change in direction of the obliquus externus. Above, the obliquus externus follows the direction of the ribs to which it is joined; below, it detaches itself to insert at the iliac crest. This line invariably ends in the back in a depression which corresponds to the inferior extremity of the thorax, at the point where the ribs cease.

In front, the flank is bordered by the relief of the fleshy fibers of the rectus abdominis on the abdominal aponeurosis. In the back, it delimits the lumbar region.

Below, it is circumscribed by the furrow of the hip, or *iliac line*. The name of this line is derived from the relationship of the hip to the iliac bone, a relationship often falsely interpreted.

Actually, approximately only the anterior third of the iliac line rests upon the corresponding part of the iliac

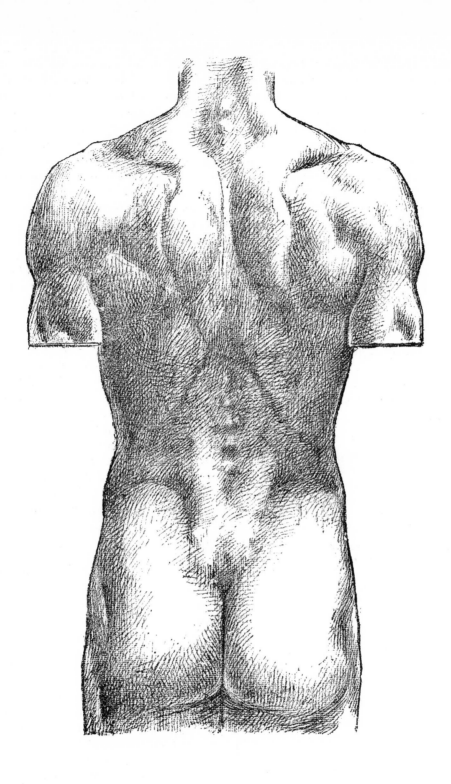

Figure 11. Torso on which the superior limit of the loins is formed by the fleshy fibers of the latissimus dorsi, because of the slight development of the spinal muscles. The contrary to this would be the torso on Plate 78, in which the superior limit of the loins is formed by the fleshy fibers of the spinal muscles.

crest, the posterior two thirds of this line are situated much lower. This may be easily observed if one compares the profile of the skeleton with the nude. There are many anatomical reasons for this, which remain to be explained (Figure 12).

I pointed out before that the lowest fibers of the obliquus externus are attached, by very short aponeurotic fibers, to the external lip of the iliac crest in such a way that the cutaneous fold formed by their relief is not situated at the level of the crest but just below. The gluteal muscles are sheathed in such a strong aponeurosis that they project only slightly from the crest. Their projection does not counteract the downward line of the cutaneous fold which, at this level, describes a slight curve of inferior convexity. Besides, the presence of a certain amount of fat at the back part of the flank accentuates this form.

In the front, however, at the anterior third of the crest, the fleshy fibers of the obliquus externus tend to separate from the line of the crest. These fibers are thinner and, therefore, their relief is less bulky than in the back. From the point where the fibers separate, the iliac line follows the bony prominence of the crest exactly and both describe curves of superior convexity. The anterior superior iliac spine forms a small projection at the anterior extremity of this line.

The surface of the flank is always convex from front to back. In very muscular subjects, it is convex from above to

Figure 12. Schematic figure showing the difference in direction of the hip and the line of the iliac crest.

below. However, in thin subjects it becomes concave from above to below and the iliac crest can be seen.

In relation to the morphology of the back part of the flank the subcutaneous pannicule of fat plays an important role in certain circumstances. This has been verified in all subjects we have observed, even in the thinnest. At the posterior part of the flank, there is a thickening of the fatty layer, necessarily varying with different subjects, but nevertheless constant. When this thickening is not particularly marked, it softens the relief of the posterior border of the obliquus externus and fills the void which, on the flayed figure, exists in the back between the obliquus externus and the latissimus dorsi at its insertion into the iliac bone. But, in many cases, the fat collects in this region and becomes localized to the point where it forms a veritable pad, prolonging the relief of the obliquus externus in the back. I am not necessarily referring to fat models because in them this pad is always greatly developed. It may also be found in thin subjects where it forms a swelling in back which reaches to the superior lumbar fosset, often partly filling it. Finally, an understanding of this fatty pad is important in modeling the female hip. It fills the iliac furrow to such an extent that only a superficial trace remains and it also fills the superior lateral lumbar fosset, erasing it completely. It hides the indications of the divisions between the flank and the buttock in such a way that the buttocks seem to rise as far as the line of the waist which, in fact, is the superior limit of the flank. These forms, characteristic of women, are often found, though attenuated, in men. On the other hand, certain women, in this respect, seem to have the masculine shape. Nature, in other words, in the infinite variety of individual forms, offers all the intermediate degrees between the male and female types.

PELVIS

The pelvis consists in front of the narrow median region of the pubis and groin. In back there is a region consisting of the prominence of the buttocks. (On the sides lie the joints of the hips.)

PUBIC REGION

The pubic region rests on the bone of the same name. The skin is usually thickened by the fat which attenuates the bony forms. It is shaded with hair. This region tends to project more in women. It is limited above by a transverse line which joins the lines of the groin and forms, with them, the front indentation of the pelvic area. On the sides, the region is bordered by the lines of the thighs, which move towards the groin. The region is somewhat triangular, and its base supports the reproductive organs.

GROIN

The line of the groin separates the thigh from the abdomen. It runs obliquely from the anterior superior iliac spine to the pubis. In an upright position, when the thigh is extended beneath the trunk, the line of the groin appears as a wide, superficial furrow. But in flexion, it becomes a deep fold. The line of the groin corresponds to Poupart's ligament and follows the same direction. It is

maintained by fibrous fasciculi which unite with the deep surface of the skin in this area, and with the adjacent ligaments. Above the line of the groin, the round form of the lower median surface of the belly projects. Beneath the line, there is a surface, often sharply defined, which corresponds to the psoas major muscle on its way to its insertion in the lesser trochanter of the femur (Figure 12).

The line of the thigh is very accentuated in fat subjects, and generally extremely clear in women. It starts, on the inside, from the line which separates the thigh from the pubic region; then it rounds the leg and ascending slightly it terminates, on the outside, a few fingers' breadth below the anterior superior iliac spine (Figure 13). At this point, it is marked by a depression which corresponds to the separation of two muscles: the sartorius and the tensor fasciae latae. This is the femoral fosset, which we will consider when we study the thigh. There is often, although less frequently on women, an accessory transverse wrinkle, at an equal distance between the anterior superior spine and the femoral fosset, which runs to the line which marks the superior limit of the pubic region.

BUTTOCKS

Behind the pelvis, there is the prominence of the buttocks. The buttocks are limited by the following: on the inside, by the line between the buttocks; below, by the curved lines which separate them from the thighs; on the outside, by the projection of the great trochanter; and above, by the inferior lumbar line and the flank line.

These boundaries enclose an area much higher than wide and it is filled by the sloping relief of the buttocks. This relief projects most at the inferior internal part where it is rounded and corresponds to the gluteus maximus. Above, on the outside, the projection of the gluteus medius is firmer and flatter. A superficial, oblique depression sometimes separates these two areas of muscle.

On the buttocks, the fat plays an important morphological role. It is thickest in the inferior, internal area. In fact, the projection of the whole region is much more often due to the accumulation of fat than to the development of muscle. This is most evident in women, whose muscular system is usually less developed and whose buttocks are, nevertheless, quite prominent. The firm buttocks of young subjects are due to a dense and resistant fatty tissue. The flat buttocks of older subjects are the result, for the most part, of the disappearance of this tissue. Models whose muscles are extremely well developed usually have a sparse fatty pannicule, and thus the projection of the buttocks is relatively slight. They are quite flat, and unless the muscle is in contraction, they have a soft and undulating quality quite different from the quality of accumulated fat (Figure 14).

As I have said, the steatopygia of the female Bushman is

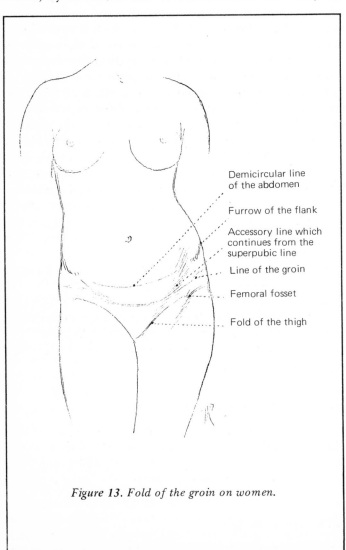

Demicircular line of the abdomen

Furrow of the flank

Accessory line which continues from the superpubic line

Line of the groin

Femoral fosset

Fold of the thigh

Figure 13. Fold of the groin on women.

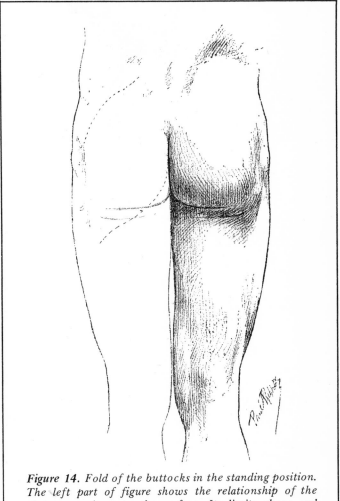

Figure 14. Fold of the buttocks in the standing position. The left part of figure shows the relationship of the gluteus maximus to the surface. Its limits above and below are indicated by the dotted line.

nothing but an exaggerated development of the fatty pannicule. It is interesting to note that, in Europeans, the relief of the buttocks is extremely variable in shape, and it offers examples of every degree of attentuation of this curious anatomical development.

On the outside, the buttock is separated from the great trochanter by a depression due to the manner in which the fleshy fibers insert into a large aponeurosis of insertion (Figure 15).

Below, the buttock is bordered by a fold which is deep on the inside and fades away on the outside. This is due to the inferior fleshy fibers of gluteus maximus which descend to the thigh, to which the lowest part of the muscle really belongs. This fold has a horizontal direction which crosses the oblique direction of the inferior border

Figure 15. Fold of the buttocks with weight on one side (female).

of the muscle. This has not always been clearly understood.

A simple examination of the nude will show that the fold of the buttock is solidly attached to the deeper parts. For example, when the weight is on one side, the fold of the buttock on the standing side will be deeply creased, forming a kind of band which encircles the internal part of the top of the thigh. However, on the other side, the fold will follow the movement of the tilted pelvis—it will descend lower and will not be as pronounced.

Anatomy offers an explanation for this. As we have seen in the anatomical sections, the deep surface of the skin at the level of the fold of the buttocks adheres to the femoral aponeurosis, which itself inserts into the ischium. However, it is important to remember that this surface attaches to the femur directly, by solid fibrous fasciculi. This was pointed out to me by my friend Paul Poirer, Chef des Travaux Anatomiques à la Faculté.

As a result, there is an intimate connection between the cutaneous fold of the buttocks and the pelvis, and the one follows the movements of the other. In effect, one can state that if the pelvis is lifted on one side, it carries with it the fold of the buttock on that side, and the fold will be higher than that of the other side.

Another consequence is that the fat of the region is in some way contained in a kind of pocket formed below by the fibers which go from the skin to the ischium, and which, since they are unable to descend to the thigh, increase the projection of the buttock. It is in this same pocket that a part of the fleshy mass of the muscle is retained and during complete relaxation this mass falls down towards the inside under the influence of gravity.

When the trunk is flexed to the front, the fold of the buttock tends to disappear, and the contracted muscle shows its form most exactly under the skin with its inferior border moving obliquely out and down (Plate 94).

The fold of the buttock is attached to the ischium only at its internal part, where it is deep. On the outside, the fold disappears before it reaches the external surface of the thigh. It is replaced by an inclined surface which descends towards the thigh, creating the transition between the region of the buttock and that of the thigh. This surface is due to the gluteus maximus.

Sometimes, there is a second fold of the buttock a little underneath and to the outside of the preceding.

At the articulation of the hip there is a projection caused by the great trochanter. The reason for this can be easily understood upon examination of the skeleton.

The projection of the great trochanter is greater than that of the iliac bone.

MOVEMENTS OF THE SHOULDER

The shoulder has great freedom of movement—it can move forwards, backwards, and upwards. Necessarily, it moves the arm at the same time. The shoulder cannot be lowered very much unless it is already in a raised position.

ARTICULAR MECHANISM

The skeleton of the shoulder is composed of two bones, the clavicle in front, and the scapula behind. These bones

form a complete half girdle which embraces laterally the summit of the thoracic cage (see Plate 31, Plate 16 and the following plates). The anterior extremity of this bony arc is closely connected to the thoracic cage at the sterno-clavicular articulation. Laterally, the center of the arc moves some distance away from the thoracic cage and articulates with the bone of the arm (scapulohumeral articulation). Finally, the posterior portion of the arc again approaches the thoracic cage, but it is not attached to the cage, it is only in contact with it. Actually, the scapula, much thickened by the muscles which cover its surface, is held against the thoracic cage simply by atmospheric pressure and by the muscles that regulate its movements.

The movements of the shoulder can be broken down into the gliding of the scapula against the thoracic cage, and the slight movement that takes place in the articulations of the clavicle with the sternum (sternoclavicular articulation) and with the scapula (acromioclavicular articulation). These articulations have been described (see page 32 and Plate 11).

In the upright position, with the arms falling freely alongside the body, the vertebral border of the scapula is almost vertical. Its distance from the median line is about half its length.

In the elevation of the shoulder, the scapula does not just describe a simple upward movement, but undergoes at the same time a slight movement of rotation on itself. Because of this, the axillary border becomes oblique and the inferior angle withdraws slightly from the cage and moves to the outside.

If one considers the solid attachment of the clavicle to the sternum and the transverse direction of this bone towards the outside, it is easy to understand that movement of the shoulder directly to the front is extremely limited. It is only possible if it is accompanied at the same time by a movement of elevation.

In the back, however, nothing stands in the way of the scapula. Also, the backward movement of the shoulders is itself very easy to perform. It is usually accompanied by a slight lowering of the point of the shoulder.

MUSCULAR ACTION

Elevation of the point of the shoulder directly upwards is produced by the contraction of the superior part of the trapezius which is attached to the clavicle, to the acromion process, and to the adjoining part of the spine of the scapula.

When this movement is performed with effort, as in the act of lifting a burden on the shoulder, other muscles enter into action as well as the trapezius. These muscles are: the rhomboids, the levator scapulae, the teres major, and the superior portion of the pectoralis major. The serratus anterior does not really participate.

The shoulder is drawn back by the inferior third of the trapezius and by the rhomboids which, while drawing the scapula towards the median line, lift the point of the shoulder. This latter movement is counterbalanced by the latissimus dorsi—through the medium of the head of the humerus, it moves the scapula from above to below and from front to back. At the same time, the latissimus dorsi straightens the trunk.

When this movement is violent, as in the act of drawing towards oneself a heavy weight, other muscles join the preceding. These muscles are the teres major and the posterior third of the deltoid.

The movement of the shoulder upwards and to the front is brought about by the superior third of pectoralis major. It expresses fear or apprehension. If it is done with violence, as in pushing the shoulder against a resistant obstacle, the serratus anterior contracts at the same time.

NORMAL POSITION OF THE SCAPULA

From the preceding details we can better understand the reasons for the normal position of the scapula. It arises naturally from the combined tonic forces of all the muscles which insert there.

Therefore, if the superior part of the trapezius and of the levator scapulae become weakened, the point of the shoulder drops down and, at the same time, the neck appears longer. If these muscles are unusually powerful, the opposite effect is produced.

Further, if the inferior part of the trapezius and of the latissimus dorsi are weak, the back becomes rounded transversely and the chest tends to become hollow. This condition also pushes the clavicles forwards and draws forward the point of the shoulder. The predominance of the tonic action of the pectoralis major and the serratus anterior will produce the same effect.

EXTERIOR FORM OF THE TRUNK DURING MOVEMENTS OF THE SHOULDER (PLATE 89 and 90)

In a direct upward movement of the shoulder, the middle part of the trapezius becomes extremely prominent. Above, this part compresses the integument of the neck, and several large wrinkles are formed there. The superior angle of the scapula approaches the median line of the back, while the inferior angle moves away from it and projects. In front, the exterior extremity of the clavicle is raised and the clavicle itself becomes oblique and the posterior triangle of the neck becomes deeper.

Movements of the shoulder to the front and back create a number of notable morphological modifications throughout the whole torso.

If the shoulder is carried to the front, the action rounds the back, tends to hollow the chest, and exaggerates the curve of the dorsal column. The modeling of the whole back part of the trunk undergoes changes which Plate 89 should clarify. On this figure, the right shoulder alone is advanced, while the left shoulder, remaining in the normal position, serves as a point of comparison. It may be easily seen that the scapular region, displaced to the outside and to the front, exhibits a few small changes in relation to the muscles teres major, infraspinatus, and the posterior third of the deltoid. The spinal region, in the upper part, is enlarged transversely and at that part the surface of the trapezius is flattened and extended. Below the trapezius, the inferior extremity of the rhomboideus major may be observed at its insertion into the inferior angle of the scapula.

But the most important modifications are in the infrascapular region. Actually, a whole new region is uncovered between the posterior border of serratus an-

terior and the spinal region. We have discussed this region in the conventional attitude but now it is much enlarged. It has become a rounded surface on which the reliefs of the ribs can be seen more or less easily. On certain subjects, on the lower part of this surface, the projections of the different muscle bundles of the serratus posterior inferior can also be seen. On the inside, the relief of the spinal muscles shows very clearly and the external limit of this form is distinctly marked (*lateral line of the back*).

It should be noted that the latissimus dorsi has not entered into the forms we have just described. As a matter of fact, this muscle, whether extended or relaxed, always molds itself exactly over the deeper forms and these alone influence the morphology of the region. On the outside, however, the anterior border of the latissimus dorsi would form in this movement a distinct relief which would almost completely cover the contracted digitations of the serratus anterior.

The backward movement of the shoulders (Plate 89, Figure 2) is always accompanied by a flattening of the back, a thrusting forward of the chest, and a throwing back of the torso. The movement of the shoulder blades towards each other is limited only when they come into contact with the adjacent muscular masses. The spinal region is reduced each side to its minimal size. Its superior part shows the strong muscular relief created by the trapezius and the rhomboids—these reliefs touch each other at the median line. In the scapular region, the swelling of several muscles is accentuated—the teres major, infraspinatus and the posterior third of the deltoid. As for the infrascapular region, its details are hidden beneath the contraction of latissimus dorsi. However, in the back the line where the fleshy fibers of latissimus dorsi originate from the aponeurosis becomes most apparent. The whole region of the loins becomes traversed with striations which follow the direction of the fibers of latissimus dorsi. These striations are caused by the pull of the fibers upon the aponeurosis from which they originate.

Laterally, the anterior border of latissimus dorsi becomes oblique above and to the back and it uncovers the flattened digitations of the serratus anterior which are not contracted.

MOVEMENTS OF THE ARM

The movements of the arm take place through the articulation of the scapula and the humerus. Because of the shape of the articular surfaces at this joint, the arm has extraordinary mobility and it is capable of moving in any direction. At the same time, the arm cannot achieve and complete these movements without a certain displacement of the scapula. Thus, when the arm is raised, the scapula undergoes a movement of rotation and its inferior angle is drawn forwards and to the outside, while its superior angle is lowered. If the arms are outstretched horizontally, or moved to the front or rear, the scapula follows the direction of the arms.

The movements of the arm fall into three categories. First, movements in a plane that is vertical and parallel to the body. These movements are produced around an anteroposterior axis of rotation, the arm moving in a half circle around the shoulder joint which is its center. The arm starts by moving out, away from the trunk forwards and to the outside, soon becomes horizontal (horizontal elevation of the arm), and then continues its course until it reaches the vertical (vertical elevation of the arm).

Second, when the arm is placed in the position of horizontal elevation, it may describe extended movements within the horizontal plane by moving around a vertical axis. In front, the hand can move well beyond the median plane of the body. In the back, this movement is much more limited and the arm can only reach a position where it makes an obtuse angle with the back.

Third, the arm can undergo movements of rotation upon itself.

MECHANISM AND MUSCULAR ACTION

The initial elevation of the arm is brought about by the supraspinatus and the deltoideus. The first, a deep muscle, has very little effect on the exterior form, because of the thickness of that portion of the trapezius which covers it and makes its shape. The deltoideus, on the contrary, is entirely subcutaneous and is very important to the morphology of the region. However, by contracting the deltoideus can lift the arm only to the horizontal; that is the limit of its action. The complete elevation of the humerus is brought about by the contraction of serratus anterior, which rotates the scapula at its external angle.

We have observed that, from the anatomical point of view, the deltoideus is formed of three portions which are easily separated in dissection; physiologically, the deltoideus may be thought of as being formed of three separate muscles: the anterior, the middle, and the posterior. Each muscle portion may act alone and may become an antagonist to the other. When elevation is carried out without effort, each portion contracts independently in order to produce the elevation, whether it is to the front, to the back, or to the outside. Thus the three portions act as antagonists between themselves in movements to the front and back. Finally, the posterior portion acts as an antagonist to the two others in the movement of vertical elevation. This portion has very little power as an elevator. When the arm is raised vertically, it appears to be relaxed, whereas the two other portions are manifestly contracted. However, when the arm is lowered, the contraction of the posterior portion becomes definitely emphasized.

According to the authorities, the serratus anterior contracts in order to complete the action of elevation only after the arm has been extended horizontally. However, it is easy to see, simply by an examination of the forms, that the serratus anterior contracts from the very beginning of the movement of elevation. It contracts, as Duchenne de Boulogne has observed, not only in order to attach the spinal border of the scapula firmly against the thorax, but also to initiate the movement of rotation which is characteristic of its action upon the scapula. Nevertheless, it is important to distinguish this from what happens when the hand is moved together with the arm to the front, or to the back, since in this case the serratus anterior enters into the action, but in a totally different manner. The action of serratus anterior may be supplemented by the middle portion of the trapezius. When the arm is in horizontal extension and carried to the front, a strong contraction

of the serratus anterior may be clearly seen and its digitations appear in strong relief. In proportion to the extent to which the arm is moved back and to the outside, in the same horizontal plane, the contraction of serratus anterior becomes weaker and the middle portion of the trapezius becomes harder. Finally, when the arm is moved to its extreme limit in the back, the digitations of the serratus anterior appear flattened and relaxed and the middle third of the trapezius contracts violently.

Lateral rotation of the humerus is brought about by the supraspinatus, the teres minor, and the infraspinatus. Only the last muscle is subcutaneous but, because it is sheathed by a strong aponeurosis, its relief is always subordinated. As rotators of the humerus these muscles play an important role in supination of the hand, as we shall see later.

When the arm is lifted vertically it may return to its normal position simply through its own weight. Under these circumstances it is the muscles of elevation that enter into action in order to moderate and restrict the arm's descent. The depressor muscles only intervene to determine the direction of the movement, or to produce it with force.

Lowering of the arm to the front and within is performed by the pectoralis major. If this movement is in a horizontal direction, the whole muscle enters into the action. Below this level only the inferior portion is involved.

Lowering to the back is produced by the posterior third of the deltoideus, though only as far as the horizontal position. Then the teres major and the rhomboids take over, and finally the latissimus dorsi and the long head of triceps brachii.

The action of lowering the arm directly to the outside is dependent upon all the depressor muscles with the exception of the superior third of pectoralis major.

EXTERIOR FORM OF THE TRUNK DURING MOVEMENTS OF THE ARM (PLATES 91, 92 and 93)

Plates 91, 92, and 93 should allow us to avoid long and tedious descriptions. When the arms are moved modifications of form occur principally within the scapular region in the back, and the pectoral region in front. Laterally and to the front, the elevation of the arm discloses a new region, the arm pit, which is morphologically extremely important. We shall study this separately.

Vertical elevation of the arm produces notable changes in the form of the back. They are the result not only of the muscular action itself but of the see-saw movement of the scapula. For instance, the spine of the scapula, which is marked by a clear depression in well muscled subjects, pivots, so to speak, at its external extremity. Accordingly, the spine moves from an almost transverse position to an almost vertical position. The scapular fosset which marks the internal extremity of the spine is carried below and to the outside, and the surface of the trapezius becomes considerably enlarged. The modeling varies with the different regions. For instance, the middle portion of the trapezius, which is attached to the acromion process and to the adjacent part of the spine of the scapula, forms a very distinct relief in contraction. The inferior portion of

the trapezius becomes flat and stretched out in the direction of its fibers. The spinal border of the scapula, released from underneath the inferior part of the trapezius which covers it in the normal attitude, forms an accentuated relief directed obliquely from above to below and from within to without. This spinal border seems thickened because of the infraspinatus muscle which fills the infraspinatus fossa. Beneath the spinal border of the scapula a triangular depression appears. This depression is limited within by the relief of the spinal muscles and below by the superior border of latissimus dorsi. In the superior angle of this depression the lower border of the rhomboideus major becomes apparent. The inferior angle of the scapula, drawn to the outside and thickened by teres major, makes a marked prominence under the latissimus dorsi which embraces it. The superior border of latissimus dorsi may be followed as far as the arm pit because of the elongated relief of teres major. From the inferior angle of the scapula the triangular relief of the serratus anterior, covered by the latissimus dorsi, may be seen moving to the outside. The infrascapular region also changes, for, between the swelling of the spinal muscles and the inferior border of serratus anterior, the thoracic cage itself is now covered only by latissimus dorsi.

The deltoideus now seems like a heart on a playing card, the point directed above and the three portions of the deltoideus becoming reasonably clear. The integuments, forced back, create a wrinkle across the external extremity of the clavicle and the acromion process.

In front, when the arm is raised vertically, there are significant changes in the pectoral region. It seems to lose in breadth what it gains in height. The relief formed by its inferior border is practically effaced and the whole portion which supports the nipple is flattened. The external angle of the pectoral region is carried very high.

The inframammary region is marked by the digitations of the serratus anterior; their reliefs jut out sharply in front of the vertical swelling of the anterior border of the latissimus dorsi. When the arm is raised the latissimus dorsi is relaxed and models itself exactly over the hard digitations of the serratus anterior.

However, if the model raises his arm and attempts to pull down a resistant object or attempts to raise his own body, the latissimus dorsi becomes hard and smooth. Its muscular bundles stand out and their insertions into the sides of the thoracic cage become apparent. At the same time the serratus anterior becomes somewhat limp and compressed above and its digitations become less distinct and more oblique.

If the arms are extended horizontally to the outside they bring about modifications in the trunk which should be easily understood from the preceding study. Horizontal elevation is, after all, but the intermediate position between repose and vertical elevation—we find all the same types of modification in the forms but they are less accentuated. Note, however, that when the arm is raised to the horizontal the shoulder blade has already begun to rotate and the synergetic action of the serratus anterior is under way. This muscle does not follow the action of the deltoideus in the elevation of the arm but, as I have already pointed out, it accompanies the action from the beginning. In the front the pectoral region becomes an irregular quadrangle and when the arm is in horizontal

elevation the deltoideopectoral dividing line takes its place as a prolongation of the clavicle.

If the arm is moved to the front or to the back it carries the scapula with it. The scapula glides over the thoracic cage approaching or drawing away from the vertebral column. Certain modifications of form occur then which I shall describe only briefly because they are much like those brought about when the shoulder is moved to the front or to the back.

ARM PIT

When the arm hangs naturally alongside the body the arm pit is hardly more than a fold running from front to back. It is only when the arm is separated from the body that the hollow of the arm pit appears. As the humerus moves to the outside the muscles of the trunk that are inserted into it are carried with it. Three muscles form the walls of the hollow of the arm pit—the pectoralis major is responsible for the wall in front and latissimus dorsi and teres major for the one behind. The hollow of the arm pit is limited above by the fasciculi of the biceps and the coracobrachialis, and within it is bordered by the thoracic wall covered by the serratus anterior. It is upon this quadrangular space that the skin sinks in, due to atmospheric pressure. The skin is also maintained in this position by the resistant aponeurotic fasciae which are attached to the skeleton of the region (summit of the coracoid process, neck of the humerus, inferior surface of the articular capsule, neck of the scapula). They form a sort of vertical compartment.

The top and bottom surfaces of the arm pit seem to continue with no line of demarcation between them and the neighboring areas; the top rises into the arm and the bottom runs into the thorax. But the front and back walls of the arm pit form clear borders. The front wall is thick and rounded; it is formed by the deep and superficial fasciculi of the pectoralis major. The rear wall, which descends lower than the other, is composed of two surfaces—above by the surface of teres major, and below by the latissimus dorsi which at this level turns about the inferior border of the teres major. As a result the rear wall is longer than the front wall. This should be borne in mind on a back view of the model as the difference in length is not visible from this position.

In vertical elevation the hollow of the arm pit changes form. It then appears as a great vertical furrow bordered in the front by pectoralis major, and in the back by latissimus dorsi and the teres major. Above, the coracobrachialis forms a prominence which is usually most distinct in lean subjects. At this level the furrow divides in two. Its anterior branch, straight and deep, twists around the coracobrachialis and the biceps and follows the border of pectoralis major as far as its meeting with the deltoideus. The posterior branch, which is more superficial, mounts towards the internal surface of the arm where it becomes continuous with the furrow that separates the biceps from the triceps. We should also point out the oblique furrow on the outside which, as it leaves the hollow of the arm pit, rounds the base of the arm. It separates the teres major from the adjacent muscles—the triceps brachii on one side, and the posterior third of the

deltoideus on the other. When the arm is raised vertically the hollow of the arm pit is directed vertically from above to below and from the outside to the front. It encroaches upon the anterior surface of the torso.

There is no region more variable than the arm pit because it is modified at every moment by the varied movements of the arm. But it is not too difficult to recognize the muscular elements that I have pointed out. Certainly, they are the best guides for understanding and representing this region.

MOVEMENTS OF THE TRUNK

Let us now examine the changes of the form that follow the movements of the trunk itself. When the model is in the conventional position the torso may carry out movements upon itself or upon the lower limbs. We shall take up here the movements of the torso upon itself, since the movements of the torso upon the limbs are a matter of the movements of the thigh on the pelvis. However, these movements, because of their particular nature, are often associated—they complement each other and are often confused with each other—and they can be distinguished only by minute analysis.

ARTICULAR MECHANISM

The diverse movements of the trunk take place in the dorsal and lumbar sections of the spinal column, but the movements are not equally divided between these two sections.

Although the movements are, in fact, quite limited in the dorsal region, they are not absent. It is an error to think that the presence of the ribs transforms the column into a rigid and immovable stalk, and that the thoracic cage can only be moved as a whole. In reality all extensive movements of the lumbar column affect the thoracic cage and it tends to increase or correct these movements by compensatory displacement.

The lumbar region of the spine, though not as mobile as the cervical region, may nevertheless perform extensive movement in every direction. It directs the movements of the torso which may be reduced to three principal ones: movements around a transverse axis (flexion and extension); movements around an anteroposterior axis (lateral inclination); movements around a vertical axis (rotation).

In *flexion* the thoracic cage approaches the pelvis, the vertebral column curves to the front, the normal curve of the thoracic column is accentuated and the normal curve of the lumbar column is effaced and replaced by an inverse curve. All this takes place in such a way that the whole thoracic-lumbar column follows a curvilinear direction of anterior convexity. The most mobile point may appear to be in the superior part of the lumbar region but there are great differences among individuals.

This movement is limited by the resistance to compression of the anterior parts of the intervertebral disks and by the distension of spinal ligaments (see Plate 7).

Extension is produced by a straightening of the thoracic region and through an exaggeration of the normal curve of the lumbar region. The limit of extension is more rapidly attained than that of flexion.

In *lateral inclination* the ribs almost come into contact with the iliac crest. The vertical direction of the articular surfaces of the lumbar column renders this movement independent of the movement of rotation (this is not the case in the cervical column). These two movements of rotation and lateral inclination often take place together. It is only for purposes of description that we separate them.

By itself the movement of rotation of the vertebral column is quite limited—much more than students imagine. This is because the movement is usually accompanied by a movement of rotation of the pelvis on the femurs, and by a twisting of the shoulders which makes the movement of the vertebral column seem more extensive.

MUSCULAR ACTION

When we recall the role that gravity plays upon muscular action and the sort of paradox that results we can understand why the extensors contract in flexion of the trunk and the flexors contract in extension. But we must also remember that this is true only in accentuated movements and in those where there is no resistance to overcome.

Flexion is caused by muscles of the abdomen—the rectus abdominis, the obliquus internus, and the obliquus externus abdominis. *Extension* is caused by the spinal and lumbar dorsal muscles, and by the transversospinal muscles beneath them. The action of these last is not revealed on the exterior.

Lateral inclination is caused by the iliocostalis lumborum, the quadratus lumborum, the intertransversarii of the lumbar region and the obliquus internus and externus.

In movements of *rotation*, two muscles, obliquus internus and longissimus dorsi, turn the anterior surface of the trunk to the side where they are situated. The obliquus externus and the transversospinal muscles turn the trunk to the opposite side.

EXTERIOR FORM DURING MOVEMENTS OF THE TRUNK (PLATE 94 and 95)

Flexion of the trunk. Since we have given a detailed description of the trunk in the upright figure, we shall only mention briefly the changes that take place in the regions we have studied.

In front the forms of the chest change very little. The belly, however, diminishes greatly in height. It is divided by a deep fold which crosses it either at the level of the navel, or a little above. On the sides this wrinkle touches a deep depression at the bottom of which one senses the costoabdominal prominence which has now disappeared. The fold is often accompanied by several other less pronounced wrinkles which are below, at the level of the navel or slightly above it. The inframammary region is slightly altered by the flexion wrinkles of the compressed integument. Finally, the demicircular line of the abdomen, which is four or five fingers' breadth below the navel, becomes a deep fold. The region below the belly tends to stand out and the lines which border it below, the transverse line of the pubis and the line of the groin, are accentuated.

The flank diminishes in height in the front where it forms a sort of cushion which effaces the lateral line of the belly. The iliac line descends a little, its posterior part tends to disappear.

On the sides the anterior borders of the latissimus dorsi form a strong relief.

The forms of the back change considerably since they depend greatly on the position of the arms and the resulting displacement of the scapula. The infrascapular region is in clear view. In its inferior part the ribs may be seen between the reliefs formed by the inferior border of the serratus anterior and the spinal muscles.

Important modifications take place in the lumbar region. It becomes longer and its muscular and bony reliefs undergo changes. But, since these changes differ according to the degree of flexion, we should study this region in two positions: light flexion and forced flexion.

All the modifications of form of which we are now speaking depend on the degree of contraction or distension of the spinal muscles. In fact, at the beginning of the flexion produced by the powerful anterior muscles of the trunk the spinal muscles, although they are extensors, enter into the action. This is because of the law of synergy which applies to antagonistic muscles: their aim is to maintain the trunk and to prevent it from giving way to any action which might impel it to the front and which might be assisted by gravity. At all times, when there is flexion in front, the spinal muscles are in contraction until the movement reaches its limit and the contraction becomes useless. When this happens these muscles are in a state of extreme distension which does not allow them to contract again without bringing the trunk towards extension.

Light flexion. In the upright position, when the trunk is balanced upon the femurs, the spinal muscles are not at all contracted, nor are the gluteal muscles. But as soon as the trunk falls to the front, all of them contract.

The lateral lumbar fossets become modified; the superior ones tend to disappear, while the inferior ones become more evident because of the contraction of the adjacent muscles, which, as we have seen, are the sole reason for their existence.

On each side of the median lumbar furrow, at the bottom of which the prominence of the lumbar spinous processes are evident, the spinal muscles offer several prominences which differ in form and volume.

On each side, rising from the sacrum, there is a considerable linear prominence. It starts at the level of the inferior lateral fosset and forms a cord-like relief bordered by the lumbar line. It ascends in a vertical direction until its fibers disappear under the aponeurotic fibers of the latissimus dorsi. The prominence is due to the contraction of the muscular and aponeurotic fibers of longissimus dorsi. At its external border, a little above the superior lateral lumbar fosset, there is a second prominence, stronger than the first and globular at its base. This second prominence rises into the dorsal region where it may be clearly seen underneath the fleshy body of the latissimus dorsi.

The second prominence is due to the fleshy fibers of the iliocostalis lumborum which run over the spinal aponeurosis. Its internal border ascends obliquely

towards the vertebral column and reaches different heights on different subjects. On those whose spinal muscles are well developed, this relief joins the median line lower than the relief of the latissimus dorsi and below this point it creates a second line running in the same direction. This second line follows the insertion of the fleshy fibers of iliocostalis lumborum and longissimus dorsi to their spinal aponeurosis.

On the outside of the relief of iliocostalis lumborum there is a line which descends to the superior lateral fosset, the lateral *line of the loins* (according to Gerdy). This is usually invisible in the upright position.

The buttocks are narrow, globular, touching on the median line, and the depression behind the great trochanters is marked. All these forms become distinct morphologically if the gluteal muscles contract.

Forced flexion. The forms which we have just described change considerably. The inferior lumbar fossets are replaced by the prominences of the posterior superior iliac spines because of the flattening of the muscles which surround them. For the same reason the median lumbar furrow is replaced by the prominences of the sacral vertebrae. However, there is always a depression on the median line at the point of junction of the sacrum and the vertebral column.

The median lumbar furrow sometimes disappears completely; it is replaced by a medial fusiform swelling caused by the prominence of the lumbar crest. This projection is never uniform; it is marked by protuberances that correspond to the summits of the spinous processes of which there are usually five. They vary greatly, however, as to number and regularity. At the junction of the dorsal column and the lumbar column, there is usually a depression; above it the dorsal crest often projects. So much for the forms caused by the bones. The muscular reliefs are much simpler. There is one on each side, a short distance from the median line. Each one is somewhat ovoid, developed in proportion to the development of the spinal muscles. These reliefs originate between the lumbar fossets and rise above the confines of the lumbar region.

The buttocks are large and flat because of the distension of the gluteal muscles. The muscular and aponeurotic fibers are clear beneath the skin.

Extension. The movement of extension of the trunk seems to have its center at the inferior part of the lumbar column. It is at this level, the level of the superior lateral lumbar fosset, that the summit of the angle between torso and pelvis is created. It is here that transverse cutaneous wrinkles appear.

Thus the lumbar region is greatly modified. The lateral reliefs of the spinal muscles form two rounded masses, soft to the touch and marked by big transverse wrinkles due to the fact that the fleshy bodies of the muscles themselves are relaxed. In fact, the spinal muscles enter into contraction only if the movement of extension is produced with effort or if it encounters resistance (see page 107). The lumbar fossets hollow out and the lateral superior fossets disappear in the bottom of a fold which continues on the outside with the iliac line and ends a little below it.

The width of the flanks diminishes in the back in the neighborhood of the loins. The superior part of the space between the ribs and pelvis is marked by a transverse depression. This space contains the fatty cushion which is at times distinct from the relief formed by the obliquus externus abdominis. The obliquus externus abdominis is depressed in front and enlarged on the sides. It is extended in its anterior part, where its fasciculi may be seen, and it is relaxed in the back.

The anterior superior iliac spine becomes most prominent. The iliac line is effaced at its anterior part, whereas, in the back, it becomes deeper and descends slightly.

The belly is flat and stretched throughout. Its costal borders are clear under the skin. The chest undergoes no modifications worthy of notice, unless these are brought about by the movements of the arms which we have studied.

Lateral inclination (Plates 97 and 98). The lumbar column may curve laterally. If this is the case the summits of the spinous processes are often visible curving in the same direction at the center of the median lumbar furrow. The curve of the median lumbar furrow varies among individuals. Usually it is uniform, disposed equally throughout the region as it continues above with the column of the back. But occasionally it is more angular, and the vertebral column follows a broken line, the break corresponding to about the middle of the lumbar region.

On the side of the convexity, that is to say on the side opposing the inclination, there is a relief in the lumbar region which mounts as far as the dorsal region. It is due to the contracted spinal muscles. On the opposing side these muscles are relaxed and the prominence they form is crossed by transverse wrinkles which reach the region of the flank. If, however, the movement is made with effort or encounters resistance, the spinal muscles tend to contract on the side of the inclination.

The flanks are the region of the trunk where the results of lateral inclination are most apparent. The two sides are greatly modified in an inverse sense. On one side the flank is lengthened, flattened and stretched, on the other it is diminished, gathered upon itself and swollen. These changes of form are a natural consequence of the approach on one side of the thoracic cage toward the pelvis, and the separation on the other side of these two bony pieces one from the other.

Thus, on the side of the flexion, the flank forms a sort of swollen cushion marked by several transverse wrinkles. These are not particularly distinct in the back in the region of the loins, but they become more delineated in front. They are bordered below by the iliac line which now becomes transformed into a deep furrow. The flank is limited above by a fold which corresponds to the top of the space between the ribs and the pelvis, and which, depending on the relaxation or contraction of intervening muscles, stops on the side or continues to the vicinity of the navel.

On the side opposite the flexion there is a feeling of flatness about the whole region. The iliac line is effaced, as well as the relief of the iliac crest, and the costoabdominal prominence. The two lateral lines which limit the flanks in the front and back are hardly visible.

There are no appreciable modifications in the abdomi-

nal region below the navel. The center of the movement evidently exists above, and it is in the region above the navel that the median abdominal line curves laterally, responding in front to the curve of the median lumbar furrow in back. From this result obvious modifications in the modeling of the surface of the rectus abdominis.

Rotation of the trunk (Plates 99 and 100). In the upright position the rotation of the trunk is almost always accompanied by a movement of rotation of the pelvis on the femoral heads. At the same time there is a movement of the shoulders, one moving to the front, the other to the rear.

It is in the region of the belly and the loins that modifications appear due exclusively to rotation of the torso. These are, however, very slight as the movement itself is always of small extent. We must remember that the two sides of the spinal lumbar muscles do not contract at the same time except in pure flexion. If the movement of rotation is made without effort the contraction of the spinal muscles takes place to oppose the direction of this movement. But if the movement encounters resistance the spinal muscles on both sides contract. Although the oblique muscles of the abdomen are also rotators, a comparison with the spinal muscles is hardly possible. We have, on each side, two superimposed oblique muscles of which the fibers are directed inversely and which act in opposition. Whatever the direction of the rotation there is always a muscle contracted on each side, either the superficial muscle or the deep one.

The most important changes that take place in rotation of the trunk occur at the superior part of the torso and they are influenced by the associated movements of shoulders and hips (Figure 16). We have already studied the forms which result when the shoulders are moved either to the front or back (see page 103).

As for the movements of rotation of the pelvis on the femurs, they are brought about by the rotators of the thigh. The fixed point of these muscles is accordingly displaced from the pelvis to the femur. Rotation of the thigh is brought about by the concurrence of antagonistic muscles acting on each side of the body.

It is because of concurrence that we find great differences between one side and the other on the hips and the buttocks. On the side opposite that to which the movement is directed the posterior part of the gluteus medius makes a distinct relief above the buttock, the gluteus maximus itself contracts and the hollow behind the great trochanter is accentuated. At the same time on the side to which the action is directed the anterior part of gluteus medius, raised by the anterior part of gluteus minimus, makes a marked relief.

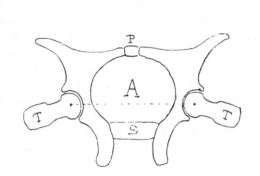
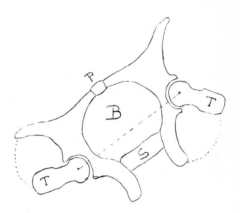

Figure 16. (left) These two schematic figures show the movements of the pelvis during rotation of the trunk. In A the pelvis is in its normal position. (P) Pubis. (S) Sacrum. (T) Great trochantor.

(right) In B, the pelvis is shown during rotation to the left. (P) Pubis. (S) Sacrum. (T) Great trochantor. Note: when the pelvis is drawn in the same direction as the trunk, it pivots on the two femoral heads. This movement is brought about by the rotator muscles of the femur, and the fixed point of these muscles is transported from the pelvis to the femur.

16. Exterior Form of the Upper Limb

We should remember that in the conventional attitude used for study the arm is placed in extension with the palm turned to the front (supination). We shall take up successively the shoulder, the upper arm, the forearm, the wrist, and the hand.

SHOULDER (PLATES 80, 81 and 82)

So far we have only studied the most prominent part of the shoulder, commonly called the point of the shoulder. As far as anatomy is concerned, the scapula region belongs to the arm, but from the point of view of morphology, it belongs to the trunk. Thus we have already studied it as part of the trunk.

Rounded in form, the shoulder projects beyond the acromion process. A single muscle, the deltoideus, supported by the head of the humerus, occupies the region which is limited in the front by the deltoideopectoral line. In the back the limits are not so precise; the posterior third of the deltoideus more or less blends with the scapular region. The surface of the deltoideus swells out in the front, it is flat in the back, and it is depressed on the outside and below towards the level of its insertion. Actually, in the living model the deltoideus is much like that on a flayed figure, though the outline is much softer. The skin around the insertion of the deltoideus is thickened by an accumulation of fat which accentuates the depth of the deltoid impression.

UPPER ARM (PLATES 80, 81 and 82)

The upper arm has a cylindrical form in lean subjects and in women. However, if the muscles are developed, it becomes flat on the sides. It is wider from front to back than from side to side.

The whole anterior part of the upper arm is occupied by the elongated relief of the biceps brachii (see page 64). This muscle is bordered by two long lateral lines which become accentuated when the muscle is contracted and the biceps brachii takes on a globular form. When the arm is rotated to the inside, the lateral line is effaced and a new one appears. This new groove runs obliquely below and to the outside and it is due to a particular disposition of the aponeurosis which sheaths the muscle. The medial line, which separates the biceps brachii from the triceps brachii, is filled in by vessels and nerves which join each other at this point.

The posterior part of the upper arm has less uniformity than the anterior part because the detail of the triceps brachii is much more considerable than that of the biceps brachii. When the triceps is relaxed, the form is full and rounded but in contraction the various parts of the muscle are very clear (see page 65). The large plane of the common tendon becomes very distinct below. It is oblique from above to the inside and is surrounded by a number of fleshy masses. The most voluminous mass, situated above and to the inside, is due to the long head of the triceps. On the outside there is slightly smaller relief which is created both by the lateral head, and, at the bottom, by the median head which is not as large as the long head. The three heads of the muscle are separated by more or less distinct lines.

On the external surface of the upper arm, the biceps brachii and triceps brachii, separated above by the insertion of the deltoideus, draw even further away from each other as they descend. The space remaining is occupied by a slightly raised triangular surface, separated from the neighboring muscles by a superficial groove, which corresponds to the brachioradialis and the extensor carpi radialis longus. The line between these last two muscles is not evident except in forced flexion (Plate 104, Figure 1) or in pronation (Plate 101, Figure 3).

Two veins mount the upper arm. On the inside there is the basilic, which is hidden in the internal groove, and the outside, the cephalic, which rises along the external border of the biceps brachii until it reaches the detoideopectoral line.

ELBOW (PLATES 80, 81 and 82)

The anterior region of the elbow is known as the bend of the arm. The elbow corresponds on the skeleton to the articulation of the humerus with the radius and ulna. It is flattened in the anteroposterior sense.

BEND OF THE ARM (PLATE 80)

The following three muscular reliefs can be seen here. One, median and superior, is formed by the inferior extremity of the biceps brachii whose fleshy fibers descend more or less down the tendon, depending on the individual model. Two others on each side and further down surround the base of the median tendon of the biceps brachii.

Of these two reliefs, the internal one, which is rounded and elevated, is formed by the superior extremity of

pronator teres. The external relief, situated on a surface further back, corresponds to the brachioradialis. Between this last surface and the median projection of the biceps brachii there is another somewhat extended plane over which the biceps brachii itself descends. This corresponds to the brachialis muscle.

As a result of these forms the wrinkle of the bend of the elbow travels over three muscular reliefs. In extension of the arm it has the shape of a V opening to the front, the external branch being the deepest. Towards the point of the V one senses the cord formed by the tendon of the biceps brachii, but this cord becomes most apparent in flexion. When the flexion is extreme the bend of the elbow has a deep transverse fold.

The veins which travel over the anterior surface of the elbow take the shape of an M, the central V being formed by the union of the median cephalic on the outside and the median basilic on the inside. This last is usually the most voluminous and the most apparent. The lateral branches correspond to the accessory cephalic vein on the outside and the basilic on the inside (Plate 72).

The region is crossed transversally by several cutaneous flexion wrinkles which run fairly close together and are situated at the level of the tendon of the biceps.

Just outside this tendon there is a depression which is usually about the size of a finger tip but it is accentuated in fat subjects and in women. On the outside there are two other superficial wrinkles which are directed transversely and which become evident in slight flexion. These wrinkles are concave and their concavity is directed towards the center of the region. They are situated some distance above the others. One, the superior, crosses the swelling of the biceps brachii above the tendon. The other, the inferior, meets the anterior surface of the forearm.

POSTERIOR PART OF THE BEND OF THE ARM (PLATE 81)

The word *elbow* can be thought of as applying to the back of the region under discussion. Towards the middle of this part, but nearer the internal than the external border, the prominence of the olecranon is situated. This prominence is surmounted in extension by a transverse cutaneous wrinkle. In fat people and often in women, the transverse fold becomes so pronounced that it effaces the prominence of the olecranon and it may, in fact, dominate the morphology of the whole region.

The olecranon is bordered medially by a depression which separates it from the medial epicondyle. At the bottom of the depression the ulnar nerve is situated. On the outside there is a depression which is remarkable for its constancy. It is bordered above by the relief of the extensor carpi radialis longus. This depression lies at the level of the lateral epicondyle and it is called the condyloid depression. One can see, in fact, at this point both the medial epicondyle and the head of the radius, and even the interarticular line which separates them. In women and children the condyloid depression is known as the dimple of the elbow.

Between the olecranon and the condyloid depression there is a triangular surface turned to the inside. Its base blends with the external border of the olecranon and its summit blends into the depression. This surface corresponds to the anconeus muscle.

The internal border of this region is prominent, and the point of the medial epicondyle is easily seen. Above the point in lean subjects there is a projection of the form of a cord due to the intermuscular dividing membrane.

The external border is formed by the strong relief of the brachioradialis and the extensor carpi radialis longus which combine to fill the obtuse angle on the skeleton between the upper arm and the forearm.

FOREARM (PLATES 80, 81 and 82)

The forearm is flat in the anteroposterior sense, contrary to the upper arm which is flat laterally. It follows that in the lateral profile the maximum width of the arm is at the upper arm (Plate 82), while from the anterior or posterior views (Plates 80 and 81), the maximum width is at the superior part of the forearm. At its inferior part the forearm diminishes in volume and becomes rather block-like, though still cylindrical in form.

These changes in the volume of the forearm are dependent on the structure of the muscles of the region. For the most part these muscles are composed of a superior fleshy mass and a long inferior tendon. The proportion between the fleshy part of the muscle and the tendinous part varies with individuals. We have already observed that there are subjects with long muscles and others with short muscles. In the forearm this general observation has consequences that are important. Among subjects with short muscles the inferior tendinous portion dominates and forms a striking contrast with the superior part which is fleshy and massive. However, among subjects with long muscles it is the superior part which dominates, and even encroaches on the tendinous portion, thus giving the whole forearm a fusiform shape.

The anterior or palmar surface of the forearm is flat throughout and at its superior portion there are two muscular reliefs separated by a median surface. The external relief is made up of the fleshy body of the brachioradialis which is supported by the extensor carpi radialis longus, projecting a little on the outside. The internal relief is created by a group of muscles which form several distinct masses. The swelling of the pronator teres, which we have noted at the fold of the arm, occupies the superior part. This muscle is separated by a superficial line, running obliquely from below to the outside from a second swelling which is due to the palmar and the flexor muscles and continues to the outer border of the forearm.

The fibrous expansion of the tendon of the biceps brachii cuts obliquely across the internal muscular swellings, it constrains them, and is sometimes the cause of a furrow which runs perpendicular to the fleshy fibers.

These two masses (the external and the internal reliefs) divide the anterior and superior part of the forearm. In lean subjects they are separated by a large and superficial furrow parallel to the axis of the forearm. In well developed subjects this furrow is much less obvious. This is because the two muscular groups may join at the

middle and even cover each other partially, while the internal border of the brachioradialis may cover a muscle of the other group (see Plate 117).

The palmar surface of the forearm narrows at its inferior part. It has a somewhat round surface which is traversed along the middle by the tendons which appear at the wrist.

The posterior surface of the forearm has several distinct muscular swellings. It is naturally divided into two parts by the crest of the ulna, which becomes a furrow due to the adjacent muscles. On the inside there is a somewhat uniform surface traversed by veins and continuous with the internal border of the forearm. This corresponds to the flexor digitorum profundus covered by the flexor carpi ulnaris. This last through the intervention of an aponeurosis takes its insertion from the crest of the ulna. On the outside, there are muscles which appertain especially to the posterior surface of the arm. As a whole their reliefs are directed obliquely from above to below and from outside to within and these become most distinct when the hand is forcefully extended. There is, first of all, parallel to the ulnar furrow, the relief of the extensor carpi ulnaris, which seems to blend with the relief of the anconeus above. Next is the relief of the extensor digitorum, generally blending into that of the extensor digiti minimi. The swelling of the extensor digitorum starts at the condyloid depression and is at first quite narrow. A different furrow separates it from the muscles of the external border, which we shall now study.

The external border of the forearm has three muscular reliefs, each of which describes a distinct curve. First of all there is the curve of extensor carpi radialis longus. Then, far below in the tendinous portion of the forearm a new curve appears. It is formed by the two small fleshy bodies of the abductor pollicis longus and the extensor pollicis brevis blended together. The elongated relief of these two muscles starts, on the posterior surface of the forearm, from under the swelling of the extensor digitorum and descends obliquely towards the external border of the arm to fade away at the wrist. At that point we can see the two tendons of these muscles. Above them we find the relief of extensor carpi radialis brevis. This is clearly fusiform, it terminates in an inferior point and as a whole its direction is parallel to the axis of the forearm. It is contiguous, in the back, to the extensor digitorum and is separated above from the extensor carpi radialis longus by an oblique furrow which appears as a depression on the profile. The fleshy body of this latter muscle blends with the brachioradialis to form a mass which, although external in the neighborhood of the elbow, then descends obliquely towards the anterior surface of the forearm. This has been described above.

As to the internal border of the forearm it offers a uniform transition through its rounded surface between the front and back of the arm.

The veins obliquely crossing this region mount from the posterior surface of the wrist towards the anterior surface of the elbow. There are several on each side but they form two groups. Outside, there are the radial or cephalic veins, on the inside the basilic. There is also a median group on the anterior surface of the forearm. At the bend of the arm this group forms an M, the middle strokes of which accentuate the relief above them.

WRIST (PLATES 80, 81 and 82)

The wrist is situated between the hand and the forearm, though its precise limits are difficult to define. Like the forearm it is generally flat, thus it has an anterior or palmar surface, a posterior surface and two sides.

The palmar surface is crossed by flexion wrinkles, which are usually three in number. They are slightly oblique, their internal extremities being somewhat higher than their external extremities. The inferior wrinkle is the strongest, it borders the heel of the hand and undulates somewhat. The middle wrinkles, about a centimeter above, describe a simple curve of inferior convexity. The superior wrinkle is the same and is less marked. These wrinkles are accentuated even in light flexion of the forearm.

Besides these cutaneous wrinkles, the most notable reliefs on the anterior surface of the wrist are the longitudinal cords formed by the palmaris longus and the flexor carpi radialis. They do not exactly follow the axis of the forearm but they are directed very slightly from above to below and from the inside to the outside. It is important to note that the tendon of the palmaris longus, the thinner but the most projecting tendon, passes outside of the anterior ligament of the carpus. It is almost in the middle of the wrist. On the inside of this tendon there is a depressed surface corresponding to the tendons of the flexor muscles. This leads to the relief of the tendon of flexor carpi ulnaris, the muscle that creates the internal border of the wrist. Outside of the tendon of palmaris longus there is a depression where the inferior extremity of the radius may be sensed. Bordering it on the extreme outside is the tendon of abductor pollicis longus.

A little to the outside of the tendon of palmaris longus there is a prominence on the wrist due to the scaphoid bone. This prominence blends below and towards the outside with the thenar eminence. It is separated from the hypothenar eminence by a slight depression. Isolated beneath the hypothenar eminence, very near the internal border of the region, the pisiform bone projects.

The dorsal surface of the wrist owes its principal morphological traits to the skeleton of the region. On the outside, the inferior extremity of the radius forms a large projecting surface. On the inside and on a slightly raised surface, the prominence of the styloid process of the ulna forms a smaller prominence. Finally, in the middle, the tendons of the extensor muscles are gathered together. It is not until they reach the hand that they form separate and distinct reliefs.

The two side views of the wrist each reveal a slight depression. The depression on the inside is quite flat and extends from the tendon of flexor carpi ulnaris in the front to that of extensor carpi ulnaris in back.

The external side of the wrist is traversed, at its middle and in the direction of the axis of the forearm, by the two united tendons of the abductor pollicis longus and extensor pollicis brevis. Posterior to these tendons,

below the styloid process of the radius, there is a depression limited by the tendons just mentioned and by that of the extensor pollicis longus. This is commonly known as the snuff-box.

HAND (PLATES 80, 81 and 82)

Strictly speaking, the hand is composed of the hand itself and the fingers.

The details of the hand are too well known for me to undertake a tedious description. I shall only describe the relationship of the exterior form to the underlying anatomy.

Body of the hand. Flattened from front to back, the hand has an anterior surface or palm, a posterior surface or dorsum, and two sides. The inferior border gives rise to the fingers.

The *palm of the hand,* depressed at the center, has at its borders several eminences of different shape and volume. The most prominent is at the outside and it corresponds to the base of the thumb. It is called the thenar eminence and is composed of two surfaces. The superior one, ovoid and projecting, rests on the bony prominences of the scaphoid and the first metacarpal; it corresponds to a muscular group of which the uniform relief is never divided. The lower one, depressed and of minor extent, corresponds to the external extremity of a single muscle, the abductor pollicis, which is superficial at this place.

At the internal side of the hand, the hypothenar eminence, due to a group of muscles of the same name, extends along the whole length of the hand, running without precise limitations within the hollow of the palm and the ulnar border of the hand. Above, the thenar and the hypothenar eminences come together without actually touching, and form the heel of the hand. Lower down the two eminences separate and, swerving away from the axis of the arm, they circumscribe the hollow of the palm. The hollow of the palm is limited below by an elongated transversal eminence which corresponds to the metacarpophalangeal articulations. This last eminence is not uniform. It reproduces the anterior concavity of the curve of the metacarpus itself which is created on either side of the hand by the projection of the bases of the index and the little finger. This eminence is also marked, when the fingers are extended and touching, by rising folds which correspond to the interdigital spaces. These are caused by small layers of fat which become folded by the tension brought about by the aponeurotic parts that adhere intimately to the deep surface of the skin of each finger.

The palm of the hand passes well below the inferior limits of the metacarpus and includes in its bony framework the superior extremities of the first phalanges.

Finally, the central depression which constitutes the hollow of the hand is maintained by the adherence of the skin to the palmar aponeurosis.

The palm of the hand is crossed by numerous wrinkles or lines, but they may be reduced to four — two principal and two accessory. They are caused by the movements of flexion of the fingers and adduction of the thumb (Figure 17).

The thenar eminence is encircled, within and below, by a long curved line which is accentuated in adduction. It is the *line of the thumb,* or life line. In flexion of the fingers a transverse line may be seen some centimeters from their base. Slightly curved, it starts at the internal border of the hand and fades away in the interdigital space between the index and middle fingers. It is created by flexion of the last three fingers and is called the *line of the fingers.* The flexion line of the index finger is actually the same as the lower extremity of the line of the thumb or life line. These are the two principal lines of the hand, but they give rise to two accessory lines that are not as profound. Thus, to the inside of the line of the thumb, there is a line which starts at the top of the hypothenar eminence and goes directly towards the space between the index finger and the middle finger. It is accentuated when the thumb is brought towards the little finger. Gerdy has called this line the *longitudinal line.* Finally there is the *oblique line* which starts at the

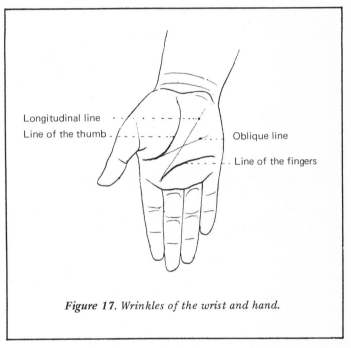

Figure 17. Wrinkles of the wrist and hand.

inferior extremity of the line of the thumb and goes towards the middle of the ulnar border of the hand. This is, of course, an accessory line to the flexion line of the fingers. It has been observed that the different lines of the hand form a capital M. The outside lines are the line of the thumb and the line of the fingers; the inside lines are the accessory lines that form the central V.

The dorsal surface or *dorsum of the hand* considered as a whole reproduces the general transverse convex form of the skeleton. The most prominent part corresponds to the second metacarpal. The surface of the region is the result of the combined forms of the anatomical elements of which it is composed — they are many. Let me mention the metacarpals and the muscles which project in the spaces between them; the lumbricales and the interossei. Also, the first dorsal interosseous running between the first and second metacarpal; the tendons of the muscles, which divide and diverge from the center of the wrist towards each finger; and the meandering and capricious veins, which come from the fingers and describe an irregular arcade of inferior convexity.

The internal side of the hand is rounded and thicker above than below. It is formed by the fleshy mass of the muscles of the hypothenar eminence which descend to embrace the inner side of the fifth metacarpal.

The external side of the hand is divided into two parts: an upper part which carries the thumb, and a lower part which corresponds to the metacarpo-phalangeal articulation of the index finger. The first metacarpal is situated on a plane anterior to that of the other metacarpals which is directed obliquely below and to the outside. Its anterior surface faces to the inside while its dorsal surface is directed to the back and to the outside. This dorsal surface is traversed by two tendons. First, there is the tendon of the extensor pollicis brevis, which is parallel to the metacarpal bone and is inserted into the superior extremity of the first phalanx. Second, there is the oblique tendon of the extensor pollicis long-us. Above, this tendon runs some distance behind the preceding one but they join together at the level of the metacarpophalangeal articulation and run as far as the last phalanx. These two tendons are most visible during extension with abduction of the thumb.

In relation to the inferior border of the hand the longitudinal palmar folds mentioned above occupy a portion of the palmar surface inferior to metacar-pophalangeal articulation. The inferior palmar line (see page 113) corresponds to the middle of the first phalanx of each finger. On the back of the hand the space be-tween the fingers is modeled in such a way that it mounts up from the inferior palmar line to the level of the metacarpophalangeal articulation.

This inferior border is convex. On the back, when the fingers are flexed, it is most convex from the knuckle of the little finger to the middle finger, much less from there to the knuckle of the index.

The fingers. The remarks I have just made concern the relationship of the fingers to the hand itself. All the fingers (except the thumb) seem longer when seen from the back than from the front. On the dorsal surface the fingers seem to start at the metacarpophalangeal articu-lation. On the palmar surface, however, the palm of the hand descends almost as far down as the middle of the first phalanx of each finger and covers the metacar-pophalangeal articulation so that the length of the finger is diminished.

The middle finger descends the lowest, the index scarcely reaches the root of the nail of the middle finger, and the so-called ring finger reaches about half-way down the nail of the same finger. The thumb reaches to the end of the first phalanx of the index, and the little finger to the end of the second phalanx of the ring finger.

Irregularly cylindrical, the fingers have four distinct surfaces, an anterior or palmar, a posterior or dorsal, and two sides. The backs of the fingers correspond al-most exactly to the form of the bony phalanges. They are rounded, and marked at the articulations by trans-verse wrinkles which create an elipse. There are also a few wrinkles between the articulations.

The palmar surface of each finger is divided into three parts by flexion wrinkles. The superior one separates the fingers from the palm of the hand and this wrinkle is doubled for the two middle fingers (the middle finger and the ring finger). These two fingers seem somewhat narrowed at this level. Of the three segments into which the flexion wrinkles divide the fingers the middle one is the shortest. The wrinkle which limits the superior ex-tremity of the middle segment is usually double, that which limits the inferior extremity is single. The skin of the palmar surface is doubled by a dense and elastic cellular tissue which is most abundant upon the last phalanx. The sides of the fingers are quite simple, save for the presence of the terminations of wrinkles coming from their dorsal and palmar surfaces.

All the fingers have three phalanges except the thumb which has two.

ROTATION OF THE ARM

The movements that occur during elevation of the arm have been studied with the trunk, as well as the modifi-cations these movements cause in the upper part of the body. However, we have reserved until now a study of rotation of the arm because there is an intimate connec-tion between rotation of the humerus and the move-ments of supination and pronation of the forearm.

Mechanism. The head of the humerus, which is almost spherical, turns upon itself in the glenoid cavity of the scapula. This movement is performed about an axis which passes through the head of the humerus and con-tinues below with the axis about which the movements of pronation and supination are made. The amount of rotation allowed to the humerus does not exceed 90° and this may be checked on the living model by ob-serving the medial epicondyle. This prominent landmark will be seen to scarcely describe a quarter of a circle. Although the movement of rotation starts at the upper arm through the rotation of the humerus, it may be continued at the forearm through the movements of pronation and supination.

These last movements take place in the articulations which unite the two bones of the forearm at their su-perior and inferior extremities. In the superior articula-tion, the head of the radius turns upon itself in the annular ring which surrounds it. In the inferior articula-tion, the inferior extremity of the radius describes an arc around the head of the ulna of almost 120 degrees. The ulna remains supposedly immobile and the radius carries the hand with it.

In rotation of the forearm the radius is not, as is generally supposed, the only bone which is displaced. The ulna contributes an inverse movement as we have already seen (see page 38). If we wish to really study the movements of the radius and ulna by themselves, the forearm must be flexed. It must be understood that this flexion in no way hinders the rotation of the two bones of the forearm; they are absolutely independent of the rotation of the humerus. If one considers the relative positions of the two bones of the forearm in various degrees of rotation, one observes the following. In the attitude of supination the two bones are side by side and parallel, but not altogether in the same plane, the radius being situated in a plane anterior to that of the ulna. As soon as the movement of pronation starts

the head of the radius turns in its fibrous ring and the inferior extremities of the two bones are displaced in inverse directions; the radius moves to the front and the ulna to the back. To the extent to which pronation is increased these movements become proportionately accentuated. Finally, at the limit of pronation, the inferior extremity of the ulna becomes external and the inferior extremity of the radius becomes internal, yet the two bones are not in the same transverse plane they were when they started. They are now in a plane slightly oblique to the initial plane. The result is that the movement of each extremity is no more than a demicircumference.

If the rotation of the humerus and the rotation of the forearm take place together the combined rotation is about three quarters of a circle.

The amount of rotation may be clearly understood by a study of the forms and the figures in Plates 101, 102, and 103. The hand is shown first in supination, the palm turned to the front; second, in demipronation, the palm turned within; and third, in pronation, the palm turned to the back. In forced pronation, which is the limit of the movement of rotation, the hand is turned to the outside. However, the hand can never turn so much that it faces the front again.

MUSCULAR ACTION

The movement of rotation of the arm is produced to a great extent by deep muscles. Thus rotation of the humerus to within is brought about by the subscapularis, a muscle situated under the shoulder blade. Its action is complemented by the teres major, which constitutes part of the scapular region, and by two other muscles which influence the exterior form considerably—the latissimus dorsi and pectoralis major. However, the last two muscles only intervene when the movement is violent. Rotation to the outside is produced by the infraspinatus and teres minor, both muscles of the scapular region.

In the forearm, supination is produced by the supinator and the biceps brachii; pronation, by pronator quadratus which is buried in the deep layers of the anterior inferior region of the forearm, and by pronator teres.

MODIFICATION OF EXTERIOR FORM (PLATES 101, 102 and 103)

When the arm is extended the movements of supination and pronation of the forearm never take place independently of the rotation of the humerus. If the arm is in supination, as soon as pronation starts the humerus begins to rotate. This rotation is very slight at the beginning of the movement. It is only when the pronation of the forearm reaches its limit that the rotation of the humerus becomes clearly accentuated, continuing and complementing the rotation of the lower arm.

We therefore cannot separate, in the study that follows, the rotation of the upper arm from that of the forearm. We have to study the morphological modifications down through the whole extent of the arm. Four stages of the movement of rotation of the arm—supination, demipronation, pronation, and forced pronation —are illustrated in Plates 101, 102, and 103.

It should be observed that the forms of the trunk are modified by these movements. In the front the pectoralis major, relaxed in supination, contracts according to the amount of rotation it produces. In forced rotation it becomes hard and projects. It is then almost spherical in form and the fasciculi appear on the surface. In the back the two scapulae, at first close together, separate. The point of the shoulder tends to be carried to the front, although this is most marked at the end of the movement. The deltoideus, at first in repose, undergoes a movement of torsion upon itself; beneath the skin its distinct fasciculi undergo a sort of twisting around the head of the humerus. The muscles of the arm, the biceps and triceps brachii, undergo the same sort of twisting and this is expressed on the exterior form by an obliquity, or spiraling almost, of the muscular eminences and the depressions which separate them.

The forearm also shows a number of changes in its general shape. Flat in supination, it becomes rounded in pronation; this is because of the superimposition of the two bones which fall across each other. Plates 101, 102, and 103 perhaps explain this better than a long and difficult verbal description. The artist should be able to follow easily the displacement of the different muscles by studying the anatomical sketches. It should be noted that the wrist retains its somewhat block-like form and it will always seem longer in supination than it does in pronation.

MOVEMENT OF THE ELBOW

Mechanism. Let me restate here that the articulation of the elbow is an actual hinge that only permits a single sort of movement (see page 38)—a movement of flexion and extension around a transverse axis passing through the inferior extremity of the humerus. This axis is not perpendicular to that of the arm but is a little oblique from above to below and from outside to within. Due to this fact the forearm does not flex directly upon the arm. Instead of meeting the shoulder, the hand is carried somewhat to the inside.

In flexion, the anterior surfaces of the forearm and the upper arm only touch near the elbow joint.

This movement is limited by the meeting of the coronoid process of the ulna with the coronoid fossa of the humerus. Extension brings the two segments of the arm into the same plane. However, sometimes the limit is passed and the forearm forms an obtuse angle opening to the back with the upper arm. I have observed this disposition, which should be classified as an acquired deformation, among certain subjects who have often performed the movement of extension with violence, such as boxers.

MUSCULAR ACTION

Extension is produced by two superficial muscles, the anconeus and the triceps brachii. Their action strongly affects the exterior form.

The lateral and medial heads of the triceps act with equal force during extension. The long head is, however, only a feeble extensor—its principal function is to fix

the head of the humerus solidly against the glenoid cavity when the arm is lowered.

Flexion of the forearm on the upper arm is produced by three flexor muscles and one of them has an additional function, the biceps brachii is not only a flexor but a supinator.

As I have pointed out, movements of supination and pronation may be executed perfectly even though the arm is flexed. If these movements are made with effort, the adductors and abductors of the arm enter into contraction. That is why, during supination, the elbow approaches the body, while during pronation it moves away.

MODIFICATION OF EXTERIOR FORMS (PLATE 104)

We have already described the forms of the arm when the arm is extended because full extension is part of the conventional attitude used for study. In this position the triceps brachii only becomes contracted when the extension is carried to its extreme limit or when it is forced. As a matter of fact, when the arm falls naturally alongside the body extension is maintained by gravity. This extension, however, is never complete.

When the arm is flexed, the triceps brachii is distended and the posterior surface of the arm becomes quite flat. In the front, the biceps becomes globular, forming a swelling which grows larger according to the effort made and the degree of flexion. As the brachialis is also contracted, its superficial relief becomes distinct and is bordered by deep grooves.

If flexion is produced (the lower arm being in demi-pronation) so that the forearm is at a right angle with the upper arm, and if action is performed with muscular effort as in the act of lifting a weight (Plate 104), then the brachioradialis will create a relief distinct from that of the extensor carpi radialis longus. In all other positions these two muscles seem to blend together. During the action described above the tendinous expansion of the biceps brachii, stretched by the muscle's contraction, will cut a deep furrow across the internal mass of the forearm.

Flexion of the forearm may at all times be accompanied by any degree of pronation or supination. I should like to point out that this produces rather complex forms which I do not think it necessary to describe.

Finally, if flexion is carried to its furthest limit, the back of the elbow takes on an angular form, its point being the olecranon.

MOVEMENTS OF THE HAND

The movements of the hand on the forearm are of two types. They take place about two axes. Movements of flexion and extension take place around a *transverse* axis and movements of adduction and abduction take place around an *anteroposterior* axis.

Flexion and extension take place in the radiocarpal articulation.

Flexion is more extended than extension and it easily attains a right angle, that is to say the hand may be placed in a plane perpendicular to the plane of the fore-

arm as long as the fingers are completely extended. As a matter of fact if the hand is clenched, the movement of flexion allowed is much less and the hand can only make an obtuse angle with the forearm. This is due to the fact that the extensor muscles of the fingers, already extended by the flexion of the fingers, restrict the hand from any further flexion.

In extension the hand always forms an obtuse angle with the forearm opening to the back. But the simultaneous flexion of the fingers augments the extension of the hand—the reason for this is analogous to the inverse movement I have just mentioned.

The movements of adduction and abduction take place in the radiocarpal articulation. Adduction is extensive; abduction is somewhat limited.

MUSCULAR ACTION

There are three extensor muscles and they each have a special action.

The extensor carpi radialis longus is an extensor and an abductor, and the extensor carpi ulnaris is an extensor and an adductor.

If the extension of the hand is made with effort, the three muscles contract simultaneously. Flexion of the fingers is always accompanied by the synergetic contraction of the extensors of the wrist.

There are three flexors: the palmaris longus, the flexor carpi radialis, and the flexor carpi ulnaris.

These muscles are synergetic with the extensors of the fingers. When they contract they make an easily visible relief because of their superficial situation on the forearm.

Lateral inclination. In abduction the hand inclines away from the body, in adduction, towards the body. Abduction is largely induced by the extensor carpi radialis longus and by the abductor pollicis longus. Adduction is produced mostly by the extensor carpi ulnaris.

MODIFICATION OF EXTERIOR FORM

In flexion of the wrist the heel of the hand is pushed within and numerous cutaneous wrinkles appear. The tendons of the flexor muscles make strong cord-like prominences on the anterior surface of the wrist. These prominences vary depending on whether the muscles are being used to move the fingers or the wrist. Therefore, the modeling of the anterior surface of the forearm depends on whether the flexors of the fingers or the flexors of the wrist have gone into action. When the hand is flexed the posterior surface of the wrist becomes rounded. The rounded upper surface of the capitate bone becomes prominent medially and above it the two lateral prominences of the inferior extremities of the bones of the forearm appear.

Extension of the hand effaces the flexion wrinkles on the anterior surface of the wrist. The relief of the scaphoid becomes exaggerated and tendons of the distended flexor carpi radialis and palmaris longus disappear at the vicinity of the wrist. On the back the summit of the angle formed by the hand and forearm is filled by a sort of intermediate inclined plane situated

close to the radial border. Beneath this surface the tendons of the extensor carpi radialis longus and brevis muscles run to their insertion in the metacarpus. Several cutaneous wrinkles limit the surface above and below.

On the forearm the fleshy bodies of these two muscles can be clearly seen.

MOVEMENTS OF THE FINGERS

Mechanism and muscular action. In flexion the different sections of the fingers form right angles between themselves, though this angle may be surpassed in the articulation between the phalanges. An exception must be made for the thumb, where the angle of flexion is less. In extension the phalanges arrange themselves in a straight line. However, this movement is usually more extended at the metacarpophalangeal articulation, and the fingers may form an obtuse angle with the back of the hand.

However, in this regard, there are many individual variations. The movements of the index finger are free; those of the last three fingers are interdependent.

Only the movements of flexion and extension can take place between the phalanges. However, at the metacarpophalangeal articulation lateral movements occur. There the fingers may withdraw from the axis of the hand (abduction) or approach it (adduction).

The thumb owes its varied and extended movements mostly to the mobility of the first metacarpal and from this mobility varying movements of apposition result. Normally the thumb lies on an anterior plane, the palmar surface of the thumb being directed a little to the inside. In movements of apposition the palmar surface of the final phalange of the thumb may touch successively the extremities of each of the other fingers. This movement is accentuated by the great mobility of the last two metacarpals and above all by that of the fifth. This last may move in an analogous action to meet the metacarpal of the thumb.

The muscular action which controls the movements of the fingers is most complex. Though an understanding of this is necessary for doctors, I do not think it is necessary for artists. It is sufficient to remember that a certain number of the muscles that move the fingers have their fleshy bodies on the forearm and their forms naturally undergo changes even when the fingers are moved but slightly.

I should also like to point out the synergetic action of the flexors of the fingers and the extensors of the thumb when the fist is clenched, as well as that of the extensor carpi ulnaris during abduction of the thumb.

MODIFICATIONS OF EXTERIOR FORM

I shall be brief in my description of the exterior forms of the hand as everyone has them directly under his eyes. In flexion, the dorsal wrinkles of the fingers are effaced and the angular bony projections which replace them are due to the inferior extremities of the bones which occupy the superior parts of the articulations. In the metacarpophalangeal articulation, the head of the metacarpal is surmounted by the tight cord of the extensor tendon and as a result the exterior form does not correspond to the rounded surface of the head of the metacarpal but takes on an angular aspect. On the palm the lines of the hand are best understood if they are simply thought of as flexion wrinkles of the fingers and flexion wrinkles of the thumb. In movements of apposition of the thumb to the other fingers, the hollow of the hand becomes deeper, while the dorsal surface becomes more rounded.

17. Exterior Form of the Lower Limb

We shall study successively the thigh, the knee, the lower leg, and the foot.

THIGH (PLATES 83, 84, 85 and 86)

The thigh is rounded and fusiform in shape only on fat subjects and on most women. As soon as the musculature is slightly developed, the thigh is seen to be formed of the three distinct muscular masses we have studied above. They are disposed this way: in the front and to the outside there is the mass of the quadriceps femoris; within and above, the mass of the adductors; and in the back, the hamstring group.

The anteroexternal mass fills the whole external surface of the thigh and only a part of the anterior surface. On the outside this mass starts beneath the great trochanter and descends to the knee. Its surface corresponds to the relief of the vastus lateralis restrained by the strong aponeurosis of the fascia lata. The tensor muscle makes a distinct eminence beneath this aponeurosis which runs from the iliac crest in front of the great trochanter. The relief of the vastus lateralis is limited in the back by a deep furrow—the *external lateral furrow*. In the front the relief blends with the swelling of the rectus femoris and the vastus medialis. The quadriceps femoris occupies the anterior and inferior part of the thigh and it is limited on the inside by the oblique surface of the sartorius. It starts above with the depression previously referred to as the femoral depression. This depression is caused by the separation of the two muscles which fall from the anterior superior iliac spine—the sartorius and the tensor of the fascia lata.

The bottom of this depression rests on the tendon of rectus femoris which disappears upwards towards the anterior inferior iliac spine where it takes its origin. The fleshy body of this same muscle, which is situated at the middle of the anterior surface of the thigh, reproduces on the side view the curve of the femur on which it rests. On the whole the rectus femoris does not form a distinct relief unless it is contracted; this relief is fusiform and is marked at its superior middle line by the superior aponeurosis of the muscle.

Below and to the inside of the thigh the vastus medialis creates a sort of ovoid mass the point of which is lost, above, between the rectus femoris and the sartorius. The larger portion descends as far down as the middle of the patella. There is often a distinct relief

formed at that point by the muscle's most inferior fibers. We shall study these with the knee.

The surface of the sartorius scarcely merits a special description. It cuts obliquely across the thigh, passing from the anterior surface to the internal surface and it corresponds exactly to the description of the muscle we have already given (see Plate 127). Above, the surface of the sartorius is reduced to a minor furrow. The whole mass of the adductors is situated above and behind it and fills the angle described by the sartorius and the fold or line of the groin. As the adductor mass descends, increasing in volume, it fills the whole internal and superior part of the thigh. It is made up of all the adductors including the gracilis, but no particular muscle stands out individually. In the back the adductors blend into the posterior mass of the thigh without leaving a line of demarcation. The posterior surface is traversed by the saphenous vein.

In the back the thigh forms a rounded relief at its superior part which extends from the internal border to the external lateral line or furrow. Above, this rounded relief is separated from the buttock by the fold of the buttock and at that point it forms a slight swelling. This swelling of the thigh becomes narrower as it descends. Lower down it is bordered by two furrows — one on the inside, which is limited by the surface formed by the tendons of the gracilis, the semitendinosus, and the semimembranosus, and one on the outside, which is a continuation of the lateral line of the thigh.

In fat subjects these muscular reliefs become minimized and the thigh, as I have said, takes on a rounded and fusiform aspect. This is usually characteristic of women. Let me bring to your attention the fact that women have a veritable parcel of fat at the external and superior part of the thigh (see page 79). This disposition is found at its highest degree of development, along with steatopygia, among the female South African Bushmen and the African Hottentots. It may also be observed frequently in the white race in various degrees of attenuation.

KNEE (PLATES 83, 84, 85 and 86)

The knee, situated between the thigh and the lower leg, corresponds to the articulation of the femur and tibia. Considered together the condyles of the femur surmounting the tuberosities of the tibia constitute a quad-

rangular mass. The patella projects in front of this mass and the inferior extremity of the patella almost descends to the articular interplane. The knee, therefore, offers four surfaces: an anterior surface, two sides, and a posterior surface, or bend of the knee.

Important changes are caused in the morphology of the anterior region of the knee through the contraction of the muscles of the thigh. The upright position is not necessarily accompanied by a contraction of the quadriceps, the extensor muscles of the thigh. But if the muscles do contract, the patella is raised, it is applied more directly against the bony surfaces, the integument stretches, and certain reliefs disappear.

Let me describe the knee both in extension and in muscular repose.

The patella dominates the middle of the region. Its upper border or base presents two rounded angles. On its posterior surface there are two facets. Its anterior surface juts forward further on the model than on the skeleton because of the serous bursa beneath it. Its inferior angle, which continues into the patellar ligament (ligamentum patellae), is ordinarily masked by a light transversal swelling of the skin that joins the two lateral prominences formed by the infrapatellar pad of fat. These prominences jut out on each side of the patella. On the median line below the patella, the patella ligament only shows on the exterior when the quadriceps is contracted. During muscular relaxation this region is often cut by a transverse cutaneous furrow which becomes deeper the more the muscle is relaxed. This furrow is very deep on the leg of the standing side of the Doryphoros of Polycleitus (see Figure 20 page 121).

When this furrow is not present, the region below the patella has a heart-shaped relief, the point of the heart descending to the anterior tubercle of the tibia where the patella tendon is inserted. The top of the heart corresponds to the two lateral fatty prominences embracing the downward point of another smaller prominence created by the inferior angle of the patella itself.

Above the patella there is a surface which corresponds to the inferior tendon of the rectus femoris. This is bordered laterally by the unequal swellings of the inferior extremities of vastus medialis and vastus lateralis.

The region above the patella should be studied in some detail (Figure 18). There is a furrow well above the patella formed by a portion of the lowest part of the fleshy body of the vastus medialis. The most inferior part of this muscle forms a swelling which is distinct from the rest of the muscle under certain conditions and under the influences of a special anatomical disposition. The most inferior fibers of the vastus lateralis often produce an analogous relief.

These forms, which might be called the inferior protuberances of the vastus medialis and of the vastus lateralis, appear clearly when the leg is extended and the model is standing at ease. They coincide with muscular relaxation and are even more evident when relaxation is complete. If the muscle contracts (the leg being in extension), they are less evident and in certain subjects disappear altogether. The separate inferior protuberance of the vastus medialis, even in slight flexion, sometimes remains distinct among subjects with extremely well developed muscles. Generally, however, this protuberance

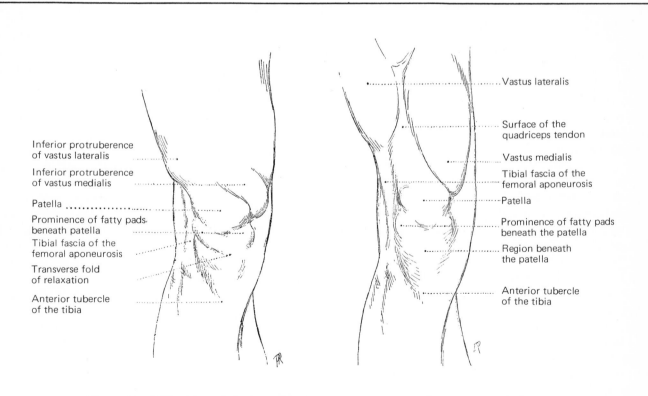

Figure 18. (left) Knee when the quadriceps muscle is relaxed (anterior aspect). (right) Knee when the quadriceps muscle is contracted (anterior aspect).

disappears, as does that of the vastus lateralis, because these are distended due to the increased flexion of the leg (Figure 19). These forms often exist among young subjects and also among women (see page 121), but they are not as clear as those on well developed subjects and sometimes they are more or less masked by subcutaneous fatty tissue.

Artists, both ancient and modern, have represented these muscular reliefs with remarkable frankness and exactitude.*

From the morphological point of view, these reliefs have the following characteristics. The vastus lateralis forms the most superior relief, and it is a more or less suppressed rounded mass. Vastus medialis forms a sort of bulge directed obliquely from above to below and from without to within. Its lower portion descends to about the level of the middle part of the patella.*

The inferior part of the vastus medialis moves to the back as a rounded extremity and reaches the elongated prominence of the sartorius (Plate 86). Above and in front of this it mounts towards the median line of the thigh where it terminates.

* Among the classical works that might be mentioned, the *Achilles*, the *Doryphoros* of Polycleitus, and the *Apollo Sauroctonus* by Praxiteles; among the modern works, *David* by Mercie and *St. John the Baptist* by Rodin.

* The inferior fibers of the vastus medialis descend lower than is generally thought. In relaxation and on the cadaver it is easy to ascertain that they pass beyond the superior border of the patella usually as far down as the level of its middle part.

Sometimes a swelling of the skin makes a sort of bridge obliquely crossing the surface of the patella. This unites the two reliefs.

I have pointed out the anatomical reason for these partly muscular reliefs (see page 71). At the inferior part of the femoral aponeurosis there is a veritable aponeurotic band. It terminates below in the resistant aponeurotic sheath which maintains the muscles of the anterior part of the thigh (Figure 20). In relaxation of the quadriceps the fleshy extremities of the vastus medialis and the vastus lateralis swell out below it. The constriction which the fibers of the band exert upon the fleshy body of the vastus medialis determines the furrow which limits the upper part of the inferior relief and separates it from the relief above. This furrow varies in depth among individuals, the variations depending on the tension of the band and upon the amount of condensation, in this area, of the aponeurotic fibers which compose the band.

This separate relief of the inferior portion of the vastus medialis is a natural form, related directly to muscular development. It appears in models of all ages but it is extremely variable and becomes apparent only in certain positions of the leg. It should be classed among the incessant modifications of form which movement imparts to different parts of the human body. The importance of studying this relief lies in the fact that it not only reveals muscular contraction, but it indicates the physiological state of the muscle, and occurs essentially in the living model (Figure 21).

Sometimes a cutaneous furrow becomes apparent

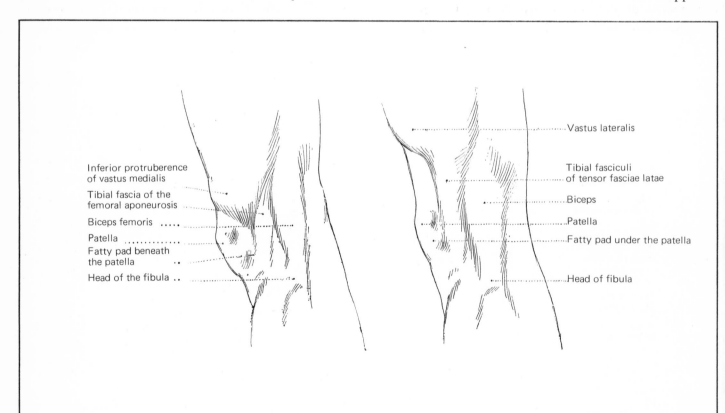

Figure 19. *(left) Knee when the quadriceps muscle is relaxed (lateral view). (right) Knee when the quadriceps muscle is contracted (lateral view).*

above the patella. I have observed it on elderly models. It is situated immediately above the patella and covers the inferior extremity of the tendon of the rectus femoris. The cutaneous origin of this furrow is indicated by the fact that it is produced by the extension of the knee and that it becomes deeper when the quadriceps is contracted because of the elevation of the patella. The muscular relief itself is lessened or, at times, even effaced, when the muscle is in action. At certain times and on certain subjects the two furrows, one muscular, one cutaneous, may both appear at the same time.

Let us now take up the two sides of the knee.

The external or lateral surface is depressed because of the muscles of the thigh above it and those of the lower leg below it. The internal or medial surface, on the contrary, seems to project.

The lateral surface of the knee is traversed towards its center by the termination of the lateral furrow of the thigh. On each side of this furrow there are two longitudinal prominences. They differ in size and shape but they both terminate below in a bony eminence. The anterior prominence is restrained and flattened. It corresponds to the tibial fasciculi of the tensor fasciae latae. It is continuous above with the relief of vastus lateralis which partly masks the larger relief of the fleshy fibers of vastus intermedius. This latter muscle only appears in flexion. The anterior prominence terminates at the external tuberosity of the tibia. The posterior longitudinal prominence, rounded and larger, is formed by the tendon of the biceps femoris and by the fleshy fibers of this muscle's short head. It starts above,

contiguous to the lateral furrow of the thigh, and descends towards the back of the knee. It terminates below at the head of the fibula.

The medial surface of the knee is more or less divided into two equal parts by the furrow which runs along the anterior border of the sartorius. In the anterior part it should be noted that the posterior border of vastus medialis is situated very far back. Below the relief of the vastus medialis there is a rounded surface corresponding to the two contiguous condyles of the femur and the tibia. These are at times divided from each other by a depression at the level of the interarticular plane. Further to the front there are the prominences due to the internal angle of the patella, to its fatty cushion, and to the lower patellar tendon.

The back part of the medial region of the knee is more uniform. The inferior extremity of the sartorius can be clearly seen; its fleshy fibers descend and sometimes pass down through the interarticular plane. Further back there is a surface which corresponds to the union of the tendons of the gracilis, the semimembranosus and the semitendinosus. The lower part of the internal surface of the knee blends into the surface of the tibia. This, however, is part of the lower leg and will be described later.

Back or bend of the knee (Plate 84). The back of the knee is somewhat hollow in flexion. In extension, however, it forms a longitudinal relief which extends above and below the limits of the region of the knee well into the posterior muscle masses of the thigh and lower leg. This relief is fairly near the middle of the back of the

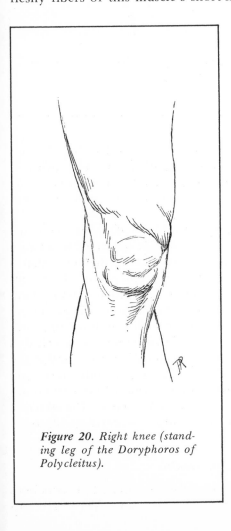

Figure 20. Right knee (standing leg of the Doryphoros of Polycleitus).

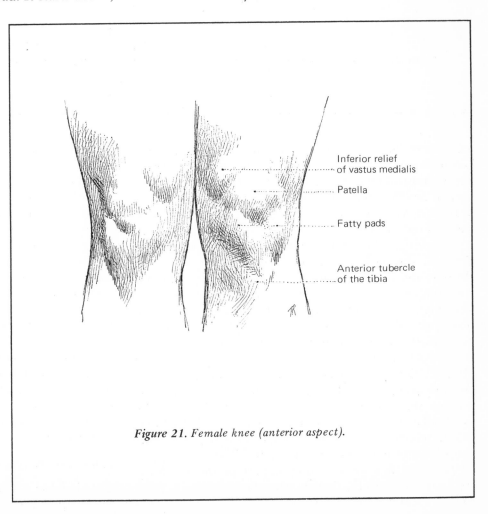

Inferior relief of vastus medialis

Patella

Fatty pads

Anterior tubercle of the tibia

Figure 21. Female knee (anterior aspect).

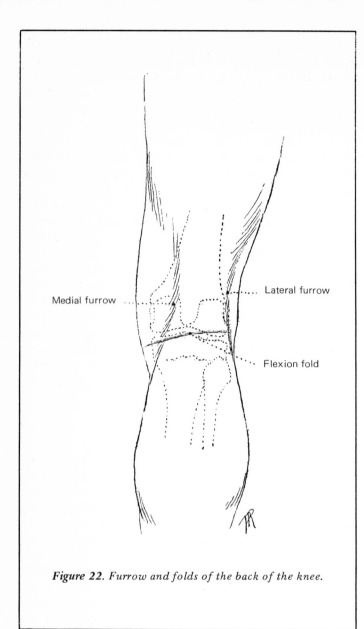

Figure 22. Furrow and folds of the back of the knee.

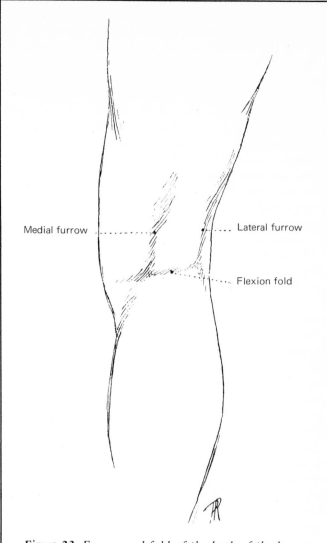

Figure 23. Furrow and fold of the back of the knee on women.

knee. It is formed, above, by the internal border of the biceps femoris on one side and the inferior extremity of the semimembranosus on the other and, below, by the medial and lateral heads of the gastrocnemius. It is filled with vessels, nerves, and fat, although these cannot be seen on the surface.

Two longitudinal furrows or lines border the median relief of the back of the knee. The external one is the deepest and it follows the tendon of the biceps, mounting obliquely as if to join the lateral external furrow of the thigh. It extends below to the head of the fibula. The more shallow internal furrow or line rises above, towards the surface of the sartorius; below, it describes a curve which embraces the knee in a concavity turned to the front, thus separating itself from the gastrocnemius (Figure 22). This line is often more distinct on women than on men because of the fat which usually accumulates on the whole internal region of the knee. On its course it is marked by several depressions, the most inferior being where it meets the flexion fold.

The fold lies on the inferior part of the region, it extends transversely, though somewhat obliquely, from below to above and from inside to outside. It corres-

ponds to the deeper articular interplane of the leg, which it crosses in an oblique direction. Although it is usually clear on models who are fat and on women, it is scarcely visible on lean subjects and it is never apparent when the leg is extended.

The back of the knee is thus framed by the two longitudinal prominences I have already described in relation to the external and internal surfaces of the knee—that is to say, by the longitudinal prominence of the biceps femoris on the outside, and by the tendinous and rounded surface which rises towards the sartorius on the inside (Figure 23). In flexion this surface shows the cordlike prominences of the various tendons of which it is composed: the tendon of the gracilis in front and in the back the united tendons of the semimembranosus and semitendinosus. These tendons form the internal border of the hollow of the back of the knee. The external border, which does not descend as low, corresponds to the biceps femoris.

LOWER LEG (PLATES 83, 84, 85 and 86)

The skeleton of the lower leg is composed of two bones of unequal size placed side by side. These are sur-

rounded by muscles which group themselves into two distinct masses, an anteroexternal mass and a much more important posterior mass. On the inside of the lower leg the internal surface of the tibia is subcutaneous throughout its whole length.

Swollen at its middle, the lower leg becomes gradually thinner below because, at this point, the muscles which compose it become tendinous. This attenuation may or may not be abrupt and it may be high or low, it depends on how far down the fleshy fibers descend upon the tendons, which in turn depends on whether the muscles are the short or long type.

The anteroexternal mass, which is completely convex, has three surfaces: that of the tibialis anterior, that of the extensors and that of the peroneal muscles.

The internal and most anterior surface runs from the anterior tuberosity of the tibia and it corresponds to the tibialis anterior. The fusiform fleshy body of this muscle directed obliquely down a little to the inside overlaps the crest of the tibia. As a result the upper anterior border of the lower leg is soft to the touch and on the profile it describes a curve which is more accentuated than that on the skeleton. About halfway down the lower leg the fleshy body of tibialis anterior is succeeded by its tendon which follows the same direction as the muscle. The tendon is important; we shall take it up when we discuss the ankle.

The surface of the *extensors* is well developed only on the inferior part of the lower leg. On the superior part it is reduced to a sort of furrow, more or less large, which runs between the two neighboring surfaces of the tibialis anterior and peroneus longus and brevis.

The surface of the peroneal muscles, completely turned to the outside, is several fingers' breadth in width. This surface starts above beneath the prominence of the fibula and it is only when the muscles are relaxed that it is uniform. In contraction, it is marked below by a median longitudinal surface due to the superimposed tendons of the two muscles. As this surface descends, it divides obliquely to the front and to the rear exposing the inferior extremity of the fibula a few fingers' breadth above its lateral malleolus. As the fibula is situated on a plane behind that of the muscles, it creates a constant depression at the level where the peroneal surface divides.

The whole posterior mass of the leg is formed by the gastrocnemius (see page 73). Its two heads are superficial and form the relief of the calf. The gastrocnemius rests on the soleus, which is well hidden except for its borders which appear on the surface of the leg on each side.

At the top of the lower leg, descending towards each other, the two heads of the gastrocnemius form longitudinal prominences on each side of the median line. The medial head of the gastrocnemius is larger and descends somewhat lower than the lateral head. It forms a strong relief on the internal surface of the leg whereas the lateral head does not extend beyond the swelling of the soleus. The result is, on the superior front view of the lower leg, the medial head of the gastrocnemius alone is visible. The rounded inferior borders of the two heads form the bottom of the calf and create a strong relief on the tendo calcaneus. The height of this relief depends on the individual.

Beneath the two heads of the gastrocnemius there is the tendo calcaneus which becomes narrower as it descends. Its sides blend with the borders of the soleus. On the outside view the external border of the soleus forms a narrow plane which mounts to the level of the head of the fibula. On the inside the swelling of this muscle may be noted on the center third of the length of the lower leg. The soleus maintains the gastrocnemius and the degree of development of the soleus has a lot to do with the thinness or thickness of the lower part of the lower leg.

On the medial surface of the leg a relief is formed by the medial head of the gastrocnemius and the internal border of the soleus. This double relief is limited in front by a curved line of anterior convexity which continues above in an inverse curve to embrace the knee as far as its internal furrow or line at the back. The entire depressed anterior part of the lower leg is occupied by the interior surface of the tibia which is subcutaneous throughout its whole length. This surface is more rounded than it is on the skeleton because of cellular tissue which thickens the skin. It is traversed by the great saphenous vein which rises to the interior border of the gastrocnemius.

ANKLE (PLATES 83, 84, 85 and 86)

The ankle forms the junction of the lower leg and the foot. They unite at a right angle. The region is made up of the skeleton which consists of the inferior extremities of the leg bones and the talus and the tendons of the muscles. The skeleton appears on the sides, the tendons in the front and back. On the inside the large internal malleolus is situated well to the front; on the outside the external malleolus is narrower, lower, and occupies the middle of the region. In the front the tendons are not too distinct but in the back a strong long tendon (tendo calcaneus), removed some distance from the leg bones, is attached at a right angle to the calcaneus, forming a most prominent relief. We will consider successively these four surfaces of the ankle.

From the front the ankle presents a transverse rounded surface facing to the outside and the tendons stand out prominently only during violent movement. This surface ends on the medial side in the front with a relief formed by the tendon of the tibialis anterior which is always distinct. This tendon descends obliquely from within to without and terminates as far down as the base of the first metatarsal. The prominence of the tendon is due to an anatomical disposition which we have already discussed (see page 73).

On the medial side of the ankle, immediately behind the tendon of tibialis anterior, the prominence of the internal malleolus takes up the whole anterior half. The posterior half is traversed by a wide furrow running over the deep muscles of the lower leg which fill the groove of the calcaneus on their way to the sole of the foot. This retromalleolar furrow is bordered in the back by the tendo calcaneus. It descends below and to the front decreasing in depth but rounding out the malleolus.

The middle of the external side of the ankle is occupied by the lateral malleolus which blends in front with the surface of the extensors. This malleolus is

formed by the inferior extremity of the fibula and further developed by the tendons of the peroneal muscles which embrace it in the back. These tendons decrease the angular form of the bony extremity and at the same time increase its volume. They only become distinct in certain movements of the foot.

A retromalleolar furrow, narrower than that on the internal side of the ankle, borders the malleolus in the back and extends under it (the inframalleolar furrow). This furrow is cut by an oblique cord which, from the summit of the malleolus, runs down and to the front, to the tuberosity of the fifth metatarsal. This cord is due to the tendon of the peroneus brevis.

Finally, at the back part of the region of the ankle, the tendo calcaneus is situated. It is the strongest tendon in the whole body. It describes from the lateral and medial points of view a slight curve of posterior concavity. From the posterior aspect it appears smallest at the height of the lateral malleolus, and at its insertion into the calcaneus it presents a slight swelling.

FOOT (PLATES 83, 84, 85 and 86)

The foot is divided into two distinct parts: the foot, so called, or vault of the foot, and the toes.

Vault of the foot. It is the skeleton, which is composed of the tarsus and the metatarsus, that dominates the general form of the region. We shall consider the foot as having two surfaces, a superior and an inferior; two borders, an external and internal; and two extremities. The vault which forms the foot is arched on the inside, depressed on the outside. It is supported by the calcaneus in back, by the heads of the toes in front, and by the fifth metatarsal at the external border. The bones of the leg do not rest on the middle of the vault but on a point of culmination situated more in back and formed by the talus (see Plates 29 and 31).

Superior surface or dorsum of the foot. The leg rests on the posterior half, more or less, of the vault, thus the inferior surface of the foot is much longer. The dorsum of the foot corresponds to the form of the skeleton, its rounded surface inclines to the front and to the outside. Its point of culmination corresponds to the articulations of the first and second cuneiforms with the first and second metatarsals. It is traversed by a number of tendons which diverge from the middle of the ankle to the anterior circumference of the foot. Proceeding from within to without these are: the tendon of the tibialis anterior which goes to the internal border of the foot; the tendon of the extensor hallucis longus; the tendons of the extensor digitorum longus; finally the tendon of the peroneus tertius, which descends towards the styloid process of the fifth metatarsal.

It should be noted that, on the outside, the relief of the extensor digitorum brevis muscle is situated below and well in front of the lateral malleolus. Also, before reaching the internal border, the surface of the dorsum of the foot is sometimes depressed into a sort of valley. (This is apparent on many ancient statues.) Finally, under the skin of the region there are numerous veins, particularly the venous arcade of the metatarsals.

Sole of the foot. This really designates that part of the foot which rests on the ground. It is composed of the hollow of the vault and opens on the inside. It is closed on the outside, in the back and front, where the foot touches the ground.

The skin of the sole of the foot is thick and filled inside with a thick deposit of fat which has a cushioning effect. The result is that no muscular detail appears in this region. The morphology, as on the dorsum of the foot, is dominated by the skeleton. At the level of the points of support the skin has certain notable characteristics. There is a thick cushion in front stretched under the metatarsophalangeal articulations and its thickest part corresponds to the big toe. This cushion is caused by the volume of the anterior extremity of the metatarsal of the big toe and the two sesamoid bones at the inferior surface of the articulation. Since this cushion encroaches upon the toes, they seem very short when seen from the plantar aspect. We have seen that the fingers are disposed in an identical manner. The skin along the whole external border of the foot has the same characteristics. In the back, beneath the calcaneus, there is a large surface of support in the form of an oval. At the summit of the vault the skin is finer and has oblique wrinkles which become exaggerated when the foot is arched.

The points of support upon the ground, which consist of the heel, the external border and the base of the toes, when considered together take up three quarters of the circumference of the foot.

The internal border, thickset and raised, takes up the transition between the plantar vaults and the internal retromalleolar furrow. The relief of the abductor hallucis appears and, right in the front, the voluminous articulation of the big toe. This region is traversed by the venous network of the medial marginal vein of the foot.

The external border is thinner and rests entirely on the ground. It is marked, in the center, by the relief of the posterior extremity of the fifth metatarsal.

The toes. The toes (except for the big toe) have all the characteristics of the fingers of the hand although they are more rounded, smaller, and end in an extremely large extremity which rests on the ground.

The big toe is much bigger than the others and is separated from them by an interval which in classical times was augmented by the thong of the sandal. Modern shoes tend to change the direction of the toes. They are squeezed together and are so compressed they become flattened on each side. These acquired deformities must be kept in mind when the direction of the toes is studied. The big toe does not follow the direction of its metatarsal which forms the internal border of the foot. It is slightly inclined to the inside, towards the median axis of the foot. This disposition, though it is certainly exaggerated by our shoes, may still be noted on classical statues. The second and third toes are more or less parallel to the first. Their axis, prolonged to the back, touches the medial malleolus. The last or fifth toe follows an inverse direction. Its axis, if prolonged to the front, converges with the axis of the other toes at a distance of about half the length of a foot. As for the fourth toe its direction is variable. Sometimes it is the

same as that of the first and second, sometimes it is parallel to the fifth. The last disposition is the one most often encountered in classical statues. One notices also, on these same statues, that the little toe is raised and does not rest on the ground.

Like the fingers, the toes are of unequal length. Sometimes the big toe is the longest, sometimes the second toe. Both these dispositions can be seen on classical statues. The third toe is shorter than the second by the length of a nail. The fourth scarcely reaches the nail of the third and the fifth is situated even farther in the back.

The dorsal surface of the toes is rounded and light wrinkles traverse the phalangeal articulations. On the inferior surface of the foot there are deep furrows separating the enlarged extremities of the toes from the sole, but the extent of the inferior surface of the toes is clear only when they are extended. In extension two flexion wrinkles become apparent and these correspond to the articulations.

MOVEMENTS OF THE HIP

Mechanism. The coxal articulation, or hip joint, presides over the movements of the thigh upon the pelvis and details have been given (see page 43). We should note here that, although the femoral head is deeply situated, the great trochanter is subcutaneous and undergoes in its different movements of articulation displacements which are of great interest to artists.

These movements are of three sorts: first, flexion and extension; second, abduction; and third, rotation.

Flexion and extension take place about a transversal axis. The great trochanter, because of its inclined neck, is situated on a plane inferior to that of the femoral head so it follows that it rises in flexion and draws itself slightly nearer to the iliac crest.

In rotation the great trochanter describes an arc of an anteroposterior circle. Thus it moves to the front in inward rotation and to the back in outward rotation.

In abduction the great trochanter rises and approaches the pelvic crest; in adduction it descends and draws away from the crest.

MUSCULAR ACTION

Rotation. All the rotators that rotate the femur to the outside are deep muscles. They are: the piriformis, the gemelli, the obturator internus and the quadratus femoris.* Their action is powerful, despite their small size, because the direction of their fleshy fibers is more or less perpendicular to their point of leverage.

The action of these muscles is counterbalanced, though incompletely, by the less energetic action of the muscles which rotate the thigh to the outside. These are the gluteus minimus and gluteus medius but solely in their anterior parts. It is because the action of these muscles is less energetic that the point of the foot is naturally directed to the outside during muscular repose. Of all these muscles, gluteus medius alone is superficial and greatly influences the exterior form. Even in rotation to the outside its relief is greatly accentuated.

Flexors and extensors. The flexor muscles are the psoas major and minor, the iliacus, the tensor of the fascia lata, the sartorius, the pectineus and, to a certain extent, the rectus femoris.

The psoas muscles, the iliacus, and the pectineus are deep muscles and their action is not obvious on the exterior. But this is not true for the tensor of the fascia lata, the sartorius, and the rectus femoris.

The psoas-iliacus muscle is a flexor and at the same time a rotator to the outside. Its action is counterbalanced by an inverse rotational action of the tensor of the fascia lata. The pectineus is a rotator and at the same time an adductor. The sartorius is a rotator and also flexes the leg. The rectus femoris is above all an extensor; as a flexor of the pelvis on the thigh it is most limited. However, this muscle intervenes in forceful movements when the leg has been previously flexed.

The extensor muscles of the thigh against the pelvis are gluteus maximus and the posterior muscles of the thigh. The gluteus maximus is a most powerful muscle but it only intervenes when the movement demands a large deployment of force.

Abduction and adduction. Abduction of the thigh is produced by the gluteus medius and minimus. These two muscles, taking their fixed point from the femur, maintain the pelvis. They come into play, for example, in walking when the leg on the opposite side leaves the ground.

Adduction. This is brought about by the powerful adductor group of the thigh. Some of these are partly flexors and at the same time rotators of the thigh to the outside. The exception is the inferior part of adductor magnus which is a rotator of the thigh to the inside. Du'chenne de Boulogne has given this muscle an important role in the attitude of the horseman.* The same movement is produced by accessory muscles, the psoas major, the adductors, etc.

MODIFICATION OF EXTERIOR FORM (PLATES 105, 106, and 107)

Extension. The attitude of extension has already been studied. It takes place in the erect position, though it should be noted that the extensor muscle *par excellence,* gluteus maximus, is not contracted in this position. Paradoxical as this may seem, it is easily explained (Figure 24). In the upright position the line through the center of gravity of the trunk passes behind the articulation of the hip joint. In this position the pull of gravity is enough to maintain extension which is limited by the distension of the strong fibrous bundle situated at the anterior part of the articulation (the iliofemoral

* The same movement is produced by accessory muscles, the psoas major, the adductors, etc.

* "This rotative action to the inside of the adductor magnus," Duchenne de Boulogne states, "is most useful in certain movements of the legs. For instance, the horseman who wishes to avoid pricking his horse with his spurs when he is squeezing its belly with his thighs may avoid this difficulty if he is aware of the rotative action to the inside of the inferior portion of adductor magnus." *Physiologie des Mouvements,* page 360.

ligament). Gluteus maximus intervenes only to reestablish the equilibrium when, through a displacement of some superior part of the body, the trunk has a tendency to fall to the front. The gluteus maximus will also contract in all violent movements of the torso. When it takes its point of support from the pelvis, the gluteus maximus carries the leg to the back. This contraction of gluteus maximus brings great changes in the region.

Consider, for example, the model in the position we have chosen for study (see Plate 78). The gluteus maximus is not contracted. But if the model moves his right leg to the back we will see at once that the buttock on this side becomes narrow, globular, and elongated, the furrow behind the great trochanter becomes exaggerated, and the whole muscle looks reniform or kidney-shaped (see the drawings below). The fold of the buttock almost disappears, and the inferior border of the muscle reveals its natural obliquity. The secondary muscular fasciculi sometimes appear on the surface. The contrast is striking in relation to the buttock on the opposite side which is large and flat.

But if, instead of moving his leg to the back, the model moves his leg slightly to the front, the forms of the region become completely changed. Now it is the opposite buttock that enters into contraction. This is because the trunk must be maintained in an upright position despite the weight of the forward leg which has a tendency to pull the trunk forward. The buttock on the side of the forward leg is now large, distended and flat. In light flexion of the trunk to the front the two buttocks contract simultaneously (see Plate 94).

Flexion. We shall now study flexion of the thigh on the pelvis produced without effort. This will enable us to clarify the role of the flexors on the exterior forms of the region (see Plates 105 and 106). It will be observed that two flexor muscles, the sartorius and the tensor fasciae latae, reveal themselves clearly under the skin. Their tendons, preparing to join each other at the level of the anterior superior iliac spine, make a marked protrusion which augments the depth of the femoral depression. The fascia lata, the long tendon of the tensor muscle, somewhat retains the mass of the vastus lateralis in the front. The rectus femoris is not contracted.

In the back the enlarged flat buttock blends into the posterior surface of the thigh. The fold of the buttock is suppressed. On the outside, at the level of the articulation of the hip, important new forms appear. The great trochanter becomes less visible. In fact, it almost disappears under the tendon of the gluteus maximus which leads to an enlargement of the buttock. The gluteus medius, which is not contracted, is divided into two parts by the fasciculi of the femoral aponeurosis which go from the iliac crest to the tendon of the gluteus maximus (see page 61). The tension of the fasciculi limits the movement and creates a furrow at this level. The back part of gluteus medius blends with the gluteus maximus; its front part forms an elongated relief which includes the striking prominence of the contracted tensor muscle.

In the front the fold of the groin is accentuated, and several new cutaneous wrinkles appear. In further flexion the same morphological characteristics appear.

Abduction. The relief of the gluteus medius becomes most apparent under two conditions; when the leg is abducted to the outside, and when the pelvis must be inclined or maintained in its position, because, for example, the leg on the opposite side is raised from the ground. In this last case the fixed point of the gluteus medius is below on the femur.

Adduction. Adduction augments the prominence of the great trochanter.

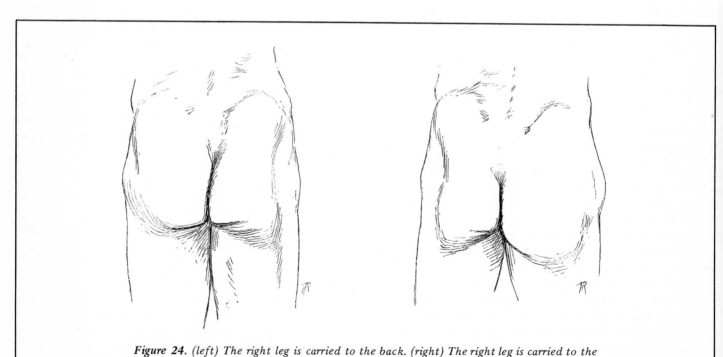

Figure 24. (left) The right leg is carried to the back. (right) The right leg is carried to the front.

MOVEMENTS OF THE KNEE

Mechanism. The movements of the lower leg on the thigh take place at the knee joint. They are of two kinds: first, movement around a transverse axis (in the manner of a hinge), *flexion and extension;* and second, movements of the lower leg around a vertical axis, *rotation.* (The point of the foot may be carried to the inside or to the outside; more rotation is possible to the outside than to the inside.)

This last movement is not possible except in the intermediate positions between flexion and extension of the knee.

MUSCULAR ACTION

Extension of the lower leg on the thigh. This movement is dominated by the powerful quadriceps femoris muscle which occupies the whole anterior part of the thigh. Its different heads all have a slightly different action. Those which are attached to the femur (vastus lateralis, vastus medialis, and vastus intermedius) are only extensors of the leg. The rectus femoris is also a flexor of the pelvis.

Flexion. Flexion is brought about by the following superficial muscles: the sartorius, which is at the same time a rotator to the inside; the vastus medialis, which is also an adductor of the thigh and a rotator of the lower leg to the inside; the semitendinosus and the biceps femoris, which are at the same time rotators of the lower leg; the semimembranosus, a flexor exclusively; and the gastrocnemius, which is an extensor of the foot.

The popliteus, a deep muscle, is a feeble flexor and a rotator to the inside.

Rotation. The rotating muscles are at the same time flexors of the lower leg on the knee. This may explain why rotation takes place only during flexion of the lower leg.

The rotators to the inside are: the semitendinosus, the vastus medialis, and the sartorius; the two last being the strongest. It should be pointed out that the popliteus, though a feeble flexor, is a powerful rotator to the inside. With the preceding muscles it counterbalances the powerful action of the biceps femoris which is a rotator to the outside.

MODIFICATION OF EXTERIOR FORM (PLATES 105, 106, and 107)

Extension. Extension has already been studied in the description devoted to forms in repose. In the conventional position the knee is extended, but it should be pointed out that the great extensor muscle, the quadriceps femoris, is more or less in relaxation. This is explained by the fact that the line from the center of gravity of the trunk passes behind the hip joint but in front of the knee joint. Thus the thigh, like the hip, maintains its position only through the weight of gravity in passive extension and movement is limited by the resistance of the distended ligaments. Under these circumstances the different parts of the quadriceps blend together into a uniform mass. However, two unequal swellings, the reliefs of the inferior extremities of the vastus medialis and lateralis, appear below. In contrast,

when the quadriceps is contracted, everything changes. The rectus femoris becomes apparent at the middle of the thigh and, on each side, the vastus medialis and vastus lateralis are clearly visible. The inferior reliefs disappear completely. The region below the patella becomes simpler, the transverse wrinkles are suppressed and the lower patellar ligament is accentuated.

Flexion. In flexion of the knee the patella, which is applied against the trochlea of the femur, sinks into the wide opening in front between the femur and the tibia. Thus the prominence the patella makes in extension becomes less the more the knee is flexed.

The ligamentum patellae is stretched and on each side the infrapatellar fat becomes more prominent as the flexion increases. In extreme flexion the fatty pads project beyond the ligament so that the ligament itself is indicated by a mild furrow.

Slightly behind this the two condyles of the femur form two appreciable reliefs under the skin. These reliefs are unequal and each has its distinct character. Within, the medial condyle shows only slightly and it is covered by the inferior extremity of the fleshy body of the vastus medialis which gives this side of the knee a rounded form. On the external side of the knee, the border of the trochlea becomes clearly visible and forms a sharp angle, though it is continuous with the lateral malleolus. The vastus lateralis retreats in flexion and the prominence of the vastus intermedius appears because it is no longer covered by the sheath of fascia lata, which is now lower down. On the outside, the articular interline is visible (Plate 105).

In the back the hollow of the knee is limited laterally by the tendons of the posterior muscles of the thigh which border it. When the knee is bent, the internal border is lower so that the hollow behind the knee does not point directly to the back but to the back and to the outside. The internal border is made up of the tendons of the semimembranosus and the semitendinosus, thickened by the exterior extremity of the sartorius. The external border is formed by the strong tendon of the biceps femoris which goes to the head of the fibula.

The hollow at the back of the knee is deepest near the lower leg; it fades away towards the thigh. It consists of a sort of excavation which receives, in forced flexion, the superior extremities of the two heads of the gastrocnemius.

MOVEMENTS OF THE FOOT

Mechanism. The movements of the foot are of two kinds. First, those which take place around a transversal axis, for instance, when the point of the foot is raised. When the point of the foot is raised it is flexion; when it is lowered it is extension (or plantar flexion). These movements take place in the tibiotarsal articulation. Second, movements which take place around an anteroposterior axis. When the point of the foot is directed within it is adduction; without, it is abduction.

Adduction is accompanied by a movement of torsion which makes the internal border of the foot rise some-

what. The external border falls and the plantar arch becomes hollow.

In abduction it is the opposite. The internal border is lowered, the external is raised, and the plantar arch is somewhat suppressed. This last movement is less powerful and more limited than adduction. All of this takes place within the articulations of the tarsus.

MUSCULAR ACTION

Extension. As Duchenne de Boulogne has demonstrated, two muscles acting simultaneously are necessary for direct extension: the triceps surae (which is the soleus and gastrocnemius considered as one) and the peroneus longus which is also an abductor. The flexor digitorum longus and the flexor hallucis longus are powerless as extensors of the foot on the lower limb.

Flexion. As in extension, direct flexion entails two muscles acting at the same time: the tibialis anterior, also an adductor, and extensor digitorum longus, also an abductor.

Abduction and adduction. The peroneus brevis abducts the foot and the tibialis posterior adducts it.

MODIFICATION OF EXTERIOR FORM

Flexion. In flexion the heel falls and the dorsum of the foot makes an acute angle with the lower leg.

In direct flexion the tendon of the tibialis anterior and those of the extensor digitorum longus make distinct prominences at the ankle. If the foot is at the same time carried within, the tendon of the tibialis anterior is augmented. If it is carried to the outside the tendon of the peroneus brevis becomes visible below the ankle.

On the leg the fleshy body of the tibialis anterior stands out and its relief blends with the extensor digitorum longus.

Extension. In extension the dorsum assumes almost the same direction as the lower leg; the heel is lifted and the projection of the back of the foot is accentuated. On the front of the lower leg the superior relief of the tibialis anterior and the extensor digitorum longus is replaced by a depression. A little to the outside, under and behind the head of the fibula, a new prominence created by the peroneus longus appears. This very interesting relief accentuates, on the front view, the curve of the lower leg at its superior part. This form also appears on a subject standing on his toes. At the same time the tendon of the peroneus longus appears below in the form of a long lateral prominence behind the lateral malleolus.

The modeling of the back of the leg differs according to whether the foot is extended or flexed.

When the subject is standing on his toes the relief of the triceps surae is very strong. All its forms stand out—the prominences and planes of the two heads of gastrocnemius, the lateral reliefs of the soleus and those of the tendo calcaneus or Achilles tendon. This last describes, on the side view, a stronger curve above the heel.

If the leg is extended and the foot does not touch the ground, the entire triceps surae will be contracted but to a lesser degree.

Finally, if the knee has been flexed and extension of the foot is produced, the whole calf together with the tendo calcaneus will be flaccid.

MOVEMENTS OF THE TOES

The toes undergo movements of flexion and extension as well as limited lateral movements. In flexion the toes press one against the other, in extension they have a tendency to separate.

In flexion the rounded extremity of the toe touches the anterior pad of the sole which becomes, except under the big toe, creased with numerous wrinkles going in varying directions. On the dorsal surface of the foot the articulations of the phalanges between themselves, and above all, the articulations of the phalanges with the metatarsals become very visible.

Extension effaces the wrinkles on the sole of the foot and brings into relief a thick cord which fills the summit of the vault. This cord runs from the heel towards the big toe and it is due to the tension of the plantar aponeurosis.

Certain cutaneous wrinkles appear on the dorsal surface at the metatarsophalangeal articulation of the big toe. The tendon of the extensor hallucis longus becomes very visible.

On the inferior surface of the foot the relief of this same articulation becomes more pronounced as extension continues.

18. Proportions

Artists through the ages have been fascinated by the proportions of the human body. They have tried to standardize them and have attempted to lay down rules or canons which could be followed in the production of works of art. Works of this nature, made by artists of ancient times, have not been passed on to us.*

Such texts as we have on the subject of proportion are categorical but more or less circumstantial. They are usually filled with conjectures drawn from works of art executed under those particular rules. Without entering too deeply into a subject which has occupied the sagacity of artist and archeologist for so long a time, it might be useful to discuss the situation as it exists today.

CANONS OF PROPORTION

The oldest text on proportion is an Egyptian canon, and Blanc believed he had discovered its key—the length of the middle finger was equal to one nineteenth the total height of the body.

The Greeks had several canons, all totally different from those of the Egyptians. The most celebrated was that of Polycleitus. This canon defined the type of athlete that so fascinated the Greeks, and above all the Dorians. This type was the strong healthy male who was excellent at gymnastics and skilled in the handling of weapons of war. Typical examples are the *Doryphoros* and the *Borghese Achilles*. According to Guillaume, the palm of the hand, or the length of the hand to the level of the root of the fingers, was the unit of measurement chosen by Polycleitus. This measurement does not apply to the canon of Lysippus, who introduced more elegance into figure. He made the heads smaller and the body less squared thus giving the whole a more graceful quality. The *Apollo Belvedere* is representative of this type.

"In all probability," states Guillaume, "it is this canon of Lysippus, maintained by Vitruvius, followed by the Byzantines, and recognized by Cennino Cennini, which the modern artists have partially adopted. In it not only the palm of the hand, but the head and its subdivisions, serve as a module."

Artists pursue a double purpose in tracing these rules of proportion. First, they seek to illuminate the reasons for the harmonies of the human body, to determine its "symmetry" in the Greek sense of balancing diverse parts with the whole. All their efforts are aimed towards the realization of a certain ideal of beauty.

But as the author of the article *Canon* has written in the *Dictionnaire de l'Academie des Beaux-Arts*, "The abstract idea of proportion is superior to proportion in reality. Proportion, like beauty itself, is a noble torment of the mind, a powerful incentive to achievement. However, it can only be realized in principle. The greatest artists have sought its key, but each one was only capable of rendering proportions that had been imprinted with the artist's own taste."

In other words, in formulating a canon, artists have never contemplated the idea of executing all their figures to correspond to a specific set of rules. The proof of this can be seen in their works. In classical times the rules varied according to the subject to be represented. These subjects were certainly very different, a mortal, perhaps, or a god, and among the gods there were Apollo, Mars, Mercury, or Eros. One can safely say that the canon varies according to the subject, otherwise the exact relationship between physical character and moral and intellectual character could not be expressed.

Such was the aim of Polycleitus when he created his famous Doryphoros. In a sense one could say that Polycleitus put the whole of art in that single work of art.

The second reason why artists, and especially modern artists, seek rules of proportion is perhaps less exalted and more a matter of technique. They want to have at hand a simple method which will allow them to construct figures in proportion. This allows them, once they are given the full size of the model, to determine the measurement of each part, or conversely, once they are given a part, to determine the size of the whole. In this way the rules become a sort of guide—they may be altered according to the taste of the artist, and their single aim is to help the artist in his work.

All the modern research seems to be derived from a somewhat obscure passage of Vitruvius. It is constantly commented upon, explained, and attempts are made to carry it to a conclusion. It is said, among other things, that the height of a figure is eight heads or ten faces, that the width is equal to the dimension of the outstretched arms, and that the figure may be placed in a circle of which the center corresponds to the navel.

* The marble statue of the *Doryphoros* in the Museum of Naples, according to a statement authorized by M. Guillaume, was only a reproduction of the celebrated work of Polycleitus; the original was of bronze. The original was accompanied by a written work explaining the proportions. This, unfortunately, has been lost.

Leonardo da Vinci demonstrated Vitruvius' ideas on proportion in the well known double figure of the man within the square and circle.

In this drawing a man, his arms outstretched and his hands opened, has first been inscribed within a square. His head, his feet, and the extremities of his middle fingers touch the sides of the square. The arms being raised a little and the legs separated, he has then been inscribed within a circle with its center at his navel. His feet and the extremities of his middle fingers touch this circle. However, Leonardo also indicated many other proportions of the body as one can see in the drawing itself. We shall return to some of these later (Figure 25).

One can study proportions in the voluminous and obscure memoirs of Albrecht Durer, in the works of Lomazzo, in those of Christopher Martinez or of Rubens, and in many other works which might be considered to be merely curiosities. But there are, of course, several works which review and summarize all the others. Of all the authors who have written on this subject, the clearest, the most precise and consistent is undoubtedly Jean Cousin.

COUSIN'S CANON OF PROPORTIONS

In his book on proportion the head is taken as a unit of length; it is measured from the summit of the cranium to the inferior limit of the chin. The head itself is subdivided into four parts.

The first section divides the forehead, the second runs

Figure 25. Facsimile of a drawing by Leonardo da Vinci.

through the eyes, the third cuts through the base of the nose, and the fourth the bottom of the chin. A fifth part could be added which would determine the length of the neck.

The horizontal middle line (on the front view) is divided into three parts, the center part being occupied by the iris. The opening of the eye is one third of its width. The greatest width of the nose is equal to the space between the eyes. The mouth has the width of an eye and a half. The ears are placed between the line of the eyes and that of the base of the nose.

The height of the body from the summit of the head to the ground is divided into eight parts, each part being equal to the head. The first, of course, is the head itself. The second extends from the chin to the nipples, the third from the nipples to the navel, the fourth from the navel to the genital organs, the fifth from the genital organs to the middle of the thigh, the sixth from the middle of the thigh to below the knee, the seventh from below the knee to the calf, and finally the eighth, from the calf to the sole of the foot. The middle of the body is thus placed at the level of the genital organs.

The principal measurements of width are: two heads at the level of the shoulders; two faces, or six lengths of the nose, at the level of the hips.

The arm is three lengths of the head thus divided: from its attachment at the shoulder to the articulation of the wrist, two heads; from the wrist to the extremity of the middle finger, one head.

As a result, on a figure with outstretched arms, the measurement from the extremities of the middle fingers would equal eight heads or the total height of the individual.

The hand equals a face or three noses, the foot is one head long.

Jean Cousin's canon is extremely simple—it relates all the dimensions of the body to the length of the head, it subdivides the head into four equal parts, and it gives each of these the length of the nose. It is a system which may be applied very easily and it is simple to understand the favor in which it has been held.

However, this system is not completely accurate and it contains a number of obscurities. For example, the fourth division, which marks the center of the body, corresponds to the genital organs, but at what particular level on these organs? And exactly where is "below the knee"? Where, "below the calf"? In a discussion of the measurements of the trunk the text mentions in one part that the second division corresponds to the nipples, but in another place that it appears that this same division corresponds to beneath the pectoral muscles.

One might expect that the plates and drawing that accompany the text would clarify the obscurities and omissions of the text. However, the drawings that relate to diverse parts of the body do not correspond to the drawings of the figure as a whole. For example, on the drawings devoted especially to the proportions of the torso, the divisions from the points of the shoulders to below the pectoral muscles, and those from the navel to the genital organs, are not the same divisions as those given in the figure as a whole. Comparable inconsistancies are present in the drawings of the leg.

GERDY'S CANON OF PROPORTIONS

The measurements adopted by Gerdy do not differ greatly from those of Jean Cousin. He uses the same measurements of height, except for the neck, to which he gives a nose and a half to two noses. He keeps the measurements of width. But at least Gerdy moves towards a greater precision by introducing various prominences created by the skeleton as points of measure. Among these are the vertebral prominences, the costoabdominal prominence and the spine of the tibia.

Gerdy's canon, like that of Jean Cousin, gives eight heads as the height of the figure. This proportion is rarely encountered in nature but artists, of course, have always known this fact. There are certain Greek statues which are eight heads high, but there are others which measure seven and three quarters heads, seven and a half, and even seven heads.

THE CANON DES ATELIERS

The proportion of seven and a half heads has been set down in a canon offered by Blanc under the name of *Canon des Ateliers*. This differs appreciably from the canon of Jean Cousin. Let us pause for a moment and examine it.

The figure in this canon is seven and a half heads high. The neck is half a head, which appears to be excessive, and the trunk five half heads from the pubis to the pit of the neck, which seems short. The trunk is further subdivided into three equal parts the length of a face. One from the pit of the neck to beneath the pectoral muscles, a second to the navel, and a third to the pubis.

The position of the knee is as vaguely indicated as it is in the canon of Jean Cousin. There are six parts from the pubis to above the knee, one part and a half to the knee, six parts from above the knee to the ankle, and a part and a half from the ankle to the ground. But the question is, where does the knee start? Where does it finish? That is what Blanc does not tell us.

ARTISTIC CANONS IN GENERAL

To sum up, the amazing thing about these artistic canons is their lack of precision as to the exact position of the points of reference. Because of this, it becomes possible to construct, following the same canon, types of varying proportions. Although it is true that this is not a matter of much importance because a canon is but a guide which the artist should be able to modify according to his taste, it does seem that if there is to be such a guide it should be most precise so that the artist may make comparisons and be aware of exactly how far he is departing from the guide when he wishes to make modifications he feels would be more fitting. An exact knowledge as to the whereabouts of landmarks is of great value in the construction of figures.

In regard to the artistic canon that follows, it might well be asked how far its proportions conform to the reality of things as they are. This question is raised because art tends to strive towards a presentation of truth and nature and it is natural for an artist to try to verify measurements drawn from different artistic traditions on the model (Figures 26 and 27). However, there is such a variety in individual proportions that to conform to things as they are it would be necessary to measure a great number of individuals and then take the average. At the same time one would have to distinguish between the different ages, the different sexes, and the different races. Happily this has become one of the functions of a rapidly developing science. I refer, of course, to the science of anthropology.

ANTHROPOLOGY AND HUMAN PROPORTIONS

Anthropology has revived the study of the proportions of the human body but from a point of view that is essentially different from that of the artist. Anthropology admits that there are as many canons as there are individuals of the human race. It relies on statistics and proceeds by averages. Instead of seeking a module as a point of departure and reproducing it over and over again along with each of the parts of which it is composed, anthropology simply states that there are certain relationships between the parts and that these relationships are necessarily elementary.

This method of approach has been aptly studied by Dr. Topinard. He has clearly indicated the path to be followed in the determination of the different human canons, although he realizes that there is still much work to be done—an enormous number of individuals must be measured with method and precision, their age and sex

*Figure 26. (left) Figure taken from **A Treatise on Painting** by Leonardo da Vinci. This figure shows that the distance from the point of the shoulder to the olecranon equals the distance from the olecranon to the metacarpophalangeal articulation of the middle finger.*

Figure 27. (right) This figure shows that the width of the shoulders equals the forearm measured from the tip of the middle finger to the olecranon.

must be clearly determined, and above all their race. This last, because of the great mixing of races, is not easily done. However, Dr. Topinard began by using the already considerable work which exists on the measurements of Europeans. Drawing on the facts of anthropology as they exist, and using the most comprehensive and trustworthy measurements, he has established the average canon for the adult male European (Figure 28).

The measurements are formulated in scientific terms, that is to say that they are all brought down to figures of which the total is 100. Although they are not really of much use to artists, it is interesting to compare them to the artistic canons and to note the many resemblances between this scientific canon and the artistic canons. As Dr. Topinard says, "This bears witness both to the excellent eye of the artist and to the value of the measurements taken by the anthropologists." Nevertheless, there are a number of divergences.

The canon of eight heads comprising the height of the body is only true for very tall people. For short people, the measurement is seven heads. In the scientific canon seven and a half heads makes up the height of the body as in the *Canon des Ateliers* of Blanc. However, the width across a figure with outstretched arms is equal to its height only one time out of ten. The rule of the artist in this regard is thus an exception. In the scientific canon the width of the outstretched arm is 104, the height of the figure being considered 100. The arm is somewhat short in the artistic canon, the neck too short in the canon of Jean Cousin, too long in that of Blanc, etc. . . . I shall pass over the other comparative details which are no of great importance.

In the face of these very interesting results, it seems to me that, since there is little room for new artistic canons, one might be able to introduce a little scientific precision especially in regard to points of reference which determine the partial measurements. This has been my aim in designing the three plates 108, 109 and 110. I have tried, besides, to simplify the measurements and to do away, as much as possible, with fractions.

RICHER: CANON OF PROPORTIONS

This canon which I am submitting to artists preserves most of the traditions which are taught in the studios; it contains besides, particularly in regard to the legs, new points of reference derived from the skeleton (Figure 29). These are of great advantage because they are fixed and hold their relative position despite the different movements. What is more, they correspond to the principal measurements of the scientific canons.

In the scientific canon the height of the figure is seven and a half heads. The width through the outstretched arms is greater than the height. The middle of the body is a little above the pubis. As in the canon of Jean Cousin, the length of the head serves as the unit of measurement.

The trunk and the head together measure four heads. The divisions fall at points of reference on the front and back of the body. The first division is at the chin; the second corresponds to the nipples; the third corresponds to the navel, or a little above, and in the back it corresponds to the superior limit of the gluteal muscles;

the fourth cuts through the inferior part of the genital organs in front and in the back it is at the level of the gluteal fold.

The leg measures four heads, from the sole of the foot to the fold of the groin which corresponds to the level of the hip joint. However, these two measurements, placed one above the other, overlap each other by one half a head. This gives a height to the figure of seven and a half heads. It places the middle of the figure at mid-distance between the inferior limit of the trunk and the superior limit of the leg. This point is slightly below the pubis.

The subdivisions of the leg are as follows: from the sole of the foot to the articular interline of the knee, two heads; from this point to the great trochanter and then to the height of the fold of the groin, two heads (Figure 30). These points of reference seem to be quite precise, because they are fixed and belong to the bony system. Also, they serve equally well when the leg is flexed and when it is extended. The articular interline of the knee is always easily found. The chapter that discusses the exterior form of the knee covers all the necessary details. The length of the thigh does not vary because the points of reference belong to the bone. If the length of the lower leg is taken from the superior limit of the tibia to the sole of the foot it is always easy to make the necessary changes that result from the movements of the foot.*

It could be said that, seen from the inside, there are three and a half heads from the ground to the perineum. The center of the patella is the middle point between the anterior superior iliac spine and the ground. The arm measures three heads, from the arm pit to the extremity of the middle finger.

The superior limit of the arm lacks a fixed point, it is below the shoulder joint, a little less than half a head from the superior border of the clavicle. A more precise determination of the length of the arm can be found by an indirect method which I shall explain. From the inferior extremity of the middle finger to just above the olecranon is two heads. The first of these heads falls well up the wrist, the hand itself measures three quarters of a head from the extremity of the middle finger to the heel. The middle finger together with the head of its metacarpal measures a half head.

The olecranon is at the middle of the distance between the point of the shoulder and the metacarpophalangeal articulation of the middle finger. This last measurement is useful in fixing the length of the arm (Figure 31).

The measurement should be taken from the acromion. However, its summit is often difficult to find because of the insertion of the deltoid. It is important to note that this measurement is only true when the arm is extended. When the arm is flexed, the descent of the olecranon causes a proportional lengthening of the upper part of the arm. The reference point of the olecranon can easily be replaced by the epicondyle, which in flexion does not change its place. It must be noted in this case that the length of the arm from the acromion to the epicondyle is changeable. For instance, if the arm is raised horizontally

* Colonel Duhousset (*Revue d'Anthropologie*, No. 4, 1889) gives approximately the same measurement and he points out that the length of the femur is equal to the tibia plus the height of the foot.

Figure 28. Parts of the body having a common measurement of a head or two half heads.

Figure 29. Parts of the body measuring one and a half heads.

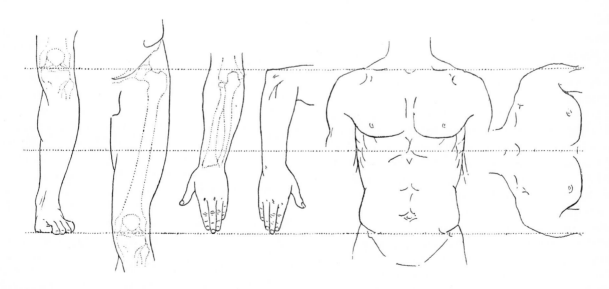

Figure 30. Parts of the body having a common measurement of two heads.

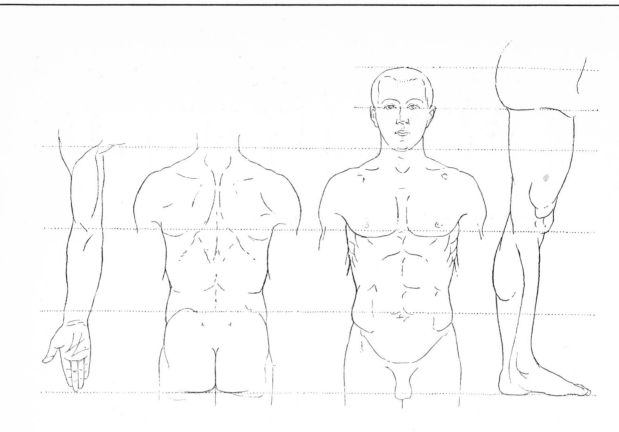

Figure 31. Parts of the body having a common measurement of three or four heads.

to the front, it is longer than when it is raised horizontally to the side.

The head is divided in half by the line of the eyes. The other subdivisions given by Cousin may be helpful although it does seem that the nose, which takes up the third division, might be too long, and that the fourth division is too narrow to include both the chin and the mouth. Leonardo da Vinci offers another measurement which appears to be more exact—that the base of the nose marks the middle point between the ridge of the eyebrows and the base of the chin.

The distance from the chin to the pit of the neck is one third of a head.

The principal measurements of the trunk are as follows: the greatest width of the shoulders is two heads; the distance between the two fossets under the clavicles is one head; the width of the chest at the level of the arm pits is a head and a half; and the distance between the two nipples is a head. The greatest width of the pelvis is more than a head and the distance between the great trochanters is a head and a half.

Among the measurements for the height of the trunk, the following are the easiest to remember. From the anterior superior iliac spine to the clavicle, two heads. From the clavicle to the costoabdominal prominence in front and to the upper part of the space between the ribs and pelvis in back, one head and a half. These places indicate the superior limits of the flank. The flank should be given a height of a half head in front and much less in back. From the superior border of the trapezius to the

inferior angle of the scapula, one head.

The twelfth dorsal vertebra is situated at the middle of the third division of the torso (when the head is included in the torso).

Finally, the distance from the pit of the neck to the pubis is equal in the back to the distance between the dorsal spine of the seventh cervical vertebra and the summit of the sacrum.

The length of the foot exceeds the height of the head by about one seventh.

Let me summarize certain parts of the body that have a common measurement:

½ HEAD

From the inferior extremity of the middle finger to the top of the head of the third metacarpal.

The height of the flank in front.

The line between the buttocks.

1 HEAD

From the chin to the line of the nipples.

From the nipples to the navel.

From the arm pit to just above the point of the elbow.

The hand, including the wrist.

The height of the buttocks.

The distance in front that separates the two subclavicular fossets.

The height of the scapular region from the superior border

of the trapezius to the inferior angle of the scapula.
(The bi-iliac diameter, measured on the iliac spines, surpasses one head.)

1 ½ HEADS

The height of the thorax from the top of the shoulder to the top of the flank.

The distance that separates the centers of the two shoulder joints.

The distance between the great trochanters.

The distance from the perineum to the articular interline of the knee.

2 HEADS

The lower leg, from the sole of the foot to the articular interline of the knee.

The thigh, from the articular interline of the knee to just above the great trochanter or to the line of the groin.

The forearm and the hand, from the extremity of the middle finger to slightly above the olecranon.

From the clavicle to the anterior superior iliac spine, and in the back from the dorsal spine of the seventh cervical vertebra to the iliac tuberosity which is marked by the lateral inferior lumbar fosset.

3 HEADS

From the chin to the gluteal fold.

From the summit of the head to the navel, or to the superior limit of the buttocks.

The arm, from the arm pit to the extremity of the middle finger.

Finally, let us recall two instances of equal measurement. Though these have nothing to do with measurements in terms of heads, they are nevertheless quite important. On the arm there is an equality of measurement between the distance from the olecranon to the top of the shoulder and the distance from the olecranon to the metacarpophalangeal articulation of the middle finger. On the leg there is an equality of measurement between the distance from the center of the patella to the anterior superior iliac spine and the center of the patella to the ground.

In offering ideas on the proportions of the human body I have had no other aim than to put at the disposition of artists certain useful and precise measurements. They represent no more than a sort of average which should be changed at will according to the artist's esthetic conception, his fantasy, or his genius.

PLATES

All the plates are made from half-life size drawings of a model one meter, 72 centimeters tall. However, because there were great advantages in devoting somewhat larger reproductions to the smaller bones of the sketelon and to anatomical details, not all the drawings have been reduced the same amount. But each plate is internally consistent; all the parts of the body shown in that plate have been reduced to the same scale. The various sizes in which the drawings have been reproduced are indicated below.

SCALE OF PROPORTIONS OF ANATOMICAL DRAWINGS

OSTEOLOGY AND ARTHROLOGY

2/5 LIFE SIZE:
Vertebrae (Plate 3, 4 and 6)
Bones of the Wrist and Hand (Plate 12)
Bones of the Foot (Plate 28, 29, and 31)

1/3 LIFE SIZE:
Head (Plate 1 and 2)
Vertebral Column (Plate 5 and 7)
Sternum, Ribs (Plate 8)
Thoracic Cage (Plate 9 and 10)
Clavicle and Scapula (Plate 11)
Coccyx (Plate 12)
Pelvis (Plate 13, 14 and 15)
Humerus (Plate 19)
Bones of the Forearm (Plate 17)
Femur (Plate 26)
Bones of the Leg (Plate 27 and 28)

1/4 LIFE SIZE:
Trunk (Plate 16, 17 and 18)
Upper Limb (Plate 23, 24 and 25)
Lower Limb (Plate 32, 33, 34 and 35)

MORPHOLOGY

1/3 LIFE SIZE:
Head (Plate 36 and 37)
Neck (Plate 35, 46 and 47)
Hand (Plate 58, Figures 4 and 5)
Foot (Plate 67)

1/4 LIFE SIZE:
Torso (Plate 38, 39, 40, 41, 42, 243,
 44, 45, 48, 49, 50, 51 and 52)
Arm (Plate 56)
Forearm (Plate 57 and 58)
Thigh (Plate 63 and 64)
Leg (Plate 65 and 66)
Full figures (Plate 53, 54, 55, 59, 60,
 61, 62, 68, 69, 70 and 71)

Plate 1: THE SKULL

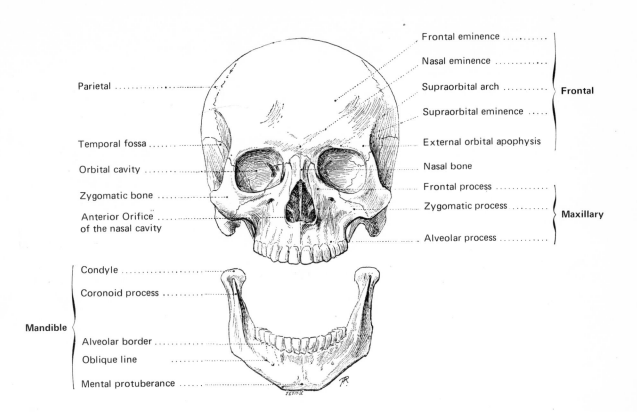

Parietal

Temporal fossa

Orbital cavity

Zygomatic bone

Anterior Orifice
of the nasal cavity

Frontal eminence
Nasal eminence
Supraorbital arch
Supraorbital eminence
External orbital apophysis
Nasal bone
} Frontal

Frontal process
Zygomatic process
Alveolar process
} Maxillary

Mandible {

Condyle
Coronoid process
Alveolar border
Oblique line
Mental protuberance

FIGURE 1: ANTERIOR ASPECT

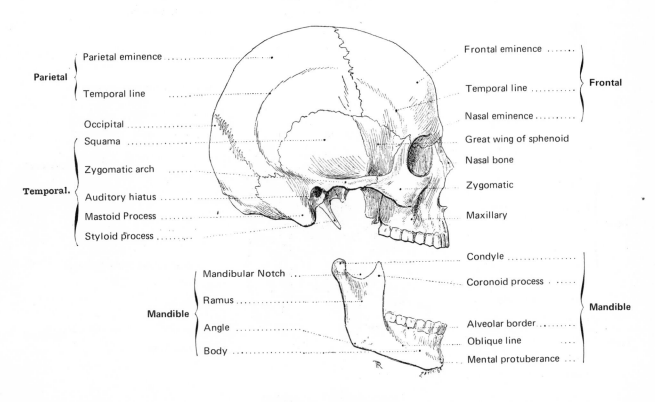

Parietal {

Parietal eminence
Temporal line

Temporal. {

Occipital
Squama
Zygomatic arch
Auditory hiatus
Mastoid Process
Styloid process

Frontal eminence
Temporal line
Nasal eminence
} Frontal

Great wing of sphenoid
Nasal bone
Zygomatic
Maxillary

Mandible {

Mandibular Notch ...
Ramus
Angle
Body

Condyle
Coronoid process
Alveolar border..........
Oblique line
Mental protuberance ...
} Mandible

FIGURE 2. LATERAL ASPECT

139

Plate 2: THE SKULL

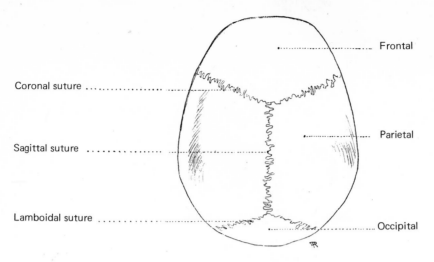

Frontal

Coronal suture

Sagittal suture

Lamboidal suture

Parietal

Occipital

FIGURE I: SUPERIOR ASPECT

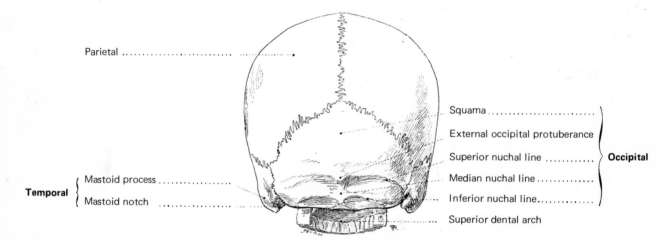

Parietal

Temporal { Mastoid process
Mastoid notch

Squama

External occipital protuberance

Superior nuchal line } **Occipital**

Median nuchal line

Inferior nuchal line

Superior dental arch

FIGURE 2: POSTERIOR ASPECT

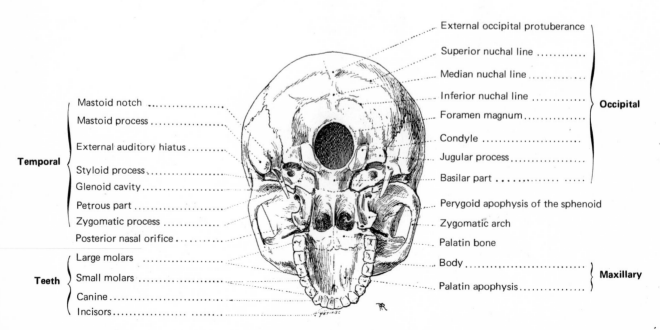

Temporal {
Mastoid notch
Mastoid process
External auditory hiatus
Styloid process
Glenoid cavity
Petrous part
Zygomatic process
Posterior nasal orifice

Teeth {
Large molars
Small molars
Canine
Incisors

External occipital protuberance
Superior nuchal line
Median nuchal line
Inferior nuchal line
Foramen magnum
Condyle
Jugular process
Basilar part
} **Occipital**

Perygoid apophysis of the sphenoid
Zygomatic arch
Palatin bone
Body
Palatin apophysis } **Maxillary**

FIGURE 3: INFERIOR ASPECT,
BASE OF CRANIUM

PLATE 3: VERTEBRAE

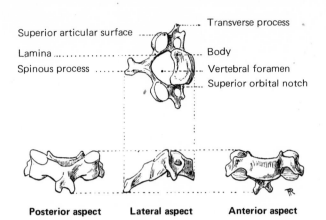

FIGURE 1: SUPERIOR ASPECT,
FOURTH CERVICAL VERTEBRA

Superior articular surface
Lamina
Spinous process
Transverse process
Body
Vertebral foramen
Superior orbital notch

Posterior aspect **Lateral aspect** **Anterior aspect**

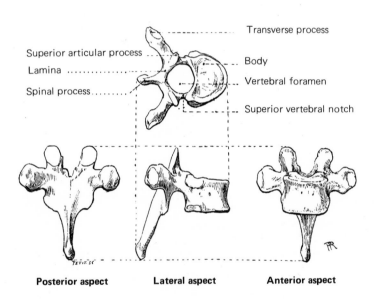

Superior articular process
Lamina
Spinal process
Transverse process
Body
Vertebral foramen
Superior vertebral notch

Posterior aspect **Lateral aspect** **Anterior aspect**

FIGURE 2: SUPERIOR ASPECT
SEVENTH DORSAL VERTEBRA

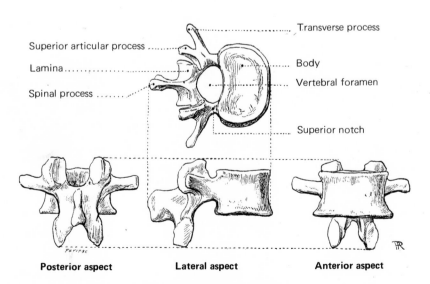

Superior articular process
Lamina
Spinal process
Transverse process
Body
Vertebral foramen
Superior notch

Posterior aspect **Lateral aspect** **Anterior aspect**

FIGURE 3: SUPERIOR ASPECT
THIRD LUMBAR VERTEBRA

Plate 4: VERTEBRAE

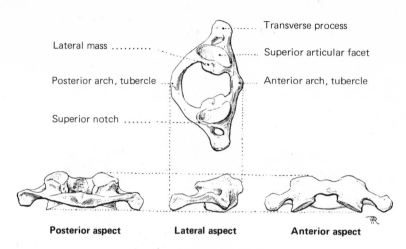

Lateral mass

Posterior arch, tubercle

Superior notch

Transverse process

Superior articular facet

Anterior arch, tubercle

Posterior aspect **Lateral aspect** **Anterior aspect**

FIGURE 1: SUPERIOR ASPECT,
FIRST CERVICAL VERTEBRA OR ATLAS

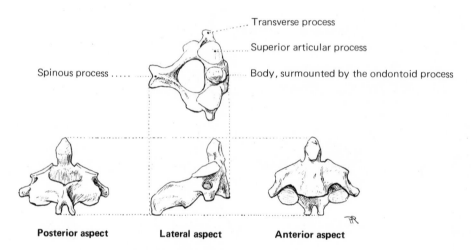

Spinous process

Transverse process

Superior articular process

Body, surmounted by the ondontoid process

Posterior aspect **Lateral aspect** **Anterior aspect**

FIGURE 2: SUPERIOR ASPECT,
SECOND CERVICAL VERTEBRA OR AXIS

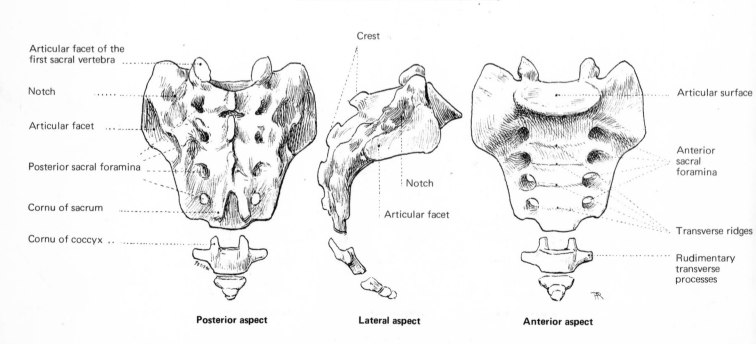

Crest

Articular facet of the
first sacral vertebra

Notch

Articular facet ...

Posterior sacral foramina

Cornu of sacrum

Cornu of coccyx

Notch

Articular facet

Articular surface

Anterior
sacral
foramina

Transverse ridges

Rudimentary
transverse
processes

Posterior aspect **Lateral aspect** **Anterior aspect**

FIGURE 3: SACRUM AND COCCYX

Plate 5: VERTEBRAL COLUMN

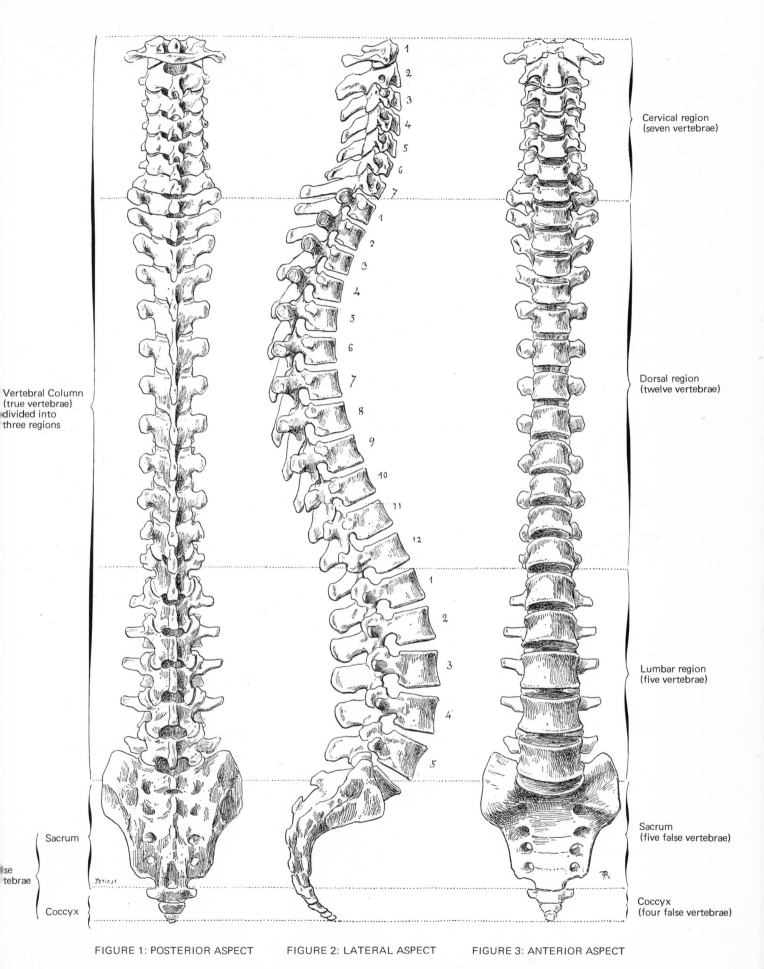

Vertebral Column (true vertebrae) divided into three regions

Sacrum

se
tebrae

Coccyx

Cervical region (seven vertebrae)

Dorsal region (twelve vertebrae)

Lumbar region (five vertebrae)

Sacrum (five false vertebrae)

Coccyx (four false vertebrae)

FIGURE 1: POSTERIOR ASPECT FIGURE 2: LATERAL ASPECT FIGURE 3: ANTERIOR ASPECT

Plate 6: LIGAMENTS OF THE HEAD AND THE VERTEBRAL COLUMN

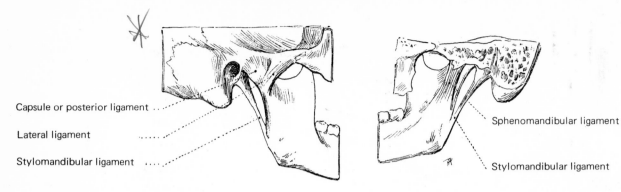

Capsule or posterior ligament

Lateral ligament

Stylomandibular ligament

Sphenomandibular ligament

Stylomandibular ligament

FIGURE 1: TEMPOROMANDIBULAR ARTICULATION,
EXTERNAL ASPECT

FIGURE 2: TEMPOROMANDIBULAR ARTICULATION,
INTERNAL ASPECT

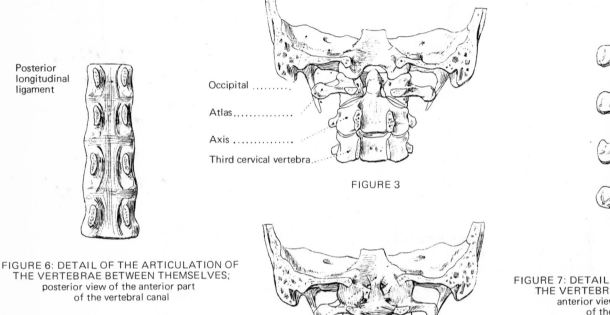

Posterior
longitudinal
ligament

Occipital

Atlas

Axis

Third cervical vertebra

FIGURE 3

Yellow
ligamen[t]

FIGURE 6: DETAIL OF THE ARTICULATION OF
THE VERTEBRAE BETWEEN THEMSELVES;
posterior view of the anterior part
of the vertebral canal

FIGURE 7: DETAIL OF THE ARTICULATIO[N]
THE VERTEBRAE BETWEEN THEMSEL[VES]
anterior view of the posterior part
of the vertebral canal

Odontoid ligament { Middle
{ Lateral

Transverse ligament

Occipitoaxial ligament (cut)

FIGURE 4

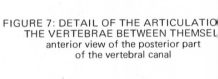

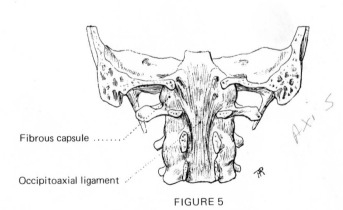

Fibrous capsule

Occipitoaxial ligament

FIGURE 5

FIGURE 3, 4, and 5: ARTICULATION OF THE OCCIPITAL, ATLAS, AND AXIS;
posterior aspect, vertebral canal is open

Plate 7: LIGAMENTS OF THE VERTEBRAL COLUMN

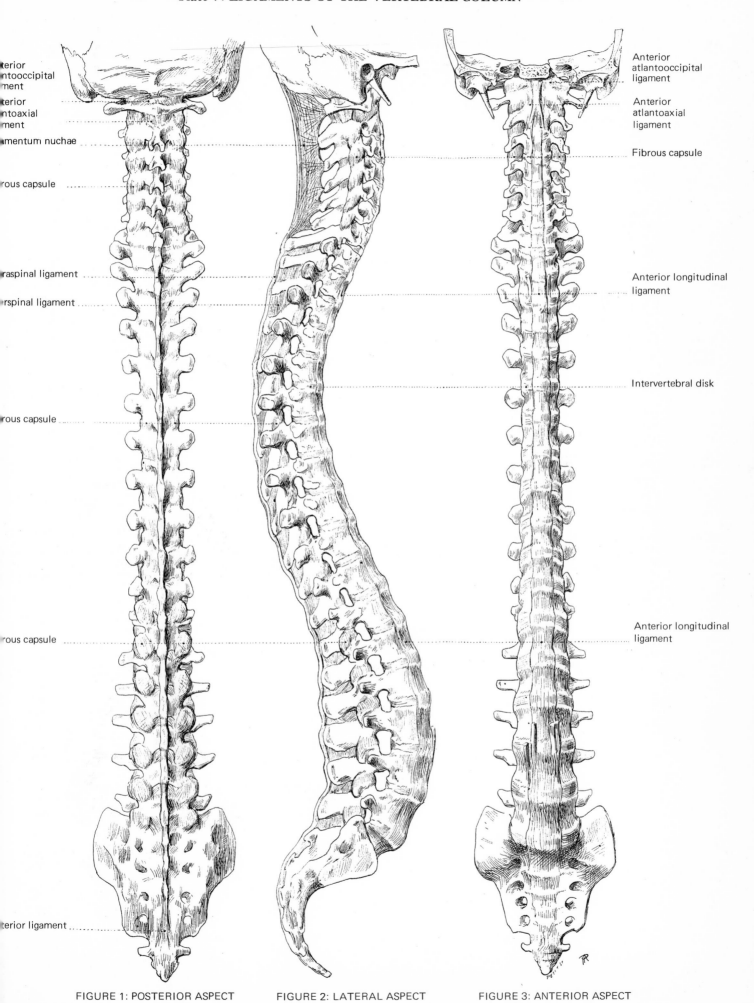

Anterior atlantooccipital ligament

Anterior atlantoaxial ligament

Ligamentum nuchae

Fibrous capsule

Supraspinal ligament

Interspinal ligament

Fibrous capsule

Fibrous capsule

Posterior ligament

Anterior atlantooccipital ligament

Anterior atlantoaxial ligament

Fibrous capsule

Anterior longitudinal ligament

Intervertebral disk

Anterior longitudinal ligament

FIGURE 1: POSTERIOR ASPECT FIGURE 2: LATERAL ASPECT FIGURE 3: ANTERIOR ASPECT

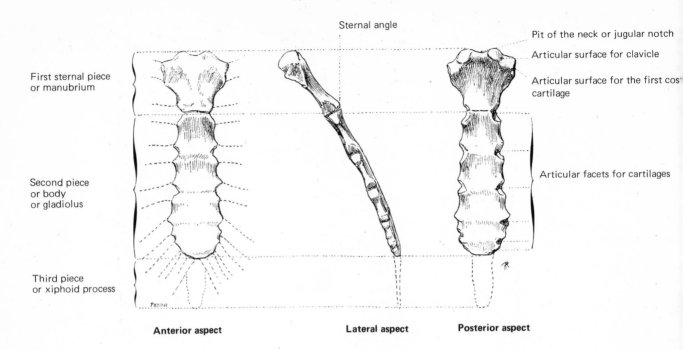

Sternal angle

Pit of the neck or jugular notch

Articular surface for clavicle

Articular surface for the first cos*
cartilage

First sternal piece
or manubrium

Second piece
or body
or gladiolus

Articular facets for cartilages

Third piece
or xiphoid process

Anterior aspect

Lateral aspect

Posterior aspect

FIGURE 1: STERNUM

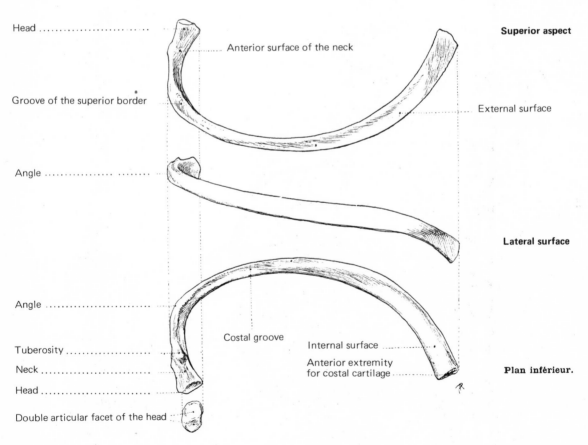

Head .

Superior aspect

Anterior surface of the neck

Groove of the superior border

External surface

Angle .

Lateral surface

Angle

Costal groove

Internal surface

Tuberosity

Neck

Anterior extremity
for costal cartilage

Plan inférieur.

Head

Double articular facet of the head . . .

FIGURE 2: SIXTH RIB

Plate 9: THORACIC CAGE

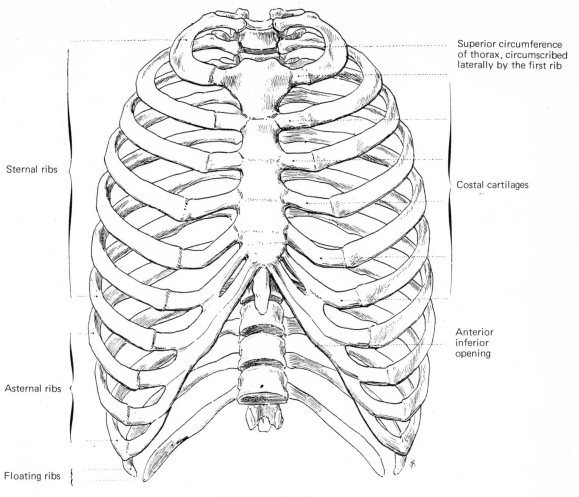

Superior circumference of thorax, circumscribed laterally by the first rib

Sternal ribs

Costal cartilages

Anterior inferior opening

Asternal ribs

Floating ribs

ANTERIOR ASPECT

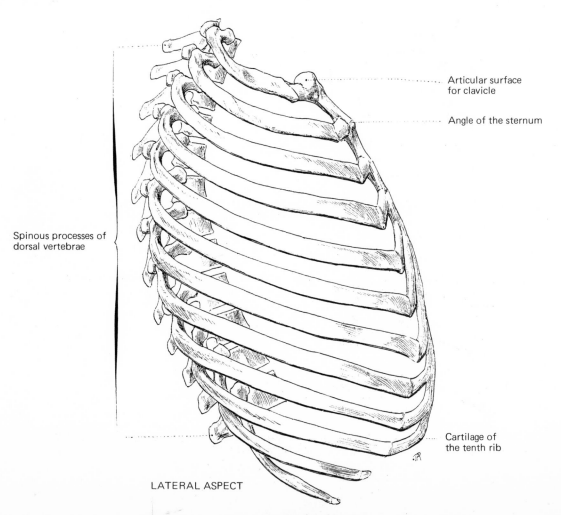

Articular surface for clavicle

Angle of the sternum

Spinous processes of dorsal vertebrae

Cartilage of the tenth rib

LATERAL ASPECT

147

Plate 10: THORACIC CAGE

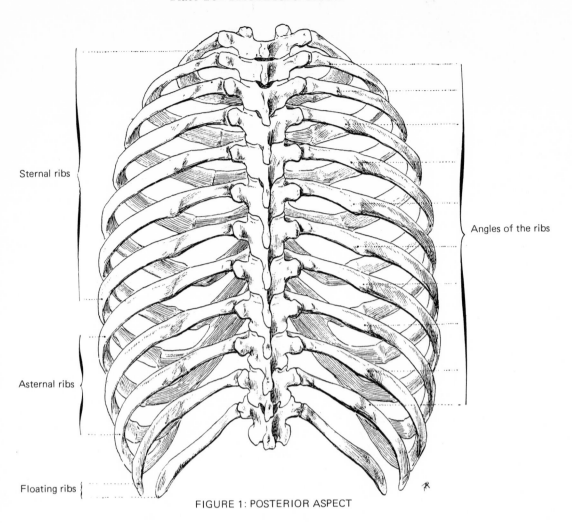

Sternal ribs

Angles of the ribs

Asternal ribs

Floating ribs

FIGURE 1: POSTERIOR ASPECT

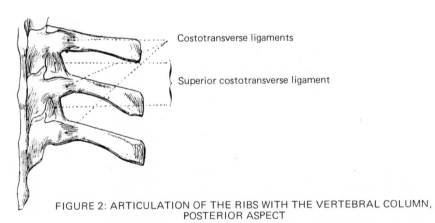

Costotransverse ligaments

Superior costotransverse ligament

FIGURE 2: ARTICULATION OF THE RIBS WITH THE VERTEBRAL COLUMN,
POSTERIOR ASPECT

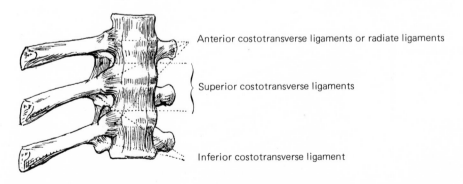

Anterior costotransverse ligaments or radiate ligaments

Superior costotransverse ligaments

Inferior costotransverse ligament

FIGURE 3: ARTICULATIONS OF THE RIBS WITH THE VERTEBRAL COLUMN,
ANTERIOR ASPECT

Plate 11: BONES OF THE SHOULDER

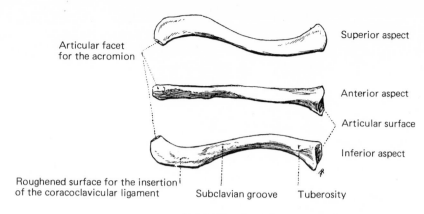

Articular facet
for the acromion

Superior aspect

Anterior aspect

Articular surface

Inferior aspect

Roughened surface for the insertion
of the coracoclavicular ligament

Subclavian groove

Tuberosity

FIGURE 1: CLAVICLE

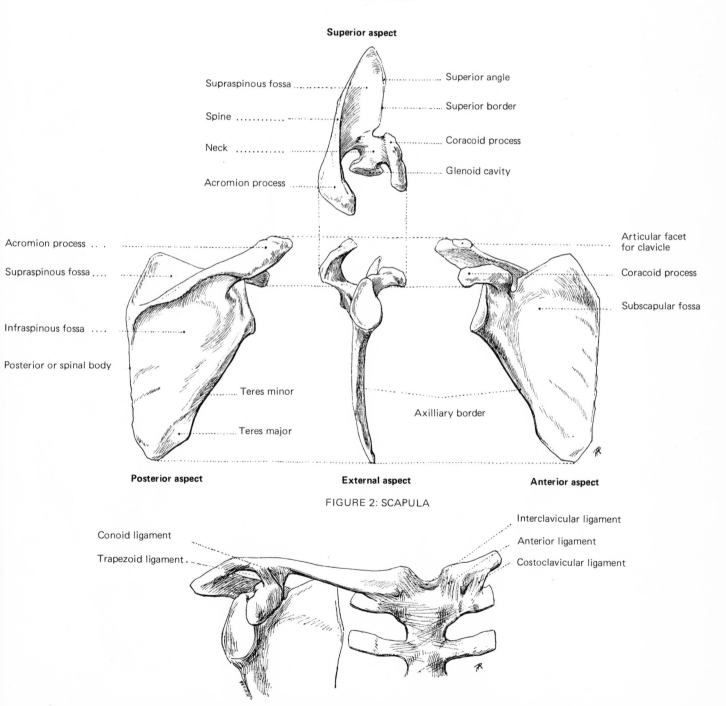

Superior aspect

Supraspinous fossa

Spine

Neck

Acromion process

Superior angle

Superior border

Coracoid process

Glenoid cavity

Acromion process

Supraspinous fossa

Infraspinous fossa

Posterior or spinal body

Teres minor

Teres major

Articular facet
for clavicle

Coracoid process

Subscapular fossa

Axilliary border

Posterior aspect

External aspect

Anterior aspect

FIGURE 2: SCAPULA

Conoid ligament

Trapezoid ligament

Interclavicular ligament

Anterior ligament

Costoclavicular ligament

FIGURE 3: ARTICULATIONS OF THE CLAVICLE

Plate 12: THE HIP BONE

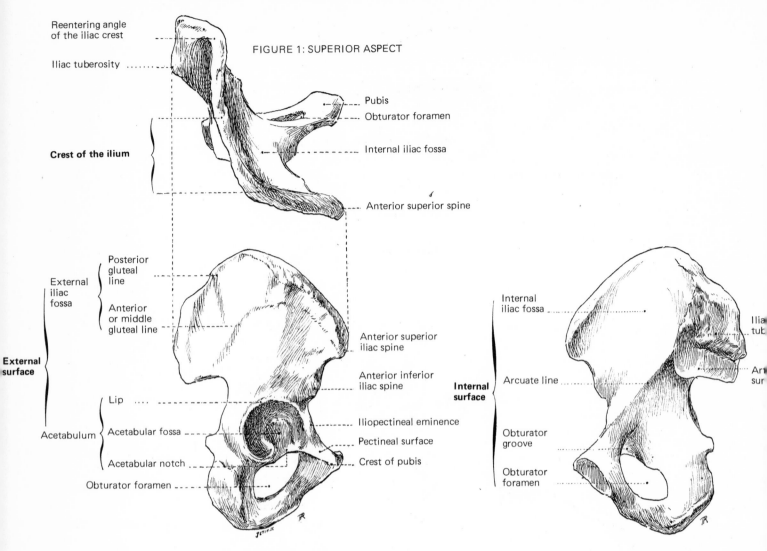

Reentering angle of the iliac crest

Iliac tuberosity

Crest of the ilium

FIGURE 1: SUPERIOR ASPECT

Pubis

Obturator foramen

Internal iliac fossa

Anterior superior spine

External surface

External iliac fossa
- Posterior gluteal line
- Anterior or middle gluteal line

Acetabulum
- Lip
- Acetabular fossa
- Acetabular notch

Obturator foramen

Anterior superior iliac spine

Anterior inferior iliac spine

Iliopectineal eminence

Pectineal surface

Crest of pubis

FIGURE 2: MEDIAL ASPECT

Internal surface

Internal iliac fossa

Arcuate line

Obturator groove

Obturator foramen

Ilia tub

Art sur

FIGURE 3: LATERAL ASPECT

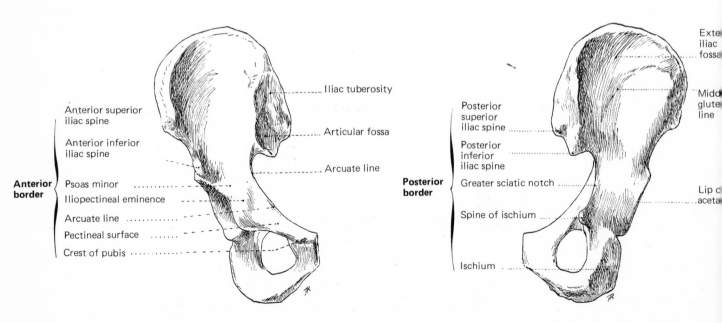

Anterior border

Anterior superior iliac spine

Anterior inferior iliac spine

Psoas minor

Iliopectineal eminence

Arcuate line

Pectineal surface

Crest of pubis

Iliac tuberosity

Articular fossa

Arcuate line

FIGURE 4: ANTERIOR ASPECT

Posterior border

Posterior superior iliac spine

Posterior inferior iliac spine

Greater sciatic notch

Spine of ischium

Ischium

Exte iliac fossa

Midd glute line

Lip c aceta

FIGURE 5: POSTERIOR ASPECT

Plate 13: MALE PELVIS

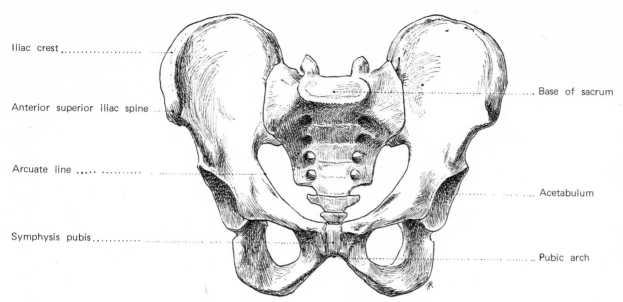

Iliac crest

Anterior superior iliac spine

Arcuate line

Symphysis pubis

Base of sacrum

Acetabulum

Pubic arch

FIGURE 1: ANTERIOR ASPECT

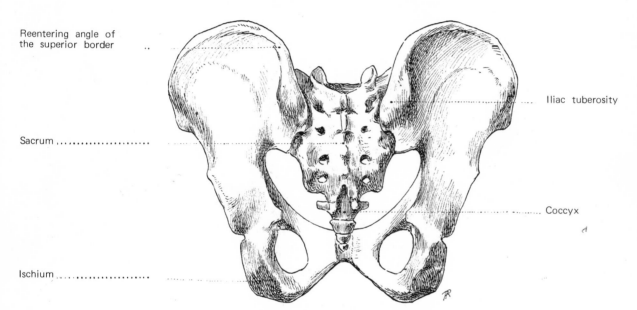

Reentering angle of
the superior border

Sacrum

Ischium

Iliac tuberosity

Coccyx

FIGURE 2: POSTERIOR ASPECT

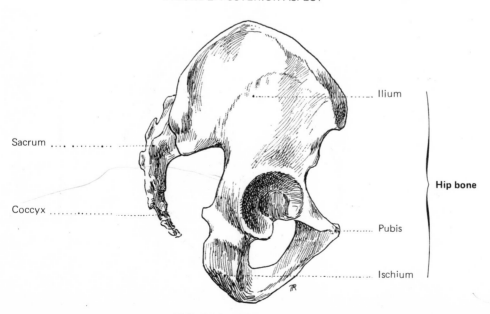

Sacrum

Coccyx

Ilium

Hip bone

Pubis

Ischium

FIGURE 3: LATERAL ASPECT

Plate 14: FEMALE PELVIS

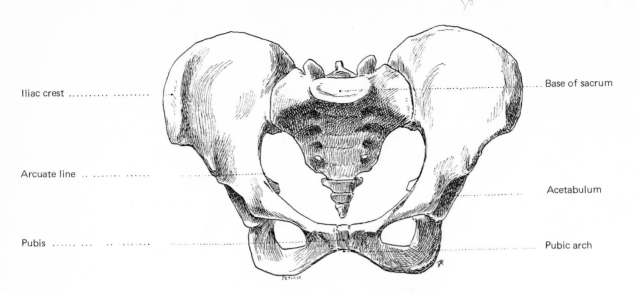

Iliac crest — Base of sacrum

Arcuate line — Acetabulum

Pubis — Pubic arch

FIGURE 1: ANTERIOR ASPECT

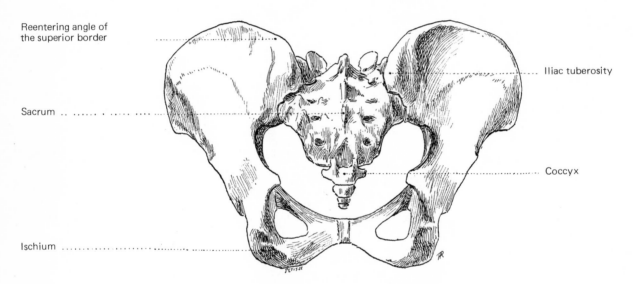

Reentering angle of
the superior border — Iliac tuberosity

Sacrum —

Ischium — Coccyx

FIGURE 2: POSTERIOR ASPECT

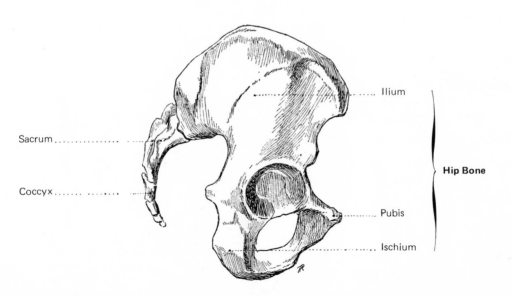

Sacrum................ — Ilium

Coccyx....... —

Hip Bone

Pubis

Ischium

FIGURE 3: LATERAL ASPECT

152

Plate 15: LIGAMENTS OF THE PELVIS

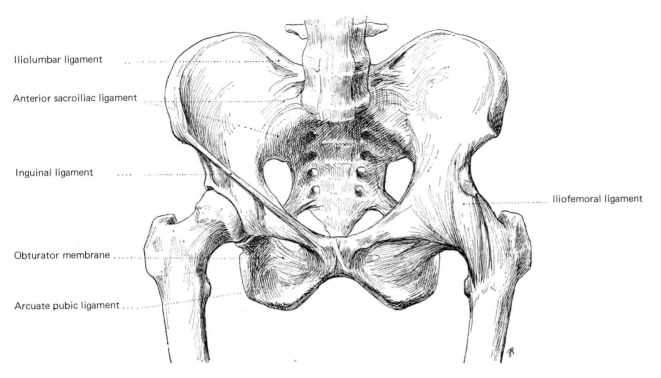

Iliolumbar ligament

Anterior sacroiliac ligament

Inguinal ligament

Iliofemoral ligament

Obturator membrane

Arcuate pubic ligament

FIGURE 1: ANTERIOR ASPECT

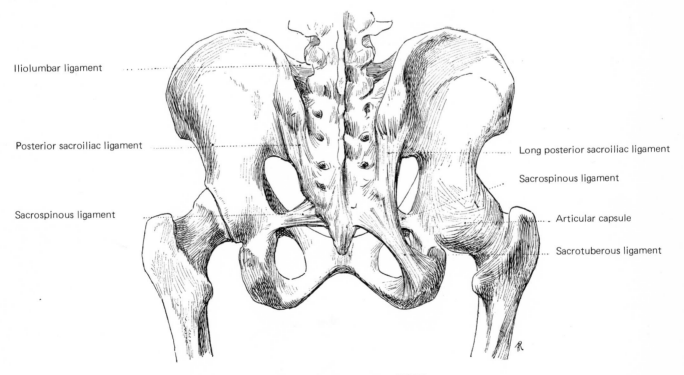

Iliolumbar ligament

Posterior sacroiliac ligament

Long posterior sacroiliac ligament

Sacrospinous ligament

Sacrospinous ligament

Articular capsule

Sacrotuberous ligament

FIGURE 2: POSTERIOR ASPECT

Plate 16: SKELETON OF THE TRUNK

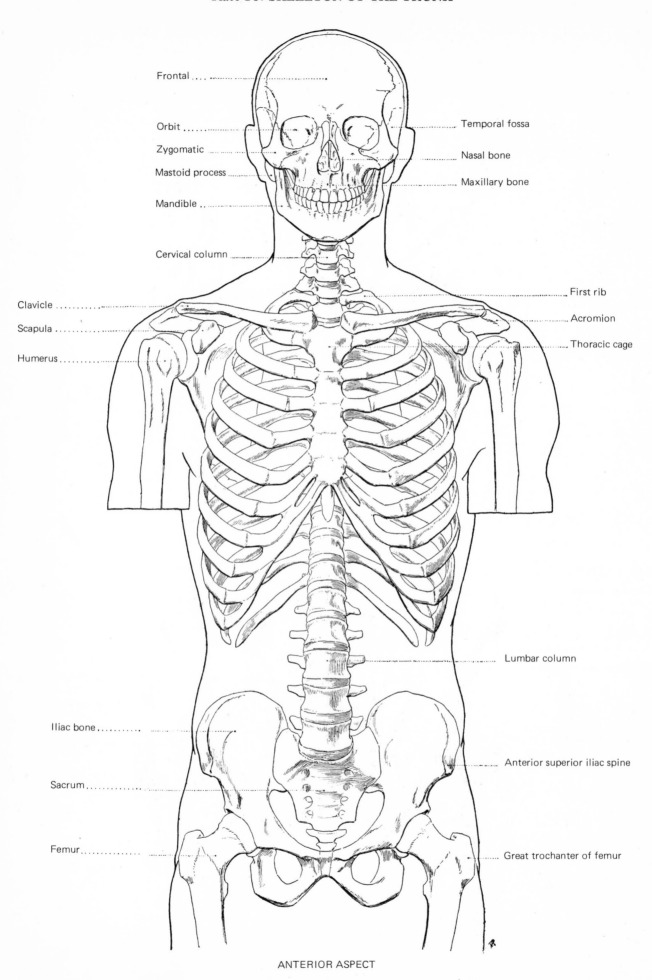

Frontal

Orbit

Zygomatic

Mastoid process

Mandible

Cervical column

Clavicle

Scapula

Humerus

Iliac bone

Sacrum

Femur

Temporal fossa

Nasal bone

Maxillary bone

First rib

Acromion

Thoracic cage

Lumbar column

Anterior superior iliac spine

Great trochanter of femur

ANTERIOR ASPECT

Plate 17: SKELETON OF THE TRUNK

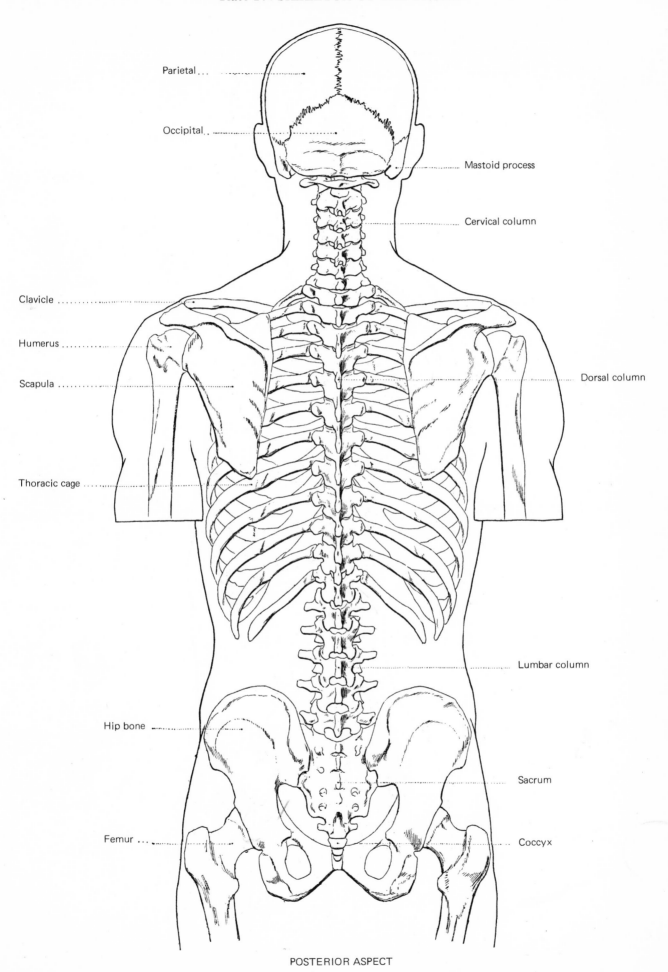

Parietal...

Occipital...

Mastoid process

Cervical column

Clavicle

Humerus

Scapula

Dorsal column

Thoracic cage

Lumbar column

Hip bone

Sacrum

Femur ...

Coccyx

POSTERIOR ASPECT

155

Plate 18: SKELETON OF THE TRUNK

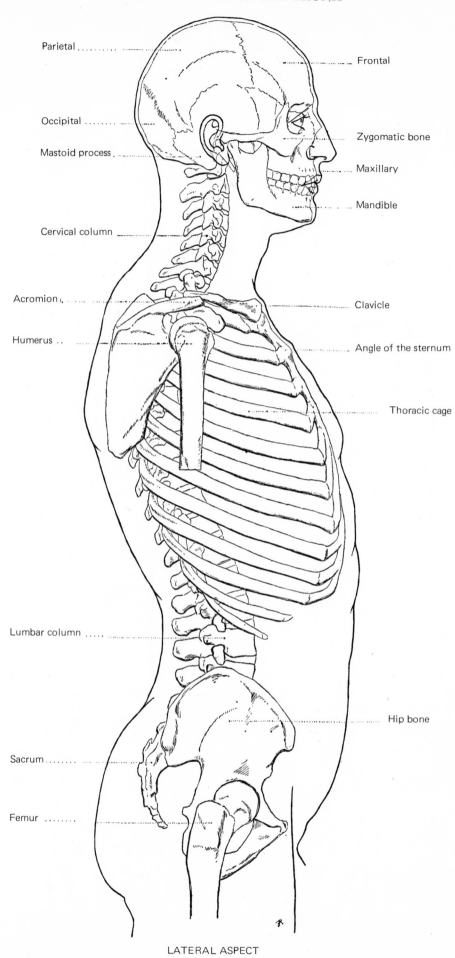

Parietal

Frontal

Occipital

Zygomatic bone

Mastoid process

Maxillary

Mandible

Cervical column

Acromion

Clavicle

Humerus ..

Angle of the sternum

Thoracic cage

Lumbar column

Hip bone

Sacrum

Femur

LATERAL ASPECT

156

Plate 19: SKELETON OF THE ARM

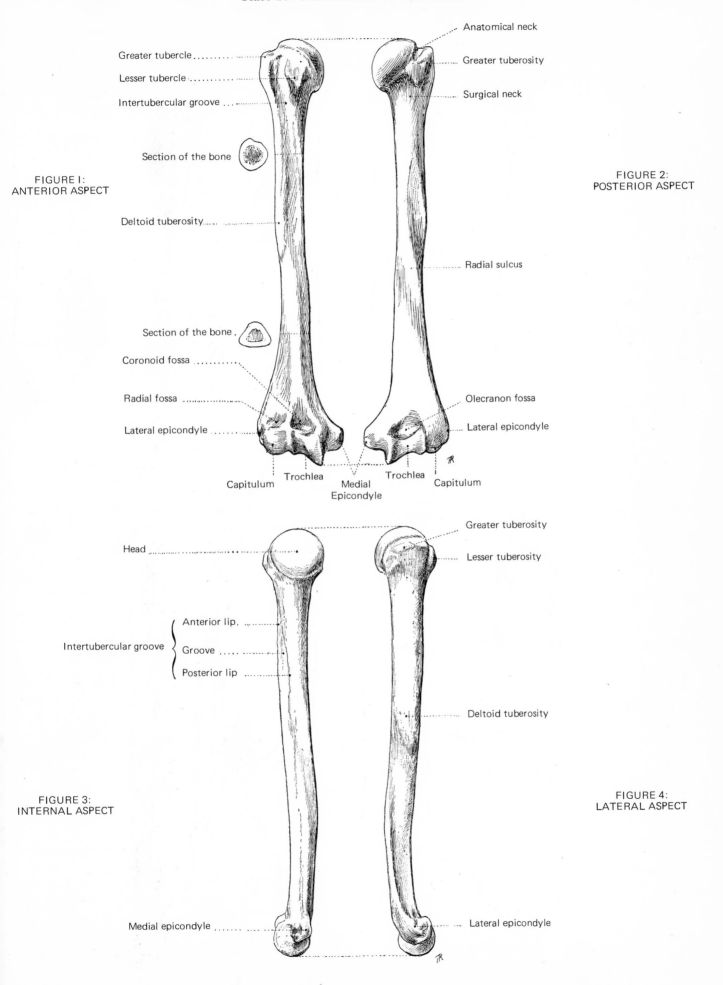

Anatomical neck

Greater tubercle............

Greater tuberosity

Lesser tubercle............

Surgical neck

Intertubercular groove ...

Section of the bone

FIGURE I:
ANTERIOR ASPECT

FIGURE 2:
POSTERIOR ASPECT

Deltoid tuberosity......

Radial sulcus

Section of the bone .

Coronoid fossa

Radial fossa

Olecranon fossa

Lateral epicondyle

Lateral epicondyle

Capitulum Trochlea

Trochlea Capitulum

Medial
Epicondyle

Greater tuberosity

Head

Lesser tuberosity

Anterior lip.

Intertubercular groove { Groove

Posterior lip

Deltoid tuberosity

FIGURE 3:
INTERNAL ASPECT

FIGURE 4:
LATERAL ASPECT

Medial epicondyle

Lateral epicondyle

157

Plate 20: BONES OF THE FOREARM

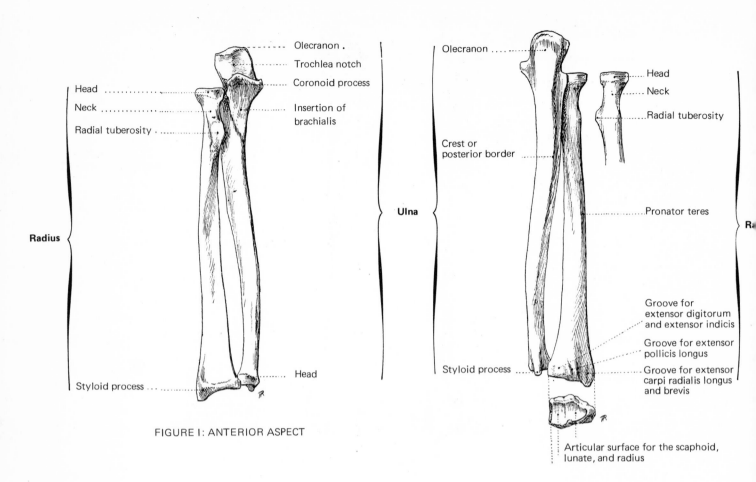

Olecranon

Trochlea notch

Coronoid process

Insertion of brachialis

Head

Neck

Radial tuberosity

Radius

Styloid process

Head

FIGURE I: ANTERIOR ASPECT

Olecranon

Ulna

Crest or posterior border

Head

Neck

Radial tuberosity

Pronator teres

R̶

Groove for extensor digitorum and extensor indicis

Groove for extensor pollicis longus

Styloid process

Groove for extensor carpi radialis longus and brevis

Articular surface for the scaphoid, lunate, and radius

FIGURE 2: POSTERIOR ASPECT

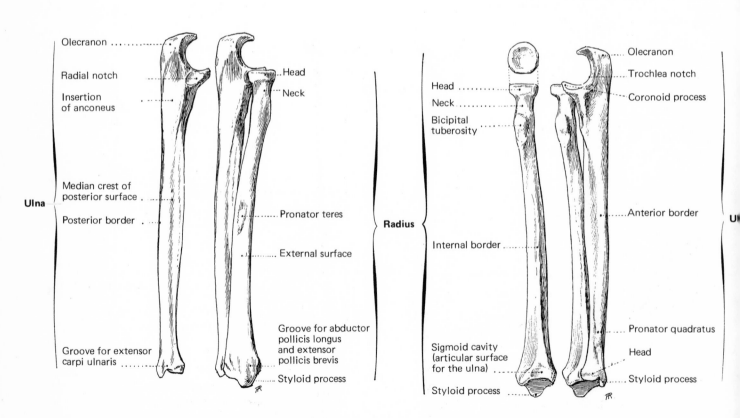

Olecranon

Radial notch

Insertion of anconeus

Head

Neck

Ulna

Median crest of posterior surface

Posterior border

Pronator teres

External surface

Groove for abductor pollicis longus and extensor pollicis brevis

Groove for extensor carpi ulnaris

Styloid process

FIGURE 3: LATERAL ASPECT

Head

Neck

Bicipital tuberosity

Radius

Internal border

Sigmoid cavity (articular surface for the ulna)

Styloid process

Olecranon

Trochlea notch

Coronoid process

Anterior border

U̶

Pronator quadratus

Head

Styloid process

FIGURE 4: MEDIAL ASPECT

Plate 21: BONES OF THE WRIST AND HAND

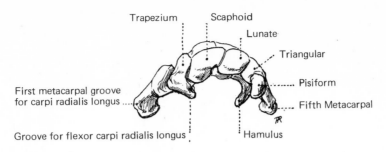

Trapezium — Scaphoid — Lunate — Triangular — Pisiform — Fifth Metacarpal — Hamulus

First metacarpal groove for carpi radialis longus

Groove for flexor carpi radialis longus

FIGURE 1: SUPERIOR ASPECT

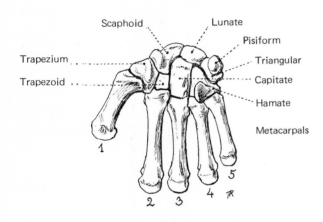

Scaphoid — Lunate — Pisiform — Triangular — Capitate — Hamate — Metacarpals

Trapezium — Trapezoid

1 2 3 4 5

FIGURE 2: ANTERIOR ASPECT

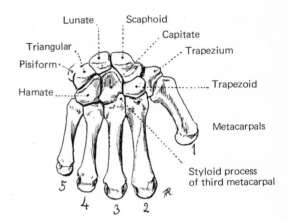

Lunate — Scaphoid — Capitate — Trapezium — Trapezoid

Triangular — Pisiform — Hamate

Metacarpals

Styloid process of third metacarpal

5 4 3 2 1

FIGURE 3: POSTERIOR ASPECT

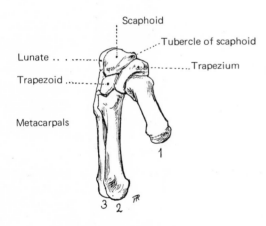

Scaphoid — Tubercle of scaphoid — Trapezium

Lunate — Trapezoid

Metacarpals

1

3 2

FIGURE 4: LATERAL ASPECT

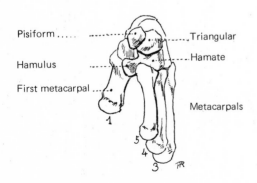

Pisiform — Triangular — Hamate

Hamulus

First metacarpal

Metacarpals

1 5 4 3

FIGURE 5: MEDIAL ASPECT

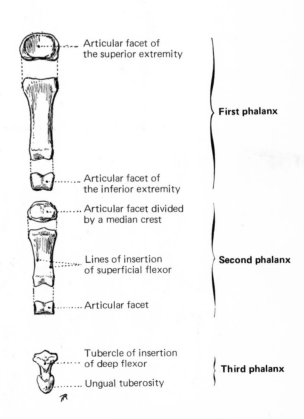

Articular facet of the superior extremity

Articular facet of the inferior extremity

First phalanx

Articular facet divided by a median crest

Lines of insertion of superficial flexor

Articular facet

Second phalanx

Tubercle of insertion of deep flexor

Ungual tuberosity

Third phalanx

FIGURE 6: BONES OF THE FINGERS, ANTERIOR ASPECT

Plate 22: LIGAMENTS OF THE ARM

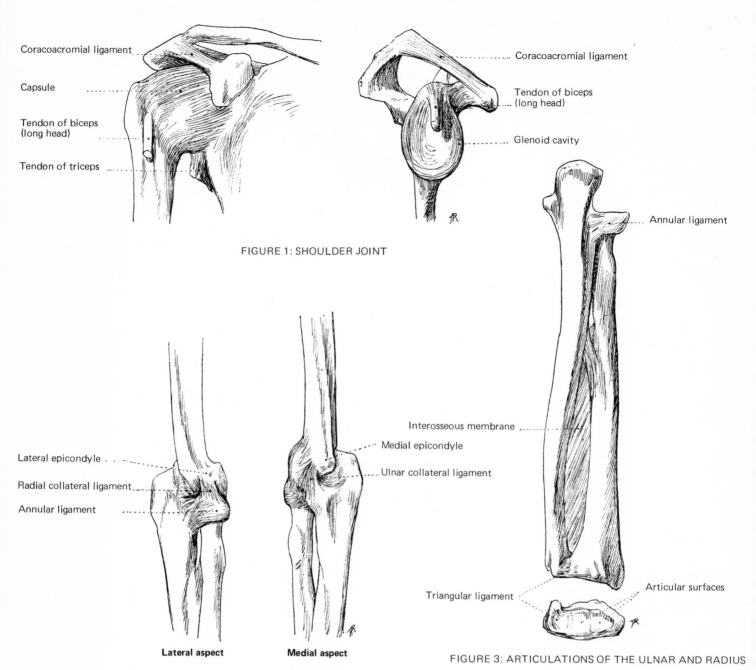

Coracoacromial ligament

Capsule

Tendon of biceps
(long head)

Tendon of triceps

Coracoacromial ligament

Tendon of biceps
(long head)

Glenoid cavity

FIGURE 1: SHOULDER JOINT

Annular ligament

Interosseous membrane

Medial epicondyle

Ulnar collateral ligament

Lateral epicondyle

Radial collateral ligament

Annular ligament

Triangular ligament

Articular surfaces

Lateral aspect **Medial aspect**

FIGURE 3: ARTICULATIONS OF THE ULNAR AND RADIUS

FIGURE 2: ARTICULATION OF THE ELBOW

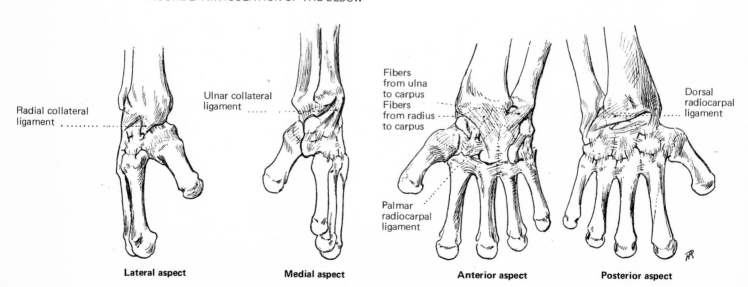

Ulnar collateral
ligament

Radial collateral
ligament

Fibers
from ulna
to carpus
Fibers
from radius
to carpus

Dorsal
radiocarpal
ligament

Palmar
radiocarpal
ligament

Lateral aspect **Medial aspect** **Anterior aspect** **Posterior aspect**

FIGURE 4: ARTICULATIONS OF THE WRIST

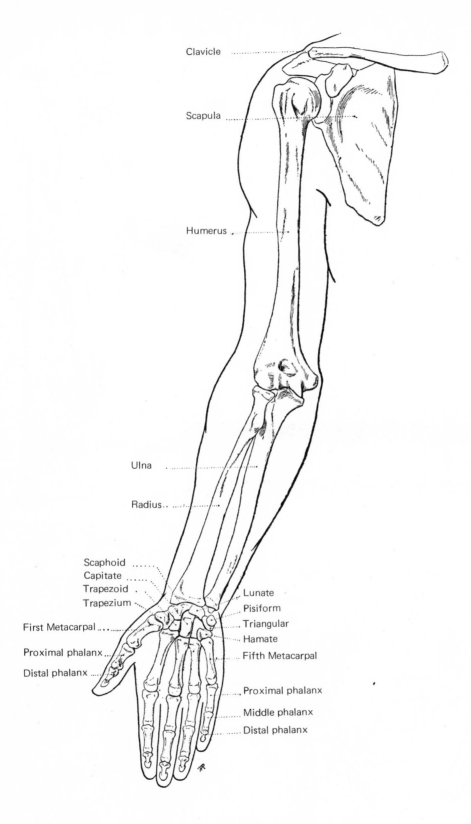

Clavicle

Scapula

Humerus

Ulna

Radius

Scaphoid
Capitate
Trapezoid
Trapezium

Lunate
Pisiform
Triangular
Hamate

First Metacarpal

Fifth Metacarpal

Proximal phalanx

Distal phalanx

Proximal phalanx

Middle phalanx

Distal phalanx

ANTERIOR ASPECT

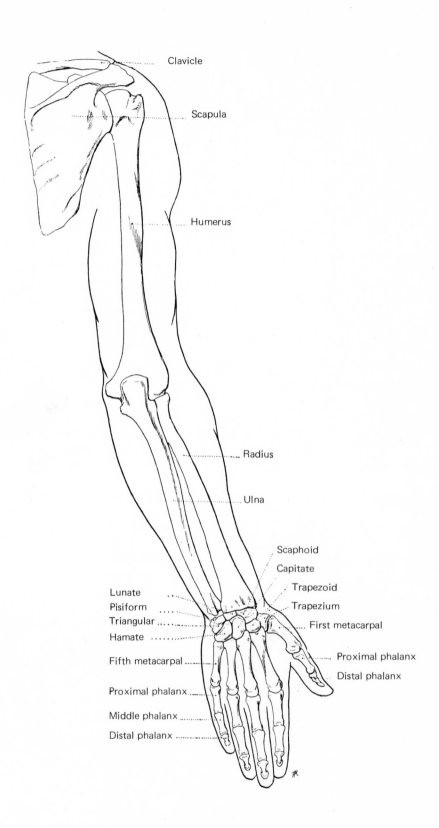

Clavicle

Scapula

Humerus

Radius

Ulna

Scaphoid

Capitate

Trapezoid

Lunate

Trapezium

Pisiform

Triangular

First metacarpal

Hamate

Fifth metacarpal

Proximal phalanx

Distal phalanx

Proximal phalanx

Middle phalanx

Distal phalanx

POSTERIOR ASPECT

Plate 25: BONES OF THE ARM

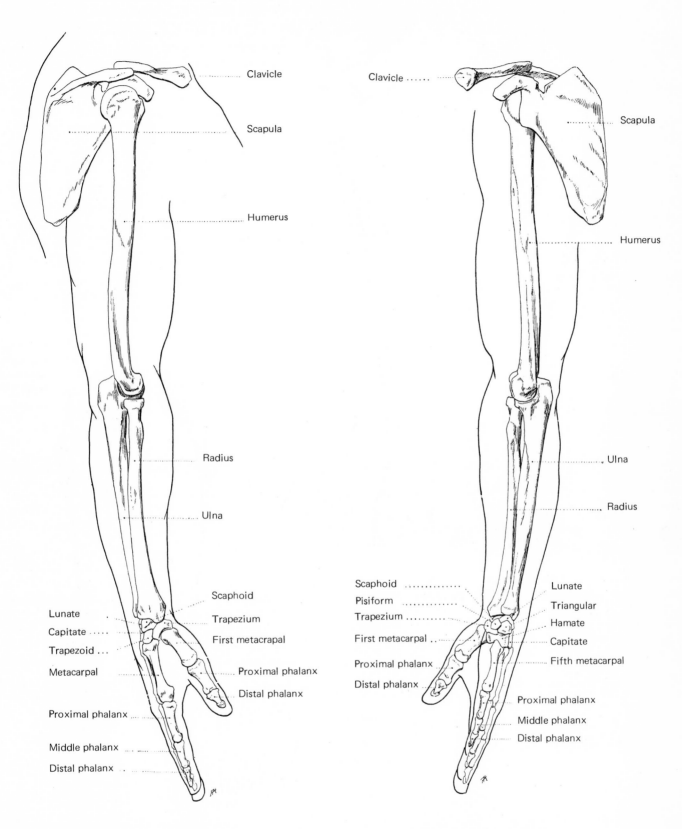

Clavicle

Scapula

Humerus

Radius

Ulna

Scaphoid

Lunate

Trapezium

Capitate

First metacrapal

Trapezoid

Metacarpal

Proximal phalanx

Distal phalanx

Proximal phalanx

Middle phalanx

Distal phalanx

Clavicle

Scapula

Humerus

Ulna

Radius

Scaphoid

Lunate

Pisiform

Triangular

Trapezium

Hamate

First metacarpal

Capitate

Proximal phalanx

Fifth metacarpal

Distal phalanx

Proximal phalanx

Middle phalanx

Distal phalanx

FIGURE 1: LATERAL ASPECT

FIGURE 2: MEDIAL ASPECT

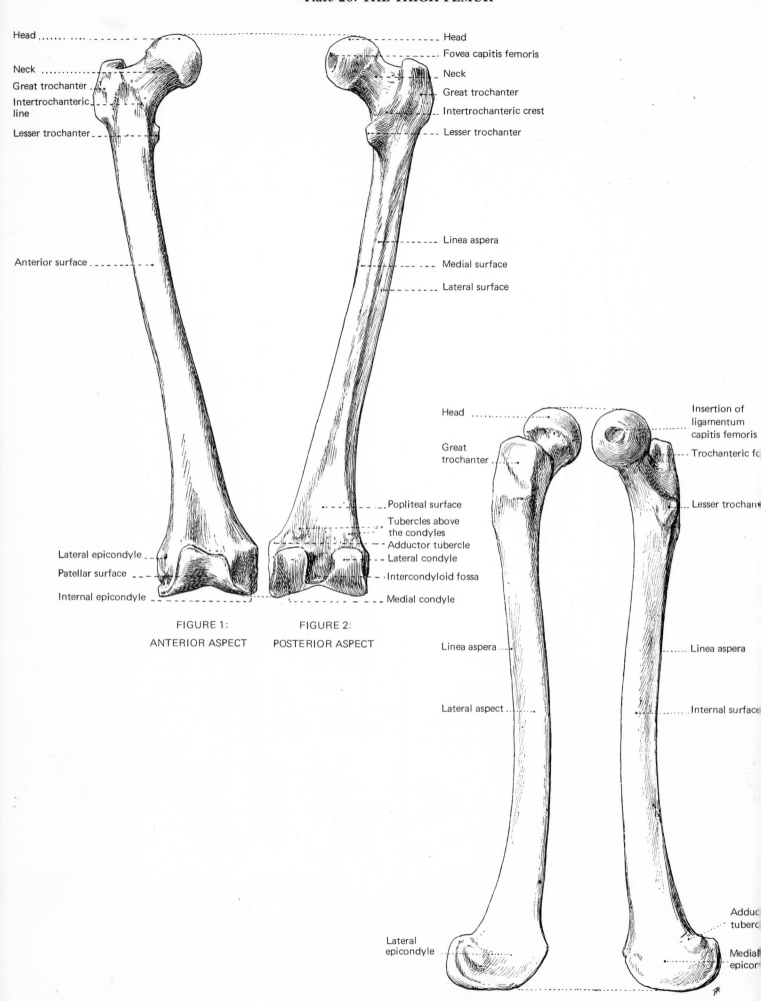

Head

Neck

Great trochanter

Intertrochanteric
line

Lesser trochanter

Anterior surface

Head

Fovea capitis femoris

Neck

Great trochanter

Intertrochanteric crest

Lesser trochanter

Linea aspera

Medial surface

Lateral surface

Lateral epicondyle

Patellar surface

Internal epicondyle

Popliteal surface

Tubercles above
the condyles

Adductor tubercle

Lateral condyle

Intercondyloid fossa

Medial condyle

FIGURE 1:
ANTERIOR ASPECT

FIGURE 2:
POSTERIOR ASPECT

Head

Great
trochanter

Insertion of
ligamentum
capitis femoris

Trochanteric fo

Lesser trochan

Linea aspera

Lateral aspect

Linea aspera

Internal surface

Lateral
epicondyle

Adduc
tuberc

Medial
epicon

FIGURE 3:
LATERAL ASPECT

FIGURE 4:
MEDIAL ASPECT

164

Plate 27: BONES OF THE LOWER LEG

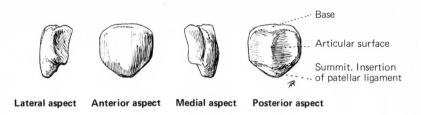

Base

Articular surface

Summit. Insertion of patellar ligament

Lateral aspect Anterior aspect Medial aspect Posterior aspect

FIGURE 1: PATELLA

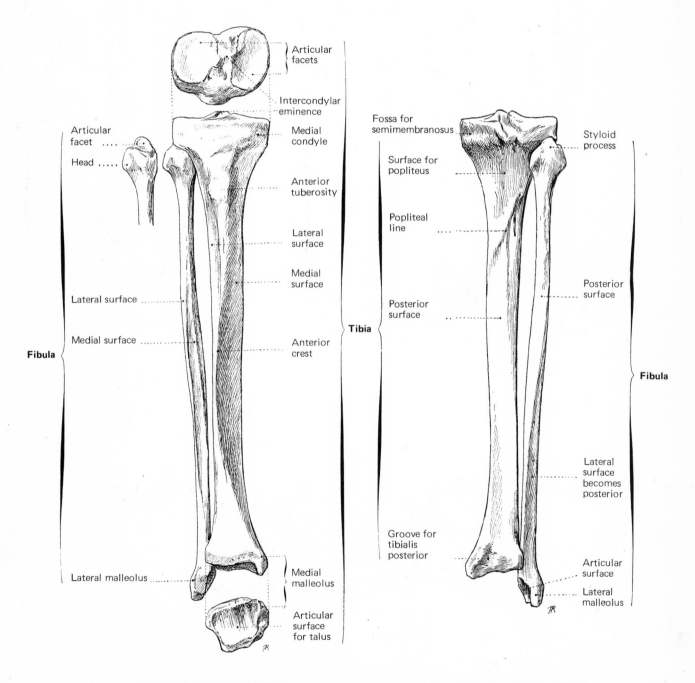

Articular facets

Intercondylar eminence

Medial condyle

Anterior tuberosity

Lateral surface

Medial surface

Anterior crest

Articular facet

Head

Lateral surface

Medial surface

Fibula

Lateral malleolus

Medial malleolus

Articular surface for talus

Tibia

Fossa for semimembranosus

Surface for popliteus

Popliteal line

Posterior surface

Groove for tibialis posterior

Styloid process

Posterior surface

Lateral surface becomes posterior

Articular surface

Lateral malleolus

Fibula

FIGURE 2: ANTERIOR ASPECT FIGURE 3: POSTERIOR ASPECT

PLATE 28: BONES OF THE LOWER LEG AND FOOT

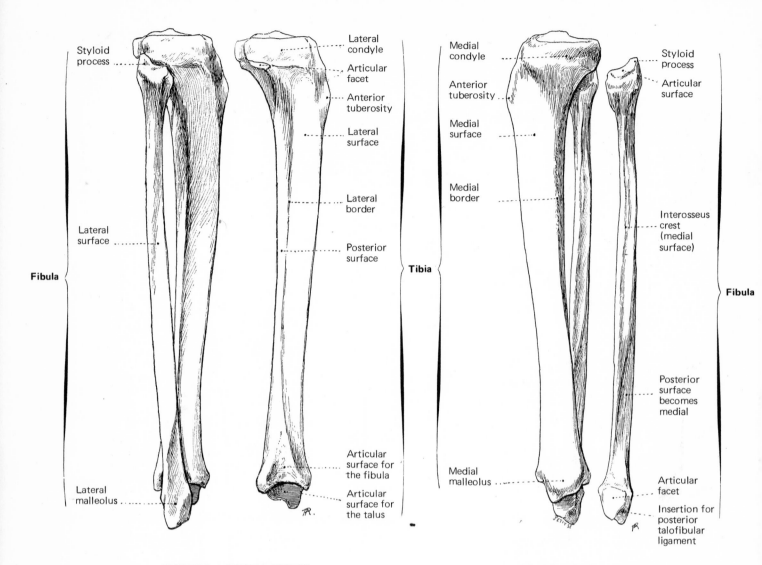

Styloid process

Lateral surface

Fibula

Lateral malleolus

Lateral condyle

Articular facet

Anterior tuberosity

Lateral surface

Lateral border

Posterior surface

Tibia

Articular surface for the fibula

Articular surface for the talus

FIGURE 1: LATERAL ASPECT

Medial condyle

Anterior tuberosity

Medial surface

Medial border

Medial malleolus

Styloid process

Articular surface

Interosseus crest (medial surface)

Fibula

Posterior surface becomes medial

Articular facet

Insertion for posterior talofibular ligament

FIGURE 2: MEDIAL ASPECT

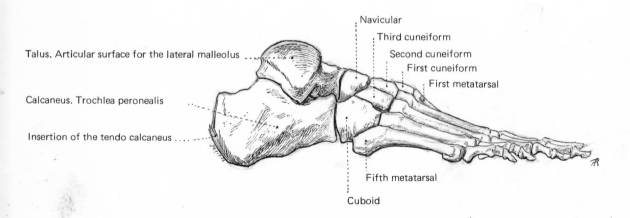

Talus. Articular surface for the lateral malleolus

Calcaneus. Trochlea peronealis

Insertion of the tendo calcaneus

Navicular

Third cuneiform

Second cuneiform

First cuneiform

First metatarsal

Fifth metatarsal

Cuboid

FIGURE 3: BONES OF THE FOOT,
LATERAL ASPECT

Plate 29: BONES OF THE FOOT

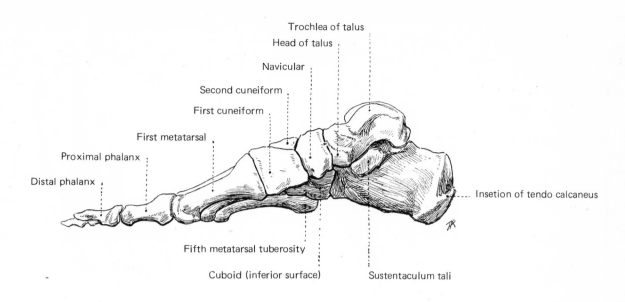

Trochlea of talus

Head of talus

Navicular

Second cuneiform

First cuneiform

First metatarsal

Proximal phalanx

Distal phalanx

Insetion of tendo calcaneus

Fifth metatarsal tuberosity

Cuboid (inferior surface)

Sustentaculum tali

FIGURE 1: MEDIAL ASPECT

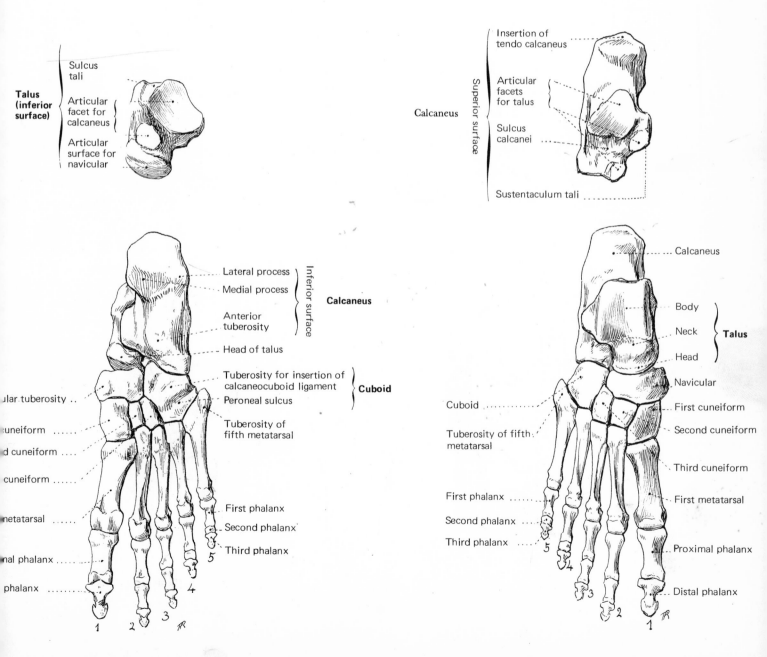

Talus (inferior surface)

Sulcus tali

Articular facet for calcaneus

Articular surface for navicular

Insertion of tendo calcaneus

Articular facets for talus

Sulcus calcanei

Sustentaculum tali

Calcaneus

Superior surface

Lateral process

Medial process

Anterior tuberosity

Head of talus

Inferior surface

Calcaneus

Tuberosity for insertion of calcaneocuboid ligament

Peroneal sulcus

Cuboid

Tuberosity of fifth metatarsal

ular tuberosity

uneiform

d cuneiform

cuneiform

metatarsal

nal phalanx

phalanx

First phalanx

Second phalanx

Third phalanx

5

4

1 2 3

FIGURE 2: INFERIOR ASPECT

Calcaneus

Body

Neck

Head

Talus

Navicular

First cuneiform

Second cuneiform

Third cuneiform

First metatarsal

Proximal phalanx

Distal phalanx

Cuboid

Tuberosity of fifth metatarsal

First phalanx

Second phalanx

Third phalanx

5

4

3

2

1

FIGURE 3: SUPERIOR ASPECT

Plate 30: LIGAMENTS OF THE KNEE

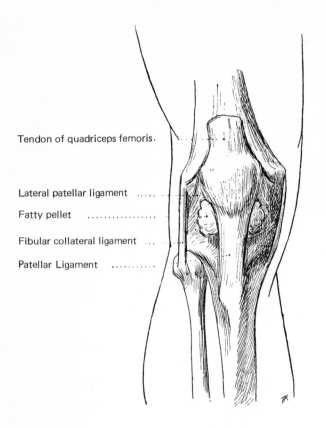

Tendon of quadriceps femoris.

Lateral patellar ligament

Fatty pellet

Fibular collateral ligament ...

Patellar Ligament

FIGURE 1: ANTERIOR ASPECT

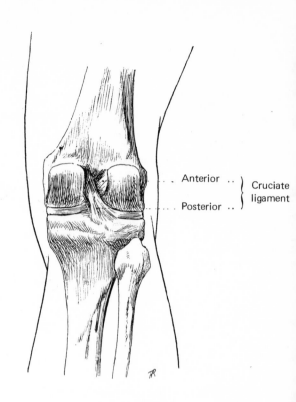

Anterior ..

Posterior ..

Cruciate ligament

FIGURE 2: POSTERIOR ASPECT

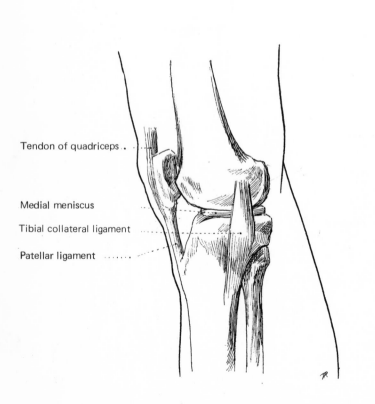

Tendon of quadriceps ...

Medial meniscus

Tibial collateral ligament

Patellar ligament

FIGURE 3: INTERNAL ASPECT

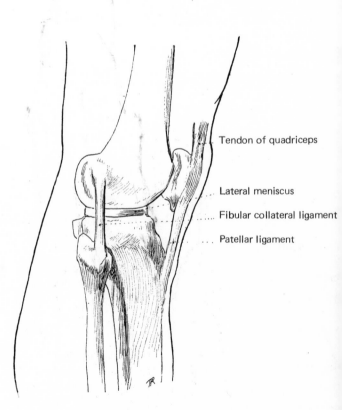

Tendon of quadriceps

Lateral meniscus

Fibular collateral ligament

Patellar ligament

FIGURE 4: MEDIAL ASPECT

Plate 31: LIGAMENTS OF THE ANKLE AND FOOT

Articulations of the Ankle

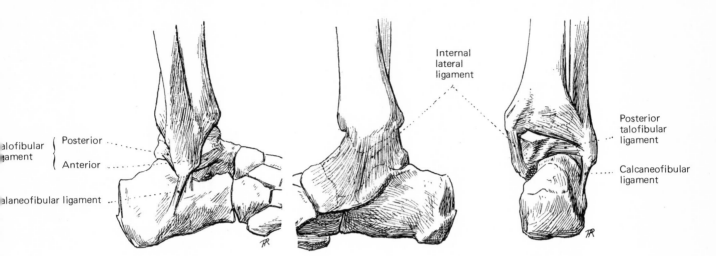

Talofibular ligament {
Posterior

Anterior
}

Calcaneofibular ligament ...

Internal lateral ligament

Posterior talofibular ligament

Calcaneofibular ligament

FIGURE 1: MEDIAL ASPECT FIGURE 2: LATERAL ASPECT FIGURE 3: POSTERIOR ASPECT

Articulations of the Foot

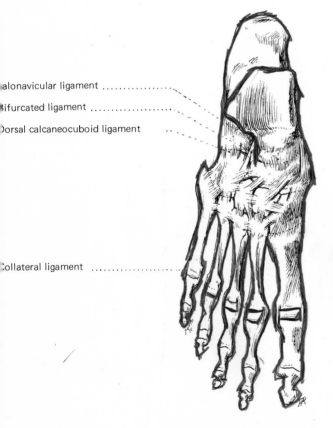
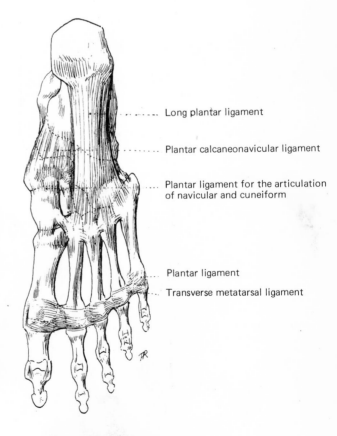

Talonavicular ligament

Bifurcated ligament

Dorsal calcaneocuboid ligament ...

Collateral ligament

Long plantar ligament

Plantar calcaneonavicular ligament

Plantar ligament for the articulation of navicular and cuneiform

Plantar ligament

Transverse metatarsal ligament

FIGURE 4: SUPERIOR ASPECT FIGURE 5: INFERIOR ASPECT

169

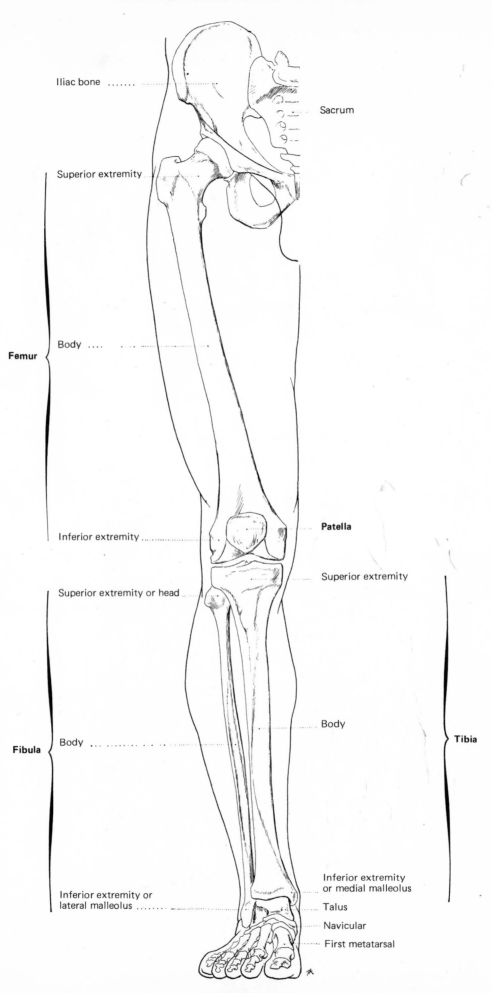

Iliac bone

Sacrum

Superior extremity

Body

Femur

Inferior extremity

Patella

Superior extremity or head

Superior extremity

Body

Fibula

Body

Tibia

Inferior extremity or medial malleolus

Inferior extremity or lateral malleolus

Talus

Navicular

First metatarsal

ANTERIOR ASPECT

Plate 33: BONES OF THE LOWER LIMB

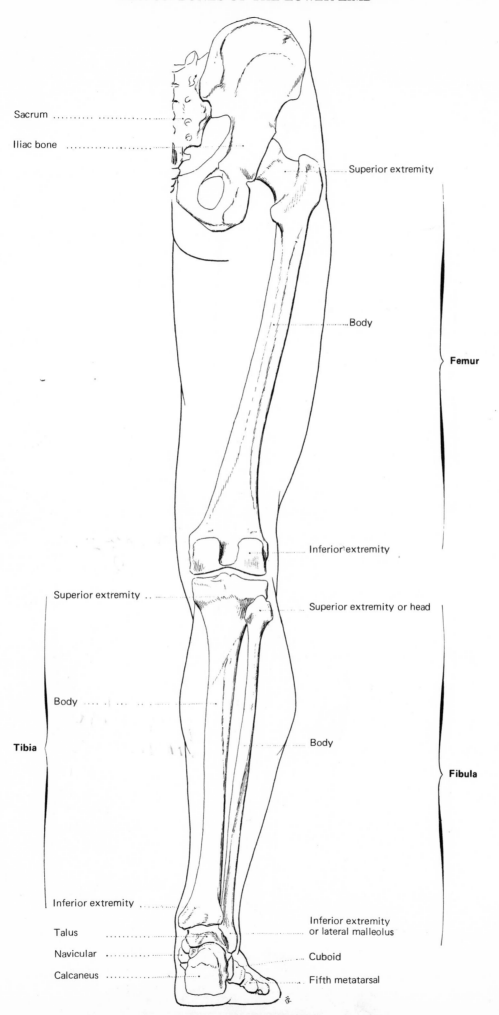

Sacrum

Iliac bone

Superior extremity

Body

Femur

Inferior extremity

Superior extremity

Superior extremity or head

Body

Body

Tibia

Fibula

Inferior extremity

Talus

Inferior extremity or lateral malleolus

Navicular

Cuboid

Calcaneus

Fifth metatarsal

POSTERIOR ASPECT

171

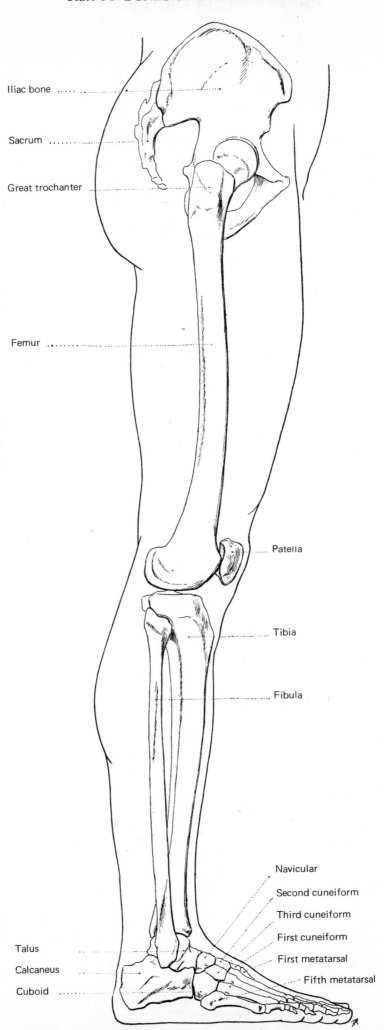

Iliac bone

Sacrum

Great trochanter

Femur

Patella

Tibia

Fibula

Navicular

Second cuneiform

Third cuneiform

First cuneiform

First metatarsal

Fifth metatarsal

Talus

Calcaneus

Cuboid

LATERAL ASPECT

Plate 35: BONES OF THE LOWER LIMB

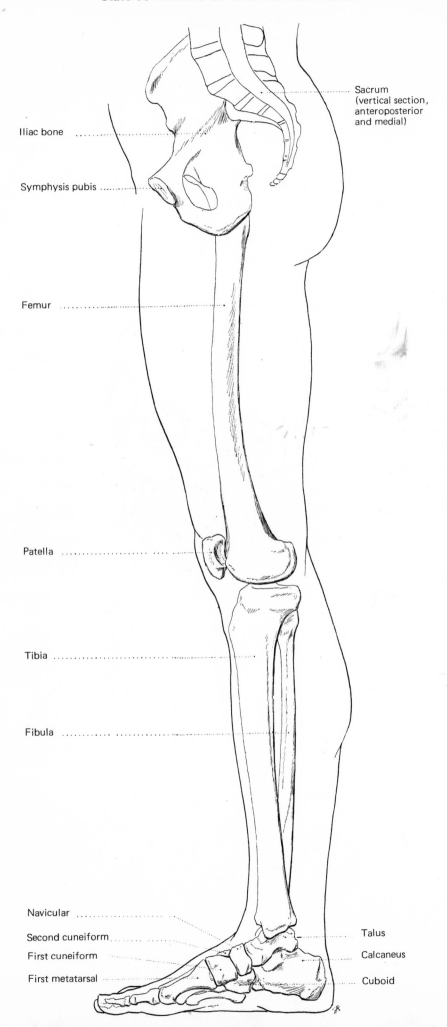

Sacrum
(vertical section,
anteroposterior
and medial)

Iliac bone

Symphysis pubis

Femur

Patella

Tibia

Fibula

Navicular

Second cuneiform

First cuneiform

First metatarsal

Talus

Calcaneus

Cuboid

MEDIAL ASPECT

Frontalis

Temporal aponeurosis

Orbicularis oculi

Levator labii superioris
 alaeque nasi

Levator labii superioris

Levator anguli oris

Zygomaticus minor

Zygomaticus major

Masseter

Buccinator

Orbicularis oris

Depressor anguli oris

Depressor labii inferioris

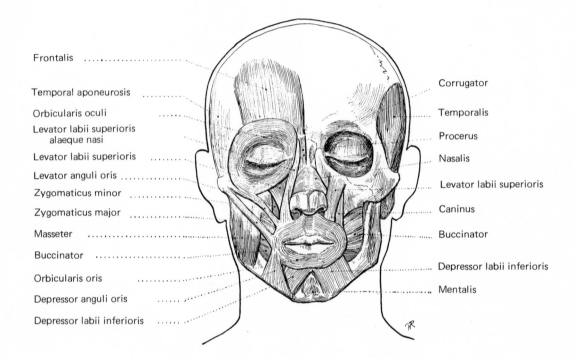

Corrugator

Temporalis

Procerus

Nasalis

Levator labii superioris

Caninus

Buccinator

Depressor labii inferioris

Mentalis

Plate 37: MUSCLES OF THE HEAD

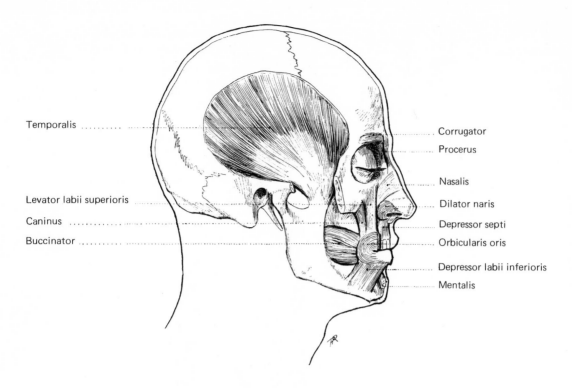

Temporalis

Levator labii superioris

Caninus

Buccinator

Corrugator

Procerus

Nasalis

Dilator naris

Depressor septi

Orbicularis oris

Depressor labii inferioris

Mentalis

FIGURE 1: DEEP LAYER

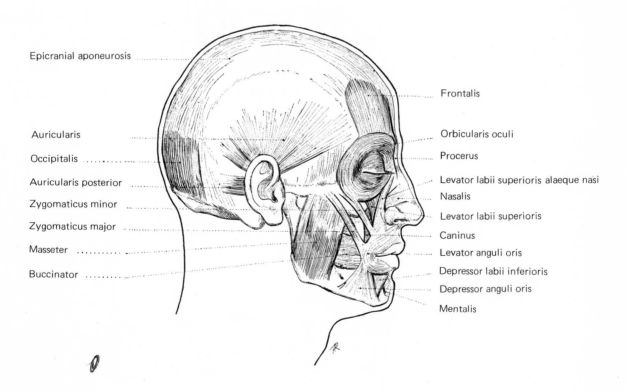

Epicranial aponeurosis

Auricularis

Occipitalis

Auricularis posterior

Zygomaticus minor

Zygomaticus major

Masseter

Buccinator

Frontalis

Orbicularis oculi

Procerus

Levator labii superioris alaeque nasi

Nasalis

Levator labii superioris

Caninus

Levator anguli oris

Depressor labii inferioris

Depressor anguli oris

Mentalis

FIGURE 2: SUPERFICIAL LAYER

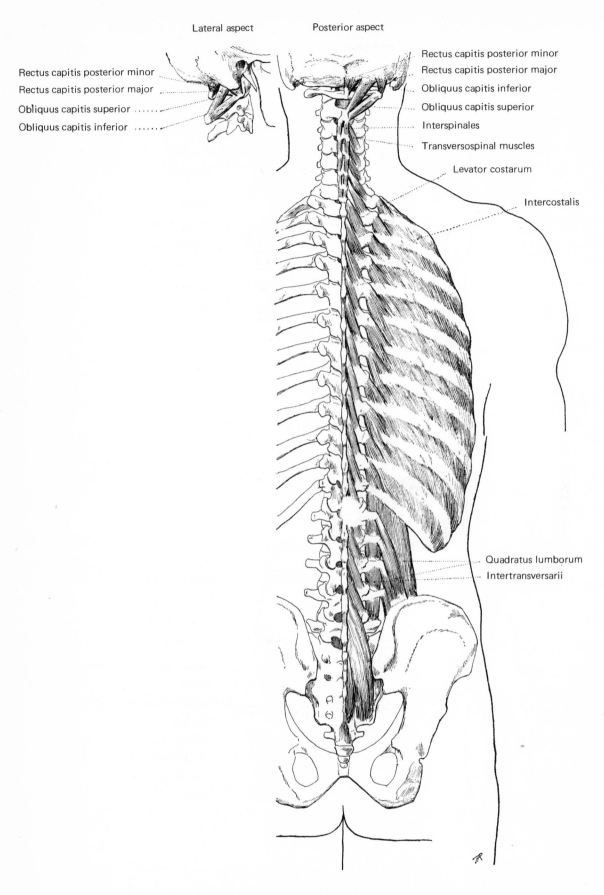

Lateral aspect

Posterior aspect

Rectus capitis posterior minor

Rectus capitis posterior major

Obliquus capitis superior

Obliquus capitis inferior

Rectus capitis posterior minor

Rectus capitis posterior major

Obliquus capitis inferior

Obliquus capitis superior

Interspinales

Transversospinal muscles

Levator costarum

Intercostalis

Quadratus lumborum

Intertransversarii

DEEP LAYER

Plate 39: MUSCLES OF THE TRUNK AND NECK (POSTERIOR REGION)

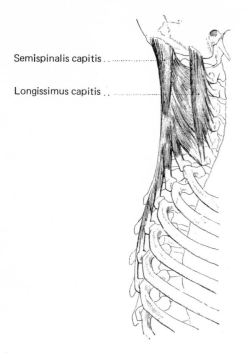

Semispinalis capitis

Longissimus capitis

FIGURE 1: LATERAL ASPECT

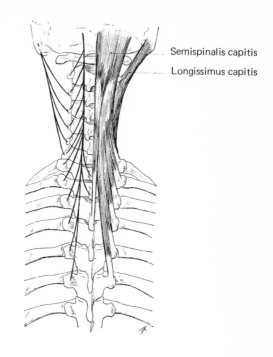

Semispinalis capitis

Longissimus capitis

FIGURE 2: POSTERIOR ASPECT

on the left side, the dark lines show
the muscular origins and insertions

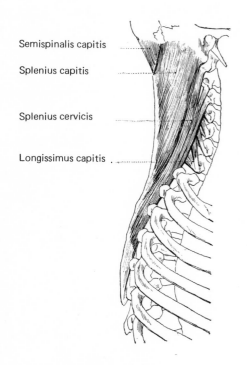

Semispinalis capitis

Splenius capitis

Splenius cervicis

Longissimus capitis

FIGURE 3: SPLENIUS, LATERAL ASPECT

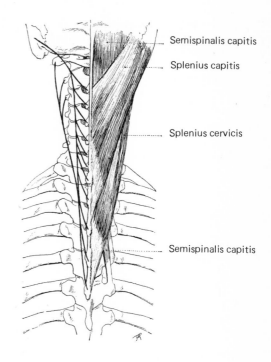

Semispinalis capitis

Splenius capitis

Splenius cervicis

Semispinalis capitis

FIGURE 4: SPLENIUS, POSTERIOR ASPECT

177

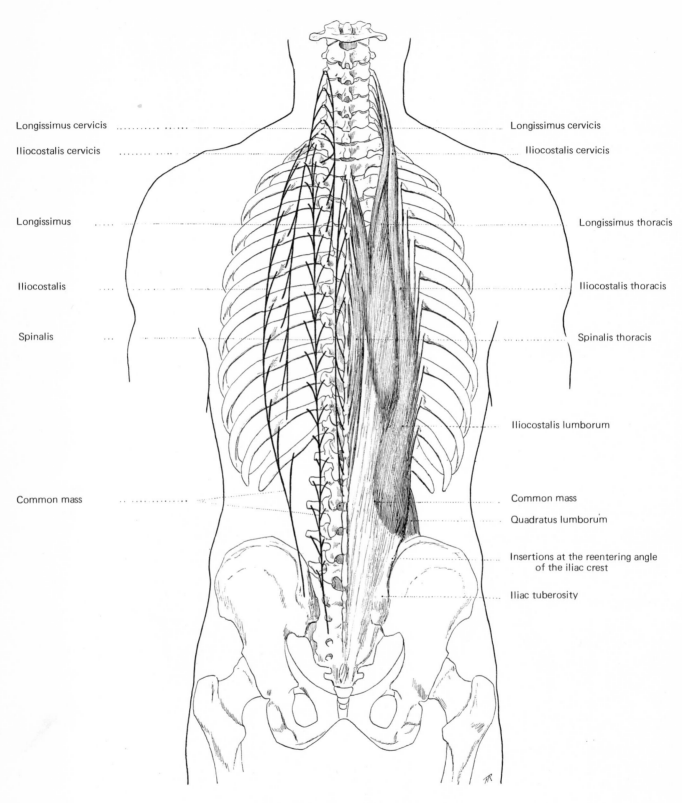

Longissimus cervicis

Iliocostalis cervicis

Longissimus

Iliocostalis

Spinalis

Common mass

Longissimus cervicis

Iliocostalis cervicis

Longissimus thoracis

Iliocostalis thoracis

Spinalis thoracis

Iliocostalis lumborum

Common mass

Quadratus lumborum

Insertions at the reentering angle
of the iliac crest

Iliac tuberosity

SPINAL MUSCLES

on the left side of the figure, the darker
lines show the origins and insertions of the muscles

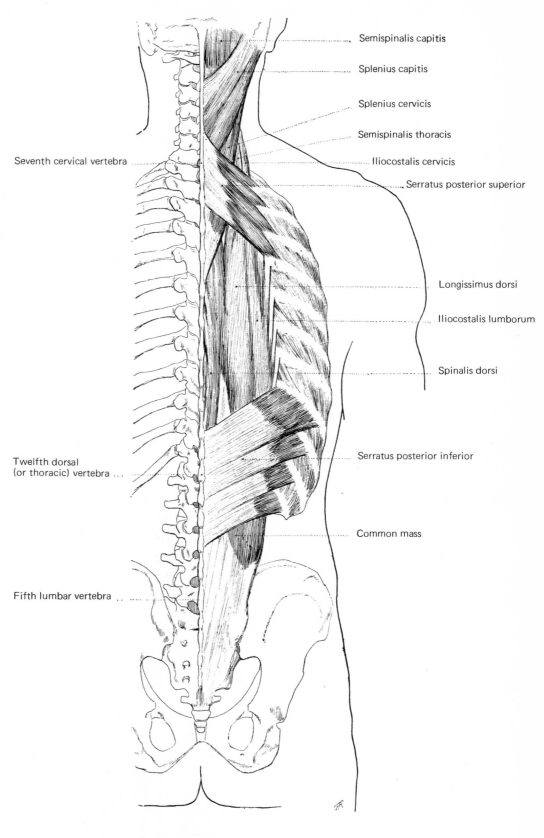

Semispinalis capitis

Splenius capitis

Splenius cervicis

Semispinalis thoracis

Iliocostalis cervicis

Serratus posterior superior

Seventh cervical vertebra

Longissimus dorsi

Iliocostalis lumborum

Spinalis dorsi

Serratus posterior inferior

Twelfth dorsal
(or thoracic) vertebra

Common mass

Fifth lumbar vertebra

SERRATUS POSTERIOR,
SUPERIOR AND INFERIOR

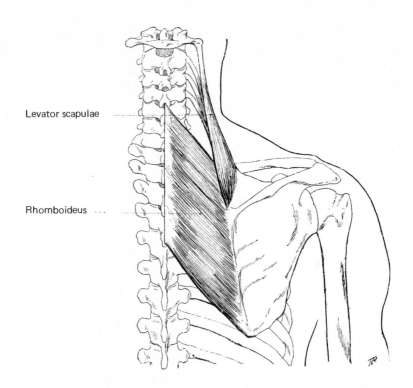

Levator scapulae

Rhomboideus

FIGURE 1: RHOMBOIDEUS AND LEVATOR SCAPULAE

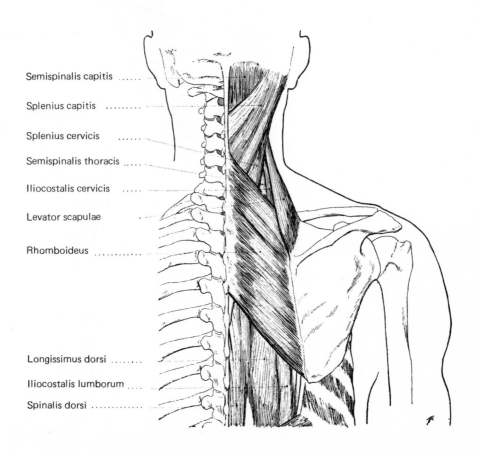

Semispinalis capitis

Splenius capitis

Splenius cervicis

Semispinalis thoracis

Iliocostalis cervicis

Levator scapulae

Rhomboideus

Longissimus dorsi

Iliocostalis lumborum

Spinalis dorsi

FIGURE 2: RHOMBOIDS AND LEVATOR SCAPULAE WITH THE ADJACENT MUSCLES

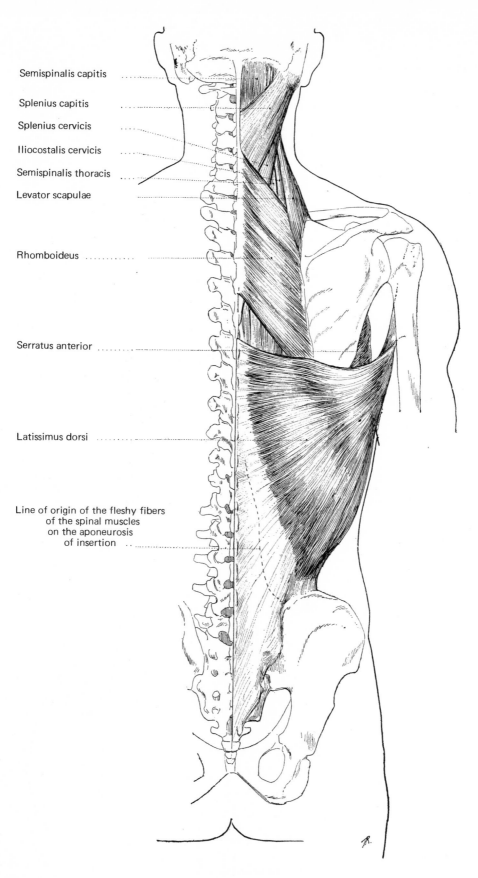

Semispinalis capitis

Splenius capitis

Splenius cervicis

Iliocostalis cervicis

Semispinalis thoracis

Levator scapulae

Rhomboideus

Serratus anterior

Latissimus dorsi

Line of origin of the fleshy fibers
of the spinal muscles
on the aponeurosis
of insertion

LATISSIMUS DORSI

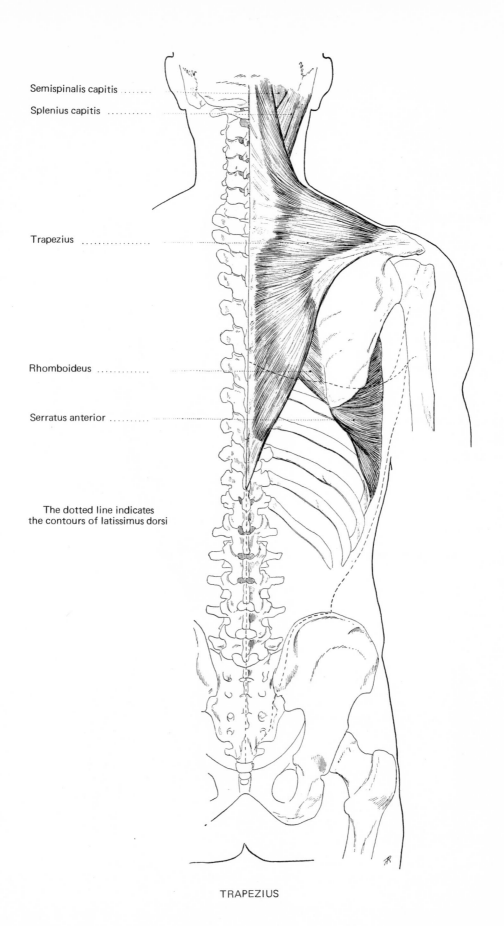

Semispinalis capitis

Splenius capitis

Trapezius

Rhomboideus

Serratus anterior

The dotted line indicates
the contours of latissimus dorsi

TRAPEZIUS

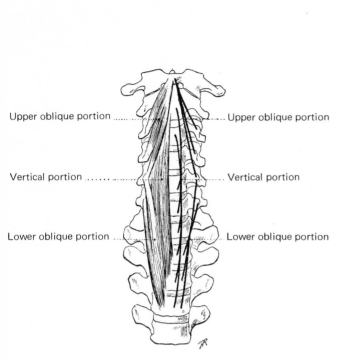

Upper oblique portion Upper oblique portion

Vertical portion Vertical portion

Lower oblique portion Lower oblique portion

FIGURE 1: LONGUS COLLI

(the lines on the right show the
muscular origins and insertions)

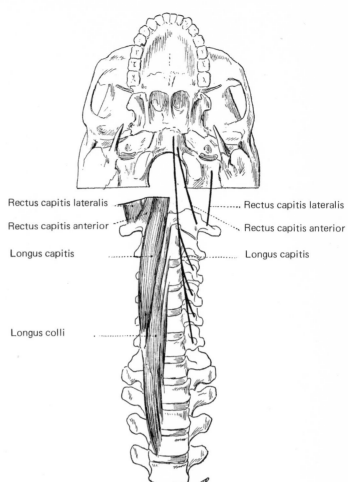

Rectus capitis lateralis Rectus capitis lateralis

Rectus capitis anterior Rectus capitis anterior

Longus capitis Longus capitis

Longus colli

FIGURE 2: ANTERIOR DEEP LAYER

(the lines on the right show the
muscular origins and insertions)

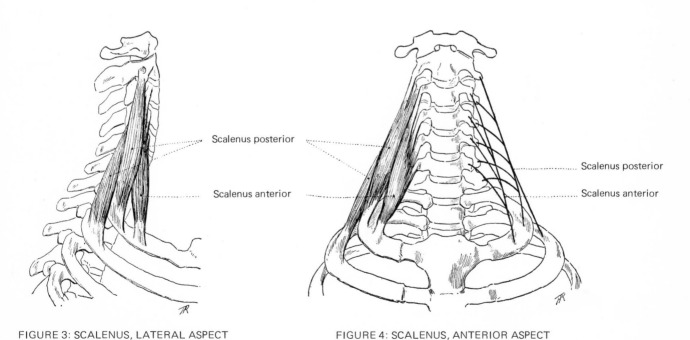

Scalenus posterior Scalenus posterior

Scalenus anterior Scalenus anterior

FIGURE 3: SCALENUS, LATERAL ASPECT

FIGURE 4: SCALENUS, ANTERIOR ASPECT

(the lines on the right show the
muscular origins and insertions)

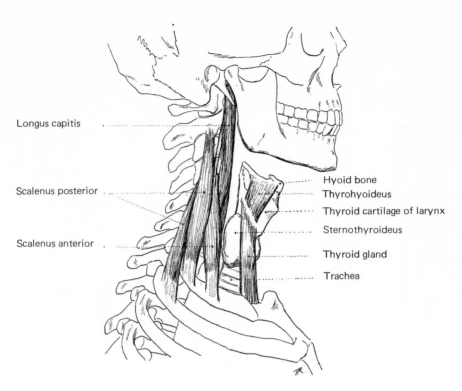

Longus capitis

Scalenus posterior

Scalenus anterior

Hyoid bone
Thyrohyoideus
Thyroid cartilage of larynx
Sternothyroideus
Thyroid gland
Trachea

FIGURE 1

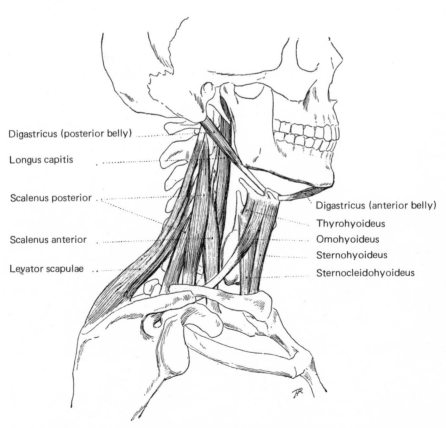

Digastricus (posterior belly)

Longus capitis

Scalenus posterior

Scalenus anterior

Levator scapulae

Digastricus (anterior belly)
Thyrohyoideus
Omohyoideus
Sternohyoideus
Sternocleidohyoideus

FIGURE 2

Plate 47: MUSCLES OF THE NECK

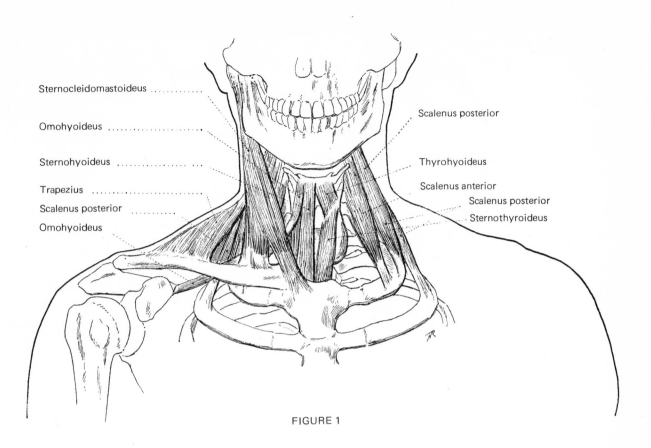

Sternocleidomastoideus

Omohyoideus

Sternohyoideus

Trapezius

Scalenus posterior

Omohyoideus

Scalenus posterior

Thyrohyoideus

Scalenus anterior

Scalenus posterior

Sternothyroideus

FIGURE 1

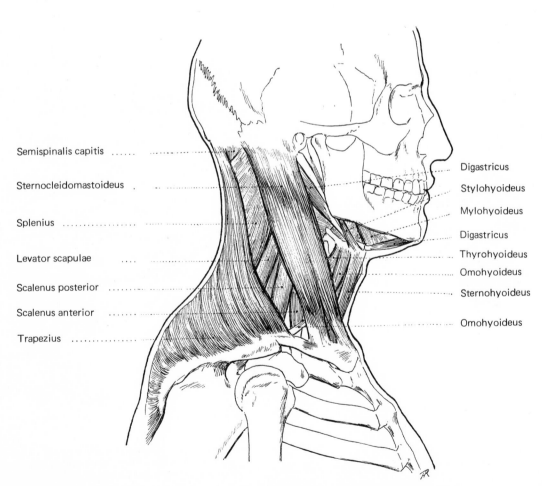

Semispinalis capitis

Sternocleidomastoideus .

Splenius

Levator scapulae

Scalenus posterior

Scalenus anterior

Trapezius

Digastricus

Stylohyoideus

Mylohyoideus

Digastricus

Thyrohyoideus

Omohyoideus

Sternohyoideus

Omohyoideus

FIGURE 2

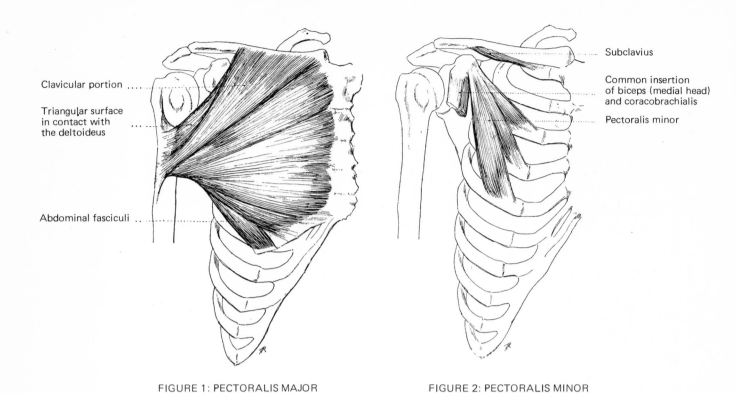

Clavicular portion

Triangular surface
in contact with
the deltoideus ...

Abdominal fasciculi ...

Subclavius

Common insertion
of biceps (medial head)
and coracobrachialis

Pectoralis minor

FIGURE 1: PECTORALIS MAJOR

FIGURE 2: PECTORALIS MINOR

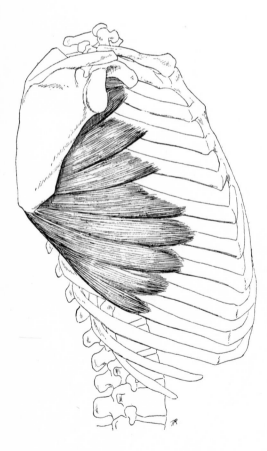

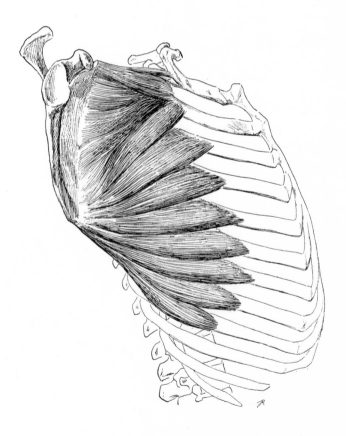

FIGURE 3: SERRATUS ANTERIOR
(scapula in normal position)

FIGURE 4: SERRATUS ANTERIOR
(the scapula separated from the thorax to show
the insertions of the muscle into its spinal border)

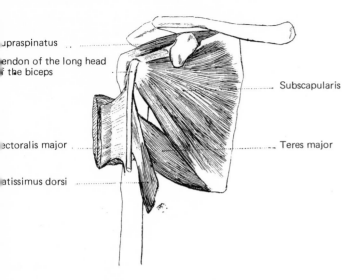

Supraspinatus

Tendon of the long head of the biceps

Subscapularis

Pectoralis major

Teres major

Latissimus dorsi

FIGURE 1: ANTERIOR ASPECT

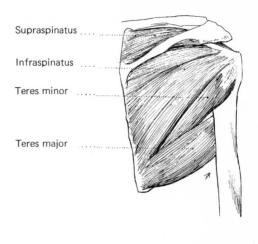

Supraspinatus

Infraspinatus

Teres minor

Teres major

FIGURE 3: POSTERIOR ASPECT

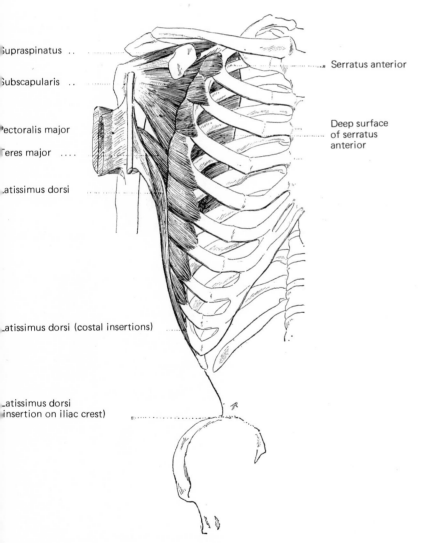

Supraspinatus

Subscapularis

Serratus anterior

Pectoralis major

Deep surface of serratus anterior

Teres major

Latissimus dorsi

Latissimus dorsi (costal insertions)

Latissimus dorsi (insertion on iliac crest)

FIGURE 2: ANTERIOR ASPECT

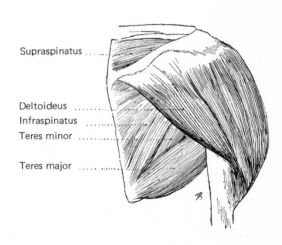

Supraspinatus

Deltoideus

Infraspinatus

Teres minor

Teres major

FIGURE 4: DELTOIDEUS POSTERIOR ASPECT

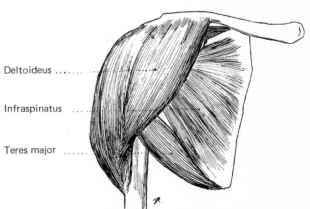

Deltoideus

Infraspinatus

Teres major

FIGURE 5: DELTOIDEUS ANTERIOR ASPECT

187

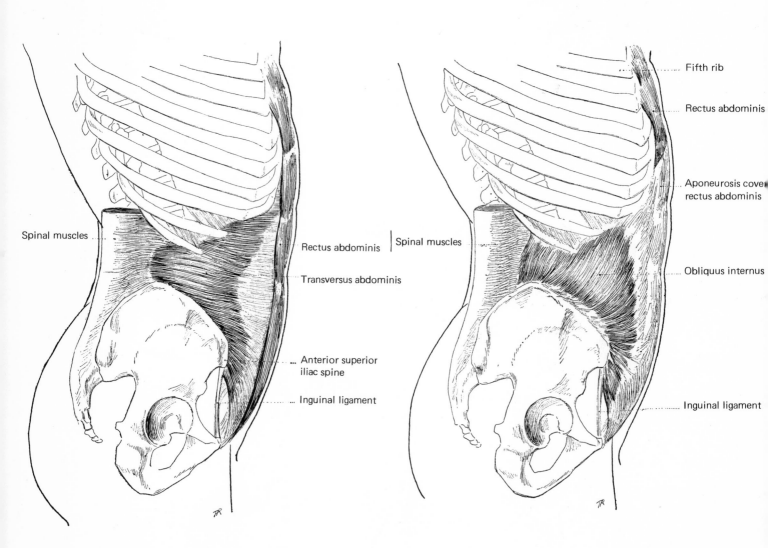

Fifth rib

Rectus abdominis

Aponeurosis cove
rectus abdominis

Spinal muscles

Rectus abdominis

Transversus abdominis

Spinal muscles

Obliquus internus

Anterior superior
iliac spine

Inguinal ligament

Inguinal ligament

FIGURE 1: TRANSVERSUS ABDOMINIS

FIGURE 2: OBLIQUUS INTERNUS, MIDDLE LAYER

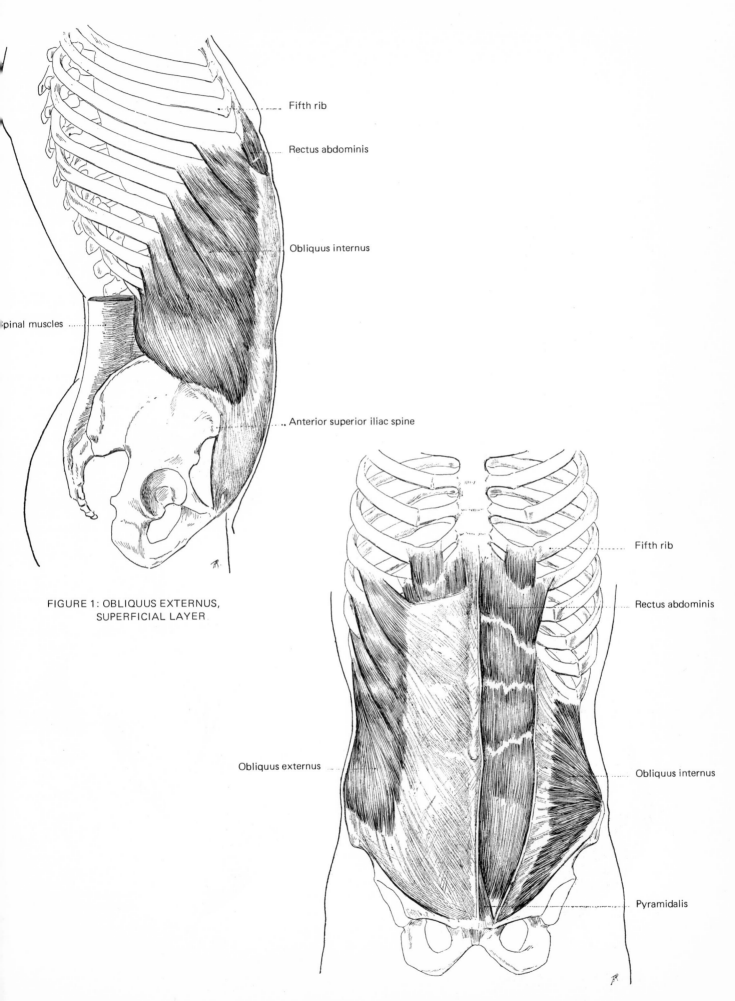

Fifth rib

Rectus abdominis

Obliquus internus

pinal muscles

Anterior superior iliac spine

FIGURE 1: OBLIQUUS EXTERNUS,
SUPERFICIAL LAYER

Fifth rib

Rectus abdominis

Obliquus externus

Obliquus internus

Pyramidalis

FIGURE 2: RECTUS ABDOMINIS

189

Plate 52: MUSCLES OF THE PELVIS

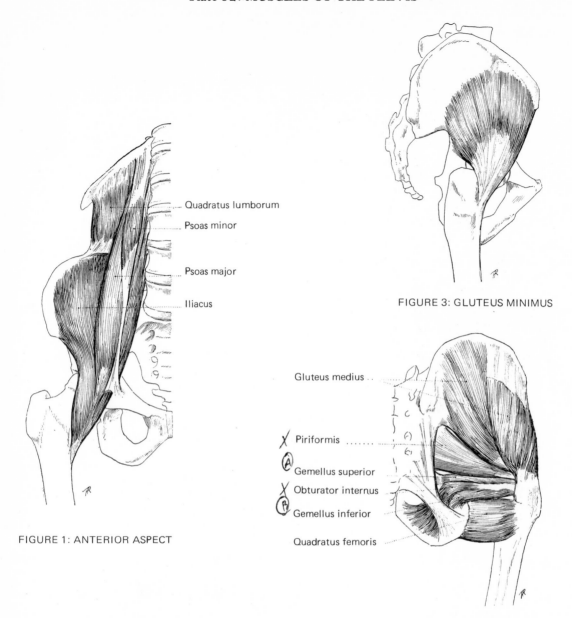

Quadratus lumborum

Psoas minor

Psoas major

Iliacus

FIGURE 1: ANTERIOR ASPECT

FIGURE 3: GLUTEUS MINIMUS

Gluteus medius

Piriformis

Gemellus superior

Obturator internus

Gemellus inferior

Quadratus femoris

FIGURE 4: POSTERIOR ASPECT
DEEP LAYER

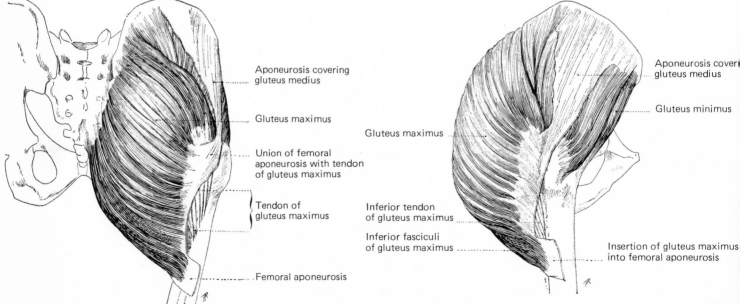

Aponeurosis covering
gluteus medius

Gluteus maximus

Union of femoral
aponeurosis with tendon
of gluteus maximus

Tendon of
gluteus maximus

Femoral aponeurosis

FIGURE 2: POSTERIOR ASPECT
SUPERFICIAL LAYER

Aponeurosis cover
gluteus medius

Gluteus minimus

Gluteus maximus

Inferior tendon
of gluteus maximus

Inferior fasciculi
of gluteus maximus

Insertion of gluteus maximus
into femoral aponeurosis

FIGURE 5: LATERAL ASPECT
SUPERFICIAL LAYER

190

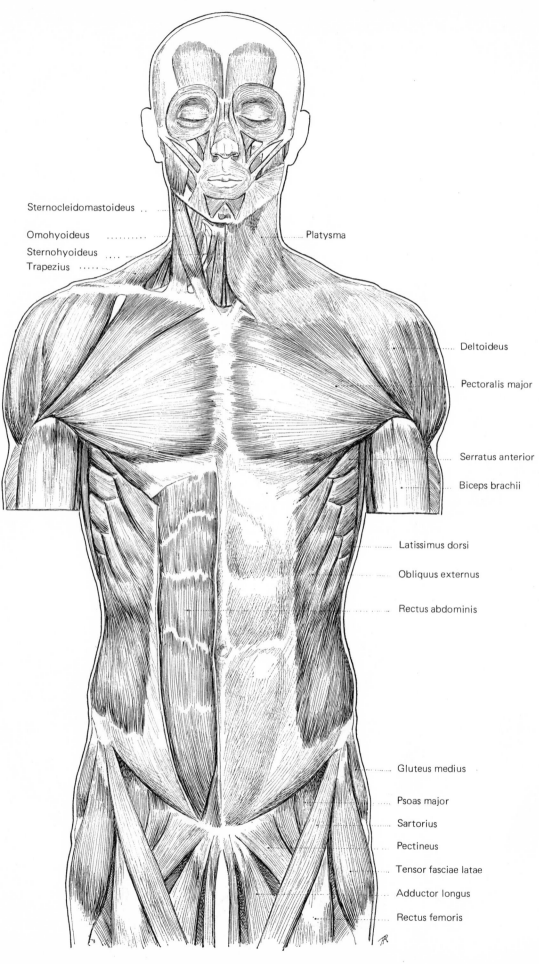

Sternocleidomastoideus

Omohyoideus

Platysma

Sternohyoideus

Trapezius

Deltoideus

Pectoralis major

Serratus anterior

Biceps brachii

Latissimus dorsi

Obliquus externus

Rectus abdominis

Gluteus medius

Psoas major

Sartorius

Pectineus

Tensor fasciae latae

Adductor longus

Rectus femoris

ANTERIOR ASPECT

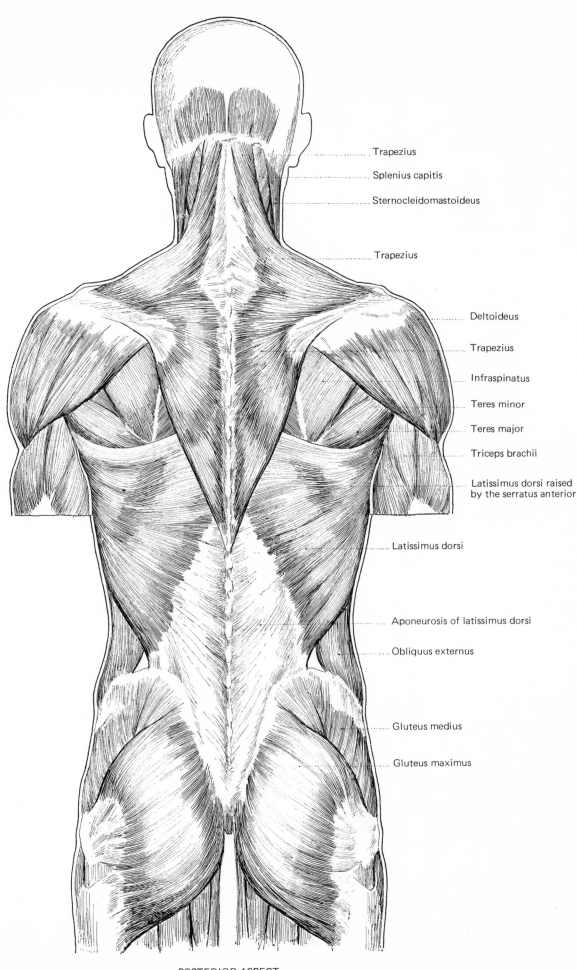

Trapezius

Splenius capitis

Sternocleidomastoideus

Trapezius

Deltoideus

Trapezius

Infraspinatus

Teres minor

Teres major

Triceps brachii

Latissimus dorsi raised
by the serratus anterior

Latissimus dorsi

Aponeurosis of latissimus dorsi

Obliquus externus

Gluteus medius

Gluteus maximus

POSTERIOR ASPECT

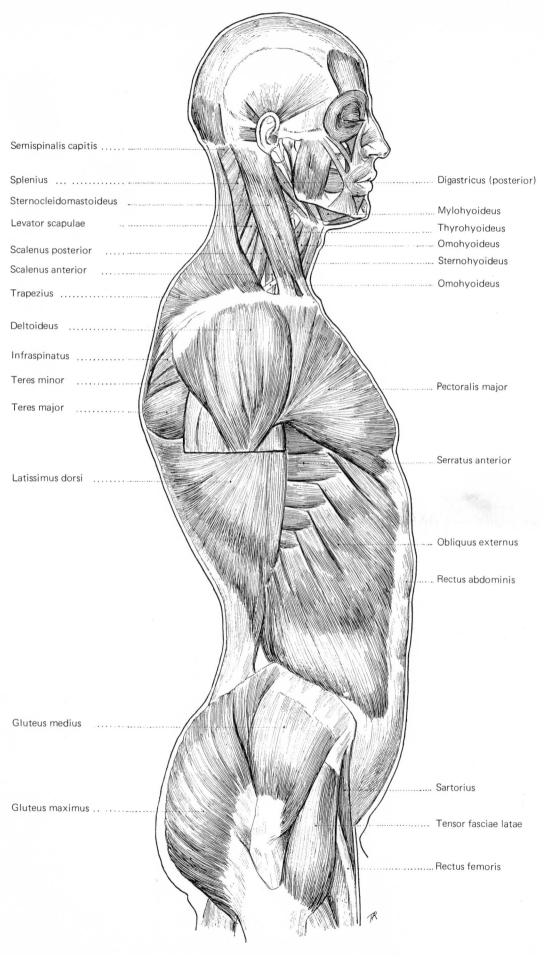

Semispinalis capitis

Splenius

Sternocleidomastoideus

Levator scapulae

Scalenus posterior

Scalenus anterior

Trapezius

Deltoideus

Infraspinatus

Teres minor

Teres major

Latissimus dorsi

Gluteus medius

Gluteus maximus

Digastricus (posterior)

Mylohyoideus

Thyrohyoideus

Omohyoideus

Sternohyoideus

Omohyoideus

Pectoralis major

Serratus anterior

Obliquus externus

Rectus abdominis

Sartorius

Tensor fasciae latae

Rectus femoris

LATERAL ASPECT

Plate 56: MUSCLES OF THE ARM

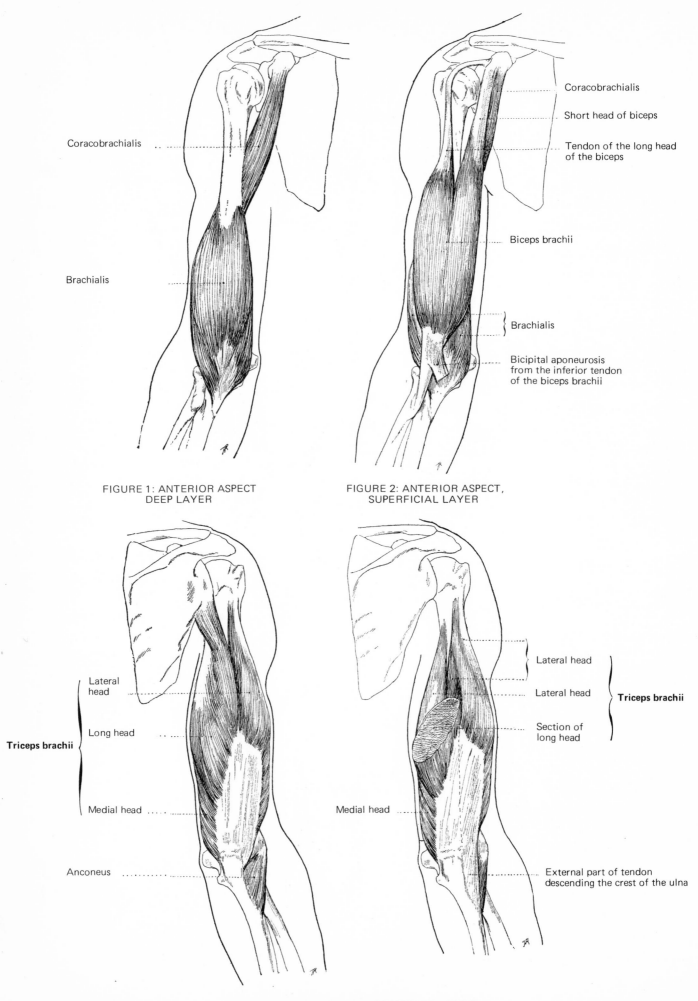

Coracobrachialis

Brachialis

FIGURE 1: ANTERIOR ASPECT
DEEP LAYER

Coracobrachialis

Short head of biceps

Tendon of the long head
of the biceps

Biceps brachii

Brachialis

Bicipital aponeurosis
from the inferior tendon
of the biceps brachii

FIGURE 2: ANTERIOR ASPECT,
SUPERFICIAL LAYER

Lateral
head

Long head

Triceps brachii

Medial head

Anconeus

Lateral head

Lateral head

Section of
long head

Triceps brachii

Medial head

External part of tendon
descending the crest of the ulna

FIGURE 3 AND 4: POSTERIOR ASPECT,
TRICEPS BRACHII

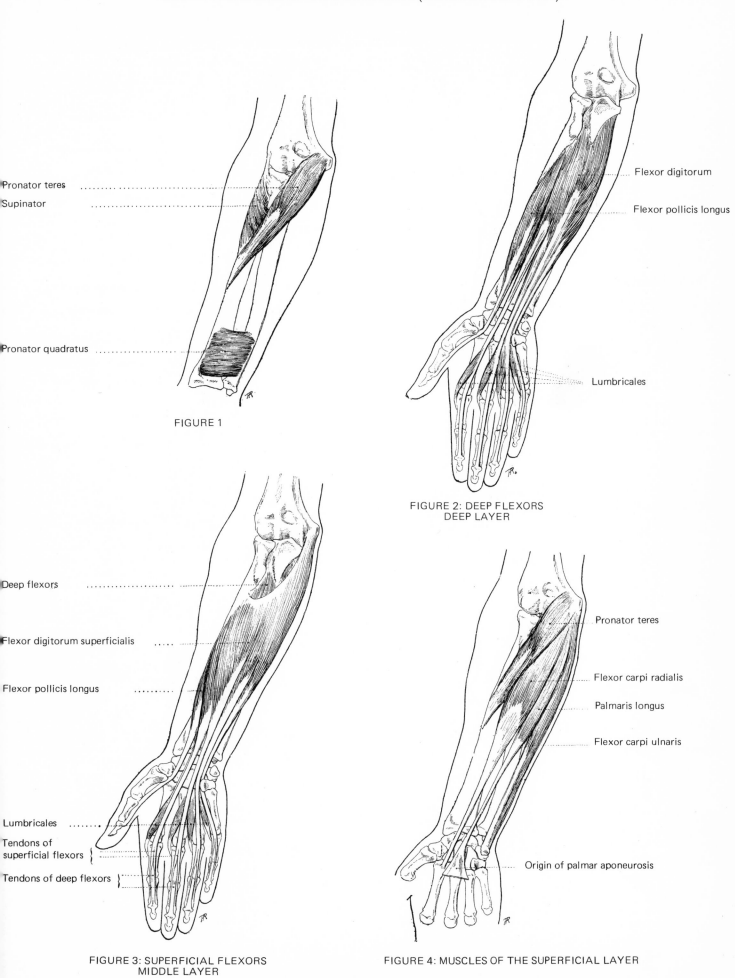

Pronator teres

Supinator

Pronator quadratus

FIGURE 1

Flexor digitorum

Flexor pollicis longus

Lumbricales

FIGURE 2: DEEP FLEXORS
DEEP LAYER

Deep flexors

Flexor digitorum superficialis

Flexor pollicis longus

Lumbricales

Tendons of
superficial flexors

Tendons of deep flexors

FIGURE 3: SUPERFICIAL FLEXORS
MIDDLE LAYER

Pronator teres

Flexor carpi radialis

Palmaris longus

Flexor carpi ulnaris

Origin of palmar aponeurosis

FIGURE 4: MUSCLES OF THE SUPERFICIAL LAYER

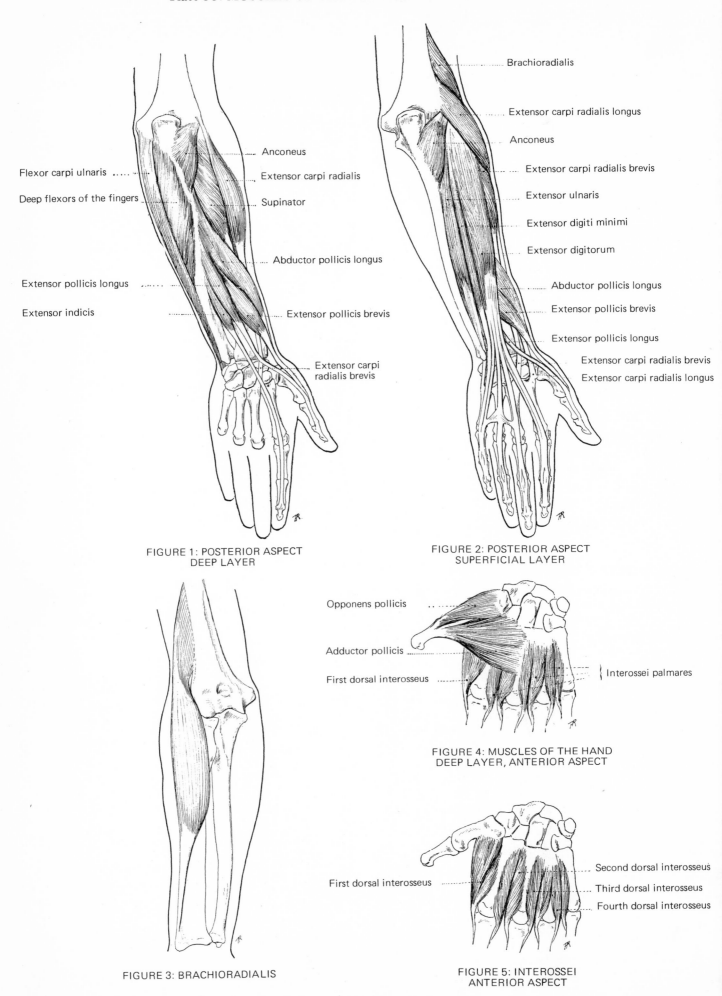

Anconeus

Extensor carpi radialis

Supinator

Flexor carpi ulnaris

Deep flexors of the fingers

Abductor pollicis longus

Extensor pollicis longus

Extensor indicis

Extensor pollicis brevis

Extensor carpi
radialis brevis

FIGURE 1: POSTERIOR ASPECT
DEEP LAYER

Brachioradialis

Extensor carpi radialis longus

Anconeus

Extensor carpi radialis brevis

Extensor ulnaris

Extensor digiti minimi

Extensor digitorum

Abductor pollicis longus

Extensor pollicis brevis

Extensor pollicis longus

Extensor carpi radialis brevis

Extensor carpi radialis longus

FIGURE 2: POSTERIOR ASPECT
SUPERFICIAL LAYER

FIGURE 3: BRACHIORADIALIS

Opponens pollicis

Adductor pollicis

First dorsal interosseus

Interossei palmares

FIGURE 4: MUSCLES OF THE HAND
DEEP LAYER, ANTERIOR ASPECT

First dorsal interosseus

Second dorsal interosseus

Third dorsal interosseus

Fourth dorsal interosseus

FIGURE 5: INTEROSSEI
ANTERIOR ASPECT

Deltoideus (anterior portion)

Deltoideus (middle portion)

Pectoralis major

Triceps brachii

Biceps brachii

Brachialis

Triceps brachii

Brachioradialis

Brachialis

Pronator teres

Extensor carpi radialis longus

Aponeurotic extension of the biceps

Flexor carpi radialis

Extensor carpi radialis brevis

Palmaris longus

Flexor digitorum superficialis

Flexor digitorum superficialis

Flexor carpi ulnaris

Abductor pollicis longus

Flexor pollicis longus

Muscles of the thenar
eminence

Palmaris brevis

Palmar aponeurosis

Muscles of the hypothenar eminence

Inferior extremities of interossei muscles

Sheaths of flexor tendons

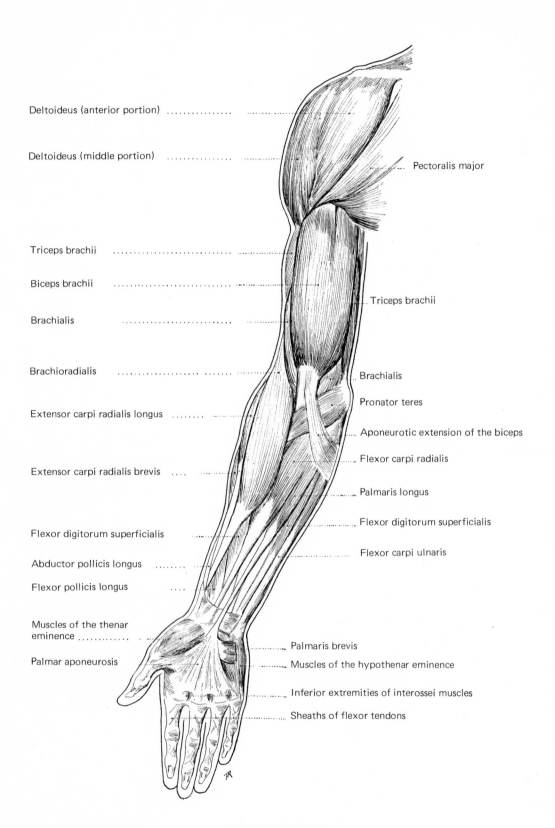

ANTERIOR ASPECT

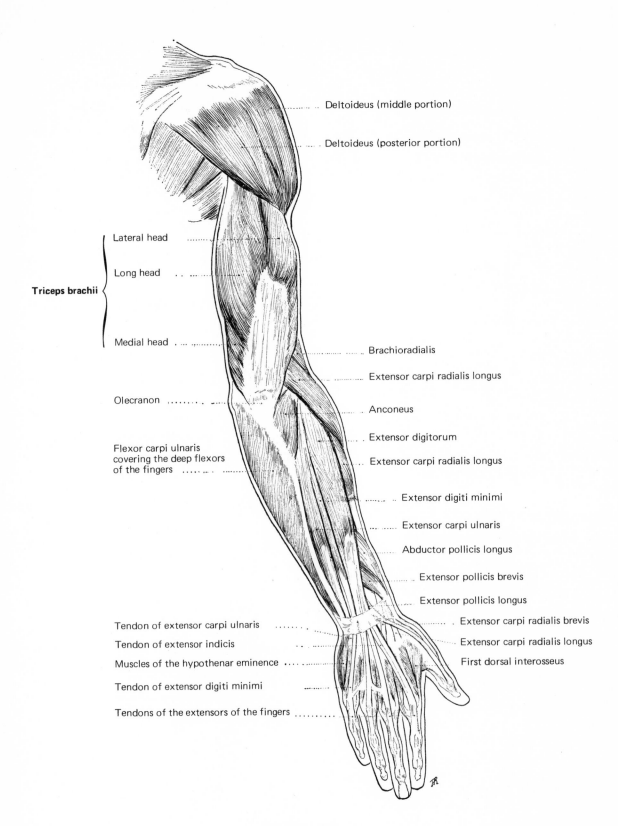

Deltoideus (middle portion)

Deltoideus (posterior portion)

Lateral head

Long head

Triceps brachii

Medial head

Brachioradialis

Extensor carpi radialis longus

Olecranon

Anconeus

Extensor digitorum

Extensor carpi radialis longus

Flexor carpi ulnaris
covering the deep flexors
of the fingers

Extensor digiti minimi

Extensor carpi ulnaris

Abductor pollicis longus

Extensor pollicis brevis

Extensor pollicis longus

Tendon of extensor carpi ulnaris

Extensor carpi radialis brevis

Tendon of extensor indicis

Extensor carpi radialis longus

Muscles of the hypothenar eminence

First dorsal interosseus

Tendon of extensor digiti minimi

Tendons of the extensors of the fingers

POSTERIOR ASPECT

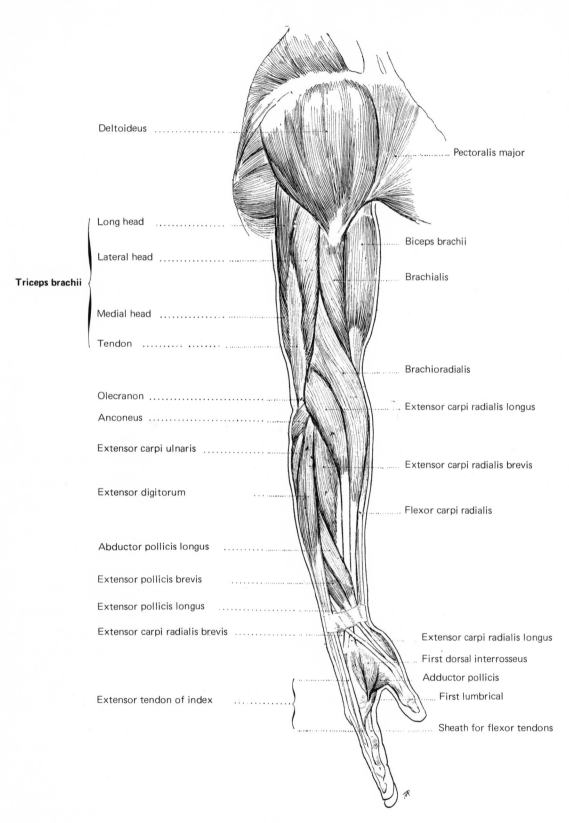

Deltoideus

Pectoralis major

Long head

Biceps brachii

Lateral head

Brachialis

Triceps brachii

Medial head

Tendon

Brachioradialis

Olecranon

Extensor carpi radialis longus

Anconeus

Extensor carpi ulnaris

Extensor carpi radialis brevis

Extensor digitorum

Flexor carpi radialis

Abductor pollicis longus

Extensor pollicis brevis

Extensor pollicis longus

Extensor carpi radialis brevis

Extensor carpi radialis longus

First dorsal interrosseus

Adductor pollicis

First lumbrical

Extensor tendon of index

Sheath for flexor tendons

LATERAL ASPECT

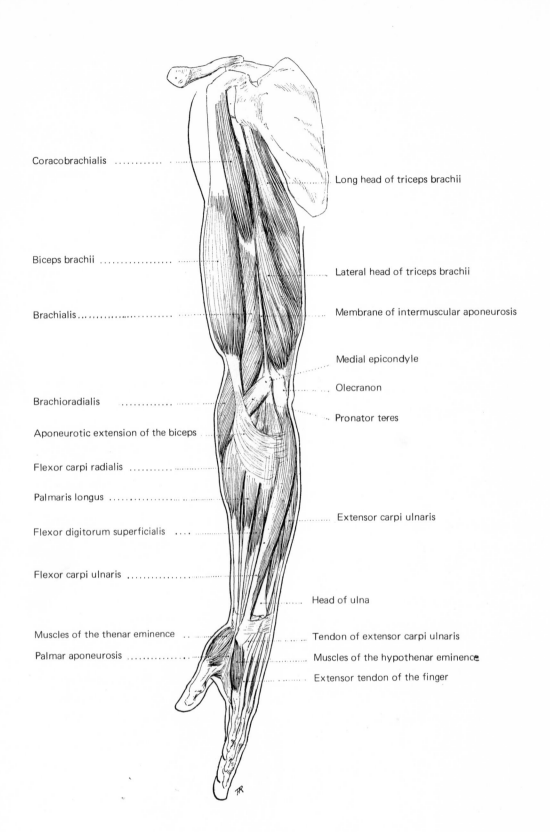

Coracobrachialis

Long head of triceps brachii

Biceps brachii

Lateral head of triceps brachii

Brachialis

Membrane of intermuscular aponeurosis

Medial epicondyle

Olecranon

Brachioradialis

Pronator teres

Aponeurotic extension of the biceps

Flexor carpi radialis

Palmaris longus

Extensor carpi ulnaris

Flexor digitorum superficialis

Flexor carpi ulnaris

Head of ulna

Muscles of the thenar eminence

Tendon of extensor carpi ulnaris

Palmar aponeurosis

Muscles of the hypothenar eminence

Extensor tendon of the finger

MEDIAL ASPECT

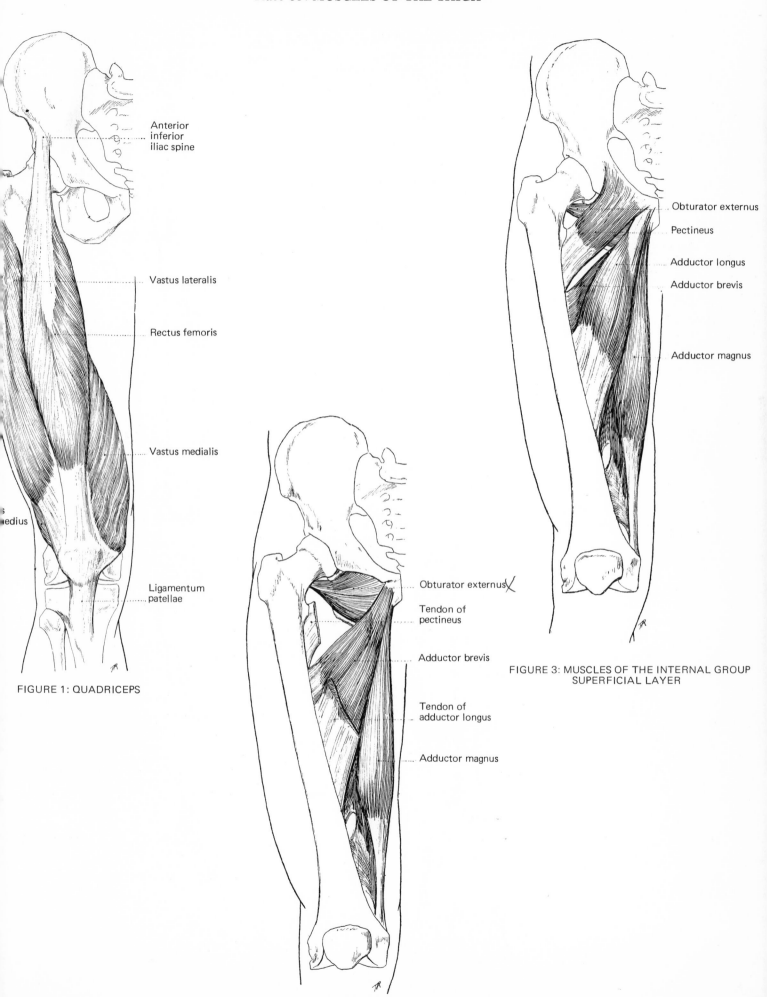

Anterior
inferior
iliac spine

Vastus lateralis

Rectus femoris

Vastus medialis

...edius

Ligamentum
patellae

FIGURE 1: QUADRICEPS

Obturator externus

Tendon of
pectineus

Adductor brevis

Tendon of
adductor longus

Adductor magnus

FIGURE 2: MUSCLES OF THE INTERNAL GROUP
DEEP LAYER

Obturator externus

Pectineus

Adductor longus

Adductor brevis

Adductor magnus

FIGURE 3: MUSCLES OF THE INTERNAL GROUP
SUPERFICIAL LAYER

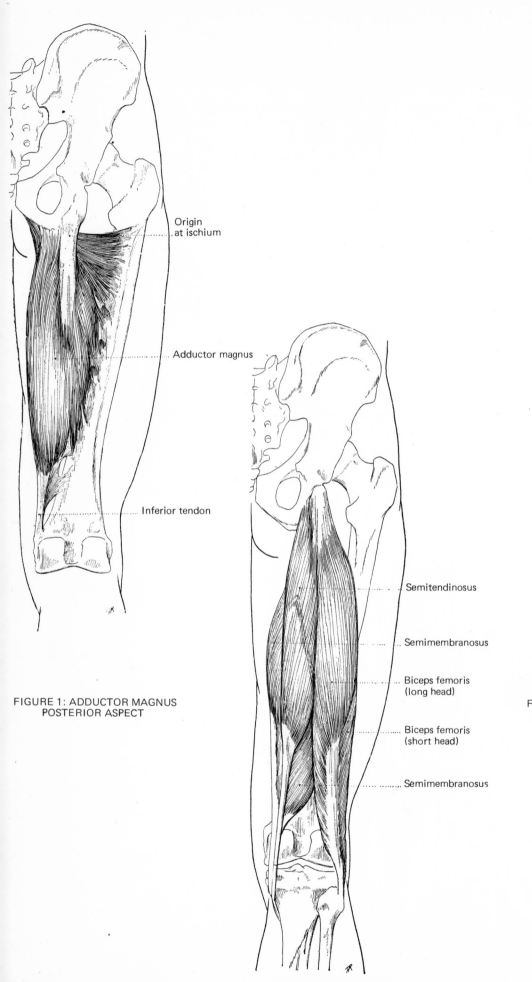

Origin
at ischium

Adductor magnus

Inferior tendon

FIGURE 1: ADDUCTOR MAGNUS
POSTERIOR ASPECT

Semitendinosus

Semimembranosus

Biceps femoris
(long head)

Biceps femoris
(short head)

Semimembranosus

FIGURE 2: MUSCLES OF THE POSTERIOR GROUP
SUPERFICIAL LAYER

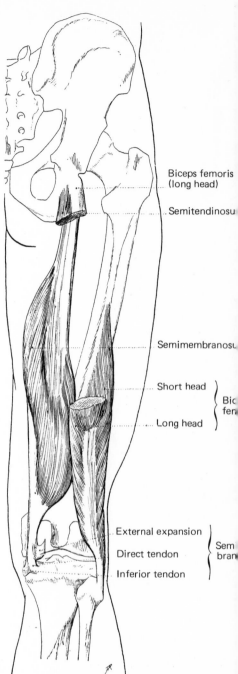

Biceps femoris
(long head)

Semitendinosu

Semimembranosu

Short head }
Long head } Bic
fen

External expansion }
Direct tendon } Sem
Inferior tendon } bran

FIGURE 3: MUSCLES OF THE POSTERIOR GROU
DEEP LAYER

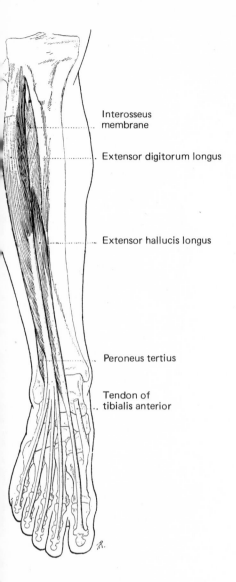

Interosseus
membrane

Extensor digitorum longus

Extensor hallucis longus

Peroneus tertius

Tendon of
tibialis anterior

RE 1: MUSCLES OF THE INTERIOR REGION
Tibialis Anterior (cut)

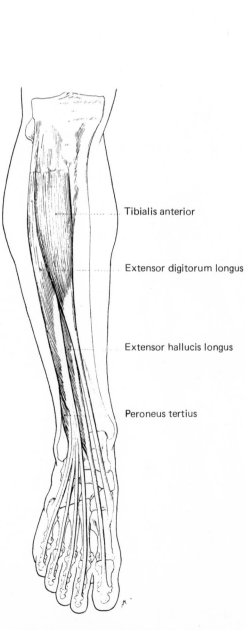

Tibialis anterior

Extensor digitorum longus

Extensor hallucis longus

Peroneus tertius

FIGURE 2: ANTERIOR REGION

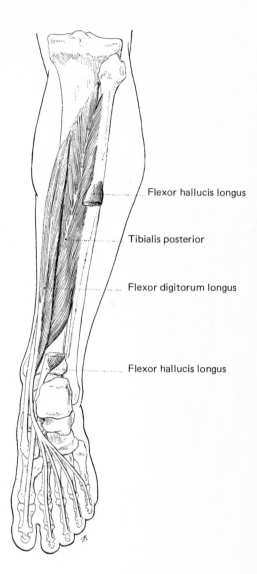

Flexor hallucis longus

Tibialis posterior

Flexor digitorum longus

Flexor hallucis longus

FIGURE 3: POSTERIOR REGION
DEEP LAYER

Plate 66: MUSCLES OF THE LEG

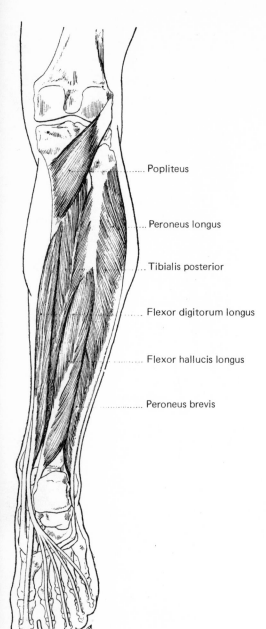

Popliteus

Peroneus longus

Tibialis posterior

Flexor digitorum longus

Flexor hallucis longus

Peroneus brevis

FIGURE 1: POSTERIOR REGION
DEEP LAYER

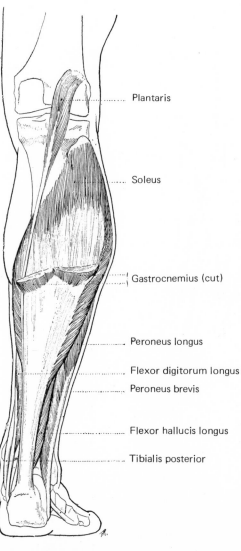

Plantaris

Soleus

Gastrocnemius (cut)

Peroneus longus

Flexor digitorum longus

Peroneus brevis

Flexor hallucis longus

Tibialis posterior

FIGURE 2: SOLEUS

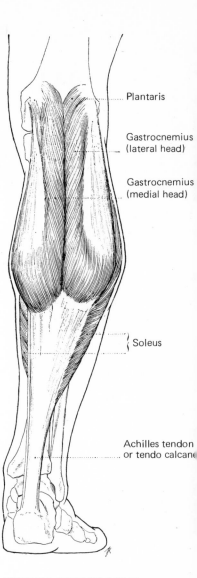

Plantaris

Gastrocnemius
(lateral head)

Gastrocnemius
(medial head)

Soleus

Achilles tendon
or tendo calcane

FIGURE 3: TRICEPS SURAL

Plate 67: MUSCLES OF THE FOOT

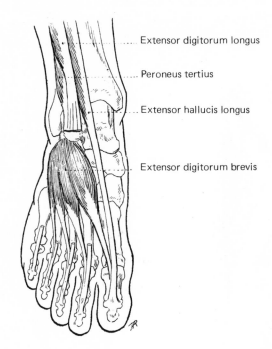

Extensor digitorum longus

Peroneus tertius

Extensor hallucis longus

Extensor digitorum brevis

FIGURE 1: DORSAL REGION

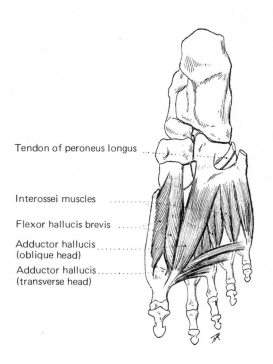

Tendon of peroneus longus

Interossei muscles

Flexor hallucis brevis

Adductor hallucis
(oblique head)

Adductor hallucis
(transverse head)

FIGURE 2: PLANTAR REGION,
DEEP LAYER

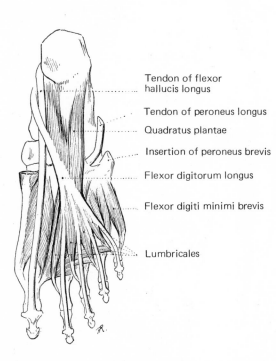

Tendon of flexor
hallucis longus

Tendon of peroneus longus

Quadratus plantae

Insertion of peroneus brevis

Flexor digitorum longus

Flexor digiti minimi brevis

Lumbricales

FIGURE 3: PLANTAR REGION
MIDDLE LAYER

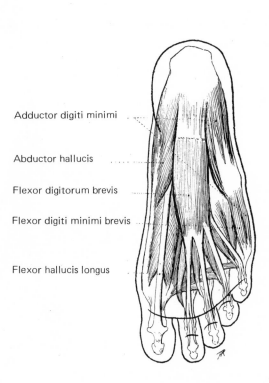

Adductor digiti minimi

Abductor hallucis

Flexor digitorum brevis

Flexor digiti minimi brevis

Flexor hallucis longus

FIGURE 4: PLANTAR REGION,
SUPERFICIAL LAYER

Plate 68: MUSCLES OF THE LOWER LIMB

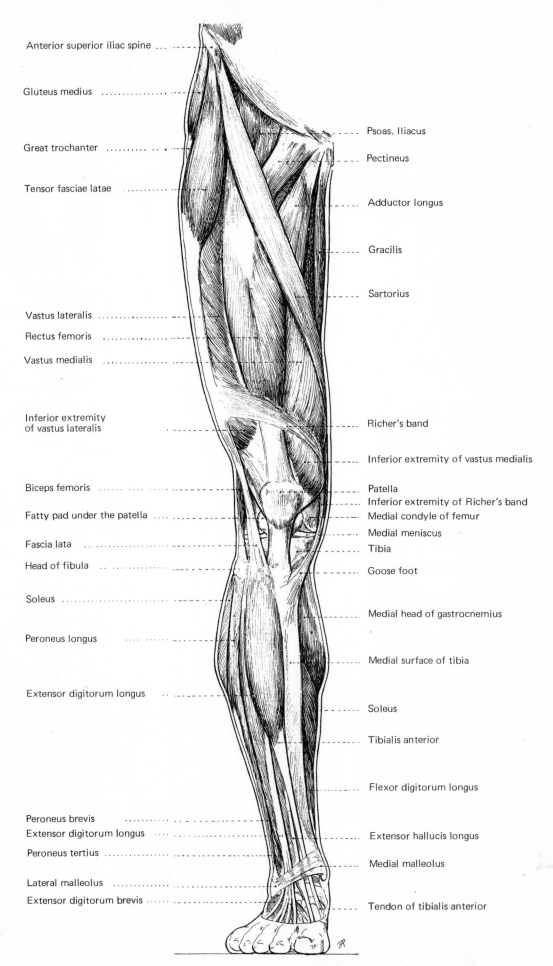

Anterior superior iliac spine

Gluteus medius

Great trochanter

Tensor fasciae latae

Vastus lateralis

Rectus femoris

Vastus medialis

Inferior extremity
of vastus lateralis

Biceps femoris

Fatty pad under the patella

Fascia lata

Head of fibula

Soleus

Peroneus longus

Extensor digitorum longus

Peroneus brevis

Extensor digitorum longus

Peroneus tertius

Lateral malleolus

Extensor digitorum brevis

Psoas. Iliacus

Pectineus

Adductor longus

Gracilis

Sartorius

Richer's band

Inferior extremity of vastus medialis

Patella

Inferior extremity of Richer's band

Medial condyle of femur

Medial meniscus

Tibia

Goose foot

Medial head of gastrocnemius

Medial surface of tibia

Soleus

Tibialis anterior

Flexor digitorum longus

Extensor hallucis longus

Medial malleolus

Tendon of tibialis anterior

ANTERIOR ASPECT

Plate 69: MUSCLES OF THE LOWER LIMB

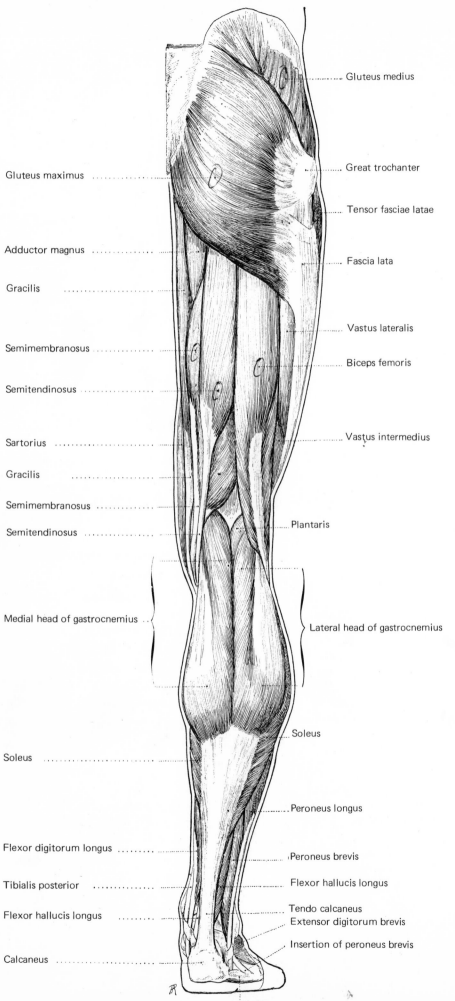

Gluteus medius

Gluteus maximus

Great trochanter

Tensor fasciae latae

Adductor magnus

Fascia lata

Gracilis

Vastus lateralis

Semimembranosus

Biceps femoris

Semitendinosus

Sartorius

Vastus intermedius

Gracilis

Semimembranosus

Semitendinosus

Plantaris

Medial head of gastrocnemius

Lateral head of gastrocnemius

Soleus

Soleus

Peroneus longus

Flexor digitorum longus

Peroneus brevis

Tibialis posterior

Flexor hallucis longus

Flexor hallucis longus

Tendo calcaneus

Extensor digitorum brevis

Insertion of peroneus brevis

Calcaneus

Abductor digiti minimi

POSTERIOR ASPECT

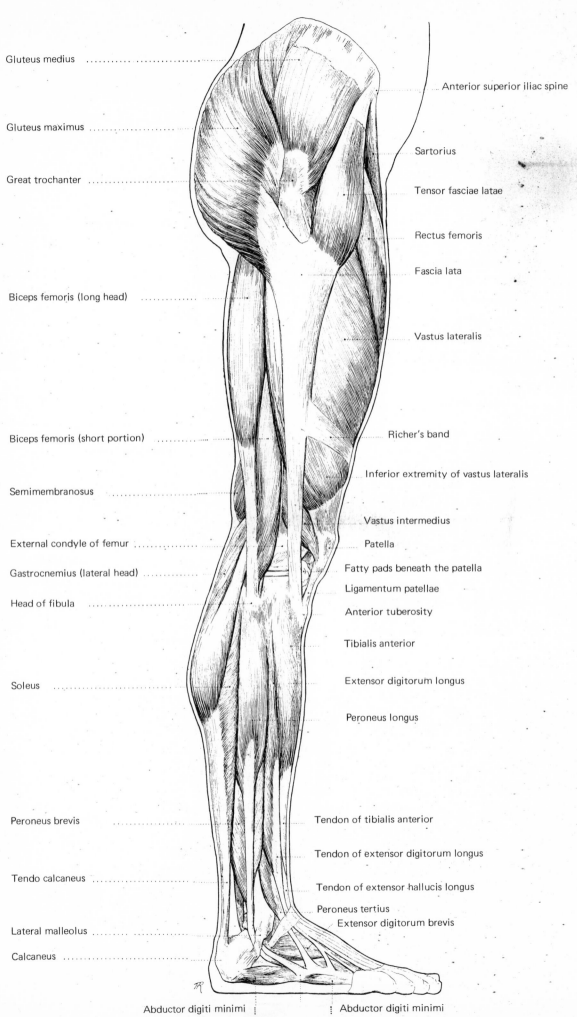

Gluteus medius

Anterior superior iliac spine

Gluteus maximus

Sartorius

Great trochanter

Tensor fasciae latae

Rectus femoris

Fascia lata

Biceps femoris (long head)

Vastus lateralis

Biceps femoris (short portion)

Richer's band

Inferior extremity of vastus lateralis

Semimembranosus

Vastus intermedius

External condyle of femur

Patella

Gastrocnemius (lateral head)

Fatty pads beneath the patella

Ligamentum patellae

Head of fibula

Anterior tuberosity

Tibialis anterior

Extensor digitorum longus

Soleus

Peroneus longus

Peroneus brevis

Tendon of tibialis anterior

Tendon of extensor digitorum longus

Tendo calcaneus

Tendon of extensor hallucis longus

Peroneus tertius

Extensor digitorum brevis

Lateral malleolus

Calcaneus

Abductor digiti minimi

Abductor digiti minimi

Tuberosity of fifth metatarsal

EXTERNAL ASPECT

Plate 71: MUSCLES OF THE LOWER LIMB

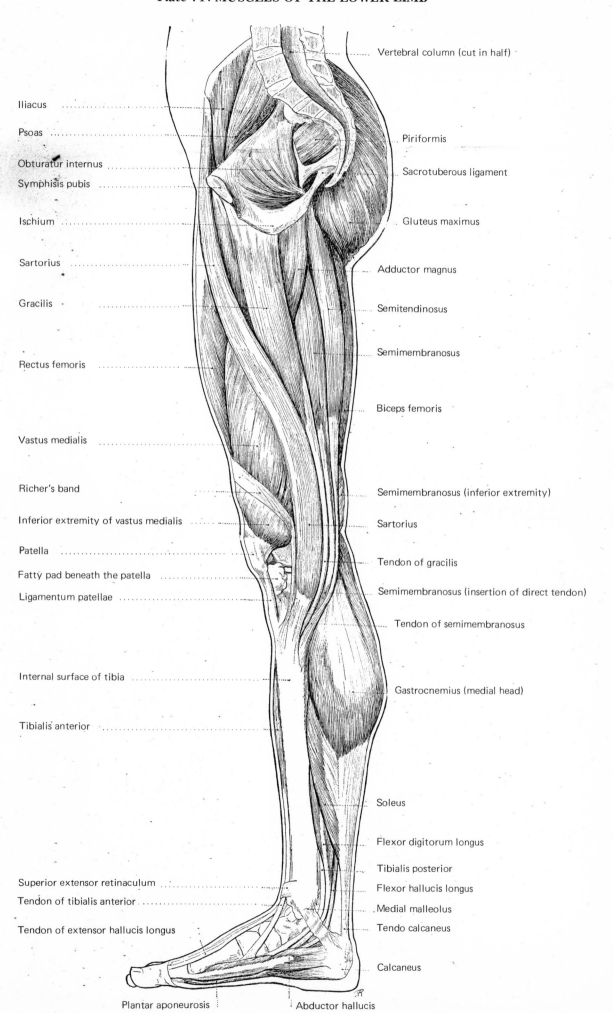

Iliacus

Psoas

Obturatur internus

Symphisis pubis

Ischium

Sartorius

Gracilis

Rectus femoris

Vastus medialis

Richer's band

Inferior extremity of vastus medialis

Patella

Fatty pad beneath the patella

Ligamentum patellae

Internal surface of tibia

Tibialis anterior

Superior extensor retinaculum

Tendon of tibialis anterior

Tendon of extensor hallucis longus

Plantar aponeurosis

Vertebral column (cut in half)

Piriformis

Sacrotuberous ligament

Gluteus maximus

Adductor magnus

Semitendinosus

Semimembranosus

Biceps femoris

Semimembranosus (inferior extremity)

Sartorius

Tendon of gracilis

Semimembranosus (insertion of direct tendon)

Tendon of semimembranosus

Gastrocnemius (medial head)

Soleus

Flexor digitorum longus

Tibialis posterior

Flexor hallucis longus

Medial malleolus

Tendo calcaneus

Calcaneus

Abductor hallucis

INTERNAL ASPECT

209

Plate 72: SUPERFICIAL VEINS

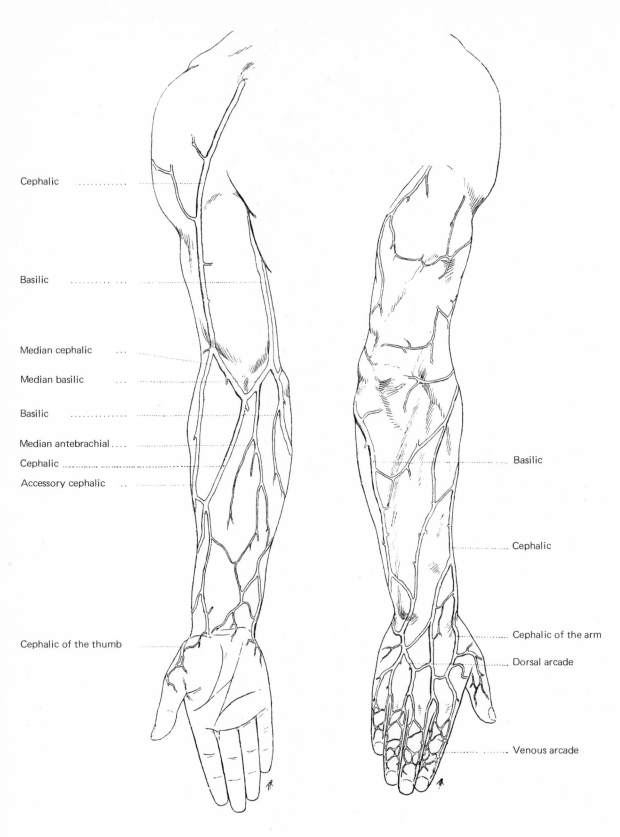

Cephalic

Basilic

Median cephalic

Median basilic

Basilic

Median antebrachial

Cephalic

Accessory cephalic

Cephalic of the thumb

Basilic

Cephalic

Cephalic of the arm

Dorsal arcade

Venous arcade

FIGURE 1: UPPER LIMB
ANTERIOR ASPECT

FIGURE 2: UPPER LIMB,
POSTERIOR ASPECT

Plate 73: SUPERFICIAL VEINS

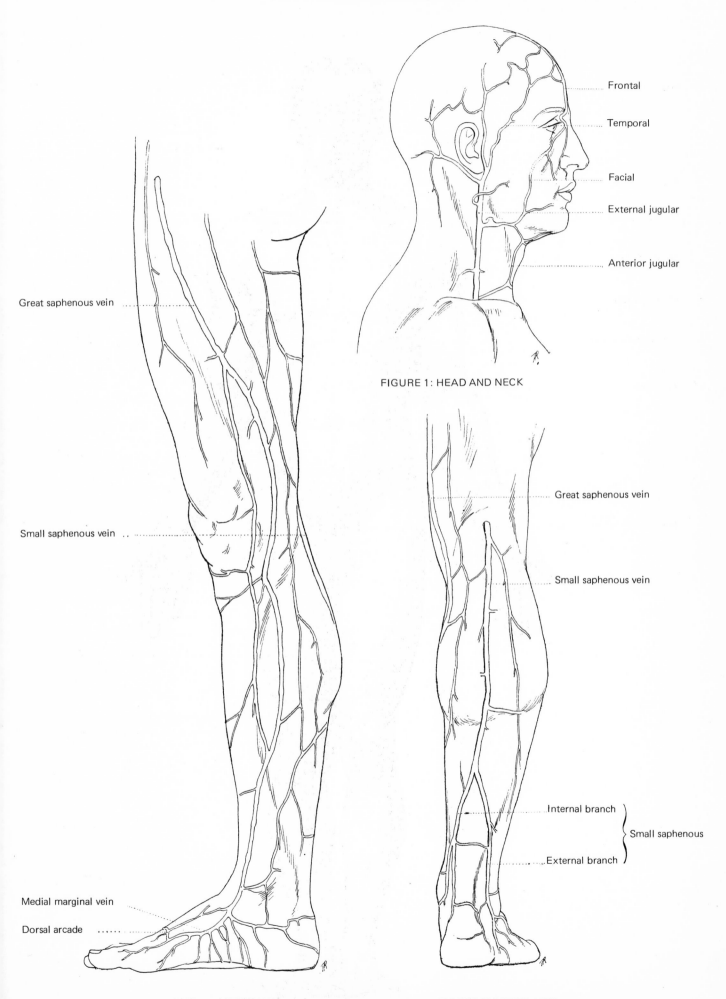

Frontal

Temporal

Facial

External jugular

Anterior jugular

FIGURE 1: HEAD AND NECK

Great saphenous vein

Small saphenous vein

Medial marginal vein

Dorsal arcade

Great saphenous vein

Small saphenous vein

Internal branch }

} Small saphenous

External branch }

FIGURE 2: LOWER LIMB
INTERNAL ASPECT

FIGURE 3: LOWER LIMB
POSTERIOR ASPECT

211

Plate 74: MORPHOLOGICAL TOPOGRAPHY

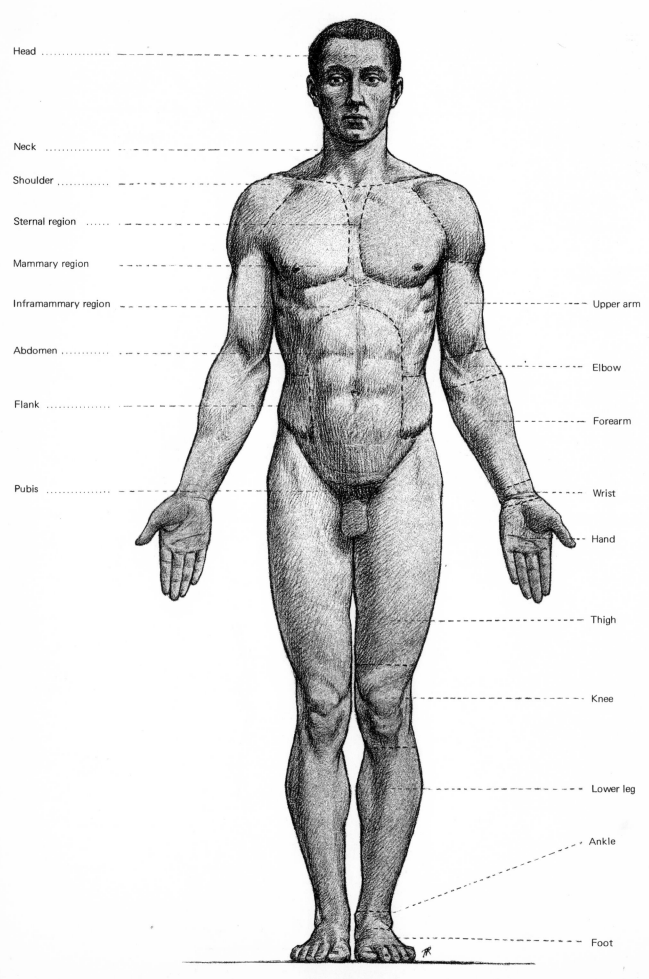

Head

Neck

Shoulder

Sternal region

Mammary region

Inframammary region

Abdomen

Flank

Pubis

Upper arm

Elbow

Forearm

Wrist

Hand

Thigh

Knee

Lower leg

Ankle

Foot

212

ANTERIOR ASPECT

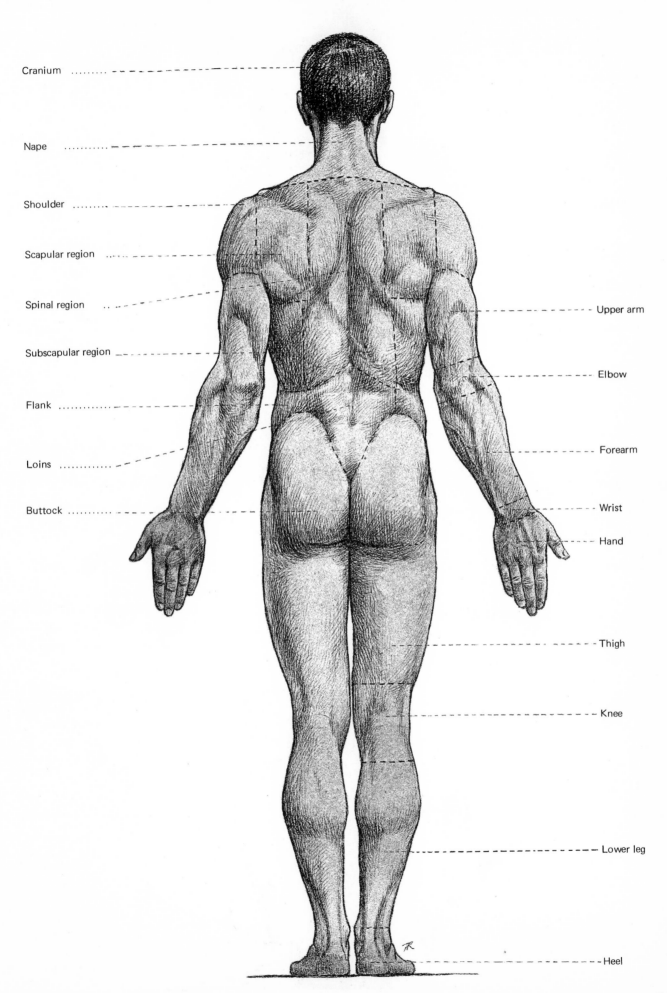

Cranium

Nape

Shoulder

Scapular region

Spinal region

Subscapular region

Flank

Loins

Buttock

Upper arm

Elbow

Forearm

Wrist

Hand

Thigh

Knee

Lower leg

Heel

POSTERIOR ASPECT

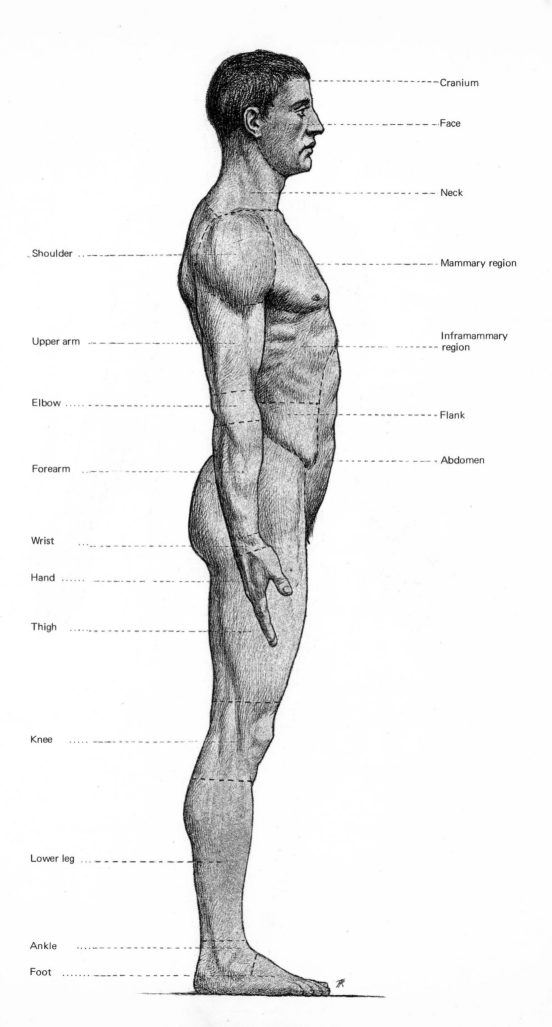

Cranium

Face

Neck

Mammary region

Inframammary region

Flank

Abdomen

Shoulder

Upper arm

Elbow

Forearm

Wrist

Hand

Thigh

Knee

Lower leg

Ankle

Foot

LATERAL ASPECT

Plate 77: EXTERIOR FORM OF THE TRUNK

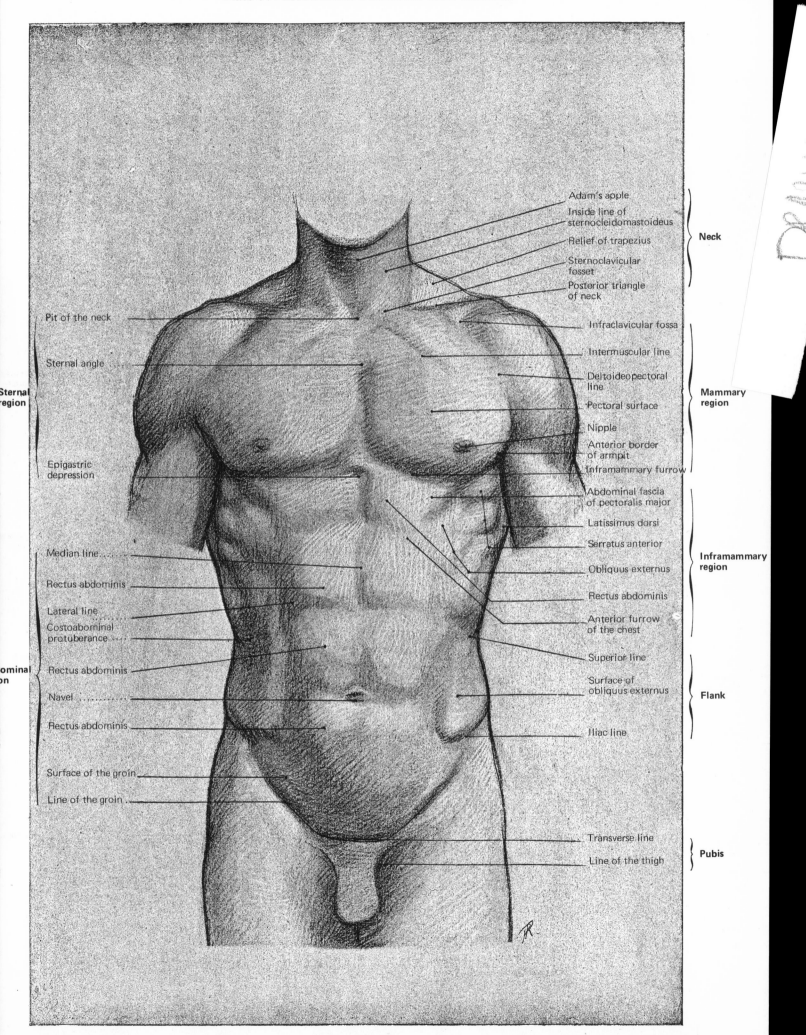

Adam's apple
Inside line of sternocleidomastoideus
Relief of trapezius
Sternoclavicular fosset
Posterior triangle of neck

Neck

Pit of the neck
Sternal angle
Epigastric depression

Infraclavicular fossa
Intermuscular line
Deltoideopectoral line
Pectoral surface
Nipple
Anterior border of armpit
Inframammary furrow

Mammary region

Abdominal fascia of pectoralis major
Latissimus dorsi
Serratus anterior
Obliquus externus
Rectus abdominis
Anterior furrow of the chest
Superior line

Inframammary region

Median line
Rectus abdominis
Lateral line
Costoabominal protuberance
Rectus abdominis
Navel

Surface of obliquus externus
Iliac line

Flank

Surface of the groin
Line of the groin

Transverse line
Line of the thigh

Pubis

Sternal region

Abdominal region

ANTERIOR ASPECT

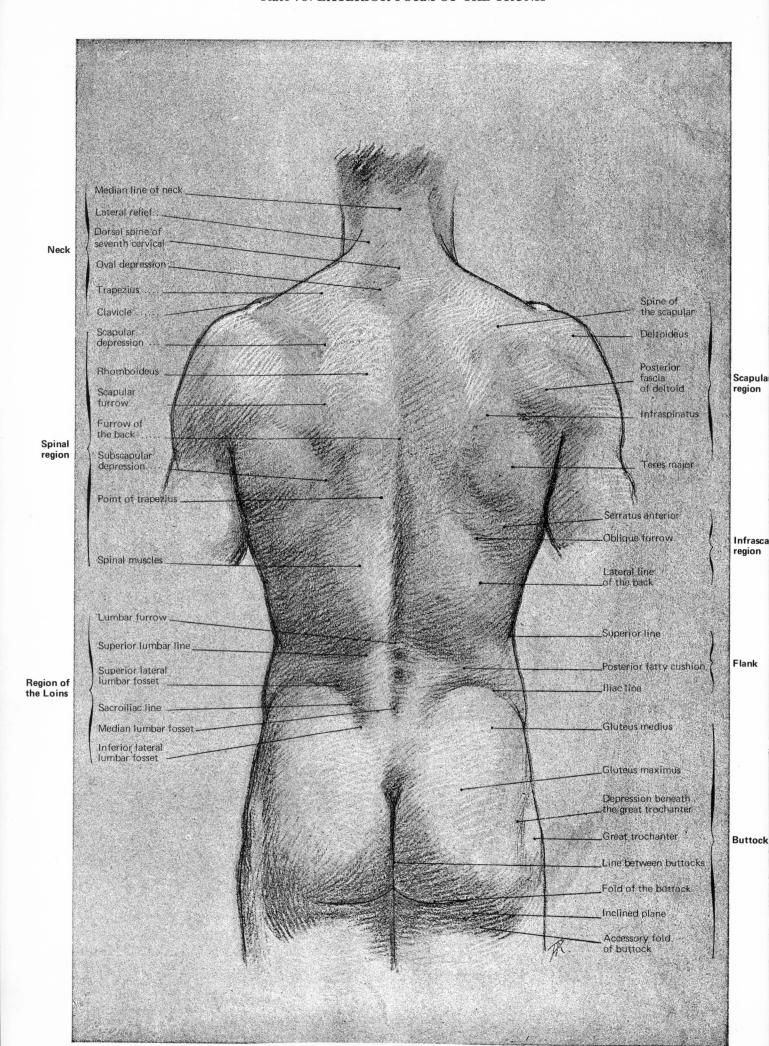

Median line of neck

Lateral relief

Dorsal spine of
seventh cervical

Neck

Oval depression

Trapezius

Clavicle

Spine of
the scapular

Deltoideus

Scapular
depression

Rhomboideus

Posterior
fascia
of deltoid

Scapular
region

Scapular
furrow

Spinal
region

Furrow of
the back

Infraspinatus

Subscapular
depression

Teres major

Point of trapezius

Serratus anterior

Oblique furrow

Infrasca
region

Spinal muscles

Lateral line
of the back

Lumbar furrow

Superior line

Superior lumbar line

Region of
the Loins

Superior lateral
lumbar fosset

Posterior fatty cushion

Flank

Iliac line

Sacroiliac line

Median lumbar fosset

Gluteus medius

Inferior lateral
lumbar fosset

Gluteus maximus

Depression beneath
the great trochanter

Great trochanter

Buttock

Line between buttocks

Fold of the buttock

Inclined plane

Accessory fold
of buttock

POSTERIOR ASPECT

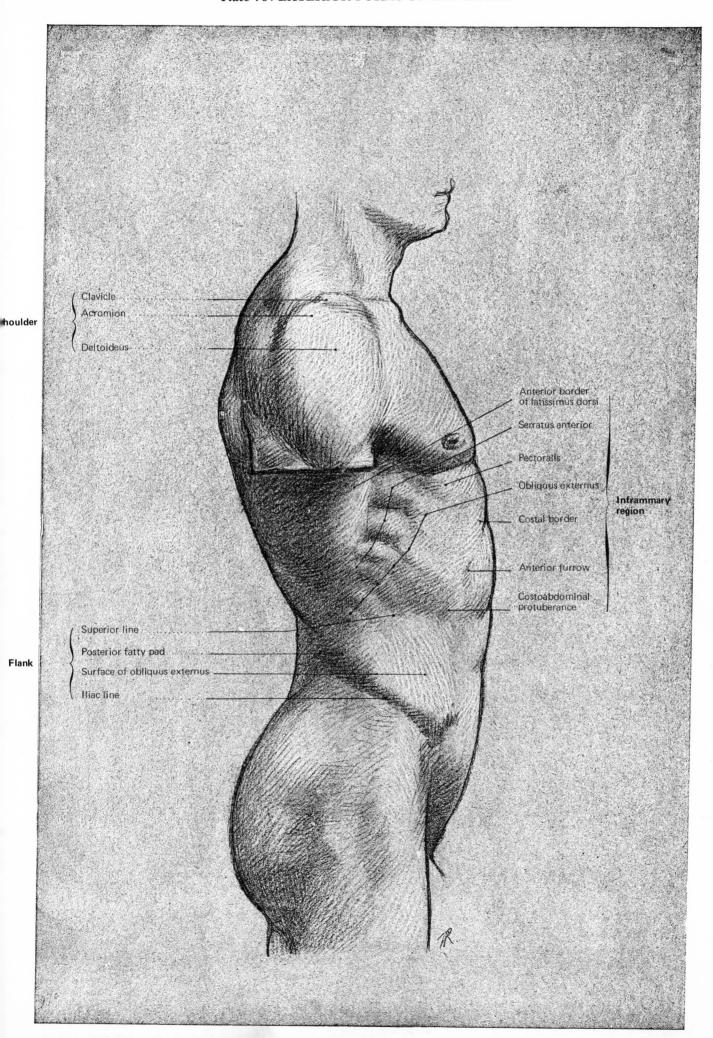

Shoulder
Clavicle
Acromion
Deltoideus

Anterior border
of latissimus dorsi
Serratus anterior
Pectoralis
Obliquus externus
Costal border
Inframmary region
Anterior furrow
Costoabdominal
protuberance

Flank
Superior line
Posterior fatty pad
Surface of obliquus externus
Iliac line

LATERAL ASPECT

Plate 80: EXTERIOR FORMS OF THE UPPER LIMB

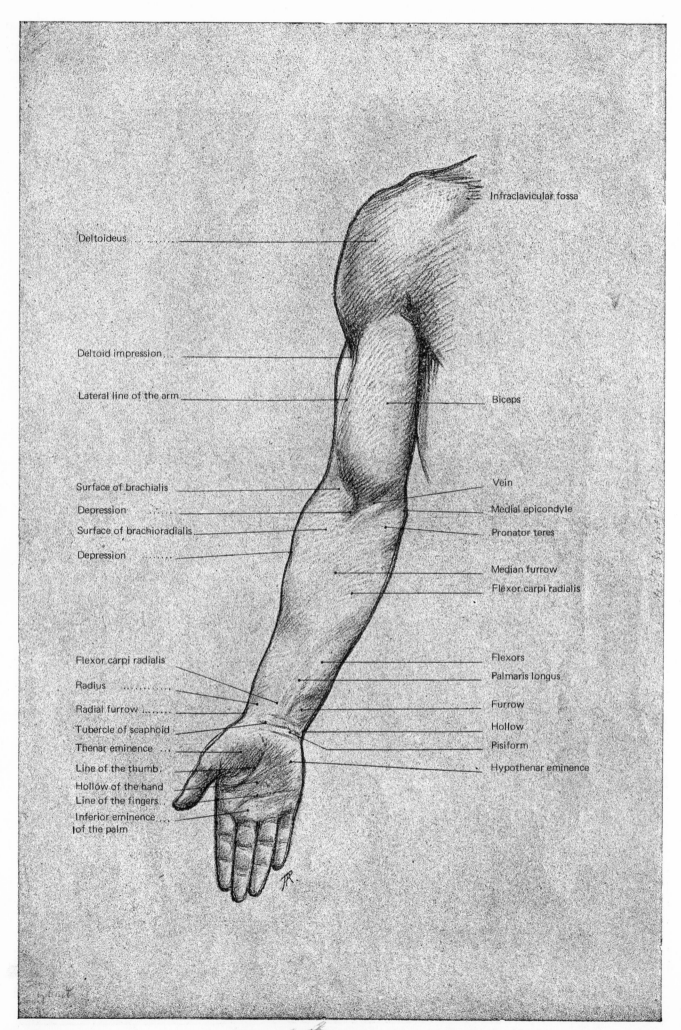

ANTERIOR ASPECT

Infraclavicular fossa

Deltoideus

Deltoid impression

Lateral line of the arm

Biceps

Surface of brachialis

Depression

Surface of brachioradialis

Depression

Vein

Medial epicondyle

Pronator teres

Median furrow

Flexor carpi radialis

Flexor carpi radialis

Radius

Radial furrow

Tubercle of scaphoid

Thenar eminence

Line of the thumb

Hollow of the hand

Line of the fingers

Inferior eminence of the palm

Flexors

Palmaris longus

Furrow

Hollow

Pisiform

Hypothenar eminence

ANTERIOR ASPECT

Plate 81: EXTERIOR FORMS OF THE UPPER LIMB

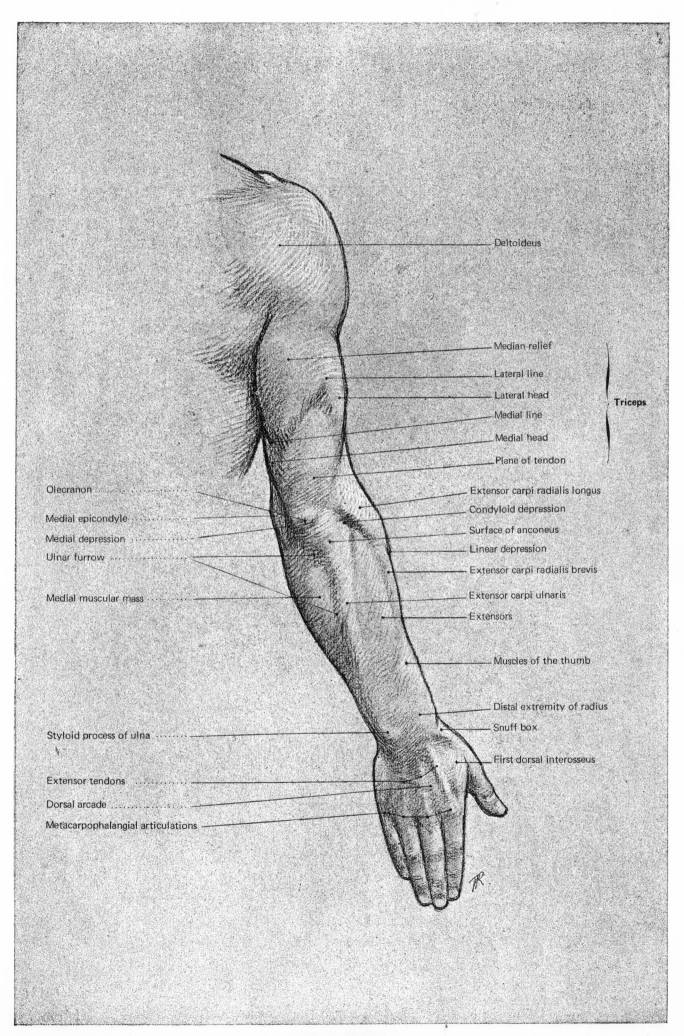

Deltoideus

Median relief

Lateral line

Lateral head

Medial line

Medial head

Plane of tendon

Triceps

Olecranon

Medial epicondyle

Medial depression

Ulnar furrow

Medial muscular mass

Extensor carpi radialis longus

Condyloid depression

Surface of anconeus

Linear depression

Extensor carpi radialis brevis

Extensor carpi ulnaris

Extensors

Muscles of the thumb

Distal extremity of radius

Snuff box

Styloid process of ulna

First dorsal interosseus

Extensor tendons

Dorsal arcade

Metacarpophalangial articulations

POSTERIOR ASPECT

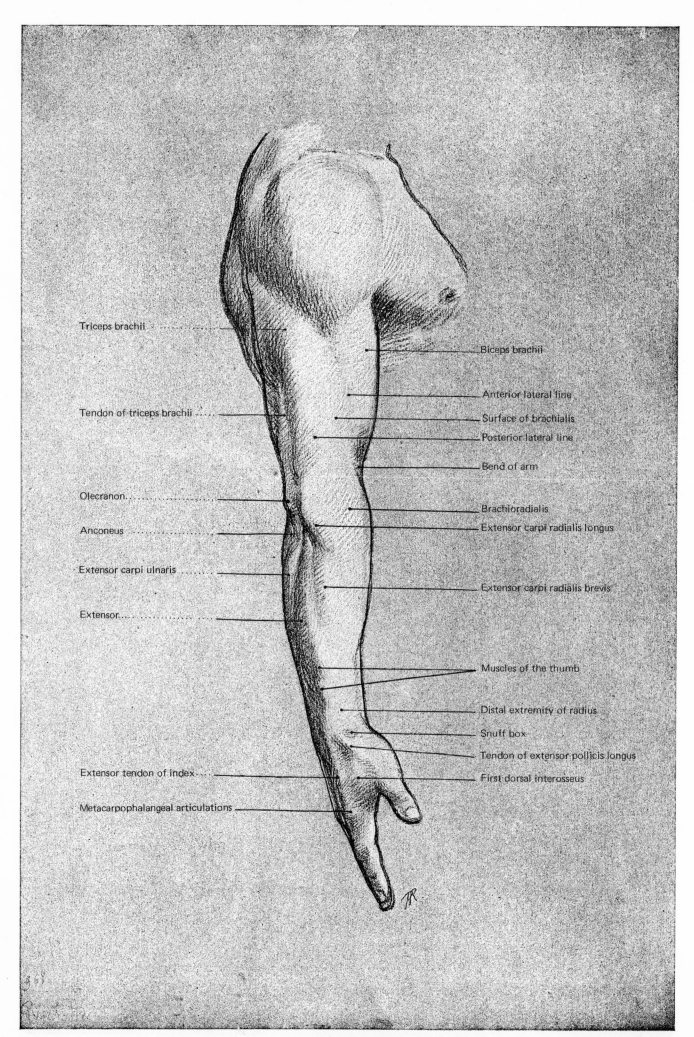

Triceps brachii

Tendon of triceps brachii

Olecranon

Anconeus

Extensor carpi ulnaris

Extensor

Extensor tendon of index

Metacarpophalangeal articulations

Biceps brachii

Anterior lateral line

Surface of brachialis

Posterior lateral line

Bend of arm

Brachioradialis

Extensor carpi radialis longus

Extensor carpi radialis brevis

Muscles of the thumb

Distal extremity of radius

Snuff box

Tendon of extensor pollicis longus

First dorsal interosseus

LATERAL ASPECT

Plate 83: EXTERIOR FORMS OF THE LOWER LIMB

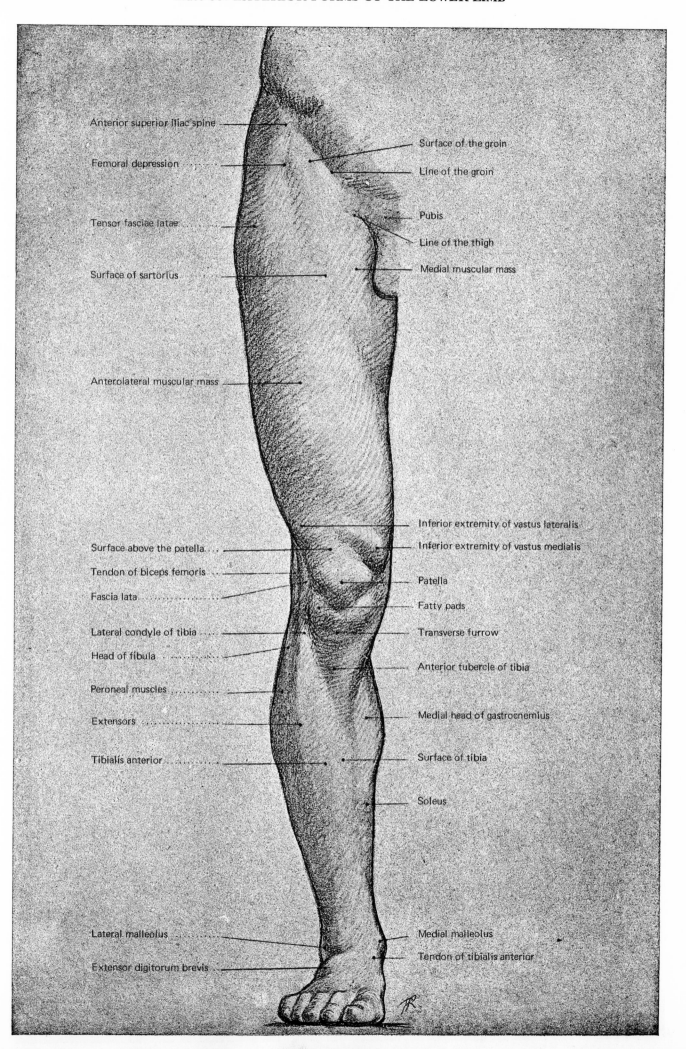

Anterior superior iliac spine

Femoral depression

Tensor fasciae latae

Surface of sartorius

Anterolateral muscular mass

Surface above the patella

Tendon of biceps femoris

Fascia lata

Lateral condyle of tibia

Head of fibula

Peroneal muscles

Extensors

Tibialis anterior

Lateral malleolus

Extensor digitorum brevis

Surface of the groin

Line of the groin

Pubis

Line of the thigh

Medial muscular mass

Inferior extremity of vastus lateralis

Inferior extremity of vastus medialis

Patella

Fatty pads

Transverse furrow

Anterior tubercle of tibia

Medial head of gastrocnemius

Surface of tibia

Soleus

Medial malleolus

Tendon of tibialis anterior

ANTERIOR ASPECT

Plate 84: EXTERIOR FORMS OF THE LOWER LIMB

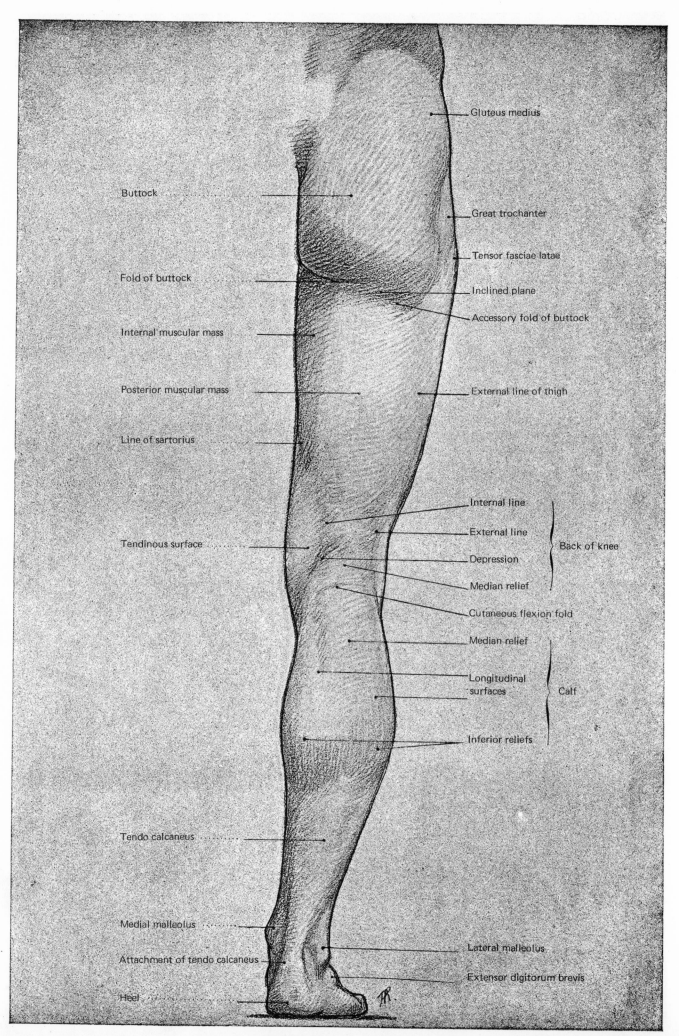

POSTERIOR ASPECT

Gluteus medius

Buttock

Great trochanter

Tensor fasciae latae

Fold of buttock

Inclined plane

Accessory fold of buttock

Internal muscular mass

Posterior muscular mass

External line of thigh

Line of sartorius

Internal line

External line

Depression Back of knee

Median relief

Tendinous surface

Cutaneous flexion fold

Median relief

Longitudinal
surfaces Calf

Inferior reliefs

Tendo calcaneus

Medial malleolus

Lateral malleolus

Attachment of tendo calcaneus

Extensor digitorum brevis

Heel

Plate 85: EXTERIOR FORMS OF THE LOWER LIMB

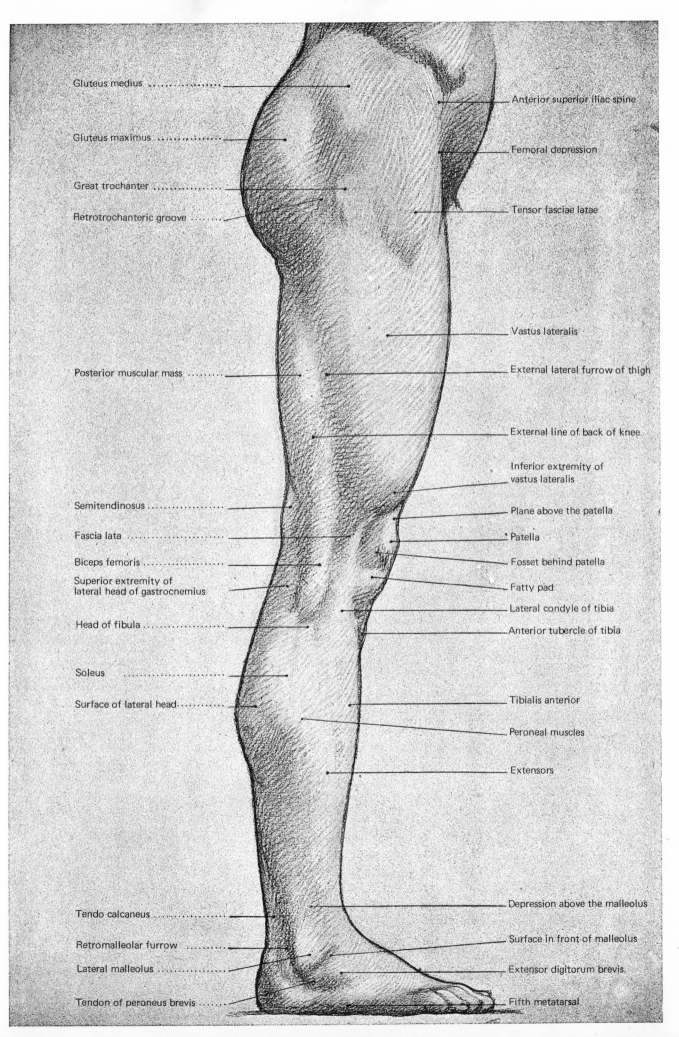

Gluteus medius

Gluteus maximus

Great trochanter

Retrotrochanteric groove

Posterior muscular mass

Semitendinosus

Fascia lata

Biceps femoris

Superior extremity of
lateral head of gastrocnemius

Head of fibula

Soleus

Surface of lateral head

Tendo calcaneus

Retromalleolar furrow

Lateral malleolus

Tendon of peroneus brevis

Anterior superior iliac spine

Femoral depression

Tensor fasciae latae

Vastus lateralis

External lateral furrow of thigh

External line of back of knee

Inferior extremity of
vastus lateralis

Plane above the patella

Patella

Fosset behind patella

Fatty pad

Lateral condyle of tibia

Anterior tubercle of tibia

Tibialis anterior

Peroneal muscles

Extensors

Depression above the malleolus

Surface in front of malleolus

Extensor digitorum brevis

Fifth metatarsal

LATERAL ASPECT

Plate 86: EXTERIOR FORMS OF THE LOWER LIMB

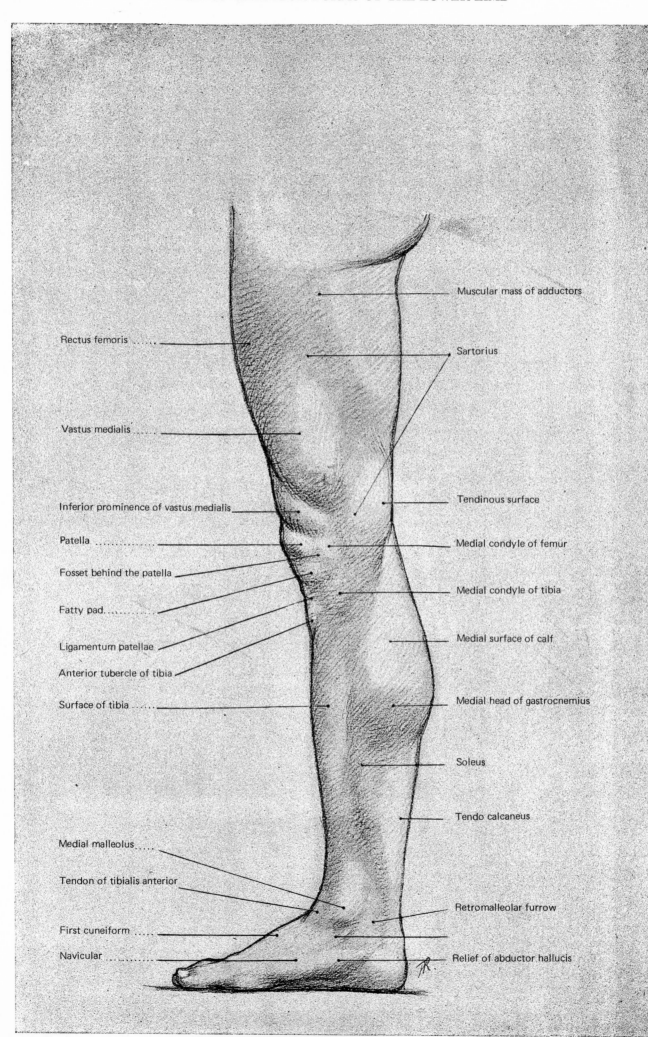

Muscular mass of adductors

Rectus femoris

Sartorius

Vastus medialis

Inferior prominence of vastus medialis

Tendinous surface

Patella

Medial condyle of femur

Fosset behind the patella

Fatty pad............

Medial condyle of tibia

Ligamentum patellae

Medial surface of calf

Anterior tubercle of tibia

Surface of tibia

Medial head of gastrocnemius

Soleus

Tendo calcaneus

Medial malleolus.....

Tendon of tibialis anterior

Retromalleolar furrow

First cuneiform

Navicular

Relief of abductor hallucis

MEDIAL ASPECT

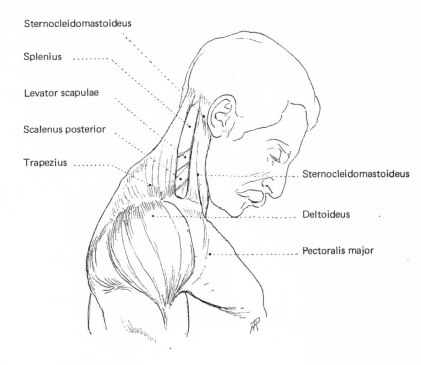

Sternocleidomastoideus

Splenius

Levator scapulae

Scalenus posterior

Trapezius

Sternocleidomastoideus

Deltoideus

Pectoralis major

FIGURE 1: FLEXION

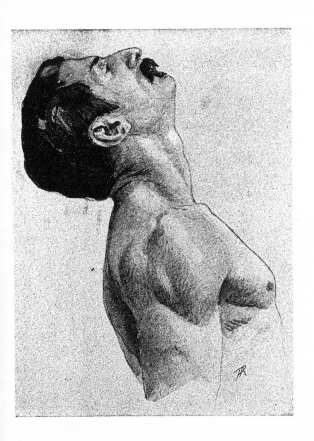

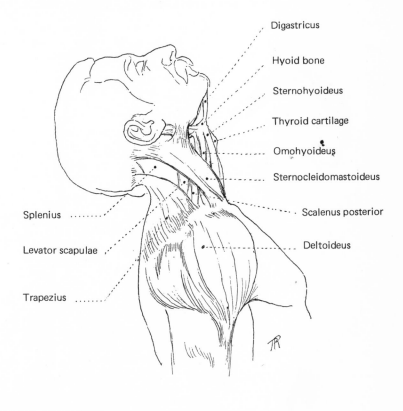

Digastricus

Hyoid bone

Sternohyoideus

Thyroid cartilage

Omohyoideus

Sternocleidomastoideus

Scalenus posterior

Deltoideus

Splenius

Levator scapulae

Trapezius

FIGURE 2: EXTENSION

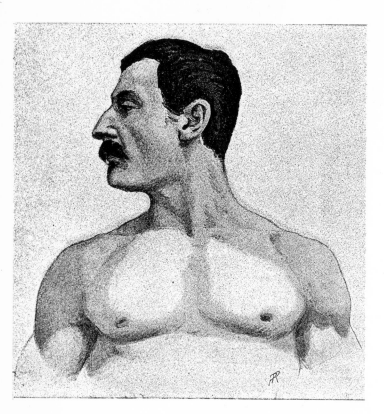

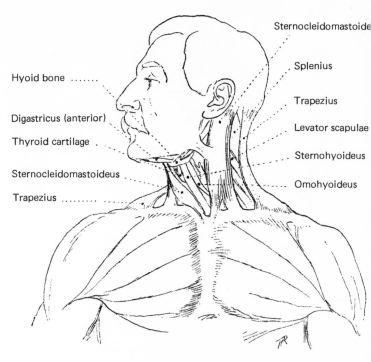

Sternocleidomastoide

Splenius

Trapezius

Levator scapulae

Sternohyoideus

Omohyoideus

Hyoid bone

Digastricus (anterior)

Thyroid cartilage

Sternocleidomastoideus

Trapezius

FIGURE 1: ROTATION

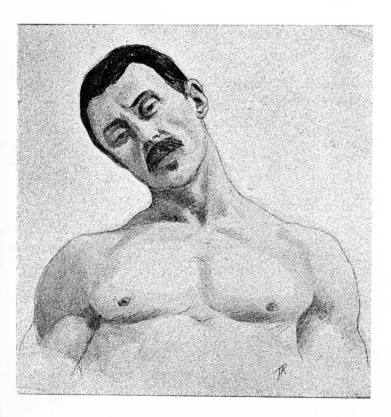

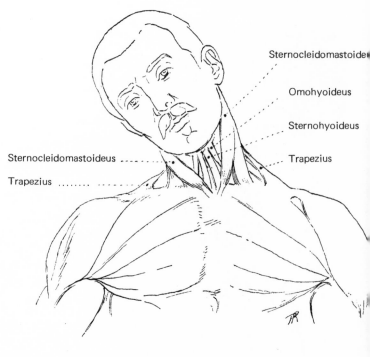

Sternocleidomastoide

Omohyoideus

Sternohyoideus

Trapezius

Sternocleidomastoideus

Trapezius

FIGURE 2: LATERAL INCLINATION

Plate 89: MODIFICATION OF EXTERIOR FORM DURING MOVEMENTS OF THE SHOULDERS

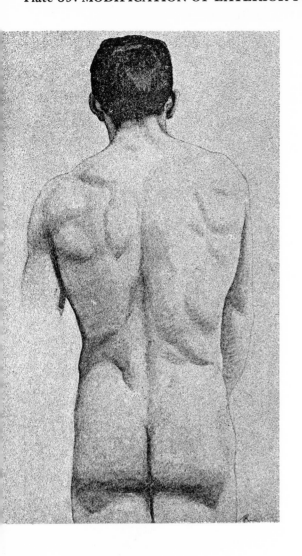

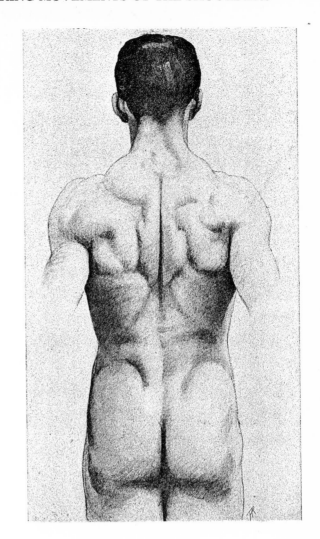

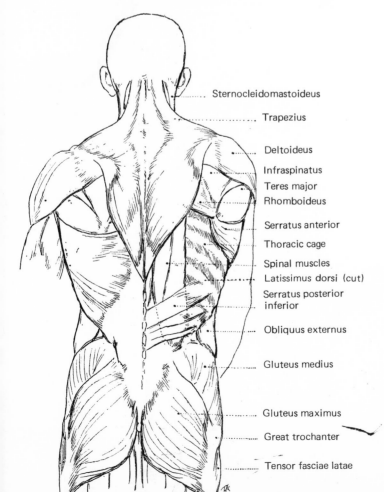

Sternocleidomastoideus

Trapezius

Deltoideus

Infraspinatus

Teres major

Rhomboideus

Serratus anterior

Thoracic cage

Spinal muscles

Latissimus dorsi (cut)

Serratus posterior inferior

Obliquus externus

Gluteus medius

Gluteus maximus

Great trochanter

Tensor fasciae latae

Sternocleidomastoideus

Trapezius

Deltoideus

Infraspinatus

Teres major

Latissimus dorsi

Obliquus externus

Gluteus medius

Gluteus maximus

Great trochanter

Tensor fasciae latae

FIGURE 1: RIGHT SHOULDER CARRIED TO THE FRONT

FIGURE 2: BOTH SHOULDERS DRAWN BACK

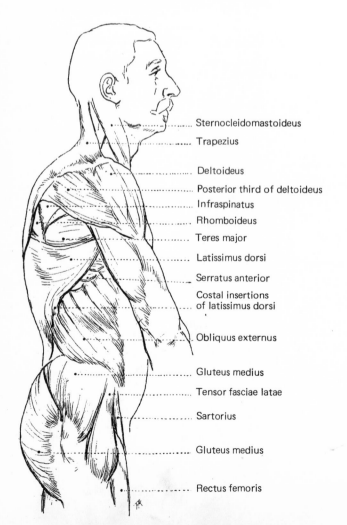

Sternocleidomastoideus

Trapezius

Deltoideus

Posterior third of deltoideus

Infraspinatus

Rhomboideus

Teres major

Latissimus dorsi

Serratus anterior

Costal insertions
of latissimus dorsi

Obliquus externus

Gluteus medius

Tensor fasciae latae

Sartorius

Gluteus medius

Rectus femoris

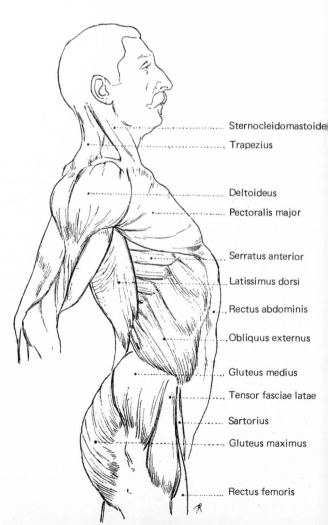

Sternocleidomastoide

Trapezius

Deltoideus

Pectoralis major

Serratus anterior

Latissimus dorsi

Rectus abdominis

Obliquus externus

Gluteus medius

Tensor fasciae latae

Sartorius

Gluteus maximus

Rectus femoris

FIGURE 1: SHOULDERS DRAWN FORWARD

FIGURE 2: SHOULDERS DRAWN BACK

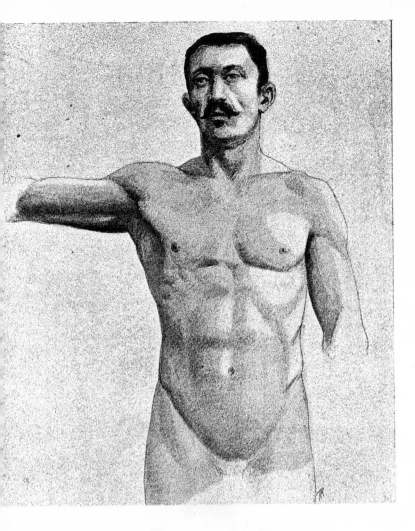

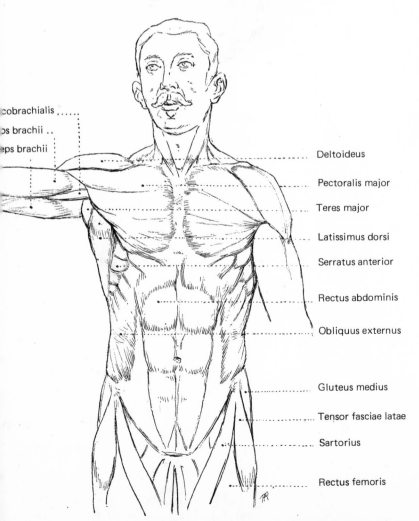

cobrachialis
s brachii
eps brachii

Deltoideus

Pectoralis major

Teres major

Latissimus dorsi

Serratus anterior

Rectus abdominis

Obliquus externus

Gluteus medius

Tensor fasciae latae

Sartorius

Rectus femoris

FIGURE 1: THE ARM EXTENDED HORIZONTALLY TO THE OUTSIDE

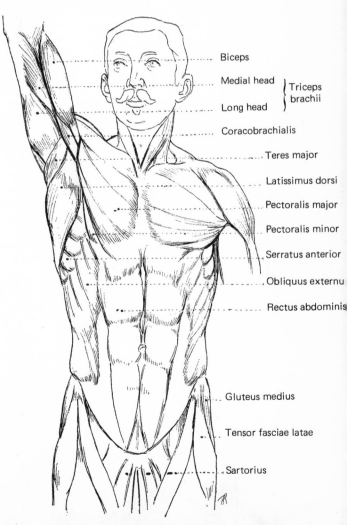

Biceps

Medial head

Long head

} Triceps
brachii

Coracobrachialis

Teres major

Latissimus dorsi

Pectoralis major

Pectoralis minor

Serratus anterior

Obliquus externu

Rectus abdominis

Gluteus medius

Tensor fasciae latae

Sartorius

FIGURE 2: THE ARM LIFTED VERTICALLY

Plate 92: MODIFICATIONS OF EXTERIOR FORM
DURING MOVEMENTS OF THE ARM

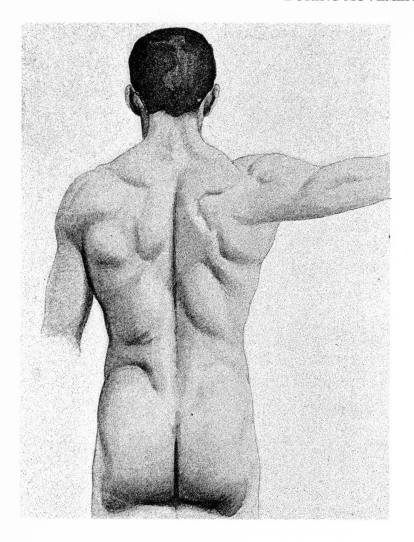

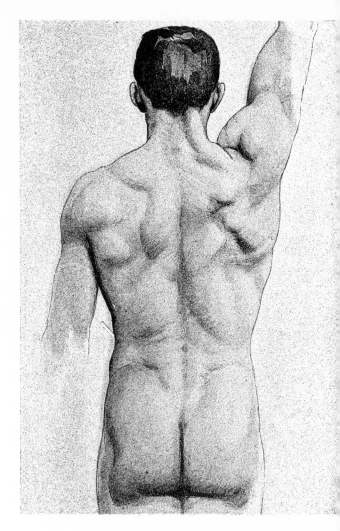

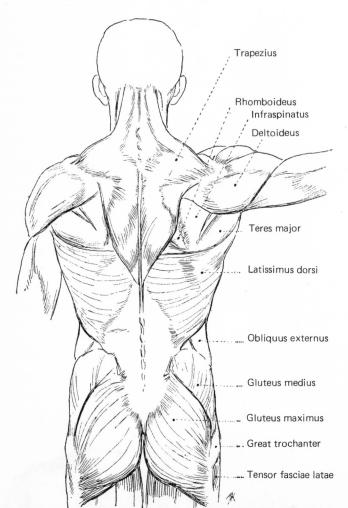

Trapezius

Rhomboideus
Infraspinatus

Deltoideus

Teres major

Latissimus dorsi

Obliquus externus

Gluteus medius

Gluteus maximus

Great trochanter

Tensor fasciae latae

FIGURE 1: THE ARM EXTENDED HORIZONTALLY TO THE OUTSIDE

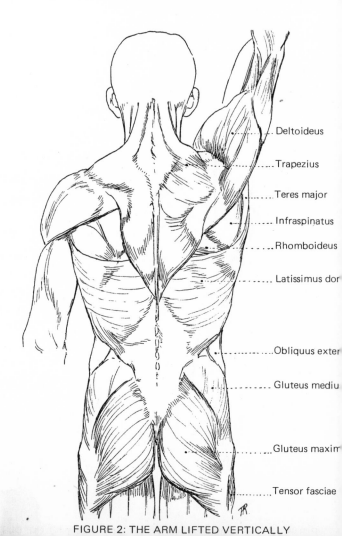

Deltoideus

Trapezius

Teres major

Infraspinatus

Rhomboideus

Latissimus dor

Obliquus exter

Gluteus mediu

Gluteus maxim

Tensor fasciae

FIGURE 2: THE ARM LIFTED VERTICALLY

Plate 93: MODIFICATIONS OF EXTERIOR FORM
DURING MOVEMENTS OF THE ARM

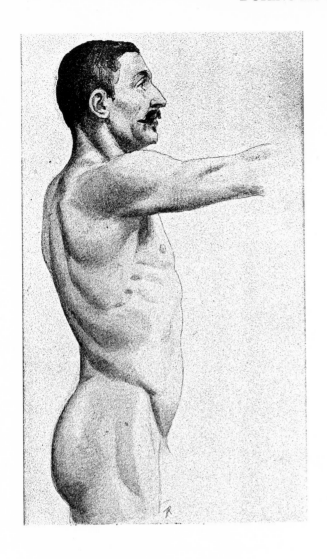

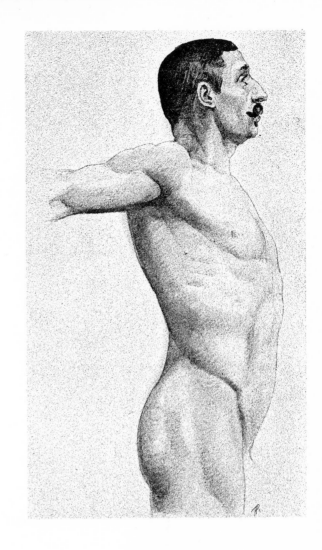

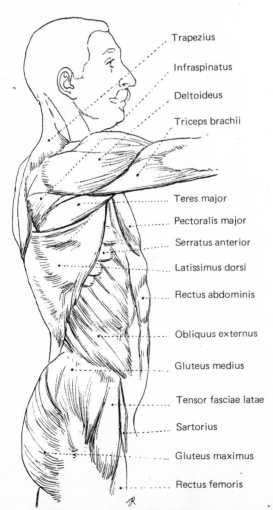

Trapezius

Infraspinatus

Deltoideus

Triceps brachii

Teres major

Pectoralis major

Serratus anterior

Latissimus dorsi

Rectus abdominis

Obliquus externus

Gluteus medius

Tensor fasciae latae

Sartorius

Gluteus maximus

Rectus femoris

FIGURE 1: THE ARM EXTENDED HORIZONTALLY TO THE FRONT

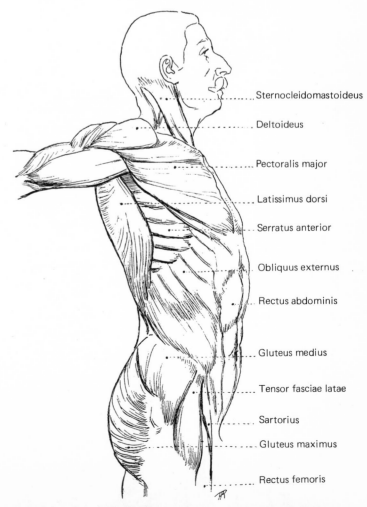

Sternocleidomastoideus

Deltoideus

Pectoralis major

Latissimus dorsi

Serratus anterior

Obliquus externus

Rectus abdominis

Gluteus medius

Tensor fasciae latae

Sartorius

Gluteus maximus

Rectus femoris

FIGURE 2: THE ARM EXTENDED HORIZONTALLY TO THE BACK

Plate 94: MOVEMENTS OF THE TRUNK

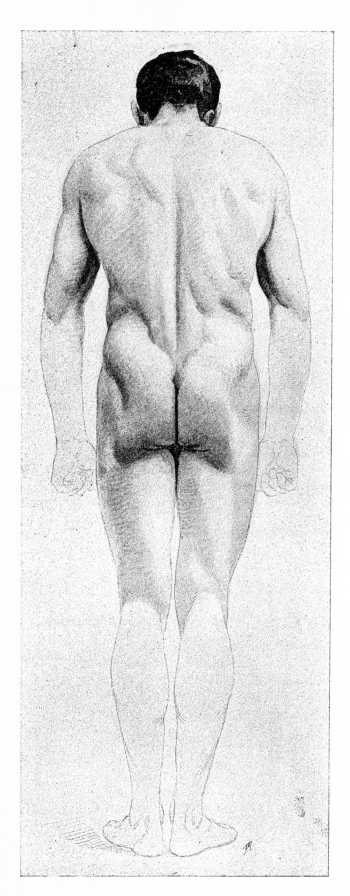

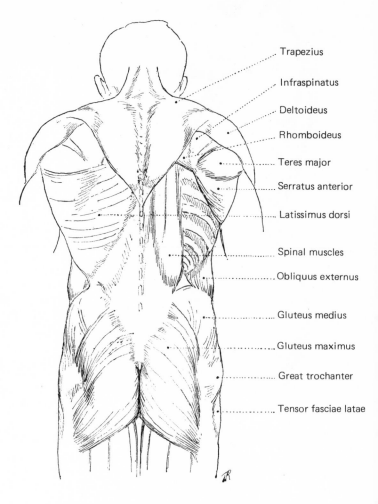

- Trapezius
- Infraspinatus
- Deltoideus
- Rhomboideus
- Teres major
- Serratus anterior
- Latissimus dorsi
- Spinal muscles
- Obliquus externus
- Gluteus medius
- Gluteus maximus
- Great trochanter
- Tensor fasciae latae

Note: The latissimus dorsi muscle on the right side has been completely left out to allow the deep muscles to show.

LIGHT FLEXION

Plate 95: MOVEMENTS OF THE TRUNK

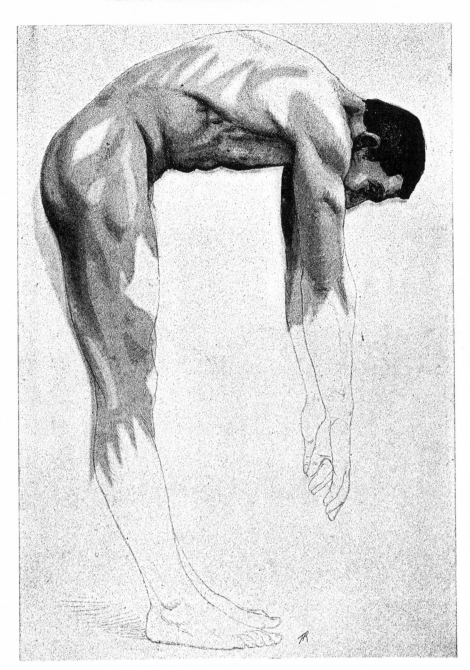

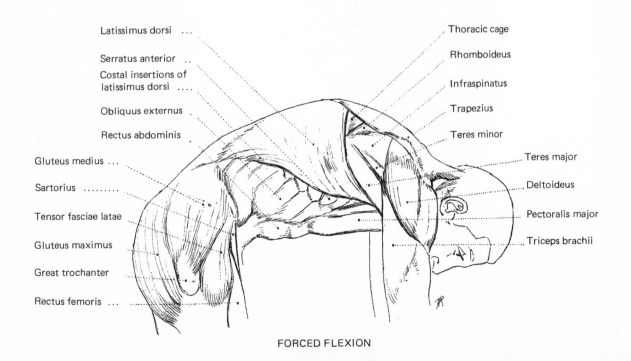

Latissimus dorsi ...

Serratus anterior ..

Costal insertions of
latissimus dorsi

Obliquus externus .

Rectus abdominis .

Gluteus medius ...

Sartorius

Tensor fasciae latae

Gluteus maximus

Great trochanter

Rectus femoris ...

Thoracic cage

Rhomboideus

Infraspinatus

Trapezius

Teres minor

Teres major

Deltoideus

Pectoralis major

Triceps brachii

FORCED FLEXION

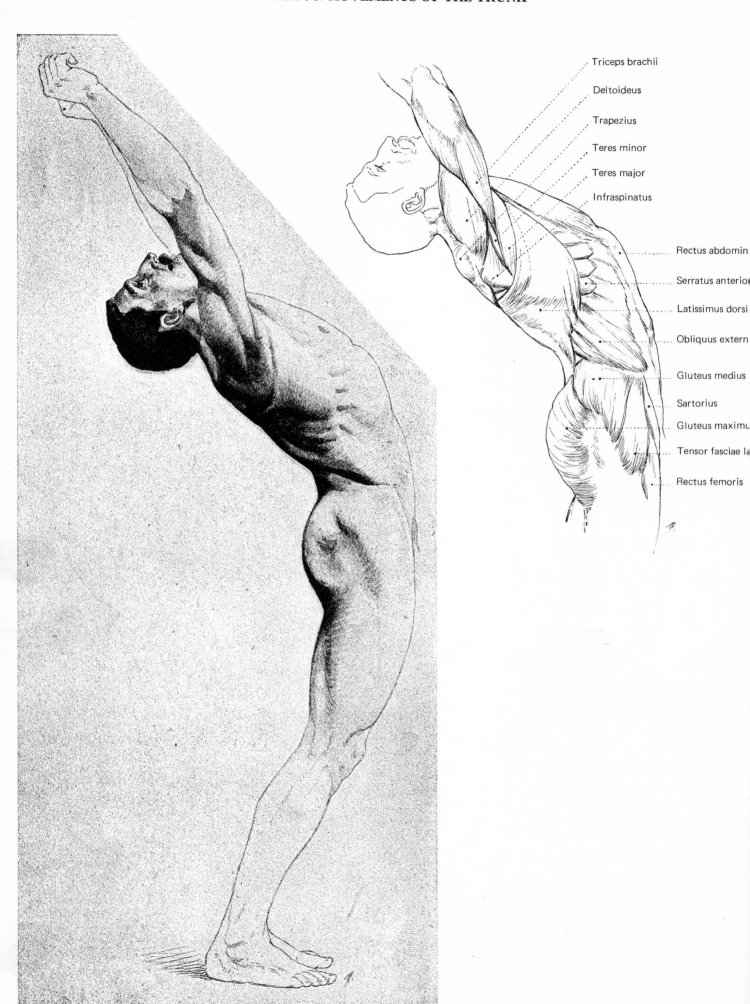

Triceps brachii

Deltoideus

Trapezius

Teres minor

Teres major

Infraspinatus

Rectus abdomin

Serratus anterio

Latissimus dorsi

Obliquus extern

Gluteus medius

Sartorius

Gluteus maximu

Tensor fasciae l

Rectus femoris

EXTENSION

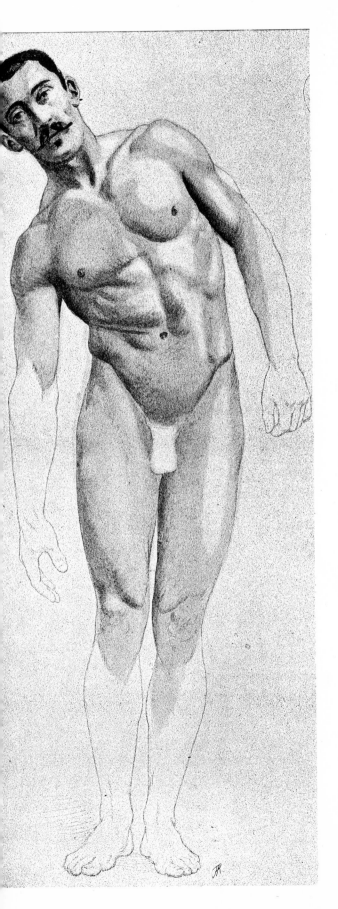

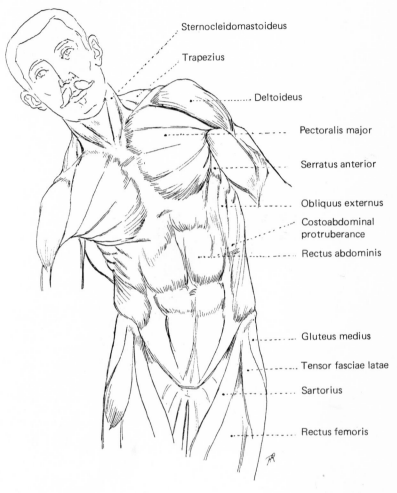

Sternocleidomastoideus

Trapezius

Deltoideus

Pectoralis major

Serratus anterior

Obliquus externus

Costoabdominal
protruberance

Rectus abdominis

Gluteus medius

Tensor fasciae latae

Sartorius

Rectus femoris

LATERAL INCLINATION
ANTERIOR ASPECT

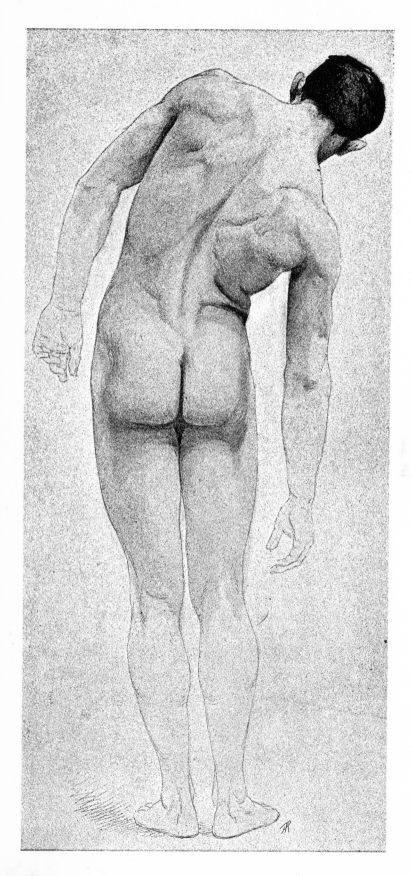

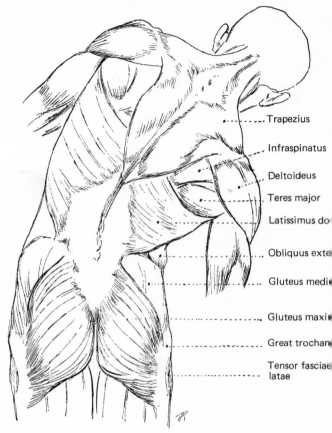

Trapezius

Infraspinatus

Deltoideus

Teres major

Latissimus do

Obliquus exte

Gluteus medi

Gluteus maxi

Great trochan

Tensor fasciae
latae

LATERAL INCLINATION
POSTERIOR ASPECT

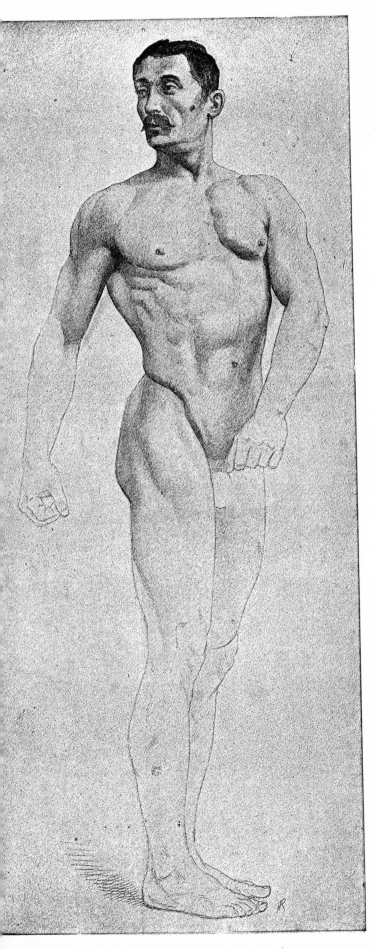

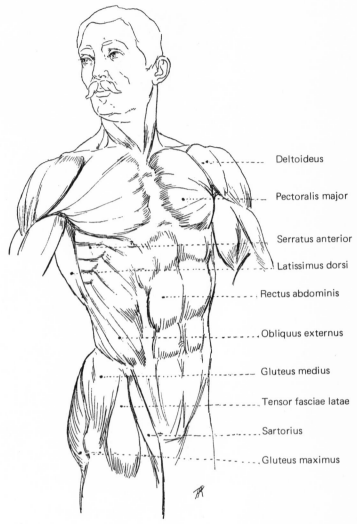

Deltoideus

Pectoralis major

Serratus anterior

Latissimus dorsi

Rectus abdominis

Obliquus externus

Gluteus medius

Tensor fasciae latae

Sartorius

Gluteus maximus

ROTATION
(towards the right)

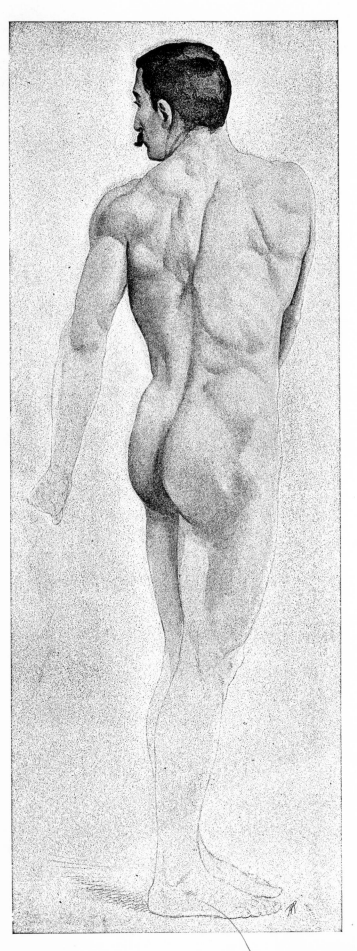

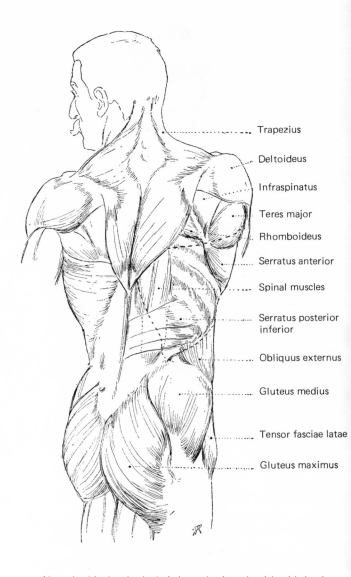

Trapezius

Deltoideus

Infraspinatus

Teres major

Rhomboideus

Serratus anterior

Spinal muscles

Serratus posterior
inferior

Obliquus externus

Gluteus medius

Tensor fasciae latae

Gluteus maximus

Note: In this sketch, the latissimus dorsi on the right side has been
left out. The dotted lines indicate the area occupied by its
fleshy body.

ROTATION
(towards the left)

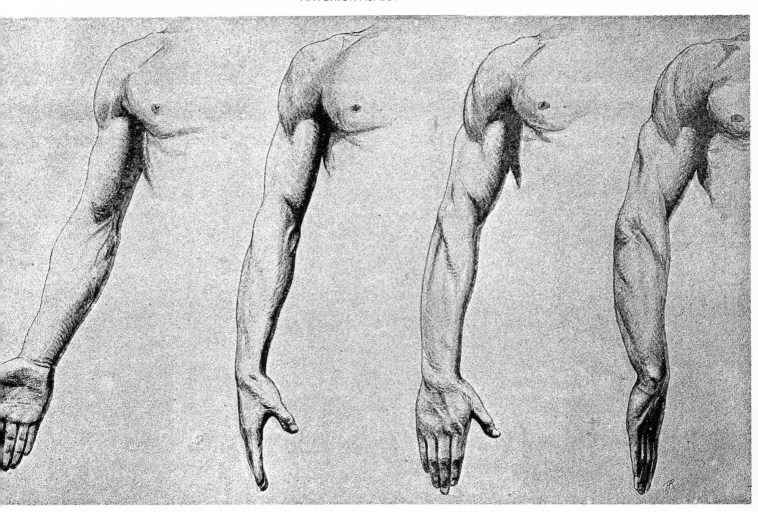

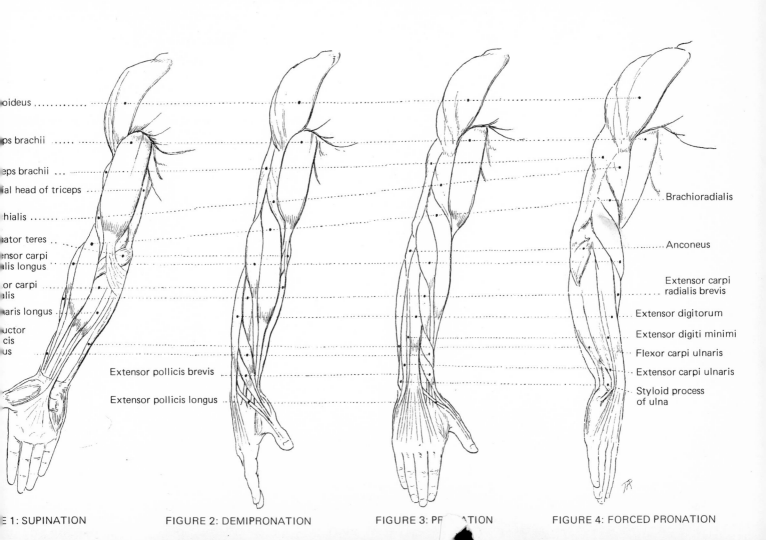

oideus

ps brachii

eps brachii ...

ial head of triceps ...

hialis

ator teres ...

nsor carpi
lis longus

or carpi
lis

aris longus

uctor
cis
us

Extensor pollicis brevis

Extensor pollicis longus

Brachioradialis

.......... Anconeus

Extensor carpi
radialis brevis

Extensor digitorum

Extensor digiti minimi

Flexor carpi ulnaris

Extensor carpi ulnaris

Styloid process
of ulna

E 1: SUPINATION FIGURE 2: DEMIPRONATION FIGURE 3: PR ATION FIGURE 4: FORCED PRONATION

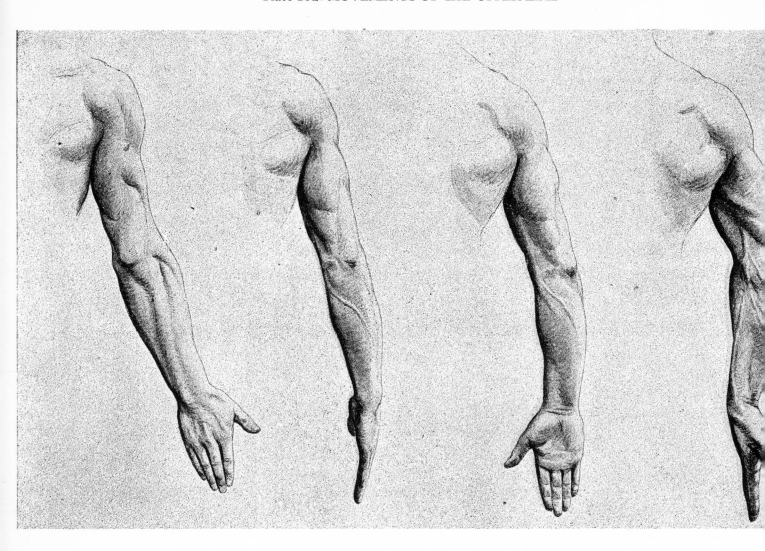

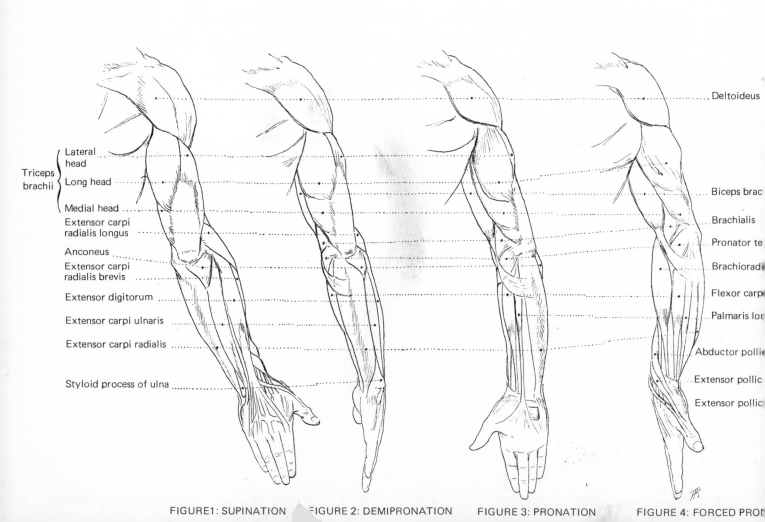

Deltoideus

Triceps brachii
Lateral head

Long head
Biceps brac

Medial head
Brachialis

Extensor carpi radialis longus
Pronator te

Anconeus
Brachioradi

Extensor carpi radialis brevis
Flexor carp

Extensor digitorum
Palmaris lor

Extensor carpi ulnaris

Extensor carpi radialis
Abductor pollic

Extensor pollic

Styloid process of ulna
Extensor pollic

FIGURE1: SUPINATION FIGURE 2: DEMIPRONATION FIGURE 3: PRONATION FIGURE 4: FORCED PRON

Plate 103: MOVEMENTS OF THE UPPER LIMB

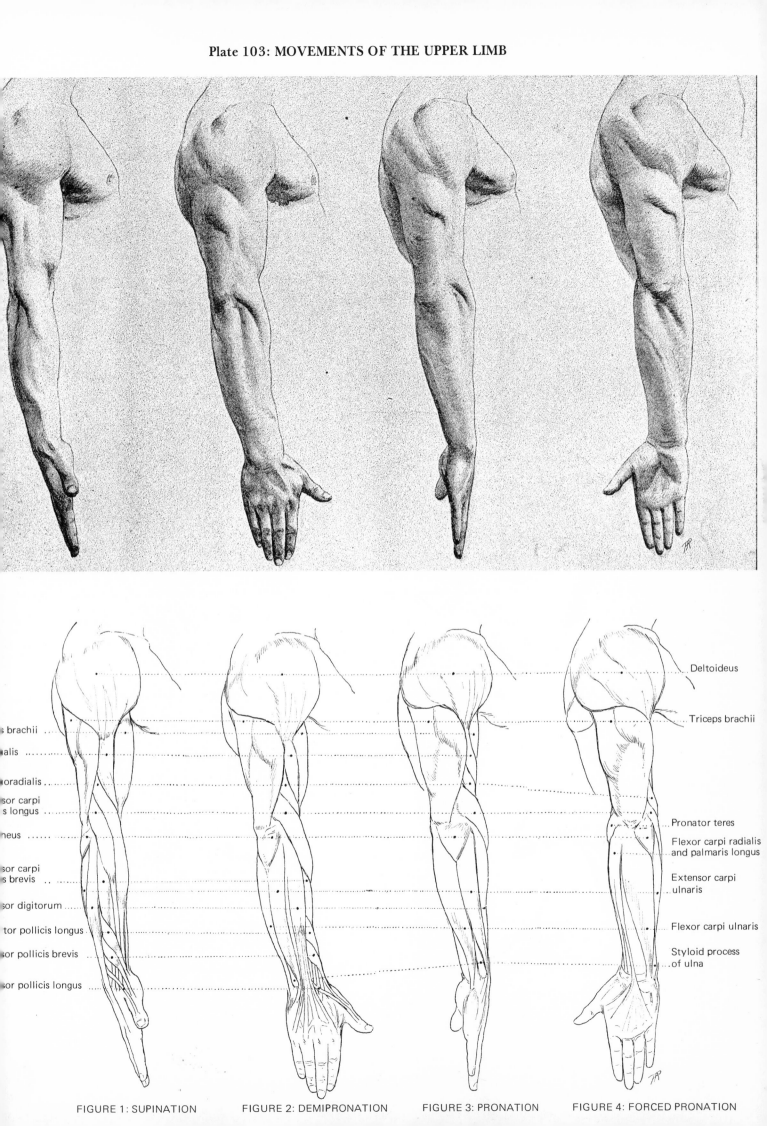

s brachii

alis

oradialis

sor carpi
s longus

neus

sor carpi
s brevis

sor digitorum

tor pollicis longus

sor pollicis brevis

or pollicis longus

Deltoideus

Triceps brachii

Pronator teres

Flexor carpi radialis
and palmaris longus

Extensor carpi
ulnaris

Flexor carpi ulnaris

Styloid process
of ulna

FIGURE 1: SUPINATION FIGURE 2: DEMIPRONATION FIGURE 3: PRONATION FIGURE 4: FORCED PRONATION

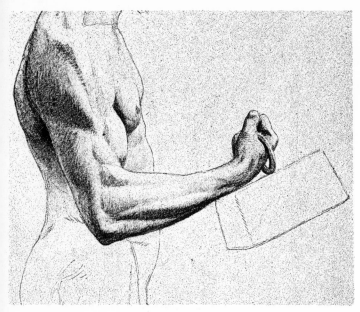

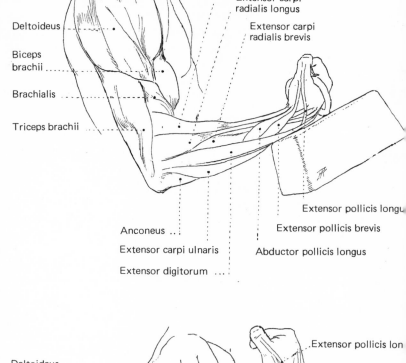

Brachioradialis

Extensor carpi radialis longus

Extensor carpi radialis brevis

Deltoideus

Biceps brachii

Brachialis

Triceps brachii

Anconeus

Extensor carpi ulnaris

Extensor digitorum

Extensor pollicis longu

Extensor pollicis brevis

Abductor pollicis longus

FIGURE 1: FLEXION AT RIGHT ANGLE

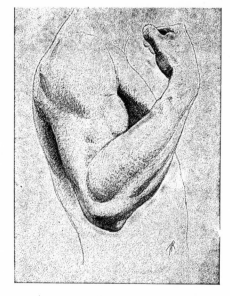

FIGURE 2: FLEXION AT ACUTE ANGLE

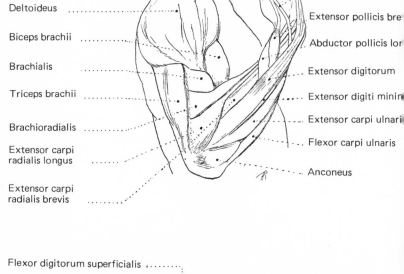

Deltoideus

Biceps brachii

Brachialis

Triceps brachii

Brachioradialis

Extensor carpi radialis longus

Extensor carpi radialis brevis

Extensor pollicis lon

Extensor pollicis bre

Abductor pollicis lon

Extensor digitorum

Extensor digiti minim

Extensor carpi ulnari

Flexor carpi ulnaris

Anconeus

FIGURE 3: FLEXION AT ACUTE ANGLE

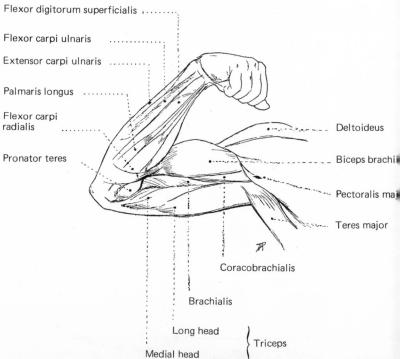

Flexor digitorum superficialis

Flexor carpi ulnaris

Extensor carpi ulnaris

Palmaris longus

Flexor carpi radialis

Pronator teres

Deltoideus

Biceps brachii

Pectoralis maj

Teres major

Coracobrachialis

Brachialis

Long head

Medial head

Triceps

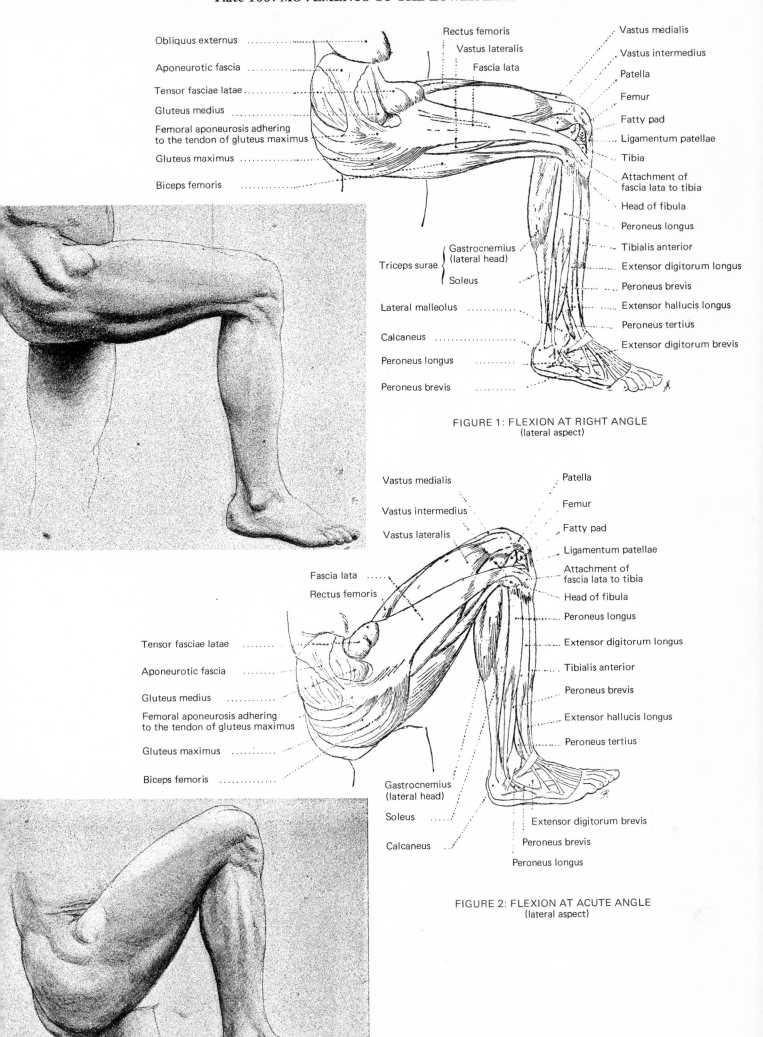

Obliquus externus

Aponeurotic fascia

Tensor fasciae latae

Gluteus medius

Femoral aponeurosis adhering
to the tendon of gluteus maximus

Gluteus maximus

Biceps femoris

Rectus femoris

Vastus lateralis

Fascia lata

Vastus medialis

Vastus intermedius

Patella

Femur

Fatty pad

Ligamentum patellae

Tibia

Attachment of
fascia lata to tibia

Head of fibula

Peroneus longus

Tibialis anterior

Extensor digitorum longus

Peroneus brevis

Extensor hallucis longus

Peroneus tertius

Extensor digitorum brevis

Triceps surae { Gastrocnemius (lateral head) / Soleus

Lateral malleolus

Calcaneus

Peroneus longus

Peroneus brevis

FIGURE 1: FLEXION AT RIGHT ANGLE
(lateral aspect)

Vastus medialis

Vastus intermedius

Vastus lateralis

Fascia lata

Rectus femoris

Tensor fasciae latae

Aponeurotic fascia

Gluteus medius

Femoral aponeurosis adhering
to the tendon of gluteus maximus

Gluteus maximus

Biceps femoris

Patella

Femur

Fatty pad

Ligamentum patellae

Attachment of
fascia lata to tibia

Head of fibula

Peroneus longus

Extensor digitorum longus

Tibialis anterior

Peroneus brevis

Extensor hallucis longus

Peroneus tertius

Gastrocnemius
(lateral head)

Soleus

Calcaneus

Extensor digitorum brevis

Peroneus brevis

Peroneus longus

FIGURE 2: FLEXION AT ACUTE ANGLE
(lateral aspect)

243

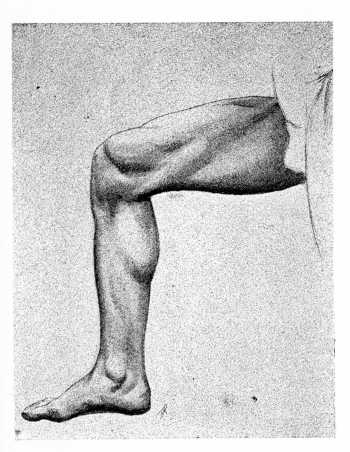

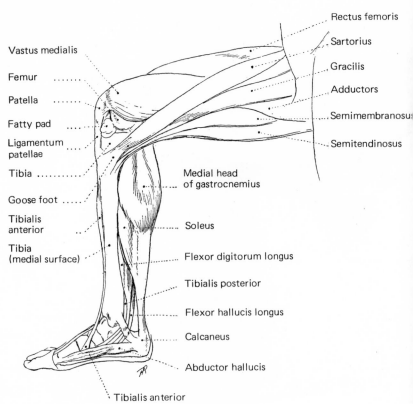

Vastus medialis

Femur

Patella

Fatty pad

Ligamentum
patellae

Tibia

Goose foot

Tibialis
anterior

Tibia
(medial surface)

Medial head
of gastrocnemius

Soleus

Rectus femoris

Sartorius

Gracilis

Adductors

Semimembranosus

Semitendinosus

Flexor digitorum longus

Tibialis posterior

Flexor hallucis longus

Calcaneus

Abductor hallucis

Tibialis anterior

FIGURE 1. FLEXION AT RIGHT ANGLE
MEDIAL ASPECT

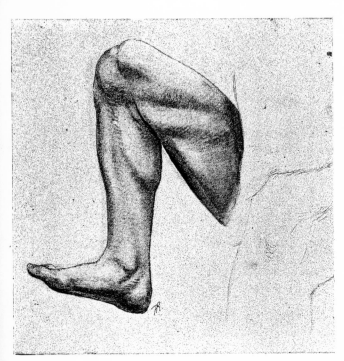

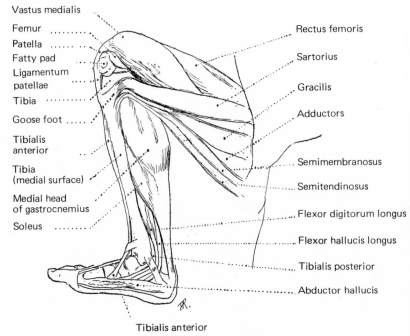

Vastus medialis

Femur

Patella

Fatty pad

Ligamentum
patellae

Tibia

Goose foot

Tibialis
anterior

Tibia
(medial surface)

Medial head
of gastrocnemius

Soleus

Rectus femoris

Sartorius

Gracilis

Adductors

Semimembranosus

Semitendinosus

Flexor digitorum longus

Flexor hallucis longus

Tibialis posterior

Abductor hallucis

Tibialis anterior

FIGURE 2. FLEXION AT ACUTE ANGLE
MEDIAL ASPECT

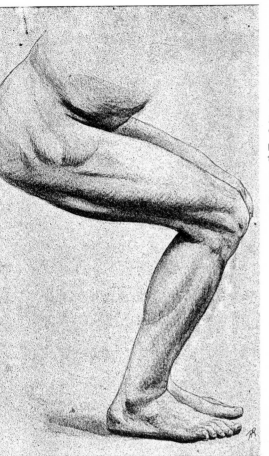
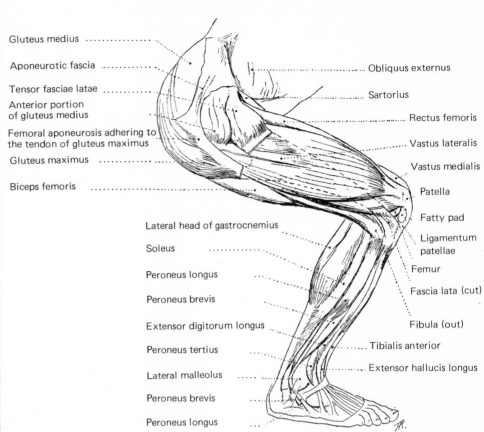

Gluteus medius

Aponeurotic fascia

Tensor fasciae latae

Anterior portion
of gluteus medius

Femoral aponeurosis adhering to
the tendon of gluteus maximus

Gluteus maximus

Biceps femoris

Lateral head of gastrocnemius

Soleus

Peroneus longus

Peroneus brevis

Extensor digitorum longus

Peroneus tertius

Lateral malleolus

Peroneus brevis

Peroneus longus

Obliquus externus

Sartorius

Rectus femoris

Vastus lateralis

Vastus medialis

Patella

Fatty pad

Ligamentum
patellae

Femur

Fascia lata (cut)

Fibula (out)

Tibialis anterior

Extensor hallucis longus

FIGURE 1. FLEXION TO RIGHT ANGLE,
FEET ON THE GROUND

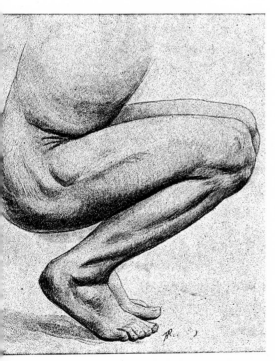
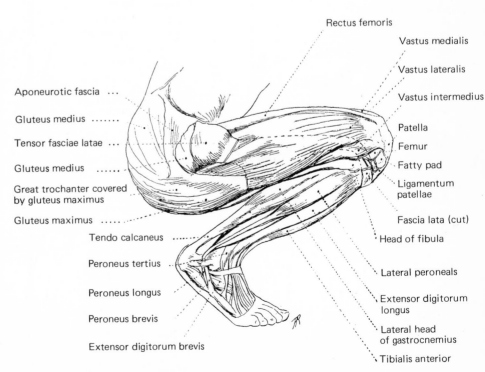

Aponeurotic fascia

Gluteus medius

Tensor fasciae latae

Gluteus medius

Great trochanter covered
by gluteus maximus

Gluteus maximus

Tendo calcaneus

Peroneus tertius

Peroneus longus

Peroneus brevis

Extensor digitorum brevis

Rectus femoris

Vastus medialis

Vastus lateralis

Vastus intermedius

Patella

Femur

Fatty pad

Ligamentum
patellae

Fascia lata (cut)

Head of fibula

Lateral peroneals

Extensor digitorum
longus

Lateral head
of gastrocnemius

Tibialis anterior

FIGURE 2. FLEXION TO ACUTE ANGLE,
FEET ON THE GROUND

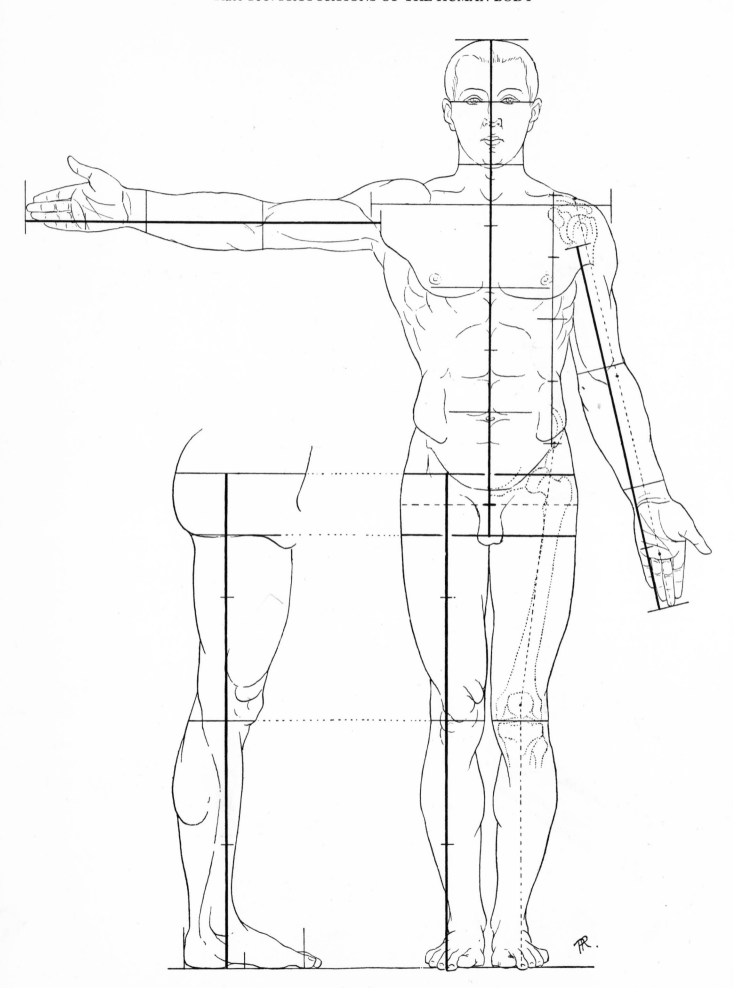

ANTERIOR ASPECT

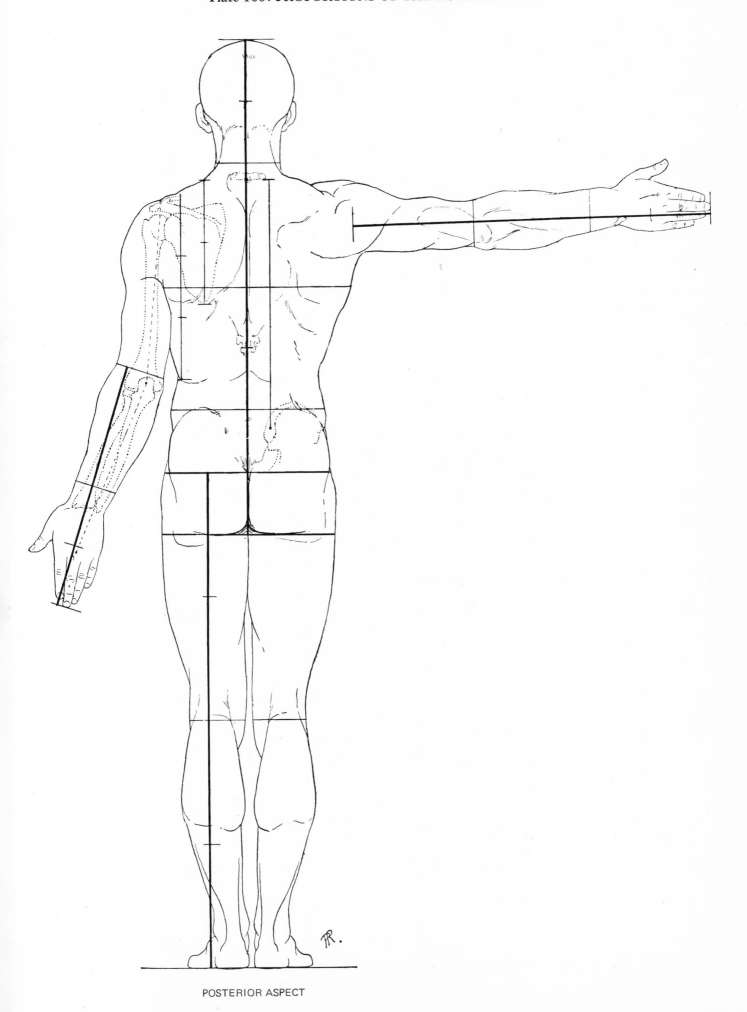

POSTERIOR ASPECT

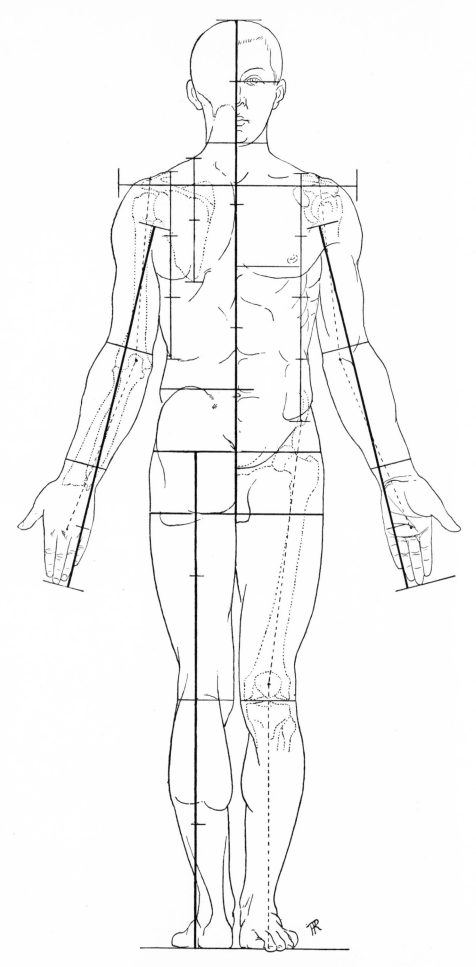

ANTERIOR AND POSTERIOR ASPECTS UNITED

Index

Abdomen, exterior form of, 97; muscles of, 60-61; muscles of lateral region, 61; semi-circular wrinkles of, 81; vein of, 77
Abdominal respiration, 31
Abductor digiti minimi, 75
Abductor hallucis, 75
Abductor pollicis brevis, 69
Abductor pollicis longus, 67
Accessory cephalic vein, 77
Acetabular fossa, 33
Acetabulum, 32, 33, 43
Achilles tendon, 42
Acromion process, 31
Acromioclavicular articulation, 32
Acromioclavicular ligament, 32
Adductor hallucis, 74
Adductor muscles of thigh, 71
Adductor pollicis, 69
Age, wrinkles of, 81
Alveolar process, 21
Amphiarthroses, 19
Anatomy, 17-81; medical, 15; purpose of, 13
Anconeus, 68
Angle of the ribs, 29, 30
Angular vein, 76
Ankle, articular surfaces of, 45; articulation of, 44-45; exterior form of, 123-124; ligaments of, 45; skeleton of, 42-43
Annular ligament, 38-39
Anterior and posterior atlantoaxial ligament, 26
Anterior and posterior atlantoöccipital membranes, 26
Anterior inferior iliac spine, 33
Anterior ligaments of knee, 44
Anterior longitudinal ligament, 25
Anterior sacroiliac ligament, 33
Anterior superior iliac spine, 33, 35
Anterior talofibular ligament, 45
Anthropology, and proportions, 131-132
Auditory canal, 22
Aspects of vertebral column, 27
Arcuate line of pelvis, 33
Arcuate pubic ligament, 33
Arm, influence on exterior form, 39-40; mechanism of, 104-105, 114-115; modification of exterior form, 115-116; movements of, 104; muscles of, 64-68 muscular action of, 104-105, 115; rotation of, 114-115; skeleton of, 36-37
Arm pit, exterior form of, 106; muscles of, 106
Arthrology, 19-20
Artist's personal image, 11-12
Atlantoaxial articulation, 26

Atlas, 25; articulation of, 26; mechanism of, 28; transverse ligaments of, 26
Auricularis, 50
Axis, 25; articulation of, 26; mechanism of, 28; transverse ligaments of, 26

Back, exterior form of, 95-97; fatty layer of, 80; muscles of, 54-56
Back of knee, wrinkle of, 80
Basilar part of occipital bone, 22
Basilic vein, 77
Belly, exterior form of, 97-98, muscles of, 60-61
Bend of arm, exterior form of, 110-111; wrinkle of, 80
Biceps brachii, 64
Biceps femoris, 72
Bifurcated ligament, 45
Bones, 19-20; articulation of, 19; classification of, 19; influence on form, 20; marrow of, 19; ossification of, 20; substance of, 19
Brachioradialis, 66-67
Brachialis, 64
Buccinator, 51
Buttocks, exterior form of, 101-102; fatty layer of, 78-79; muscles of, 63-64

Calcaneocuboid articulation, 45; ligaments of, 45
Calcaneofibular ligament, 45
Calcaneonavicular ligament, 45
Calcaneus bone, 42
Caninus, 51
Canon des Ateliers, see proportions
Canons of proportion, 129-131
Capitulum of humerus, 36
Capitate bone, 37
Carpal bones, 39; articulation of, 39; articulation with metacarpals, 39
Carpus, 37
Cartilage, 20
Cephalic vein, 77
Cervical vertebrae, 24
Charcot, Dr. Jean-Martin, 15
Cheek, bones of, 21-23; exterior form of, 87; muscles of, 51
Chest, exterior form of, 93; fatty layer of, 80; muscles of, 58; muscles of anterior and lateral regions, 58
Chin, bones of, 23; exterior form of, 87; muscles of, 52
Chondrosternal articulations, 30
Clavicle, 31; and scapula, 32; articulations of, 32
Clavicular extremity of sternum, 29
Coccyx, 25

Collateral ligaments, 39; of knee, 44
Compact substance of bones, 19
Conjunctiva, 86
Conoid ligament, 32
Conventional attitude of study, 13
Coracobrachialis, 64
Coracohumeral ligament, 38
Cornea, 86
Coronoid process of ulna, 36
Coronoid fossa of ulna, 36
Costoclavicular ligaments, 32
Coracoid process of scapula, 32
Corrugator, 50
Costal cartilages, 29; articulations with ribs, 30
Costal groove, 29
Costotransverse (superior and inferior) ligaments, 30
Cousin, on proportion, 130 et passim
Cranium, 21-23; anterior aspect of, 21; coronal suture of, 23; denticular suture of, 21; glenoid cavity of, 23; inferior aspect of, 22-23; inferior nuchal line of, 23; lamboidal suture of, 23; lateral aspect of, 22; median nuchal line of, 23; posterior aspect of, 22; superior aspect of, 23
Crest of pubis, 33
Cruciate ligaments, 44
Cuboid bone, 43; ligaments of, 45
Cuneiform bones, 43; ligaments of, 45

Da Vinci, Leonardo, see Leonardo da Vinci
Denticular suture of cranium, 21
Deltoideus, 60
Deltoid ligament, 45
Depressor anguli oris, 52
Depressor labii inferioris, 51
Depressor septi, 51
Diaphragm, 60
Diarthroses, 19
Dilator naris, 51
Dimensions of vertebral column, 27
Dissection, purpose of, 15
Dorsal radiocarpal ligament, 39
Dorsal column, 29
Dorsal venous arch, 77
Dorsal vertebrae, 24
Dürer, Albrecht, 130

Ear, 87-88; antihelix of, 88; concha of, 87; exterior form of, 87-88; helix of, 87; lobe of, 87; muscles of, 51; scapha of, 88; tragus of, 88
Elbow, articular surfaces of, 38; articulation of, 38; exterior form of, 110;

mechanism of, 38, 115; movements of, 115; muscular action of, 116
Epicranial muscles, 52
Epigastric hollow, 34
Ethmoid bone, 22
Expiration, 31
Expression, face, 50-52, 83
Extensor carpi radialis brevis, 67
Extensor carpi radialis longus, 67
Extensor carpi ulnaris, 68
Extensor digiti minimi, 68
Extensor digitorum, 67-68
Extensor digitorum brevis, 74
Extensor digitorum longus, 72
Extensor hallucis longus, 72
Extensor pollicis brevis, 67
Extensor pollicis longus, 67
Exterior form, 83-135; of abdomen, 97; of ankle, 123-124; of arm, 110; of arm pit, 106; of back, 95-97; of belly, 97-98; of bend of arm, 110-111; of buttocks, 101-102; of cheek, 87; of chin, 87; of ear, 87-88; of elbow, 110; of eye, 85-86; of flank, 98-100; of forearm, 111-112; of forehead, 85; of foot, 124; of groin, 100-101; of hand, 113-114; of head, 85-88, 90; of inframmary region, 95; of infrascapular region, 97; of knee, 118-122; of loins, 98; of lower limb, 118-128; of neck, 88-89; of nose, 86; of pubic region, 100; of scapular region, 96-97; of shoulder, 110; of sternal region, 93; of spinal region, 96; of temple, 87; of throat, 118; of trunk, 92-109; of upper limb, 110-117
External iliac fossa, 32
External jugular vein, 76
External occipital protuberance, 22, 27
External orbital apophyses, 21
Eye, bones of, 21-23; exterior form of, 85-86; muscles of, 50

Flexor carpi radialis, 66
Flexor carpi ulnaris, 66
Flexor digitorum longus, 73
Flexor digitorum profundus, 65
Flexor digitorum superficialis, 66
Flexor hallucis longus, 73
Flexor pollicis brevis, 69
Flexor pollicis longus, 65-66
Forehead, muscles of, 50
Face, expression of, 50-52, 83; exterior form of 85-87; muscles of, 50-52; skeleton of, 21-23;
Facial vein, 76
False pelvis, 33
False vertebrae, articulations of, 26
Fascia, 48
Fatty layer, 78-80; of abdomen, 78, 80; of breast, 78, 80; of buttocks, 78; influence on external form, 78; of lower limb, 78; of neck, 78; of thigh, 78; of upper limb, 78; variations in, 78-79
Fatty tissue, 78
Fatty tissue of interposition, 80, of armpit, 80; of cheekbones, 80; of patella, 80; of popliteal space, 80
Fibrous capsule; 25
Fibula, 42; articulation with tibia, 44; dimensions of, 42; external malleolus of, 42; influence on exterior form, 46; interosseus border of, 42; styloid process of, 42

Fingers, collateral veins of, 77; extensor wrinkles of, 80; exterior form of, 114; mechanism of, 117; muscles of, 68; muscular action of, 117; modification of exterior form of, 117; movements of, 117; skeleton of, 37-38
Femur, 41; adductor tubercle of, 41; articulation with knee, 44; dimensions of, 41, 46; influence on exterior form, 46; mechanism of, 43; medial and lateral condyles of, 41
Foot, articulation of, 45, 46; abduction of, 128; adduction of, 128; extension of, 128; exterior form of, 124; fatty layer of, 80, flexion of, 128; mechanism of, 45; modification of exterior form of, 128; movements of, 127-128; muscular action of, 128; muscles of, 74-75; muscles of dorsal region, 74; muscles of external region, 75; muscles of internal region, 75; muscles of middle region, 74; muscles of plantar region, 74; papilliary wrinkles of, 81; skeleton of, 41; sole of, 124; superior surface of, 124; toes, 124-125; vault of, 124
Foramen magnum, 21
Forearm, anteroexternal region of, 65; anterior superficial layer of muscles of, 66; articulation of bones of, 38; deep layer of muscles of, 67; exterior form of, 111-112; external superficial muscles of, 66-67; mechanism of, 38; middle layer of muscles of, 65-66; muscles of, 65-68; posterior region of muscles of, 67; pronation of, 36; radius and ulna of, 36-37
Forehead, bones of, 21; exterior form of, 85; muscles of, 50
Form, visualizing, 11, 12
Flank, exterior form of, 98-100; fatty layer of, 80; muscles of, 61
Flat bones, 19
Flexor digiti minimi brevis, 75
Flexor digitorum brevis, 74-75
Flexor hallucis brevis, 75
Free cartilage, 19
Frontal bone, 22
Frontal eminences, 21
Frontalis, 50
Frontal process of cranium, 21
Frontal vein, 76

Gastrocnemius, 73-74
Gemelli, 53
Genohyoideus, 57
Gerdy, see proportions
Gracilis, 71
Greater sciatic notch, 33
Great saphenous vein, 76-77
Great trochanter, 41
Greeks, proportions of, 129
Groin, exterior form of, 100-101
Gladiolus, 29
Glenoid cavity, 32
Gluteus maximus, 63-64
Gluteus medius, 63
Gluteus minimus, 63

Head, articular mechanism of, 89-90; exterior form of, 85-88-90; movements of, 89; muscles of, 50-52; muscular action of, 90; skeleton of, 21-23
Hand, articulation of, 38-39; exterior form of, 85-88; 113-114; hypothenar emi-

nence of, 69; modification of exterior form of, 116-117; movements of, 116; muscular action of, 116; muscles of 68-69; papilliary wrinkles of, 81; skeleton of, 37; thenar eminence of, 69
Hamate bone, 37
Hip, abduction of, 125-127; adduction of 125-127; articulations of, 42-43; bone 32; extension of, 125-127; extensors of 125-127; fibrous capsule of, 43; flexion of, 125-127; mechanism of, 43, 125 modification of exterior form of, 125-127; movements of, 125; muscular action of, 125-127; rotation of, 125-127
Humerus, 36; dimensions of, 40; lateral condyle of, 36; medial condyle of, 36
Hypothenar eminence, see hand

Iliac crest, 33
Iliac tuberosity, 33
Iliacus, 63
Iliofemoral ligament, 43
Iliolumbar ligament, 33
Iliopectineal eminences, 33
Ilium, 32
Infrahyoid muscles, 57
Inframammary region, exterior form of, 9!
Infrascapular region, exterior form of, 9!
Infraspinous fossa, 31
Infraspinatus, 59
Inguinal (Poupart's) ligament, 33, 35
Inspiration, 31
Interarticular ligament, 30
Intercostales, 58
Intercostal spaces, 30
Interclavicular ligaments, 32
Internal iliac fossa, 33
Interossei, 74
Interossei dorsales, 68
Interossei palmares, 68
Interosseous talocalcaneal ligament, 45
Interspinal ligament, 26
Intertrochanteric line and crest, 41
Ischial spine, 33
Ischium, 32

Jaw, mechanism of, 23; muscles of, 52 skeleton of, 23

Knee, articulation of, 43; back of, 121 122; bend of, 121-122; bones of, 44 extension of, 127; in extension of lower leg, 127; exterior form of, 118-122 flexion of, 127; ligaments of, 44; mechanism of, 44; 127; menisci of, 44; modification of exterior form of, 127; movements of, 127; muscular action of, 127

Lacrimal gland, 22
Laminae, 24, 25
Lateral condyle of humerus, 36
Latissimus dorsi, 55-56
Leonardo da Vinci, 130, 134
Lesser sciatic notch, 33
Lesser trochanter, 41
Levator labii superioris, 51
Levator labii superioris alaeque nasi, 51
Levator scapulae, 55
Ligaments, acromioclavicular, 32; annular, 38, 39; anterior and posterior altanto-axial, 26; anterior, of knee, 44; anterior longitudinal, 25; anterior sacroiliac, 33; anterior talofibular, 45; arcuate pubic, 33; altas, axis, transverse of, 26; axis,

altas, transverse of, 26; calcaneofibular, 45; bifurcated, 45; calcaneonavicular, 45; capitis femoris, 43; collateral, of knee, 44; conoid, 32; coracohumeral, 38; costoclavicular, 32; coracoclavicular, 32; costotransverse (superior and inferior), 30; cruciate, 44; deltoid, 45; dorsal radiocarpal, 39; iliofemoral, 43; iliolumbar, 33; inguinal (Poupart's) 33, 35; interarticular, 30; interclavicular, 32; interosseous talocalcaneal, 45; interspinal, 26; occipitoaxial, 26; odontoid, 26; of calcaneocuboid articulation, 45; of cuboid bone, 45; of cuneiform bones, 45; of navicular bone, 45; of tarsometatarsal articulations, 45; palmar, 39; palmar radiocarpal, 39; posterior cervical (ligamentum nuchae), 26; posterior longitudinal, 25; posterior sacroiliac (short and long), 33; Poupart's (inguinal), 33, 35; radial collateral, 38, 39; radiate sternocostal, 30; sacrospinous, 33; sacrotuberous, 33; sciatic, 33; sphenomandibular, 23; stylomandibular, 23; supraspinal, 26, 27; talofibular (anterior and posterior), 45; talonavicular (plantar and dorsal), 45; transverse of atlas and axis, 26; transverse metacarpal, 39; transverse metatarsal, 45; trapezoid, 32; triangular, 38; ulnacarpal, 39; ulnar collateral, 38, 39; yellow, 26, 27

Ligamentum capitis femoris, 43
Ligamentum nuchae (posterior cervical ligament), 26
Linea aspera, 41
Line, 12, 14
Locomotion, wrinkles of, 80
Loins, exterior form of, 98; muscles of, 54-56
Long bones, 19
Longissimus capitis, 54
Longus capitis, 53
Lower leg, anteroexternal region of muscles of, 72-73; deep layer of muscles of, 73; exterior form of, 123; muscles of, 72-74; posterior region of muscles of, 73; skeleton of, 41-42; superficial layer of muscles of, 73-74; veins of, 77
Lower limb, exterior form of 118-128; muscles of, 70-75; skeleton of, 41-46; veins of, 77
Longus colli, 56, 57
Lumbar fossa, inferior, 35; superior lateral, 35
Lumbar vertebrae, 24, 25
Lumbricales, 68, 74
Lunate bone, 37

Mammary region, exterior form of, 94-95; muscles of, 58-59
Mandible, 23, condyles of, 23; coronoid process of, 23; inferior maxillary angle of, 23; lateral ligament of, 23; mandibular notch of, 23; mental spines of, 23; mylohyoid line of, 23; rami of, 23
Mandibular foramen, 23
Manubrium, 29
Masseter, 52
Mastoid process, 22, 23
Measurements, of body, 132-135
Median antibrachial vein, 77
Median marginal vein, 77
Mentalis, 52
Menisci, 44

Metacarpophalangeal articulation, 39; mechanism of, 39
Metacarpus, bones of 37; articulation with carpus, 39; mechanism of, 39; muscles of 68-69;
Metatarsophalangeal articulation, 45
Metatarsus, 42, 43; muscles of, 74-75
Morphology, 83-135
Mouth, bones of 21-23; exterior form of, 86; muscles of, 51-52
Muscles, 47-49; of abdomen, 60, 61; antagonistic action of, 69; of chin, 52; composition of, 47; disposition of fibers of, 47-48; of ear, 51; of eye, 50; of face, 50; of forehead, 50; of foot, 74-75; of hand, 68; of head, 50-52; of jaw, 52; of lower limb, 70-75; nature of, 47-49; of neck, 53-63; of nose, 51; of pelvis, 62-63; relationship to exterior form, 49; of shoulder, 59; of trunk, 56-63; of upper limb, 64-69
Muscular contraction, 48
Muscular force, 48-49
Muscle groups, 49
Mylohyoideus, 57
Myology, 47-49

Nasal bones, 21
Nasal canal, 22
Nasal eminence, 21
Nasalis, 51
Navel, 12
Navicular bone, 42-43; ligaments, of, 45
Neck, anterior region of, 88; articular mechanism of, 89-90; effect of movement on form of, 90; exterior forms of, 88-89; flexion of, 90; flexion wrinkles of, 80; lateral inclination of, 91; movements of, 89; muscles of, 53-63; muscular action of, 90; posterior triangle of, 89; rotation of, 90-91; skeleton of, 24; veins of, 77
Necklace of Venus, 80
Nose, exterior form of, 86; bones of, 21-23; muscles of, 51

Obliquus capitis superior, 53
Obliquus capitis inferior, 53
Obliquus externus abdominis, 61
Obliquus internus abdominis, 61
Obturator internus, 63
Obturator externus, 63
Obturator foramen, 32, 33
Obturator groove, 33
Obturator membrane, 33
Occipital bone, 26; articulation of, 26; mechanism of, 28
Occipitalis, 50
Occipitoaxial ligaments, 26
Odontoid ligaments, 26
Olecranon fossa 36;
Omohyoideus, 57
Opponens pollicis, 69
Optic foramen, 22; nerve, 22
Orbicularis oris, 51
Orbicularis palpebrarum, 50
Orbital cavity, 22
Osteology, 19-20

Palmaris longus, 66
Palmar ligament, 39
Palmar radiocarpal ligament, 39
Palatine processes, 22

Palm, fatty later of, 80
Panniculus adiposus, 78-79
Pelvis, articulations of, 33; deep muscles of, 62; dimensions of, 33; exterior form of, 100; influence on form of, 35; ligaments of, 33; mechanism of, 34; middle layer gluteal muscles of, 63; muscles of, 61-63; reentering angle of, 35; skeleton of, 32
Parietal bones, 22
Pareital eminence, 22
Patella, 41, 42
Pectineal and arcuate lines, 33
Pectineal surface, 33
Pectoralis major, 58-59
Pectoralis minor, 58
Pelvic arch, 33
Perichondrium, 19
Periosteum, 19
Peroneal sulcus, 43
Peroneus brevis, 73
Peroneus longus, 73
Perspective, in plates, 11, 13
Phalanges, of foot, 43; of hand 37-38, 39
Piriformis, 63
Plantaris, 73-74
Plates, 137-149; anatomical, 13; models for, 14, 15; morphological, 14; myological, 14; osteological, 13
Platysma, 58
Polycleitus, 129
Popliteal surface, 41
Popliteus, 73
Posterior cervical ligament (ligamentum nuchae), 26
Posterior inferior iliac spine, 33
Posterior longitudinal ligament, 25
Posterior sacroiliac (short and long) ligaments, 33
Posterior superior iliac spine, 33, 35
Poupart's (inguinal) ligament, 33, 35
Procerus, 51
Pronator teres, 66
Pronator quadratus, 65
Proportions, 11, 129-135; and anthropology, 131-132; of Cousin, 130; of Gerdy, 131; of the Greeks, 129; canons of, 129-131; criticism of, 131; history of, 129-131; of Leonardo da Vinci 130, 131; of Canon des Ateliers, 131; of Richer, 132-135; system of, 132-135
Psoas major, 63
Psoas minor, 63
Pubic arch, 33
Pubic symphysis, 33
Pubic region, exterior form of, 100
Pubis, 32
Pyramidalis, 61

Quadratus femoris, 63
Quadratus lumborum, 60
Quadratus plantae, 74
Quadriceps femoris, 70-71

Radial collateral ligament, 38, 39
Radial fossa, 36
Radial tuberosity, 37
Radial vein, 77
Radiate sternocostal ligaments, 30
Radiocarpal articulation, 38-39
Radioulnar (superior and inferior) articulation, 38
Radius, 37; dimensions of, 40

Rectus abdominis, 60-61
Rectus capitis lateralis, 53
Rectus capitis posterior major, 53
Rectus capitis posterior minor, 53
Reentering angle of pelvis, 33, 35
Rhomboideus, major and minor, 55
Ribs, 29-30; anterior extremity of, 29; articulations with costal cartilages, 30, articulations with vertebral column, 30; body of, 29; costal cartilage of, 29; head of, 29; general characteristics of, 29-30; influence on form of, 35; neck of, 29; particular characteristics of, 30
Richer, see proportions
Rubens, Peter Paul, 130

Sacral cornua, 25
Sacral hiatus, 25
Sacral vertebrae or sacrum, 25
Sacroiliac articulation, 33
Sacrospinalis, 54-55
Sacrospinous ligament, 33
Sacrotuberous ligament, 33
Sacrovertebral angle, 26
Sartorius, 71
Scalenus anterior, 57
Scalenus posterior, 57
Scaphoid bone, 37
Scapula, 31; and clavicle, 32; influence on form of, 35; neck of, 32; normal position of, 103; spine of, 31
Scapular region, exterior form of, 96-97
Sciatic ligaments, 33
Seatopygia, 79
Semimembranosus, 72
Semitendinosus, 72
Semispinalis capitis, 54
Serratus anterior, 59
Serratus posterior inferior, 55
Serratus posterior superior, 55
Shoulder, articular mechanism of, 102-103; articulation of, 38; bones of, 31-32; exterior form of, 110; mechanism of, 38; movements of, 102; muscles of, 59; muscular action of, 103
Skeleton, 21-46; influence on form of, 12; of foot, 41; of hand, 37; of head, 21-23; of lower limb, 36-40; of neck, 24; of pelvis, 32; of spinal column, 26-27; of trunk, 24-28, 34-35; of thorax, 29-35; of upper limb, 36-40
Skin, 80-87; adherence of, 80; color of, 81; elasticity of, 80; epidermis of, 81; fatty tissue of, 78-81; mobility of, 80; sebaceous glands of, 81; suboriferous glands of, 81; thickness of, 80
Small saphenous vein, 77
Soleus, 73-74
Splenius capitis and splenius cervicis, 54
Sphenomandibular ligament, 23
Spinal column, 30
Spinal muscles, 54-55; fatty layer of, 80
Spinal region, exterior form of, 96; muscles of, 54-55; skeleton of, 26-27
Spongy substance of bones, 19
Sternal region, exterior form of, 93; muscles of, 58-59, 60-61; skeleton of, 29, 30
Sternoclavicular articulation, 32
Sternocleidomastoideus, 57-58; surface of, 88
Sternum, 29, 30, 31, 34; clavicular extremity of, 29; gladiolus of, 29; man-

ubrium of, 29; measurements of, 29; xiphoid process of, 29
Sternothyroideus, 57
Styloid process, 22, 36, 37
Stylomandibular ligament, 23
Style, 11
Squama, 22
Subscapularis, 59
Subclavius, 58
Subscapular fossa, 31
Subtalar articulation, 45-46; mechanism of, 45
Sulcus calcanei, 42
Sulcus tali, 42
Superciliary arch, 21
Superficial epigastric vein, 76
Superficial veins, 76-77
Superior maxillary bones, 21
Supinator of forearm, 65
Suprahyoid muscles, 57
Supraorbital margins, 21
Supraspinal ligament, 26-27
Supraspinatus, 59
Supraspinous fossa, 31
Sustentaculum tali, 42
Sutures, 19; coronal, 23; lamboidal, 23; sagittal, 23
Symphyses, 19
Symphysis pubis, 33
Synovial membrane, 19, 27

Talofibular (anterior and posterior) ligament, 45
Talonavicular (plantar and dorsal) ligament, 45
Talus bone, 42; articulations of, 45; medial malleolar facet of, 42
Tarsometatarsal articulations, 45, 46; ligaments of, 45
Tarsus, 41, 42
Temperomandibular articulation, 23
Temple, exterior form of 87; skeleton of, 21-23
Temporalis, 52
Temporal bone, 22
Temporal fossa, 22
Temporal vein, 76
Tensor fasciae latae, 11, 71
Teres major, 59-60
Teres minor, 59
Thenar eminence, muscles of, 68-69
Thigh, anterolateral muscle group of, 70-71; exterior form of, 118; fatty layer of, 79; internal muscle group of, 71; muscles of, 70-72; posterior muscle group of, 71-72
Throat, 88
Thoracic respiration, 31
Thorax, anterior arch of, 31; anterior aspect of, 30; articulation of, 30; dimensions of, 31; exterior form of, 92-95; inferior circumference of, 31; influence on form of, 34; in general, 30; lateral aspect of, 30-31; mechanism of, 31; muscles of, 58-59; posterior aspect of, 30; superior circumference of, 31; skeleton of, 29-31
Thyrohyoideus, 57
Tibia, 41; anterior tuberosity of, 42; articulation with fibula, 44; articulation with knee, 44; crest of, 41; dimensions of, 42, 46; influence on exterior form, 46; intercondylar eminence of, 41; medial and lateral condyles of, 42

Tibialis anterior, 72-73
Tibialis posterior, 73
Tibiofibular syndesmosis, 44
Tibiotarsal articulation, mechanism of,
Toes, exterior form of, 125; movements 128
Tone, in drawing, 12
Transverse ligaments (atlas, axis), 26
Transverse metacarpal ligaments, 39
Transverse metatarsal ligament, 45
Transversospinal muscles, 53
Transversus abdominis, 61
Trapezium bone, 37; articulation with fi metacarpal, 39
Trapezius, 56
Trapezoid bone, 37
Trapezoid ligament, 32
Triangular ligament, 38
Triceps brachii, 65
Trochanteric fossa, 41
Trochlea of ulna, 36
Trochlea peronealis, 42
True pelvis, 33
True vertebrae, articulations of, 25
Trunk, anterolateral cervical muscle reg of, 56; articular mechanism of, 1 107; deep layer muscles of, 56; d ing movements of the arm, 105-1 extension of, 107-109; exterior fo of, 92-109; flexion of, 107-109; flex folds of, 80; influence on exterior fc of, 34-35; influence of shoulder m ment on, 103-104; lateral inclination 107-109; middle layer muscles of, modification of form of, 107-109; mc ments of, 106-107; muscles of, 63; muscular action of, 107; poste muscle region of, 53; rotation of, 1 109; skeleton of, 24-28; 34-35; su ficial muscle layer of, 57
Tuberosity of ischium, 33

Ulna, 36 coronoid process of, 36; cranon process of, 36; radial notch 36; styloid process of, 36; troch notch of, 36;
Ulnacarpal ligament, 39
Ulnar collateral ligament, 38, 39
Upper arm, muscles of, 64; exterior fo of, 110; skeleton of, 36
Upper limb, exterior form of, 110-1 muscles of, 64-69; skeleton of, 36 superficial veins of, 76

Veins, 76-77; blood in, 76; circulation blood in, 76; color of, 76; congest of, 76; disposition of, 76; effect of tion on, 76; nature of, 76; of abdon 77; of fingers, 77; of lower limb, 76 of neck, 77; of upper limb, 76-77;
Vertebrae, 24-28; atlas, 25; arches of, 25; articular processes of, 24; axis, cervical, 24; common characteristics 24; distinctive characteristics of, dorsal, 24; false, 24; false, articulati of, 26; foramen of, 24, 25; lamina 24; lumbar, 24, 25; pedicle of, 24; tr verse processes of, 24; true, 24; true ticulations of, 25; true, spe characteristics of, 25; sacral, 25; spir processes of, 24; thoracic, 24
Vertebral column, anterior aspect of, articulation with ribs, 30; curves of, equilibrium of, 28; dimensions of (

casians, Europeans, Negroes, Yellow races), 27; influence on form of, 34; lateral aspect of, 27; movements of, 28; posterior aspect of, 27

Vertebral arch, 24-25

Vertebral foramen, 24-25

Vertebral column, in general, 26-27; mechanism of, 27

Vomer, 22

Wrinkles, 80-81; of age, 81; of bend of arm, 80; of extensors of fingers, 80; of bend of knee, 80; of flexion of neck, 80; of flexion of trunk, 80; of locomotion, 80; of skin, 80-81; papilliary, of hand, 81; papilliary, of foot, 81; semicircular, of abdomen, 80

Wrist, articulation with hand 38-39; exterior form of, 112-113; mechanism with hand, 39

Xiphoid process, 29, 31

Yellow ligaments, 25-26

Zygomatic arch, 22

Zygomatic bones, 21, 22

Zygomatic processes, 21, 23

Zygomaticus major, 51

Zygomaticus minor, 51

Edited by Heather Meredith-Owens
Designed by James Craig and Robert Fillie.
Set in eleven point Baskerville by JD Computer Type Inc.
Printed and bound by Halliday Lithographic Corporation
Graphic Production by Frank De Luca

$1.75
PPS-58
PRAEGER PAPERBACKS

THE SINO-SOVIET DISPUTE

Documented and Analyzed by
G. F. HUDSON
RICHARD LOWENTHAL
and
RODERICK MacFARQUHAR

THE
SINO-SOVIET
DISPUTE

THE
SINO-SOVIET
DISPUTE

Documented and Analyzed

by

G. F. HUDSON, RICHARD LOWENTHAL,
and RODERICK MacFARQUHAR

FREDERICK A. PRAEGER, *Publisher*

NEW YORK

BOOKS THAT MATTER

Published in the United States of America in 1961 by
Frederick A. Praeger, Inc., Publisher
64 University Place, New York 3, N. Y.

First published in Great Britain in 1961 as a special supplement
by *The China Quarterly*

THE SINO-SOVIET DISPUTE is published in two editions:

A Praeger Paperback (PPS-58)
A clothbound edition

This book is Number 95 in the series of
Praeger Publications in Russian History and World Communism

Manufactured in the United States of America

PREFACE

THE object of this booklet is to document and analyse the dispute between Moscow and Peking over global policies that came into the open at the beginning of 1960 and was dramatically concluded, temporarily at any rate, at the Moscow conference of 81 Communist parties last November. Our examination commences with a general introduction by G. F. Hudson of the background to the dispute. Richard Lowenthal's analysis of the course of the dispute during 1960 is a revised and lengthier version of an article that originally appeared in *The China Quarterly* and has since been reproduced by *Commentary* in America and as a supplement to *Preuves* in France. A long note clarifies the economic issues that affect Sino-Soviet relations.

Finally, the bulk of the booklet is devoted to documenting the dispute in the hopes that it may serve as a useful and permanent work of reference. Mr. Lowenthal's article naturally deals with the major points raised by these documents; but since many of them are of formidable length, I have thought it worth while to analyse some in detail, describing their argument and delineating what seem to me their crucial passages. I have included as appendices two " inside " reports from the Indian magazine *Link*, the reliability of whose Indian Communist sources lends considerable credence to accounts which fit in well with what could be observed from the outside.

<div style="text-align: right;">R. MacF.</div>

CONTENTS

Preface v

Date Summary ix

Introduction *G. F. Hudson* 1

Diplomacy and Revolution: The Dialectics
of a Dispute *Richard Lowenthal* 9

Sino-Soviet Economic Relations 35

DOCUMENTATION *Roderick MacFarquhar*

1. Points of Departure 39
 Khrushchev's Twentieth Congress Speech (Extract) 42
 The 1957 Moscow Declaration (Text) 46
 Khrushchev's Twenty-first Congress Speech (Extract) 56

2. The Rival Views Propounded 58
 Khrushchev's Speech in Peking (Sept. 30, 1959) (Extract) 61
 The Warsaw Treaty Powers' Declaration (Text) 63
 K'ang Sheng's Speech at the Warsaw Treaty Powers'
 Meeting (Text) 72

3. The Conflict Raised to the Ideological Plane 78
 "Long Live Leninism!" (From *Red Flag*) (Text) 82
 "Forward Along the Path of the Great Lenin" (From
 People's Daily) (Extract) 112
 The Soviet Reply 114
 Kuusinen's Speech at the Lenin Anniversary Meeting
 (Extract) 116

4. Battle Joined 123
 The Chinese Attack at the WFTU Meeting (Text of
 Report) 123
 Infantile Leftism 126
 "Fighting Weapon of Communist Parties" (From
 Sovyetskaya Rossiya) (Extract) 127
 "The Ideological Weapon of Communism" (From
 Pravda) (Extract) 129

5. The Bucharest Conference 132
 Khrushchev's Bucharest Speech (Extract) 132
 P'eng Chen's Reply (Extract) 139
 The Bucharest Communique (Extract) 140

6. Renewed Soviet Attacks 142
 "Problems of Peace and War in Present-day Conditions"
 (From *Pravda*) (Extract) 143
 A Threat to Cut Off Aid? (From *Sovyetskaya Latvia*)
 (Extract) 149
 "Outstanding Factor of our Times" (From *Pravda*)
 (Tass Summary) 150
 "The Struggle for Peace is the Primary Task" (From
 Pravda Ukrainy) (Extract) 152
 "Lenin's Theory of the Socialist Revolution and Present-
 day Conditions" (From *Kommunist*) (Extract) 153

7. The Moscow Conference 157
 "The Path of the Great October Revolution is the Common Path of the Liberation of Mankind" (From *Red Flag*) (Extract) 159
 "Hold High the Red Banner of the October Revolution . . ." (From *People's Daily*) (Extract) 161
 "A Basic Summing-up of Experience Gained in the Victory of the Chinese People's Revolution" (From *Red Flag*) (Extract) 162
 Kozlov's Anniversary Speech (Extract) 167
 "Give Full Play to the Revolutionary Spirit of the 1957 Moscow Declaration" (From *People's Daily*) (Extract) 171
 "Unity under the Banner of Marxism-Leninism" (From *Pravda*) (Extract) 173

8. The 1960 Moscow Statement 174
 The 1960 Moscow Statement (Text) 177

9. Soviet and Chinese Interpretations of the Statement 206
 Khrushchev's Report on the Moscow Conference (Extract) 207
 Chinese Communist Party Resolution on the Moscow Conference (Extract) 221

10. Appendices: "Inside" Reports of the Dispute 225
 The Chinese Position 225
 The Soviet Position 226

DATE SUMMARY

1956.	February 14	Khrushchev Addresses CPSU's Twentieth Congress.
1957.	November 22	Ruling Communist Parties Issue Declaration in Moscow.
1959.	January 27	Khrushchev Addresses CPSU's Twenty-first Congress.
	September 15	Khrushchev Arrives in Washington at Start of American Tour.
	September 30	Khrushchev Arrives in Peking for China's Tenth Anniversary Celebrations.
1960.	February 4	Meeting of Warsaw Treaty Powers in Moscow.
	March 23	Khrushchev Begins French Tour.
	April 19	Chou En-lai Arrives in Delhi to Discuss Sino-Indian Border Dispute.
	April 22	90th Anniversary of Birth of Lenin.
	May 5	Khrushchev Announces U-2 Shot Down over Soviet Territory.
	May 16	Opening of Summit Conference in Paris.
	June 5	WFTU Meeting Opens in Peking.
	June 16	Eisenhower Visit to Japan Cancelled due to Rioting in Tokyo.
	June 24	Bucharest Communiqué issued.
	July 11	Moscow Announces an American RB47 Plane Shot Down over Soviet Waters.
	August	Reports of Soviet Technicians Leaving China.
	August 30	Partial Blockade of West Berlin Initiated.
	September 19	Khrushchev arrives in New York with Satellite Leaders for UN General Assembly Session.
	November	Moscow Conference of World Communist Leaders.
	December 2	Liu Shao-ch'i Starts Goodwill Tour of Russia.
	December 6	81 Party Statement Published.
	December 29	Peking Reveals Severity of 1960 Natural Disasters.
1961.	January 6	Khrushchev Reports on Moscow Conference.
	January 18	Chinese Party Resolution on Moscow Conference Passed.

THE
SINO-SOVIET
DISPUTE

Introduction

By G. F. HUDSON

EVER since the Chinese Communists set up their government in Peking in 1949 and promptly concluded a treaty of military alliance with the Soviet Union, there has been speculation in the West about the reality and durability of the Sino-Soviet partnership. It was from the outset reasonable to assume that the Chinese Communists' heritage of national pride, their consciousness of the vast size and population of China and their sense of achievement in having carried through their revolution with a minimum of Russian aid would render them unwilling blindly to follow the lead of Moscow and inclined to formulate foreign as well as domestic policies of their own.

For the first six years, however, after the establishment of the Communist régime in China there was very little sign of dissension; on the contrary, Sino-Soviet relations were marked by a remarkable degree of harmony. The Chinese emphasised not only their devotion to the doctrine of Marxism-Leninism but their desire to learn from " the Soviet experience," and a well-organised Sino-Soviet Friendship Association expended much energy, with full Party backing, in glorifying the Soviet Union in general and Stalin in particular in propaganda to the Chinese people. Above all, the Korean war brought Russia and China together; both had the strongest common interest in preventing the overthrow of the Communist régime in North Korea after the failure of its attack on the South, and while China put in an army to fight against the United Nations forces, Russia provided arms and equipment and the threat of intervention if the war should be extended to Chinese territory.

The first serious trouble between Moscow and Peking occurred in connection with the Twentieth Congress of the Soviet Communist Party, and it was significant that it arose over Khrushchev's attack on the memory of Stalin. It was noticed at the time by some Western observers that the terms of eulogy in which mention of Stalin was made in Mao Tse-tung's message of greeting to the Congress were so contrary to the tenor of Khrushchev's speech to the secret session a few days later as to require the inference that the Chinese leader had either not been informed of what was about to be done or had disagreed with it. It has now been reported that one of the grievances brought by the Chinese in the Conference of the Eighty-one Parties last November was Khrushchev's failure to consult Peking before deciding on the demolition

1

of the Stalin myth. This was certainly no small matter, for whatever may have been the expediency of the action taken in relation to Soviet domestic politics, the discredit cast on the personality which Communists throughout the world had done their utmost to build up in propaganda over two and a half decades was clearly a concern of the whole international movement and not of the Soviet party alone.

It was the paradox of this extraordinary episode that Khrushchev in demanding that other Communist parties simply fall into line with a decision taken in Moscow to degrade Stalin was invoking precisely that supreme authority over the international movement which Stalin had acquired and which largely depended on his prestige as an almost superhuman being. Once the former " leader of progressive mankind " had been denounced as a tyrant and a fraud, the question was inevitably asked among Communists—and not only in Peking—whence Khrushchev could derive the right to issue instructions to the comrades of all lands.

The Chinese in particular questioned the wisdom of what had been done, but even more they resented the lack of consultation, and this was to be a permanent element in all subsequent policy conflicts; it raised the issue of " polycentrism " in the conditions of the post-Stalin era. In the days when Russia had been the only Communist-governed state and all other Communist parties had lacked any control of state-power, it had been natural enough for all non-Russian Communists to look to the Kremlin for a guidance which had been in practice words of command, but now that there were several other Communist parties with the powers and responsibilities of sovereign governments—and one of them ruled over the most populous nation in the world—it was no longer appropriate for a single party to lay down articles of faith and policy for all. The situation demanded some kind of new machinery for inter-party consultation, especially as the former organisation of the Comintern no longer existed. But the Soviet leadership was not at all disposed to give up the complete freedom of policy-making to which it had become accustomed, and outside the Soviet Union also there was a widespread recognition among zealous Communists of the need for a sort of international High Command if the Communist states were to maintain an effective coalition against the capitalist enemy..

The Chinese party about this time seems to have arrived at a view which sought to hold a balance between the claims of the non-Soviet Communist states to independence and acceptance of a Soviet " leadership " in the interest of the unity of the *bloc* as a whole. According to this view Communist-governed states should be free from Soviet interference in their internal affairs and should make their voices heard in matters of general concern, but should acknowledge the primacy of the

Soviet Union in the making and execution of a common policy. This attitude gained for China for a while the reputation of being the champion of "liberalism" within the *bloc*, for the Poles, in their struggle for a "Polish road to socialism," received moral support and encouragement from Peking.

On the other hand, the Chinese line also involved a most rigorous condemnation of Titoism as guilty of the unpardonable crime of neutrality between the two world camps, and by implication condemnation of those who were too tolerant of this heresy. The consequences of the Chinese view came out clearly in relation to the troubles in Eastern Europe in the autumn of 1956. In Poland the revolt was canalised within the Communist Party, the armed forces remained under party control and there was no question of breaking away from the Soviet alliance which alone guaranteed the Oder-Neisse frontier against German revisionism; China, therefore, backed Gomulka and is said to have intervened actively to restrain Khrushchev from military action against Poland after the rebuff he received from the central committee of the Polish party on his uninvited attendance at their deliberations on October 19.

In Hungary, on the other hand, the Communist Party had lost control of the armed forces, the insurgents demanded multi-party democracy and international neutrality, and only the Russian army could keep the country within the Communist camp; here China pressed for ruthless military intervention when Moscow was hesitating. The Chinese attitudes were opposite in the two cases, but each was judged on a consistent principle.

The line which Peking took on this upheaval in Eastern Europe was, however, less important than the fact that it took a line at all. Poland and Hungary were Russia's satellite states with which China hitherto had not been supposed to have any political concern. It was an epoch-making event when China claimed the right to have a say in what Russia should do about their affairs and sent Chou En-lai to assist in their settlement. The intervention appears not to have been entirely unwelcome to the Kremlin, for the sudden outbreaks had produced so much confusion and dissension in Moscow and had for the time being so lowered the prestige of the C.P.S.U. that the good offices of China were very useful in helping the Soviet Communist leadership to emerge from a dangerous and humiliating situation. The episode nevertheless gave China a new importance and sense of power. The Chinese position was that any counter-revolution in a Communist-ruled country or conflict between Communist states concerned all Communists everywhere and not Russia alone; there was an implicit challenge to the exclusive supreme authority which had belonged to the Kremlin under

Stalin and which Khrushchev in spite of his repudiation of " Stalinism " was in practice trying to preserve.

It was not, however, the aim of Mao Tse-tung at this stage to deny to the Soviet Union a special position in the Communist camp; on the contrary, the Chinese emphasis was on the unity of the camp as a military coalition standing in opposition to the camp of imperialism led by the United States, and this unity was held to require a joint command. At Moscow in November 1957, when a manifesto of ruling Communist parties was issued to mark the fortieth anniversary of the October Revolution, it was Mao Tse-tung who exerted himself to persuade Gomulka to acknowledge the " leadership " of the Soviet Union in the " socialist camp." But this leadership was conceived by the Chinese as a high command for carrying out agreed basic policies on behalf of all Communist parties and states, just as General Eisenhower in the invasion of France held command over both American and British forces in order to carry out the agreed aims of the two governments without any implication of American control over Britain.

The value of such formal recognition of Soviet primacy from the Chinese point of view was to check Titoist tendencies in the European satellite countries by ranging them definitively on the side of the Soviet Union in world affairs and excluding any deviations into neutralism. It was assumed that the Soviet Union itself would exercise its leadership in the right direction, that is to say against America, and that the ears which might listen to the siren voices of Washington would be found, not in Moscow, but in Warsaw.

In the following year, however, the Soviet government, evidently without consulting Peking, took a major initiative in world affairs which the Chinese regarded as injurious to themselves. In response to the American landing of troops in the Lebanon, Khrushchev demanded a summit conference of the three Western Powers and the Soviet Union together with India to discuss the problems of the Middle East. When the Western Powers demurred and countered with a proposal to hold a summit conference within the framework of a meeting of the United Nations Security Council, Khrushchev appeared at first willing to agree. Suddenly, however, he dashed off to Peking and in the end the whole project was dropped. Although the course of Russo-Chinese relations during this episode remains obscure, there is no need to doubt the inference that was drawn by diplomatic observers at the time—that Peking had protested strongly against a summit conference on the Middle East at which Communist China would not be represented, and that Khrushchev had called it off in response to Chinese pressure.

It was generally supposed that what had aroused the ire of Mao was the idea of such a meeting being held in the Security Council where

China would be represented by a nominee of Chiang Kai-shek. But the signs were that Peking objected no less to the inclusion of India instead of China to represent Asia in a Big Five summit conference. The Chinese stood firmly on their formal status as one of the five Great Powers recognised as such by permanent membership of the Security Council, and although in the circumstances of American non-recognition of Communist China they did not object to a Big Four meeting without China on European affairs, it was quite another matter to bring in India as a substitute for China in dealing with the affairs of Western Asia. It was indeed a piece of monumental tactlessness for Khrushchev ever to have supposed that the Chinese would put up with such an affront.

For their part, the Russians were offended by the claims put forward for the rural communes organised throughout China in the late summer of 1958. By asserting that with the advent of the communes, the achievement of Communism in China was no longer a distant prospect, the Chinese appeared to suggest that their society was overtaking the Soviet one, that it was jumping over whole "historic stages" as Moscow later put it. Both Khrushchev and Mikoyan went so far as to denigrate the communes in discussions with Americans, and it is doubtful whether the modification of the most extravagant Chinese claims at the end of 1958 wiped out Russian indignation over the affair.

The year 1959 saw the development in Soviet foreign policy of two trends both of which gave rise to increasing apprehension and resentment in Peking; the first was the policy of direct approach to the United States with the aim of reaching agreements *à deux* between Khrushchev and President Eisenhower, and the second the effort to cultivate close relations with India and Indonesia, with both of which countries Communist China had come into conflict. With the first of these policies Peking did not at first quarrel; negotiations of a sort had been going on for years over Germany and Berlin, and the invasion of the United States by the successive onsets of Mikoyan, Kozlov and Khrushchev himself seemed at first sight to be no more than a new move in the cold war.

But as the campaign showed signs of bringing about a genuine *détente* between Russia and America, the Chinese Communists naturally began to wonder what there would be for them in an agreement of the two super-Powers. It soon became evident that there would be very little. Khrushchev had a sufficiently difficult task in trying to persuade President Eisenhower to make concessions to Russia over Berlin; he was not going to jeopardise his chances of success by also pressing the claims of China, to which Washington was notoriously even more resistant. Mao Tse-tung was suddenly confronted with the prospect of

being left out in the cold while the leaders of the socialist and imperialist camps got together in a mutually advantageous deal.

By this time, after repeated manifestations of Khrushchev's disregard for the views and interests of his Chinese ally, Mao probably had a profound distrust of him. But how was he to be prevented from going ahead with his new policy? How was China to be safeguarded against the effects of the " Camp David spirit "? The Soviet Union was far too strong and self-confident, with its booming industrial production, its sputniks and its luniks, to be turned aside by any normal methods of persuasion or diplomatic pressure.

There was only one way for China to exert a compelling influence on Khrushchev, and that was by attacking him at his most vulnerable point—his standing as the supreme representative of the Marxist-Leninist cause. He was the leader of a party which based its claim to permanent and exclusive rule over Russia and to the loyalties of Communists throughout the world on an ideology of which it had been the first successful practical exponent. If it could now be shown that the First Secretary of the C.P.S.U. was betraying the principles for which not only Stalin but also Lenin had stood, that he had in fact fallen into heresy, then the very basis of his power would be undermined and he would have at least to compromise with the purists of Peking in order to save himself from the anathema.

Communist China was further goaded into launching such an attack on the Soviet leadership by the distinctly unfriendly attitude of Moscow towards China's conflicts with two of her Asian neutralist neighbours— India and Indonesia. These were disputes which had arisen not from any Chinese attempt to promote a Communist revolution in either country, but over issues concerning frontiers and rights of Chinese residents such as the most bourgeois of Chinese governments might have taken up; indeed, the quarrel with Indonesia was quite ludicrously out of keeping with the general Communist line, for by protesting against Indonesian legislation to exclude Chinese from the retail trade they had so efficiently engrossed, the Peking Government was making itself the champion abroad of those very interests of small private enterprise which in China it was doing its utmost to destroy.

But whatever the logic of their contentions with India and Indonesia the Chinese expected from the Russians at least a degree of moral support for them in accordance with the solidarity of the " socialist camp " against all outsiders. The Soviet Union, however, had been taking considerable trouble to cultivate friendly relations with the neutral nationalist governments of Asia, including those of India and Indonesia, and to influence their foreign policies to the advantage of

Soviet interests; this was a pattern of policy which was not to be discarded merely in order to please Mao Tse-tung. Khrushchev had already in 1958 sought to substitute India for China in a Big Five conference; he continued to woo and flatter India and carefully avoided taking China's side in the conflict which developed with India over the disputed frontier.

The friction between Moscow and Peking which developed from this Soviet courting of China's adversaries (in a region of the world which the Chinese regarded as geographically within their sphere of interest rather than Russia's) was brought to a head when at the beginning of 1960 Khrushchev in pursuit of his indefatigable personal diplomacy made a second tour of South and South-East Asia. He glorified the Soviet Union on every possible occasion and made the most extravagant professions of undying friendship for the peoples of India and Indonesia, but he did nothing to honour China or to present the Chinese case either in Delhi or Jakarta. The insult was symbolised by the fact that Khrushchev was in India on the occasion of the 10th Anniversary of the signing of the Sino-Soviet treaty. Chinese anger at this performance expressed itself in an almost complete news boycott; the tour was not mentioned in the Chinese press for a week and thereafter was treated as a matter of no importance. The impression produced by the Khrushchev tour was probably the last straw in causing Mao to lose patience with Khrushchev and embark on a systematic campaign against him.

As far as the Paris summit conference was concerned the Chinese campaign launched a month previously was almost certainly not a decisive factor in causing its breakdown; a deadlock at the conference was rendered in any case likely by the hardening of the American attitude over Berlin after American policy-makers had had time to repair the breaches effected in President Eisenhower's vulnerable personality by Khrushchev's personal assault tactics. When it became clear to Khrushchev that he was not going to get the great diplomatic triumph which he had hoped to obtain from the kindling of the Camp David spirit, he preferred that the summit conference should collapse at the outset in a blaze of Russian moral indignation at U.2 aggression over Russian territory rather than end in an anticlimax of agreement to disagree. But in thus for the time being raising rather than reducing international tension he may well have been influenced by the new pressure of Chinese ideological criticism which meant that any public setback in diplomacy would be used against him by the Maoist opposition.

The wrecking of the summit conference was not, however, the end of the affair; it was only the beginning. Within a few days of Khrushchev's theatrical display of intransigence, in which he showed himself

to all appearances the implacable foe of the imperialist warmongers of Washington, he had given notice that he would again seek an agreement, if not any more with the Eisenhower administration, then with the President due to be elected in November.

Chinese suspicions were not allayed; it was clear that there was to be no fundamental change in the policy of direct approach to the United States, but only a postponement of it. The ideological conflict between Russia and China was thus not abated, but intensified, after the collapse of the summit conference. What China sought to get from the Kremlin was an admission that American imperialism was incorrigible and that nothing more than a temporary truce with it was possible; this was the real significance of the argument over the inevitability of war. The controversy was carried on with all the Communists of the world as audience and jury, and in the end the conference of the eighty-one parties had to be summoned to settle the dispute.

Since its manifesto was proclaimed to the world there has been discussion among Western commentators of the question whether Russia or China was the winner in the form of words that was adopted to restore the unity of the Communist camp. But the very fact that the conference had to be held was a success for Peking; it meant that the Kremlin, when subjected to criticism from China, could no longer ride roughshod over it and expect the international movement blindly to follow a Russian lead, but needed to put its case to a world assembly of Communist parties. This need arose from the fact that the Communist Party of China could not be silenced or suppressed by any " organisational " means; Khrushchev could not deal with the opposition of Mao as Stalin had dealt with Trotsky or Bukharin. Tito had already demonstrated that a Communist leader in control of a state could only be subjugated by Moscow through the use of military force across a frontier with all the international complications this might involve; in 1960 a state greater than Yugoslavia—indeed potentially the greatest on earth—was defying Moscow, and the only answer was reference to a Marxist-Leninist world parliament. In a manner that Khrushchev could not relish, the era of Stalin was over.

Diplomacy and Revolution:
The Dialectics of a Dispute

By RICHARD LOWENTHAL

THE policy declaration and the appeal to the peoples of the world adopted last December by the Moscow conference of eighty-one Communist parties mark the end of one phase in the dispute between the leaderships of the ruling parties of China and the Soviet Union—the phase in which the followers of Mao for the first time openly challenged the standing of the Soviet Communists as the fountain-head of ideological orthodoxy for the world movement. But the "ideological dispute" which began in April was neither a sudden nor a self-contained development: it grew out of acute differences between the two Communist Great Powers over concrete diplomatic issues, and it took its course in constant interaction with the changes in Soviet diplomatic tactics. Hence the total impact of that phase on Soviet foreign policy on one side, and on the ideology, organisation and strategy of international Communism on the other, cannot be evaluated from an interpretation of the Moscow documents alone, but only from a study of the process as a whole, as it developed during the past year on both planes.[1]

To say that the 1960 Chinese challenge to Soviet ideological authority grew out of pragmatic disagreements over foreign policy is not to take the view that the varieties of Communist ideology are a mere cloak for conflicts of national interest. The profound differences in the history of the Soviet and Chinese Communist parties, both in the strategy by which they conquered power and in the methods they used afterwards for transforming society, have clearly produced a different ideological climate,

[1] I have not attempted here to deal with the impact of the dispute on Chinese foreign policy, as distinct from Chinese ideology. Owing to the absence of diplomatic relations with the main enemy, the scope for Chinese diplomacy outside the *bloc* is somewhat limited. As experts on the subject have suggested in past issues of this review, the chief effect of the dispute in this field seems to have been to make the Chinese leaders try to mend some of their national quarrels with neutral Asian states, notably Burma, Nepal and Indonesia, and to reduce the temperature of their conflict with India: apparently they realised at some point that the multiplication of these quarrels made them needlessly vulnerable to Soviet criticism of their general views on war and peaceful co-existence—views that had, after all, been formulated primarily with an eye to relations with the "imperialist" West, and above all with the United States. On the main issue, the repetition of the proposal for an atom-free zone in the Pacific on August 1 may have been intended to stake out a Chinese negotiating position in case of Soviet-American agreement on a permanent ban on nuclear tests —a price to be exacted for agreement to be kept out of the nuclear club.

9

different forms of inner-party life and a different " style of work "; and the fact that Mao Tse-tung could only win control of the Chinese party and lead it to victory by repeatedly defying Stalin's advice has contributed to the formation of a Chinese Communist leadership which is highly conscious of those differences.

This is not the place either to discuss the origin and nature of the distinctive ideological climate of Chinese Communism in detail, or to trace its various manifestations from Mao's first " rectification " movement of 1941 to the methods adopted after his victory for the " re-education " of hostile classes, or from the reaction to Soviet " de-stalinisation " and the subsequent crisis in the Soviet *bloc* to the " Hundred Flowers " campaign and to the creation of the communes. Suffice it to say that while some of these manifestations of Chinese originality took an apparently " liberal " and others an apparently " extremist " form, their common characteristic is a historically conditioned tendency to believe that almost anything is possible to a revolutionary party armed with the right consciousness—an exaltation of faith and will over all " objective conditions " of the productive forces and all given class structures which exceeds that shown by the Bolshevik model, and is even more remote from the original Marxian doctrine than the latter.

A party leadership conditioned by this ideological climate will obviously perceive both the internal problems and the national interests of the state it governs in a peculiar way; to that extent, the ideological difference constitutes a kind of permanent potential for rivalry between the two Communist Great Powers. Yet it does not by itself explain the timing and content of any particular dispute between them. For given the manifestly overriding importance of their common interests, the potential rivalry can only become actual when concrete policy disagreements arise which cannot be settled by the ordinary means of intra-*bloc* diplomacy, and which the weaker and dependent ally regards as sufficiently vital to take recourse to the public use of the ideological weapon. This was done by China in muted hints during the 1958 disagreements, and much more openly in 1960.

THE CHINESE VIEW

In both cases, Chinese misgivings seem to have been based on a sense of insufficient Soviet diplomatic and military support in their longstanding conflict with the United States, and to have been acutely aggravated by Mr. Khrushchev's efforts to achieve a Soviet-American *détente* —by his repeated bids for a " summit conference " without Communist China, and by his visit to the U.S. in September 1959. The Chinese leaders apparently feared, probably not without reason, that such a *détente* would further diminish Soviet interest in taking serious risks on

their behalf, and increase Soviet interest in preventing them from taking any such risks themselves.[1a] Above all, Soviet willingness to make disarmament one of the main items on any summit agenda, combined with the agreed temporary ban on nuclear test explosions and the continued negotiations for a permanent ban, must have given rise to Chinese anxiety lest the Russians might be willing on certain conditions to enter a commitment to close the " nuclear club." The mere fact of negotiation on that subject apparently precluded them from receiving Soviet aid in developing nuclear weapons of their own, and thus helped to delay their becoming a world power of the first rank; an actual Soviet commitment would have faced them with the choice of either accepting permanent inferiority in this field, or—if they went ahead successfully in developing and testing the weapon themselves—of defying an agreement of the world's leading powers in isolation.

Whatever the Chinese may have said in their private representations to Moscow, they did not think it advisable to spell out these fears in public. But during the winter of 1959–60—roughly from Khrushchev's visit to Peking, on his return from his talks with Eisenhower, at the beginning of October to the Moscow conference of the Warsaw Pact states in early February—they openly attacked the assumptions on which the effort to achieve a Soviet-American *détente* was officially based.[2] The core of their argument was that the policy of American " imperialism " and of Eisenhower, its " chieftain," could not change in substance even if it was temporarily disguised by peace-loving phrases; hence nothing could be gained by seeking an understanding with the U.S. in an atmosphere of *détente*, only by isolating this " main enemy " and putting maximum pressure on him. A period of quite visible, concrete disagreement on policy towards the Eisenhower administration thus preceded the Chinese Communists' generalised, ideological attack on Soviet authority.

The most striking characteristic of that period is the apparent unconcern with which the Soviet leaders pursued their preparations for a " summit conference," despite the increasingly outspoken Chinese protests. The impression that Mao Tse-tung had refused to approve the concept of a *détente* based on " mutual concessions " as advanced by Khrushchev was confirmed when the latter, addressing the Supreme Soviet on his return to Moscow, coupled his advocacy of that concept with blunt

[1a] Since this was written, a report based on unpublished Communist documents in the possession of Western governments has stated that a scheme for a joint Russo-Chinese Pacific naval command broke down owing to Soviet fears of being drawn by the Chinese into a war over Formosa. See Edward Crankshaw in the London *Observer*, February 12 and 19, 1961.

[2] For a full study of the development of the Chinese arguments during that phase, see A. M. Halpern, " Communist China and Peaceful Coexistence," *The China Quarterly*, No. 3, p. 16.

warnings against the "Trotskyite adventurism" of a policy of "neither peace nor war,"[3] and when the theoretical organ of the Chinese Communists developed an analysis of American foreign policy directly opposed to Khrushchev's optimism in the following months.[4] Nevertheless, Khrushchev announced to the Supreme Soviet in January 1960 a substantial reduction of Soviet conventional forces and military expenditures as his advance contribution to the ten-power disarmament negotiations, and also indicated willingness to help overcome the deadlock in the negotiations on an inspection system for a permanent ban on nuclear test explosions—a most sensitive issue from the Chinese point of view.

Within a week, the standing committee of the Chinese National People's Congress, in a resolution formally approving the Soviet disarmament proposals, solemnly announced to the world that China would not be bound by any agreements to which she was not a party; but when this stand, together with warnings against illusions about a change in the character of American policy, was repeated at the conference of Warsaw Treaty ministers in early February by the—possibly uninvited—Chinese observer, his speech was not published in any European member state of the Soviet *bloc*, and the declaration adopted by the conference showed virtually no concessions to his point of view.[5] To cap it all, Khrushchev spent most of the remainder of February, including the tenth anniversary of the Sino-Soviet alliance, in India and Indonesia, two countries with which China was involved in acute conflicts of national interest, and showed throughout the journey an almost ostentatious detachment from Chinese claims and actions.

All during the winter, the Chinese thus experienced the inherent weakness in the position of a dependent ally who urges the stronger partner to pay more heed to his interests, but is unable to switch sides if the latter turns a deaf ear: none of their objections, raised first in secret and then with increasing publicity, were able to deflect Khrushchev from his course. There remained to them one weapon—to interfere directly not with the Soviet policy of *détente*, but with the *détente* itself—by urging on Communist and revolutionary nationalist movements in the non-Communist world a bolder forward policy than was compatible with the plans of Soviet diplomacy. But this meant that the Chinese Communists must set themselves up as rivals to their Russian comrades in advising these movements—in other words, that they must generalise the dispute and raise the question of ideological authority.

3 Moscow Radio, October 31, 1959.
4 *e.g.* Yü Chao-li, "The Chinese People's Great Victory in the Fight against Imperialism," *Peking Review*, September 22, 1959, from *Red Flag*, No. 18, 1959; *idem*, "Excellent Situation for the Struggle for Peace," *Peking Review*, January 5, 1960, from *Red Flag*, No. 1, 1960; editorial, *People's Daily*, January 21, 1960.
5 See the text of both the declaration and K'ang Sheng's speech in *The China Quarterly*, No. 2, pp. 75-89.

During the later part of the winter 1959–60, a number of cases became known where Chinese representatives had opposed Soviet delegates in closed sessions of the directing organs of such international front organisations as the World Peace Council, the Afro-Asian Solidarity Committee, the World Federation of Trade Unions, etc.[5a] The central issue in these clashes was whether the "peace campaign" was the priority task to which all other forms of revolutionary struggle must be subordinated, as the Russians maintained, or whether it was only one among many forms of the struggle against imperialism, which must in no circumstances be isolated and "set in opposition" to more militant forms of revolutionary action, as the Chinese argued. It was as a platform for these discussions in the international movement that the Chinese Communists published in April their ideological statements on the teachings of Lenin —documents which, despite all later elaborations and modifications, have remained basic for that phase of the dispute.[6]

THE QUESTION OF WAR

It has been implied in subsequent Soviet polemics, against "dogmatists and sectarians," and innumerable times spelt out in Western comment, that the central thesis of those Chinese statements was the continued validity of Lenin's belief in the inevitability of world war. That is not so. Every one of the Chinese documents in question quoted with approval the sentence in the 1957 Moscow declaration (based in turn on the resolution of the Twentieth Congress of the CPSU) that, owing to the growth of the forces of peace, "it is now realistically possible to prevent war." [6a] What none of them approved, however, is the formula of the Twenty-first Congress on the emerging possibility "even before the full victory of Socialism in the world, while capitalism continues to exist in part of the world, to banish world war from the life of human society." The difference is that, in the Chinese view, the latter phrase implies the

[5a] *e.g.*, at the Rome meeting of the Presidium of the World Peace Council and the sessions of the secretariat of the Afro-Asian Solidarity Committee in Cairo in January 1960. Chinese contributions had disappeared from *Problems of Peace and Socialism*, the Soviet-controlled international Communist monthly edited in Prague, since November 1959.

[6] Yü Chao-li, "On Imperialism as a Source of War in Modern Times," and "On the Way for all Peoples to struggle for Peace," NCNA, March 30, 1960, from *Red Flag*, No. 7, 1960; Editorial "Long Live Leninism," *Peking Review*, April 26, 1960, from *Red Flag*, No. 8, 1960; Editorial, *People's Daily*, April 22, 1960; Lu Ting-yi, "Get United under Lenin's Revolutionary Banner," speech at Lenin commemoration meeting in Peking, April 22, 1960 (NCNA same date).

[6a] This applies to all Chinese texts available for scrutiny. Mr. Crankshaw's summing up of a secret Communist report, referred to in Note 1a above, repeats the Soviet charge that the Chinese regard nuclear war as inevitable. (See particularly his second article in *Observer*, Feb. 19.) But he quotes no Chinese statements, and indicates that the report in question was rendered by the leader of a satellite Communist party favouring the Soviet view, and may have come into Western possession by a deliberate Soviet leak.

disappearance of any serious *danger* of world war while capitalism still exists; the Chinese Communists felt that this presupposed a change in the nature of imperialism—and that they had to deny such a possibility in order to contest the Khrushchevian hope of converting the ruling circles of the U.S. to a genuine acceptance of "peaceful coexistence" from realistic motives.

The picture drawn by the Chinese was that of an unchanged, though weakened, imperialism which would resort to war whenever it could to defend its sphere of exploitation, but might be prevented from doing so in any particular case by the "forces of peace." In practice, they agreed with the Soviets in regarding an all-out attack on the Soviet *bloc* as unlikely, but argued that inter-imperialist war was still possible, and insisted that colonial wars against national liberation movements were virtually inevitable: the latter could only be "stopped" by vigorous support for the revolutionary movements. But the Communists would fail to give support if they were "afraid" of another world war, if they "begged the imperialists for peace," or if they tolerated or even spread illusions about the warlike nature of imperialism, instead of mobilising the masses everywhere for an all-out struggle against it.

This analysis implied three charges of "muddle-headed concessions to revisionism" against Khrushchev's policy: exaggeration of the dangers of nuclear war, which might paralyse the will to resist imperialism or at any rate lead to excessive caution; illusions about the growth of a "realistic" tendency towards peaceful coexistence among such "chieftains of imperialism" as Eisenhower, which might lead to a relaxation of vigilance among the Communist governments and movements; and as a result, excessive reliance on diplomatic negotiation as a means to avert war, causing a desire to restrain revolutionary movements and "just wars" of liberation, instead of welcoming them as the best means to weaken the imperialists and stop *their* wars. Accordingly, the Chinese ideologists argued that it was all right for a Communist to seek a meeting with Eisenhower, but wrong to say that he believed in the latter's peaceful intentions; all right to propose "general and complete disarmament," but wrong to tell his own followers that there was a real chance of obtaining it; all right to propagate peaceful coexistence, but wrong to advise the Algerian nationalists to try and negotiate a cease-fire with President de Gaulle. They accepted peace *propaganda* as a means of revolutionary struggle against imperialism, but not peace *diplomacy* of a kind which might even temporarily mitigate the forms of that struggle.

THE SOVIET REPLY

The Russians, aware that there could be no serious negotiation without an atmosphere of *détente* and at least the pretence of believing in the

14

peaceful intentions of the other side, recognised that this was an attack on their whole coexistence diplomacy; but they had to answer it on the ideological plane. Through the mouth of Otto Kuusinen, a member of the secretariat of the CC CPSU who had begun work in the Comintern in Lenin's time, they insisted [7] that Lenin had differentiated between militarist diehards and possible partners for peaceful coexistence in the imperialist camp, and had foreseen that changes in military technique might one day make war impossible. They argued that the growing strength of the " Socialist camp " and the destructive potential of nuclear weapons and long-range rockets had in fact provided a realistic basis for a diplomacy based on similar differentiation at the present time, and claimed as telling proof of their thesis the success of Khrushchev's personal diplomacy in general, and of his " historic visit " to the U.S. in particular, in largely dispersing the climate of the Cold War and restoring businesslike relations between the two different social systems. Yet only a few weeks later Khrushchev himself, even while maintaining this position in theory, reversed himself in practice to the extent of wrecking the summit conference on the ground that negotiation with Eisenhower had become impossible after his assumption of responsibility for the U 2 incident.

Western discussion of the causes of this *volte-face* has necessarily remained inconclusive in the absence of direct evidence of the motives of the Russian rulers and the course of their deliberations in the critical period. But a coherent analysis of the Sino-Soviet dispute is impossible without at least venturing a hypothesis. I have elsewhere stated my reasons for rejecting the theory that a decisive weakening of Khrushchev's position by some combination of " neo-Stalinist " or " pro-Chinese " elements in the Soviet leadership took place at that time [8]; indeed, I know of no convincing evidence for the assumption that such a grouping exists at all. On the other hand, Khrushchev's Baku speech of April 25 showed his anxieties, following a number of authorised American policy statements, lest the summit meeting might fail to yield the Western concessions on Berlin which he expected, and his desire to increase the pressure in that direction; and his initial reaction to the U 2 incident is consistent with the assumption that he regarded it not as a reason for evading the summit conference, but as an occasion for making the pressure more effective by driving a wedge between Eisenhower and his " diehard militarist " advisers. [9]

[7] Speech at Lenin commemoration meeting in Moscow, April 22, 1960: *Pravda*, April 23.

[8] " The Nature of Khrushchev's Power," *Problems of Communism*, July/August 1960.

[9] See Khrushchev's speeches to the Supreme Soviet on May 5 and 7, and at the reception of the Czechoslovak Embassy in Moscow on May 9.

By marking the complete failure of this crude attempt at differentiation, the President's assumption of personal responsibility for the spy-flights, whatever its other merits or demerits, must have been a double blow to Khrushchev: it deprived him of the last hope of obtaining substantial concessions at the summit, and it put him clearly in the wrong on one important part of his public argument with his Chinese allies. A failure to reach his summit objectives thus became certain at the very moment at which, from the viewpoint of his prestige in the " Socialist camp " and the Communist world movement, he could least afford such a failure: hence it seems natural that, with the full support of his colleagues, he decided rather to wreck the conference in advance unless he could still force a last-minute differentiation by obtaining a public apology from Eisenhower.

Within a few days, Khrushchev demonstrated by his refusal to go ahead with an East German peace treaty pending a possible summit conference with Eisenhower's successor that he had not abandoned the " general line " of his diplomacy but only intended to change the time schedule. But the Chinese Communists not only were not content with that, but felt that now they had been proved right by events, they were in a strong position to force a broad change of policy by pressing home their ideological attack.

PEKING PRESSES ITS ATTACK

The attempt was made officially and in fact publicly at the beginning of June at the Peking session of the General Council of the WFTU by the Chinese Vice-President of that body, Liu Chang-sheng, and there is reason to suppose that even more comprehensive and outspoken criticisms of Soviet policy were communicated non-publicly at the same time, at least to selected leaders of the Communist world movement. Liu's speech [10] went beyond the April documents in demanding a " clarification " of the Communist attitude towards war, denouncing " indiscriminate " opposition to war and calling for active support for " just wars " of liberation; in sharply opposing the formulation of the Soviet Twenty-first Congress about " eliminating war forever while imperialism still exists " as " entirely wrong " and leading to " evil consequences of a serious nature which, in fact, we already see at present," though he too admitted the possibility of preventing a new world war; and in condemning any belief that proposals for general and complete disarmament could be accepted, and that the funds formerly earmarked for war purposes could be used for the welfare of the masses and for assisting underdeveloped countries while imperialism still existed as " downright whitewashing and

[10] NCNA, June 8, 1960.

embellishing imperialism " and thus " helping imperialism headed by the U.S. to dupe the people."

Yet the Chinese had misjudged their chances of forcing a change of the Soviet line. At the WFTU session, they found themselves vigorously counter-attacked by both the Russian and the major European movements, and finally isolated with only the Indonesian trade unions on their side. Moreover, this seems to have been the point at which the Soviet leaders decided to give battle in defence of their ideological authority, and first of all to whip into line those European satellite parties which had in the past shown signs of sympathy for Chinese intransigence. They took the initiative in calling a conference of all ruling Communist parties to meet on the occasion of the Rumanian party congress later that month; and in the meantime the Soviet press began to publish warnings against the dangers of " dogmatism " and " sectarianism " in the international movement,[11] while the Italian delegates returning from Peking published the fact that the Chinese had been isolated and defeated in a major international discussion on the problems of the struggle for peace and disarmament.[12]

Now that the issue of authority was out in the open, the field of the dispute kept broadening. Already in April, the speaker at the Peking celebration of Lenin's birthday, Lu Ting-Yi, had claimed for Mao's creation of the communes the succession to Lenin's concept of " uninterrupted revolution," and had attacked people who in Socialist construction " rely only on technique and not on the masses " and deny the need for further revolutionary struggle in the transition to the higher stage of Communism.[13] Now *Pravda* quoted Engels and Lenin for their criticism of the Blanquist wish to " skip all the intermediate stages on the road to Communism " in the illusion that " if power were in their hands, communism could be introduced the day after tomorrow."[14] Yet the original Sino-Soviet disagreement about the communes had been ended in the winter of 1958–59 with the withdrawal of the Chinese claim that this institution constituted a short cut to the Communist stage, and an understanding that the Chinese would go on developing and the Soviets and their European satellites rejecting that institution without further debate. The revival of the issue now only made sense as part of the attempt by each side to throw doubt on the other's ideological orthodoxy.

11 Articles on the fortieth anniversary of Lenin's " Leftwing Communism, an Infantile Disorder," by D. Shevlyagin in *Sovyetskaya Rossiya*, June 10, and by " N. Matkovsky " in *Pravda*, June 12, 1960; *Pravda* editorial " Full Support " on the Soviet disarmament proposals, June 13, 1960.

12 Foa in *Avanti*, June 15; Novella in *Unita*, June 19, 1960.

13 NCNA, April 22, 1960.

14 N. Matkovsky on June 12.

THE BUCHAREST CONFERENCE

On the eve of the Bucharest conference, a *Pravda* editorial stated bluntly that " among Socialist countries, there cannot be two opinions on the question of peace or war. Socialists believe that in present condition there is no necessity for war, that disarmament is not only needed but possible, and that peaceful coexistence between nations is a vital neces sity." [15] Coupled with a quote from Khrushchev's December speech to the Hungarian party congress about the need for all Communist govern ments to " synchronise their watches," and his warning that " if the leaders of any one of the Socialist countries would set themselves up to be above the rest, that can only play into the hands of our enemies," this indicated the Soviet leaders' intention to force a clear decision that would be binding on all ruling parties.[15a]

But at Bucharest, this intention was at least partly foiled by the Chinese. Khrushchev's public attack [16] on people who quote the words of Lenin without looking at the realities of the present world, and whom Lenin would set right in no uncertain manner if he came back today, was plain enough for all the satellite leaders to understand that the time for manoeuvring between the two colossi was over, and for all but the Albanians to rally round. His account of how Soviet strength and Soviet skill had again and again foiled the war plans of the " imperialists," from Suez in 1956 to the Turkish-Syrian crisis of 1957 and the U.S. landing in the Lebanon after the Iraqi revolution of 1958, if historically dubious, was propagandistically effective as a demonstration of the meaning of his " peace policy " for a Communist audience. But the Chinese delegate P'eng Chen was clearly instructed neither to submit nor to carry the ideological debate to a conclusion at this point: he evaded a decision by a skilful withdrawal to prepared positions.

In public, P'eng Chen appeared as the advocate of Communist unity at almost any price, to be achieved on the basis of the 1957 Moscow declaration to which all but the Yugoslavs had agreed.[17] This committed the Chinese once more to recognition of the possibility of preventing or " checking " imperialist wars—a possibility that, P'eng claimed, could only be fulfilled by the united strength of the " Socialist camp " and the determined mobilisation of mass action against the imperialists. But it was also intended to commit the Russians once again to the 1957 thesis that the aggressive circles of the U.S. were the main enemy of peace and

[15] June 20, 1960.
[15a] According to the secret Communist report referred to above, the internal corre spondence between the Soviet and Chinese Central Committees reached a first climax at the same time with an 80-page all-round critique of the Chinese party by the Soviets dated June 21, the opening day of the Bucharest conference. The Chinese themselves are said to have communicated this document to the other parties present.
[16] Speech at the Bucharest Congress on June 21, 1960, as carried by TASS.
[17] Text in NCNA, June 22, 1960.

all popular aspirations, and that " revisionism " was the main danger within the ranks of the Communist movement. Having said that much, he Chinese representative spoke no word about *détente*, disarmament or the " elimination of war from the life of mankind " before the disappearance of capitalism.

Behind the scenes, he seems to have argued that the 1957 conference of ruling Communist parties had been called chiefly to settle problems of Communist power and " Socialist construction "; the questions now in dispute, being concerned with world-wide revolutionary strategy, could only be decided by a conference representing the whole Communist movement. Khrushchev might well complain about Chinese " factional " methods of carrying the quarrel into the ranks of other parties; in the end he had to agree to put up the dispute officially for worldwide inner-party discussion in preparation for a November conference in Moscow, and to content himself with a brief interim communiqué which, while stressing the primary importance of the " peace campaign," did not go beyond the 1957 declaration on any controversial point.

This fell far short of what the Soviet leaders had expected. The decisive showdown was not only postponed for several months, but it would take place before an audience of revolutionary parties many of whose members were less closely tied to Soviet control than the East European satellites, and might well regard the Chinese slogans of unconditional revolutionary solidarity as more attractive than the Soviet readiness to subordinate their struggle to the needs of co-existence diplomacy whenever that seemed expedient. Thus an Algerian Communist might prefer Chinese offers of aid for the F.L.N. to the repeated Russian advice favouring negotiation with de Gaulle; an Iraqi Communist might recall that neither Soviet support for Kassem's régime nor his own party's Soviet-ordered retreat from its earlier offensive policy had obtained for it a legal, let alone a dominating, position under that régime; an Indonesian Communist might resent the manner in which Khrushchev had ignored his party during his official visit, and the general Soviet wooing of the " bourgeois nationalist " régime of Soekarno that limited the democratic rights of the Communists as well as of other parties and favoured a neutralist *bloc* with the " renegade " Tito. And would not the Communists of Latin America be sensitive to the Chinese argument that as Yankee imperialism was the main enemy, any attempts to relax Soviet-American tension were bound to weaken Soviet support for them as well as for China?

Yet without the co-operation of these movements, Khrushchev's coexistence diplomacy could not be carried through: he needed their discipline, and the Chinese had launched their ideological attack on his authority precisely in order to undermine that. Now they had created a

situation in which the objects of the struggle, the Communist movements *in partibus infidelium,* were to act to some extent as its arbiters. True, the Russians had still the advantage of the prestige and resources of a world Power as well as of older organisational ties : all the foreign Communists knew that the Soviets *could* help them more—financially, diplomatically, and ultimately militarily—than the Chinese, yet they were less certain that the Soviets *would* always help them to the limits of their ability. Hence Khrushchev seems to have felt that in preparation for the November meeting, not only the circulation of new Soviet documents and the dispatch of new emissaries to the wavering parties were needed, but above all new proofs of the spirit of revolutionary internationalism animating his foreign policy.

Soviet Foreign Policy Hardens

The fact that he had already decided to postpone his new summit approach until after the U.S. presidential elections made it easier for him to furnish that proof : for he could now afford to increase rather than relax tension for a time without serious damage to his future diplomatic chances, and perhaps even in the hope to improve them by creating a dark backdrop for the next display of his sunny smile—provided only that he did not allow matters to get really out of hand. The weeks after Bucharest thus offered the strange spectacle of the Soviet leaders conducting themselves on the world stage in the very style which Peking's ideological theses had seemed to demand, while at the same time launching a vigorous campaign against those theses throughout the Communist world movement !

The Bucharest communiqué had not yet been published when Russia demonstratively walked out of the ten-power disarmament talks at Geneva, just before the Western counter-proposals for which she had been calling so insistently were officially submitted. There followed within a few days the shooting down of an American plane over the Arctic, the first Soviet note on the Congo accusing all the Western powers of backing Belgian military intervention as part of a plot to restore colonial rule, and as a climax Khrushchev's personal threat to use intercontinental rockets against the U.S. if the latter should attack Cuba. Yet during the same period, Khrushchev used his visit to Austria to insist again and again on the horrors of nuclear world war and on the need to avoid even local wars because of the risk that they might spread; and even in his most reckless gestures he took care not to do anything irrevocable. The Geneva test negotiations were *not* broken off; the Cuban rocket threat was soon " explained " as symbolic, while in the Congo the Russians refrained from backing their policy with force; and a proposal for taking the disarmament negotiations out of the U.N. and for calling

instead for a disarmament conference of " all governments " including China, which the Chinese managed to get adopted by a Stockholm session of the World Peace Council in July, was promptly dropped down the memory hole by Moscow in favour of Khrushchev's suggestion that all heads of government of the member states should personally attend the next U.N. assembly session in order to discuss the Soviet plan for general and complete disarmament.

The same contradiction between the desire to keep the lines of negotiation open and the need to pose constantly as an uninhibited revolutionary agitator also dominated Khrushchev's subsequent behaviour at the U.N. assembly itself. He did not back the neutrals' initiative for a new summit meeting but left the onus of killing it to the West. He depreciated the importance of his own proposals for " general and complete disarmament," for the sake of which so many heads of government had come, by devoting far more energy to his attack on " colonialism " in general and on the U.N. secretariat in particular, and by choosing a language and style of behaviour more apt to inspire revolutionary movements outside than to influence delegates inside the assembly hall. He followed his attack on the secretariat by proposals for a reform of the latter and of the Security Council which appealed to the natural desire of the new African and Asian member states for stronger representation in the leading organs of the U.N., but then suggested that any such changes in the Charter should be postponed until the delegates of the Chinese People's Republic had been seated. These inconsistencies are incomprehensible unless the fact is borne in mind that during all that time Khrushchev was engaged in an effort to prove his revolutionary zeal and international solidarity in preparation for the Moscow conference.

Meanwhile the line for the ideological campaign itself had been laid down by a meeting of the central committee of the CPSU in mid-July, which had approved the conduct of its delegation at Bucharest, led by Khrushchev, oddly enough after a report by secretariat member F. R. Kozlov who had not been there. As developed during late July and August in the Soviet press and the statements of pro-Soviet leaders of foreign Communist parties, the campaign showed some significant changes of emphasis.[18] It was more uncompromising than ever on the need to avoid the horrors of nuclear war, and the rejection of all attempts to belittle them or to regard any kind of international war as desirable. It insisted that good Marxist-Leninist revolutionaries were entitled and indeed obliged to adopt on this matter conclusions different from Lenin, both because of the new techniques of destruction and because of the change

18 F. Konstantinov and Kh. Momdzhan, " Dialectics and the Present," *Kommunist* No. 10, 1960; *Pravda* editorial, July 20; speech by M. A. Suslov, *Pravda*, July 30; Y. Frantsev, *Pravda*, August 7; B. Ponomarev, *Pravda*, August 12; Togliatti speech to Italian CC, *Pravda*, July 28; T. Zhivkov in August issue of *World Marxist Review*.

in the relation of world forces to the disadvantage of imperialism. It vigorously defended the possibility not only of stopping each particular war, but of altogether "eliminating war from the life of society" with the further growth of the strength of the "Socialist camp," even while capitalism still existed on part of the globe, as the Twenty-first Congress had laid down; and it claimed that the Soviet programme of general and complete disarmament was a realistic policy goal that could be achieved, even though this might require time, "mutual concessions" and compromises. Any opposition to this general line of peaceful coexistence was to be eliminated from the Communist movement as "Trotskyite adventurism."

MOSCOW AND PEKING SHIFT THEIR GROUND

But the new campaign no longer laid stress on Khrushchev's differentiation between "realistic statesmen" and "diehard militarists" in the enemy camp, and no longer mentioned "relaxation of international tension" as a condition of coexistence diplomacy. Instead, the goals of peace and disarmament were now put forward, in language first used by the Chinese critics, as having to be "imposed" on the imperialists by the strength of the "Socialist camp" and the relentless struggle of the masses. Peaceful coexistence was now described as "the highest form of the class struggle," and justified as leading not to an even temporary weakening, but to an intensification of revolutionary movements everywhere, including civil wars and colonial revolts whenever the imperialists attempted to hold back the rising tide by force. It was only international wars, wars between states, that should be avoided by the policy of peaceful coexistence; and it was explicitly admitted that imperialist intervention against revolutionary movements might lead to "just wars of liberation," and that in that case the duty of the Socialist camp was to support the latter—though not necessarily with troops—and to seek to end the intervention. In short, it was now claimed that there was no contradiction at all between the diplomacy of coexistence and the policy of unconditional revolutionary solidarity: both had become compatible in an age where, owing to the growing strength of the "Socialist camp," the "dictatorship of the proletariat had become an international force" as once predicted by Lenin.

This interpretation of Soviet policy evidently placed its authors in a very strong position to meet the Chinese ideological challenge; yet as the Chinese had intended, and as Khrushchev's simultaneous actions illustrated, it was bound greatly to reduce the credibility and effectiveness of the coexistence campaign in non-Communist eyes. The Soviets could hope to succeed in restoring their international ideological authority to the exact extent to which they were prepared temporarily to weaken the

political impact of their diplomacy. It was an expression of that dilemma that when the chief ideological spokesman of Yugoslav Communism, Vice-President Edvard Kardelj, published a pamphlet in defence of coexistence and against the Chinese cult of revolutionary war,[19] *Pravda* immediately turned against him and accused him of all the revisionist sins of which the Chinese had accused the Soviets [20]—not only because he had been so tactless as to name the Chinese as his target, which the Soviets had never done, but because he had taken a consistent position with which they could not afford to identify themselves. For Kardelj had argued that real peaceful coexistence between states with different social systems required that these systems should not become the basis of permanent " ideological *blocs* " in foreign policy; and this concept was, of course, as incompatible with Soviet practice as with the new definition of coexistence as " the highest form of the class struggle."

During the same period, the Chinese Communists were also shifting their ground. They stopped belittling the horrors of nuclear war and claiming that only cowards could fear them,[21] and repeatedly protested their willingness to fight for peaceful coexistence and the prevention or stopping of wars. But they kept rubbing in the formula of the Moscow declaration of 1957 about the role of the aggressive U.S. circles as the centre of world reaction and the need for vigilance against its war plans camouflaged by peace talk, which they felt had been borne out by Khrushchev's experience with Eisenhower; and they pictured peaceful coexistence and disarmament as goals which could be " imposed " on the enemy only " to some extent " and for limited periods, without the slightest assurance of permanence or completion before the final, worldwide victory of the Communist cause.[22] In other words, they remained adamant in their rejection of the thesis of the Twenty-first Congress about " eliminating war from the life of mankind " before that final victory.

THE QUESTION OF ROADS TO POWER

Parallel with that, the Chinese concentrated on extolling the importance of revolutionary violence, including revolutionary war. While the Russians now *admitted* that peaceful coexistence did not *exclude* colonial uprisings and civil wars, and that imperialist intervention in these cases *might lead* to " just wars of liberation," the Chinese stressed revolutionary

[19] " Socialism and War," first published in *Borba*, August 12–20, 1960.

[20] A. Arzumanyan and V. Koryonov, *Pravda*, September 2, 1960.

[21] The last Chinese statement on those lines seems to have been the article on the tenth anniversary of the outbreak of the Korean War by Gen. Li Chih-min, *People's Daily*, June 25, 1960.

[22] *People's Daily* editorial commenting on Bucharest communiqué, June 29 ; Liao Ch'eng-chih's speech to Bureau of World Peace Council in Stockholm, July 10 ; Ch'en Yi's speech in Peking, NCNA, July 15 ; Li Fu-ch'un's speech to the Vietnamese party congress, NCNA, September 6.

violence as the normal and classical road for the advance of the Communist cause, and support for just wars as the *criterion* of true internationalism. In fact, they abandoned the safe ground of the 1957 Moscow declaration (on which they were otherwise relying in that phase) to the extent of attacking its thesis, taken over from the Twentieth Congress of the CPSU, that the Communist seizure of power might take place in some countries without violent upheaval and civil war, as a peaceful revolution carried out with the help of the legal parliamentary institutions. Ignoring the examples given by the Russians at the time—such as the annexation of Esthonia and the Czechoslovak coup of February 1948—the Chinese now insisted that the bourgeoisie would never and nowhere abandon power without resorting to violence, and that it was " muddle-headed " at best to confuse the peaceful construction of Socialism *after* the seizure of power with the necessarily violent conquest of power itself.[23] To this, the Soviets replied with renewed charges of " Blanquism." [24]

Of all the differences raised in the 1960 dispute, this argument on the violent and non-violent roads to power seemed most artificial, at least in its generalised form. The Soviets had started talking about the " parliamentary road " in order to ease the tactical position of the Communist parties in the West, and it was chiefly the latter which made propagandist use of the formula. But in the weeks before the crucial Moscow meeting, the Chinese effort was chiefly directed at those Communist parties in underdeveloped countries for which the Chinese experience had long been regarded as a natural model; and most of these had developed alternately in co-operation or conflict with nationalist dictators, but had certainly no prospect of gaining power by " parliamentary " means. Only in the case of the faction-ridden Indian Communist Party—a party operating legally in an under-developed country with effective parliamentary institutions—was there a serious struggle going on between a " right wing " advocating and a " left wing " rejecting the " parliamentary road " to power; and it was primarily with an eye to the Indian " left wing " that the Chinese now engaged in a general denunciation of the Soviet concept of that road as " revisionist."

The Soviets replied to this twist by a similar piece of demagogy—accusing the Chinese of a sectarian refusal to work with broad nationalist movements against imperialism unless these movements subscribed in advance to Communist principles and leadership.[25] As a general

[23] In public, this came out most clearly in the last weeks before the Moscow Conference, notably in comments on the publication of the fourth volume of the works of Mao, *e.g. People's Daily*, October 6, and above all *Red Flag* editorial, November 2. But it is clear from Soviet reaction that the point must have been raised internally before.

[24] A. Belyakov and F. Burlatsky in *Kommunist* No. 13, 1960.

[25] Y. Zhukov in *Pravda*, August 26.

charge, this was as untrue as the Chinese attack on the alleged " revisionism " of Moscow's " peaceful road "; the close contacts maintained by Peking with the Algerian and many African nationalists proved that daily. But Peking's conflicts with the Indian and Indonesian governments, due in fact not to doctrinaire prejudice but to Chinese chauvinism, and its support for leftish malcontents in several Asian Communist parties against Moscow's wooing of nationalist dictators gave to the charge a semblance of substance.

Soviet-Chinese relations seem to have reached their low point in August and early September. It was during that period that an unusually large number of Soviet technicians left China, while many Chinese students returned from Russia: that the organ of the Soviet-Chinese Friendship Society disappeared from the streets of Moscow; and that the expected Chinese scholars failed to turn up at the Orientalists' Congress there. It was then, too, that a number of Soviet provincial papers printed an article explaining that in contemporary conditions, not even a huge country like China could build Socialism in isolation and without the aid and backing of the Soviet Union,[26] while Peking's theoretical voice published a statement of the need for China to rely chiefly on her own resources for the fulfilment of her plans.[27] We do not know the inside story behind those visible symptoms—whether Moscow really tried to apply economic pressure and failed, or whether Peking made a gratuitous demonstration of her capacity for " going it alone." [27a] Chinese criticism, at any rate, had not been silenced by October 1st,[27b] when the Russians used the eleventh birthday of the CPR to make again a show of friendship; on the contrary, some of Peking's most polemical utterances came in the last weeks before the Moscow conference,[28] whereas the Soviet ideological campaign had rather abated since the middle of September. But by then the Soviets could afford to stop arguing in

[26] S. Titarenko in *Sovyetskaya Latviya, Bakunsky Rabochy et al.*, August 16, 1960.

[27] Li Fu-ch'un in *Red Flag*, No. 16, 1960.

[27a] Since the above was written, it has been reasonably well established that the Soviets took the initiative in withdrawing large numbers of technicians, giving as their reason Chinese attempts to influence them ideologically against official Soviet policy. Both the pro-Soviet secret report referred to by Crankshaw and a pro-Chinese account by the West Bengal Communist leader H. K. Konar, published in the Indian weekly *The Link* and quoted by B. Nikolayevsky in *The New Leader* of Jan. 16, 1961, agree on this.

[27b] According to the report summarised by Crankshaw, the Chinese CP circularised their systematic counter attack to the Soviet charges, going back to their disapproval of Mr. Khrushchev's 1956 " destalinisation " speech and to complaints of " unprincipled " Soviet behaviour in Poland and Hungary later that year, only on Sept. 10, 1960. Once again, the reported Chinese position is confirmed by the pro-Chinese account of Konar, referred to in the previous note, and based on Chinese statements made to the author at the North Vietnamese party congress at about the same time.

[28] *Cf.* the articles quoted in note 22 above; also Marshal Lo Jui-ch'ing's article for the (North) *Korean People's Forces Journal* on the tenth anniversary of Chinese intervention in Korea, NCNA, October 25, 1960.

public, for the Chinese had been largely, though not completely, isolated in the international movement: early in September, even the North Vietnamese party fell in line with the Soviet position.[29]

The mere duration of the Moscow conference—almost three weeks of argument behind closed doors—showed that agreement on a new common statement of principles was anything but easy. This time, the Chinese had sent the strongest possible team short of exposing Mao himself to the risk of defeat—a delegation led by Liu Shao-ch'i and the Party secretary Teng Hsiao-p'ing; and reports that he fought for every clause and comma, and finally yielded to the majority view on some crucial points only under the threat of an open ideological breach do not seem implausible. Halfway through the debates, the anniversary of the 1957 declaration was commented on by editorials in Moscow and Peking which still showed a marked difference of emphasis [30] on the primacy of revolutionary struggle in the *People's Daily*, on the " general line " of peaceful coexistence in *Pravda*; while at the same time a Chinese delegate to a session of the Afro-Asian Solidarity Committee threw off all restraint and claimed publicly that there could be no peaceful coexistence in those countries before the liquidation of colonialism, as the oppressed peoples would never accept " coexistence between the rider and the horse." [31] But it seems established that as the Moscow conclave wore on, the Chinese were only able to retain the support of a few Asian parties that were traditionally dependent on them or largely recruited from the Chinese minorities, of some rather weak Latin American parties, and of the faithful Albanians long tied to them by common enmity against the Yugoslav " revisionists."

THE MOSCOW STATEMENT

The long document on the strategy of international Communism that was agreed in the end thus marks a clear Soviet victory on almost all the points that had still been in dispute in the preceding three months. But the Soviet position as defended since the July session of the central committee of the CPSU already contained substantial concessions to the original Chinese criticism of Soviet policy.

The 1960 Moscow declaration starts from the Soviet analysis that Lenin's views are partly outdated because the present epoch is no longer primarily that of imperialism, but of the growing preponderance of the " Socialist world system " over the forces of imperialism. On this basis, it accepts not only the possibility of ending war forever with the worldwide victory of Socialism, but of " freeing mankind from the nightmare

[29] See P. J. Honey's analysis of the North Vietnamese Party Congress in *The China Quarterly*, No. 4, p. 66.
[30] *People's Daily*, November 21 ; *Pravda*, November 23.
[31] NCNA, November 21.

of another world war even now "—of " banishing world war from the life of society even while capitalism still exists in part of the world." The thesis of the Twenty-first Congress of the CPSU which the Chinese had fought to the last has thus been reluctantly accepted by them,[31a] and so has the full description of the horrors of nuclear war. The declaration also proclaims the possibility not of preventing all local wars, but of " effectively fighting the local wars unleashed by the imperialists " and extinguishing them, and stresses the unanimity of all Communists in their support for " peaceful coexistence " and negotiation as the only alternative to destructive war. Finally, it recognises the " historic " importance which a fulfilment of the Soviet programme for general and complete disarmament would have, and states that its achievement, though difficult, may be accomplished in stages if the masses and the governments of the " Socialist camp " resolutely fight for it.

At the same time, " peaceful coexistence " is described as " a form of the class struggle " (not, as in some Soviet documents, as " the highest form," because in the Chinese party doctrine that rank remains reserved for revolutionary war). The hope of preserving peace is squarely based on the strength of the " Socialist camp," the revolutionary movements and their sympathisers; it is admitted that the latter may be found also in " certain strata of the bourgeoisie of the advanced countries " who realise the new relation of forces and the catastrophic consequences of a world war, but this appears as a marginal factor. Gone are Khrushchev's " realistic statesmen " and his successful goodwill visits; the emphasis is on the fact that the aggressive, warlike nature of imperialism has not changed, and that " American imperialism " as such—not only, as stated in 1957, " the aggressive imperialist *circles* of the United States "—has become the " main centre of world reaction, the international gendarme, the enemy of the peoples of the whole world." [31b] While condemning " the American doctrine of the Cold War," the document thus defines coexistence in rigid Cold War terms.

The declaration allots to the " peace campaign " pride of place as likely to unite the broadest possible fronts under Communist leadership, and rejects the " slander " that the Communists need war for extending their sway or believe in " exporting revolution." But it also calls for the most determined international support, both by the mass movement and by " the power of the Socialist world system," of revolutionary movements anywhere against " the imperialist export of counter-revolution." The statement that " the Socialist states ... have become an international force exerting a powerful influence on world developments.

[31a] It has not, however, to my knowledge so far been quoted in Chinese comments on the Moscow declaration.
[31b] This formula in turn, has not been quoted in Mr. Khrushchev's report on the conference.

Hence real possibilities have appeared to settle the major problems of our age in a new manner, in the interest of peace, democracy and Socialism . . ." assumes a special meaning in this context: for the first time since Stalin's victory over Trotsky, active support for international revolution is proclaimed as an obligation of the Soviet Government and all other Communist governments. But the crucial question of whether that obligation includes the risk of war, of whether " peaceful coexistence " or " revolutionary solidarity " is to receive priority in case of conflict, is not settled explicitly—for the possibility of conflict between the two principles is not admitted.

On the question of violent or peaceful roads to power, the view of the Russians and of the 1957 declaration that both may be used according to circumstances is clearly upheld. Equally " broadminded " are the declaration's new directives for the policy of the Communists in underdeveloped countries towards their " national bourgeoisie "—*i.e.,* toward the nationalist, neutralist and non-Communist, though in fact hardly ever bourgeois régimes that have emerged from the struggle for national independence. The Communists are advised to aim at " national democratic " régimes, defined by their willingness to support the Soviet *bloc* against the " imperialists," to create the preconditions of progressive internal development by land reform, and to grant full freedom for the activity of the Communist Party and of Communist-controlled " mass organisations." They are told that those sections of the " national bourgeoisie " which oppose land reform and suppress the Communists, having taken a reactionary turn at home, will sooner or later also side with imperialism abroad. But again, the crucial question of a nationalist dictatorship that is willing to take Soviet aid and to vote anti-Western in the U.N., but gaols its own Communists is shirked [31c]; nor is there any clear indication of who is to interpret the ambiguous directives in case of conflict.

IDEOLOGICAL AUTHORITY

Thus matters come back to the ultimate issue of ideological authority —of the right to interpret ambiguous principles in a changing situation. Here, the Soviets score a clear but very limited victory: they emerge as the most successful, but not as the only orthodox interpreters of the true doctrine. The Soviet Union is hailed as the only country that, having completed " Socialist construction," is engaged in building the " higher stage " of Communism; the Chinese communes are not even mentioned, and the Soviet argument that Communist abundance is not

[31c] In practice, President Nasser's régime in the UAR continues to enjoy Soviet diplomatic backing while being vigorously attacked in Soviet-controlled organs of the Communist world movement.

possible short of the highest level of technical productivity, including automation, is hammered home. The CPSU is unanimously declared to be "the universally recognised vanguard of the world Communist movement," and its superior experience in conquering power and transforming society is stated to have fundamental lessons for all parties; the decisions of its Twentieth Congress in particular are said to have opened a new era for the whole international movement. But that new era now turns out to be an era of polycentric autonomy—just as the bolder spirits thought at the time.

For under the new declaration, the spiritual authority of the CPSU is not incarnated in the shape which all doctrinaire authority, and certainly all authority in the Bolshevik tradition, requires by its nature—the shape of hierarchical discipline. It is not only that the declaration repeats the ancient pious formula about the independence and equality of all Communist parties; it is that it fails to establish a visible, single centre for their dependence. It provides for irregular conferences, whether world-wide or regional, for mutual co-ordination, and for bipartite consultations betwen any two parties in case of differences. This may be intended to rule out the circulation of Chinese attacks on CPSU policy to third parties before they have raised the matter in Moscow directly; but it does not, on the face of it, prevent them from broadening the discussion again the next time they fail to get satisfaction in their direct contact with the "vanguard of the world movement." [31d] Clearly, the primacy of that vanguard is no longer that of an infallible Pope: the rule of *Moscow locuta, causa finita* is valid no more. For the first time in its forty years of history, international Communism is entering a "conciliary" period.

One phase of open ideological controversy between Moscow and Peking has thus ended. The Chinese have withdrawn their open challenge to the Marxist-Leninist orthodoxy of the Soviet Communists, but not before they had extracted from it as much advantage for their foreign policy as they could hope to gain without risking an open breach. The underlying differences of interest and viewpoint remain, though their public expression will now be muted for some time. But the phase that has now closed has not only had a considerable immediate impact on Soviet foreign policy; it is bound to produce lasting changes in the constellation of factors shaping that policy, in Soviet-Chinese relations, and in relations within the Communist world movement.

A measure of the immediate effect is the uncertainty of direction

[31d] According to the report summarised by Crankshaw, the Chinese explicitly affirmed their right to form factions in the international movement during the Moscow discussions, and finally accepted the declaration only on condition that another world conference should be called within two years.

shown by Soviet diplomacy from the wrecking of the summit conference in May to the end of 1960. Having set out to induce the U.S., by a mixture of pressure and courtship, to abandon some exposed positions and allies for the sake of a temporary understanding with their chief antagonist, the Kremlin did not indeed abandon that objective, but wavered visibily between it and the Chinese objective of isolating the U.S. as the one irreconcilable enemy. The oscillations were too fast, the conciliatory gestures too half-hearted, and the brinkmanship too risky to be explained merely as the conscious use of zig-zag tactics to " soften up " the opponent; even if the Soviets intended all the time to reserve the next serious offer of relaxation for the next American President, a cool calculation of diplomatic expediency would hardly have led them to commit themselves in the meantime to the point to which they have gone over, say, Laos or Cuba. By depriving them of the power automatically to subordinate all revolutionary movements everywhere to Soviet diplomatic needs, the Chinese forced Stalin's successors to compete for authority over those movements by playing up to them to some extent; and this meant that, while failing to impose on the Kremlin a policy made in Peking, the Chinese forced it to deviate from its own concepts to a significant extent.

Nor have they lost this power of interference as a result of the Moscow conference. True, they have failed to establish a power of veto over Soviet diplomacy in general and Soviet-American contacts in particular, as would have been the case if the Chinese theses of an unconditional priority of revolution over peace and of the hopelessness of any serious disarmament agreement with the " imperialists " had been adopted. There is nothing in the Moscow declaration that would make it *impossible* for the Soviets still to agree with the Western powers on a permanent ban on nuclear test explosions with proper guarantees of inspection, hence on an attempt to close the " atomic club." But there is much in it that will enable the Chinese to make it more difficult, and generally to raise suspicion against any direct Russo-American talks, and nothing that specifically endorses Mr. Khrushchev's methods of personal diplomacy, from his pursuit of summit meetings to his proposals for " reforming " the United Nations. In fact, if the text of the declaration is viewed in the context of the events leading up to it, it suggests that the Soviet Communist Party was only able to win on the controversial questions of principle by silently disavowing some of the more spectacular actions of its leader, and that the latter has emerged from the fight with his personal prestige noticeably impaired.

The declaration's approval of the " general line " of peaceful co-existence and of the aim to eliminate world war in our time permits the Soviets to go on pursuing their strategy of using both negotiation and

violence short of world war as means to gain their ends; but it is not enough to assure them of tactical freedom to decide, in the light of their own interests alone, when and how far to use one or the other. To regain that freedom of manoeuvre, the Soviets would have either needed a plain and brutal statement that local revolutions may in certain circumstances have to be subordinated to the interest of preserving world peace and thus protecting the achievements of " Socialist construction " against a nuclear holocaust; or they would have required an equally plain recognition of their right to act as the only legitimate interpreters of revolutionary doctrine for the world movement, and to enforce the strategic and tactical consequences of their interpretation by means of centralised discipline. But either way of ensuring Soviet primacy, so natural in the Stalinist age when the Soviet Union alone was " the fatherland of all toilers," proved impossible in the post-Stalinist age of " the Socialist World System " proclaimed by Khrushchev himself.

On one side the doctrine that " the dictatorship of the proletariat has become an international factor," first announced in Russia by M. A. Suslov and now substantially incorporated in the declaration, amounts to a partial repeal of Stalin's " Socialism in a single country ": it does not, of course, deny what was achieved under the latter slogan, but it restores, in the new world situation, the idea of a duty of the Communist powers to aid the progress of world revolution for which Trotsky fought. Even if this principle of solidarity is not formulated as an absolute and unlimited obligation, it is enough to expose Soviet diplomacy to constant pressure to take bolder risks—pressure of the kind which the Chinese mobilised effectively during the past year, and are free to use again.

POLYCENTRIC COMMUNISM

On the other hand, the declaration's recognition of the Soviet Communist Party as the " vanguard " of the world movement falls far short of establishing a permanent and unchallengeable doctrinaire authority, let alone a single centre endowed with disciplinary powers. It even falls far short of the position conceded to the Soviet Union and the Soviet Communist Party at the time of the 1957 Moscow declaration—on Mao Tse-tung's initiative. Then, the Soviet Union was consistently described as being " at the head of the Socialist camp," and Mao publicly went out of his way to speak of the need for a single leader both among Communist states and parties, and to insist that only the Russians could fill both roles.

Now, the Chinese talk quite openly and naturally about the special responsibilities of " the two great Socialist powers," the Soviet Union and China; and in the declaration itself, the vanguard role of the Soviet

party is balanced in part by the recognition of the " enormous influence " exerted by the Chinese revolution on the peoples of Asia, Africa and Latin America by its encouraging example to all movements of national liberation. In 1957, the failure to found a new formal international organisation only increased the influence of the large international liaison machinery developed within the secretariat of the central committee of the CPSU, compared with which all bilateral and regional contacts were bound to be of subordinate importance. Now, the failure formally to establish a single centre legitimates the *de facto* existence of two centres in Moscow and Peking, both with world-wide links and without any agreed division of labour, which will continue to cooperate on the basis of the declaration but also to give different advice on the questions it has left open and to compete for influence. And if Moscow is still the stronger power and the older authority, Peking is closer in its type of revolutionary experience and the emotional roots of its anti-colonialist ardour to those parts of the world where the chances of Communist revolution are most promising.

In a long-range view, the relative victory of the Soviets in the 1960 phase of the dispute thus appears less important than the fact that this phase has marked a new stage in their abdication of their former position of exclusive leadership. The reports that the Soviets themselves expressed during the Moscow conference a wish that they should no longer be described as being " at the head of the Socialist camp " may well be true : finding themselves unable any longer to exert effective control over the whole world movement, they may have preferred not to be held responsible for all its actions by their enemies. In a *bloc* containing two great powers, in an international movement based on two great revolutions, such a development was indeed to be expected as soon as important differences appeared between them. But while the two protagonists remain as determined to continue to co-operate as they are unable to settle their disagreements, the result is not a two-headed movement with neatly separated geographic spheres of control, but a truly polycentric one : many Communist parties outside the Soviet *bloc* may in future be able to gain increased tactical independence, based on their freedom of taking aid and advice from both Moscow and Peking, simultaneously or alternately—with all the risks that implies for the future unity of its doctrine and strategy.

The victory of Communism in China, and the subsequent growth of Communist China into a great power, thus appears in retrospect as the beginning of the end of the single-centred Communist movement that Lenin created, and the single-centred Soviet *bloc* that Stalin built. The process took a decisive step forward in 1956, when the Twentieth Congress of the CPSU recognised the existence of a " Socialist world

system " and of different roads to power, and when the destruction of the Stalin cult inflicted an irreparable blow on the type of Soviet authority that had depended on the infallibility of the " father of nations." Mao's victory had killed the uniqueness of the Soviet Union; Khrushchev's speech buried the myth built around that uniqueness.

It was at that moment that the spectre of " polycentric Communism " first appeared. But when destalinisation was quickly followed by the crisis of Russia's East European empire, the façade of single-centred unity was restored in the following year with the help of China's prestige and Mao's authority. Now that China herself has brought back the spectre she helped to exorcise three years ago, the process is no longer reversible. This time, polycentric Communism has come to stay.

POSTSCRIPT

The above was written before the publication of Khrushchev's report on the Moscow conference,[32] given on January 6 to the party organisations of the Higher Party school, the Academy of Social Sciences and the Institute of Marxism-Leninism. Compared to the text of the Declaration, the report is distinguished by two diplomatic omissions and two theoretical elaborations.

Krushchev has made no mention of the role of U.S. imperialism as the gendarme of world reaction, etc., which would have embarrassed him in resuming diplomatic approaches to the new American administration; reactions to President Kennedy's first statements in Moscow and Peking have already confirmed that the original foreign policy difference the two great Communist Powers remains intact after the formal burial of the ideological dispute that arose from it.

The report also fails to define the new concept of " national democracy," created to designate the desirable type of régime in the under-developed, ex-colonial countries, by the criteria of land reform and freedom of Communist organisation given in the declaration. In view of the diplomatic importance of Soviet relations not only with Nasser's U.A.R. but with the traditionalist autocracy of Mohammed V of Morocco, this is understandable.

But Khrushchev is more precise than the declaration in his comment on " wars of national liberation." He goes further than any previous Soviet participant in the debate in agreeing with the Chinese that such just wars are " inevitable " so long as imperialism and colonialism exist, and he is emphatic about the need for all Communists to give them their fullest support. But he solves the apparent contradiction with his preceding condemnation of " local wars "—which might lead to the

[32] *Kommunist*, Nr. 1, 1961.

disaster of nuclear world war—by arguing that these wars of liberation are in their origin not " wars between states," but popular insurrections, and that the support which the Communist Powers must give them should consist not in taking the initiative to internationalise the conflict, but in preventing the intervention of the major imperialist Powers by the threat of their own counter-intervention—as in Vietnam and in the Cuban revolution—and thus assuring the victory of " the people." This is the most explicit formulation yet of the Soviet practice of " all aid by threats and indirect support short of war " for revolutionary movements.

Finally, Khrushchev confirms publicly that it was the Soviet delegation that asked for the omission of the flattering formula placing the Soviet Union " at the head of the Socialist Camp " and the CPSU " at the head of the Communist World movement," which Mao had bestowed on them at the 1957 conference; and he bluntly states his reason that this would have been a source of difficulties rather than advantages, as they are not in fact any longer in a position to act as a single centre giving directives. The polycentrism implicit in the declaration is thus made explicit for the first time through the mouth of the highest authority of Soviet Communism.

In the circumstances, Khrushchev's assurance that the Communist parties will in future be able to " synchronise their watches " without the help of a statute regulating their relations, merely by the light of their common ideology, amounts to little more than the hope that Russia and China will continue to be able to compromise their differences in the light of their common interests. Even assuming that this will still be true for a long time, nothing so far indicates that the achievement of compromise will in future be easier, or the effects on the world Communist movement less critical, than in the recent past.

Sino-Soviet Economic Relations

WHEN the Soviet delegation led by Kumykin, Deputy Minister of Foreign Trade, arrived in Peking early in February 1961 to hold preliminary talks on questions of mutual assistance and economic cooperation, the Chinese Foreign Minister referred to eternal, unbreakable, brotherly friendship and monolithic solidarity between the two countries. Marshal Ch'en Yi also praised the tremendous help received from the Soviet Union during the last decade and promised to remain for ever grateful for this assistance. A day or two earlier F. V. Konstantinov, Editor of *Kommunist*, arriving in Peking for the anniversary of the Sino-Soviet Treaty of Friendship had been greeted with equal warmth, in the name of a solidarity as firm as a rock and as hard as steel. As if to protect the newly forged bonds against assaults from hostile quarters, Radio Peking played the Soviet cantata "For ever we are together."

These manifestations seem to differ from others that have become known in the recent past. Chou En-lai when asked last year by Edgar Snow whether the Soviet Union had given China any aid without compensation was said to have replied: "Generally speaking, no; but in a specific sense, one can say yes." Blueprints came to the Chinese Prime Minister's mind, but no reference was made to capital equipment or technical expertise.

There had been cases of more generous acknowledgment of Soviet assistance, as in the *People's Daily* on February 14, 1959, when Soviet assistance was described as unprecedented in history. But on the whole, the emphasis has been on self-reliance rather than foreign aid. Li Fu-ch'un writing last autumn in the party journal Red Flag (August 1960) stressed that "the party has held consistently that we should mainly rely on our own efforts." In fact, this had been the general theme of public pronouncements at least as far back as the inauguration of the second Five Year Plan in 1956. Peking radio summarised thus the sentiments of the Communist leadership (29/5/57): "China should never rely on foreign aid for Socialist industrialisation."

It is sometimes argued that the apparently conflicting accounts of Sino-Soviet economic relations are merely the two sides of one and the same coin, the shining front facing the foreigner greedily looking at cash, but turned on its smudgy back becoming legal tender in China's indigenous bazaars. A more plausible explanation may be gauged from

Sino-Soviet ambivalence in the ever-changing relation between the two states. As to the facts of the case, even the magnitude of Soviet assistance to China is open to doubt. Only two loans of February 1950 and October 1954, providing the equivalent of $430 million, are among the few items known of Sino-Soviet relations. Thereafter the analyst enters the realm of the uncertain if not the fantastic.

After the fortieth anniversary of the October revolution the Soviet Union stated its aid to countries within the Communist camp to total some 28,000 million roubles or $7,000 million at the official rate of exchange. Li Hsien-nien, the Chinese Minister of Finance, quoted in his budget report of June 1957 the Chinese share in this gigantic pro-gramme of aid. The Soviet Union had extended to China economic assistance amounting to nearly 5,300 million yuan, or the same amount in roubles at the exchange rate apparently operating in Sino-Soviet transactions. If the " international " exchange rate of 1 yuan=1.70 roubles was applied, one-third of Soviet assistance to countries of the *bloc* would have been involved.

This sum included no doubt charges for the return to China of the Changchun Railway, the harbour of Port Arthur, the Soviet share in the joint-stock companies and the value of some fifty Manchurian plants first dismantled and then restored to China. This left large amounts unexplained since the two long term loans of 1950 and 1954 amounted to little more than 1,700 million roubles. Some observers have drawn the conclusion that large consignments of military aid granted during and after the Korean war or short term debts on trading accounts must have increased China's indebtedness to the Soviet Union. Others have dismissed Soviet claims of large scale assistance as phantoms since the agreements of mutual assistance of April 1956 and February 1959 excluded the possibility of long term credits and imposed repayment out of current production.

However this may be, sizeable short term debts did accumulate. Economic assistance is sometimes barely distinguishable from trade on deferred terms, and in fact Soviet trading practice allows for " technical credits," *i.e.*, swings which require payment of 2 per cent. interest if they surpass agreed ceilings. China made extensive use of this provision. Trading balances to the amount of almost $1,000 million accrued between 1950 and 1955 in favour of the Soviet Union providing China with substantial medium term credits. In 1956 she began to repay these and her trading deficit with the Soviet Union is likely to have declined by now to little more than $350 million. China began to repay her long term debts to the Soviet Union in 1954 and only two-fifths of these remain unpaid. The size of China's debts from invisible imports is unknown.

In 1956 when China was engaged in designing her second Five Year Plan, the Soviet leaders were preoccupied in Eastern Europe with political movements which were brought under control only at the expense of almost $1,000 million in short term credits. This unforeseen expenditure not only contributed to the premature termination of Soviet Russia's sixth Five Year Plan; it also prevented the Soviet Union from including in its foreign aid programme its most dependable ally China. Little wonder that the Chinese felt incensed to find that rebellion yielded better reward than loyalty. Much of the seed that has poisoned Sino-Soviet relations in recent years was sown in the autumn of 1956.

Whatever the causes of recent discord, there can be no doubt that Soviet economic assistance to China has been crucial for its industrialisation programme. This holds good in particular in case of her fuel and power economy, her iron and steel plants, and her chemical and engineering industries. Soviet Russia's share in China's foreign trade has increased from a mere 5 per cent. before the revolution to as much as 50 per cent. and more of a greatly increased volume from 1952 onwards. The Soviet Union has thus become China's main foreign supplier. Russia's exports to China are three times as large as those to all under-developed countries taken together. Since 1950 Sino-Soviet trade turnover has risen several times and it now amounts to about $2,000 million. A substantial part of Russia's exports consists of machinery and other capital goods. In 1959 half of all Soviet exports of machinery and nearly three of every four complete plants sent abroad went to China. During the last decade Soviet Russia has probably supplied complete plants and factory equipment to the tune of over $2,000 million.

At the same time China has found a wide open market for her surplus farm products, mineral ores and industrial consumer goods. She rivals with East Germany for first place among Soviet Russia's importers, supplying twice as much to the Soviet Union as all under-developed countries taken together. Whereas only five years ago foodstuffs provided the bulk of China's exports to Russia, by now they have been replaced largely by industrial consumer goods, particularly textiles.

Although probably no more than one-half of almost three hundred industrial projects undertaken under the auspices of Sino-Soviet agreements has been completed, Soviet Russia has contributed substantially to China's take-off from agrarian backwardness to semi-industrial development. Within the last decade China's share in the Soviet *bloc*'s industrial potential has doubled from 5 per cent. in 1950 to 10 per cent. in 1960. The provision of over 10,000 Soviet specialists has not been the least of Russia's contribution. The reduced rate of Soviet industrial supplies in 1957 and 1960 and the termination of service of certain

Soviet technicians last year caused dislocations in China's economy which provided a measure of her dependence upon continued Soviet economic assistance. Last year's rate of growth was probably no more than 5 per cent., a small increase by Chinese standards.

Two mediocre harvests aggravated the situation sufficiently to turn China from a food surplus producer to an importer of grain and sugar to the tune of $250 million or more. Since the temporary removal of political discord the Soviet Union has allowed China to spread the payment of last year's unpaid loan service over the next four or five years. Up to $200 million may be involved.

As a result of the disruptions of normal development, Chinese economic plans in spheres of potential influence may well have been delayed. Sino-Soviet friction in developing countries has thus been less in evidence than might have been the case otherwise. The economic ties of China have of course remained predominantly with the members of the Sino-Soviet *bloc*. She has so far offered to developing countries little more than $300 million in credits and grants and her trade with these countries amounts to a mere $400 million. Mongolia and some countries of South-East Asia seem to provide the only cases of economic rivalry, if not conflict, between China and the Soviet Union.

In view of her continued economic dependence on the Soviet Union China would seem unlikely to exploit fully, for some years to come, the possibilities of infiltration if this brings her into open conflict with the Soviet Union. The consequences of a lasting rift between the two chief Communist Powers would be serious to both; for China it could amount to a setback from which to recover it might take her the better part of a decade. However serious her dissent from Soviet Russia's political concepts, economic considerations would seem unlikely to allow friction to endanger monolithic solidarity within the *bloc*.

DOCUMENTATION

By RODERICK MACFARQUHAR

1. Points of Departure

THIS section contains the three important theoretical assessments of the world situation which form the background to the dispute during 1960: Khrushchev's assessment during the course of his report on February 14, 1956, to the Twentieth Congress of the Soviet Communist Party (CPSU), the assessment made by the ruling Communist Parties at their meeting in Moscow in November 1957 after the 40th anniversary celebrations of the Bolshevik revolution, and Khrushchev's further and, in Communist terms, even more optimistic assessment in his report to the CPSU's Twenty-first Congress on January 27, 1959.

That the assessments can be described as theoretical of course does not mean that they have no relevance to Soviet or Communist practice. In fact, ruling Communists normally feel obliged to justify important policies in Marxist-Leninist terms. Consequently theoretical innovations such as the two Khrushchev assessments represent invariably indicate major policy changes that have occurred or are about to take place.

Khrushchev's speech to the CPSU's Twentieth Congress contained two major modifications of Marxist-Leninist doctrine relevant to the dispute of 1960. First, he affirmed that the doctrine that war was inevitable so long as imperialism existed was no longer true. Lenin had argued that imperialist countries would quarrel among themselves over markets and exploitable underdeveloped territories with mounting bitterness. First one then another country would win a temporary advantage (the " law of uneven development ") and the resultant instability would lead inevitably to war.[1]

Khrushchev accepted Lenin's view that this instability would remain so long as imperialism persisted, and with it the " economic basis giving rise to wars." But he argued that the " epoch-making changes of the last decades " (i.e., since the outbreak of World War II) entailed that " war is not fatalistically inevitable." These changes were: the growth of a powerful Communist bloc, the existence of a large number of non-

[1] For a discussion of Lenin's views see R. N. Carew Hunt, *The Theory and Practice of Communism* (London: Bles, 1950), pp. 161–167.

Communist countries with populations totalling hundreds of millions (*i.e.*, neutrals such as India and Indonesia) who were opposed to war (and, of course, were not allies of the West), the strength of the labour movement in capitalist countries, and the development of an international peace movement.

Khrushchev had only modified Lenin's views; war was still possible and Communists had to be careful lest it break out. But this modification was the basis for the whole diplomacy of " peaceful co-existence." This policy had two major aims. On the one hand it would reduce East-West tension so as to avert the danger of a thermo-nuclear holocaust which would devastate the Soviet Union as much as America.[2] This reduction of tension would also enable Moscow to soften up the West in order to gain its ends in Europe and in particular in Germany. This policy was already in operation. It will be remembered that by the time Khrushchev made this speech he had, with the then-Premier Bulganin, helped foster the " Geneva spirit " at the 1955 summit conference and that he and Bulganin had arranged to visit Britain in the spring of 1956.

The second aim of the peaceful co-existence policy was to allow the Russians to spread their influence throughout the neutralist world by trade, aid, glad-handing and the exploitation of anti-colonialism.[3] Since Khrushchev was clearly convinced that he could gradually oust the West this way, he doubtless needed to be sure that Soviet diplomatic victories would not frighten a militant West into attacking the Soviet Union. " Peaceful coexistence " diplomacy was designed partly to get the West to accept the march of world revolution.

Khrushchev's second major modification of Marxism-Leninism at the Twentieth Congress was his assertion that the weakening of capitalism relative to the growing power of the Communist *bloc* meant that it might be possible to introduce Communist rule in various countries by parliamentary means rather than by revolutionary violence. At the time it appeared that Khrushchev wished to help Western Communist Parties whose failure decisively to increase their influence was in many cases attributable to the popular image of them as bloodthirsty revolutionaries controlled from Moscow.

But in fact, Khrushchev talked of the possibility of " peaceful transition " in reference both to " capitalist *and former colonial countries* " (emphasis added). It would seem he was also concerned to assure men like Nehru and Sukarno that Soviet aid and friendship was not merely

[2] Malenkov had revealed in 1954 (*Pravda*, March 13) that he realised war would be as disastrous for Russia as the West though no Soviet leader has ever admitted to sharing this belief in such downright terms.

[3] Khrushchev's trip with Bulganin to India, Burma and Afghanistan late in 1955 was his first to the neutralist world. During it the Soviet Union made its first major aid agreements with the neutralist world.

a smoke screen behind which local Communist Parties were preparing *coups d'état*.

The Declaration issued in Moscow in 1957 by the leaders of the Communist *bloc* countries including China (Mao Tse-tung attended the conference in person) confirmed both of Khrushchev's theoretical innovations. But it contained important modifications of the Khrushchev presentation of those theses.

While war was stated not to be inevitable, there was no reference to those Western leaders on whose " sobering up " Khrushchev, in his Twentieth Congress speech, clearly relied in suggesting that deals with the West were possible. A major addition was made to the list of forces whose growing power could prevent war—the national liberation movement.[4] " Peaceful transition " to Communism was still regarded as possible, but only capitalist countries were referred to when the doctrine's applicability was discussed.

The " harder " tone of the Declaration as compared with Khrushchev's Twentieth Congress speech doubtless reflected the general worsening in the international situation between early 1956 and late 1957, a period which had seen the Hungarian revolt, the Suez war, and further tension in the Middle East. The disastrous effect of de-Stalinisation in Eastern Europe and of the " hundred flowers " and rectification in China meant that this was a time for reaffirming Communist principles in the strongest terms. Besides, the launching of the first sputnik shortly before the meeting made the most strident reassertion of the power of Communism almost inevitable.

But, with the benefit of hindsight, it can be suggested that Mao may have insisted on the insertion of the national liberation movement and on the exclusion of former colonies from the category of countries in which " peaceful transitions " might be engineered.

At the Twenty-first CPSU Congress, Khrushchev went beyond his original assertion that war was no longer inevitable. He said that when the Soviet Union had become the world's leading industrial power and with China and the other Communist countries produced over half the world's industrial output, there would be " an actual possibility of excluding *world* war from the life of society " (emphasis added). Clearly the new formulation was more optimistic than the old and could be made the basis of even greater reliance on " peaceful co-existence." This was the period of the Macmillan visit to Moscow and the Mikoyan visit to America and the slow march towards a summit conference. Before the end of the year, Nixon was to open the American exhibition in Moscow and Khrushchev, himself, was to tour the United States.

[4] Khrushchev referred separately and at length to the national liberation movement, but did not accord it a role in helping maintain world peace.

Khrushchev's Twentieth Congress Speech

The peaceful co-existence of the two systems. The Leninist principle of peaceful co-existence of states with different social systems has always been and remains the general line of our country's foreign policy.

It has been alleged that the Soviet Union puts forward the principle of peaceful co-existence merely out of tactical considerations, considerations of expediency. Yet it is common knowledge that we have always, from the very first years of Soviet power, stood with equal firmness for peaceful co-existence. Hence, it is not a tactical move, but a fundamental principle of Soviet foreign policy.

This means that if there is indeed a threat to the peaceful co-existence of countries with differing social and political systems, it by no means comes from the Soviet Union or the rest of the socialist camp. Is there a single reason why a socialist state should want to unleash aggressive war ? Do we have classes and groups that are interested in war as a means of enrichment ? We do not. We abolished them long ago. Or perhaps, we do not have enough territory or natural wealth, and perhaps we lack sources of raw materials or markets for our goods ? No, we have enough and to spare of all those. Why then should we want war ? We do not want it, and as a matter of principle we renounce any policy that might lead to millions of people being plunged into war for the sake of the selfish interests of a handful of multi-millionaires. Do those who shout about the " aggressive intentions " of the U.S.S.R. know all this ? Of course they do. Why then do they keep up the old monotonous refrain about some imaginary " Communist aggression "? Only to stir up mud, to conceal their plans for world domination, a " crusade " against peace, democracy and socialism.

To this day the enemies of peace allege that the Soviet Union is out to overthrow capitalism in other countries by " exporting " revolution. It goes without saying that among us Communists there are no supporters of capitalism. But this does not mean that we have interfered, or plan to interfere, in the internal affairs of countries where capitalism still exists. Romain Rolland was right when he said that " freedom is not brought in from abroad in baggage trains like Bourbons ". It is ridiculous to think that revolutions are made to order. We often hear representatives of bourgeois countries reasoning thus : " The Soviet leaders claim that they are for peaceful co-existence between the two systems. At the same time they declare that they are fighting for communism, and say that communism is bound to win in all countries. Now if the Soviet Union is fighting for communism, how can there be any peaceful co-existence with it ? " This view is the result of bourgeois propaganda. The ideologists of the bourgeoisie distort the facts and deliberately confuse questions of ideological struggle with questions of relations between states, in order to make the Communists of the Soviet Union look like advocates of aggression.

When we say that the socialist system will win in the competition between the two systems—the capitalist and the socialist systems—this by no means signifies that its victory will be achieved through armed interference by the socialist countries in the internal affairs of the capitalist countries. Our certainty of the victory of communism is based on the fact that the socialist mode of production possesses decisive advantages over the capitalist mode of production. Precisely because of this, the ideas of Marxism-Leninism are more and more capturing the minds of the broad masses of the working

people in the capitalist countries, just as they have captured the minds of millions of men and women in our country and the people's democracies. We believe that all working men in the world, once they have become convinced of the advantages communism brings, will sooner or later take the road of struggle for the construction of socialist society. Building communism in our country, we are resolutely against war. We have always held and continue to hold that the establishment of a new social system in this or that country is the internal affair of the peoples of the countries concerned. This is our attitude, based on the great Marxist-Leninist teaching.

The principle of peaceful co-existence is gaining ever wider international recognition. This principle is one of the cornerstones of the foreign policy of the Chinese People's Republic and the other people's democracies. It is being actively implemented by the Republic of India, the Union of Burma and a number of other countries. And this is natural, for in present-day conditions there is no other way out. Indeed, there are only two ways: either peaceful co-existence or the most destructive war in history. There is no third way.

We believe that countries with differing social systems can do more than exist side by side. It is necessary to proceed further, to improve relations, strengthen confidence between countries and co-operate. The historical significance of the famous five principles, put forward by the Chinese People's Republic and the Republic of India and supported by the Bandung Conference and the world public in general, lies in the fact that they provide the best form for relations between countries with differing social systems in present-day conditions. Why not make these principles the foundation for peaceful relations among all countries in all parts of the world? It would meet the vital interests and demands of the peoples if all countries subscribed to these five principles.

The Possibility of Preventing War in the Present Era

Millions of people all over the world are asking whether another war is really inevitable, whether mankind, which has already experienced two devastating world wars, must still go through a third one? Marxists must answer this question, taking into consideration the epoch-making changes of the last decades.

There is, of course, a Marxist-Leninist precept that wars are inevitable as long as imperialism exists. This precept was evolved at a time when (i) imperialism was an all-embracing world system, and (ii) the social and political forces which did not want war were weak, poorly organised, and hence unable to compel the imperialists to renounce war.

People usually take only one aspect of the question and examine only the economic basis of wars under imperialism. This is not enough. War is not only an economic phenomenon. Whether there is to be a war or not depends in large measure on the correlation of class, political forces, the degree of organisation and the awareness and determination of the people. Moreover, in certain conditions the struggle waged by progressive social and political forces may play a decisive role. Hitherto the state of affairs was such that the forces that did not want war and opposed it were poorly organised and lacked the means to check the schemes of the war-makers. Thus it was before the First World War, when the main force opposed to the threat of war—the world proletariat—was disorganised by the treachery of the

43

leaders of the Second International. Thus it was on the eve of the Second World War, when the Soviet Union was the only country that pursued an active peace policy, when the other great powers to all intents and purposes encouraged the aggressors, and the right-wing Social-Democratic leaders had split the labour movement in the capitalist countries.

In that period this precept was absolutely correct. At the present time, however, the situation has changed radically. Now there is a world camp of socialism, which has become a mighty force. In this camp the peace forces find not only the moral, but also the material means to prevent aggression. Moreover, there is a large group of other countries with a population running into many hundreds of millions which are actively working to avert war. The labour movement in the capitalist countries has today become a tremendous force. The movement of peace supporters has sprung up and developed into a powerful factor.

In these circumstances certainly the Leninist precept that so long as imperialism exists, the economic basis giving rise to wars will also be preserved, remains in force. That is why we must display the greatest vigilance. As long as capitalism survives in the world, the reactionary forces representing the interests of the capitalist monopolies will continue their drive towards military gambles and aggression, and may try to unleash war. But war is not fatalistically inevitable. Today there are mighty social and political forces possessing formidable means to prevent the imperialists from unleashing war, and if they actually do try to start it, to give a smashing rebuff to the aggressors and frustrate their adventurist plans. In order to be able to do this, all the anti-war forces must be vigilant and prepared, they must act as a united front and never relax their efforts in the battle for peace. The more actively the peoples defend peace, the greater will be the guarantees that there will be no new war.

Forms of Transition to Socialism in Different Countries

In connection with the radical changes in the world arena new prospects are also opening up as regards the transition of countries and nations to socialism.

As long ago as the eve of the Great October Socialist Revolution, Lenin wrote: "All nations will arrive at socialism—this is inevitable, but not all will do so in exactly the same way, each will contribute something of its own in one or another form of democracy, one or another variety of the dictatorship of the proletariat, one or another rate at which socialist transformations will be effected in the various aspects of social life. There is nothing more primitive from the viewpoint of theory or more ridiculous from that of practice than to paint, ' in the name of historical materialism ', *this* aspect of the future in a monotonous grey. The result will be nothing more than Suzdal daubing " [*Works*, Russian edition, Vol. 23, p. 58].

The experience of history has fully confirmed Lenin's brilliant precept. Alongside the Soviet form of reconstructing society on socialist lines, we now have the form of people's democracy.

In Poland, Bulgaria, Czechoslovakia, Albania and the other European people's democracies this form sprang up and is being utilised in conformity with the concrete historical, social and economic conditions and peculiarities of each of these countries. It has been thoroughly tried and tested in the course of ten years and has fully proved its worth.

Much that is unique in socialist construction is being contributed by the People's Republic of China, whose economy prior to the victory of the revolution was exceedingly backward, semi-feudal and semi-colonial in character. Having taken over the decisive commanding positions, the people's democratic state is using them in the social revolution to implement a policy of peaceful reorganisation of private industry and trade and their gradual transformation into a component of socialist economy.

The leadership of the great cause of socialist reconstruction by the Communist Party of China and the Communist and Workers' Parties of the other people's democracies, exercised in keeping with the peculiarities and specific features of each country, is creative Marxism in action.

In the Federal People's Republic of Yugoslavia, where state power belongs to the working people, and society is founded on public ownership of the means of production, specific concrete forms of economic management and organisation of the state apparatus are arising in the process of socialist construction.

It is probable that more forms of transition to socialism will appear. Moreover, the implementation of these forms need not be associated with civil war under all circumstances. Our enemies like to depict us Leninists as advocates of violence always and everywhere. True, we recognise the need for the revolutionary transformation of capitalist society into socialist society. It is this that distinguishes the revolutionary Marxists from the reformists, the opportunists. There is no doubt that in a number of capitalist countries the violent overthrow of the dictatorship of the bourgeoisie and the sharp aggravation of class struggle connected with this are inevitable. But the forms of social revolution vary. It is not true that we regard violence and civil war as the only way to remake society.

It will be recalled that in the conditions that arose in April 1917 Lenin granted the possibility that the Russian Revolution might develop peacefully, and that in the spring of 1918, after the victory of the October Revolution, Lenin drew up his famous plan for peaceful socialist construction. It is not our fault that the Russian and international bourgeoisie organised counter-revolution, intervention and civil war against the young Soviet state and forced the workers and peasants to take to arms. It did not come to civil war in the European people's democracies, where the historical situation was different.

Leninism teaches us that the ruling classes will not surrender their power voluntarily. And the greater or lesser degree of intensity which the struggle may assume, the use or the non-use of violence in the transition to socialism, depends on the resistance of the exploiters, on whether the exploiting class itself resorts to violence, rather than on the proletariat.

In this connection the question arises of whether it is possible to go over to socialism by using parliamentary means. No such course was open to the Russian Bolsheviks, who were the first to effect this transition. Lenin showed us another road, that of the establishment of a republic of Soviets—the only correct road in those historical conditions. Following that course, we achieved a victory of world-wide historical significance.

Since then, however, the historical situation has undergone radical changes which make possible a new approach to the question. The forces of socialism and democracy have grown immeasurably throughout the world, and capitalism has become much weaker. The mighty camp of socialism with its

population of over 900 million is growing and gaining in strength. Its gigantic internal forces, its decisive advantages over capitalism, are being increasingly revealed from day to day. Socialism has a great power of attraction for the workers, peasants and intellectuals of all countries. The ideas of socialism are indeed coming to dominate the minds of all working mankind.

At the same time the present situation offers the working class in a number of capitalist countries a real opportunity to unite the overwhelming majority of the people under its leadership and to secure the transfer of the basic means of production into the hands of the people. The right-wing bourgeois parties and their governments are suffering bankruptcy with increasing frequency. In these circumstances the working class, by rallying around itself the working peasantry, the intelligentsia, all patriotic forces, and resolutely repulsing the opportunist elements who are incapable of giving up the policy of compromise with the capitalists and landlords, is in a position to defeat the reactionary forces opposed to the interests of the people, to capture a stable majority in parliament, and transform the latter from an organ of bourgeois democracy into a genuine instrument of the people's will. In such an event this institution, traditional in many highly developed capitalist countries, may become an organ of genuine democracy—democracy for the working people.

The winning of a stable parliamentary majority backed by a mass revolutionary movement of the proletariat and of all the working people could create for the working class of a number of capitalist and former colonial countries the conditions needed to secure fundamental social changes.

In the countries where capitalism is still strong and has a huge military and police apparatus at its disposal, the reactionary forces will, of course, inevitably offer serious resistance. There the transition to socialism will be attended by a sharp class, revolutionary struggle.

Whatever the form of transition to socialism, the decisive and indispensable factor is the political leadership of the working class headed by its vanguard. Without this there can be no transition to socialism.

It must be strongly emphasised that the more favourable conditions for the victory of socialism created in other countries are due to the fact that socialism has won in the Soviet Union and is winning in the people's democracies. Its victory in our country would have been impossible had Lenin and the Bolshevik Party not upheld revolutionary Marxism in battle against the reformists, who broke with Marxism and took the path of opportunism.

Such are the considerations which the central committee of the Party considers it necessary to set out with regard to the forms of transition to socialism in present-day conditions. . . .

[From text in *Soviet News Booklet No. 4* (London: Soviet Embassy, 1956).]

*

The 1957 Moscow Declaration

Representatives of the Albanian Party of Labour, the Bulgarian Communist Party, the Hungarian Socialist Workers' Party, the Vietnamese Working People's Party, the Socialist Unity Party of Germany, the Communist Party of China, the Korean Party of Labour, the Mongolian People's Revolutionary Party, the Polish United Workers' Party, the Rumanian Workers' Party, the Communist Party of the Soviet Union and the

Communist Party of Czechoslovakia discussed their relations, current problems of the international situation and the struggle for peace and socialism.

The exchange of opinions revealed identity of views of the parties on all the questions examined at the meeting and unanimity in their assessment of the international situation. In the course of discussion the meeting also touched upon general problems of the international Communist movement. In drafting the declaration the participants in the meeting consulted with representatives of the fraternal parties in the capitalist countries. The fraternal parties not present at this meeting will assess and themselves decide what action they should take on the considerations expressed in the declaration.

1. The main content of our epoch is the transition from capitalism to socialism which was begun by the great October socialist revolution in Russia. Today more than a third of the population of the world—over 950 million people—have taken the road of socialism and are building a new life. The tremendous growth of the forces of socialism has stimulated the rapid extension of the anti-imperialist national movement in the post-war period. During the last 12 years, besides the Chinese People's Republic, the Democratic Republic of Vietnam and the Korean People's Democratic Republic, over 700 million people have shaken off the colonial yoke and established national independent states. The peoples of the colonial and dependent countries, still languishing in slavery, are intensifying the struggle for national liberation. The progress of socialism and of the national-liberation movement has greatly accelerated the disintegration of imperialism. With regard to the greater part of mankind imperialism has lost its one-time domination. In the imperialist countries society is rent by deep-going class contradictions and by antagonisms between those countries, while the working class is putting up increasing resistance to the policy of imperialism and the monopolies, fighting for better conditions, democratic rights, for peace and socialism.

In our epoch world development is determined by the course and results of the competition between two diametrically opposed social systems. In the past 40 years socialism has demonstrated that it is a much higher social system than capitalism. It has ensured development of the productive forces at a rate unprecedented and impossible for capitalism, and the rise of the material and cultural levels of the working people. The Soviet Union's strides in economy, science and technology and the results achieved by the other socialist countries in socialist construction are conclusive evidence of the great vitality of socialism. In the socialist states the broad masses of the working people enjoy genuine freedom and democratic rights, people's power ensures political unity of the masses, equality and friendship among the nations and a foreign policy aimed at preserving universal peace and rendering assistance to the oppressed nations in their emancipation struggle. The world socialist system, which is growing and becoming stronger, is exerting ever greater influence upon the international situation in the interests of peace and progress and the freedom of the peoples.

While socialism is on the upgrade, imperialism is heading towards decline. The position of imperialism has been greatly weakened as a result of the disintegration of the colonial system. The countries that have shaken off the yoke of colonialism are defending their independence and fighting for economic sovereignty, for international peace. The existence of the socialist

system and the aid rendered by the socialist nations to these countries on principles of equality and co-operation between them and the socialist nations in the struggle for peace and against aggression help them to uphold their national freedom and facilitate their social progress.

In the imperialist countries the contradictions between the productive forces and production relations have become acute. In many respects modern science and engineering are not being used in the interests of social progress for all mankind because capitalism fetters and deforms the development of the productive forces of society. The world capitalist economy remains shaky and unstable. The relatively good economic activity still observed in a number of capitalist countries is due in large measure to the arms drive and other transient factors.

However, the capitalist economy is bound to encounter deeper slumps and crises. The temporary high business activity helps to keep up the reformist illusions among part of the workers in the capitalist countries. In the post-war period some sections of the working class in the more advanced capitalist countries, fighting against increased exploitation and for a higher standard of living, have been able to win certain wage increases, though in a number of these countries real wages are below the pre-war level. However, in the greater part of the capitalist world, particularly in the colonial and dependent countries, millions of working people still live in poverty. The broad invasion of agriculture by the monopolies and the price policy dictated by them, the system of bank credits and loans and the increased taxation caused by the arms drive have resulted in the steady ruin and impoverishment of the main mass of the peasantry. There is a sharpening of contradictions not only between the bourgeoisie and the working class but also between the monopoly bourgeoisie and all sections of the people, between the United States monopoly bourgeoisie on the one hand and the peoples, and even the bourgeoisie of the other capitalist countries on the other. The working people of the capitalist countries live in such conditions that, increasingly, they realise that the only way out of their grave situation lies through socialism. Thus, increasingly favourable conditions are being created for bringing them into active struggle for socialism.

The aggressive imperialist circles of the United States, by pursuing the so-called " positions of strength " policy, seek to bring most countries of the world under their sway and to hamper the onward march of mankind in accordance with the laws of social development. On the pretext of " combating Communism " they are angling to bring more and more countries under their dominion, instigating destruction of democratic freedoms, threatening the national independence of the developed capitalist countries, trying to enmesh the liberated peoples in new forms of colonialism and systematically conducting subversive activities against the socialist countries. The policy of certain aggressive groups in the United States is aimed at rallying around them all the reactionary forces of the capitalist world. Acting in this way they are becoming the centre of world reaction, the sworn enemies of the people. By this policy these anti-popular, aggressive imperialist forces are courting their own ruin, creating their own grave-diggers.

So long as imperialism exists there will always be soil for aggressive wars. Throughout the post-war years the American, British, French and other imperialists and their stooges have conducted and are conducting wars in Indo-China, Indonesia, Korea, Malaya, Kenya, Guatemala, Egypt, Algeria,

Oman and Yemen. At the same time the aggressive imperialist forces flatly refuse to cut armaments, to prohibit the use and production of atomic and hydrogen weapons, to agree on immediate discontinuation of the tests of these weapons; they are continuing the " cold war " and arms drive, building more military bases and conducting the aggressive policy of undermining peace and creating the danger of a new war. Were a world war to break out before agreement on prohibition of nuclear weapons is reached it would inevitably become a nuclear war unprecedented in destructive force.

In West Germany militarism is being revived with United States help, giving rise to a hot-bed of war in the heart of Europe. Struggle against West German militarism and revanchism, which are now threatening peace, is a vital task facing the peace-loving forces of the German people and all the nations of Europe. An especially big role in this struggle belongs to the German Democratic Republic—the first workers—peasant state in German history with which the participants in the meeting express their solidarity and which they fully support.

Simultaneously the imperialists are trying to impose on the freedom-loving peoples of the Middle East the notorious " Eisenhower-Dulles doctrine " thereby creating the danger of war in this area. They are plotting conspiracies and provocations against independent Syria. The provocations against Syria and Egypt and other Arab countries pursue the aim of dividing and isolating the Arab countries in order to abolish their freedom and independence.

The S.E.A.T.O. aggressive bloc is a source of war danger in East Asia.

The question of war or peaceful co-existence is now the crucial question of world policy. All the nations must display the utmost vigilance in regard to the war danger created by imperialism.

At present the forces of peace have so grown that there is a real possibility of averting wars as was demonstrated by the collapse of the imperialist designs in Egypt. The imperialist plan to use the counter-revolutionary forces for the overthrow of the People's Democratic system in Hungary have failed as well.

The cause of peace is upheld by the powerful forces of our era: the invincible camp of socialist countries headed by the Soviet Union ; the peace-loving countries of Asia and Africa taking an anti-imperialist stand and forming, together with the socialist countries, a broad peace zone ; the international working class and above all its vanguard—the Communist Parties ; the liberation movement of the peoples of the colonies and semi-colonies ; the mass peace movement of the peoples ; the peoples of the European countries who have proclaimed neutrality, the peoples of Latin America and the masses in the imperialist countries are putting up increasing resistance to the plans for a new war. The unity of these powerful forces can prevent the outbreak of war. But should the bellicose imperialist maniacs venture, regardless of anything, to unleash a war, imperialism will doom itself to destruction, for the peoples will not tolerate a system that brings them so much suffering and exacts so many sacrifices.

The Communist and Workers' Parties taking part in the meeting declare that the Leninist principles of peaceful co-existence of the two systems, which has been further developed and brought up to date in the decisions of the 20th Congress of the C.P.S.U. is the sound basis of the foreign policy of the socialist countries and the dependable pillar of peace and friendship among

the peoples. The idea of peaceful co-existence coincides with the 5 principles advanced jointly by the Chinese People's Republic and the Republic of India and with the programme adopted by the Bandung Conference of Afro-Asian countries. Peace and peaceful co-existence have now become the demands of the broad masses in all countries.

The Communist Parties regard the struggle for peace as their foremost task. They will do all in their power to prevent war.

2. The meeting considers that in the present situation the strengthening of the unity and fraternal co-operation of the socialist countries, the Communist and Workers' Parties and the solidarity of the international working-class, national liberation and democratic movements acquire special significance.

At bedrock of the relations of the world socialist system and all the Communist and Workers' Parties lie the principles of Marxism-Leninism, the principles of proletarian internationalism which have been tested by life. Today the vital interests of the working people of all countries call for their support of the Soviet Union and all the socialist countries who, pursuing a policy of preserving peace throughout the world, are the mainstay of peace and social progress. The working class, the democratic forces and the working people everywhere are interested in tirelessly strengthening fraternal contacts for the sake of the common cause, in safeguarding from enemy encroachments the historical, political and social gains effected in the Soviet Union—the first and mightiest socialist power—in the Chinese People's Republic and in all the socialist countries, in seeing these gains extended and consolidated.

The socialist countries base their relations on principles of complete equality, respect for territorial integrity, state independence and sovereignty and non-interference in one another's affairs. These are vital principles. However, they do not exhaust the essence of relations between them. Fraternal mutual aid is part and parcel of these relations. This aid is a striking expression of socialist internationalism.

On a basis of complete equality, mutual benefit and comradely mutual assistance, the socialist states have established between themselves extensive economic and cultural co-operation that plays an important part in promoting the economic and political independence of each socialist country and the socialist commonwealth as a whole. The socialist states will continue to extend and improve economic and cultural co-operation among themselves.

The socialist states also advocate all-round expansion of economic and cultural relations with all other countries, provided they desire it, on a basis of equality, mutual benefit and non-interference in each other's internal affairs. The solidarity of the socialist countries is not directed against any other country. On the contrary, it serves the interests of all the peace-loving peoples, restrains the aggressive strivings of the bellicose imperialist circles and supports and encourages the growing forces of peace. The socialist countries are against the division of the world into military blocs. But in view of the situation that has taken shape, with the western powers refusing to accept the proposals of the socialist countries for mutual abolition of military blocs, the Warsaw pact organisation, which is of a defensive nature, serves the security of the peoples of Europe and supports peace throughout the world, must be preserved and strengthened.

The socialist countries are united in a single community by the fact that

they are taking the common socialist road, by the common class essence of the social and economic system and state authority, by the requirements of mutual aid and support, identity of interests and aims in the struggle against imperialism, for the victory of socialism and communism, by the ideology of Marxism-Leninism, which is common to all.

The solidarity and close unity of the socialist countries constitute a reliable guarantee of the sovereignty and independence of each. Stronger fraternal relations and friendship between the socialist countries call for a Marxist-Leninist internationalist policy on the part of the communist and workers parties, for educating all the working people in the spirit of combining internationalism with patriotism and for a determined effort to overcome the survivals of bourgeois nationalism and chauvinism. All issues pertaining to relations between the socialist countries can be fully settled through comradely discussion, with strict observance of the principles of socialist internationalism.

3. The victory of socialism in the U.S.S.R. and progress in socialist construction in the people's democracies find deep sympathy among the working class and the working people of all countries. The ideas of socialism are winning additional millions of people. In these conditions the imperialist bourgeoisie attaches increasing importance to the ideological moulding of the masses; it misrepresents socialism and smears Marxism-Leninism, misleads and confuses the masses. It is a prime task to intensify Marxist-Leninist education of the masses, combat bourgeois ideology, expose the lies and slanderous fabrications of imperialist propaganda against socialism and the Communist Movement and widely propagate in simple and convincing fashion the ideas of socialism, peace and friendship among nations.

The meeting confirmed the identity of views of the Communist and Workers Parties on the cardinal problems of the socialist revolution and socialist construction. The experience of the Soviet Union and the other socialist countries has fully borne out the correctness of the Marxist-Leninist proposition that the processes of the socialist revolution and the building of socialism are governed by a number of basic laws applicable in all countries embarking on a socialist course. These laws manifest themselves everywhere, alongside a great variety of historic national peculiarities and traditions which must by all means be taken into account.

These laws are: guidance of the working masses by the working class, the core of which is the Marxist-Leninist Party; in effecting a proletarian revolution in one form or another and establishing one form or other of the dictatorship of the proletariat; the alliance of the working class and the bulk of the peasantry and other sections of the working people; the abolition of capitalist ownership and the establishment of public ownership of the basic means of production; gradual socialist reconstruction of agriculture; planned development of the national economy aimed at building socialism and communism, at raising the standard of living of the working people; the carrying out of socialist revolution in the sphere of ideology and culture and the creation of a numerous intelligentsia devoted to the working class, the working people and the cause of socialism; the abolition of national oppression and the establishment of equality and fraternal friendship between the peoples; defence of the achievements of socialism against attacks by internal enemies; solidarity of the working class of the country in question with the working class of other countries, that is proletarian internationalism.

Marxism-Leninism calls for a creative application of the general principles of the socialist revolution and socialist construction depending on the concrete conditions of each country, and rejects mechanical imitation of the policies and tactics of the Communist Parties of other countries. Lenin repeatedly called attention to the necessity of correctly applying the basic principles of communism, in keeping with the specific features of the nation, of the national state concerned. Disregard of national pecularities by the proletarian party inevitably leads to its divorce from reality, from the masses and is bound to prejudice the cause of socialism and conversely, exaggeration of the role of these peculiarities or departure, under the pretext of national peculiarities, from the universal Marxist-Leninist truth on the socialist revolution and socialist construction is just as harmful to the socialist cause.

The participants in this meeting consider that both these tendencies should be combated simultaneously. The Communist and Workers' Parties of the socialist countries should firmly adhere to the principle of combining the above universal Marxist-Leninist truth with the specific revolutionary practice in their countries, creatively apply the general laws governing the socialist revolution and socialist construction in accordance with the concrete conditions of their countries, learn from each other and share experience. Creative application of the general laws of socialist construction tried and tested by experience and the variety of forms and methods of building socialism used in different countries, represent a collective contribution to Marxist-Leninist theory.

The theory of Marxism-Leninism derives from dialectical materialism. This world outlook reflects the universal law of development of nature, society and human thinking. It is valid for the past, the present and the future. Dialectical materialism is countered by metaphysics and idealism. Should the Marxist political party in its examination of questions base itself not on dialectics and materialism, the result will be one-sidedness and subjectivism, stagnation of thought, isolation from life and loss of ability to make the necessary analysis of things and phenomena, revisionist and dogmatist mistakes and mistakes in policy. Application of dialectical materialism in practical work and the education of the party functionaries and the broad masses in the spirit of Marxism-Leninism are urgent tasks of the Communist and Workers' Parties.

Of vital importance in the present stage is intensified struggle against opportunist trends in the working class and communist movement. The meeting underlines the necessity of resolutely overcoming revisionism and dogmatism in the ranks of the Communist and Workers' Parties. Revisionism and dogmatism in the working class and communist movement are today, as they have been in the past, international phenomena. Dogmatism and sectarianism hinder the development of Marxist-Leninist theory and its creative application in the changing conditions, replace the study of the concrete situation with merely quoting classics and sticking to books, and leads to the isolation of the party from the masses. A party that has withdrawn into the shell of sectarianism and that has lost contact with the masses cannot bring victory to the cause of the working class.

In condemning dogmatism, the Communist Parties believe that the main danger at present is revisionism or, in other words, right-wing opportunism, which as a manifestation of bourgeois ideology paralyses the revolutionary energy of the working class and demands the preservation or restoration of capitalism. However, dogmatism and sectarianism can also be the main

danger at different phases of development in one party or another. It is for each Communist Party to decide what danger threatens it more at a given time.

It should be pointed out that the conquest of power by the proletariat is only the beginning of the revolution, not its conclusion. After the conquest of power the working class is faced with the serious tasks of effecting the socialist reconstruction of the national economy and laying the economic and technical foundation of socialism. At the same time the overthrown bourgeoisie always endeavours to make a comeback; the influence exerted on society by the bourgeoisie, the petty bourgeoisie and their intelligentsia, is still great. That is why a fairly long time is needed to resolve the issue of who will win—capitalism or socialism. The existence of bourgeois influence in an internal source of revisionism, while surrender to imperialist pressure is its external source.

Modern revisionism seeks to smear the great teachings of Marxism-Leninism, declares that it is "outmoded" and alleges that it has lost its significance for social progress. The revisionists try to exorcise the revolutionary spirit of Marxism, to undermine faith in socialism among the working class and the working people in general. They deny the historical necessity for a proletarian revolution and the dictatorship of the proletariat during the period of transition from capitalism to socialism, deny the leading role of the Marxist-Leninist party, reject the principles of proletarian internationalism and call for rejection of the Leninist principles of party organisation and, above all, of democratic centralism, for transforming the Communist Party from a militant revolutionary organisation into some kind of a debating society.

The experience of the international communist movement shows that resolute defence by the communist and workers' parties of the Marxist-Leninist unity of their ranks and the banning of factions and groups sapping unity guarantee the successful solution of the tasks of the socialist revolution, the establishment of socialism and communism.

4. The communist and workers' parties are faced with great historic tasks. The carrying out of these tasks necessitates closer unity not only of the communist and workers' parties, but of the entire working class, necessitates cementing the alliance of the working class and peasantry, rallying the working people and progressive mankind, the freedom and peace-loving forces of the world.

The defence of peace is the most important world-wide task of the day. The communist and workers' parties in all countries stand for joint action on the broadest possible scale with all forces favouring peace and opposed to war. The participants in the meeting declare that they support the efforts of all states, parties, organisations, movements and individuals who champion peace and oppose war, who want peaceful co-existence, collective security in Europe and Asia, reduction of armaments and prohibition of the use and tests of nuclear weapons.

The communist and workers' parties are loyal defenders of the national and democratic interests of the peoples of all countries. The working class and the peoples of many countries are still confronted with the historic tasks of struggle for national independence against colonial aggression and feudal oppression. What is needed here is a united anti-imperialism and anti-feudal front of the workers, peasants, urban petty bourgeoisie, national bourgeoisie and other patriotic democratic forces. Numerous facts show that the greater

and stronger the unity of the various patriotic and democratic forces, th greater the guarantee of victory in the common struggle.

At present the struggle of the working class and the masses of the peopl against the war danger and for their vital interest is spearheaded against th big monopoly group of capital as those chiefly responsible for the arms rac as those who organise or inspire plans for preparing a new world war wh are the bulwark of aggression and reaction. The interests and the policy o this handful of monopolies conflict increasingly not only with the interests o the working class but the other sections of capitalist society: the peasant intellectuals, petty and middle urban bourgeoisie. In those capitalist coun tries where the American monopolies are out to establish their hegemon and in the countries already suffering from the United States' policy of econo mic and military expansion, the objective conditions are being created fo uniting, under the leadership of the working class and its revolutionar parties, broad sections of the population to fight for peace, the defence o national independence and democratic freedoms, to raise the standard o living, to carry through radical land reforms and to overthrow the ru of the monopolies who betray the national interests.

The profound historic changes and the decisive switch in the balance o forces in the international sphere in favour of socialism and the tremendou growth of the power of attractions exerted by socialist ideas among th working class, working peasantry and working intelligentsia create mor favourable conditions for the victory of socialism.

The forms of the transition of socialism may vary for different countrie The working class and its vanguard—the Marxist-Leninist Party—seek t achieve the socialist revolution by peaceful means. This would accord wit the interests of the working class and the people as a whole as well as wit the national interests of the country.

Today in a number of capitalist countries the working class led by it vanguard has the opportunity, given a united working-class and popula front or other workable forms of agreement and political co-operatio between the different parties and public organisations, to unite a majority o the people, to win state power without civil war and ensure the transfer o the basic means of production to the hands of the people. Relying on th majority of the people and decisively rebuffing the opportunist elements in capable of relinquishing the policy of compromise with the capitalists an landlords, the working class can defeat the reactionary, anti-popular force secure a firm majority in parliament, transform parliament from an instru ment serving the class interests of the bourgeoisie into an instrument servin the working people, launch a non-parliamentary mass struggle, smash th resistance of the reactionary forces and create the necessary conditions fo peaceful realisation of the socialist revolution. All this will be possible onl by broad and ceaseless development of the class struggle of the worker peasant masses and the urban middle strata against big monopoly capita against reaction, for profound social reforms, for peace and socialism.

In the event of the ruling classes resorting to violence against people, th possibility of non-peaceful transition to socialism should be borne in mind Leninism teaches, and experience confirms, that the ruling classes never re linquish power voluntarily. In this case the degree of bitterness and th forms of the class struggle will depend not so much on the proletariat a on the resistance put up by the reactionary circles to the will of th

overwhelming majority of the people, on these circles using force at one or another stage of the struggle for socialism.

The possibility of one or another way to socialism depends on the concrete conditions in each country.

In the struggle for better conditions for the working people, for preservation and extension of democratic rights, winning and maintaining national independence and peace among nations, and also in the struggle for winning power and building socialism, the communist parties seek co-operation with the socialist parties. Although the right-wing socialist party leaders are doing their best to hamper this co-operation there are increasing opportunities for co-operation between the communists and socialists on many issues. The ideological differences between the communist and the socialist parties should not keep them from establishing unity of action on the many pressing issues that confront the working-class movement.

In the socialist countries where the working class is in power the Communist and Workers' Parties which have the opportunity to establish close relations with the broad masses of the people should constantly rely on them and make the building and the defence of socialism the cause of millions who fully realise that they are masters of their own country. Of great importance for enhancing the activity and creative initiative of the broad masses and their solidarity, for consolidating the socialist system and stepping up socialist construction are the measures taken in recent years by the socialist countries to expand socialist democracy and encourage criticism and self-criticism.

To bring about real solidarity of the working class, of all working people and the whole of progressive mankind, of the freedom-loving and peace-loving forces of the world, it is necessary above all to promote the unity of the Communist and Workers' Parties and to foster solidarity between the Communist and Workers' Parties of all countries. This solidarity is the core of still greater solidarity, it is the main guarantee of the victory of the cause of the working class.

The Communist and Workers' Parties have a particularly important responsibility with regard to the destinies of the world socialist system and the international Communist movement. The Communist and Workers' Parties represented at the meeting declare that they will tirelessly promote their unity and comradely co-operation with a view to further consolidating the commonwealth of socialist states in the interests of the international working-class movement, of peace and socialism.

The meeting notes with satisfaction that the international Communist movement has grown, withstood numerous serious trials and won a number of major victories. By their deeds, the Communists have demonstrated to the working people on a world-wide scale the vitality of the Marxist-Leninist theory and their ability not only to propagate the great ideals of socialism but also to realise them in exceedingly strenuous conditions.

Like any progressive movement in human history, the Communist movement is bound to encounter difficulties and obstacles. However, as in the past, no difficulties or obstacles can change now, nor will they be able to change in the future, the objective laws governing historical progress or affect the determination of the working class to transform the old world and create a new one. Ever since they began their struggles the Communists have been baited and persecuted by the reactionary forces; but the Communist movement heroically repels all attacks, emerging from the trials stronger and more steeled. The Communists, by further consolidating their unity, counter

attempts by the reactionary forces to prevent human society from marching towards a new era.

Contrary to the absurd assertions of imperialism about a so-called crisis of communism, the Communist movement is growing and gathering strength. The historic decisions of the 20th Congress of the C.P.S.U. are of tremendous importance not only to the C.P.S.U. and to the building of Communism in the U.S.S.R., they have opened a new stage in the world Communist movement and pushed ahead its further development along Marxist-Leninist lines. The results of the Congresses of the Communist Parties of China, France, Italy and other countries in recent times have clearly demonstrated the unity and solidarity of the party ranks and their loyalty to the principles of proletarian internationalism. This meeting of the representatives of Communist and Workers' Parties testifies to the international solidarity of the Communist movement.

After exchanging views, the participants in the meeting arrived at the conclusion that in present conditions it is expedient besides bilateral meetings of leading personnel and exchange of information, to hold, as the need arises, more representative conferences of Communist and Workers' Parties to discuss current problems, share experience, study each other's views and attitudes and concert action in the joint struggle for the common goals—peace, a democracy and socialism.

The participants in the meeting unanimously express their firm confidence that, by closing their ranks and thereby rallying the working class and the peoples of all countries, the Communist and Workers' Parties will surmount all obstacles in their onward movement and accelerate further big victories for the cause of peace, democracy and socialism.

[NCNA, November 22, 1957.]

*

Khrushchev's Twenty-first Congress Speech

The conclusion drawn by the Party's 20th Congress to the effect that war is not fatally inevitable has been fully justified. At present we have even more grounds for reaffirming the correctness of this deduction. There now exist enormous forces capable of rebuffing the imperialist aggressors and inflicting defeat upon them in the event of their unleashing world war.

What new things on the international arena will be introduced by the fulfilment of the economic plans of the Soviet Union and all the socialist countries of Europe and Asia? As a result of this, real possibilities will be created for doing away with war as a means of solving international issues. Indeed, when the U.S.S.R. becomes the world's foremost industrial power, when the C.P.R. becomes a mighty industrial power, while all socialist countries taken together will produce more than half the world's industrial output, the international situation will change radically. The successes of the countries of the socialist camp will undoubtedly exert a tremendous influence on the consolidation of the peace-loving forces throughout the world. One need not doubt that by that time the States championing the consolidation of peace will be joined by new countries, freed of colonial oppression.

The idea of the inadmissibility of war will take still deeper root in the consciousness of nations. The new correlation of power will be so obvious that even the most obdurate imperialists will clearly realise the hopelessness of any attempt to launch a war against the socialist camp. Relying on the

might of the camp of socialism, the peace-loving peoples will then be able to force the bellicose imperialist circles to renounce plans for another world war.

Thus, even before the complete victory of socialism on earth, while capitalism still remains in part of the world, there will be an actual possibility of excluding world war from the life of society. Some people may say: " But capitalism will remain, and therefore adventurers who could start a war will remain also." This is correct and should not be forgotten. While capitalism exists, there will always be some people to be found who, contrary to reason, may want to plunge into a hopeless enterprise. But by this they will only speed up the downfall of the capitalist system. Any attempt at aggression will be cut short and the adventurers will find themselves where they should be. . . .

[Translated in *Supplement to the Summary of World Broadcasts (Part I)*, " Twenty-first Congress of the C.P.S.U.," No. 1: First Day's Proceedings, January 30, 1959, issued by the B.B.C., London.]

2. The Rival Views Propounded

THE feelings with which Mao Tse-tung and his colleagues greeted Khrushchev at Peking airport on September 30, 1959, can only be guessed at. The Soviet leader was gracing the Chinese Communist régime's tenth anniversary celebrations with his presence. But he had come to China, as he said in his speech at the airport, "immediately after my return to Moscow from my visit to the United States of America, literally speaking, by changing from one plane to another." From the fact that China's anti-American propaganda had not been modified during that trip, Peking's hostility to Khrushchev's peace diplomacy could be inferred. That night at the tenth anniversary banquet, Khrushchev told his Chinese hosts three things: that he believed Eisenhower wanted to relax East-West tension, that peaceful co-existence had been approved by Lenin, and that strong though the *bloc* was it must not test the stability of the capitalist system by force. That he felt compelled to make the latter point must be construed as indicating he felt some members of the *bloc* thought differently. That Mao chose neither to make any speeches welcoming Khrushchev nor to comment on his American trip is a negative item whose significance cannot be gauged; but it was surely odd that the leader of the Chinese revolution should not have made any official statements on this important anniversary.

Over the succeeding months, the Chinese were digesting what Khrushchev had told them and deciding, their comment on the international scene makes clear, against falling into line.[5] The inevitable clash between the two views finally occurred at the meeting of the Warsaw Treaty Powers in Moscow in February 1960.

. It is worth noting that the circumstances surrounding the summoning of the meeting were mysterious enough to suggest that at first either the Chinese were not invited or they did not want to come. On January 28, Moscow Radio announced that the Communist Party and Government leaders of the European satellites would be coming to Moscow for an agricultural conference on February 2. Delegations of observers from North Korea and Outer Mongolia were to attend "by invitation." But then on February 3 it was revealed that the Foreign Ministers of the Warsaw Treaty countries had been meeting since February 1 in

[5] For an extended discussion see A. M. Halpern, "Communist China and Peaceful Co-existence," *The China Quarterly*, No. 3, 1960. Halpern suggests the Chinese had made up their minds by early December 1959.

preparation for a conference on February 4. On the same day, Peking Radio made its first announcement about the agricultural conference and simultaneously stated that Chinese observers would be attending the Warsaw Treaty meeting. By now Moscow Radio was saying that the Koreans and Mongolians were attending " at their own request," presumably to still questions as to why the Chinese and the North Vietnamese had not been invited.

An agricultural conference did meet, but the innocuous communiqué which it produced did not seem likely to have been sufficient justification for top-level delegations to come to Moscow. Presumably it had been intended all along to hold a Warsaw Treaty conference to discuss policy towards the West, but the probability of a clash with the Chinese in some form had made the Russians want to keep the conference secret. In any event the conference became the occasion for the public juxtaposition of the opposed viewpoints of Moscow and Peking in the form of the Declaration of the Warsaw Treaty Powers on the one side and the speech of the Chinese observer at the conference, K'ang Sheng, on the other.

It is worth noting that while the Chinese Press published both the Declaration and their observer's speech, the press of the Soviet Union and the East European satellites never even mentioned the latter document. Thus readers of the *People's Daily* were henceforth able to see clearly against whom China's subsequent polemics were directed, while Soviet newspaper readers always had to rely on inside information or intelligent if not over-difficult guesswork.

These two documents, unlike most of those issued during the subsequent course of the dispute, are couched in concrete rather than theoretical terms. Thus it is here possible to perceive some of the major policy considerations underlying the ideological stands later adopted.

The tone of the Warsaw Treaty Powers' Declaration is relatively mild and optimistic, while that of K'ang Sheng's speech is tough and pessimistic. The former does not mention " American imperialism"; the latter mentions it repeatedly. The former refers to N.A.T.O. strengthening of " German militarism " but adds that the conferees " express confidence that the plans of the West German revenge-seekers will not be supported by the present allies of the Federal Republic of Germany either "; K'ang Sheng's speech states that the " speeded-up revival of West German militarism " is " an important component part of the U.S. imperialist policy of war and aggression." Where K'ang condemns, the Declaration reproves more in sorrow than in anger.

The basis of the Declaration's optimistic assertion that the "world has now entered on a period of negotiations concerning a settlement of the principal international issues in dispute " is, predictably, the increasing power of the forces of peace. These forces it lists as the growing

economic power of the Soviet camp; Soviet technical achievements, particularly in rocketry; and action for peace on the part of the Communist *bloc* and independent countries of Asia, Africa and Latin America.

The Declaration cites four pieces of concrete evidence to underpin its optimism: the creation of a permanent UN committee for the peaceful exploration of outer space; the East-West agreement of 1959 on the peaceful use of the Antarctic; the exchange of top-level visits between East and West; and the cessation of nuclear testing over a considerable period (this being just before the first French test).

K'ang Sheng admits that there "have appeared certain tendencies towards relaxation of the international tension created by imperialism." This he attributes to the "repeated struggles" of the Communist *bloc*, and in particular its strength and unity; the national revolutionary forces; and the "forces of peace and democracy." Thus at the very beginning of the dispute, the Chinese asserted the importance of the "national revolutionary movement" in the achievement of *bloc* aims.

But K'ang's speech implicitly rejects the suggestion that the time for negotiation has come—"the struggle for disarmament is a long-term and complicated" one. It affirms that the United States is only making "peace gestures"—"its imperialist nature will not change"—behind which arms expenditure is increased, disarmament proposals are sabotaged and more nuclear tests are prepared for—behind which, in effect, war is plotted. He does not make the Declaration's distinction between Western statesmen who want relaxation and those who want to continue the cold war; according to K'ang, the bellicose "U.S. ruling circles" are a monolithic group.

The speech ignores the Antarctic and outer space agreements cited in the Declaration as evidence that substantial negotiations are possible. There is no mention of the cessation of nuclear tests as such; one is left to infer it from the allusion to America's announcement that it felt free to resume testing at any time. As for Khrushchev's visit to the United States—this is explained away in terms of the general thesis as a meaningless gesture which Washington was compelled to make.

The major policy consideration shaping the Soviet analysis contained in the Declaration would seem to be the need to "rule out completely the possibility of a new war, which in the present conditions would lead to the death of hundreds of millions of people and the annihilation of whole states." Though elsewhere the Declaration talks in the habitual Communist manner of the routing of a violator of the peace (by implication the U.S.A.), it is more probable that the Declaration represents another acknowledgment by Moscow that the Soviet Union, too, would be devastated in a nuclear war—and that therefore agreements with the West on nuclear testing and disarmament are vital.

The key to the Chinese analysis is contained in the passage where K'ang Sheng argues that because "U.S. imperialism" has always adopted a " discriminatory attitude against our country in international relations," China had to declare that " any international disarmament agreement and all other international agreements which are arrived at without the formal participation of the Chinese People's Republic and the signature of its delegate cannot, of course, have any binding force on China." [6]

The implication was clear. In the absence of Soviet efforts to aid China in attaining its objective of removing American forces from the Far East in general and the Formosa Strait in particular, and in the absence of any voluntary abdication on the part of the United States, Peking would go its own way and would not collaborate in attempts to reduce East-West tension. The speech's linking of the German and Japanese menaces indicates a feeling that Moscow should not be content with achieving a *modus vivendi* with the West over Germany, but should not rest satisfied until it had helped China get rid of American troops from Japan. (The Soviet Union protested strongly to Japan about the signing of the new security treaty with America, but made no protest in Washington.)

The more intransigent Chinese attitude would seem to be the product also of another factor hinted at in K'ang's speech. Peking, recalling probably the warmth of Vice-President Nixon's reception in Poland in 1959, perhaps genuinely feared that the West might be able to use an easing of international tension to subvert the peoples of at least Eastern Europe—witness K'ang's warning that America was dreaming of " peaceful evolution " in the Communist *bloc,* albeit a warning that was coupled the obligatory assertion that the dream would not be realised.

Khrushchev's Speech in Peking

Comrades! Socialism brings to the people peace—that greatest blessing. The greater the strength of the camp of socialism grows, the greater will be its possibilities for successfully defending the cause of peace on this earth. The forces of socialism are already so great that real possibilities are being created for excluding war as a means of solving international disputes.

In our time the leaders of governments in some capitalist countries have begun to show a certain tendency towards a realistic understanding of the situation that has emerged in the world.

When I spoke with President Eisenhower—and I have just returned from the United States of America—I got the impression that the President of the U.S.A.—and not a few people support him—understands the need to relax international tension.

Perhaps not every bourgeois leader can pronounce the words " peaceful co-existence " well, but they cannot deny that two systems exist in the

[6] China had already made this point clear when it formally supported the Supreme Soviet's disarmament proposal. (See *Peking Review*, No. 4, 1960.)

world—the socialist and the capitalist. The recognition of this fact ran like a red thread through all the talks; this was repeatedly spoken about by the President and other leaders. Therefore we on our part must do all we can to exclude war as a means of settling disputed questions, and settle these questions by negotiations.

The leaders of the capitalist countries cannot but take account of such a decisive factor of modern times as the existence of the powerful world camp of socialism. There is only one way of preserving peace—that is the road of peaceful co-existence of states with different social systems. The question stands thus: either peaceful co-existence or war with its catastrophic consequences. Now, with the present relation of forces between socialism and capitalism being in favour of socialism, he who would continue the "cold war" is moving towards his own destruction. The "cold war" warriors are pushing the world towards a new world war in the fires of which those who light it will be the first to get burned.

Already in the first years of the Soviet power the great Lenin defined the general line of our foreign policy as being directed towards the peaceful co-existence of states with different social systems. For a long time, the ruling circles of the Western Powers rejected these truly humane principles. Nevertheless the principles of peaceful co-existence made their way into the hearts of the vast majority of mankind.

The leaders of many capitalist states are being forced more and more to take account of realities, and to recast their international relations because in our century it is impossible to resolve questions of relations between two systems successfully other than on the basis of the principles of peaceful co-existence. There is no other way.

We are convinced that the peaceful foreign policy of the socialist states, defending peace on earth, will continue to gain new victories. No small efforts will have to be exerted to achieve this. But it is well worth fighting for such a high aim with unsparing efforts.

Comrades! The socialist countries have achieved great successes in developing their economies and as a consequence have created mighty potential forces on the basis of which they can successfully continue their advance. They have the means to defend themselves from the attacks of the imperialist aggressors if these should attempt by interference in our countries' affairs to force them to leave the socialist path and return to capitalism. That old time has gone never to return.

But we must think realistically and understand the contemporary situation correctly. This, of course, does not by any means signify that if we are so strong, then we must test by force the stability of the capitalist system. This would be wrong: the peoples would not understand and would never support those who would think of acting in this way. We have always been against wars of conquest. Marxists have recognized, and recognize, only liberating, just wars; they have always condemned, and condemn, wars of conquest, imperialist wars. This is one of the characteristic features of Marxist-Leninist theory.

It is not at all because capitalism is still strong that the socialist countries speak out against war, and for peaceful co-existence. No, we have no need of war at all. If the people do not want it, even such a noble and progressive system as socialism cannot be imposed by force of arms. The socialist countries therefore, while carrying through a consistently peace-loving policy, concentrate their efforts on peaceful construction, they fire the hearts of

men by the force of their example in building socialism, and thus lead them to follow in their footsteps. The question of when this or that country will take the path to socialism is decided by its own people. This, for us, is the holy of holies. . . .

[*Peking Review*, No. 40, 1959.]

*

Declaration of Member-States of the Warsaw Treaty

THE member-states of the Warsaw Treaty note with satisfaction that a definite change for the better has become noticeable in the international situation since the last conference of the Political Consultative Committee of the Warsaw Treaty Organisation in May 1958. For the first time after many years of the cold war, relations that are normal for peacetime are beginning to be established between the states belonging to the antagonistic groupings, tension has been markedly reduced and prospects are opening up for a strengthening of mutual confidence. The world has now entered on a period of negotiations concerning a settlement of the principal international issues in dispute, with the aim of establishing a lasting peace, and the advocates of the cold war are sustaining a defeat.

The important changes that have taken place in recent years in the correlation of forces in the world arena underlie this improvement in the international situation.

These have been years of rapid expansion of the economic power of the Soviet Union, the Chinese People's Republic and the other Socialist countries and of their further rallying within the framework of a united Socialist camp. These have been years marked by very great achievements of the Soviet Union in science and technology. The putting of the first artificial earth satellite into orbit, the launching of a rocket to the surface of the Moon and the fathoming of the mystery of the reverse side of the Moon, which is never seen from the Earth—such are the magnificent results of these achievements by the world's first Socialist state which have raised mankind to a new level in its struggle to understand and conquer the forces of nature.

And lastly, recent years have been marked by another upsurge in the activity of all countries of the Socialist camp aimed at consolidating peace, and also by the further enhancement of the international role of the peace-loving countries of Asia, Africa and Latin America which have liberated themselves from colonial and semi-colonial dependence.

As a result, the correlation of forces in the world is changing more and more in favour of those who are coming out for the discontinuance of the race in nuclear rockets and other armaments, for the ending of the cold war, and for peaceful co-existence among all states, irrespective of their social systems and ideologies. A situation has taken shape in which any attempt by any aggressive state to resort to arms in order to solve international disputes, to take the road of war, would lead to the immediate and complete routing of the violator of peace.

The opinion is increasingly gaining ground in the minds of the peoples, and in the minds of many political leaders and statesmen, including those in the West, that, given the present level of weapons of mass destruction and the means for their immediate delivery to any point on the Earth, war in

63

general can no longer be a means of solving international disputes, that the only feasible way is to build relations between states on the basis of peaceful co-existence.

The participants in the conference note with profound satisfaction the increasing importance of such a form of contacts between states as meetings and discussions between the leading statesmen of various countries of the East and the West. These contacts, the development of which the member-states of the Warsaw Treaty have always advocated, are, as experience shows, of great positive significance.

The historic visit to the United States of Nikita Krushchov, the Chairman of the U.S.S.R. Council of Ministers, and his talks with Mr. Dwight D. Eisenhower, the President of the United States, have played an outstanding role in this respect. As a result of this visit the ice of the cold war was broken in the relations between the two strongest Powers in the world—the U.S.S.R. and the United States—and a new stage was opened in the development of international relations as a whole. An important contribution to the improvement in the international climate was also made, as is well known, by the discussions between the leaders of the Soviet and British Governments that were held at the time of the visit to Moscow by Mr. Harold Macmillan, the Prime Minister of the United Kingdom.

The participants in the conference expressed the hope that Nikita Khrushchov's forthcoming visit to France and the visit to the U.S.S.R. of Signor Gronchi, the President of the Italian Republic, will lead to a further strengthening of the mutual relations between states, and above all between the states of Europe, and will promote the strengthening of world peace.

It is the common and wholehearted desire of the participants in the conference that President Eisenhower's visit to the Soviet Union next summer should lead to a further development of the relations between the U.S.S.R. and the United States towards friendship and co-operation, which would be an important guarantee of the inviolability of peace throughout the world.

The exchange of visits between statesmen, which has been stepped up in recent years, has become a stable factor making for a *rapprochement* between the states of the Socialist camp and the peace-loving independent countries of Asia, Africa and Latin America.

The friendly meetings and talks of the leaders of the Soviet Union, the Polish People's Republic, the Czechoslovak Republic, the German Democratic Republic, the Rumanian People's Republic and other member-states of the Warsaw Treaty with the leaders of such countries as India, Indonesia, Burma, Cambodia, Afghanistan, the United Arab Republic, Ethiopia, Guinea and others, promote the concrete successful development of peaceful co-existence in vast regions of the world. All participants in the conference express their determination to continue strengthening and developing friendship with the peace-loving states of Asia, Africa and Latin America on the basis of equality and mutual respect, in the interests of peace.

The improvement in the international situation is already bearing fruit in many spheres of international relations.

Late in 1959 an important agreement on the peaceful uses of the Antarctic was concluded between twelve states, including the U.S.S.R., the United States, the United Kingdom and France, under which a vast though still uninhabited continent is completely removed from the sphere of war

preparations in any form, including the staging of nuclear tests, and has been endorsed as a zone of peaceful exploration and scientific co-operation between states. Another useful step in the right direction is the decision taken by the United Nations General Assembly in December 1959, to set up a permanent United Nations committee for the peaceful exploration of outer space, among the members of which are seven Warsaw Treaty states: Albania, Bulgaria, Hungary, Poland, Rumania, the U.S.S.R. and Czechoslovakia.

At the same time, the participants in the conference note that the consolidation of peace is still being stubbornly resisted by influential forces in the Western countries. These are either circles which do not see behind the profits they are receiving from the manufacture of armaments the mortal danger that would threaten them in the event of war, or politicians so stuck in the ice of the cold war that they cannot conceive of normal peaceful relations between states.

The N.A.T.O. countries are not only continuing to maintain inflated armies, but are actually increasing the numerical strength of those armies, paying particular attention to the West German Bundeswehr, which is commanded by former Nazi generals and officers. The Bundeswehr has been equipped with rocket weapons. The Federal Republic of Germany has been enabled to start the manufacture of these weapons. Moreover, measures are being taken towards equipping the Bundeswehr with nuclear weapons. It is a fact that the session of the N.A.T.O. Council, held in December 1959, discussed plans for further increasing the size of the armed forces of the states belonging to that military *bloc.*

Parallel with the strengthening of West German militarism, there has been a marked revival of the militarist forces in Japan and the further involvement of that country in military preparations, as is shown by the recent signing of a new military treaty between Japan and the United States.

The continuation of the arms race by the members of N.A.T.O., and also S.E.A.T.O., Cento, and their allies, can in no way be justified by considerations of defence. It shows that the opponents of peaceful co-existence have not laid down their arms.

This is also borne out by the systematic propaganda of mistrust and hatred between states with different social systems which is still being conducted by influential political and military leaders in the West and by a section of the Press. The opponents of the consolidation of peace do not want talks on the settlement of international disputes and are seeking to prevent agreement from being reached even where possibilities for it have become apparent.

But no efforts by the advocates of the cold war can alter the fact that awareness of the need for peaceful co-existence is becoming the decisive factor in the development of international relations in our time. The balance of forces in the world is in favour of the peaceable states, and the forces of peace are greatly superior to the forces of war. All this provides favourable conditions for reaching the goals for which the Warsaw Treaty states have been striving consistently all along: the relaxation of international tension and the development of friendly co-operation between all countries.

Naturally, the greatest importance is attached to the problem of disarmament. This is the main problem of international life in our day. The

question of whether it will be possible to rule out completely the possibility of a new war, which in the present conditions would lead to the death of hundreds of millions of people and the annihilation of whole states, depends on its solution.

The interests of mankind require that rocket nuclear weapons, with their tremendous destructive potential, should never be allowed to be used.

And the surest way to achieve this is the destruction of all types of armaments, of all weapons of war, that is to say, the general and complete disarmament of all states. That is why the proposal for such disarmament, submitted by the Soviet Union in the United Nations, is in keeping with the most vital interests of mankind. From this stems the great influence which this proposal of the U.S.S.R. is exerting on the peoples. Very significant is the unanimity with which the United Nations approved the idea of general and complete disarmament at the last, 14th session of the General Assembly. The fact that this decision was adopted on the basis of a draft resolution jointly prepared by two such powers as the U.S.S.R. and the United States is also gratifying.

In order to make agreement on disarmament a reality for the first time in history, it is necessary, above all, to proceed from words to practical deeds. This is the most important historical task of the present generation. The Warsaw Treaty countries, having exchanged views at the present conference concerning the prospects for the impending disarmament talks, have come to the conclusion that the situation at the present time is more favourable than ever before for fruitful disarmament talks between countries of the East and West.

The disarmament proposal submitted by the Soviet Government in the United Nations reflects the common position of the Warsaw Treaty countries, of all the Socialist states. All the countries belonging to the Warsaw Treaty Organisation declare their desire to become parties to the future agreement on general and complete disarmament.

The states represented at this meeting feel satisfaction that the first country to take practical steps towards implementing this United Nations resolution was a country belonging to the Warsaw Treaty Organisation, the Soviet Union, which has unilaterally decided to reduce its armed forces by 1,200,000 men. The strength of the Soviet armed forces will now be below the level which the Western Powers themselves suggested in 1956 for the Soviet Union and the United States, and also below the actual strength of the American armed forces, even though the United States has a much smaller territory and much shorter frontiers than the U.S.S.R. The reduction of the Soviet armed forces by one-third in conditions in which Western military *blocs* are proceeding with the arms race is an act of good will which should impel the other states to take reciprocal steps in the sphere of disarmament and to reply to trust by trust.

Some people in the West are always ready to misconstrue, to misrepresent any good deed, any good initiative in international relations. This is what the opponents of disarmament are doing now when they allege that the new reduction of the Soviet armed forces is not a step towards disarmament, but rearmament. Only deliberate bad faith can explain such irresponsible contentions in face of practical steps in the sphere of disarmament.

Who does not realise that only states which have no aggressive intentions can unilaterally reduce their armed forces?

In present conditions there is no need for big armies and military bases on foreign soil for the defence of a country. Would a state harbouring predatory plans voluntarily carry out a reduction in its armed forces? It is clear that even if those armed forces were reorganised with the aim of increasing their combat power, it would not be in its interests to cut their numerical strength.

The states represented at the conference regard the Soviet Union's decision on another big reduction of its armed forces, taken in agreement with the other countries of the Socialist camp, as a common contribution by the Warsaw Treaty Organisation to the cause of disarmament, as an initiative facilitating agreement between the states of the East and West on general and complete disarmament.

The states united in the Warsaw Treaty Organisation are consistently and unswervingly carrying through a policy aimed at ending the arms race. Since its inception, the Warsaw Treaty Organisation has cut the total strength of the armed forces of its member-states by 2,596,500 men, and the present unilateral reduction of the strength of the Soviet armed forces will bring this figure up to 3,796,500 men.

Can the N.A.T.O. states claim the credit for similar measures, the importance of which for strengthening peace is obvious to all? Unfortunately, N.A.T.O. measures up to the present time have been directed towards stepping up war preparations and accumulating armed forces and armaments.

The member-states of the Warsaw Treaty consider it necessary to emphasise the positive example set by the German Democratic Republic, which has voluntarily reduced the strength of its armed forces to 90,000 men and refrained from introducing compulsory military service. This attitude which has been adopted by the German Democratic Republic and is prompted by a desire to do its utmost to facilitate a relaxation of tension, has the full support of all states of the Warsaw Treaty Organisation. Of great importance for the cause of peace and the national future of Germany is the fact that the German Democratic Republic is proving by its policy that Germany, if she renounces nuclear arming and the policy of revenge, revision of frontiers and militarism, can live in peace and prosperity and have a worthy place in the family of nations.

The states represented at the conference call upon the member-states of the North Atlantic Treaty Organisation, and especially on those among them who have the greatest military strength, to respond to the unilateral reduction of the armed forces of the U.S.S.R. by reducing their own armed forces, and to follow the example set by the Soviet Union.

The participants in the conference are proceeding on the basis of the assumption that the Soviet Union's disarmament proposals should be thoroughly examined in the 10-Power committee which is to begin its work on March 15 this year. In this connection they agreed that the Governments of the U.S.S.R., Poland, Czechoslovakia, Rumania and Bulgaria, that is to say the member-states of the Warsaw Treaty Organisation which belong to the 10-power committee, shall instruct their representatives on that committee to facilitate in every way fruitful work by the committee and press for the early drafting of a treaty on general and complete disarmament.

Of course, a successful and speedy solution to the problem of general and complete disarmament calls for efforts not only on the part of the

member-states of the Warsaw Treaty Organisation. Such efforts are also called for on the part of the Western Powers. The participants in the conference express the hope that the Western Powers will also make their contribution to an early solution of the disarmament problem.

A mutual and honest desire for agreement will make it possible to avoid the repetition of a situation in which efforts to agree on disarmament are drowned in floods of speeches and resolutions.

An effective system of international control over general and complete disarmament is necessary for the successful implementation of such disarmament. Control, divorced from practical steps in the sphere of disarmament, could be used in the present situation for purposes diametrically opposed to disarmament: to search for a breach in the defence systems of other countries and to collect information facilitating the drawing up of plans for an attack on this or that country. That is why the states which have no aggressive intentions show a natural concern for the amount of international control to correspond to the real extent of the disarmament of the states. In conditions of general and complete disarmament the states will have no reason to fear each other. Every possibility will exist there for any check, for any inspection. If disarmament is general and complete, control will also be all-embracing and complete.

The states represented at the conference consider it necessary to re-emphasise their interest in an agreement on disarmament such as would provide complete confidence that no side would violate disarmament commitments or would have the possibility of rearming in secret.

The member-states of the Warsaw Treaty note it as a positive fact that for a long time not a single atomic or hydrogen bomb has been exploded in any part of the world. However, though nuclear explosions are not being staged for the time being, there is no international agreement banning them. The peoples do not want just a truce on the nuclear test front; they expect that such tests will be ended once and for all. Anxiety is also created by certain attempts to go back on the positive practical achievements towards the discontinuance of nuclear tests.

If the tests were really resumed by one of the sides, that might set off a kind of chain reaction as a result of which our planet would again become the arena for competition in holding nuclear weapon tests, with all the hazardous consequences this would entail. It would also be difficult to reconcile this with the resolution of the United Nations, which unanimously urged the parties to the Geneva talks—the U.S.S.R., the United States and the United Kingdom—not to resume nuclear weapon tests and to expedite the conclusion of an international agreement on this question.

The Soviet Government's decision not to resume nuclear tests in the future, if only the Western Powers do not resume such test explosions, provides favourable conditions for concluding a treaty on the discontinuance of nuclear weapon tests. The states represented at this conference express the hope that all parties to the Geneva talks will exert the greatest possible efforts to secure in the near future the cessation of all kinds of nuclear weapon tests in the atmosphere, on the surface, underground and under water.

The participants in the conference had a thorough exchange of views on the German question.

The states represented in the Warsaw Treaty Organisation have experienced more than once what German aggression brings to the peoples.

It is the common concern of all these states that German militarism should never again imperil the security of Germany's neighbours and world peace, and this makes them determined to come out in favour of signing a peace treaty with Germany. The liquidation of the remnants of the Second World War and the conclusion of a peace treaty are imperative for the peaceful development of the whole of Germany and for making the peoples confident that firm barriers have been set up against the outbreak of another war in Europe.

At a time when the German Democratic Republic is expressing its complete readiness to enter into negotiations and conclude a peace treaty at any moment, the other German state—the Federal Republic of Germany—is opposing the conclusion of such a treaty. An abnormal and unprecedented situation has emerged in which the conclusion of a peace treaty is refused by a state which is a successor of the defeated side—the aggressor who surrendered unconditionally fifteen years ago.

The policy of the Federal Republic of Germany is designed to obstruct successful talks between the powers and a settlement of outstanding international problems. Attempts are also being made to cancel out the results which have already been achieved during the negotiations, for instance, the narrowing of the gap in the views of the sides on some questions which was achieved by the parties to the Geneva Foreign Ministers' conference in 1959.

Why does the Government of the Federal Republic of Germany so stubbornly resist the conclusion of a peace treaty? It does so above all because the peace treaty is called upon to consolidate the situation that has arisen as a result of the war, including the German state frontiers, and the Government of the Federal Republic is against this. Only one conclusion is possible: The Government of the Federal Republic of Germany expects that an opportune moment may arise for altering the frontiers established in Europe as a result of the defeat of Nazi Germany. In the present conditions, however, this means a policy of preparing a new war, for none of the states on whom the Federal Republic is attempting to make territorial claims will ever surrender its lands, as the Government of the Federal Republic should realise. All reasonable people understand that these frontiers are inviolable.

The Warsaw Treaty states declare with the utmost determination that these calculations of the West German Government are doomed to failure. The German Democratic Republic, as an impregnable bastion of peace, is barring to German militarists the road to new aggressive gambles. The Warsaw Treaty states declare that they support the measures taken by the Government of the German Democratic Republic to safeguard peace against the revenge-seeking policy of the Adenauer government. The joint might of the Socialist camp is a firm guarantee against encroachment on the independence of the German Democratic Republic, or a new seizure of Poland's western lands, or a violation of the integrity of the Czechoslovak frontiers.

The participants in the conference express confidence that the plans of the West German revenge-seekers will not be supported by the present allies of the Federal Republic of Germany either.

It is the deep conviction of the participants in the conference that the population of the Federal Republic, too, thirsting as they are for peace, cannot and will not support the plans of the West German revenge-seekers. The participants in the conference are convinced that the population of

69

Western Germany deserves a better fate than that of being a tool in the hands of the violators of peace. In the past, the Germans were driven repeatedly to this by the greedy imperialist policy of their rulers, and time and time again the German people had to pay a heavy price.

The conclusion of a peace treaty, the renunciation of all ideas of revenge or revision of frontiers, the renunciation of the policy of Germany's re-militarisation and atomic arming—such is the best road towards ensuring the security of all European nations and the peaceful future of the German nation. This road is being consistently followed by the German Democratic Republic. If the Federal Republic of Germany, too, were to take to this road, that would be its most convincing contribution to the cause of strengthening peace and facilitating general and complete disarmament.

The Government of the Federal Republic of Germany is turning down the proposal for a peace treaty because it does not want to allow the question of West Berlin to be settled on the basis of it being transformed into a free city. The Government of the Federal Republic is going so far as to demand that West Berlin, which lies within the territory of the German Democratic Republic, be incorporated in Western Germany, and since this cannot be done, it prefers to preserve there the occupation régime which enables it to use West Berlin as a seat of unrest and military danger.

The Government of the Federal Republic of Germany opposes a peaceful settlement with Germany because it does not want the question of Germany's unity to be settled peacefully by means of talks between the two German states and the conclusion of a peace treaty.

Going in the face of all common sense, it does not want to see that for over ten years there have existed two German states which have chosen different paths of development. Disregarding the vital interests of the German people, the Government of the Federal Republic of Germany is rejecting the only possible way to the reunification of the country—that of talks with the G.D.R., which has been repeatedly offered by the Government of the German Democratic Republic. The Government of the Federal Republic is thereby demonstrating its hostility to the cause of German unity.

The Government of the Federal Republic of Germany does not want to hear of a peace treaty because it is afraid lest the conclusion of that treaty might put an end to the present situation in Western Germany which enables it to bring people to trial merely for having the courage to stand by their progressive convictions and come out in defence of the national rights of the German people and the interests of peace. All the actions of the Government of the Federal Republic of Germany show that it is clearing the way, step by step, for the establishment in Western Germany of a régime that should look like a democratic régime but which, in actual fact, would be close to the régime which plunged the world into a murderous war and led the German people to an unparalleled national catastrophe. Could the brazen Nazi and anti-Semitic outrages of the Fascist elements in Western Germany, which the world has recently witnessed, have occurred if conditions were different? Recently the Government of the Federal Republic of Germany did not scruple to take under its wing the organisers of those disgraceful demonstrations, and some West German officials, in the best Nazi tradition, have tried to lay the blame for those demonstrations on the Communists.

All this can only increase the people's mistrust of the policy of the

Federal Republic. Under these circumstances, an even more active struggle for the conclusion of a peace treaty with Germany becomes a necessity.

The countries represented at the present conference stand for peaceful co-operation and good-neighbourly relations with all states, including the Federal Republic of Germany, and they are sparing no efforts to achieve such co-operation in practice.

The Warsaw Treaty states are striving for a peaceful settlement with Germany, together with the other allied and associated Powers which took part in the war against Germany. This means the conclusion of a peace treaty which, in the existing conditions, can only be signed by both German states. At the same time, they cannot agree that the solution of these questions be postponed indefinitely, which can only encourage the militarist and revenge-seeking forces of Western Germany.

If the efforts towards the conclusion of a peace treaty with both German states do not meet with support and if the solution of this question comes up against attempts at procrastination, the states represented at the present conference will have no alternative but to conclude a peace treaty with the German Democratic Republic, together with the other states that are ready for this, and solve on this basis the question of West Berlin as well.

The states represented at the present conference reaffirm their inflexible desire for an improvement in the relations between countries of the East and West, for the strengthening of confidence between them, and for the development of all forms of international co-operation.

They continue to stand for the unhampered development of international trade, for the strengthening of contacts between statesmen, public leaders and organisations, and for exchanges of achievements in the fields of culture, science and technology, which enrich the peoples of all countries.

The ending of war propaganda, subversive appeals and attempts to threaten by the use of force would be of great importance for improving the international climate and eliminating suspicion in international relations.

As regards the Warsaw Treaty countries, war propaganda has been outlawed on their territories, and they are ready, for their part, to take further measures to have the atmosphere of mutual suspicion and sharp polemics in the relations between states superseded by good will and trust.

With the present noticeable relaxation of international tension, the proposal for the conclusion of a non-aggression pact between the two groups of states, the Warsaw Treaty and the North Atlantic Treaty Organisations, which has still not met with a positive solution, acquires even greater importance than in the past years. Convinced that the task of concluding a non-aggression pact between N.A.T.O. and the Warsaw Treaty Organisation, far from losing its topicality, is becoming steadily more important, the participants in the conference consider it necessary to declare that this offer still stands and that they are ready at any time to sign a non-aggression pact with the N.A.T.O. states.

The conclusion of bilateral non-aggression pacts between states belonging to different military groupings and the establishment in Europe of zones free from atomic and hydrogen weapons could also play a not inconsiderable part in improving the international situation.

The participants in the conference welcome with great satisfaction the agreement between the Soviet Union, the United States, Great Britain and France to hold a summit meeting in Paris in May this year. The governments of the Warsaw Treaty countries have long pressed for such a meeting

to be held, regarding it—as was pointed out in their Declaration of May 24, 1958—as " the most important means in the existing situation of safeguarding mankind against a military calamity and turning the course of international developments towards the consolidation of peace."

The Warsaw Treaty states consider that the forthcoming meeting of the heads of government should discuss such important and urgent questions as the problem of general and complete disarmament; the question of a German peace treaty, including the establishment of a free city of West Berlin; the prohibition of atomic and hydrogen weapon tests; and East-West relations. Proceeding on the basis of the conviction that any international problem, however complex it may seem, can be settled given reasonable consideration for the interests of the parties and a general desire for peace, the participants in the conference express the hope that the heads of government will succeed in finding the correct ways to a successful solution of the aforementioned questions in the interests of strengthening universal peace, and that the forthcoming summit meeting will be a turning point in East-West relations.

Now, on the eve of crucial talks between statesmen of the East and the West, on the eve of a meeting at the summit, it is especially important, in the opinion of the Warsaw Treaty countries, that all states should do everything in their power to create a situation facilitating the success of the coming talks. The states represented at the present conference declare that they will act precisely in this direction and urge all other countries to promote the success of East-West talks and to refrain from any steps capable of complicating these negotiations.

The governments of the Warsaw Treaty countries note with satisfaction that their untiring efforts aimed at the termination of the arms race, the elimination of dangerous seats of international conflicts, and the ending of the cold war, are meeting with ever wider support from the peoples of the world and are yielding positive results. They are unanimous in believing that in our time the states do not and cannot have any greater or nobler task than that of contributing to the establishment of lasting peace on earth. Moscow, February 4, 1960.

[Text as published in *Soviet News* (London: Soviet Embassy), No. 4207, February 5.]

K'ang Sheng's Speech to the Warsaw Treaty Meeting

Comrade Chairman, Dear Comrades:

In the capacity of an observer of the People's Republic of China, I have the honour to attend this regular conference of the Political Consultative Committee of member states of the Warsaw Treaty. We are convinced that the convening of this conference will make new contributions to further relaxing the international situation and encouraging the people of the world in their struggle against the expansion of armaments and war preparations and for a lasting peace. We wish the conference success.

The current international situation continues to develop in a direction favourable to peace. There have appeared certain tendencies towards relaxation of the international tension created by imperialism. Comrade Nikita Khrushchov made a successful visit to the United States. Prompted by the Soviet Union's foreign policy of peace and the peace-loving people and countries of the world, an East-West summit conference will soon be

convened. As to the disarmament question, a certain measure of agreement has also been reached on procedural matters. The Chinese people and all other peace-loving people and countries the world over rejoice at this. The emergence of such a situation is not accidental. This is the result of repeated struggles waged by the Socialist forces, the national revolutionary forces and the forces of peace and democracy against the imperialist war forces, the result of the East wind prevailing over the West wind.

The incomparable strength and the firm unity of the Socialist camp headed by the Soviet Union and its outstanding and effective efforts in the cause of peace are the decisive factors in this tendency towards easing the international situation. We are happy to see that construction in all the Socialist countries is gathering speed and their material strength greatly enhanced. The Soviet Union, particularly, has scored brilliant achievements in carrying out its enormous Seven-Year Plan. The Soviet success in successive launchings of man-made earth satellites and cosmic rockets marks the fact that in the most important fields of science and technology, the Soviet Union has left the United States far behind. The balance of world forces has undergone a further, huge change favourable to peace and Socialism thereby greatly fortifying the will to struggle, and confidence in victory, of the people throughout the world.

The unswerving struggle carried out by the powerful world forces of peace has caused repeated setbacks to the U.S. imperialists' " position of strength " and " brink of war " policies. Not only is the United States becoming increasingly isolated politically as the days go by, but militarily, its forces are dispersed and it is lagging behind in new weapons; economically, too, its situation is becoming increasingly difficult. In these circumstances, and particularly under pressure of the strong desire for peace of the people everywhere, the U.S. ruling circles were obliged to make some peace gestures. Of course it is better to talk peace than to talk war. Nevertheless, even the U.S. ruling circles themselves do not try to hide the fact that the change in their way of doing things is aimed at numbing the fighting spirit of the people of the world by means of the " strategy to win victory by peace," wrecking the unity of the peace forces of the world and disintegrating the Socialist camp; they are even dreaming of a so-called " peaceful evolution " in the Socialist countries. These wild ambitions of the U.S. ruling circles will, of course, not be realised. While being obliged to make certain peace gestures, the U.S. ruling circles are still pushing ahead vigorously with their arms expansion and war preparations, making a strenuous effort to develop inter-continental ballistic missiles, setting up and expanding missile bases in various places, claiming to be ready at any time to resume nuclear weapons tests, and actively trying to strengthen and patch up military *blocs* in an attempt to gain time to improve their inferior military position.

U.S. President Eisenhower's State of the Union Message recently gave the clearest indication that the new tricks of the United States are designed to gain precisely what it failed to obtain by its old tricks. The actions of the United States prove fully that its imperialist nature will not change. American imperialism still remains the arch enemy of world peace. All those throughout the world who are working sincerely for peace must maintain their vigilance against U.S. double-dealing. If our Socialist camp and the people of all countries in the world continue to strengthen unity, continue to fortify our strength and thoroughly smash all the intrigues and

schemes of the enemy of peace, U.S. war plans can be set back even further and even checked, and the cause of defence of peace will certainly win still greater victories.

At the present time universal disarmament is an important question relating to the defence of world peace. Since World War II, the Soviet Union has time and again made positive proposals for disarmament, the banning of atomic weapons and the ending of nuclear weapons tests. The Soviet Union and other Socialist countries have, on their own initiative, reduced their armed forces. Not long ago, the Soviet Union proposed general and complete disarmament at the U.N. General Assembly. It later adopted a law at the Supreme Soviet session, again slashing its armed forces unilaterally by 1·2 million men. These facts convincingly demonstrate the sincerity of the Soviet Union and other Socialist countries for peace and their confidence in their own strength.

Although U.S. imperialism dare not oppose disarmament in so many words, it has always in fact sabotaged universal disarmament. Whenever certain U.S. proposals were accepted by the Soviet Union, the United States always concocted new pretexts for a retreat from its original position, creating all kinds of difficulties and preventing by every means the reaching of agreement on the disarmament question. U.S. actions prove that it will not abandon its policy of the arms race. Therefore, the struggle for universal disarmament is a long-term and complicated struggle between us and imperialism.

The Chinese Government and the Chinese people have always stood for universal disarmament, and actively supported the proposals concerning disarmament made by the Soviet Union and other Socialist countries. Since 1951, the Chinese Government has on its own initiative again and again reduced its armed forces. The present Chinese armed forces are less than half their original size. We shall continue to work tirelessly for universal disarmament together with the Soviet Union and other Socialist countries. We hope that the countries concerned will reach agreement on this question of universal disarmament. The Chinese Government has never hesitated to commit itself to all international obligations with which it agrees. But U.S. imperialism, hostile to the Chinese people, has always adopted a discriminatory attitude against our country in international relations. Therefore, the Chinese Government has to declare to the world that any international disarmament agreement and all other international agreements which are arrived at without the formal participation of the Chinese People's Republic and the signature of its delegate cannot, of course, have any binding force on China.

The German question has a particularly important place among outstanding international issues. Its solution has a bearing not only on the security of Europe but also on the peace of the world. The permanent division of Germany and the speeded-up revival of West German militarism are an important component part of the U.S. imperialist policy of war and aggression. The recent frenzied war cries of Adenauer and the rampant anti-semitic activities started by the West German Fascist forces are the outcome of U.S. instigation and support. The Governments of the Soviet Union and the German Democratic Republic have time and again put forward reasonable proposals for settlement of the German question. But all these proposals have been rejected by the United States and West Germany. In its efforts to come to agreement with the Western Powers on

the conclusion of a German peace treaty and on ending the occupation régime in West Berlin, the Soviet Union has made many concessions, whereas the Western Powers have to date made no appropriate response. The Chinese Government and people will steadfastly support the basic stand taken by the Soviet Union and the German Democratic Republic on the solution of the German question, and the struggle of the German people for the reunification of their motherland on the basis of peace and democracy.

While intensifying its efforts to re-arm West Germany, U.S. imperialism is reviving Japanese militarism in the East, and has signed a Japan-U.S. treaty of military alliance with the Kishi Government, its close follower. The Chinese Government has issued a statement strongly condemning this act of the U.S. and Japanese reactionaries which threatens the peace and security of Asia. The Soviet Government, too, has sent a memorandum to the Japanese Government, pointing out that the treaty seriously endangers the interests of the Soviet Union, China and many other countries in the Asian and Pacific regions. The people of all lands, including the Japanese people, are unanimous in their firm opposition to this further step of military collusion between the U.S. and Japanese reactionaries.

The Chinese Government and people hold that West Germany and Japan, which are supported energetically by U.S. imperialism, have become two sources of serious war danger. All peace-loving peoples and countries of the world must maintain a high state of vigilance against this, and exert every effort to prevent the militarism of these two countries from violating world peace.

In other parts of Asia, U.S. imperialism also continues to create international tension. The Chinese People's Volunteers withdrew from Korea on their own initiative long ago, but U.S. forces are still hanging on in South Korea and are trying hard to obstruct Korea's peaceful reunification. The United States, supporting the reactionary forces in Laos, undermined the Geneva agreements and the Vientiane agreements and provoked civil war in Laos. At the Sino-American ambassadorial talks, China has persistently advocated the principle of settling disputes between China and the United States by means of peaceful negotiation and without resort to force or threat of force. But the United States has all along refused to reach agreement with China in accordance with this principle and up till now is occupying our territory of Taiwan. The U.S. navy and air force have been constantly making military provocations against our country despite our repeated warnings. Therefore, the Chinese people and all the people of the world must unite still more closely and resolutely smash U.S. schemes for new wars and aggression in Asia.

The foreign policy of our Socialist countries has always firmly adhered to the principle of peaceful coexistence among countries with different social systems. We Socialist countries will never encroach upon others, but neither will we tolerate encroachment by others. Lenin said that to achieve peaceful coexistence, no obstacle would come from the Soviet side. Obstacles could come only from imperialism, from the side of American (as well as any other) capitalists. We will continue to adhere to Lenin's principle of peaceful coexistence. Our efforts to carry out this principle have won the support of increasing numbers of people. But if the imperialist reactionaries mistake this for a sign of weakness and dare to impose war on us, then they will only be inviting their own destruction.

The Chinese people have always sympathised with and supported the

national and democratic movements of the peoples of Asia, Africa, and Latin America and striven for long-term, friendly relations with the nationalist countries in Asia and Africa on the basis of the Five Principles of Peaceful Coexistence jointly initiated by our country with India and Burma. To realise their ulterior aims, the imperialists have tried by every means to undermine our country's unity with these countries. One of their chief tricks to undermine this unity is to use the border issue and the overseas Chinese issue, which are legacies of history, to sow discord and cook up anti-Chinese plots in a vain attempt to isolate China. The reactionary forces in certain Asian countries also make use of these issues to try to undermine the friendship between the people of their countries and the Chinese people. They attempt to use the anti-Chinese campaign to divert the attention of the people of their countries from domestic issues and to create pretexts for suppressing the democratic, progressive forces in their own countries. In our relations with certain Asian nationalist countries, there once appeared small patches of dark cloud, but the sun cannot be overshadowed for long and friendship between our people and the people of these countries will certainly be maintained and developed.

Recently the Indonesian Government and our Government have exchanged the instruments of ratification of the treaty concerning the question of dual nationality, set up a joint committee to implement the treaty and started talks on questions relating to the return of overseas Chinese to their homeland. A certain period of time is needed for an overall settlement of the overseas Chinese question and there may still be some twists and turns. But, if both sides treasure their friendship, persist in peaceful consultations and seriously carry out the agreements already reached, the overseas Chinese question can be solved justly and reasonably.

China and Burma have always had friendly relations. Recently, the Prime Minister of Burma Ne Win visited our country and signed with the Chinese Premier the Sino-Burmese Treaty of Friendship and Mutual Non-Aggression and an agreement between the two Governments on the boundary question. This not only signifies that friendly relations of the two countries have entered a new stage, but also sets a new example for friendship and solidarity among the Afro-Asian countries. The Sino-Burmese border question is a complicated one left over by history. The imperialist reactionaries used this question to sow dissension and cause division. But both Chinese and Burmese Governments sincerely desire peace and friendship, so the two parties were able to reach agreement in principle speedily and pave the way for an overall, thorough settlement of this question. The Sino-Burmese Treaty of Friendship and Mutual Non-Aggression offers striking proof that the Five Principles of Peaceful Coexistence have certainly not " outlived themselves " or " become defunct " as certain reactionary elements and instigators of war allege, but, on the contrary, are showing their great vitality with increasing clarity. These facts thoroughly give the lie to the slanders of the imperialists and all reactionaries about China's " aggression." They amply prove that China's sincerity in abiding by the Five Principles of Peaceful Coexistence can stand the test of time and history. Those who attempt to isolate China have failed to do so. On the contrary, they have isolated themselves.

Strengthening the unity of the countries of the Socialist camp is a matter of the utmost importance. Our unity is built on the ideological basis of Marxism-Leninism, on the basis of proletarian internationalism. The

Moscow meetings of the Communist and Workers' Parties of the Socialist countries held in 1957 ushered in a new historic period in our unity. The Declaration adopted at this meeting is the charter of solidarity of our Socialist camp. The imperialists, the modern revisionists and the reactionaries in all countries are always dreaming that changes in their favour will occur within our countries and splits will occur in the unity between our countries. The greater the difficulties they come up against, the more they hope to save themselves from their doom by sabotage within our countries and by undermining the unity between our countries. However, in face of our great unity, their futile calculations can never be realised. The Chinese Communist Party and the Chinese people have always taken the safeguarding of the unity of the Socialist camp headed by the Soviet Union as their sacred international duty. They have always regarded an attack against any Socialist country by the imperialists and all reactionaries as an attack against China. They have always considered that the modern revisionists of Yugoslavia are renegades to the Communist movement, that revisionism is the main danger in the present Communist movement and that it is necessary to wage a resolute struggle against revisionism. This stand of ours is firm and unshakable. Working for the cause of peace and Socialism, we Socialist countries will certainly extend further support and help to each other. As long as the Socialist camp is united, the unity of the peoples of the world has a firm nucleus and the victory of our cause has a reliable guarantee.

The present situation is extremely favourable to us. Let us hold aloft the banner of peace, the banner of Socialism and Communism and march victoriously towards our great goal!

[*Peking Review*, No. 6, 1960.]

3. The Conflict Raised to the Ideological Plane

THE publication of the article "Long Live Leninism!" in the Chinese Communist Party's theoretical journal *Red Flag* (No. 8, 1960) on April 16, marked the start of the most important and bitter stage of the dispute. The opening shots had already been fired in the previous issue of *Red Flag* [7]; but "Long Live Leninism!" must rank as the major statement of the four issued by Peking on the occasion of the ninetieth anniversary of the birth of Lenin [8] because of its comprehensive nature and its translation of the most recent Sino-Soviet policy disagreements into ideological terms.

By stating their position in theoretical language, by asserting their orthodoxy in Leninist terms, the Chinese were doing two things. They were challenging the right of Moscow to act as supreme arbiter of *bloc* policy by alleging Khrushchev to be guilty of doctrinal deviations; and they were affirming their determination to persist in their own views. Such a challenge to his leadership and his policies by the second power of the *bloc* Khrushchev had to reject in the strongest terms.

The first section of "Long Live Leninism" outlines the scope of the problems to be discussed. A series of "irrefutable truths" which Lenin revealed are first listed: as long as imperialism exists the possibility of war remains; the liberation of the proletariat must be through revolution not reformism; the struggle between Communism and capitalism will embrace a whole historical epoch; the fundamental question concerning the proletarian revolution is the establishment of the proletarian dictatorship by smashing the bougeois state machine; the proletariat must have its own genuinely revolutionary party.

Since the Bolshevik revolution there had been a number of important changes in the world situation—tremendous economic and technological progress in the Soviet Union, the establishment of the Communist *bloc*, the continuing disintegration of the colonial system, the increasing instability of capitalism. The forces of Communism had surpassed those

[7] See "Imperialism—Source of War in Modern Times—and the Path of the Peoples' Struggle for Peace" by Yü Chao-li, reproduced in *Peking Review*, No. 15, 1960.

[8] The other two were the *People's Daily* editorial on the actual anniversary, April 22, entitled "Forward Along the Path of the Great Lenin," and the speech made by Lu Ting-yi, Chairman of the Communist Party's Propaganda Department, at the Lenin anniversary meeting in Peking on the same day. Both statements and "Long Live Leninism!" are reproduced in *Peking Review*, No. 17, 1960.

of capitalism. Did this mean that the aforementioned teachings of Lenin had lost some or all of their validity?

The second section discusses the question of epochs, refuting Tito's assertion that the world had entered upon a new epoch of tranquillity in which nations could devote themselves to internal construction and consider problems of international economic co-operation rather than those of war and peace. The main concern of this section is to tackle the question of rockets and nuclear weapons, in effect to reject the idea that the invention of these weapons necessitates both *blocs* seeking a *modus vivendi* in order to avoid joint suicide. That the argument is aimed at Khrushchev and not just Tito is indicated by the statement that besides the Yugoslav dictator "there are people who hold incorrect views because they are not able to approach the question from the materialist standpoint of history."

The importance of the new weapons is minimised by a reference to them as "specific details of technological progress" and it is stated categorically that "it is not technique but man, the masses of the people, that determine the fate of mankind." Even if the "imperialists" were to launch a war, it would only mean their destruction, "the result will certainly not be the annihilation of mankind." Here the Chinese were of course on the solid ground of orthodoxy, an orthodoxy which for all his hints Khrushchev had not yet had the desire or, perhaps, the courage to reject in the way Malenkov had.

The question of war and peace is considered in detail in section three though the Chinese attitude has already been made clear in the preceding argument. It is allowed that "some new questions have now arisen concerning peaceful co-existence," that due to the power of the Communist *bloc* the West would have to consider whether an attack on it would not result in its own extinction—a roundabout admission that nuclear weapons had made war more dangerous and therefore less likely. The 1957 Declaration's assertion that the forces of peace could prevent war is quoted; even the possibility of a nuclear test ban agreement is mentioned.

But yet the article goes on to assert: "War is an inevitable outcome of systems of exploitation and the source of modern wars is the imperialist system. Until the imperialist system and the exploiting classes come to an end, wars of one kind or another will always occur." The wars might be inter-imperialist wars, attacks by imperialist nations on "oppressed nations" (*i.e.*, neutralists such as Egypt), revolutionary civil wars, or East-West wars.

What is quite clear from this categorical statement is that the Chinese refused to accept the optimistic analysis made by Khrushchev at the CPSU's Twenty-first Congress which is nowhere referred to. What is

not so clear is how the Chinese reconciled their acceptance of Khrushchev's revision of Leninism at the Twentieth Congress, embodied in the 1957 Declaration, with their assertion that some form of war was inevitable.

Clearly there is a contradiction here. A possible explanation of it that would jibe with what seem to be the main policy considerations of the Chinese would be that in signing the 1957 Declaration, Mao Tse-tung committed himself to too imprecise a definition of " war." The section from the Declaration quoted in " Long Live Leninism! " almost certainly means *world* war though it only refers to " war." Khrushchev, himself, in his Twenty-first Congress speech, referred to *world* war as we emphasised in the discussion of his remarks.

Certainly the Chinese do not concede much by agreeing *world* war is not inevitable; for even so, other wars must occur and so peace must be struggled for, and this means that international tension will be maintained. But an admission that war in general was not inevitable would imply an overall easing of the international situation and a dampening of the national revolutionary movement in particular. Now the Chinese, as we have seen, consider the latter a vital component in the struggle for peace, *i.e.*, a major method of sapping the strength of the West. And any general easing of international tension would, we have suggested, result in the freezing of what is for China a basically unfavourable situation in the Far East.

The next two sections are concerned with the problem of " peaceful transition " and the attitude towards parliament in bourgeois countries to be adopted by local Communist Parties. The argument would seem designed to undermine the position adopted by Khrushchev at the Twentieth Congress. " Peaceful transition " is described in Lenin's words as an " extraordinarily rare opportunity "; the general rule remains that civil war must be the road to power for Communists. The use of parliament is to enhance the political consciousness of the masses; it would be " difficult to imagine " that a Communist Party could introduce a Communist programme by this method. The article continues:

> A series of experiences in the capitalist countries long ago proved this point fully and the experience in various European *and Asian countries* after the Second World War provide additional proof of it (emphasis added).

It is reasonable to suppose that while the Chinese mention Western Europe, their primary concern here is with Asia, and probably with India in particular. Certainly the reference to the bourgeoisie's ability to dissolve parliament when necessary, or to use various open and underhand tricks to turn a working-class party which is the biggest party in parliament into a minority, or to reduce its seats in parliament, even

when it has polled more votes in an election would apply neatly, from a Communist point of view, to the events in Kerala over the previous nine months.

Clearly the general aim of the Chinese is to prevent the sapping of the revolutionary vigour of Asian Communist Parties. They allude to the disastrous results for the Chinese Communist Party when it lowered its revolutionary standards. But doubtless national considerations played a considerable role in determining the Chinese to put forward their analysis. China was involved in major disputes with India and Indonesia, and the attitude adopted by Peking had considerably lessened the friendliness of those two powers towards Mao's régime. The Bandung " spirit " had disappeared. The benefit to China of cultivating Mr. Nehru and President Sukarno must have seemed extremely marginal; while if the Communist Parties in those leaders' countries were to adopt more revolutionary tactics, China might well expect to benefit from any internal weakening that ensued.

Besides, a prominent aspect of Soviet friendship for the neutralist countries was the granting to them of considerable quantities of aid. The Chinese could well feel aggrieved at the comparatively niggardly treatment they had received bearing in mind their relationship to the Soviet Union; they might hope that a new and more jaundiced view of the neutralists would result in the diversion of more aid to themselves.

The national liberation movement is mentioned only in passing in these two sections (which are followed by a final call for supporting Leninism and combating " revisionism "). It is treated at somewhat greater length in Yü Chao-li's article mentioned above. The not unexpected conclusion is that the

> masses of the oppressed fighting for complete national independence . . . form an important and indispensable force in the peace movement. . . . To achieve world peace, people everywhere should give their support to national liberation movements in the colonial and semi-colonial countries, to the anti-imperialist struggles of countries which have already won national independence and to the righteous wars for national liberation and against imperialist aggression.

From the point of view of the dispute, the main interest in the *People's Daily* editorial of April 22 is its extended documentation of the Chinese case propounded at the Warsaw Treaty meeting, namely that the United States is not really interested in peace and only makes " peace gestures " to hide its preparations for war. The thirty-seven items of documentation, which range from America's support of the Tibet resolution in the UN to Under-secretary of State Dillon's analysis of Soviet foreign policy, are all drawn from the period succeeding Khrushchev's talks with Eisenhower at Camp David. They are used to support the conclusion that

even after the Camp David talks and even on the eve of the East-West summit conference, we see no change at all in substance in U.S. imperialist war policy, in the policy carried out by the U.S. Government and by Eisenhower personally.

This passage strongly suggests that this editorial together with all the other Chinese pronouncements issued at this juncture were issued with the imminent summit conference in mind, perhaps in a last attempt to sway Khrushchev, certainly with a view to emphasising Peking's continuing rejection of his policy towards the West. The passage is a firm rejection of Soviet propaganda claiming valuable gains were achieved by the Camp David meeting and Khrushchev's personal vouching for Eisenhower as a man of peace as distinct from the advocates of the cold war among his advisers.[9]

There is a hint in the editorial that Khrushchev may have asked Mao Tse-tung without success to display moderation on the eve of the summit, for the editorial asks of no one in particular:

> Can it be bad for peace, can it aggravate tension if we explain the true state of affairs to the Chinese and world public, or can concealing the truth help peace and help relax tension?

"Long Live Leninism!"

I

APRIL 22 of this year is the ninetieth anniversary of the birth of Lenin.

1871, the year after Lenin's birth, saw the heroic uprising of the Paris Commune. The Paris Commune was a great, epoch-making revolution, the first dress rehearsal of universal significance in the proletariat's attempt to overthrow the capitalist system. When the Commune was on the verge of defeat as a result of the counter-revolutionary attack from Versailles, Marx said:

> If the Commune should be destroyed, the struggle would only be postponed. The principles of the Commune are perpetual and indestructible; they will present themselves again and again until the working class is liberated. ("Speech on the Paris Commune," *Collected Works of Marx and Engels*, 1st Russ. ed., Vol. XIII, part 2, p. 655.)

What is the most important principle of the Commune? According to Marx, it is that the working class cannot simply take hold of the existing state machine, and use it for its own purposes. In other words, the proletariat should use revolutionary means to seize state power, smash the military and bureaucratic machine of the bourgeoisie and establish the proletarian dictatorship to replace the bourgeois dictatorship. Anyone familiar with the history of proletarian struggle knows that it is precisely this fundamental question which forms the dividing line between Marxists on the one hand and opportunists and revisionists on the other, and that after the death of Marx and Engels it was none other than Lenin who waged a thoroughly uncompromising struggle against the opportunists and revisionists in order to safeguard the principles of the Commune.

[9] See Khrushchev's speech in Peking on p. 61, above.

The cause in which the Paris Commune did not succeed finally triumphed forty-six years later in the Great October Revolution under Lenin's direct leadership. The experience of the Russian Soviets was a continuation and development of the experience of the Paris Commune. The principles of the Commune continually expounded by Marx and Engels and enriched by Lenin in the light of the new experience of the Russian revolution, became a living reality for the first time on one-sixth of the earth. Marx was perfectly correct in saying that the principles of the Commune are perpetual and indestructible.

In their attempt to strangle the new-born Soviet State, the imperialist jackals carried out armed intervention against it, in league with the Russian counter-revolutionary forces of that time. But the heroic Russian working class and the people of the various nationalities of the Soviet Union drove off the foreign bandits, wiped out the counter-revolutionary rebellion within the country and thus consolidated the world's first great Socialist Republic.

Under the banner of Lenin, under the banner of the October Revolution, a new world revolution began, with the proletarian revolution playing the leading role. A new era dawned in human history.

Through the October Revolution, the voice of Lenin quickly resounded throughout the world. The Chinese people's anti-imperialist, anti-feudal May 4 Movement in 1919, as Comrade Mao Tse-tung put it, " came into being at the call of the world revolution of that time, of the Russian Revolution and of Lenin." (" On New Democracy," *Selected Works of Mao Tse-tung*, Lawrence and Wishart, London, 1954, Vol. III, p. 146.)

Lenin's call is powerful because it is correct. Under the historical conditions of the imperialist era, Lenin revealed a series of irrefutable truths concerning the proletarian revolution and the proletarian dictatorship.

Lenin pointed out that the oligarchs of finance capital in a small number of capitalist powers, that is, imperialists, not only exploit the masses of people in their own countries, but oppress and plunder the whole world, turning most countries into their colonies and dependencies. Imperialist war is a continuation of imperialist policy. World wars are started by the imperialists because of their insatiable greed in struggling for world markets, sources of raw materials and fields for investment, and to redivide the world. So long as capitalist imperialism exists in the world, the sources and possibility of war will remain. The proletariat should guide the masses of people to an understanding of the sources of war and to struggle for peace and against imperialism.

Lenin asserted that imperialism is monopolistic, parasitic or decaying, moribund capitalism, that it is the final stage in the development of capitalism and therefore is the eve of the proletarian revolution. The emancipation of the proletariat can only be arrived at by the road of revolution, and certainly not by the road of reformism. The liberation movement of the proletariat in the capitalist countries should ally itself with the national liberation movements in the colonies and dependent countries; this alliance can smash the alliance of the imperialists with the feudal and comprador reactionary forces in the colonies and dependent countries, and will therefore inevitably put a final end to the imperialist system throughout the world.

In the light of the law of the uneven economic and political development of capitalism, Lenin came to the conclusion that, because capitalism developed extremely unevenly in different countries, socialism would achieve

victory first in one or several countries but could not achieve victory simultaneously in all countries. Therefore, in spite of the victory of socialism in one or several countries, other capitalist countries will still exist, and this will give rise not only to friction but also to imperialist subversive activities against the socialist states. Hence the struggle will be protracted. The struggle between socialism and capitalism will embrace a whole historical epoch. The socialist countries should maintain constant vigilance against the danger of imperialist attack and do their best to guard against this danger.

The fundamental question of all revolutions is the question of state power. Lenin showed in a comprehensive and penetrating way that the fundamental question of the proletarian revolution is the proletarian dictatorship. The proletarian dictatorship, established by smashing the state machine of the bourgeois dictatorship by revolutionary means, is an alliance of a special type between the proletariat and the peasantry and all other working people; it is a continuation of the class struggle in another form under new conditions; it involves a persistent struggle, both sanguinary and bloodless, violent and peaceful, military and economic, educational and administrative, against the resistance of the exploiting classes, against foreign aggression and against the forces and traditions of the old society. Without the proletarian dictatorship, without its full mobilization of the working people on these fronts to wage these unavoidable struggles stubbornly and persistently, there can be no socialism, nor can there be any victory for socialism.

Lenin considered it of prime importance for the proletariat to establish its own genuinely revolutionary political party which completely breaks with opportunism, that is, a Communist Party, if the proletarian revolution is is to be carried through and the proletarian dictatorship established and consolidated. This political party is armed with the theory of Marxist dialectical materialism and historical materialism. Its programme is to organize the proletariat and all oppressed working people for class struggle, to set up proletarian rule and passing through socialism to reach the final goal of communism. This political party must identify itself with the masses and attach great importance to their creative initiative in the making of history; it must closely rely on the masses in revolution and must do the same in socialist and communist construction.

These truths were constantly set forth by Lenin before and after the October Revolution. The world reactionaries and philistines of the time thought these truths of Lenin terrifying. But we see these truths winning victory after victory in the practical life of the world.

In the forty years and more since the October Revolution, tremendous new changes have taken place in the world.

Through its great achievements in socialist and communist construction, the Soviet Union has transformed itself from an economically and technically very backward country in the days of imperial Russia into a first-rate world power with the most advanced technology. By its economic and technological leaps the Soviet Union has left the European capitalist countries far behind and left the United States behind, too, in technology.

The great victory of the anti-fascist war in which the Soviet Union was the main force broke the chain of imperialism in Central and Eastern Europe. The great victory of the Chinese people's revolution broke the chain of imperialism on the Chinese mainland. A new group of socialist

countries was born. The whole socialist camp headed by the Soviet Union has one-quarter of the earth's land space and over one-third of the world's population. The socialist camp has now become an independent world economic system, standing opposite the capitalist world economic system. The gross industrial output value of the socialist countries now accounts for nearly 40 per cent. of the world total, and it will not be long before it surpasses the gross industrial output value of all the capitalist countries put together.

The imperialist colonial system has disintegrated and is disintegrating further. The struggle naturally has its twists and turns, but on the whole the storm of the national liberation movement is sweeping over Asia, Africa and Latin America on a daily increasing scale. Things are developing towards their opposites: There the imperialists are going step by step from strength to weakness, while the people are going step by step from weakness to strength.

The relative stability of capitalism, which existed for a time after the First World War, ended long ago. With the formation of the socialist world economic system after the Second World War, the capitalist world market has greatly shrunk. The contradiction between the productive forces and production relations in capitalist society has become more acute. The periodic economic crises of capitalism no longer come as before once every ten years or so, but occur almost every three or four years. Recently, some representatives of the U.S. bourgeoisie have admitted that the United States has suffered three " economic recessions " in ten years, and they now have premonitions of a new " economic recession " after just having pulled through the one in 1957–58. The shortening of the interval between capitalist economic crises is a new phenomenon. It is a further sign that the world capitalist system is drawing nearer and nearer to its inevitable doom.

The unevenness in the development of the capitalist countries is worse than ever before. The domain of the imperialists has shrunk more and more, so that they collide with one another. U.S. imperialism is constantly grabbing markets and spheres of influence away from the British, French and other imperialists. The imperialist countries headed by the United States have been expanding armaments and making war preparations for more than ten years, while West German and Japanese militarists, defeated in the Second World War, have risen again with the help of their former enemy— U.S. imperialism. The imperialists of these two countries have come out to join in the scramble for the capitalist world market, are now once again talking long and loudly about their " traditional friendship " and are engaging in new activities for a so-called " Bonn-Tokyo axis with Washington as the starting point." West German imperialism is looking brazenly around for military bases abroad. This aggravates the bitter conflicts within imperialism and at the same time heightens the threat to the socialist camp and all peace-loving countries. The present situation is very much like that after the First World War when the U.S. and British imperialists fostered the resurgence of German militarism, and the outcome will again be their " picking up a rock only to drop it on their own feet." The U.S. imperialists' creation of world tension after the Second World War is a sign not of their strength but of their weakness and precisely reflects the unprecedented instability of the capitalist system.

The U.S. imperialists, in order to realize their ambition for world domination, not only carry out all kinds of premeditated sabotage and

subversion against the socialist countries, but also, under the pretext of opposing " the communist menace," in their self-appointed role of world gendarme for suppressing the revolution in various countries, deploy their military bases all around the world, seize the intermediate areas and carry out military provocations. Like a rat running across the street while every one shouts " Throw something at it!" the U.S. imperialists run into bumps and bruises everywhere and, contrary to their intentions, everywhere arouse a new upsurge of the people's revolutionary struggle. Now, they themselves are becoming aware that, in contrast with the growing prosperity of the socialist world headed by the Soviet Union, " the influence of the United States as a world power is declining." In them, one " can only see the decline and fall of ancient Rome."

The changes taking place in the world in the past forty years and more indicate that imperialism rots with every passing day while for socialism things are daily getting better. It is a great, new epoch that we are facing and its main characteristic is that the forces of socialism have surpassed those of imperialism, that the forces of the awakening people of the world have surpassed those of reaction.

The present world situation has obviously undergone tremendous changes since Lenin's lifetime, but these changes have not proved the obsoleteness of Leninism; on the contrary, they have more and more clearly confirmed the truths revealed by Lenin and all the theories he advanced during the struggle to defend revolutionary Marxism and develop Marxism.

In the historical conditions of the epoch of imperialism and proletarian revolution, Lenin carried Marxism forward to a new stage and showed all the oppressed classes and people the path along which they could really shake off capitalist-imperialist enslavement and poverty. These forty years have been forty years of victory for Leninism in the world, forty years in which Leninism has found its way deeper into the hearts of the world's people. Leninism has not only won and will continue to win great victories in countries where the socialist system has been established, but is also constantly achieving new victories in the struggles of all oppressed peoples

The victory of Leninism is acclaimed by the people of the whole world and at the same time cannot but incur the enmity of the imperialists and all reactionaries. The imperialists, to weaken the influence of Leninism and paralyse the revolutionary will of the masses, launch the most barbarous and despicable attacks and slanders against Leninism, and, moreover, put up and utilize the vacillators and renegades within the workers' movement to distort and emasculate the teachings of Lenin. At the end of the nineteenth century when Marxism was putting various anti-Marxist trends to rout spreading widely throughout the workers' movement and gaining a predominant position, the revisionists represented by Bernstein proposed to revise the teachings of Marx, in keeping with the needs of the bourgeoisie. Now, when Leninism is guiding the working class and all oppressed classes and nations of the world to great victories in the march against imperialism and all kinds of reactionaries, the modern revisionists represented by Tito propose to revise the teachings of Lenin (that is, modern Marxist teachings), in keeping with the needs of the imperialists. As pointed out in the Declaration of the meeting of representatives of the Communist and Workers' Parties of the socialist countries held in Moscow in November 1957, " The existence of bourgeois influence is an internal source of revisionism, while surrender to imperialist pressure is its external source." Old revisionism

ttempted to prove that Marxism was outmoded, while modern revisionism ttempts to prove that Leninism is outmoded. The Moscow Declaration said:

> Modern revisionism seeks to smear the great teaching of Marxism-Leninism, declares that it is "outmoded" and alleges that it has lost its significance for social progress. The revisionists try to kill the revolutionary spirit of Marxism, to undermine faith in socialism among the working class and the working people in general.

This passage of the Declaration has put it correctly; such is exactly the situation.

Are the teachings of Marxism-Leninism now "outmoded"? Does the whole, integrated teaching of Lenin on imperialism, on proletarian revolution nd proletarian dictatorship, on war and peace, and on the building of ocialism and communism still retain its vigorous vitality? If it is still valid nd does retain vigorous vitality, does this refer only to a certain portion of t or to the whole? We usually say that Leninism is Marxism in the epoch of mperialism and proletarian revolution, Marxism in the epoch of the victory of socialism and communism. Does this view remain correct? Can it be aid that Lenin's original conclusions and our usual conception of Leninism, ave lost their validity and correctness, and that therefore we should turn ack and accept those revisionist and opportunist conclusions which Lenin ong ago smashed to smithereens and which have gone disgracefully bankupt in actual life? These questions now confront us and must be answered. Marxist-Leninists must thoroughly expose the absurdities of the imperialists nd modern revisionists on these questions, eradicate their influence among he masses, awaken those they have temporarily hoodwinked and further rouse the revolutionary will of the masses.

II

THE U.S. imperialists, open representatives of the bourgeosie in many ountries, the modern revisionists represented by the Tito clique, and the ight-wing social democrats, in order to mislead the people of the world, do ll they can to paint an utterly distorted picture of the contemporary world ituation in an attempt to confirm their ravings on how "Marxism is outmoded," and "Leninism is outmoded too."

Tito's speech at the end of last year referred repeatedly to the so-called new epoch" of the modern revisionists. He said, "Today the world has ntered an epoch in which nations can relax and tranquilly devote themselves o their internal construction tasks." Then he added, "We have entered an poch when new questions are on the agenda, not questions of war and eace but questions of co-operation, economic and otherwise, and when conomic co-operation is concerned, there is also the question of economic ompetition." (From Tito's speech in Zagreb, December 12, 1959.) This enegade completely writes off the question of class contradictions and class truggle in the world, in an attempt to negate the consistent interpretation of Marxist-Leninists that our epoch is the epoch of imperialism and proletarian evolution, the epoch of the victory of socialism and communism.

But how do things really stand in the world?

Can the exploited and oppressed people in the imperialist countries relax"? Can the peoples of all the colonies and semi-colonies still under mperialist oppression "relax"?

Has the armed intervention led by the U.S. imperialists in Asia, Africa nd Latin America become "tranquil"? Is there "tranquillity" in our

Taiwan Straits when the U.S. imperialists are still occupying our country's Taiwan? Is there " tranquillity " on the African continent when the people of Algeria and many other parts of Africa are subjected to armed repressions by the French, British and other imperialists? Is there any " tranquillity " in Latin America when the U.S. imperialists are trying to wreck the people's revolution in Cuba by means of bombing, assassination and subversion?

What kind of " construction " is meant in saying " (they) devote themselves to their internal construction tasks "? Everyone knows that there are different types of countries in the world today, and principally two types of countries with social systems fundamentally different in nature. One type belongs to the socialist world system, the other to the capitalist world system. Is Tito referring to the " internal construction tasks " of arms expansion which the imperialists are carrying out in order to oppress the peoples of their own countries and oppress the whole world? Or is it the " internal construction " carried out by socialism for the promotion of the people's happiness and in the pursuit of lasting world peace?

Is the question of war and peace no longer an issue? Is it that imperialism no longer exists, the system of exploitation no longer exists, and therefore the question of war no longer exists? Or is it that there can be no question of war even if imperialism and the system of exploitation are allowed to survive for ever? The fact is that since the Second World War there has been continuous and unbroken warfare. Do not the imperialist wars to suppress national liberation movements and the imperialist wars of armed intervention against revolutions in various countries count as wars? Even though these wars have not developed into world wars, still do not these local wars count as wars? Even though these wars were not fought with nuclear weapons, still do not wars using so-called conventional weapons count as wars? Does not the U.S. imperialists' allocation of nearly 60 per cent. of the 1960 budget outlay to arms expansion and war preparations count as a bellicose policy on the part of U.S. imperialism? Will the revival of West German and Japanese militarisms not confront mankind with the danger of a new big war?

What kind of " co-operation " is meant? Is it " co-operation " of the proletariat with the bourgeoisie to protect capitalism? Is it " co-operation " of the colonial and semi-colonial peoples with the imperialists to protect colonialism? Is it " co-operation " of socialist countries with capitalist countries to protect the imperialist system in its oppression of the peoples in these countries and suppression of national liberation wars?

In a word, the assertions of the modern revisionists about their so-called " epoch " are so many challenges to Leninism on the foregoing issues. It is their aim to obliterate the contradiction between the masses of people and the monopoly capitalist class in the imperialist countries, the contradiction between the colonial and semi-colonial peoples and the imperialist aggressors, the contradiction between the socialist system and the imperialist system, and the contradiction between the peace-loving people of the world and the warlike imperialist bloc.

There have been different ways of describing the distinctions between different " epochs." Generally speaking, there is one way which is merely drivel, concocting and playing around with vague, ambiguous phrases to cover up the essence of the epoch. This is the old trick of the imperialists, the bourgeoisie and the revisionists in the workers' movement. Then there is another way, which is to make a concrete analysis of the concrete situation

with regard to the overall class contradictions and class struggle, putting forward strictly scientific definitions, and thus bringing the essence of the epoch thoroughly to light. This is the work of every serious Marxist.

On the features that distinguish an epoch, Lenin said:

> . . . We are speaking here of big historical epochs; in every epoch there are and there will be, separate, partial movements sometimes forward, at other times backwards, there are, and there will be, various deviations from the average type and average tempo of the movements.
>
> We cannot know how fast and how successfully certain historical movements of the given epoch will develop. But we can and do know *which class* occupies a central position in this or that epoch and determines its main content, the main direction of its development, the main characteristics of the historical situation in the given epoch, etc.
>
> Only on this basis, *i.e.*, by taking into consideration first and foremost the fundamental distinctive features of different " epochs " (and not of individual episodes in the history of different countries) can we correctly work out our tactics. . . . (" Under a False Flag," *Collected Works*, 4th Russ. ed., Vol. XXI, p. 125.)

An epoch, as referred to here by Lenin, presents the question of which class holds the central position in an epoch and determines its main content and main direction of development.

Faithful to Marx's dialectics, Lenin never for a single moment departed from the standpoint of analysing class relations. He held that: " Marxism judges ' interests ' by the class antagonisms and the class struggles which manifest themselves in millions of facts of everyday life." (" Collapse of the Second International," *Selected Works*, International Publishers, New York, 1943, Vol. V, p. 189.) He stated:

> The method of Marx consists, first of all, in taking into consideration the *objective* content of the historical process at the given concrete moment, in the given concrete situation, in understanding first of all *which* class it is whose movement constitutes the mainspring of possible progress in this concrete situation. . . . (" Under a False Flag." *Collected Works*, 4th Russ. ed., Vol. XXI, p. 123.)

Lenin always demanded that we examine the concrete process of historical development on the basis of class analysis, instead of talking vaguely about " society in general " or " progress in general." We Marxists must not base proletarian policy merely on certain passing events or minute political changes, but on the overall class contradictions and class struggle of a whole historical epoch. This is a basic theoretical position of Marxists. It was by taking a firm stand on this position that Lenin, in the new period of class changes, in the new historical period, came to the conclusion that the hope of humanity lay entirely with the victory of the proletariat and that the proletariat must prepare itself to win victory in this great revolutionary battle and establish a proletarian dictatorship. After the October Revolution, at the Seventh Congress of the Russian Communist Party (Bolsheviks) in 1918, Lenin stated:

> We must begin with the general basis of the development of commodity production, the transition to capitalism and the transformation of capitalism into imperialism. Thereby we shall be theoretically taking up and consolidating a position from which nobody who has not betrayed socialism can dislodge us From this follows an equally inevitable conclusion: the era of social revolution is beginning. (" Report on Revising the Programme and Name of the Party," *Selected Works*, International Publishers, New York, 1943, Vol. VIII, p. 317.)

This is Lenin's conclusion, a conclusion which up to the present still requires deep consideration by all Marxists.

The formulation of revolutionary Marxists that ours is the epoch of imperialism and proletarian revolution, the epoch of the victory of socialism and communism is irrefutable, because it grasps with complete correctness the basic features of our present great epoch. The formulation that Leninism is the continuation and development of revolutionary Marxism in this great epoch and that it is the theory and policy of proletarian revolution and proletarian dictatorship is also irrefutable, because it is precisely Leninism that exposed the contradictions in our great epoch—the contradictions between the working class and monopoly capital, the contradictions among the imperialist countries, the contradictions between the colonial and semi-colonial peoples and imperialism, and the contradictions between the socialist countries, where the proletariat has triumphed, and the imperialist countries. Leninism has, therefore, become our banner of victory. Contrary, however, to this series of revolutionary Marxist formulation, in the so-called " new epoch " of the Titos, there is actually no imperialism, no proletarian revolution and, needless to say, no theory and policy of the proletarian revolution and proletarian dictatorship. In short, with them, the fundamental focal points of the class contradictions and class struggles of our epoch are nowhere to be seen, the fundamental questions of Leninism are missing and there is no Leninism.

The modern revisionists assert that in their so-called " new epoch," because of the progress of science and technology, the " old conceptions " of Marx and Lenin are no longer applicable. Tito made the following assertion: " We are not dogmatists, for Marx and Lenin did not predict the rocket on the moon, atomic bombs and the great technical progress." (From Tito's speech in Zagreb, December 12, 1959.) Not dogmatists, that's fine. Who wants them to be dogmatists? But one can oppose dogmatism to defend Marxism-Leninism or one can actually oppose Marxism-Leninism in the name of opposing dogmatism. The Titos belong to the latter category. On the question of what effect scientific and technological progress has on social development, there are people who hold incorrect views because they are not able to approach the question from the materialist viewpoint of history. This is understandable. But the modern revisionists, on the other hand, are deliberately creating confusion on this question in a vain attempt to make use of the progress in science and technology to throw Marxism-Leninism to the winds.

In the past few years, the achievements of the Soviet Union in science and technology have been foremost in the world. These Soviet achievements are products of the Great October Revolution. These outstanding achievements mark a new era in man's conquest of nature and at the same time play a very important role in defending world peace. But, in the new conditions brought about by the development of modern technology, has the ideological system of Marxism-Leninism been shaken, as Tito says, by the " rocket on the moon, atomic bombs and the great technical progress " which Marx and Lenin " did not predict "? Can it be said that the Marxist-Leninist world outlook, social-historical outlook, moral outlook and other basic concepts have therefore become what they call stale " dogmas " and that the law of class struggle henceforth no longer holds good?

Marx and Lenin did not live to the present day, and of course could not see certain specific details of technological progress in the present-day

world. But what, after all, does the development of natural science and the advance of technology augur for the capitalist system? Marx and Lenin held that this could only augur a new social revolution, but could certainly not augur the fading away of social revolution.

We know that both Marx and Lenin rejoiced in the new discoveries and progress of natural science and technology in the conquest of nature. Engels said in his " Speech at the Graveside of Karl Marx ":

> Science was for Marx a historically dynamic, revolutionary force. However great the joy with which he welcomed a new discovery in some theoretical science whose practical application perhaps it was as yet quite impossible to envisage, he experienced quite another kind of joy when the discovery involved immediate revolutionary changes in industry, and in historical development in general. (*Selected Works of Marx and Engels*, Foreign Languages Publishing House, Moscow, 1955, Vol. II, p. 168.)

Engels added: " For Marx was before all else a revolutionist." Well said! Marx always regarded all new discoveries in the conquest of nature from the viewpoint of a proletarian revolutionist, not from the viewpoint of one who holds that the proletarian revolution will fade away.

Wilhelm Liebknecht wrote in his *Reminiscences of Marx*:

> Marx made fun of the victorious European reaction which imagined that it had stifled the revolution and did not suspect that natural science was preparing a new revolution. King Steam, who had revolutionized the world in the previous century, was coming to the end of his reign and another incomparably greater revolutionary would take his place, the electric spark.
> . . . The consequences are unpredictable. The economic revolution must be followed by a political one, for the latter is only the expression of the former.
> In the manner in which Marx discussed this progress of science and mechanics, his conception of the world, and especially what has been termed the materialist conception of history, was so clearly expressed that certain doubts which I had hitherto still maintained melted away like snow in the sunshine of spring. (Wilhelm Liebknecht and Paul Lafarge's *Reminiscences of Marx*, Lawrence & Wishart, p. 15.)

This is how Marx felt the breath of revolution in the progress of science and technology. Marx held that the new progress of science and technology would lead to a social revolution to overthrow the capitalist system. To Marx, the progress of natural science and technology further strengthens the whole position of the Marxist world outlook and the materialist conception of history, and certainly does not shake it. The progress of natural science and technology further strengthens the position of the proletarian revolution, and of the oppressed nations in their fight against imperialism, and certainly does not weaken it.

Like Marx, Lenin also viewed technological progress in connection with the question of revolution in the social system. Thus Lenin held that:

> The age of steam is the age of the bourgeoisie, the age of electricity is the age of socialism. (" Report on Work of All-Russia Central Executive Committee and People's Council," *Collected Works*, 4th Russ. ed., Vol. XXX, p. 310.)

Please note the contrast between the revolutionary spirit of Marx and Lenin and the modern revisionists' shameful attitude of betraying the revolution!

In class society, in the epoch of imperialism, Marxist-Leninists can only

approach the question of the development and use of technology from the viewpoint of class analysis.

Inasmuch as the socialist system is progressive and represents the interests of the people, the socialist countries want to utilize such new techniques as atomic energy and rocketry to serve peaceful domestic construction and the conquest of nature. The more the socialist countries master such new techniques and the more rapidly they develop them, the better will they attain the aim of high-speed development of the social productive forces to meet the needs of the people, and the more will they strengthen the forces for checking imperialist war and increase the possibility of defending world peace. Therefore, for the welfare of their peoples and in the interest of peace for people the world over, the socialist countries should, wherever possible, master more and more of such new techniques serving the well-being of the people.

At the present time, the socialist Soviet Union clearly holds the upper hand in the development of new techniques. Everybody knows that the rocket that hit the moon was launched by the Soviet Union and not by the United States, the country where capitalism is most developed. This shows that only in the socialist countries can there be unlimited prospects for the large-scale development of new techniques.

On the contrary, inasmuch as the imperialist system is reactionary and against the people, the imperialist powers want to use such new techniques for military purposes of aggression against foreign countries, to intimidate the people within their own countries, to make weapons for human slaughter. To the imperialist powers, the emergence of such new techniques only means pushing to a new stage the contradiction between the development of the social productive forces and the capitalist relations of production. What this will bring about is not by any means the perpetuation of capitalism but the further rousing of the revolution of the people in those countries and the destruction of the old, criminal, cannibalistic system of capitalism.

The U.S. imperialists and their partners use weapons like atom bombs to threaten war and blackmail the whole world. They declare that anyone who does not submit to the domination of U.S. imperialism will be destroyed. The Tito clique echoes this line, it takes up the U.S. imperialist refrain to spread terror of atomic warfare among the masses. U.S. imperialist blackmail and the chiming in of the Tito clique can only temporarily dupe those who do not understand the real situation, but cannot cow the people who have awakened. Even those who for the time being do not understand the real situation will gradually come to understand it with the help of the advanced elements.

Marxist-Leninists have always maintained that in world history it is not technique but man, the masses of people, that determine the fate of mankind. There was a theory current for a time among some people in China before and during the War of Resistance to Japanese Aggression, which was known as the " weapons-mean-everything theory "; from this theory they concluded that since Japan's weapons were new and its techniques advanced while China's weapons were old and its techniques backward, " China would inevitably be subjugated." Comrade Mao Tse-tung in his work *On the Protracted War* published at that time refuted such nonsense. He made the following analysis: The Japanese imperialists' war of aggression against China was bound to fail because it was reactionary, unjust, and being unjust lacked popular support; the Chinese people's war of resistance

against Japan would certainly win because it was progressive, just, and being just enjoyed abundant support. Comrade Mao Tse-tung pointed out that the most abundant source of strength in war lay in the masses, and that a people's army organized by awakened and united masses of people would be invincible throughout the world. This is a Marxist-Leninist thesis. And what was the outcome? The outcome was that the Marxist-Leninist thesis triumphed and the "theory of national subjugation" ended in defeat. During the Korean war after the Second World War, the triumph of the Korean and Chinese peoples over U.S. aggressors far superior in weapons and equipment again bore out this Marxist-Leninist thesis.

An awakened people will always find new ways to counteract a reactionary superiority in arms and win victory for themselves. This was so in past history, it is so at present, and it will still be so in the future. Because the socialist Soviet Union has gained supremacy in military techniques, the U.S. imperialists have lost their monopoly of atomic and nuclear weapons; at the same time, as a result of the awakening of the people the world over and the awakening of the people in the United States itself, there is now in the world the possibility of concluding an agreement for the banning of atomic and nuclear weapons. We are striving for the conclusion of such an agreement. Unlike the bellicose imperialists, the socialist countries and peace-loving people the world over actively and firmly stand for the banning and destruction of atomic and nuclear weapons. We are always struggling against imperialist war, for the banning of atomic and nuclear weapons and for the defence of world peace. The more broadly and profoundly this struggle is waged and the more fully and thoroughly exposed are the brutish faces of the bellicose U.S. and other imperialists, the more will we be able to isolate these imperialists before the people of the world, the greater will be the possibility of tying their hands and the better it will be for the cause of world peace. If, on the contrary, we lose our vigilance against the danger of the imperialists launching a war, do not work to arouse the people of all countries to rise up against imperialism but tie the hands of the people, then imperialism can prepare for war just as it pleases and the inevitable result will be an increase in the danger of the imperialists launching a war and, once war breaks out, the people may not be able quickly to adopt a correct attitude towards it because of complete lack of preparation or inadequate preparation, thus being unable to vigorously check the war. Of course, whether or not the imperialists will unleash a war is not determined by us; we are, after all, not chiefs-of-staff to the imperialists. As long as the people of all countries enhance their awareness and are fully prepared, with the socialist camp also mastering modern weapons, it is certain that if the U.S. or other imperialists refuse to reach an agreement on the banning of atomic and nuclear weapons and should dare to fly in the face of the will of all humanity by launching a war using atomic and nuclear weapons, the result will be the very speedy destruction of these monsters encircled by the peoples of the world, and the result will certainly not be the annihilation of mankind. We consistently oppose the launching of criminal wars by imperialism, because imperialist war would impose enormous sacrifices upon the peoples of various countries (including the peoples of the United States and other imperialist countries). But should the imperialists impose such sacrifices on the peoples of various countries, we believe that, just as the experience of the Russian revolution and the Chinese revolution shows, those sacrifices would be repaid. On the débris of a dead imperialism, the

victorious people would create very swiftly a civilization thousands of times higher than the capitalist system and a truly beautiful future for themselves.

The conclusion can only be this: whichever way you look at it, none of the new techniques like atomic energy, rocketry and so on has changed, as alleged by the modern revisionists, the basic characteristics of the epoch of imperialism and proletarian revolution pointed out by Lenin. The capitalist-imperialist system absolutely will not crumble of itself. It will be overthrown by the proletarian revolution within the imperialist country concerned, and the national revolution in the colonies and semi-colonies. Contemporary technological progress cannot save the capitalist-imperialist system from its doom but only rings a new death knell for it.

III

THE modern revisionists, proceeding from their absurd arguments on the current world situation and from their absurd argument that the Marxist-Leninist theory of class analysis and class struggle is obsolete, attempt to totally overthrow the fundamental theories of Marxism-Leninism on a series of questions like violence, war, peaceful coexistence, etc.

There are also some people who are not revisionists, but well-intentioned persons who sincerely want to be Marxists, but get confused in the face of certain new historical phenomena and thus have some incorrect ideas. For example, some of them say that the failure of the U.S. imperialists' policy of atomic blackmail marks the end of violence. While thoroughly refuting the absurdities of the modern revisionists, we should also help these well-intentioned people to correct their erroneous ideas.

What is violence? Lenin had a lot to say on this question in his book *The State and Revolution.* The emergence and existence of the state is in itself a kind of violence. Lenin introduced the following elucidation by Engels:

> . . . it (this public power) consists not merely of armed men, but of material appendages, prisons and coercive institutions of all kinds. . . . (*Selected Works,* International Publishers, New York, Vol. VII, p. 10.)

Lenin tells us that we must draw a distinction between two types of states different in nature, the state of bourgeois dictatorship and the state of proletarian dictatorship, and between two types of violence different in nature, counter-revolutionary violence and revolutionary violence; as long as there is counter-revolutionary violence, there is bound to be revolutionary violence to oppose it. It would be impossible to wipe out counter-revolutionary violence without revolutionary violence. The state in which the exploiting classes are in power is counter-revolutionary violence, a special force for suppressing the exploited classes in the interest of the exploiting classes. Both before the imperialists had atomic bombs and rocket weapons, and since they have had these new weapons, the imperialist state has always been a special force for suppressing the proletariat at home and the people of its colonies and semi-colonies abroad, has always been such an institution of violence; even if it is compelled not to use these new weapons, the imperialist state will of course still remain an imperialist institution of violence until it is overthrown and replaced by the people's state, the state of the dictatorship of the proletariat of that country.

Never since the dawn of history have there been such large-scale, such utterly vicious forces of violence as those of present-day capitalist imperialists. For the past ten years and more, the U.S. imperialists have, without any

scruples, adopted means of persecution a hundred times more savage than before, trampling upon the outstanding sons of the country's working class, trampling upon the Negro people, trampling upon all progressives, and moreover, recklessly declaring that they intend to put the whole world under their rule of violence. They are continuously expanding their forces of violence, and at the same time the other imperialists also take part in the race to increase their forces of violence.

The bloated military build-up of the imperialist countries headed by the United States has appeared during the unprecedentedly grave general crisis of capitalism. The more frantically the imperialists carry the expansion of their military forces to a peak, the nearer they draw to their own doom. Now even some representatives of the U.S. imperialists have premonitions of the inevitable extinction of the capitalist system. But will the imperialists themselves put an end to their violence? Will those in power in the imperialist countries abandon of their own accord the violence they have set up just because imperialism is drawing near to its doom?

Can it be said that, compared with the past, the imperialists are no longer addicted to violence, or that there has been a lessening in the degree of their addiction?

Lenin answered such questions on several occasions long ago. He pointed out in his book *Imperialism, the Highest Stage of Capitalism*:

> . . . for politically imperialism is in general a striving towards violence and reaction. (*Selected Works*, International Publishers, New York, Vol. V, p. 83.)

After the October Revolution, in his book *The Proletarian Revolution and the Renegade Kautsky* he made a special point of recounting history, comparing the differences between pre-monopoly capitalism and monopoly capitalism, *i.e.*, imperialism. He said:

> Pre-monopoly capitalism, which reached its zenith in the seventies of the nineteenth century, was, by virtue of its fundamental *economic* traits (which were most typical in England and America) distinguished by its relative attachment to peace and freedom. Imperialism, *i.e.*, monopoly capitalism, which finally matured only in the twentieth century, is, by virtue of its fundamental *economic* traits, distinguished by the least attachment to peace and freedom, and by the greatest and universal development of militarism everywhere. (*Selected Works*, International Publishers, Vol. VII, pp. 125–126.)

Of course, these words of Lenin were uttered in the early period of the October Revolution, when the proletarian state was newly born, and its economic forces still young and weak, while with the lapse of forty years and more the face of the Soviet state itself, and of the whole world has undergone a tremendous change, as we have already described. Then, are the foregoing pronouncements of Lenin obsolete, because the nature of imperialism has changed owing to the might of the Soviet Union, the might of the forces of socialism and the might of the forces of peace? Or, is it that imperialism, although its nature has not changed, will no longer resort to violence? Do these ideas conform to the real situation?

The socialist world system has obviously gained the upper hand in its struggle with the capitalist world system. This great historic fact has weakened the position of imperialist violence in the world. But will this fact cause the imperialists never again to oppress the people of their own country, never again engage in outward expansion and aggressive activities? Can it make the warlike circles of the imperialists " lay down the butcher knife "

and " sell their knives and buy oxen "? Can it make the groups of munitions merchants in the imperialist countries change over to peaceful pursuits?

All these questions confront every serious Marxist-Leninist, and require deep consideration. It is obvious that whether these questions are viewed and handled correctly or incorrectly has a close bearing on the success or failure of the proletarian cause and the destiny of humanity.

War is the most acute form of expression of violence. One type is civil war, another is foreign war. Violence is not always expressed by war, its most acute form. In capitalist countries, bourgeois war is the continuation of the bourgeois policies of ordinary times, while bourgeois peace is the continuation of bourgeois wartime policy. The bourgeoisie are always switching back and forth between the two forms, war and peace, to carry on their rule over the people and their external struggle. In what they call peace time, the imperialists rely on armed force to deal with the oppressed classes and nations by such forms of violence as arrest, imprisonment, sentencing to hard labour, massacre and so forth, while at the same time they also carry on preparations for using the most acute form of violence— war—to suppress the revolution of the people at home, to carry out plunder abroad, to overwhelm foreign competitors and to stamp out revolutions in other countries. Or, peace at home may exist side by side with war abroad.

In the initial period of the October Revolution, all the imperialist powers resorted to violence in the form of war against the Soviet Union, which was a continuation of their imperialist policies; in the Second World War, the German imperialists used violence in the form of large scale war to attack the Soviet Union, which was a continuation of their imperialist policy. But on the other hand, the imperialists also established diplomatic relations of peaceful coexistence with the Soviet Union in different periods, which is also, of course, a continuation of imperialist policy in another form under certain conditions.

True, some new questions have now arisen concerning peaceful co-existence. Confronted with the powerful Soviet Union and the powerful socialist camp, the imperialists must at any rate carefully consider whether they wouldn't hasten their own extinction, as Hitler did, or bring about the most serious consequences for the capitalist system itself, if they should attack the Soviet Union, attack the socialist countries.

" Peaceful Co-existence "—this is a new concept which arose only after socialist countries appeared in the world following the October Revolution. It is a new concept formed under circumstances Lenin had predicted before the October Revolution, when he said:

> Socialism cannot achieve victory simultaneously in all countries. It will achieve victory first in one or several countries, while the others will remain bourgeois or pre-bourgeois for some time. (" The War Program of the Proletarian Revolution," *Selected Works*, F.L.P.H., Moscow, 1952, Vol. I, part 2, p. 571.)

This new concept is one advanced by Lenin after the great Soviet people overcame the armed imperialist intervention. As was pointed out above, at the outset the imperialists were not willing to co-exist peacefully with the Soviet Union. The imperialists were compelled to " co-exist " with the Soviet Union only after the war of intervention against the Soviet Union had failed, after there had been several years of actual trial of strength, after the Soviet state had planted its feet firmly on the ground,

and after a certain balance of power had taken shape between the Soviet state and the imperialist countries. Lenin said in 1920:

> We have won conditions for ourselves under which we can exist alongside the capitalist powers, which are now forced to enter into trade relations with us. (" Our Internal and External Situation and the Party's Tasks," *Collected Works*, 4th Rus. ed., Vol. XXXI, p. 384.)

It can be seen that the realization of peaceful co-existence for a certain period between the world's first socialist state and imperialism was won entirely through struggle. Before the Second World War, the 1920–40 period prior to Germany's attack on the Soviet Union was a period of peaceful co-existence between imperialism and the Soviet Union. During all those twenty years, the Soviet Union kept faith with peaceful co-existence. However, in 1941, Hitler was no longer willing to co-exist peacefully with the Soviet Union, the German imperialists perfidiously launched a savage attack on the Soviet Union. Owing to victory in the anti-fascist war, with the great Soviet Union as the main force, the world saw once again a situation of peaceful co-existence between the socialist and capitalist countries. Nevertheless, the imperialists have not given up their designs. The U.S. imperialists have set up networks of military bases and guided missile bases everywhere around the Soviet Union and the entire socialist camp. They are still occupying our territory Taiwan and continually carrying out military provocations against us in the Taiwan Straits. They carried out armed intervention in Korea, conducting a large-scale war against the Korean and Chinese peoples on Korean soil, which resulted in an armistice agreement only after their defeat—and up to now they are still interfering with the unification of the Korean people. They gave aid in weapons to the French imperialist occupation forces in their war against the Vietnamese people, and up to now they are still interfering with the unification of the Vietnamese people. They engineered the counter-revolutionary rebellion in Hungary, and up to now they are continually making all sorts of attempts at subversion in the East European and other socialist countries. The facts are still just as Lenin represented them to a U.S. correspondent in February 1920: on the question of peace, " there is no obstacle on our side. The obstacle is the imperialism of American (and all other) capitalists." (*Collected Works*, 4th Russ. ed., Vol. XXX, p. 340.)

The foreign policy of socialist countries can only be a policy of peace. The socialist system determines that we do not need war, absolutely would not start a war, and absolutely must not, should not and could not encroach one inch on the territory of a neighbouring country. Ever since its founding, the People's Republic of China has adhered to a foreign policy of peace. Our country together with two neighbouring countries, India and Burma, jointly initiated the well-known Five Principles of Peaceful Co-existence ; and at the Bandung Conference of 1955, our country together with various countries of Asia and Africa adopted the ten principles of peaceful co-existence. The Communist Party and Government of our country have in the past few years consistently supported the activities for peace carried out by the Central Committee of the Communist Party and the Government of the Soviet Union headed by Comrade N. S. Khrushchev, considering that these activities on the part of the Communist Party and the Government of the Soviet Union have further demonstrated before the people of the world the firmness of the socialist countries' peaceful foreign policy as well as the

need for the peoples to stop the imperialists from launching another world war and to strive for a lasting world peace.

The Declaration of the Moscow Conference of 1957 states:

> The cause of peace is upheld by the powerful forces of our era: the invincible camp of socialist countries headed by the Soviet Union; the peace-loving countries of Asia and Africa taking an anti-imperialist stand and forming, together with the socialist countries, a broad peace zone; the international working class and above all its vanguard—the Communist Parties; the liberation movement of the peoples of the colonies and semi-colonies; the mass peace movement of the peoples; the peoples of the European countries who have proclaimed neutrality, the peoples of Latin America and the masses in the imperialist countries who themselves are firmly resisting plans for a new war. An alliance of these mighty forces could prevent war.

So long as there is a continuous development of these mighty forces, it is possible to maintain the situation of peaceful co-existence, or even to obtain some sort of official agreement on peaceful co-existence or to conclude an agreement on prohibition of atomic and nuclear weapons. That would be a fine thing in full accord with the aspirations of the peoples of the world. However, even under those circumstances, as long as the imperialist system still exists, the most acute form of violence, namely war, has by no means ended in the world. The fact is not as described by the Yugoslav revisionists, who declare obsolete Lenin's definition that " war is the continuation of politics " (" Active Co-existence and Socialism," *Narodna Armija*, November 28, 1958), a definition which he repeatedly explained and upheld in combating opportunism.

We believe in the absolute correctness of Lenin's thinking: War is an inevitable outcome of systems of exploitation and the source of modern wars is the imperialist system. Until the imperialist system and the exploiting classes come to an end, wars of one kind or another will always occur. They may be wars among the imperialists for redivision of the world, or wars of aggression and anti-aggression between the imperialists and the oppressed nations, or civil wars of revolution and counter-revolution between the exploited and exploiting classes in the imperialist countries, or, of course, wars in which the imperialists attack the socialist countries and the socialist countries are forced to defend themselves. All these kinds of wars represent the continuation of the policies of definite classes. Marxists-Leninists absolutely must not sink into the mire of bourgeois pacifism, and can only appraise all these kinds of wars and thus draw conclusions for proletarian policy by adopting the method of concrete class analysis. As Lenin put it: " Theoretically, it would be quite wrong to forget that every war is but the continuation of politics by other means." (" The War Program of the Proletarian Revolution," *Selected Works*, F.L.P.H., Moscow, 1952, Vol. I, part 2, p. 572.)

To attain their aim of plunder and oppression, the imperialists always have two tactics: the tactics of war and the tactics of " peace "; therefore, the proletariat and the people of all countries must also use two tactics to counter the imperialists: the tactics of thoroughly exposing the imperialists' peace fraud and striving energetically for a genuine world peace, and the tactics of preparing for a just war to end the imperialist unjust war when and if the imperialists should unleash it.

In a word, in the interests of the people of the world, we must thoroughly

shatter the falsehoods of the modern revisionists and uphold the Marxist-Leninist viewpoints on the questions of violence, war and peaceful co-existence.

The Yugoslav revisionists deny the inherent class character of violence and thereby obliterate the fundamental difference between revolutionary violence and counter-revolutionary violence; they deny the inherent class character of war and thereby obliterate the fundamental difference between just war and unjust war; they deny that imperialist war is a continuation of imperialist policy, deny the danger of the imperialists unleashing another big war, deny that it will be possible to do away with war only after doing away with the exploiting classes, and even shamelessly call the U.S. imperialist chieftain Eisenhower "the man who laid the cornerstone for eliminating the cold war and establishing lasting peace with peaceful competition between different political systems" ("Eisenhower Arrives in Rome," *Borba*, December 4, 1959); they deny that under the conditions of peaceful co-existence there are still complicated, acute struggles in the political, economic and ideological fields, and so on. All these arguments of the Yugoslav revisionists are aimed at poisoning the minds of the proletariat and the people of all countries, and are helpful to the imperialist policy of war.

IV

Modern revisionists seek to confuse the peaceful foreign policy of the socialist countries with the domestic policies of the proletariat in the capitalist countries. They thus hold that peaceful co-existence of countries with differing social systems means that capitalism can peacefully grow into socialism, that the proletariat in countries ruled by the bourgeoisie can renounce class struggle and enter into "peaceful co-operation" with the bourgeoisie and the imperialists, and that the proletariat and all the exploited classes should forget about the fact that they are living in a class society, and so on. All these views are also diametrically opposed to Marxism-Leninism. They are put forward in an attempt to protect imperialist rule and hold the proletariat and all the rest of the working people perpetually in capitalist enslavement.

Peaceful co-existence of nations and people's revolutions in various countries are in themselves two different things, not one and the same thing; two different concepts, not one; two different kinds of question, and not one and the same kind of question.

Peaceful co-existence refers to relations between nations; revolution means the overthrow of the oppressors as a class by the oppressed people within each country, while in the case of the colonial and semi-colonial countries, it is first and foremost a question of overthrowing alien oppressors, namely, the imperialists. Before the October Revolution the question of peaceful co-existence between socialist and capitalist countries simply did not exist in the world, as there were as yet no socialist countries; but there did exist at that time the questions of the proletarian revolution and the national revolution, as the peoples in various countries, in accordance with their own specific conditions, had long ago put revolutions of one kind or the other on the agenda of the day to determine the destinies of their countries.

We are Marxist-Leninists. We have always held that revolution is each nation's own affair. We have always maintained that the working class can

only depend on itself for its emancipation, and that the emancipation of the people of any given country depends on their own awakening, and on the ripening of revolution in that country. Revolution can neither be exported nor imported. No one can prevent the people of a foreign country from carrying out a revolution, nor can one produce a revolution in a foreign country by using the method of " helping the rice shoots to grow by pulling them up."

Lenin put it well when he said in June 1918:

> There are people who believe that the revolution can break out in a foreign country to order, by agreement. These people are either mad or they are provocateurs. We have experienced two revolutions during the past twelve years. We know that revolutions cannot be made to order, or by agreement; they break out when tens of millions of people come to the conclusion that it is impossible to live in the old way any longer. (" The Fourth Conference of Trade Unions and Factory Committees of Moscow," *Selected Works*, International Publishers, New York, Vol. VII, p. 414.)

In addition to the experience of the Russian revolution, is not the experience of the Chinese revolution also one of the best proofs of this? The Chinese people, under the leadership of the Chinese Communist Party, have experienced several revolutions. The imperialists and all the reactionaries, like lunatics, have always asserted that our revolutions were made to order from abroad, or in accordance with foreign agreements. But people all over the world know that our revolutions were not imported from abroad, but were brought about because our people found it impossible to continue to live in the old China and because they wanted to create a new life of their own.

When a socialist country, in the face of imperialist aggression is compelled to launch counter-attacks in a defensive war, and goes beyond its own border to pursue and eliminate its enemies from abroad, as the Soviet Union did in the war against Hitler, is this justified? Certainly it is completely justified, absolutely necessary and entirely just. In accordance with the strict principles of Communists, such operations by the socialist countries must be strictly limited to the time when the imperialists launch a war of aggression against them. Socialist countries never permit themselves to send, never should and never will send their troops across their borders unless they are subjected to aggression from a foreign enemy. Since the armed forces of the socialist countries fight for justice, when these forces have to go beyond their borders to counter-attack a foreign enemy, it is only natural that they should exert an influence and have an effect wherever they go; but even then, the emergence of people's revolutions and the establishment of the socialist system in those places and countries where they go will still depend on the will of the masses of the people there.

The spread of revolutionary ideas knows no national boundaries. But these ideas will only yield revolutionary fruit in the hands of the masses of people themselves, under specific circumstances in a given country. This is so not only in the epoch of proletarian revolution, but also in the epoch of bourgeois revolution. The bourgeoisie of various countries at the time of their revolution took Rousseau's *Social Contract* as their gospel, while the revolutionary proletariat in various countries take as their gospels Marx's *Communist Manifesto* and *Capital* and Lenin's *Imperialism, the Highest Stage of Capitalism* and *The State and Revolution*. Times vary, the classes vary, the ideologies vary and the character of the revolutions varies. But

no one can hold back a revolution in any country if there is a desire for that revolution and when the revolutionary crisis there has matured. In the end the socialist system will replace the capitalist system. This is an objective law independent of human will. No matter how hard the reactionaries may try to prevent the advance of the wheel of history, revolution will take place sooner or later and will surely triumph. The same applies to the replacement of one society by another throughout human history. The slave system was replaced by the feudal system which, in its turn, gave way to the capitalist system. These, too, follow laws independent of human will. These replacements were carried out through revolution.

That notorious old revisionist Bernstein once said, " Remember ancient Rome, there was a ruling class that did no work, but lived well, and as a result, this class weakened. Such a class must gradually hand over its power." That the slave-owners as a class weakened was a historical fact that Bernstein could not conceal, any more than the present U.S. imperialists can conceal the fact of their own steady decline. Yet Bernstein, shameless, self-styled " historian " that he was, chose to cover up the following basic facts of ancient Roman history: the slave-owners never " handed over power " of their own accord; their rule was overthrown by protracted, repeated, continuous slave revolutions.

Revolution means the use of revolutionary violence by the oppressed class, it means revolutionary war. This is also true of the bourgeois revolution. Lenin has put it well:

> History teaches us that no oppressed class ever achieved power, nor could achieve power, without going through a period of dictatorship, i.e., the conquest of political power and suppression by force of the most desperate, frenzied resistance always offered by the exploiters. . . . The bourgeoisie . . . came to power in the advanced countries through a series of insurrections, civil wars, the suppression by force of kings, feudalists, slave-owners and their attempts at restoration. ("Theses on Bourgeois Democracy and Proletarian Dictatorship Presented to the First Congress of the Communist International," Lenin Against Revisionism, F.L.P.H., Moscow, 1959, p. 488.)

Why do things happen this way?

In answering this question, again we have to quote Lenin.

In the first place, as Lenin said: " No ruling class in the world ever gave way without a struggle." (" Speech at Workers' Conference of Presnia District," Collected Works, 4th Russ. ed., Vol. XXVIII, p. 338.)

Secondly, as Lenin explained: " The reactionary classes themselves are usually the first to resort to violence, to civil war; they are the first to ' place the bayonet on the agenda.' " (" Two Tactics of Social-Democracy in the Democratic Revolution," Selected Works, F.L.P.H., Moscow, Vol. I, part 2, p. 142.)

In the light of this how shall we conceive of the proletarian socialist revolution?

In order to answer this question we must quote Lenin again.

Let us read the following passage by him.

> Not a single great revolution in history has ever been carried out without a civil war and no serious Marxist will believe it possible to make the transition from capitalism to socialism without a civil war. (" Prediction," Collected Works, 4th Russ. ed., Vol. XXVII, p. 457.)

These words of Lenin here explain the question very clearly.

And here is another quotation from Lenin:

> *If* socialism had been born peacefully—but the capitalist gentlemen did not wish to let it be born thus. . . . Even if there had been no war, the capitalist gentlemen would still have done all they could to prevent such a peaceful development. Great revolutions, even when they began peacefully, like the great French Revolution, have ended in desperate wars which have been started by the counter-revolutionary bourgeoisie. (" First All-Russian Conference of Social Education," *Collected Works*, 4th Russ. ed., Vol. XXIX, p. 334.)

This is also very clearly put.

The Great October Revolution is the best material witness to the truth of these propositions of Lenin.

So is the Chinese revolution. No one will ever forget that it was only after twenty-two years of bitter civil war under the leadership of the Chinese Communist Party that the Chinese people and the Chinese proletariat won nationwide victory and captured state power.

The history of the proletarian revolution in the West after the First World War tells us: even when the capitalist gentlemen do not exercise direct, open control of state power, but rule through their lackeys—the treacherous social-democrats, these despicable renegades will surely be ready at any time, in accordance with the dictates of the bourgeoisie, to cover up the violence of the bourgeois White Guards and plunge the proletarian revolutionary fighters into a blood bath. This is just the way it was in Germany at that time. Vanquished, the big German bourgeoisie handed over state power to the social-democrats. The social-democrat government, on coming to power, immediately set about a bloody suppression of the German working class in January 1919. Let us recall how Karl Liebknecht and Rosa Luxembourg, whom Lenin called " the best representatives of the world proletarian International " and " the immortal leaders of the international socialist revolution," shed their blood as a result of the violence of the social-democrats of the day. Let us also recall, in Lenin's words, " the vileness and shamefulness of these murders " (*A Letter to the Workers of Europe and America*, F.L.P.H., Moscow, 1954, p. 16) perpetrated by these renegades—these so-called " socialists " for the purpose of preserving the capitalist system and the interest of the bourgeoisie! Let us, in the light of bloody facts both of the historical part and of the modern capitalist world, examine all this nonsense about the " peaceful growth of capitalism into socialism " put out by the old revisionists and their modern counterparts.

Does it follow, then, that we Marxist-Leninists will refuse to adopt the policy of peaceful transition even when there exists the possibility of such peaceful development? No, decidedly not!

As we all know, Engels, one of the great founders of scientific communism, in the famous work *Principles of Communism* answered the question: " Can private property be eliminated by peaceful means?" He wrote:

> One would wish that it could be thus, and Communists, of course, would be the last to object to this. Communists know well that all plots are not only futile, but even pernicious. They know very well that revolutions cannot be thought up and made as one wishes and that revolutions have always and everywhere been the necessary result of existing conditions, which have absolutely not depended on the will and leadership of separate parties and whole classes. But at the same time, they see that the development of

102

the proletariat in nearly all civilized countries is being violently suppressed and that in this way the opponents of the Communists are working as hard as they can for the revolution. . . . ("Principles of Communism," *Collected Works of Marx and Engels*, 2nd Russ. ed., Vol. IV, p. 331.)

This was written over a hundred years ago, yet how fresh it is as we read it again!

We also know that for a time following the Russian February Revolution, in view of the specific conditions of the time, Lenin did adopt the policy of peaceful development of the revolution. He considered it "an extraordinarily rare opportunity in the history of revolutions" ("The Tasks of the Revolution," *Collected Works*, 4th Russ. ed., Vol. XXVI, p. 45) and grasped tight hold of it. The bourgeois Provisional Government and the White Guards, however, destroyed this possibility of peaceful development of the revolution and so drenched the streets of Petrograd in the blood of the workers and soldiers marching in a peaceful mass demonstration in July. Lenin, therefore, pointed out:

> The peaceful course of development has been rendered impossible. A non-peaceful and most painful course has begun. ("On Slogans," *Selected Works*, F.L.P.H., Moscow, Vol. II, part 1, p. 89.)

We know too that as the Chinese War of Resistance to Japanese Aggression came to an end, there was a widespread and ardent desire for peace in the country. Our Party then conducted peace negotiations with the Kuomintang, seeking to institute social and political reforms by peaceful means, and in 1946 an agreement on achieving peace throughout the country was reached with the Kuomintang. The reactionary Kuomintang clique, however, defying the will of the whole people, tore up this agreement and, with the support of the U.S. imperialists, launched a civil war on a nationwide scale, leaving the people with no option but to counter it with a revolutionary war. As we never relaxed our vigilance or gave up the people's armed forces even in our struggle for peaceful reform but were fully prepared, the people were not cowed by the war, but those who launched the war were made to eat their own bitter fruit.

It would be in the best interests of the people if the proletariat could attain power and carry out the transition to socialism by peaceful means. It would be wrong not to make use of such a possibility when it occurs. Whenever an opportunity for "peaceful development of the revolution" presents itself Communists must seize it, as Lenin did, so as to realize the aim of the socialist revolution. However, this sort of opportunity is always, in Lenin's words, "an extraordinarily rare opportunity in the history of revolutions." When in a given country a certain local political power is already surrounded by revolutionary forces or when in the world a certain capitalist country is already surrounded by socialism—in such cases, there might be a greater possibility of opportunities for the peaceful development of the revolution. But even then, the peaceful development of the revolution should never be regarded as the only possibility and it is therefore necessary to be prepared at the same time for the other possibility, *i.e.*, non-peaceful development of the revolution. For instance, after the liberation of the Chinese mainland, although certain areas ruled by slave-owners and serf-owners were already surrounded by the absolutely predominant people's revolutionary forces, yet, as an old Chinese saying goes, "Cornered beasts will still fight," a handful of the most reactionary slave-owners and serf-owners still gave a last kick, rejecting peaceful reforms and launching armed

rebellions. Only after these rebellions were quelled was it possible to carry out the reform of the social systems.

At a time when the imperialist countries and the imperialists are armed to the teeth as never before in order to protect their savage man-eating system, can it be said that the imperialists have become very "peaceable" towards the proletariat and the people at home and the oppressed nations abroad, as the modern revisionists claim, and that therefore, the "extraordinarily rare opportunity in the history of revolutions" that Lenin spoke about after the February Revolution, will become a normal state of affairs for the world proletariat and all the oppressed people, so that what Lenin referred to as a "rare opportunity" is easily available to the proletariat in the capitalist countries? We hold that these views are completely groundless.

Marxist-Leninists should never forget this truth: the armed forces of all ruling classes are used in the first place to oppress their people at home. Only on the basis of oppression of the people at home can the imperialists oppress other countries, launch aggression and wage unjust wars. In order to oppress their own people they need to maintain and strengthen their reactionary armed forces. Lenin once wrote in the course of the Russian revolution of 1905:

> A standing army is used not so much against the external enemy as against the internal enemy. ("The Army and the Revolution," *Collected Works*, 4th Russ. ed., Vol. X, p. 38.)

Is this conclusion valid for all countries where the exploiting classes dominate, for capitalist countries? Can it be said that it was valid then but has become incorrect now? In our opinion, this truth remains irrefutable and the facts are confirming its correctness more and more. Strictly speaking, if the proletariat of any country fails to see this clearly it will not be able to find the way to liberation.

In *The State and Revolution* Lenin centred the problem of revolution on the smashing of the bourgeois state machine. Quoting the most important passages from Marx's *Civil War in France*, he wrote:

> After the revolution of 1848–49, the state power became "the national war engine of capital against labour." (*Selected Works of Lenin*, F.L.P.H., Moscow, 1952, Vol. II, part 1, p. 240.)

The main machine of the bourgeois state power to wage an anti-labour war is its standing army. Therefore, ". . . the first decree of the commune . . . was the suppression of the standing army, and the substitution for it of the armed people. . . ." (*ibid.*, Vol. II, part 1, p. 241.)

So this question, in the last analysis, must be treated in the light of the principles of the Paris Commune which, as Marx puts it, are perpetual and indestructible.

In the seventies of the nineteenth century Marx took Britain and the United States to be exceptions, holding that as far as these two countries were concerned there did exist the possibility of " peaceful " transition to socialism, because militarism and bureaucracy were at an early stage of development in these two countries. But in the era of imperialism, as Lenin put it, " this qualification made by Marx is no longer valid " for these two countries " have today completely sunk into the all-European filthy, bloody morass of bureaucratic-military institutions which subordinate everything to themselves and trample everything underfoot." (" The State and Revolution," *Selected Works*, F.L.P.H., Moscow, 1952, Vol. II, part 1, pp. 237–238.) This was one

of the focal points of the debate Lenin had with the opportunists of the day. The opportunists represented by Kautsky distorted this "no longer valid" conclusion of Marx, in an attempt to oppose the proletarian revolution and proletarian dictatorship, that is, to oppose the revolutionary armed forces and armed revolution which are indispensable to the liberation of the proletariat. The reply Lenin gave to Kautsky was as follows:

> The revolutionary dictatorship of the proletariat is violence against the bourgeoisie; and the necessity for such violence is *particularly* created, as Marx and Engels have repeatedly explained in detail, by the existence of *militarism and bureaucracy.* But it is precisely these institutions that were non-existent in England and America in the seventies of the nineteenth century, when Marx made his observations (they *do* exist in England and in America *now*). ("Proletarian Revolution and the Renegade Kautsky," *Selected Works, International Publishers,* New York, Vol. VII, p. 125.)

It can thus be seen that the proletariat is compelled to resort to the means of armed revolution. Marxists have always wanted to follow the peaceful way in the transition to socialism. As long as the peaceful way is there to adopt, Marxist-Leninists will never give it up. But it is precisely this way that the bourgeosie seeks to block when it possesses a powerful, militaristic and bureaucratic machine of oppression.

The above quotation was written by Lenin in November 1918. How do things stand now? Is it that Lenin's words were historically valid, but are no longer so under present conditions, as the modern revisionists allege? Everybody can see that with hardly any exception the capitalist countries, particularly the few imperialist powers headed by the United States, are trying hard to strengthen their militaristic and bureaucratic machine of oppression, and especially their military machine.

The Declaration of the Moscow Meeting of the Representatives of the Communist and Workers' Parties of the Socialist Countries of November 1957, states:

> Leninism teaches, and experience confirms, that the ruling classes never relinquish power voluntarily. In this case the bitterness and forms of the class struggle will depend not so much on the proletariat as on the resistance put up by the reactionary circles to the will of the overwhelming majority of the people, on these circles using force at one or another stage of the struggle for socialism.

This is a new summing up of the experience of the struggle of the international proletariat in the few decades since Lenin's death.

The question is not whether the proletariat is willing to carry out a peaceful transformation; it is rather whether the bourgeoisie will accept such a peaceful transformation. This is the only possible way in which followers of Lenin can approach this question.

So contrary to the modern revisionists who seek to paralyse the revolutionary will of the people by empty talk about peaceful transition, Marxist-Leninists hold that the question of possible peaceful transition to socialism can be raised only in the light of the specific conditions in each country at a particular time. The proletariat must never allow itself to one-sidedly and groundlessly base its thinking, policy and its whole work on the calculation that the bourgeoisie is willing to accept peaceful transformation. It must, at the same time, prepare for alternatives: one for the peaceful development of the revolution and the other for the non-peaceful development of the revolution. Whether the transition will be carried out through

armed uprising or by peaceful means is a question that is fundamentally separate from that of peaceful co-existence between the socialist and capitalist countries; it is an internal affair of each country, one to be determined only by the relation of classes in that country in a given period, a matter to be decided only by the Communists of that country themselves.

V

After the October Revolution in 1919, Lenin discussed the historical lessons to be drawn from the Second International. He said that the growth of the proletarian movement during the period of the Second International " was in breadth, at the cost of a temporary fall in the revolutionary level, a temporary increase in the strength of opportunism, which in the end led to the disgraceful collapse of this International." (" Third International and Its Place in History," *Selected Works*, F.L.P.H., Moscow, 1952, Vol. II, part 2, p. 199.)

What is opportunism? According to Lenin, " Opportunism consists in sacrificing fundamental interests in order to gain temporary, partial benefits." (" Speech at Conference of Activists of the Moscow Party Organization," *Collected Works*, 4th Russ. ed., Vol. XXXI, p. 412.)

And what does the fall in the revolutionary level mean? It means that the opportunists seek to lead the masses to focus their attention on their day-to-day, temporary and partial interests only, and forget their long-term, fundamental and overall interests.

Marxist-Leninists hold that the question of parliamentary struggle should be considered in the light of long-term, fundamental and overall interests.

Lenin told us about the limitations of parliamentary struggle, but he also warned communists against narrow-minded, sectarian errors. In his well-known work *Left-wing Communism, an Infantile Disorder*, Lenin elucidated the experience of the Russian revolution, showing under what conditions a boycott of parliament is correct and under what other conditions it is incorrect. Lenin held that every proletarian party should make use of every possible opportunity to participate in necessary parliamentary struggles. It was fundamentally wrong and would only harm the cause of the revolutionary proletariat for a Communist Party member to engage only in empty talk about the revolution, while being unwilling to work perseveringly and painstakingly, and shunning necessary parliamentary struggles.

Lenin then criticized the mistakes of the communists in some European countries in refusing to participate in parliament. He said:

> The childishness of those who " repudiate " participation in parliament consists precisely in the fact that they think it possible to " solve " the difficult problem of combating bourgeois-democratic influences *within* the working-class movement by such " simple," " easy," supposedly revolutionary methods, when in reality they are only running away from their own shadow, only closing their eyes to difficulties and only trying to brush them aside with mere words. (*Selected Works*, F.L.P.H., Moscow, 1952, Vol. II, part 2, p. 443.)

Why is it necessary to engage in parliamentary struggle? According to Lenin, it is for the purpose of combating bourgeois influences within the ranks of the working-class movement, or, as he pointed out elsewhere:

> Precisely for the purpose of educating the backward strata of its own

class, precisely for the purpose of awakening and enlightening the under-developed, downtrodden, ignorant, rural *masses*. (*Selected Works*, F.L.P.H., Moscow, 1952, Vol. II, part 2, p. 383.)

In other words, it is to enhance the political and ideological level of the masses, to co-ordinate parliamentary struggle with revolutionary struggle, and not to lower our political and ideological standards and divorce parliamentary struggle from the revolutionary struggle.

Identify with the masses but no lowering of revolutionary standards—this is a fundamental principle which Lenin taught us to firmly adhere to in our proletarian struggle.

We should take part in parliamentary struggles, but have no illusions about the bourgeois parliamentary system. Why? Because so long as the militarist-bureaucrat state machine of the bourgeoisie remains intact, parliament is nothing but an adornment for the bourgeois dictatorship even if the working-class party commands a majority in parliament or becomes the biggest party in it. Moreover, so long as such a state machine remains intact, the bourgeoisie is fully able at any time, in accordance with the needs of its own interests, either to dissolve parliament when necessary, or to use various open and underhanded tricks to turn a working-class party which is the biggest party in parliament into a minority, or to reduce its seats in parliament, even when it has polled more votes in an election. It is, therefore, difficult to imagine that changes will take place in a bourgeois dictatorship itself as the result of votes in parliament and it is just as difficult to imagine that the proletariat can adopt measures in parliament for a peaceful transition to socialism just because it has won a certain number of votes in parliament. A series of experiences in the capitalist countries long ago proved this point fully and the experiences in various European and Asian countries after the Second World War provide additional proof of it.

Lenin said: "The proletariat cannot be victorious unless it wins over to its side the majority of the population. But to limit or condition this to the gathering of a majority of votes at elections while the bourgeoisie remains dominant is the most utter stupidity or simply swindling the workers." ("Elections to the Constituent Assembly and the Dictatorship of the Proletariat," *Collected Works*, 4th Russ. ed., Vol. XXX, p. 243.) Modern revisionists hold that these words of Lenin are out of date. But living realities bear witness to the fact that these words of Lenin are still the best medicine, though bitter tasting, for proletarian revolutionaries in any country.

Lowering revolutionary standards means lowering the theoretical standards of Marxism-Leninism. It means lowering political struggles to the level of economic ones and restricting revolutionary struggles to within the limits of parliamentary struggles. It means bartering away principles for temporary benefits.

At the beginning of the 20th century Lenin in *What Is to Be Done?* drew attention to the question that "the spread of Marxism was accompanied by a certain lowering of theoretical standards." Lenin cited Marx's opinion contained in a letter on "The Gotha Programme" that we may enter into agreements to attain the practical aims of the movement, but we must never trade in principles and make "concessions" in theory. Afterwards, Lenin wrote the following words which by now are well known to almost all Communists:

Without a revolutionary theory there can be no revolutionary movement. This cannot be insisted upon too strongly at a time when the fashionable preaching of opportunism is combined with absorption in the narrowest forms of practical activity." ("What Is to Be Done?" *Selected Works*, International Publishers, New York, Vol. II, p. 47.)

What an important revelation this is to revolutionary Marxists! It was precisely under the guidance of this thought—that the Bolshevik Party headed by the great Lenin must firmly uphold revolutionary Marxist theory —that the entire revolutionary movement in Russia gained victory in October 1917.

The Chinese Communist Party also gained experience in regard to the above-mentioned question on two occasions. The first was during the 1927 revolutionary period. At that time Chen Tu-hsiu's opportunism as shown over the policy towards the Communist Party's united front with the Kuomintang was a departure from the principles and stand which a Communist Party should uphold. He advocated that the Communist Party should in principle be reduced to the level of the Kuomintang. The result was defeat for the revolution. The second occasion was during the period of the War of Resistance to Japanese Aggression. The Central Committee of the Chinese Communist Party firmly upheld the Marxist-Leninist stand, exposed the differences in principle between the Communist Party and the Kuomintang in their attitudes towards the conduct of the war against Japan, and held that the Communist Party must never make concessions in principle on such attitudes. But the right opportunists represented by Wang Ming repeated the mistakes made by Chen Tu-hsiu ten years earlier and wanted to reduce the Communist Party in principle to the level of the Kuomintang. Therefore, our entire Party carried out a great debate with the right opportunists throughout the Party. Comrade Mao Tse-tung said:

... If the Communists forget this point of principle, they will not be able to guide the Anti-Japanese War correctly, they will be powerless to overcome the Kuomintang's one-sidedness, and they will lower themselves to a stand which is against their principles and reduce the Communist Party to the level of the Kuomintang. They will then commit a crime against the sacred cause of the national revolutionary war and the defence of the motherland. ("After the Fall of Shanghai and Taiyuan," *Selected Works*, Lawrence & Wishart, London, Vol. II, pp. 105–106.)

It was precisely because the Central Committee of our Party refused to make the slightest concessions on question of principle, and because it adopted a policy of both unity and struggle in our Party's united front with the Kuomintang, that we were able to consolidate and expand the Party's positions in the political and economic fields, consolidate and expand the national revolutionary united front and, consequently, strengthen and expand the forces of the people in the War of Resistance to Japanese Aggression. It also enabled us to smash the large-scale attacks launched by the Chiang Kai-shek reactionaries after the conclusion of the War of Resistance to Japanese Aggression and win nation-wide victory in the great people's revolution.

Judging by the experience of the Chinese revolution, mistakes of right deviation are likely to occur in our Party when the proletariat enters into political co-operation with the bourgeoisie, whereas mistakes of "left" deviation are likely to occur in our Party when these two classes break away from each other politically. In the course of leading the Chinese revolution, our Party has waged struggles against "left" adventurism on

many occasions. The "left" adventurists were unable to take a Marxist-Leninist viewpoint on the correct handling of the complex class relations in China ; they failed to understand how to adopt different correct policies towards different classes at different historical periods, but only followed the erroneous policy of struggle without unity. Had this mistake of "left" adventurism not been overcome, it would have been impossible for the Chinese revolution to advance to victory.

In line with Lenin's viewpoint the proletariat in any country, if it wants to gain victory in the revolution, must have a genuinely Marxist-Leninist party which is skilled at integrating the universal truths of Marxism-Leninism with concrete revolutionary practice in its own country, correctly determining whom the revolution should be directed against at different periods, settling the question of organizing the main force and its allies and the question of whom it should rely on and unite with. The revolutionary proletarian party must rely closely on the masses of its own class and on the semi-proletariat in the rural areas, namely, the broad masses of poor peasants and establish the worker-peasant alliance led by the proletariat. Only then is it possible, on the basis of this alliance, to unite with all the social forces that can be united with and so establish the united front of the working people with all the non-working people that can be united with in accordance with specific conditions in the different countries at different periods. If it fails to do so, the proletariat will not be able to achieve its purpose of gaining victory in the revolution at different periods.

The modern revisionists and certain representatives of the bourgeoisie try to make people believe that it is possible to achieve socialism without a revolutionary party of the proletariat and without the series of correct policies of the revolutionary party of the proletariat mentioned above. This is sheer nonsense and pure deception. The *Communist Manifesto* by Marx and Engels pointed out that there were different kinds of "socialism," there was petty-bourgeois "socialism," bourgeois "socialism," feudal "socialism," etc. Now, as a result of the victory of Marxism-Leninism and the decay of the capitalist system, more and more of the mass of the people in various countries are aspiring to socialism and a more motley variety of so-called "socialisms" have emerged from among the exploiting classes in certain countries. Just as Engels said, these so-called "socialists" also "wanted to eliminate social abuses through their various universal panaceas and all kinds of patchwork, without hurting capital and profit in the least," they "stood outside the labour movement and looked for support rather to the 'educated' classes." ("Preface to the German Edition of the Manifesto of the Communist Party," *Selected Works of Marx and Engels*, F.L.P.H., Moscow, 1958, Vol. I, p. 31.) They only put up the signboard of "socialism" but actually practise capitalism. In these circumstances it is extremely important to adhere firmly to the revolutionary principles of Marxism-Leninism and to wage an irreconcilable struggle against any tendency to lower the revolutionary standards, especially against revisionism and right opportunism.

In regard to the question of safeguarding world peace at the present time there are also certain people who declare that ideological disputes are no longer necessary, or that there is no longer any difference in principle between communists and social democrats. This is tantamount to lowering the ideological and political standards of communists to those of the bourgeoisie

and social democrats. Those who make such statements have been influenced by modern revisionism and have departed from the stand of Marxism-Leninism.

The struggle for peace and the struggle for socialism are two different kinds of struggle. It is a mistake not to make a proper distinction between these two kinds of struggle. The social composition of those taking part in the peace movement is, of course, more complex; it also includes bourgeois pacifists. We communists stand right in the forefront in defending world peace, right in the forefront in opposing imperialist wars, in advocating peaceful co-existence and opposing nuclear weapons. In this movement we shall work together with many complex social groups and enter into necessary agreements for the attainment of peace. But at the same time we must uphold the principles of the working-class party and not lower our political and ideological standards and reduce ourselves to the level of the bourgeois pacifists in our struggle for peace. It is here that the question of alliance and criticism arises.

" Peace " in the mouths of modern revisionists is intended to whitewash the war preparations of the imperialists, to play again the tune of " ultra imperialism " of the old opportunists, which was long since refuted by Lenin, and to distort our communist policy concerning peaceful co-existence of countries with two different systems into elimination of the people's revolution in various countries. It was that old revisionist Bernstein who made this shameful and notorious statement: The movement is everything, the final aim is nothing. The modern revisionists have a similar statement: The peace movement is everything, the aim is nothing. Therefore, the " peace " they talk about is in practice limited to the " peace " which may be acceptable to the imperialists under certain historical conditions. It attempts to lower the revolutionary standards of the peoples of various countries and destroy their revolutionary will.

We communists are struggling in defence of world peace, for the realization of the policy of peaceful co-existence. At the same time we support the revolutionary wars of the oppressed nations against imperialism. We support the revolutionary wars of the oppressed people for their own liberation and social progress because all these revolutionary wars are just wars. Naturally, we must continue to explain to the masses Lenin's thesis concerning the capitalist-imperialist system as the source of modern war; we must continue to explain to the masses the Marxist-Leninist thesis on the replacement of capitalist imperialism by socialism and communism as the final goal of our struggle. We must not hide our principles before the masses.

VI

We are living in a great new epoch in which the collapse of the imperialist system is being further accelerated, the victory of the people throughout the world and their awakening are constantly advancing.

The peoples of the various countries are now in a much more fortunate situation than ever before. In the forty-odd years since the October Revolution, one-third of all mankind have freed themselves from oppression by capitalist imperialism and founded a number of socialist states where a life of lasting internal peace has really been established. They are exerting their influence on the future of all mankind and will greatly speed the day when universal, lasting peace will reign throughout the world.

Marching in the forefront of all the socialist countries and of the whole socialist camp is the great Soviet Union, the first socialist state created by the workers and peasants led by Lenin and their Communist Party. Lenin's ideals have been realized in the Soviet Union, socialism has long since been built and now, under the leadership of the Central Committee of the Communist Party of the Soviet Union and the Soviet Government headed by Comrade Khrushchev, a great period of the extensive building of communism is already beginning. The valiant and enormously talented Soviet workers, peasants and intellectuals have brought about a great, new labour upsurge in their struggle for the grand goal of building communism.

We, the Chinese Communists and the Chinese people, cheer every new achievement of the Soviet Union, the native land of Leninism.

The Chinese Communist Party, integrating the universal truths of Marxism-Leninism with the concrete practice of the Chinese revolution, has led the people of the entire country in winning great victories in the people's revolution, marching along the broad common road of socialist revolution and socialist construction charted by Lenin, carrying the socialist revolution to full completion and it has already begun to win great victories on the various fronts of socialist construction. The Central Committee of the Chinese Communist Party creatively set down for the Chinese people, in accordance with Lenin's principles and in the light of conditions in China, the correct principles of the general line for building socialism, the big leap forward and the people's communes, whch have inspired the initiative and revolutionary spirit of the masses throughout the country and are thus day after day bringing about new changes in the face of our country.

Under our common banner of Leninism, the socialist countries in Eastern Europe and the other socialist countries in Asia have also attained progress by leaps and bounds in socialist construction.

Leninism is an ever victorious banner. For the working people throughout the world, holding firm this great banner means taking hold of truth and opening up for themselves a road of continuous victory.

Lenin will always live in our hearts. And when modern revisionists endeavour to smear Leninism, the great banner of the international proletariat, our task is to defend Leninism.

All of us remember what Lenin wrote in his famous work *The State and Revolution* about what happened to the teachings of revolutionary thinkers and leaders in the past struggles of various oppressed classes for liberation. Lenin wrote that after the death of these revolutionary thinkers and leaders distortions ensued, " emasculating the essence of the revolutionary teaching, blunting its revolutionary edge and vulgarizing it." Lenin continued,

> At the present time, the bourgeoisie and the opportunists within the working-class movement concur in this "doctoring" of Marxism. They omit, obliterate and distort the revolutionary side of this teaching, its revolutionary soul. They push to the foreground and extol what is or seems acceptable to the bourgeoisie. ("The State and Revolution," *Selected Works*, F.L.P.H., Moscow, 1952, Vol. II, part 1, p. 202.)

Just so, at the present time we are again confronted by certain representatives of U.S. imperialism who once again assuming the pious mien of preachers, even declare that Marx was "a great thinker of the nineteenth century" and even acknowledge that what Marx predicted in the nineteenth century about the days of capitalism being numbered, "is well-grounded" and "correct"; but, these preachers continue, after the advent of the

twentieth century, and especially in recent decades, Marxism has become incorrect, because capitalism has become a thing of the past and has ceased to exist, at least in the United States. After hearing such nonsense from these imperialist preachers, we cannot but feel that the modern revisionists are talking the same language as they do. But the modern revisionists do not stop at distorting the teachings of Marx, they go further to distort the teachings of Lenin, the great continuer of Marxism who carried Marxism forward.

The Declaration of the Moscow Meeting pointed out that "the main danger at present is revisionism, or, in other words, right-wing opportunism." Some say that this judgment of the Moscow Meeting no longer holds good under today's conditions. We hold this to be wrong. It makes the people overlook the importance of the struggle against the main danger—revisionism, and is very harmful to the revolutionary cause of the proletariat. Just as from the beginning of the seventies of the nineteenth century there was a period of "peaceful" development of capitalism during which the old revisionism of Bernstein was born, so under the present circumstances when the imperialists are compelled to accept peaceful co-existence and when there is a kind of "internal peace" in many capitalist countries, revisionist trends find it easy to grow and spread. Therefore, we must always maintain a high degree of vigilance against this main danger in the working-class movement.

As pupils of Lenin and as Leninists, we must utterly smash all attempts of the modern revisionists to distort and carve up the teaching of Lenin.

Leninism is the complete and integrated revolutionary teaching of the proletariat, it is a complete and integrated revolutionary world outlook which, following Marx and Engels, continues to express the thinking of the proletariat. This complete and integrated revolutionary teaching and revolutionary outlook must not be distorted or carved up. We hold the view that the attempts of the modern revisionists to distort and carve up Leninism are nothing but a manifestation of the last ditch struggle of the imperialists facing their doom. In face of continuous victories in building communism in the Soviet Union, in face of continuous victories in building socialism in the socialist countries, in face of constant strengthening of the unity of the socialist camp headed by the Soviet Union and of the steadfast and valiant struggles being waged by the increasingly awakened peoples of the world seeking to free themselves from the shackles of capitalist imperialism, the revisionist endeavours of Tito and his ilk are completely futile.

Long live great Leninism!

[*Red Flag*, No. 8, 1960. (Translated in *Peking Review*, No. 17, 1960.)]

"Forward Along the Path of the Great Lenin"

U.S. imperialism holds nothing but venom for the peace efforts of the socialist camp headed by the Soviet Union. It openly proclaims a policy of hostility to the People's Republic of China, and brazenly attacks the just stand of the Chinese people in safeguarding world peace and opposing imperialist war. The Chinese people have made a timely exposure of the fact that the U.S. Government headed by Eisenhower is, since the Camp David talks between Comrade Khrushchev and Eisenhower last September, still continuing to actively carry out arms expansion and war preparations

and enlarging its aggression. U.S. imperialist spokesmen spread the slander that the Chinese people do not seem enthusiastic about relaxing the international situation. But this monstrous lie is really too brazen for words. Since the U.S. Government and Eisenhower himself are in actual fact engaged in arms expansion, war preparations and enlarging aggression, and this runs counter to the demand for easing the international situation, how would it help the international situation if this should be concealed or even whitewashed, prettified and extolled? On the contrary, that would only make the tension-makers all the more reckless and unbridled.

Facts speak louder than eloquence. Just have a look at the following brief summary of the words and deeds of the U.S. Government and Eisenhower against peace since the Camp David talks last September:

On October 16, 1959, U.S. Assistant Secretary of State Andrew H. Berding said in a speech that the United States could not accept peaceful co-existence because it would mean accepting the status quo of the socialist camp.

On October 21, the U.S. railroaded an illegal resolution on the so-called "Tibet question" through the United Nations General Assembly interfering in China's internal affairs and slandering the putting down by the Chinese Government of the rebellion of a reactionary group of serf-owners in the Tibet region.

On October 22, the U.S. State Department issued a statement on the third anniversary of the counter-revolutionary revolt in Hungary, slandering the Hungarian and Soviet Governments and "honouring" the counter-revolutionary elements who launched the revolt. . . .

The facts listed here are, of course, far from exhaustive, and are limited to data issued openly by the U.S. Government and American publications. Nevertheless, we should like to ask: Are these still not facts? Are these still not the principal facts of present U.S. policy? Can it be said that all this has been concocted by the Chinese Communists? Can it be said that these are only insignificant, trifling survivals of former times in U.S. policy? Naturally, the facts do not bear this out. The fact is, even after the Camp David talks and even on the eve of the East-West summit conference, we see no change at all in substance in U.S. imperialist war policy, in the policy carried out by the U.S. Government and by Eisenhower personally. U.S. imperialism is not only doing its utmost to expand its aggressive military strength, but is also impatiently fostering the militarist forces of West Germany and Japan and turning these countries into hotbeds of new war Let it be clearly understood that all this is affecting the fate of all mankind. It is absolutely necessary to oppose militarism in West Germany and Japan, and militarism fostered by the United States in other countries. But now it is, first of all, the war policy of U.S. imperialism that plays the decisive role in all this. Departing from this point is departing from the heart and essence of the matter. If the peace-loving people of the world do not concentrate their strength on continuously and resolutely exposing this war policy of the U.S. authorities and waging a serious struggle against it, the result will inevitably be a grievous calamity.

What right have the Chinese people, standing in the foremost ranks of the struggle for peace together with the peoples of the Soviet Union and the other socialist countries, to maintain silence on all these facts? What right have we to let Americans do, say and know about all these things, and

not let the peoples of China and other countries know about them? Can it be bad for peace, can it aggravate tension, if we explain the true state of affairs to the Chinese and world public, or can concealing the truth help peace and help relax tension? Can it be that, according to the logic of the U.S. imperialists, that is how peace is to be "preserved"? Or is this the "peace in freedom" referred to by Eisenhower and his ilk?

The U.S. imperialists who actively plan for new war do indeed hope that we will conceal the true state of affairs; hope that we will abandon the standpoints of Marxism-Leninism; hope that we will believe the nature of imperialism can change or even that it has already changed; hope that in the struggle to safeguard world peace we, just like the bourgeois pacifists, will not mobilize and rely on the broadest masses of people who are against imperialism, against imperialist war, and against imperialist aggression; hope that we will exaggerate as much as possible the peace gestures which the imperialist aggressive forces are compelled to make and put the masses off their guard or exaggerate the might of the imperialist aggressive forces in war, and so throw the masses of the people into a panic. In short, the plotters of new war hope that we, like them, will not really want peace and will not want real peace, so that they can suddenly force war on the peoples, just as they did in the First and Second World Wars. . . .

[*People's Daily*, editorial, April 22. From text in *Peking Review*, No. 17, 1960.]

THE SOVIET REPLY

The Soviet reply to "Long Live Leninism!" and, presumably, to Chinese representations to Moscow during the preceding months was given by Otto Kuusinen, a member of the CPSU Presidium who had been prominent in the international Communist movement during Comintern days. In his speech at the Lenin anniversary meeting at Moscow's Sports Palace on April 22, Kuusinen made the first public allegation that those who opposed the CPSU's "creative development" of Leninism with respect to peace, war and peaceful co-existence were adopting a "dogmatic position." He reasserted the conclusions of the CPSU's Twentieth and Twenty-first Congresses, reaffirming the importance of the "powerful factors" making for peace.

These factors still did not include the national liberation movement; the statement that "imperialism *has* been weakened by the collapse of the colonial system" (emphasis added) would seem to refer to countries like India which had already achieved independence rather than to rebel movements like the Algerian FLN. The importance of Kuusinen's failure to include the national liberation movement here is underlined by the way in which he refers to it later in his speech. He states that even though the imperialists may achieve temporary successes, they can never defeat the anti-colonialist struggle. His attitude seems to be that the Communist *bloc* does not need to concern itself too much with the national liberation movement because it will take care of itself.

At this point it may be convenient to discuss the importance of the

national liberation movement in the Sino-Soviet dispute. The opposing positions of Moscow and Peking first came to the surface during the Middle Eastern crisis after the Iraqi revolution in the summer of 1958. Chinese propaganda indicated that if Mao had been in Khrushchev's shoes he would have moved troops into Iraq to guard against the danger of a counter-coup that the American move into the Lebanon must have made the Communists think possible. Khrushchev, however, was fully aware that any such action on his part might well lead to a Russo-American clash on the ground with a high probability of a nuclear war ensuing. This risk he could not take and instead he called for a summit conference. However, Chinese representations at this time were clearly very strong for Khrushchev felt compelled to fly secretly to Peking and attempt to co-ordinate Sino-Soviet views. As the prospect of American intervention in Iraq soon faded, he was able, in effect, to abandon his demands for a summit conference.[10]

From the development of that crisis, Khrushchev probably drew two conclusions: (1) that any Soviet involvement with the national liberation movement would certainly worsen East-West relations and carry with it the risk of a Russo-American clash; and (2) that involvement was unnecessary since the national liberation movement would succeed anyway.

It was doubtless such conclusions that caused Khrushchev to handle the FLN very gingerly whereas the Chinese soon officially recognised the movement as the Algerian Government. The Chinese position was that by encouraging such movements the West was weakened more considerably and more quickly. They were prepared, it seemed, to risk world war if that was what the policy involved. Khrushchev was not—hence the consistent Soviet underplaying of the importance of the national liberation movement in the " fight for peace."

In his speech, Kuusinen again made the distinction between " thick-skulled opponents of peace " and " sober-minded statesmen " among whom he presumably included Eisenhower. Even more important, he rejected the Chinese attempt to minimise the significance of the invention of nuclear weapons with the theoretical argument that man, not technique, determined the fate of mankind. Kuusinen, referring to Lenin, suggested that weapons could indeed have a decisive influence on the likelihood of war.

Finally, we must note that Khrushchev took this opportunity also to

[10] Khrushchev had originally called for a " summit " within the framework of the Security Council; after his visit to China he called instead for a " summit " outside the UN, ostensibly so that he would not have to deal with Nationalist China. While the Chinese might well have resented Khrushchev's readiness to sit down with the Nationalists, the point to note is that the Soviet change of attitude made a " summit " far less likely, as Khrushchev must have known it would. The diminishing fervour of Soviet demands for a " summit " can also be taken as a sign of Soviet intentions.

justify Soviet aid to neutralist countries. His argument seems to be that this policy increases confidence in the Soviet Union on the part of the neutralists—and that this confidence will bring the neutralists' diplomacy more into line with Soviet diplomacy as well as increase the pro-Communist forces within the neutralist countries. (" The confidence . . . will have its bearing on the further strengthening of peace and social progress.")

Kuusinen's Speech at the Lenin Anniversary Meeting

The great teaching of Lenin—Leninism—is the Marxism of our epoch. As a loyal Marxist, Lenin further developed the teaching of Marx in conformity with changing historical conditions. Allegiance to the teaching of Lenin demands of our party that it, too, taking present-day conditions into consideration, should further develop Marxism-Leninism, always applying its fundamental provisions in a creative way.

Such allegiance to Leninism is demanded of our party by its responsibility to the working class, to the entire Soviet people, and also to the international communist movement. For our party, thanks to its wealth of experience has set an example of struggle for socialism, an example of the successful accomplishment of the most complicated tasks of building socialism and communism.

Our party proves its allegiance to Marxism-Leninism by its deeds and by its policy. Lenin wrote that politics is a science and an art. Emphasising the unbreakable ties between the theory and practice of Marxism, he pointed out: " Marxism lies in the ability to determine what policy should be pursued in the given conditions."

What is the specific policy our party is pursuing in the present conditions? How does it fulfil Lenin's behests? What is the aim of the policy of the party and the Soviet government?

It seems to me appropriate at this meeting, devoted to the memory of our unforgettable teacher, to try to throw light on these questions. . . .

Policy of Friendship with the Peoples Who Have Cast Off the Yoke of Colonialism

Comrades, true to the behests of Lenin, our party has always backed the liberation struggle of the oppressed peoples and their right of self-determination. When, after the Second World War, Lenin's forecasts concerning the liberation of the peoples of the East came true on a gigantic scale and when dozens of new independent states were founded on the wreckage of colonial empires, our Soviet state was confronted with new and important tasks.

The peoples who for centuries had borne on their shoulders the yoke of colonial exploitation now needed, not only moral and political support, but also economic assistance in developing their national economy.

As for our relations with countries of the socialist camp—the Chinese People's Republic, the Korean Democratic People's Republic and the Democratic Republic of Viet Nam, the Mongolian People's Republic—those relations have been determined from the very outset by the principles of socialist internationalism. Close alliance and fraternal friendship, mutual

ssistance and co-operation in building socialism and communism—that is he foundation of these relations.

But we have a broader understanding of the international duty of our ocialist country—we understand it as rendering assistance to those liberated eoples, too, who are not included in the world system of socialism. All-ound, disinterested assistance in strengthening their political and economic ndependence is the foundation of our relations with the newly-created states. Of course, we do not impose assistance on anyone, but we help when we are sked to do so.

The road to the consolidation of the independence of the liberated ountries is the road of developing their national economy, promoting the dvance of their culture and improving the living standards of the people. ndustrialisation is of tremedous importance for such countries. It is recisely here that the young states need support most of all. Understanding his, the Soviet Union is accordingly developing its economic co-operation vith them.

The supplying of up-to-date industrial equipment, assistance in building arge enterprises, in prospecting for and exploiting natural resources, in raining national cadres of specialists—these are the principal aspects of oviet assistance. The Soviet Union's participation in building the gigantic teel works at Bhilai, in the construction of the Aswan High Dam, a steel vorks in Indonesia and dozens of other industrial projects accords with the ital interests of the peoples of the East.

One often hears the claim that the western countries also have a strong lesire to help the peoples who have cast off the yoke of imperialism. Generally speaking, it would only be fair if the colonial powers were to eturn to the owners even a part of the wealth they have appropriated. However, this is not the case here.

The western powers, as in the past, still continue to hinder the indepen-ent development and industrialisation of underdeveloped countries. The ature of their " assistance " is determined, as we know, by their military lans, which are obviously a danger to the independence of the recipient ountries.

It is said in the West that a struggle for the countries of the East has ow developed and it is alleged that the Soviet Union is seeking to tie them o its chariot. But does the Soviet Union seek to draw the eastern countries nto war *blocs* like S.E.A.T.O., Cento, etc.? Does the Soviet Union attach olitical strings to its assistance? Does it demand the right to intervene in lomestic affairs? No, that is precisely how the western powers act.

Thus, the liberated peoples have two aspects of assistance, two policies efore their eyes. Is it surprising that those peoples increasingly dissociate hemselves from the policy of the West? They understand that assistance s a good thing if it is disinterested, and friendship is firm if it is sincere.

The consolidation of independence and the successful development of he liberated countries brings closer the time when they will achieve their egitimate right, on an equal footing with other states, to take part in the olution of all major international problems. This was rightly pointed out y Nikita Khruschev when he addressed the Indonesian Parliament.

The confidence which Soviet policy enjoys in the countries of the East s a matter of great importance. It will have its bearing on the further trengthening of peace and social progress. We owe this confidence to the

fact that underlying Soviet policy are the principles worked out by th great Lenin.

Struggle for Peace and Peaceful Co-existence

Lenin's behest to our party and all communists was: Fight tirelessl for peace and work to end wars. He said: "The ending of wars, peac between the nations, the stopping of plunder and violence—it is precisel this that is our ideal." (*Works, vol.* 21, *p.* 264, *Russian edition.*)

In the West at the present time there are glib propagandists who alleg that Lenin was against the peaceful co-existence of the two systems. Thes falsifiers pick out individual quotations from Lenin's works, or even frag ments of quotations dating back to the time of the Civil War and militar intervention. But it was the world bourgeoisie itself which, by its inter vention, added to the struggle of the Russian proletariat the character of a international clash. It is clear that at the time of the intervention th question of the peaceful co-existence of socialism and capitalism wa relegated to the background.

But then, these gentlemen carefully pass over in silence Lenin's entir policy during the first years of Soviet power, his line towards establishing businesslike co-operation with capitalist states, the line which was clearl expressed in Lenin's directives to the Soviet delegates to the first internationa conferences, for instance in Genoa in 1922.

In that period Lenin developed his idea of the peaceful economic com petition of the two systems. To use Lenin's expression, this is the "rivalr of two methods, two formations, two kinds of economy—communist an capitalist."

"We shall prove," Lenin continues, "that we are the stronger."

"Of course, the task is a difficult one, but we have said and continue to say that socialism has the power of example. Force is of avail in relation to those who want to restore their power. But that exhausts the value of force and after that only influence and example are of avail. We must demonstrate the importance of communism practically, by example." (*Works, vol.* 31 *p.* 426, *Russian edition.*)

The principles of peaceful co-existence, both then and now, form the basis of the whole of Soviet foreign policy. During recent years ou party has been creatively developing this idea of Lenin's. Of decisive impor tance in this connection was the conclusion drawn by the 20th and 21st Party Congresses about there being no fatal inevitability of wars in ou epoch, about the possibility of preventing wars. By drawing this conclusion the party has made a new contribution to Marxism.

Of course, aggressiveness is inherent in the nature of imperialism. But one should not dogmatically consider only this aspect of the matter. The fact that powerful forces counteracting war have appeared should not be ignored. One should not overlook the fact that the time has gone, never to return, when imperialism had the whole world under its sway. Capitalism can no longer make the whole world follow its laws. A powerful world system of socialism is already in existence; imperialism has been weakened by the collapse of the colonial system; a vast "zone of peace" has come into being; the forces of peace and democracy are now more closely united and better organised even in the imperialist countries themselves. Don't these powerful factors have practical significance in settling the question of peace and war?

Therefore, in order to be loyal to Marxism-Leninism today it is not ufficient to repeat the old truth that imperialism is aggressive. The task s to make full use of the new factors operating for peace in order to save umanity from the catastrophe of another war. A dogmatic position is a ackward position. The correctness of our foreign policy of creative _eninism, making use of all the factors for peace, is proved best of all by he success of this policy. The persistent struggle of the Soviet government, bounding in initiative, has yielded fruit. A tangible easing of international ension has been achieved. The cold war is gradually receding. Business-ike relations, including cultural contacts, are being established between tates with different social systems. The most burning questions of the nternational situation have, at long last, become the subject of serious East-West negotiations.

The active struggle of the Soviet government for peace and peaceful :o-existence gives our foreign policy an innovative and creative character. This is demonstrated in the frankness with which the most burning issues of world politics are approached, in the combination of firmness, based on principle, with readiness to agree to sensible compromises. This is a truly democratic foreign policy which is being carried out openly before the eyes of the peoples.

In its practical activity the Soviet government is widely cultivating personal contacts with both statesmen and public leaders of bourgeois countries.

The numerous state visits to foreign countries by the head of the Soviet government, Nikita Krushchev, have, as we know, acquired tremendous importance. They have been of historic significance in improving the Soviet Union's relations with other states and in improving the international situation as a whole. These visits have confirmed once again that the Leninist policy of the peaceful co-existence of states with different social systems, pursued by our party and the Soviet government headed by Comrade Nikita Khrushchev, is the only correct and viable policy. All of us remember full well the moving demonstrations of friendship by masses of people during Nikita Krushchev's stay in the United States of America, India, Indonesia, Burma, Afghanistan and France on his great mission of goodwill.

The change in the balance of forces on the international scene, the growing might of the socialist camp and the obviously disastrous consequences of another war—all this leads to a split in the ruling circles of the imperialist states. There appear, alongside the thick-skulled opponents of peace, sober-minded statesmen who realise that a war with the use of weapons of mass destruction would be madness.

Such are the dialectics of military-engineering progress: A new weapon created for war begins to exert an influence in favour of peace. For Marxists there is nothing mysterious in this. The classics of Marxism have never denied the fact that new types of weapons can not only bring about a radical change in the art of war but can also influence politics.

For instance, Engels wrote about this in *Anti-Dühring*. And Nadezhda Krupskaya tells us that Lenin foresaw that " the time will come when war will become so destructive as to be impossible."

Lenin told Krupskaya about his talk with an engineer who had said that an invention was then in the making which would render it possible to destroy a large army from a distance. It would make a war impossible.

" Ilyich," Krupskaya writes, " talked about it with great enthusiasm. It wa obvious that he passionately wanted war to become impossible."

The division among influential circles of the bourgeoisie is undoubtedl of importance for a successful struggle for peace. Already Lenin pointe out that it is by no means a matter of indifference to us, of course, whethe we are dealing with those representatives of the bourgeois camp who ar inclining towards a military solution of a problem, or with representative of the bourgeois camp who are inclining towards pacifism, even of th most feeble kind and one which, from the communist viewpoint, will no stand up to the slightest criticism (*Works, vol. 33, p. 236, Russian edition*)

The achievements in the struggle for peace provide a favourable basi for further advancement. The main task now is to achieve disarmament It is very significant that it was precisely our socialist state, which possesse a generally recognised superiority in the military sphere, which put forwar the proposal for general and complete disarmament and made this task th pivotal point of world politics.

Just imagine, comrades, a situation in which all these famous sputniks luniks and our other celestial envoys had been made in the United States and our country had been sending up rockets which persisted in coming down. Who would believe, then, that the American authorities would mak a proposal for total disarmament? I don't believe it, nor do you. Obviously no one would believe it! The diehard imperialists, naturally, are doing everything in their power to prevent the Soviet proposals from being accepted.

They represent the interests of those groups of monopoly capital which by no means want to give up the fat profits they get from the policy of militarisation and of the arms race. They are the leaders of the Pentagon— the American Defence Department, which continues to call recklessly for new military gambles. They are the " big shots " of N.A.T.O., who see the only meaning of their activity in turning the peaceful fields of Europe into the theatre of another destructive war. They are the militarist revenge-seeking forces who are rearing their heads in Western Germany and Japan. Yes, the cause of peace has many enemies. The danger they represent should not be underestimated. They are real vultures. Therefore the vigilance of the peoples must not be weakened.

A vigorous struggle against the bellicose imperialists is necessary in order to frustrate their aggressive plans. There is only one way to bring the aggressors to their senses; they must be convinced beyond a shadow of doubt that if they dare to unleash another war, then a formidable force will rise against them everywhere, at the front and in the rear, and will not let them escape just retribution. This force must constantly re-remind the enemies of peace: *Memento mori!*—Remember that you must die! If you start a war, you will be hanged as the Nazi ringleaders were hanged in Nuremberg! Crimes against humanity will not go unpunished. Thus, the foreign policy line of our party, inspired by the ideas of the great Lenin, has stood the test of life and has earned wide international recognition. Being fully in keeping with the interests of the Soviet people, this line, at the same time, is imbued with consistent internationalism. It expresses the vital interests of the international working-class movement and of all pro-gressive mankind.

The Century of the Implementation of Lenin's Great Ideas

Comrades, our century—the 20th century—is a most important stage in the history of mankind. This is the century which is witnessing the implementation of Lenin's great ideas. . . .

Naturally, Marxism-Leninism does not indulge in the futile forecasting of events. But that does not mean that it is altogether impossible to foresee the historical prospects of the second half of our century. We see clearly the basic tendencies of historical progress.

Firstly, it is perfectly clear that the Soviet people will carry out ever more successfully the great programme of communist construction. The majestic goals of the Seven-Year Plan will be achieved ahead of schedule. . . .

Secondly, the other countries of the socialist camp will go forward side by side with the Soviet Union. . . .

Thirdly, judging by everything, the second half of our century will bring complete liberation to the oppressed and dependent nations.

Following its major victories in the middle of the century, the Asian national liberation movement is continuing to achieve ever new successes in the struggle for the complete political and economic independence of the nations. Most of the Arab nations have already thrown off the imperialist yoke in Africa. The Negro nations of Africa have also awakened and set up their first independent states. All the African colonies have proclaimed the militant slogan of their peoples' movements: "Independence during the lifetime of our generation!" Africa has now voiced an even stronger demand: "Immediate independence!" A national movement is also surging in the formally free, but actually dependent, countries of Latin America.

Of course, we must not ignore the fact that the imperialists will do everything possible to smother the national liberation movement of the oppressed nations. But haven't they done everything possible in that direction before? Nevertheless, the movement has continued to grow and has become an invincible force.

The imperialists have achieved temporary successes only in countries where they have obtained the support of corrupt local reactionaries. But can the freedom-loving peoples be expected to tolerate for long the rule of traitors to the nation—accomplices of foreign imperialists? Of course not. The days of colonialism are numbered.

Fourthly, the great struggle of the peoples to safeguard lasting peace throughout the world will grow year by year.

Already today, the correlation of forces is such that the peoples and states advocating the cause of universal peace are the stronger. However, the most rabid imperialists threaten to unleash a terrible nuclear war, which would subject the peoples to brutal mass annihilation. That is why the peoples cannot give up the struggle for reliable guarantees of peace. This is a question of life and death for them.

All the factors which have made for the successes recently achieved in the effort to safeguard peace and lessen international tension, will continue to assume ever greater scope. Lenin's idea of struggling to deliver mankind from the terrible nightmare of war has gripped the minds of vast bodies of people in all continents and has therefore become a major force which will continue to grow and will, finally, make any military aggression impossible.

It is from this that the tempestuous streams of historical progress are now flowing, in spite of all kinds of obstacles.

As for the prospects of the countries of modern capitalism, it will be best if we leave the concrete evaluation of those prospects within the competence of the Marxist-Leninists of each particular capitalist country. After all, they know the situation in their countries better than anyone else. Here we can only state the general directions in which the basic laws of social development, laid down by the science of historical materialism, are operating and will continue to operate in those countries. . . .

[From text published in *Soviet News* (London: Soviet Embassy) No. 4255.]

4. Battle Joined

The U-2 incident and the resultant disruption of the summit conference at the beginning of May gave a great fillip to the Chinese campaign against Khrushchev's policies. On the one hand, the Chinese now had the kind of evidence they needed to clinch their case that nothing had altered since Camp David; furthermore Eisenhower's assumption of responsibility for the incident meant that the Soviet distinction between advocates of the cold war and sober-minded Western statesmen, and Khrushchev's personal guarantee of Eisenhower's sincerity had been completely undermined.[11] From the practical point of view, the worsening of East-West relations meant that the Chinese need not fear any Soviet deal with America in the near future.

However, Khrushchev's speech in East Berlin immediately after the summit fiasco made it clear that he was not abandoning his policies. One of the consequences was that the Chinese chose to try and thrash out the dispute at an international forum, the general council session of the Communist-dominated World Federation of Trade Unions (WFTU) which met in Peking from June 5 to 9. The reason for raising the issue at this particular meeting must have been that the Chinese hoped to convert workers' leaders to their advocacy of revolutionary struggle.

A principal Chinese delegate, Liu Chang-sheng, Vice-Chairman of the WFTU and Vice-Chairman of the All-China Federation of Trade Unions, emphasised the distinction between *world* war and other wars which Mao had possibly failed to make in 1957,[12] accepting the possibility of preventing world war, but asserting that wars of national liberation were inevitable and just and should be supported. He rejected as an " unrealistic illusion " the idea that America would agree to general disarmament, though he admitted the possibility of a nuclear test ban. He suggested that the kind of " peace diplomacy " favoured by Khrushchev was less important for the Communist cause than revolutionary struggle.

Behind the scenes at the council session, however, the Chinese were not allowed to have things their way as the reports of Italian delegates showed.

The Chinese Attack at the WFTU Meeting

Liu Chang-sheng said that the question of war and peace is one with which everyone is concerned and he wished to express some views on this question. With regard to the question of war and peace, he said, we have

11 See above p. 61. 12 See above p. 80.

always stood for safeguarding world peace, for peaceful co-existence between countries with different social systems, for the relaxation of international tension and for disarmament. But on this question there still exist some problems involving basic principles that must be clarified, otherwise people would go astray in regard to the question of safeguarding peace.

As to what attitude we should adopt towards war, Liu Chang-sheng said, we must first of all make a distinction as to its nature. A war between imperialist countries in a scramble for colonies is an unjust war. An imperialist war to suppress the colonial people and the people at home and to commit aggression against other countries is also an unjust war. On the other hand, a revolutionary war waged by the colonial peoples and by the oppressed peoples of the imperialist countries for their own liberation is a just war. Since the imperialists use armed force to suppress the oppressed peoples and nations, the oppressed peoples and nations cannot but take up arms themselves. We must stand for and uphold just revolutionary wars, and oppose and stop unjust wars. It is wrong to talk indiscriminately about whether or not war should be supported or whether or not it should be opposed, without making a specific analysis of its nature.

Liu Chang-sheng continued: The question of whether or not war can be averted, in our opinion, refers mainly to a world war. As to whether a world war can be averted, it should be pointed out that, on the one hand, under the conditions of the steady growth of the forces of the socialist countries, the forces of the liberation movements in the colonies and semi-colonies and the forces of the revolutionary movements and peace movements of the peoples of the countries the world over, and the united struggle of these forces, there exists the possibility of stopping the imperialists from unleashing a new world war. But, on the other hand, so long as there is imperialism, the root cause of war remains, the breeding ground of war remains, and the war maniacs remain, and that is why there still exists the danger of imperialism launching a new world war. If we only talk about the possibility of stopping the imperialists from launching a world war, but not about the danger of imperialism launching a world war, and are not on the alert against the military adventures of the war maniacs, we will only lull ourselves and the people. This will only help imperialism in its arms expansion and war preparations and, once it launches a war, the peoples of various countries, taken off guard, may be thrown into a state of alarm and confusion and even suffer unduly heavy losses. It is entirely wrong to believe that war can be eliminated for ever while imperialism still exists. The spreading of such illusions about imperialism among the peoples of all lands will lead to evil consequences of a serious nature and, in fact, we can already see such consequences at present.

Liu Chang-sheng said that as to imperialist wars of suppression against colonies and semi-colonies, national liberation wars of the colonial and semi-colonial peoples against imperialism, wars of suppression against the people by the exploiting classes and people's revolutionary wars in the capitalist countries, wars of such nature have always existed in history, and have never stopped in the capitalist world since the Second World War. The wars in Indo-China, in Algeria, over the issue of the Suez Canal and in Cuba are all such wars. In the future, as long as imperialism and the exploiting system are still in existence, such wars of different nature will still

be unavoidable. The belief that wars of the above-mentioned types can be avoided is entirely wrong and contrary to fact. Such views will deprive the oppressed peoples of their fighting spirit and in the face of armed suppression by the enemy, prevent them from arming themselves to actively fight the enemy, who is armed to the teeth, and to liberate themselves. This will, in effect, keep the oppressed peoples for ever in the state of enslavement.

Liu Chang-sheng went on: We stand for peaceful co-existence between socialist and capitalist countries. Since World War II, we socialist countries have spared no effort in striving for peaceful co-existence and have unswervingly pursued various policies of peace, but the imperialist countries headed by the United States have all along clung to their cold war policy, persisted in arms expansion and war preparations and created tension. We should make it clear to the people that they should not be intimidated by the cold war waged by imperialism, that they should resolutely oppose its cold war policy, expose its ugly face and wage a head-on struggle against it. Only thus can the cold war be prevented from developing into a hot one.

Liu Chang-sheng further stated: We must take into full account the fact that because internal crises are worsening day by day in the imperialist countries and because they want to intensify their oppression and rule over the people at home and in the colonial countries, the imperialists will, for a long time to come, keep up their cold war policy, impose cold war on the people of the world and continue to maintain their massive military forces and the entire state machine. To safeguard world peace and oppose imperialism will, therefore, be a long-drawn-out struggle for the peoples of various countries.

Liu Chang-sheng said: We support the disarmament proposals put forward by the Soviet Union. It is of course inconceivable that imperialism will accept proposals for general and complete disarmament. The purpose of putting forward such proposals is to arouse the people throughout the world to unite and oppose the imperialist scheme for arms drive and war preparations, to unmask the aggressive and bellicose nature of imperialism before the peoples of the world in order to isolate the imperialist bloc headed by the United States to the greatest extent, so that they will not dare unleash a war lightly. But there are people who believe that such proposals can be realised when imperialism still exists and that the " danger of war can be eliminated " by relying on such proposals. This is an unrealistic illusion. As to the view that after disarmament, imperialism would use the funds earmarked for war purposes for " the welfare of the labouring masses " and for " assisting underdeveloped countries " and that this would " bring general progress to people as a whole without exception " —this is downright whitewashing and embellishing imperialism, and indeed this is helping imperialism headed by the United States to dupe the people throughout the world.

Liu Chang-sheng pointed out that only when socialist revolution is victorious throughout the world can there be a world free from war, a world without arms. Such a world is inconceivable while imperialism still exists. This is not a question of whether we want it or not; the question is that the imperialists will never lay down their arms of their own accord. They will not lay down their arms because they want to suppress the people of their own countries; they will not lay down their arms because they want to

suppress the colonies; they will not lay down their arms because they want to carry on expansion and aggression against other countries. History has confirmed and will continue to confirm this.

We hold that the utmost efforts must be made to reach agreement on the banning of nuclear weapons and to prevent the outbreak of a nuclear war in the world, Liu Chang-sheng said. The mastery of nuclear weapons by the Soviet Union has now deprived U.S. imperialism of its atomic monopoly. The Soviet Union and the other socialist countries should continue to develop their lead in the sphere of atomic energy and at the same time the people throughout the world should wage a more extensive struggle against imperialism and against nuclear weapons. Only in these circumstances can such agreement be reached. But even if agreement is reached, imperialism can still tear it to pieces. And even if in their own interests the imperialists dare not unleash a large-scale nuclear war, they still can wage war with the so-called conventional weapons. Therefore, in all circumstances people throughout the world should maintain sharp vigilance against imperialism and should not adopt a naïve attitude towards U.S. and other imperialism.

Liu Chang-sheng pointed out: To win world peace, the struggle of the world's peoples and diplomatic negotiations carried out by the socialist countries should go hand in hand. It should not be supposed that since diplomatic negotiations are needed, the struggle of the peoples can thus be dispensed with. On the contrary, diplomatic negotiations must be backed up by the united struggle of the world's peoples. To win world peace, we should mainly rely on the struggles waged by the peoples of various countries. We should increase the might of the socialist countries, continuously develop the strength of the liberation movements in colonial and dependent countries, continuously expand the revolutionary forces of the people within the imperialist countries, and continuously expose the imperialist bloc headed by the United States and the modern revisionists who are in the service of imperialism. At the same time, we should make full use of our tactics and exploit the contradictions between the imperialist countries and the various monopoly capital groups within the imperialist countries. We hold that as long as we make the above-mentioned efforts and rally all the forces that can be united around the anti-imperialist struggle to form a broad united front, we can certainly defeat the bellicose forces of imperialism and win the great victory in the defence of world peace.

[Liu Chang-sheng at the WFTU Council session, June 8, 1960. *Peking Review* No. 24, 1960.]

INFANTILE LEFTISM

Meanwhile the Russians had evidently been preparing to take action against the propagation of the " dogmatist " views of the Chinese in the international Communist movement. On June 10, an article appeared in *Sovyetskaya Rossiya* to mark the fortieth anniversary of Lenin's *Left-wing Communism—An Infantile Disorder* by D. Shevlyagin. It warned against two leftist mistakes—contempt for making compromises with the bourgeoisie in working towards Communism and condemnation of the policy of peaceful co-existence. In fact the Chinese had never taken up such positions publicly, for obvious reasons; but certainly the views

they had officially committed themselves to indicated that that might well be how they felt. Another commemorative article, this time in *Pravda*, seemed designed to reactivate the commune controversy of 1958. The author asserted that the desire to build socialism " on the basis of imperialist handouts " (Tito) or " attempts to skip entire historic stages " (Mao) served only " the enemies of the working class. . . ." This article also hinted at Peking's indignation at Khrushchev's American visit.

"Fighting Weapon of Communist Parties "

The Communist movement develops and strengthens together with the growth of the working-class movement, and it is constantly its task in the first instance to solve more and more new, general and specific problems of the class struggle of the proletariat and its allies. It happens that not only groups of Communists but also the leadership of individual parties are not up to the task of solving such problems, lose their Marxist-Leninist orientation and fall into leftism or right-wing opportunism. An example of this are the revisionist standpoints of the present leadership of the Union of Communists of Yugoslavia.

In the years of the Second World War the Communist Party organisations of Spain, which had correctly begun an armed partisan movement, in their leftish manner continued this struggle for a long time even after the end of the war, although the international situation and internal conditions had already changed substantially. This error was exposed by the Party and corrected in 1948-49, and the activities of Communists were directed towards work in the masses, including the various fascist organisations, which has already yielded many positive results. . . .

The book *Left-wing Communism—An Infantile Disorder* takes on particularly great significance in connection with the fact that in recent years a number of Communist Parties have appeared in countries which have recently achieved or are still striving for national independence. The Communist movement in these countries is living through its " childhood days," and for it this Leninist work will be of very great help.

By the end of the Second World War and in the post-war years, as a result of the rapid upsurge of the working-class and national-liberation movement, many Communist Parties, which thanks to their war-time service had grown into large parties, emerged from prolonged underground activities. Certain parties, however, revealed inability to orientate themselves in the new conditions. The methods and means of long years of underground struggle against the class enemy were no longer suitable. In the new conditions it was necessary to establish relations with the broader masses of the working people, to seek allies in the middle strata of town and village and also, according to circumstances and the latest tasks of the struggle, temporary agreements with specific strata of the national bourgeoisie, particularly in countries where the main task was liberation from imperialist and colonial oppression. In this connection it is useful to recall Lenin's instruction to the effect that " history in general, and the history of revolutions in particular, is always richer in content, more diverse, more multiform, more vital, more 'cunning,' than is imagined by the best Parties, the most conscious vanguards of the most advanced classes."

Lenin understood the good intentions of those comrades who were in

a hurry to race ahead, to accelerate the oncoming of socialist revolution, but he most resolutely warned against the danger of degenerating into Blanquists, who, not wishing to remain " at intermediary stations and not wanting to compromise," as Engels expressed it, could not be considered Communists.

Lenin's doctrine about the conditions of compromise, which are worked out in great detail in *Left-wing Communism—An Infantile Disorder*, are the basis of the struggle of Communists for the achievement of unity of action of the working class with all strata of the petty and middle bourgeoisie in the joint struggle against the arbitrary rule of the monopolies and their alliance with the imperialist forces of other countries. This struggle does not do away with or replace the tasks of carrying out socialist revolution, but, on the contrary, is directly bound up with this task, since it unleashes the initiative of the masses, brings them into political, general democratic and gradually also into revolutionary struggle for the victory of a socialist revolution.

Lenin's doctrine about " compromises " acquires great importance in modern conditions, when Communists, especially in countries where many tasks of bourgeois-democratic revolution and the achievement of national independence still have to be solved, must be able to conclude alliances not only with the peasantry but also with certain strata of the national bourgeoisie in the interests of struggle against foreign oppression. Here, as Lenin pointed out, " one has only to take a small step beyond this— apparently a step in the same direction—and the truth becomes error." The point is not to be at the tail-end of events, but also not to rush ahead, not to put forward precocious slogans of socialist transformations where conditions are not ripe for this. . . .

For the purpose of drawing into active political life the broadest masses of the working people and the middle strata of town and village and bringing up among them allies of the working class in the struggle for transition to socialism, Communist Parties have worked out programmes of struggle for democratic reforms (the agrarian question, nationalisation of monopolies, the establishment of a democratic government, proclamation of the policy of not joining aggressive *blocs* and the policy of peaceful co-existence). However, on the path of the implementation of these programmes, even Communist Parties which are powerful and hardened in class struggle are running up against survivals of leftism, the erroneous views of comrades whom V. I. Lenin ironically described as " terrible revolutionaries." Essentially the standpoint of these comrades is nothing more than the passive awaiting of that certain " hour " when, in their view, the general collapse of capitalism must automatically occur. . . .

Present-day leftism in the Communist movement is also manifested in both concealed and overt resistance to the Communist parties' policy of establishing collaboration with working people in the ranks of the social-democratic, Catholic and various other bourgeois-radical parties and organisations. The policy of achieving peaceful co-existence, of cessation of the arms race and establishment of peace and friendship between peoples of capitalist and socialist countries is interpreted by present-day leftists as a " deviation " from Marxism-Leninism, and they take the slightest aggravation of the international situation as proof of their sectarian views. Although from the outside they seem " terribly revolutionary," they do harm to the

cause of rallying the working class to the struggle against the aggressive designs of the imperialists, for the cessation of the "cold war" and the strengthening of peace throughout the world. . . .

[D. Shevlyagin in *Sovyetskaya Rossiya,* June 10, 1960.]

"The Ideological Weapon of Communism"

The search for a separate path to socialism for each country individually, the desire to build socialism on the basis of imperialist handouts or attempts to skip entire historic stages serve only the enemies of the working class interested in weakening socialism. Unmasking the false, anti-marxist views of the advocates of "separate paths," Comrade N. S. Khrushchev said: "If such a point of view is adopted, it may well result in so many 'paths' that people will get lost, as in a forest, and will not know how to reach their goal. In life there is only a single, Leninist path toward the construction of socialism and Communism, a path tested by historical experience, the path of the great October socialist revolution. . . ."

V. I. Lenin demonstrated the unsoundness and harm of the slogans of the leftists who rejected the idea of Communist compromises with other parties and groups. He said that the leftists, though considering themselves Marxists, had forgotten the fundamental truths of Marxism. Vladimir Ilyich (Lenin) recalled a statement by F. Engels who once criticised the Blanquists (followers of Blanqui, an early French Communist) for wanting to skip through all intermediate stages directly to Communism without taking account of the new historical development, and remarked that if power will be in their hands, "Communism will be introduced" the day after tomorrow. Engels described as childish naivety the Blanquists' attempts to put forward their own impatience as a theoretically convincing argument.

"Naive and utterly inexperienced people," Lenin wrote, "imagine that it is sufficient to admit the permissibility of compromises in general in order to obliterate the dividing line between opportunism, against which we wage and must wage an uncompromising struggle, and revolutionary Marxism or Communism.

"But if such people do not yet know that all dividing lines in nature and in society are mutable and, to a certain extent, conditional, they cannot be assisted in any way other than by a long process of training, education, enlightenment, political and everyday experience."

Creatively developing Marxist-Leninist theory under the new conditions and generalising the great experience of socialist construction in our country in full accordance with the principles of social development, the Twenty-first Party Congress laid out a well-grounded, full-fledged programme for the transition from socialism to Communism. That programme is the concrete embodiment of the general line of the Communist Party in the present stage.

Characterising the process of transition from socialism to Communism, Comrade N. S. Khrushchev told the Twenty-first Party Congress:

"We must not hurry and hastily introduce what has not yet ripened. That would lead to distortions and compromise our cause. But neither must we rest on our laurels because such a course would lead to stagnancy."

The course of social development is objective. We consider erroneous and incorrect the statements of leftists in the international Communist

movement to the effect that since we have taken power into our hands we can at once introduce Communism, by-passing certain historical stages in its development.

Such statements contradict Leninism. Lenin taught us that to try to anticipate the result of a fully developed, fully consolidated and established, fully unfolded and matured Communism amounts to the same thing as to try to teach higher mathematics to a four-year-old child.

The left-sectarian sentiments and tendencies against which Lenin's book was directed find their expression in some places even in our time. Some persons mistakenly consider the course of the achievement of peaceful co-existence of our countries with different political systems, the struggle to halt the arms race and to strengthen peace and friendship among peoples and the talks between leaders of socialist and capitalist countries as some kind of deviation from the positions of Marxism-Leninism.

Lenin taught that the very complex struggle for Communism and the struggle against the international bourgeoisie could not be waged while renouncing in advance agreements and compromises on specific questions with possible, even if temporary, unstable allies for the exploitation, even though temporarily, of contradictory interests among the enemies.

While pursuing in some cases compromises in the name of the interests of development of the revolutionary movement, Communists never depart from positions of principle. " In questions of ideology," said Comrade N. S. Khrushchev, " we have firmly stood and will continue to stand firmly, like a rock, on the principles of Marxism-Leninism." . . .

V. I. Lenin's book teaches us a truly creative approach to the solution of practical problems arising in life and serves as a mighty ideological weapon of the Communist and workers' parties in the struggle for peace and socialism.

Forty years have passed since the publication of the first edition of *Left-Wing Communism—An Infantile Disorder*. During that time the conditions of the class struggle have changed repeatedly both in the international and in the national arenas. A world-wide socialist system has been formed and the balance of power has changed radically in favour of socialism.

There has been a great increase in the number of Communist and workers' parties. While there were a total of forty Communist parties and groups when V. I. Lenin wrote his book, there are now Communist and workers' parties in eighty-six countries, with a total membership of more than 36,000,000 people.

In recent years the Communist parties have demonstrated great creative enthusiasm. True to Lenin's behests, the fraternal parties are creatively developing Marxist-Leninist theory and applying it to present-day conditions. A great contribution to the cause of the further development of Marxism-Leninism was made by our Party at its Twentieth and Twenty-first Congresses.

Of major importance for international affairs have been the decisions of the congresses on such questions of principle as the peaceful co-existence and competition of the two systems, the possibility of preventing war in this era, the form of transition of various countries of socialism, and the ways of strengthening the world socialist system. The congress decisions were approved unanimously by all Communist and workers' parties.

All the basic statements in Lenin's book are still vital at the present time. They are directed against rightist opportunists, present-day revisionists and leftist doctrinaires. The Communist parties, while regarding revisionism as their greater danger, draw attention at the same time to sectarianism and dogmatism, which can also represent great danger at certain stages of development of a given party. . . .

The great force and vitality of Leninism lie in the successful and multi-faceted activity of the Communist and workers' parties. They are reflected in the fiery speeches of Communists for peace, against war, for general disarmament, and for peaceful co-existence of countries with different social-political systems. The vitality and force of Leninism are also evident in the upsurge of the workers' movement in the capitalist countries and in the successes of the national liberation movement of peoples against colonialism. The vitality and force of Leninism are also found in the great achievements of the Soviet people in successfully building Communism and in the victories of all socialist countries that unswervingly pursue Lenin's course.

[N. Matkovsky in *Pravda*, June 12, 1960.]

5. The Bucharest Conference

According to Indian Communist sources,[13] the Chinese did not expect the onslaught upon their views made by Khrushchev before all the leaders of the East European Communist parties, except Albania's Enver Hoxha, at the Rumanian party congress in Bucharest in June. Khrushchev dealt scornfully with those who " mechanically " repeated the words of Lenin decades after they had been formulated under very different historical conditions. As to the specific problem of accounting for the break-up of the summit conference and the disappearance of the Camp David spirit, Khrushchev still clung to the distinction between sober-minded Western statesmen (among whom he included de Gaulle and Macmillan) and the advocates of the cold war. Since he could no longer count Eisenhower among the former, he put his faith in the election of a more amenable American president at the end of the year.

Khrushchev laid great stress on the destructiveness of a nuclear war, omitting any claim that only imperialism would be wiped out in the event of such a catastrophe. He also cautioned that a local war could lead to a world nuclear conflict. He did not list the national liberation movement as a factor making war less likely.

The chief Chinese delegate to the Rumanian Congress, P'eng Chen, would not appear to be the kind of man to be cowed by Khrushchev's attack.[14] He took his stand firmly on the 1957 Declaration and called for Communist unity. According to Indian Communist sources, he said that the Chinese central committee would discuss and reply to the criticisms later on.[15] In any event, the communiqué issued after the discussions of the international situation merely reaffirmed support for the 1957 Declaration.

Khrushchev's Bucharest Speech

Comrades, questions of international relations, questions of war and peace, have always deeply concerned the mass of the people. That is natural. More than once in history the anti-national policy of the imperialists, their desire for a redivision of the world, for the seizure of new colonies, have subjected mankind to the horrors of devastating wars. But no matter how terrible wars have been in the past, if the imperialist circles should succeed in unleashing another world war, its calamities would be incomparably more terrible. For millions of people might burn in the

[13] Quoted in the *Hindustan Times* of New Delhi, November 14, 1960.
[14] A burly, self-confident looking man, P'eng is a senior member of the Chinese Politburo and ranks second to Teng Hsiao-p'ing in the Party secretariat.
[15] *Hindustan Times, loc. cit.*

conflagration of hydrogen explosions, and for some states a nuclear war would be literally a catastrophe. That is why the Marxist-Leninist parties, in all their activity, have always been consistent champions of a reasonable peace-loving policy, of the prevention of another world war. . . .

The Communists are realists ; they are aware that in present conditions, when there are two world systems, it is imperative to build mutual relations between them in such a way as will preclude the possibility of war breaking out between states. Only madmen and maniacs can now call for another world war. As for people of sound mind—and they are in the majority even among the most deadly enemies of Communism—they cannot but be aware of the fatal consequences of another war.

It is common knowledge that the Soviet government and the governments of the other socialist countries have by their deeds, by their realistic policy, proved to all the peoples of the world their loyalty to the idea of peaceful co-existence between states. The proposals on general and complete disarmament and on the ending of nuclear weapon tests and the complete prohibition of those tests, the reduction in the armed forces of the socialist countries—I do not think there is any need to list here all the peaceable actions taken by our side—all this is concrete evidence of our desire to prevent war and really strengthen the cause of peace.

We made serious preparations for the Paris conference of the heads of government of the four powers. It will be recalled that the United States Administration, by its cynical provocations, torpedoed the conference before it had even begun. The name of the spy pilot Powers, though he is only a small poisonous bug in the service of the Pentagon brass, will go down covered with ignominy in the history of the United States, together with the names of those who sent him on that piratical flight.

The events in Paris were not accidental. These are the tactics of imperialism. The imperialists, headed by the aggressive circles of the United States of America, have been opposed and are now opposed to the policy of peaceful co-existence between states.

I remember a conversation with Mr. Dillon, the U.S. Under-Secretary of State, at Camp David.

Since it happened on a Sunday, the United States President flew off in a helicopter to pray to God and he told me that Mr. Dillon would like to have a talk with me on economic matters and questions of trade.

That worshipper there probably prayed to God for a safe flight for Powers. This, by the way, seems to indicate that the Lord does not serve the imperialists now. The President of the United States prayed to God for a safe flight for the spy plane, and we shot that plane down. Whom did God help? He sided, so to speak, with socialism. When I told Mr. Dillon during the conversation that it was necessary to create conditions for peaceful co-existence, he asked me the cynical question: " What does co-existence mean? I don't understand it."

You see what a cynical person Mr. Dillon is. Of course, he and his like would prefer to exist alone, without the socialist countries. However, that is no longer within their power.

The question might be asked: If the imperialists oppose peaceful co-existence, how did they come to agree to the meeting of the heads of government which was to have been held in Paris?

One must bear in mind that the attitude to the question of peaceful

co-existence is not everywhere the same in the imperialist countries. During the conversations I had in Paris with President de Gaulle and Prime Minister Macmillan, it seemed to me that they showed a certain understanding of the necessity for peaceful co-existence and were even persuading me themselves that the policy of co-existence must be the guiding principle in the future relations between states with different social systems.

Not all representatives of the ruling circles of the United States of America have as yet learned to pronounce the words "peaceful co-existence," and some of them, like Dillon, claim that they don't understand the meaning of these words and refuse to carry through their policy in a spirit of peaceful co-existence.

Time, however, is the best teacher and it will also teach those diehards. Sooner or later they will realise that the alternative to peaceful co-existence is a bloody war. Let them make their choice. And victory will be on our side!

As for the American people, it must be expected that they will draw the appropriate conclusions and will produce leaders who understand the necessity for peaceful co-existence between states with different social systems.

It must also be borne in mind that the imperialist countries are not monolithic; they have their internal contradictions. On the one hand, there is the working class, the working peasantry and the working intelligentsia, and on the other, there are the monopolists, the capitalists who wax fat on the exploitation of the working class, of all the working people.

The peoples of those countries, especially the working class, the peasantry, the working intelligentsia, and even part of the bourgeoisie, do not want a war or are afraid of war. Some do not want it and others are afraid of it. The slogans of the struggle for peace, against war, are close to the hearts of the peoples. And under the pressure of these popular forces the governments of the imperialist states were driven to consent to a meeting between the heads of government. But they planned in advance to wreck that meeting and to blame it on the Soviet Union. The persons who wrecked the conference are now shedding crocodile tears. They are grieving as Judas did after he had betrayed Christ.

They crucified that conference and now they allege that the Soviet Union is to blame because it did not of its own free will get caught in the snares which were laid by the imperialist powers.

We are not living in the days when the legend of Christ was created; we are living in the twentieth century. Sober-minded representatives of the capitalist world now admit that it is impossible to halt the progress of socialism. And this robs some gentlemen of their common sense; they resort to steps which can be bluntly called provocative. They are getting nervous, they are raving. In such conditions even persons who don't want to unleash war might get unduly frightened, press the wrong button, and the consequences would be irrevocable.

That is why it is necessary to arouse the conscience of the peoples, enhance their vigilance, organise and strengthen the struggle against the aggressive policy of imperialism, against colonialism, and to support and help the peoples who are fighting to liberate themselves from imperialist, colonial oppression. It is necessary to assist those peoples who have already gained their political independence but are economically dependent and to enable them to grow stronger and firmly pursue a policy that is in keeping

with the interests of peace. All this means that we must still more actively expose the evils of imperialism, its vices. In order to prevent war—including a local war, because a local war might grow into a world war—each people in their own country must bring pressure to bear on their government and force it to adhere to the principles of peaceful co-existence between states with different social sytems. . . .

Though the Paris conference was wrecked by the aggressive circles of the United States, this did not remove the urgent problems still awaiting solution. In order to establish normal relations between states and to preclude the possibility of another world war, we must solve the problem of general disarmament, destroy the means of waging war and disband the national armed forces, it goes without saying, under appropriate international control. We must eliminate the remnants of the Second World War, conclude a peace treaty with the two German states and solve the problem of West Berlin on this basis. . . .

What conclusion can be drawn from the collapse of the conference? If the United States government continues the policy proclaimed by Herter, if it continues overflights—this will, of course, have the most serious consequences for the cause of peace.

The statesmen now directing United States policy have shown their aggressiveness and irreconcilability. They are so much blinded by hatred for Communism that this does not let them understand correctly the prevailing conditions in the world. The present leaders of the United States are evidently unable to cultivate in the proper way relations between states with differing social systems.

It is not for us, it is for the American people to decide who will be the next President of the United States. But our state, our people, who want to live in peace and friendship with the American people, are naturally interested in the election of such a President and the formation of such a government that would understand and correct the mistakes made by the present government of the United States.

The Soviet Union and the United States are great world powers. History itself has assigned them such a place. Much depends on our two powers how the international situation will develop in the future—along the road of strengthening peace or along the road of straining relations.

The Soviet government has done everything for the further development of the relations which had slightly improved between our two countries. But the American leaders are doing everything so that the world reverts to the worst times of the cold war. And this is not being done accidentally; it is being done according to plan, as Secretary of State Herter and the President of the United States have virtually admitted. For they have confirmed that the spy plane was deliberately sent into the Soviet Union. Naturally, every government and every thoughtful statesman understands that the dispatch of a spy plane and intrusion into the air-space of another country cannot be conducive to the improvement of relations between states, cannot facilitate a solution of the problems which should have been discussed at a summit meeting.

What line must we pursue in these conditions? Should we accept this " challenge " and give up the efforts exerted by the peoples of our countries to secure a relaxation of international tension, the ending of the cold war and the normalisation of international relations? No, such a policy would be

incorrect. Had we embarked upon this road, it would have meant that we had taken the cue from the imperialists, who wax rich on the cold war and arms race. This would have met their wishes. Consequently, they would have been, so to say, rewarded for their provocative actions. We cannot allow this to happen. By bringing down the U-2 we have not only brought down a spy and *agent provocateur*, but also the self-conceit of the American imperialists, of the Pentagon military.

All the peoples want peace, including the American nation. I did not doubt this before my visit to the United States and became even more convinced of this after I had been there. And if today some people are intoxicated by the torpedoing of the meeting, the lies, slander and the all-out efforts to stir up the cold war, this is a temporary circumstance which sooner or later will have to give way to a more healthy atmosphere.

What has happened is another convulsion of imperialism. Aggressive circles will continue their attempts to provoke us. This is why we, the representatives of the socialist world, the representatives of the working class, the representatives of the working peasantry, must bravely and resolutely rebuff the militarists and foil their aggressive designs. . . .

We do not intend to yield to provocations and to deviate from the general line of our foreign policy, which was laid down by the 20th C.P.S.U. Congress and approved in the Declaration of the Communist and Workers' Parties, adopted in 1957, during the celebrations of the 40th anniversary of the Great October Socialist Revolution.

This is a policy of co-existence, a policy of consolidating peace, easing international tension and doing away with the cold war.

The thesis that in our time war is not inevitable has a direct bearing on the policy of peaceful co-existence proclaimed at the 20th and 21st Congresses of our party. Lenin's propositions about imperialism remain in force and are still a lodestar for us in our theory and practice. But it should not be forgotten that Lenin's propositions on imperialism were advanced and developed tens of years ago, when the world did not know many things that are now decisive for historical development, for the entire international situation.

Some of Lenin's propositions on imperialism date back to the period when there was no Soviet Union, when the other socialist countries did not exist.

The powerful Soviet Union, with its enormous economic and military potential, is now growing and gaining in strength; the great socialist camp, which now numbers over 1,000 million people, is growing and gaining in strength; the organisation and political consciousness of the working class have grown, and even in the capitalist countries it is actively fighting for peace. Such factors are in operation now as, for instance, the broad movement of peace champions; the number of countries coming out for peace among nations is increasing. It should also be pointed out that imperialism no longer has such a rear to fall back upon as the colonial system which it had formerly.

Besides, comrades, one cannot mechanically repeat now on this question what Vladimir Ilyich Lenin said many decades ago on imperialism, and go on asserting that imperialist wars are inevitable until socialism triumphs throughout the world. We are now living in such a period when the forces

136

of socialism are increasingly growing and becoming stronger, where ever-broader masses of the working people are rallying behind the banner of Marxism-Leninism.

History will possibly witness such a time when capitalism is preserved only in a small number of states, maybe states for instance, as small as a button on a coat. Well? And even in such conditions would one have to look up in a book what Vladimir Ilyich Lenin quite correctly said for his time, would one just have to repeat that wars are inevitable since capitalist countries exist?

Of course, the essence of capitalism, of imperialism, does not change even if it is represented by small countries. It is common knowledge that a wolf is just as bloodthirsty a beast of prey as a lion or a tiger, although he is much weaker. That is why man fears less to meet a wolf than a tiger or a lion. Of course, small beasts of prey can also bite, essentially they are the same but they have different possibilities, they are not so strong and it is easier to render them harmless.

Therefore one cannot ignore the specific situation, the changes in the correlation of forces in the world and repeat what the great Lenin said in quite different historical conditions. If Lenin could rise from his grave he would take such people, as one says, to task and would teach them how one must understand the essence of the matter.

We live in a time when we have neither Marx, nor Engels, nor Lenin with us. If we act like children who, studying the alphabet, compile words from letters, we shall not go very far. Marx, Engels and Lenin created their immortal works which will not fade away in centuries. They indicated to mankind the road to Communism. And we confidently follow this road. On the basis of the teaching of Marxism-Leninism we must think ourselves, profoundly study life, analyse the present situation and draw the conclusions which benefit the common cause of Communism.

One must not only be able to read but also correctly understand what one has read and apply it in the specific conditions of the time in which we live, taking into consideration the existing situation, and the real balance of forces. A political leader acting in this manner shows that he not only can read but can also creatively apply the revolutionary teaching. If he does not do this, he resembles a man about whom people say: "He looks into a book, but sees nothing!"

All this gives grounds for saying with confidence that under present conditions war is not inevitable.

He who fails to understand this does not believe in the strength and creative abilities of the working class, underestimates the power of the socialist camp, does not believe in the great force of attraction of socialism, which has demonstrated its superiority over capitalism with the utmost clarity.

Is the possibility of the imperialists unleashing war under present conditions ruled out? We have said several times and we repeat once again: No, it is not. But the imperialist countries cannot fail to take into account the power of the Soviet Union, the power of the socialist camp as a whole. Naturally, the imperialists do not want to trigger off war in order to perish in it. They would like to destroy the socialist countries. Therefore today even the stupid, frenzied representatives of the imperialist circles will think twice about our power before they start a military gamble.

Even the crazy Hitler, if he had believed that the war which he launched against the Soviet Union would end in the routing of his fascist hordes and

in his hiding in a Berlin shelter in the fifth year of the war and shooting a bullet into his head, he would not have taken such a mad decision on war against our country. This is quite clear!

And if the imperialists do unleash a war, will our socialist camp be in a position to cut it short? Yes, it will. Let me cite an instance. When France, Britain and Israel attacked Egypt in 1956, our intervention put an end to this imperialist war which had been started by the aggressive forces to deprive Egypt of her independence. We helped the people of Egypt who were heroically fighting for the freedom of their country. . . .

The Soviet government addressed messages to Anthony Eden, Guy Mollet, and Ben-Gurion, warning them that there was a country which could deal a devastating blow unless aggression was stopped. And the war ended literally 22 hours later. Eden and Mollet—that so-called socialist leader, but actually a rabid imperialist colonialist—and Ben-Gurion, their errand boy, immediately had their tails between their legs.

Thus the Soviet Union and all the countries of the socialist camp fulfilled their duty and the war was ended. Was it not a demonstration of the strength of socialism? And this happened soon after the 20th Congress of our party proclaimed the thesis that under the present conditions war is not inevitable and that, in the event of it being unleashed, we have the possibility of thwarting the adventurist plans of the aggressors, to make the developments take the desired turn.

It is to be remembered that this happened in 1956. Now, the Soviet Union has created such powerful military facilities of which the imperialists have no full idea, in spite of all their espionage flights.

Or let us take another example. In 1957 we prevented Syria from being attacked by Turkey, which was incited to this adventure by the United States imperialists. And in 1958, after the revolution in Iraq, the Americans and British concentrated their forces and were preparing to attack Iraq. The American imperialists egged on Turkey, Iran and Pakistan to attack Iraq. The Americans were in such a hurry preparing for this attack that they even violated Austria's sovereignty by flying their troops stationed in Germany right over the territory of neutral Austria to Lebanon and Jordan. But in that case as well they had to stop short and did not dare to start aggression against Iraq in view of the resolute warning served by the Soviet Union and other socialist countries. They flew there, stayed for a while and flew away with nothing to show for their efforts. And the Iraq Republic continues to exist and grow in strength.

It should be emphasised that in the case of Syria, as in the case of Iraq, the point in question was to beat off the aggression which the United States —the strongest imperialist state—was preparing against those countries.

The American imperialists and their adventurist policy have discredited themselves to such an extent that they have come to be hated, not only by the peoples of the socialist countries, but also by the population of their allied states.

The bloody puppet Syngman Rhee has been thrown out of South Korea with ignominy. The former Turkish Premier, Menderes, the obedient executor of the will of the Americans, is now in prison.

Even on Taiwan, that American-occupied island, the United States Embassy was smashed up in spite of the brutal terror of Chiang Kai-shek, that American lackey. You know very well that millions of Japanese are coming out against the American invaders with contempt and hatred. To put

the matter in a nutshell, in the countries from which the American imperialists are not as yet being kicked out the peoples' anger is welling up and the forces of protest are maturing. And it is common knowledge that if lightning strikes, a thunderbolt is bound to come too. . . .

The U.S.S.R. pursued a policy of peace even when it stood alone, facing the powerful camp of imperialist states. We are also pursuing this policy now when the forces of peace are undoubtedly superior to the forces of war and aggression.

This position of ours stems from our firm belief in the stability of the socialist system, in our system, and therefore don't worry about the future of socialism.

No world war is needed for the triumph of socialist ideas throughout the world. These ideas will get the upper hand in the peaceful competition between the countries of socialism and capitalism. . . .

[Speech to Rumanian Communist Party Congress in Bucharest on June 21. From text in *Soviet News* (London: Soviet Embassy), June 22, No. 4292, 1960.]

P'eng Chen's Reply

U.S. imperialism, the most vicious enemy of the people of the world, is now more isolated than ever. In trying to extricate itself from its plight, it has, in the past few years, taken great pains to play the trick of faking peace while actually preparing for war. It has worked in every way to use peace as a camouflage for its aggression and preparations for a new war. However, it only serves as a good teacher by negative example. Recently the crimes of the United States in intruding into the Soviet airspace and sabotaging the four-power conference of government heads have stripped U.S. imperialism and its head, Eisenhower, of all their disguises and bared the utterly ferocious features of U.S. imperialism. This has provided an instructive lesson to the people of the world. Imperialism is, after all, imperialism and its fine words can never be trusted. . . .

Comrades! The development of the international situation has fully testified to the correctness of the Declaration of the Moscow Meeting of the Communist and Workers' Parties of the Socialist Countries two and a half years ago. The Declaration pointed out on the one hand that " so long as imperialism exists there will always be soil for aggressive wars," that the aggressive circles of the United States are " the centre of world reaction " and " the sworn enemies of the people," and that " all the nations must display the utmost vigilance in regard to the war danger created by imperialism." On the other hand the Declaration pointed out that " the forces of peace have so grown that there is a real possibility of averting war." So long as there is unity among the socialist camp headed by the Soviet Union, the international working class and its vanguard, the peoples of Asia, Africa and Latin America struggling for their liberation, the peoples of various capitalist countries fighting against monopoly capital and all peace-loving countries and peoples in the world, it is possible to check war and safeguard peace. This is to say that the aggressive and predatory nature of imperialism will never change, that U.S. imperialism is the arch enemy of world peace, and that the peoples of the world must never entertain any unrealistic illusions about imperialism, especially U.S. imperialism. They must maintain a high degree of vigilance, carry on a persistent struggle against U.S. imperialism and its lackeys and maintain solidarity and mutual support in the struggle.

This is also to say that the forces of the masses of the people of various countries and their struggle are the decisive factor in checking war and defending world peace. War can be held at bay and world peace preserved only by continually strengthening the forces of the people in the countries of the socialist camp, the liberation movements of the Asian, African and Latin American peoples and the revolutionary struggle of the people in various capitalist countries and by relying on their alliance in the resolute struggle against U.S. imperialism and its lackeys so as to isolate U.S. imperialism to the greatest extent.

In the face of the powerful growth of the struggle waged by the people in the world against imperialism and its lackeys, our sacred duty as Communists is to strengthen the unity of our socialist camp and the international communist movement on the basis of the Moscow Declaration. At the same time we must unite all the international forces with whom it is possible to unite to form the broadest anti-imperialist united front with this great unity as its core. The unity of the socialist camp and the international communist movement is the most reliable guarantee for the cause of world peace, liberation of the working class and all the oppressed nations. Imperialism fears most this unity of ours and is trying by every means to disrupt it. Modern revisionists, represented by the Tito clique, exactly in keeping with the needs of imperialism, are doing their utmost to disrupt this great unity of ours, thus serving imperialism and especially U.S. imperialism. For the defence of the unity of the socialist camp and the international communist movement, we must carry the struggle against modern revisionism to the end. We must thoroughly expose them for the renegades they are, completely wipe out the ideological poison spread by them and utterly smash all their criminal sabotage activities. . . .

[Speech on June 22, 1960; *Peking Review*, No. 26, 1960.]

The Bucharest Communiqué

Representatives of the Communist and Workers' Parties of the socialist countries, attending the Third Congress of the Rumanian Workers' Party . . . decided to take advantage of their stay in Bucharest to exchange opinions on current problems of the present international situation, and the conclusions for the fraternal parties coming from them.

The participants in the conference noted unanimously that all international events and the developments of the countries of the world socialist system fully reaffirmed the correctness of the Marxist-Leninist theses of the Declaration and the Peace Manifesto adopted by the Communist and Workers' Parties in Moscow in November 1957.

The participants in the conference reaffirmed their allegiance to the principles of the Declaration and Peace Manifesto, which are the charter of the present-day Communist and workers' movement, a programme of its struggle for peace, democracy and socialism.

The representatives of the Communist and Workers' Parties of the socialist countries believe that all the conclusions of the Declaration and the Peace Manifesto—on peaceful co-existence between countries with different social systems, on the possibility of preventing wars in the present period, on the need for vigilance of the peoples with regard to the danger of war, since the existence of imperialism means there is a basis for wars of aggression—can be fully applied in the present situation, too.

" The Communist Parties," the Declaration emphasises, " regard the struggle for peace as their paramount task. Shoulder to shoulder with all peace-loving forces they will do their utmost to prevent war."

The Declaration also draws an important conclusion about the forms of the transition of countries from capitalism to socialism. " In the present conditions in a number of capitalist countries, the working class, headed by its vanguard, has the possibility . . . of breaking the resistance of reactionary forces and creating the necessary conditions for the peaceful accomplishment of the socialist revolution." All the same, it is also necessary to take into account the possibility of the working class gaining victory for the socialist revolution by non-peaceful means. . . .

Bucharest, June 24, 1960.

[From text in *Soviet News* (London: Soviet Embassy) No. 4296, June 28, 1960.]

6. Renewed Soviet Attacks

THERE were a number of indications during the new few months that the dispute continued.[16] The absence of Mikoyan from Moscow and of Teng Hsiao-p'ing and P'eng Chen from Peking in late summer was accompanied by reports that they were attempting to hammer out a compromise in south Russia. The Chinese, however, refrained from any further major assaults on the Soviet position, perhaps feeling that the U-2 incident, the collapse of the summit conference and the cancellation of Eisenhower's visit to Japan were sufficient vindication of their cause until the whole dispute could be thrashed out at some form of conference. But the Soviet press renewed its attacks on the Chinese, presumably after the matter had been discussed at the CPSU central committee session in mid-July.

Writing in *Pravda* on August 7, Yu Frantsev, a leading Soviet theoretician, conceded that the national liberation movement was an important force making for the preservation of peace, though he did not list it second in the Chinese manner. As if to extract a *quid pro quo* for this concession, Frantsev asserted that the Bucharest conference confirmed that all ruling Communist Parties supported the conclusions of the CPSU's *Twenty-first* Congress, a claim for which there was certainly no visible proof.

Frantsev also attempted to prove that Lenin had foreseen the kind of international situation now existing and would have analysed it in much the same way as Khrushchev himself. To earlier Chinese charges that over-optimistic talk about peace would dull the vigilance of the proletariat, Frantsev retorted that leftist views on peace and war sapped the morale of the proletariat and enabled the imperialists to accuse Communists of aggressiveness.

An article by S. Titarenko reproduced in a number of Soviet provincial papers on August 16 contained an implied threat that Soviet aid might be withheld if China did not fall into line. An article published in *Pravda Ukrainy* on August 30 compared the dogmatists to Trotskyists. A. Belyakov and F. Burlatsky, writing in *Kommunist* (No. 13, 1960) emphasised, as Khrushchev had done at Bucharest, that nuclear war would be a disaster for the "whole of humanity," clearly rejecting the comforting Maoist thesis that it would result only in the destruction of imperialism and "certainly not . . . the annihilation of mankind." [17] They asserted, too, that Soviet advocacy of peaceful co-existence did not imply advocacy of peace between classes within states—but at the same

[16] See above p. 25.
[17] See " Long Live Leninism!", p. 93.

time reaffirmed the possibility of " peaceful transition to socialism " under conditions of peaceful co-existence. This argument reinforced the earlier attack in a *Pravda* article by Academician E. Zhukov on dogmatists who allowed themselves to sneer at bourgeois nationalist revolutions in Africa and Asia.

" Problems of War and Peace in Present-day Conditions "

The Great October Revolution marked the beginning of a new historical epoch whose content is the transition from capitalism to socialism. Socialism has triumphed fully and definitively in our country: the Soviet people are successfully building a communist society. A world system of socialism has arisen and is growing stronger. No single phenomenon in the world can now be correctly understood unless one regards the world system of socialism as of paramount importance.

A third of mankind has cast off the yoke of capitalism, is creating a new type of society and has achieved gigantic successes in subduing the forces of nature and developing technology to an astounding extent. Millions of people have been freed from the yoke of colonialism. The question arises: In these conditions can the imperialists, as in the old days, arbitrarily drive the peoples into bloody slaughter? Will the bloody element of war rage over the globe as in the past?

An answer to this most important question was given by the Twentieth Congress of the CPSU, which on the basis of profound Marxist-Leninist analysis of the present day reached the conclusion that in our time there is no fatal inevitability of war. The transformation of socialism into a world system, the growth of the might of the Soviet Union, of all the countries of socialism, the growth of the consciousness and organisation of all the forces standing for peace in capitalist countries, the unprecedented development of the peace movement, the appearance of " peace zones " on the map of the world, the growth of the national-liberation movement—all this has radically altered the world situation. There are now no forces in the world that could halt the dynamic development of the world system on socialism.

The implementation of the economic plans of the USSR and of all the other socialist countries will introduce still greater changes into the international situation. When the USSR becomes the world's first industrial power, when the Chinese People's Republic becomes a mighty industrial power and all the socialist countries together turn out more than half the world's industrial production, then the influence of the socialist countries on the strengthening of the peace-loving forces will grow still further. The present-day Peace Partisan Movement, which has embraced all countries and all peoples, represents a great social force, whose activity in the struggle against war will grow more and more. The idea of the impermissibility of war will take still deeper root in the minds of the peoples. Relying on the might of the camp of socialism, the peace-loving peoples will then be able to compel the militant circles of imperialism to abandon their plans for a new world war. These ideas form the basis of the conclusions of the Twenty-first Congress of the CPSU to the effect that even before the complete victory of socialism on the earth and while capitalism continues to exist in part of the world, a real possibility will arise of excluding world war from the life of society.

The proposition that it is possible in our time to prevent war and preserve peace was developed in the Declaration and Peace Manifesto adopted at the Conference of Fraternal Parties in Moscow in the autumn of 1957. The principles of the Declaration and Peace Manifesto, which constitute the charter of the present day communist and working-class movement, have triumphed in the struggle against revisionism, dogmatism and sectarianism, which are contrary to the creative character of Marxism-Leninism and impede the mobilisation of all the forces of the socialist camp, of the revolutionary working-class and liberation movement, to the struggle for peace and socialism against imperialism.

The Conference of Representatives of the Communist and Workers' Parties of the Socialist Countries held in Bucharest in June 1960 confirmed with fresh force that the Communist and Workers' Parties unanimously support the conclusions of the Twentieth and Twenty-first Congresses of the CPSU, which have exerted a tremendous influence on the international situation in the interests of peace and socialism, and support the principles of the Declaration and Peace Manifesto. The Conference in Bucharest demonstrated the fidelity of the international communist movement to Marxism-Leninism, the readiness of all the fraternal parties to continue to strengthen the solidarity of the world socialist camp and to preserve like the apple of their eye the unity of the international communist movement. The July Plenum of the Central Committee of the CPSU adopted unanimously a resolution on the results of the Conference of Representatives of Communist and Workers' Parties in Bucharest. The Plenum fully and entirely approved the political line and activity of the CPSU Delegation headed by Comrade N. S. Khrushchev at this Conference and the communiqué of the Conference. The Central Committee of the CPSU confirmed its fidelity to the principles of the Declaration and Peace Manifesto and expressed complete solidarity with the statement by the Communist and Workers' Parties which participated in the Bucharest Conference to the effect that the struggle for peace remains the cardinal task of the communist movement.

Has the Nature of Imperialism Changed?

Imperialism no longer dominates the whole globe, as in the past. Barring the way to the implementation of its plans there now stands not one socialist country in capitalist encirclement, but a world system of socialism. Imperialism does not have its former hinterland in the form of the colonial system. The peoples of countries which have liberated themselves from colonial oppression and also of countries which are struggling for their national independence are resolutely opposed to imperialism, to its rapacious colonial policy and predatory aggressive wars. On the international arena the number of states coming out for peace is increasing. Within the capitalist countries the organisation and consciousness of the working class is growing. Is the aggressive nature of imperialism changing in the course of these processes? No, it is not. By its social nature imperialism remains rapacious. But do the imperialists still have their former opportunities to manifest their rapacious nature unimpeded on the world arena? No, these opportunities are diminishing. . . .

The aggressive nature of imperialism remains, but its opportunities are diminishing—this is the peculiarity of the present-day international situation. Whoever notices only one side of a question and closes his eyes to the other

is not a Marxist and cannot correctly understand the present-day international situation.

Contemporary revisionists and reformists close their eyes to the aggressive nature of imperialism and proclaim that imperialism has allegedly changed since the time when the classics of Marxism-Leninism wrote about it, and that the wolves have allegedly been "transformed" into sheep. The point, the revisionists and reformists preach, is not that it is getting more and more difficult for the wolves to use their teeth but that the wolves do not have any teeth and no longer have any desire to live at the expense of others. In that case there would be no need to wage the struggle for peace.

On the other hand, the dogmatists and sectarians claim that while imperialism exists it retains its rapacious nature and even now the question of whether there will be a war or not allegedly depends on its whim. In this case, the struggle for peace loses its perspective.

The position of creative, consistent Marxism-Leninism on these questions is different. . . .

At the present time there is no fatal inevitability of wars. But it would be mistaken to suppose that it is possible to ensure lasting peace without a struggle. The issue is decided by the struggle of the masses, in the first place by the assiduous and consistent struggle for peace of the camp of socialism and the world communist movement. Communists are not fatalists and are not Utopian dreamers. In the struggle for peace they rely on actual possibilities contained in the historical situation and convert these possibilities into reality. The characteristic feature of the present-day international situation consists precisely in the fact that imperialism, without changing its aggressive nature, is forfeiting its former opportunities of lording it on the world arena, while the opportunities of the world socialist system to curb the aggressive aspirations of the imperialists are growing.

War is the continuation of politics by other means. In order to continue imperialist policy on the world arena by force of arms, with the help of war, it is necessary to dispose of the appropriate means and opportunities. The desire alone of the imperialists is not enough. It is well-known that the imperialists have undertaken wars, proceeding from the balance of forces, at a time when they have been able to count on success. Beasts of prey undertake wars in the hope of booty and not in order to break their teeth. This is the ABC of Marxism. Even a wild beast chooses the moment for the most successful attack and also chooses its victim, in accordance with its own strength. The issue of war is decided by the correlation of forces on the world arena. And at present the balance of these forces is not in favour of the imperialists. . . .

The conclusions of the Twentieth and Twenty-first Congresses of the CPSU and of the Declaration and Peace Manifesto on the possibility of averting war are based on a scientific analysis of the contemporary international situation; they are confirmed by the whole course of world events and retain their full validity. These conclusions are an expression of the creative character of Marxist-Leninism.

Lenin on War and Peace in the Epoch of Imperialism

V. I. Lenin taught us to approach the question of wars from the point of view of dialectical materialism. But such an approach requires that one take account of the concrete situation, of the changed balance of strength

in the world. In combating the right- and " left "-wing opportunists, Lenin stressed that the question of wars could be decided only in the light of the new historical situation. . . .

V. I. Lenin showed that predatory wars stemmed from the fact that the imperialists enjoyed undivided sway in the world, from the fact that they had divided the world up amongst themselves and were waging a struggle for its redivision. He wrote about the first world war: " The objective conditions of socialism have fully ripened, and the present war is a war of capitalists for the privileges and monopolies which might defer the collapse of capitalism." The imperialists would like, with the help of war, to prolong the existence of capitalism, to slow down the historical process which is inevitably leading to the replacement of capitalism by a new, socialist system of society. The working class, the working people, on whom fall all the burdens of imperialist wars, are the opponents of these wars: predatory wars are at variance with the socialist system, based on the international solidarity of the peoples, which is being created by the working people.

While fighting against the deception of the people by pacifist phrases, Lenin indicated to mankind the correct road to peace. He taught the working people that " the blessings which they expect from peace are impossible without a series of revolutions." He spoke out against the illusion that " present governments, present ruling classes, are *capable*, without being ' trained ' (or removed) by a series of revolutions, of [achieving] a peace in some way satisfactory to democracy and the working class."

Why did Lenin write about a *series of revolutions* which alone can radically change the world situation and create conditions for the appearance of those blessings of peace awaited by the masses? Lenin did not entertain any illusions as to how the capitalist world would greet the socialist revolution after it had triumphed initially in one country: a country in which the socialist revolution triumphed might be subjected to intervention by capitalist states. The people, having taken the fate of their country into their own hands, would reply to this intervention with a just, defensive war. Lenin wrote that " socialism having triumphed in one country does not in any way immediately exclude all wars in general." He pointed out that this was a matter for the future, the result of a series of revolutions.

Now there has occurred a series of revolutions which have removed capitalism from tremendous expanses of the globe. There exists a world system of socialism. The time has irrevocably passed when international relations were an arena for the arbitrary will of imperialists, aggressors and invaders.

During Lenin's life there was no world system of socialism, but the brilliant strategist of the proletarian revolution foresaw that mankind would inevitably be faced with the historic " task of transforming a dictatorship of the proletariat from a national one (*i.e.*, existing in one country and incapable of determining world politics) into an international one (*i.e.*, a dictatorship of the proletariat in at least several of the advanced countries, capable of exerting a decisive influence on the whole of world politics)." At the present stage, as Lenin foresaw, the mighty world system of socialism is already capable of exerting and is exerting a decisive influence on world politics.

The General Line of our Foreign Policy

Leninism proceeds from the fact that in the final analysis the question of the victory of the new social system over the old is decided in the most important sphere of man's activity, in production. " Labour productivity," wrote Lenin, " is in the last analysis the most important and chief thing for the triumph of the new social system." This is one of the basic ideas of Leninism which determine the process of the transition from capitalism to communism. Socialism is developing its gigantic potentialities in the sphere of creative productive labour. Through the smoke of the battles of the civil war Lenin clearly saw this most important task of the new society. At the height of the fierce battles against Denikin's followers he pondered the question of relations with the technically and economically advanced capitalist countries " during the period when socialist and capitalist states will exist side by side." Lenin put forward and substantiated the principle of the peaceful co-existence of countries with different social systems.

For the contemporary historical period the principle of peaceful co-existence put forward by Lenin is the only correct and necessary one in the relations between the countries of socialism and capitalism. The policy of peaceful co-existence conforms to the interests of the working class, of all working people, to the interests of communism. Today, while struggling against the " cold war " policy, we are winning over to our side wide sections of the public in the capitalist countries and we are isolating the most aggressive representatives of monopoly capital both in the world arena and inside capitalist countries. This is promoting the triumph of the cause of peace, democracy and socialism.

The struggle for peace, for the peaceful co-existence of countries with different social systems, is the general line of the foreign policy of the socialist camp. The peace-loving foreign policy of the Soviet Union and of the other socialist states is meeting with the support and approval of all peoples. The Soviet proposals for universal and total disarmament, whose implementation could save mankind from the fear of a new war, are a graphic manifestation of this policy.

A new and immeasurably more favourable situation has now come about in the struggle for communism compared with the time when the working class in our country had only just taken power into its hands. " Even at that time," N. S. Khrushchev has noted, " we spoke of the broad opportunities which communism opens up before people, while we ourselves in fact were going around in torn breeches, barefoot and hungry. Certain bourgeois leaders hoped then that our people would be tempted by the ' charms of bourgeois civilization.' But now the Soviet Union—a country where a communist society is being built—has the opportunity of demonstrating communism before the whole world not only as the most advanced doctrine but also of demonstrating the material and spiritual riches which the Soviet man is receiving as a result of building a socialist system."

The nearer our country advances towards communism the less will the " charms of bourgeois civilization " tempt the working people of the capitalist countries. The policy of the " carrot and the stick," on which the bourgeoisie places its main reliance, will suffer one failure after another. The new world situation is bringing into prominence the struggle for the utilisation of all the gigantic advantages which the socialist system possesses. The imperialists have long feared this historical prospect. They have openly

attempted to frustrate with the help of wars the peaceful competition of socialism with capitalism. Then, going over to the "cold war" methods, they tried, as N. S. Khrushchev has said, "to compel the socialist countries to expend their material means on non-productive purposes." By imposing on us the arms race, they evidently counted not only on halting the development of the science and culture of socialist countries but in bringing them to ruin and in this way discrediting the socialist system. All these plans of the imperialists have failed.

The time is not far distant when the socialist camp will overtake the advanced capitalist countries in per capita production. The Soviet Union will be the country with the highest standard of living for the working people and with the shortest working day, and its population will be exempted entirely from taxes.

In peaceful competition with capitalism, socialism is winning great victories. Over the past six years our industrial production has increased by 90 per cent., while that of the U.S.A. has gone up by 15 per cent. Over the last six years per capita output of industrial products in the USSR has grown by 71 per cent., and in the U.S.A. by 0·3 per cent. Industrial production as a whole in the countries of the socialist system has grown almost six-fold compared with the pre-war level, while in the capitalist countries industrial production has increased approximately two-fold over the same period.

The successes of the Soviet Union and of the socialist camp are now acknowledged by all. Recently the *New York Times* wrote: "The times have long passed when Americans could permit themselves to scoff at communist plans for economic growth, and both our main parties have tacitly admitted this fact during the past few weeks."

Socialist society proposes to capitalism, instead of producing means of destroying people, to organise competition in the production of means of production and of means of consumption. The fact that the imperialists have waged the "cold war" without risking going over to open direct war against the socialist countries shows the growing might of the camp of socialism, in the first place of the Soviet Union. At the present time the Soviet Union, the world camp of socialism, has real possibilities of successfully fighting for the liquidation of the "cold war." The imperialists have repeatedly based their calculations on the hope that our party and the Soviet government would depart from the Leninist general line of their foreign policy and that people who are alien to Leninism would deflect communists from the Leninist path in the sphere of world politics. Then it would be easier for the imperialists to spread their absurd fables about the "aggressiveness of communism." The imperialists have for a long time frightened countries with these fables. But as a result of the consistent peace-loving policy of the Soviet Union, of our Party, the imperialists have now been revealed in their true aspects as aggressors, and the mask of "peaceableness" has been torn off them. All people of common sense can see that the communists, the Soviet Union, all the countries of the socialist camp, are fighting undeviatingly for peace, and that communism is an ideology and policy of construction, of peaceful creation by the masses.

Do not Slacken Vigilance

In 1918 the "left" phrase-mongers asserted that for the Soviet country to maintain peaceful relations with the capitalist countries would mean the

148

" legalisation " of imperialism. In criticising the writings of the " left " communists, Lenin asked them: " Perhaps the authors think that the interests of the international revolution required that it be given a *push*, and that such a push would be a war, and not peace, which might produce on the masses an impression that imperialism was being ' legalised '? " And Lenin answered this question most decisively: " Such a ' theory ' would signify a complete break with Marxism, which has always rejected the idea of giving a ' push ' to revolutions, which develop in accordance with the acuteness of the class contradictions which give rise to revolutions."

In present-day conditions a revival of views like those of the " left " communists would merely play into the hands of the imperialists by helping them to spread false stories about the " aggressiveness of communism." A revival of such left sectarian views would merely have a demoralizing influence on the builders of the new society: why construct, build, create, if one knows in advance that all the fruits of one's labour will be destroyed by the tornado of war? Such views have nothing in common with communism. Nor can one fail to see that as a result of modern warfare the productive forces, including the main productive force—the working people —would suffer considerably and mankind would experience tremendous difficulties in erecting the new social system on the ruins remaining after a military catastrophe. A destructive war would only make difficult the process of constructing a new society.

The socialist system not only does not create military conflicts between peoples, it destroys the soil from which such conflicts can arise. It removes this soil in economics, politics and ideology. The socialist states are fighting for the elimination of the distrust between peoples which has been nurtured by capitalism.

Imperialism, in kindling enmity between peoples, is attempting to drown in the blood of the peoples everything of value that there is in modern civilization.

By extending and intensifying its influence in world politics socialism is striving to set limits to the activity of the imperialists in the sphere of international relations so that the aggressors shall not be able at their own whim to unleash wars and doom the millions of working people to torment and destruction.

While the imperialists refuse to disarm, the greatest vigilance is necessary against all their intrigues, and readiness to deal a crushing rebuff to any provocation by them. Through the efforts of the Party the Government and the whole people, we have created tremendous possibilities for once and for all discouraging the aggressors from undertaking military provocations.

Our Party, the Soviet Government, are waging an indefatigable struggle for peace, for peaceful co-existence. With pride in our Party, in our Government, we repeat today Lenin's words: " Our peaceful policy is approved by an overwhelming majority of the world's population." In the struggle for peace the whole Soviet people is taking part, enhancing by its selfless labour the influence of our State, of the whole socialist camp on the development of the world, bringing nearer the triumph of communism.

[Yu. Frantsev in *Pravda*, August 7, 1960.]

A Threat to Cut Off Aid?

Now, when there is a great commonwealth of socialist countries forming a mighty bulwark of peace and social progress, it is necessary to approach

in a new way the question of the conditions and the possibilities of victorious socialist construction in various countries. In the period when the USSR was the only country of proletarian dictatorship in the world, it did not have the possibility of relying on anybody's direct economic or military aid. The working class and the working peasantry of the USSR could count only on their own strength and resources both in the construction of a socialist economy and in ensuring the country's military security.

The situation is now completely different. The working class of any country knows well that, in the struggle for socialism, it will always receive fraternal support from the Soviet Union and the whole camp of socialism. Lenin's teaching about the victory of socialism in particular countries should now be considered in direct connection with the successes of the socialist camp.

Could one imagine the successful construction of socialism going on in present day conditions even in so great a country as, let us say, China, if that country were in a state of isolation and could not rely on the collaboration and aid of all other socialist countries? While being subjected to an economic blockade by the capitalist countries such a country would be subjected simultaneously to military blows from outside. It would experience the greatest difficulties even if it succeeded in withstanding the furious attacks of the enemy. . . .

[S. Titarenko in *Sovyetskaya Latvia*, August 16, 1960.]

"Outstanding Factor of Our Times"

Under the onslaught of the peoples rising to freedom, the last mainstays of present-day imperialist slaveowners in colonial countries are crumbling. Academician E. Zhukov writes in *Pravda* today in an article headlined "Outstanding Factor of our Times," in which he analyses the most essential problems of the contemporary national liberation movement.

The emergence of new national states and the progressive development of certain states which have existed relatively for a long time as a result of the disintegration of the colonial system of imperialism, the author stresses, is a significant phenomenon of our days. Dogmatists and sectarians, Academician Zhukov goes on, who fail to understand the laws of social development, contend that the realisation of the Leninist principle of peaceful co-existence retards the development of the national liberation movement and dooms it to stagnation. Describing this point of view as deeply erroneous, Zhukov goes on: The experience of development of the USSR and other socialist nations, their active policy of peace and the unselfish aid they are rendering to underdeveloped countries inspire the peoples of these countries and strengthen their confidence in the success of their just cause.

Further, Academician Zhukov writes: Only petty-bourgeois leftists and hopeless dogmatists can deny the great historic significance of the fact of the formation of national states in Asia and Africa, even though many of these states have not yet attained economic independence and have not solved a number of pressing social problems advanced by life.

After noting that most of the new national states of Asia and Africa are headed by bourgeois politicians appearing under the flag of nationalism, the author notes that this, however, does not detract from the progressive historic significance of the present breakthrough of the front of imperialism. Doctrinaires and "leftists," the article goes on, who allow themselves to

sneer at such forms of national liberation movement as do not fit into the customary sociological schemes forget that there exists no such thing in nature as "pure" revolutionary processes. It is quite natural that in the national liberation anti-imperialist movement, the front of participants is much wider than in a social revolution. Failure to understand the multiplicity of forms of national liberation movement, Zhukov goes on, and a haughty attitude towards anti-imperialist actions when, in definite historic conditions, non-proletarian elements come to the forefront, represent sectarianism of a most dangerous kind leading to self-isolation. Citing then Lenin's words about the unequal development of capitalism in various countries, the author writes: Hence it follows that it is impossible to skip over a definite historic stage and consequently the task of socialist transformation cannot be mechanically placed on the order of the day in all countries [at the same time, Tass Russian version added]. What is needed is a concrete historic approach to the solution of the question of the paths of development of any given country.

Speaking about the relations between socialist countries and states fighting for independence, the author goes on: The main and most essential thing which unites socialist states and non-socialist national states is their common anti-imperialist position, their common interest in the earliest liquidation of the colonial system and in the all-round economic and cultural progress of peoples who temporarily fell back in their development, in establishing genuine equality of nations and consolidating lasting peace on earth.

Only imperialist provocateurs, the author stresses, who have made anti-communism their banner in the policy of aggression and fresh colonial adventures, raise the cry of "Communist conspiracy" about any just national liberation struggle of the peoples, no matter who stands at its head. Marxism-Leninism, Academician Zhukov writes in this connection, resolutely condemns as a reactionary Utopia the very idea of "exporting" revolution to other countries and rejects any imposition upon other countries of social systems and institutions which are not the product of internal development. The Soviet Union, the article says, is rendering and will continue to render unselfish support to national states defending their sovereignty from imperialist encroachments and in doing so it has no other aims except seeing these states free and prosperous as quickly as possible.

The continuing disintegration of the colonial system, Academician Zhukov writes in conclusion, strikes the imperialist colonialists with fear. This is eloquently attested by the events in the Congo, where the colonialists are attempting to confront a young sovereign state which expresses the indomitable will of the Congolese people to independence and freedom with their own united front, using for this purpose "NATO solidarity," the venality of certain tribal chiefs and the obsequiousness of highly-placed manipulators from the United Nations machine. Colonialists spare no efforts to retard the historic process of regeneration of formerly enslaved peoples. Vain efforts! The lesson of life is: Wherever the people rise to freedom the entire process of social life is accelerated, along with an intense upsurge of national economy and culture.

[Text of Tass summary in English, August 26, 1960. Reproduced in *Summary of World Broadcasts* (London: B.B.C.), Part 1, SU/421/B/1.]

151

" The Struggle for Peace is the Primary Task "

The international " weather " is changeable. Do you remember how clearly the barometer turned to " clear " when N. S. Khrushchev's visit to America took place? But recently, as a result of a number of provocations by American rulers the wind of the " cold war " has again blown up. This changeability reflects to a certain extent the effect on the world scene of two conflicting forces—the progressive forces of socialism and the reactionary forces of capitalism. And although with every year we can see more clearly the tendency towards a steady improvement of the international situation, which is an undoubted achievement of the progressive forces, the forces of reaction sometimes manage to halt the approach of warm weather and even to induce some fog.

There are, however, people who do not see and do not wish to see which is the predominant tendency. Their whole attention is absorbed by current changes in the international situation. They can't, as we say, see the wood for the trees.

Some of them exploit every bright period on the international horizon to shout repeatedly at the top of their voices: " We have long been asserting that imperialism is now nothing like what it was when Marx and Lenin described it, it has become good—' humane,' ' popular,' ' peace-loving.' . . ."

The others—they usually raise their voices imperiously when the international situation has deteriorated—declare gloomily: " Our epoch is the epoch of imperialism, wars and proletarian revolutions; so long as imperialism exists, wars are inevitable, and so said Lenin." Yes, they base themselves on Marxism-Leninism but not on its essential features, not on its living soul but on the letter, the formality, forgetting that Lenin himself more than once ridiculed those who treat Marx's teaching as a dogma. Lenin himself more than once stressed the creative character of Marxism and its continuous development in accordance with changes in the life of society. Failing to take these changes into account, the prophets of gloom draw obviously incorrect conclusions from Lenin's formulae: If, they say, wars are inevitable under imperialism, then what sort of peaceful co-existence can you talk about? And the struggle for peace, they say, has no future, it only distracts revolutionary parties from their main tasks in the development of the class struggle. People who make such assertions are dogmatists and sectarians. . . .

Even now, such weapons are being produced that their use in the event of war would have catastrophic consequences for the whole of humanity. The Soviet Union's great service lies in the fact that it has not permitted the imperialists to acquire a monopoly over the new weapons and has equipped its army with powerful weapons which are superior to the weapons of foreign military adventurers. Today even the most rabid maniacs from the Pentagon must realise that with modern weapons war will be suicide for the person who launches it.

And even with such superiority we are against war. The first secretary of the C.C. of the Communist Party of Czechoslovakia, Antonin Novotny, has stated: " We are fighting with all our strength for the final defeat of imperialism. But we are convinced that our strength gives us the possibility of achieving complete victory by peaceful means. The devastation which would be brought about by another war would be too great a price to pay for our victory, it would throw humanity back hundreds of years

and would inflict great harm on the cause of proletarian revolution. . . . We are fighting for the victory of life over death and therefore our banner is peace. . . ."

The adventurist policy of the Trotskyists and the Bukharinists of playing at revolution in 1918 almost spelled the end of the young Soviet Republic. In our time the emergence of views, similar to the views of the " left communists," can only play into the hands of the communists who spread false stories about the aggressive nature of world communism. . . .

Any kind of attempt to assess the policy of peaceful co-existence, of averting wars and the struggle for disarmament as a retreat from Marxist-Leninist positions on the class struggle of the proletariat, attempts to spread doubt about the correctness of the theoretical principles laid down by the Twentieth and Twenty-first Congresses of the CPSU, is a retreat from Marxism-Leninism, a demonstration of dogmatism and sectarianism which is capable of causing serious harm to the development of the international communist movement. . . .

[G. Nikolnikov in *Pravda Ukrainy*, August 30, 1960.]

" Lenin's Theory of the Socialist Revolution and Present-day Conditions "

There are two erroneous approaches to Lenin's theory of the socialist revolution—the revisionist and the dogmatic.

The revisionists try to impose the idea, openly or covertly, that this theory has allegedly become outdated. . . .

The supporters of the other erroneous theory, the dogmatic one, shut their eyes to the new factors which the present era introduces into the theory of scientific socialism. Admitting in words that big shifts have occurred in the world in the last couple of dozen years, the supporters of this point of view nevertheless fail to draw the necessary conclusions from them. They question the new principles of theory and tactics of a socialist revolution worked out by the communist movement in recent years, and try to dispute them, referring to quotations from the works of V. I. Lenin taken out of context. In these cases Lenin's ideas are either misinterpreted or else are mechanically extended to new historical conditions.

It must be emphasised that in general such a bookish approach is unacceptable in Marxism-Leninism as a creative teaching and is absolutely inapplicable to the theory of a socialist revolution. It must be rejected in principle as being contrary to the spirit of Leninism. . . .

An appreciation of the internal situation of the world capitalist system as a whole and of each country in particular remains the starting point, as before. However, it is impossible to limit ourselves to this under present-day conditions. Today it is necessary to take into account not only the tendencies in the development of imperialism, but also the new position which capitalism occupies in the world, the balance of forces of the two systems, the influence of the successes in the building of socialism and communism on the world liberation movement, and the part played by the national liberation fight of the peoples. . . .

Today, when the U.S.A. no longer holds a monopoly in atomic weapons, when the might of the world system of socialism has grown out of all knowledge, the possibility of paralysing imperialist interference in a revolution, in the internal affairs of this or that country, has tremendously

increased. Is not that proved by the stopping of the Anglo-Franco-Israeli aggression against Egypt on the demand of the USSR and other peace-loving forces? Is not that proved by the successful development along the revolutionary road by the heroic people of Cuba, despite the burning hatred of the American imperialists and all their attempts to strangle the revolution? . . .

Generally speaking, the relationship between war and revolution is much more complicated than some people imagine. It must be considered from every angle, and that is a concretely historical way. The influence of wars on the social processes, on the liberation movement of the masses and the conditions of its development have always been of a contradictory character. Wars have always been tremendous disasters for the popular masses, causing the worker starvation and destruction in the rear and death and disablement at the front. They led to the destruction of the productive forces of the community and thereby obstructed its progress. Besides that, the preparations for a predatory war and the war itself led to a strengthening of reaction, to an active attack by the ruling classes against the rights and liberties of the masses and against their militant organisations. . . .

It is notable that the October revolution was carried out under the banner of peace, whilst the civil war was started, not by the communists, but by the forces of internal and foreign counter-revolution. . . .

A world war with the employment of thermo-nuclear weapons would make no distinctions between front and rear. It would lead to the complete destruction of the main centres of civilisation and the wiping out of whole nations, and would bring immeasurable disaster to the whole of humanity. It is only madmen who could wish for such a catastrophe. . . .

It is obvious, therefore, that modern nuclear war of itself could in no way be a factor which would hasten revolution or bring nearer the victory of socialism. On the contrary, it would throw back humanity, the world revolutionary workers' movement and the cause of building socialism and communism for many dozens of years. . . .

The policy of peaceful co-existence assists in taking advantage of the struggle between two tendencies among the ruling circles of the capitalist countries—the militant aggressive one and the moderate sober one—in the interests of peace. People are to be found, however, who assert that the thesis of peaceful co-existence almost amounts to preaching " class peace." Such people misinterpret Lenin's conception of peaceful co-existence which, as is well known, applies to the sphere of inter-state (and by no means inter-class) relations and in no way implies a cessation of the fight between the two systems or some kind of armistice in the contradictions between socialism and capitalism. The contradictions continue and the class war in the international arena continues, but the forms of that war are different—economic competition and an ideological fight in place of war. . . .

Thus there can be no doubt that the strengthening of peace and peaceful co-existence is a factor which favours the expansion of the liberation movement and the activisation of the class war in the capitalist countries. Lasting peace creates more favourable conditions for accelerating the development of the socialist system, improves the prospects of the liberation movement and increases the possibilities for a revolutionary snapping of more links in the capitalist system. . . .

Anti-fascist unity was achieved on a wide scale during the second world

war. Peoples-Democratic revolutions which developed in the countries of Europe and Asia served as an obvious example of the importance which universal democratic aims and movements have assumed in our days. These revolutions developed under anti-fascist democratic slogans (and in places where survivals feudalism had been preserved, under anti-feudalist slogans as well). Experience has also shown that under proper direction by the working class and its Marxist-Leninist parties, democratic revolutions have a tendency to develop into socialist revolutions relatively swiftly. . . .

In the post-war period, the communist parties in the capitalist countries have enriched the tactics of the democratic, anti-monopolistic fight with new ideas and forms. The new features which have been introduced by the communist parties into this question can be found in a summarised form in the decisions of the Rome conference of representatives of the communist parties of the capitalist countries held in November 1959. The programme for the anti-monopoly war proposed by this conference is a model of a creative approach to the assessment of the modern conditions of the fight of the working class and the working out of the tactical slogans and forms of this fight. . . .

Communists are by no means opposed in principle to regulation of the economy by the state. The working class accepts battle on the field which has been created by the process of the objective development of capitalism itself. If the ruling groups of monopolistic capitalism resort on a wide scale to measures of government interference in economic life, the working class does not of necessity have to reject state interference as such. We are talking about something different. Would it not be possible by means of an organised fight by the working class and all the popular masses to achieve the introduction of such regulating measures as would be directed against the ruling sections of the bourgeoisie, the monopolies, and would be in the interests of the people? In other words, government regulation becomes one of the new objectives around which the fight of the main social forces of the modern capitalist society develops. . . .

Dogmatically minded people spring up to ask: " But is any fight for democratic transformation really necessary? Would it not be better to immediately carry out a socialist revolution which would once and for all settle the problems of peace and the problems of democracy? Does not the fight for democratic transformations distract the working class from the prospects of revolution? " Some people even maintain that the decisions of the Rome conference are contrary to the Marxist theory of the class war, since they do not contain any call for the direct revolutionary overthrow of capitalism and the establishment of a dictatorship of the proletariat. It would be a good thing to remind such people of the following statement by Lenin on combining the fight for the immediate and final objectives of the working class, for reform and revolution: " For a genuine revolutionary the greatest danger, and even perhaps the only danger, is to exaggerate revolutionary feelings, to disregard the limits and conditions for an able and successful application of the revolutionary method. It was this that led real revolutionaries, more than anything else, to break their necks, when they began to write ' Revolution ' in capital letters, to exalt ' Revolution ' into something almost divine, to lose their heads, to lose the capacity to realise, weigh up and make sure, in the most cool-headed and sober way, at what moment and in what circumstances, in what sphere of action it was necessary

to be able to act in a revolutionary way, and at what moment and in what circumstances, in what sphere of action it was necessary to change to a reformist type of action " (*Works*, Vol. 33, pp. 86–87). . . .

In the process of the fight for peace and democracy the masses are able to recognise the true features of the monopolies as being the chief enemies of peace, independence and national liberty, the people responsible for the deterioration of the position of various sections of the population. It is only in the course of a fight of this kind that there can be forged a coalition of the anti-monopolist forces, where the working class will assume its leading position, whilst its allies will acquire confidence in its leadership and its programme of radical social transformations. . . .

Lenin constantly stressed that the proletariat must become proficient in all forms of fighting, both non-peaceful and peaceful. He wrote that the revolutionary class, in order to secure its ends, " must master *all*, without the smallest exception, forms and sides of social activity " and must be prepared to make " the most sudden and unexpected switch from one form to another " (*Works*, Vol. 31, p. 76). This principle rests today, as formerly, at the foundation of the approach of the Marxist-Leninist parties to the problem of the means by which the working class is to capture power. Any attempt to ignore the diversity of methods for the seizure of power by the working class, to identify revolution with an armed rising and civil war, throws the workers' movement back. . . .

When Marx and Engels were prepared to admit a peaceful transition to socialism in Britain and the U.S.A., they indicated the main internal factor which distinguished these countries from the countries of the European continent, the comparative weakness of the military and bureaucratic castes. At the same time the working class already predominated in the population of Britain. Under such conditions a socialist overthrow would not of necessity cause the bourgeoisie to use the most extreme forms of violence and therefore would not call for corresponding counter-measures by the proletariat. In the era of monopoly capitalism, when these countries did not differ from the countries of the European continent in the increase of militarism and bureaucracy, the question of a peaceful proletarian revolution in the U.S.A. and Britain ceased to apply, as Lenin pointed out. . . .

The case may be different in a transition to socialism under conditions of peace and peaceful co-existence. Here, for a number of countries, it is more probable than it was formerly that there may be peaceful roads to revolution, a conquest of power without a civil war or an armed rising. But for this it would be necessary that the ruling classes should be deprived of the possibility of taking up arms, of using the police, army and government machinery to crush the revolutionary movement of the masses. A situation of this kind might develop from a number of causes—the weakening of militarism as the result of a successful disarmament policy; a considerable part of the army and the government machine coming over onto the side of the people; the recognition by the ruling circles of the hopelessness of an open fight against the masses. It is obvious that if such favourable conditions are absent, the revolutionary struggle will inevitably assume non-peaceful forms.

[A. Belyakov and F. Burlatsky in *Kommunist*, No. 13, 1960.]

7. The Moscow Conference

WITH the announcement on November 4 of the composition of the Chinese delegation to the celebration of the forty-second anniversary of the Bolshevik revolution in Moscow, it became immediately apparent that the Chinese were determined to fight to the bitter end for their views. Mao was not going, presumably because he did not want to suffer the loss of " face " that a defeat would mean. But Mao's number two in the party, Liu Shao-ch'i, the head of state, was to lead the delegation with Teng Hsiao-p'ing, the party's general secretary, as his deputy. All the previous principal characters on the Chinese side were included—P'eng Chen, Lu Ting-yi, K'ang Sheng. The presence of Liao Ch'eng-chih, Chairman of the Chinese Afro-Asian Solidarity Committee, and Liu Ning-yi, Chairman of the All-China Trade Union Federation, men who had done a good deal of travelling in pursuit of their international " front organisation " activities, meant that the Chinese were well aware they would need to use all possible influence with Communist Parties from outside the *bloc* and, in particular, from Asia, Africa and Latin America. The delegation, made up of six Politburo members and five other members of the central committee, contained every senior Chinese theoretician or propagandist apart from Mao and the editor of *Red Flag,* Ch'en Po-ta, who presumably stayed at home to be ready to loose thunderbolts from Peking if necessary.

The stage was set for the conference by three articles in the Chinese press and the speech by Frol Kozlov, the member of the Soviet Presidium who currently appears destined to succeed Khrushchev, at the traditional meeting in the Moscow Sports Palace on November 6, the eve of the anniversary of the Bolshevik revolution.

The Chinese articles consisted of two on the Bolshevik revolution and one on the experience of the Chinese revolution to mark the publication of the fourth volume of Mao's selected works.

The major theme common to all these articles was on the need for revolutionary violence to smash bourgeois state power; this, it was affirmed, was the lesson taught by both the Soviet and Chinese revolutions. The *Red Flag* article on Mao's works affirmed that the Chinese revolution proved the validity of the lessons of the Paris Commune (also alluded to at the beginning of " Long Live Leninism! ") and the Bolshevik revolution in a " big eastern country." This appears to be a counter-attack against the views outlined in the article by Belyakov and Burlatsky (see above p. 156), a rejection of the idea that " peaceful

157

transition" may be possible in other "big, eastern" countries such as India or Indonesia. In particular, this article emphasised the importance of disorganising the bourgeois army, whereas the Soviet article just mentioned talked somewhat loosely of the army "coming over" to the side of the proletariat. At the same time, the article goes to some lengths to prove that Mao has always been against "leftism," presumably to refute Soviet charges against his current policies; it also affirmed that Mao had never been against the use of parliamentary struggle.[19] It would seem that the Russians when criticising the Chinese for advocating revolutionary violence as opposed to "peaceful transition" argued that the Chinese themselves had co-operated with the bourgeoisie —to which the Chinese replied in this article that this was a "muddle-headed" confusion of the seizure of power by violence and the carrying out of socialist transformation by peaceful means. The Chinese also lambasted "certain muddle-headed people" for thinking that national revolutions would endanger world peace, citing their own revolution as evidence that they would in fact increase the power of the peace forces.

The *People's Daily* editorial of November 7 reaffirmed the importance of the national independence movements for the Communist cause.

Kozlov repeated the Soviet acceptance of the national liberation movement as a force for peace. He indicated that the resolution on colonialism which Khrushchev had proposed to the U.N. on September 23, 1960, had been in part designed to counter Chinese allegations that peaceful co-existence implied "softness" on colonialism. Kozlov withdrew the Soviet claim that the signing of the Bucharest communiqué implied the acceptance by all ruling Communist Parties of the conclusions of the CPSU's Twenty-first Congress on peace and war. He could not report much success in Khrushchev's dealings with the West; he even scratched Macmillan off the list of "sober-minded" Western statesmen. But he did not abandon hope of negotiations producing results.

One of the few "inside" accounts of the course of the Moscow conference confirms Western speculation that it must have been extremely bitter, lasting as it did most of November.[20] According to this version, the conference began with a preparatory meeting at which the

[19] Any Communist familiar with Chinese Communist history would have been aware that the leftists cited by the article had been acting under Soviet orders.

[20] Edward Crankshaw in the London *Observer*, February 12 ("The Moscow-Peking Clash Exposed") and February 19 ("Moscow-Peking Clash: More Disclosures"). The fact that no admission that a conference was being held was made until it was over and a final document could be published, indicates that it was feared agreement might be impossible.

Chinese disputed every point of a draft declaration drafted by Mr. Suslov. Later, in full session, Teng Hsiao-p'ing led the Chinese attack, condemning the CPSU as opportunist, revisionist, and lacking deep knowledge of Marxism-Leninism. He described its ideas about disarmament as absurd, criticised aid to Nehru and Nasser as a mistake which could only help imperialism, and asserted that peaceful co-existence should be regarded as nothing more than a tactical weapon with which to deceive the enemy.[21]

Towards the end of the conference, the *People's Daily*, breaking the Communist press silence on the points in dispute, maintained since the conference had begun, anticipated the anniversary of the 1957 Declaration to emphasise the importance of the national liberation struggle. *Pravda* replied by reaffirming the CPSU's positions on peaceful co-existence.

"The Path of the Great October Revolution is the Common Path of the Liberation of Mankind"

Forty-three years ago, the proletariat and all other working people of Russia, led by V. I. Lenin, the great teacher of revolution, continuing the cause of the Paris commune, carried out an armed uprising, overthrew the counter-revolutionary rule of the landlord-capitalist class and won a great victory in the world-shaking proletarian revolution. Subsequently, after three years of heroic struggle, they smashed the armed intervention by fourteen capitalist countries, crushed the domestic counter-revolutionary rebellions and safeguarded the great victory of the October Revolution. As Lenin pointed out, "Revolutionary violence won a magnificent victory in the October Revolution.". . .

Fundamentally speaking, the path of the October Revolution is the common bright path of advance of entire humanity. Historical facts have times on end proved to us that without smashing the state machine of the capitalist class by revolutionary means, without establishing the dictatorship of the proletariat, there can be no socialism, no genuine liberation of the proletariat and the other labouring people. Lenin had more than once pointed out that the theory of the dictatorship of the proletariat is the most important component of Marxism and "only he is a Marxist who extends the recognition of the class struggle to the recognition of the dictatorship of the proletariat. This is what constitutes the most profound difference between the Marxist and the ordinary petty (as well as big) bourgeois." Lenin had also constantly pointed out that to recognise the dictatures in of the proletariat required that the Party go deep among the tens of millions of the labouring masses, devote its main efforts to leading the masses to carry out struggle, constantly raise their revolutionary level, make long, painstaking and persistent preparations for realising the dictatorship of the proletariat, combine the struggle for the immediate interests of the proletariat with the struggle for its long-term interests and oppose the erroneous tendency of sacrificing the fundamental interests of the proletariat in favour of the immediate interests. To put into effect the programme of the dictatorship of the proletariat, Lenin, in leading the revolution, waged persistently a firm

struggle against the opportunists and revisionists of the second international and their Russian counterparts, the Mensheviks. On the eve of the October Revolution, these opportunists and revisionists did everything to oppose the launching of an armed uprising by the Russian proletariat. After the October Revolution, they again tried their utmost to oppose the conversion of the Soviets into a state organisation of the dictatorship of the proletariat, the dissolution of the reactionary constituent assembly of the capitalist class, the defeat and rout of the reactionary troops etc. Lenin stressed: " The point is whether the old state machine (bound by thousands of threads to the bourgeoisie and permeated through and through with routine and inertia) shall remain, or be destroyed and replaced by a new one. Revolution consists not in the new class commanding, governing with the aid of the old state machine, but in this class smashing this machine and commanding, governing with the aid of a new machine. Kautsky slurs over this basic idea of Marxism, or he has utterly failed to understand it." . . .

Lenin wrote the great work *The State and Revolution* on the eve of the outbreak of the October Revolution, theoretically defending and developing the fundamental idea of Marxism on smashing the state machine of the capitalist class and realising the dictatorship of the proletariat, further elucidating in detail the path of the Paris Commune and laying a solid theoretical foundation for the victory of the Russian proletariat in the October socialist revolution and the realisation of the dictatorship of the proletariat. This was of extremely great significance for the revolutionary cause of the proletariat of the whole world and the cause of mankind's liberation. . . .

The experiences of the Soviet Union and other socialist countries prove that only under the conditions of the dictatorship of the proletariat is it possible to realise the socialist transformation of the national economy and carry out socialist and Communist construction. . . .

The declaration of the Moscow meeting of Communist and Workers' Parties of the Socialist Countries which is of great historic significance sums up the experience of the international Communist movement in the past hundred years, especially the past forty years. The declaration points out that the " guidance of the working masses by the working class, the core of which is the Marxist-Leninist party, in effecting a proletarian revolution in one form or another and establishing one form or another of the dictatorship of the proletariat is a major universal law." The modern revisionists represented by the Yugoslav Tito clique deny the historical necessity of carrying out the proletarian revolution and the dictatorship of the proletariat in the period of transition from capitalism to socialism and do all they can to oppose the proletarian revolution and the dictatorship of the proletariat. Their " revision " of Marxism-Leninism is precisely an attempt to depart from the highroad of the liberation of the proletariat. Therefore, the task of all Communists is to resolutely oppose revisionism and defend this Marxist-Leninist path blazed by the October Revolution.

Compared with forty-odd years ago, the situation of the world has changed considerably. Socialism has triumphed in areas inhabited by more than one-third of the population of the globe and comprising one-fourth of its territory. The socialist countries headed by the Soviet Union, aiding each other and working closely together, are successfully building socialism, and enjoying an economic upsurge in common. With the support of the socialist

and other progressive forces of the world, the national liberation movement has made tremendous progress in the colonies and semi-colonies of Asia, Africa and Latin America. The workers' movement in the capitalist countries and the world-wide peoples' movement for peace, have also grown remarkably. As a result of these changes, the domain of imperialism has become daily smaller, the contradictions within the imperialist system are steadily sharpening, and the imperialist countries are having a very hard time. The situation in the world today shows that we are living in a new epoch in which the forces of peace prevail over the forces of war, the forces of the people over the forces of reaction and the forces of socialism over the forces of imperialism, a new epoch which is unprecedentedly favourable to the proletarian revolution in different countries of the world, a new epoch which is unprecedentedly favourable to the national revolution in the colonies and semi-colonies, a new epoch in which the collapse of the imperialist system is being further accelerated and the victory of the people throughout the world and their awakening are constantly mounting. At present, the primary task of the peoples of the world is to form the broadest united front against imperialism headed by the United States, resolutely oppose U.S. imperialism's policies of aggression and war, stand firm against colonialism, promote the growth of the national liberation movement and facilitate the progress of the revolutionary struggle of the working people in the imperialist countries against the bellicose groups and monopoly capital, so as to achieve the aim of preventing imperialism from starting a world war and safeguarding world peace.

Imperialism will never reconcile itself to its doom. Imperialism, U.S. imperialism in particular, is making frantic efforts to expand armaments and prepare for war, to uphold everywhere the system of national oppression and enslavement and foster reactionary governments and forces in all parts of the world, and sparing no effort to plot for the subversion of the socialist countries. The socialist camp headed by the great Soviet Union is the strong bulwark for the defence of world peace and the struggle for the liberation of mankind. To continue to develop and increase the might of the socialist camp and consolidate its unity is the sacred duty of the peoples of the socialist countries. The Chinese people have done, are doing and will continue to do their utmost to fulfil this sacred duty. Imperialism and its running dogs, the modern revisionists, have used all despicable tactics to undermine the unity of the countries of the socialist camp. However, their acts of sabotage have invariably ended in ignominious failure, and will inevitably suffer one defeat after another in the future as well. . . .

[*Red Flag*, No. 20–21, 1960. From text released by NCNA, October 31, 1960.]

" Hold High the Red Banner of the October Revolution. March from Victory to Victory "

Since the great October Revolution, the national liberation movements in colonies and semi-colonies have entered a new stage. Today, the nationalist, democratic movements in Asia, Africa and Latin America are in a new upsurge. The Soviet Union and the other socialist countries have given warm support and tremendous encouragement to the national independence movements in various countries; the people in all the countries which are struggling for national independence look upon the Soviet Union and the other socialist

countries as their most faithful friends. The successful development of national independence movements has greatly weakened the strength of the imperialist system and at the same time rendered tremendous support to the building of socialism in the socialist countries and to the struggle of the world's people for peace. The October Revolution has closely linked together the cause of socialist revolution of the proletariat in all countries and the struggle of all oppressed nations for liberation. The linking together of the socialist revolution and the national liberation movement has accelerated the collapse of the imperialist system and speeded up the victorious progress in the struggle of all oppressed nations for national independence, democracy and freedom. . . .

[*People's Daily*, November 7, 1960. From text released by NCNA on same day.]

" A Basic Summing-up of Experience Gained in the Victory of the Chinese People's Revolution "

In summing up the experience of the Paris Commune, Karl Marx put forward the famous proposition that the working class cannot simply lay hold of the ready-made state machinery and wield it for its own purposes. . . .

Why was the great October Revolution able to succeed? Because the Russian proletariat under the leadership of the great Lenin's Bolshevik Party thoroughly smashed the old Russian militarist, bureaucratic state machine, established the dictatorship of the proletariat and set up a new Soviet state machine, transforming the state from an instrument for suppression of the majority of people by the exploiting few into one of suppression of the exploiting few by the majority.

The establishment of the system of the people's democracies in a series of European and Asian countries towards the end of and after the Second World War was also due to the smashing of the old militarist, bureaucratic state machine in these countries, by their own people, or by their own people with the assistance of the Soviet Army which was pursuing the bandit troops of the German fascists.

The Central Committee of the Chinese Communist Party has stressed repeatedly that the Chinese Revolution was the continuation of the October Revolution. Why was the great revolution of the Chinese people able to succeed? For the same reason. How could victory have been achieved if we did not overthrow the counter-revolutionary dictatorship of the big landlord class and the big bourgeoisie and smash the old state machine of the warlords, bureaucrats and secret agents? The victory of the Chinese revolution substantiated afresh, in a big eastern country, the Marxist-Leninist theory of the state and revolution.

The specific historic conditions underlying the revolution are usually not completely identical in various countries; they often vary from country to country. The concrete process whereby the reactionary state machine was smashed and the revolutionary state machine established during the Chinese revolution had its own characteristics.

The October Revolution started with the armed uprising of the Russian working class in the capital. Its course of development was characterised by the taking over first of the cities and then of the countryside. But the Chinese revolutionary war which began in the autumn of 1927, namely the revolutionary war under the independent leadership of the Chinese Communist

Party, first succeeded in a number of rural areas on the basis of the agrarian revolution, then the success was gradually extended and finally victory was achieved in the cities. In other words, its course was characterised by growth from setting up small revolutionary bases in the rural areas to large revolutionary bases; from the establishment of a few revolutionary bases to the establishment of many and from encirclement of the cities by the rural areas to the ultimate taking over of the cities.

This process means that the seizure of political power by the Chinese people took place at first in one place and then another and area by area, and so did their smashing of the reactionary state machine. Through this process of revolutionary development, which took twenty-two years to accomplish, the Chinese proletariat and the Chinese people won victory throughout the country and achieved their aim.

This course of development of the Chinese revolution was propounded by Comrade Mao Tse-tung....

After the betrayal of the revolution by Chiang Kai-shek, the former capitulationists represented by Ch'en Tu-hsiu joined hands with the counter-revolutionary Trotskyites and became liquidationists. They declared that the Chinese revolution had ended and held that the Chinese people should not touch Chiang Kai-shek's counter-revolutionary state machine but should only engage in legal activities under the reactionary rule of Chiang Kai-shek, with a "National Assembly" as the central slogan. They also shamelessly acclaimed Chiang Kai-shek's counter-revolutionary wars and slandered the revolutionary wars and guerrilla wars of the peasants led by the proletariat as a "Movement of Roving Insurgents" which was doomed to fail. Comrade Mao Tse-tung refuted the counter-revolutionary babble of the Trotskyite–Ch'en Tu-hsiu liquidationists and held firmly to the banner of the Chinese people's revolution. He maintained that "a single spark can start a prairie fire" and that revolutionary armed forces and revolutionary bases, though small and existing only in the rural areas as they did, had great vitality and an unlimited future.

On the other hand, there were in our revolutionary ranks at that time a group of petty-bourgeois "Left" adventurists who controlled the leading organs of the party for several years and beat down a large number of correct leading comrades headed by Comrade Mao Tse-tung so that they could not raise their heads. These "Left" adventurists denied the protracted nature and the tortuous character of China's revolutionary struggle, failed to comprehend that the Chinese revolution had to pass through a process of developing from small to big and from the countryside to the cities and impatiently wanted to take big cities. They were unwilling to carry out among the people the arduous task of building up the forces of the revolution, engaged in wishful thinking that the Chinese revolution could be won overnight and that Chiang Kai-shek's counter-revolutionary state machine could be smashed root and branch in one, single "decisive battle." It was in fact, impossible for "Left" adventurism to achieve the aim of overthrowing the reactionary rule of Chiang Kai-shek and really strengthen and extend the forces of the revolution. On the contrary, such blind actions could only lead to the weakening of the revolutionary forces, and the position of the revolution. During the ten years' civil war in 1927–36, Comrade Mao Tse-tung unceasingly opposed this anti-Marxist-Leninist "Left" opportunist line and forcefully drew attention to the necessity of

establishing a solid foundation of revolutionary bases in the countryside " thus placing ourselves in an invincible position."

Comrade Mao Tse-tung maintained that above all the bases in the countryside which at the beginning were small in area and still few in number should be firmly held and continuously expanded and developed; in this way it would be possible " to come ever nearer the goal of attaining nationwide political power." Comrade Mao Tse-tung's victory against " Left " adventurism in 1935 led to the quick resuscitation of the forces of the revolution which had dwindled at that time to only one-tenth of their former strength and guaranteed the Chinese revolution a path of sound development. . . .

Comrade Mao Tse-tung said during the period of the war of resistance to Japanese aggression in his *Problems of War and Strategy,* " According to the Marxist theory of the state, the army is the main component of the political power of the state. Whoever wants to seize state power and to keep it must have a strong army."

Armed revolution against armed counter-revolution, which the Chinese people conducted for a long period, was precisely a process of unceasingly smashing the armed forces of the counter-revolution and building up the armed forces of the revolution, precisely a process of unceasingly shattering the state machine of the counter-revolution and building up the state machine of the revolution, and precisely a process of unceasingly reducing the area under the rule of the counter-revolution and expanding the revolutionary bases and the liberated areas.

In the same article mentioned above, Comrade Mao Tse-tung said: " The task of the proletarian parties in the capitalist countries is to prepare for the final overthrow of capitalism by educating the workers and building up strength through a long period of legal struggle. There we find long legal struggle, the utilisation of the platform of the legislative body, economic and political strikes. . . ." And he further said that in those countries, " War or . . . armed insurrection should not be launched until the bourgeoisie becomes really helpless, until the majority of the proletariat are determined to take up arms and wage war and until the peasant masses are willing to give assistance to the proletariat." But China was in a condition different from this. According to Comrade Mao Tse-tung, in a semi-colonial and semi-feudal country like China, there was no parliament to be utilised, nor did there exist the legal right to organise the workers to conduct strikes. " In China the main form of struggle is war and the main form of organisation is the army." Such a war was mainly a peasants' war and such an army was an army with the peasants as its main component.

We Communists are aware that even in the capitalist countries parliaments are only an ornament of the bourgeois dictatorship. To fail to understand this is utter stupidity. Of course it is also stupidity if, when the circumstances call for it, the political parties of the proletariat do not make use of such an instrument as the parliament to conduct legal struggle. In China, we say, there was no parliament to make use of, and so our main form of struggle was revolutionary war and our main form of organisation was the army; but this by no means signified that all the possible conditions for carrying on legal struggle should not be made use of; such a notion was also stupid. But in the period of the ten years' civil war the " Left " opportunists within our party committed precisely this stupidity.

Either to restrict revolutionary struggle solely to legal struggle or to refuse completely to make use of such legal struggles as are possible and necessary is equally mistaken. Comrade Mao Tse-tung has always sharply criticised such errors.

Comrade Mao Tse-tung has always maintained that a revolutionary party must seize every opportunity to make use as far as possible of the contradictions of the enemy, develop the progressive forces, win over the middle-of-the-road forces and isolate the reactionary forces. He has opposed all kinds of one-sidedness. He said that our policy " is neither unity to the exclusion of struggle nor struggle to the exclusion of unity, but a combination of both. . . ."

Combating Right opportunism, Comrade Mao Tse-tung repeatedly stated the following truth: " Without armed struggle there would be in China no place for the proletariat, the people or the Communist Party and no victory for the revolution." (Introductory remarks to *The Communist*.)

Is not this the fact?

The Chinese Communist Party held a series of talks with Chiang Kai-shek in the period after the Japanese surrender and before Chiang Kai-shek launched a new, all-out counter-revolutionary civil war. Comrade Mao Tse-tung personally went to Chungking for direct talks with Chiang Kai-shek and agreement was reached on peace and national reconstruction. The " summary of conversations between the representatives of the Kuomintang and the Chinese Communist Party," signed on October 10, 1945, laid down in its very first article " The Basic Policy on Peace and National Reconstruction," providing unequivocally for " determined efforts to avert civil war." But, three days after the signing of the agreement, on October 13, Chiang Kai-shek secretly released an order for so-called " Bandit suppression," for attacks on the liberated areas. The political consultative conference closed on January 31, 1946, yet scarcely ten days later, on February 10, an incident occurred at Chiaochangkou, Chungking, in which Kuomintang secret agents wrecked the mass rally held to celebrate the Political Consultative Conference and committed brutal acts of suppression there. From January to June 1946, the Kuomintang and the Communist Party concluded cease-fire agreements on three occasions, yet each was immediately violated by ever bigger military attacks by Chiang Kai-shek. . . .

Chiang Kai-shek often made this proposition to Chinese Communists: You hand over your army, and I will give you democracy and let you join the organs of political power. The Right opportunists lent a willing ear to these words from Chiang Kai-shek and showed much interest in them. Comrade Mao Tse-tung on the contrary always reminded us that we must not fall into this trap laid by Chiang Kai-shek. In circumstances where the Chiang Kai-shek reactionaries continuously strengthened their counter-revolutionary state machine, would it have been possible to win democracy peacefully? Would it have been possible to win political power peacefully? Obviously not.

The Right opportunists did not believe that the masses of the people are the creators of history and did not see the great strength of the people; what they perceived was only the phenomenon of the superficial strength of the Chiang Kai-shek reactionaries, not the weakness which was the essence. The Right opportunists' illusions about Chiang Kai-shek's Kuomintang meant in fact that they were cowed by its superficial strength. Marxist-Leninists

scorned this weak-kneed, impotent attitude of the Right opportunists and held that the task was to expose the reactionaries as only outwardly strong but really weak inside, and so to inspire the masses of the people to dare to wage struggle and seize victory. Comrade Mao Tse-tung fulfilled precisely this task. At a time when Chiang Kai-shek with the backing of U.S. imperialism expanded his army to well over four million men, that is to say at the time when the counter-revolutionary state machine of China's big landlords and big bourgeoisie reached its peak, Comrade Mao Tse-tung penetratingly pointed out that the Chiang Kai-shek reactionaries were nothing but paper tigers and that the Chinese people should prepare themselves, and indeed they had the strength, to overthrow the reactionary rule of Chiang Kai-shek's Kuomintang, found a new China of people's democracy and make themselves the masters of their country.

Things turned out exactly as Comrade Mao Tse-tung predicted; the massive counter-revolutionary army under Chiang Kai-shek, hammered and battered by the People's Liberation Army, rapidly fell to pieces in just over three years. . . .

As Lenin once pointed out in contending with the renegade Kautsky: " Not a single great revolution has ever taken place, or ever can take place, without the ' disorganisation' of the army. For the army is the most ossified instrument for supporting the old régime, the most hardened bulwark of bourgeois discipline, buttressing the rule of capital, and preserving and fostering among the working people the servile spirit of submission and subjection to capital." (Lenin: *The Proletarian Revolution and the Renegade Kautsky*.) By this Lenin meant that it was not possible for the oppressed classes to gain emancipation and put themselves in the ruling position unless they smashed the old, counter-revolutionary army, unless they smashed this principal component of the counter-revolutionary state machine. These words of Lenin, written after the October Revolution, take us back some forty years, but can we say they have become outdated? Of course not. In the forty years and more since the great October Revolution the revolutionary experience of a whole series of countries in Europe and Asia, the experience of the great revolution of the Chinese people, plus the experience gained from the revolutionary struggles which the people of various countries are now waging, have proved, and are still proving with ever greater force, that these words of Lenin have not become outdated at all; they have proved, and are still proving with ever greater force the vitality of the truth revealed in Lenin's words.

For the proletariat and the masses to take political power, smash the old, reactionary state machine and set up a new, revolutionary state machine is one thing. It is quite another thing, having taken political power and relying on it, to proceed to the socialist transformation of the system of ownership of the means of production. The two must not be confused. Only when the former exist can the latter be done. This is how it was in the Soviet Union; this is how it was in the socialist countries in Europe and Asia, and this is how it was in the People's Republic of China, too.

It is muddle-headed to confuse these two things—the seizing of political power by the proletariat and the carrying out by the proletariat of socialist transformation by peaceful means after it seizes political power. Such muddle-headedness conceals the most fundamental question, expounded time and again by Lenin, namely: " The basic question in any revolution is that of state power."

History tells us that people's revolutions in all countries stem from the needs of the people and are the result of the development of class struggle. These revolutions are made within a country by certain oppressed classes to overthrow certain oppressing classes, by certain exploited classes to overthrow certain exploiting classes. Marxist-Leninists have always held that revolution cannot be imported, nor can it be exported. To say that revolution can be imported or exported is entirely wrong. Precisely this is the slander the imperialists and reactionaries in various countries hurl against the people's revolution in any country, but such slanders can in no way check the advance of the revolutionary movement in any country or prevent the rise of revolution in any country.

No Marxist-Leninist party advocates that the socialist countries resort to war between states to spread revolution. The Titoist clique of Yugoslavia slanders the socialist countries with intending to use " war between states " to spread revolution. This is nothing but nonsense in the service of imperialism.

The development of the revolutionary forces of the people in the various countries and their successes in revolution are fundamental factors in preventing imperialism from launching a world war and in preserving world peace. The victory won by the Chinese people in their great revolution and the founding of the Chinese People's Republic have added to the strength of the socialist camp headed by the Soviet Union, expanded the forces standing . guard over world peace and to a great extent frustrated the adventurist policies and plans of the imperialists for starting a new world war. The stronger the socialist camp becomes, the greater the development of the people's revolutionary movements in the various countries and the more countries that win victory in their revolution, the greater will be the safeguards for world peace. The modern revisionists and certain muddle-headed people pit the revolutions in the various countries against world peace, alleging that revolution cannot be carried out if world peace is to be preserved. This is a completely preposterous standpoint which runs fundamentally counter to Marxism-Leninism. . . .

The socialist revolution cannot triumph at a single stroke in all the countries of the world simultaneously. It will come, separately and gradually, as a result of the inherent factors of society in the various countries and the political awakening of the people themselves, their own efforts and their preparations for revolution. . . .

[*Red Flag*, No. 20–21, 1960. From text released by NCNA, November 2, 1960.]

Kozlov's Anniversary Speech

The emergence of socialism beyond the confines of a single country represents one of the greatest victories in the age-old struggle between labour and capital.

It has entailed fundamental changes in the political, economic and ideological life of all mankind. The time of the universal rule of imperialism is gone irrevocably. The world socialist system, the formation of which constitutes the greatest event in history after the victory of the Great October Socialist Revolution, is now becoming the decisive factor in the development of human society.

On the world scene there has also emerged a group of states which refuse to take their cue unconditionally from the imperialist powers. The peoples

of Asia, Africa and Latin America, who in hard-fought struggle against the colonialists have won independence or are fighting for it, are taking an increasingly active part in international life and are making their contribution to the weakening of the positions of imperialism.

The positions of the working class have become stronger in the countries of monopoly capital. There has been an increase in the influence of the Marxist-Leninist parties, of which there are now 87 uniting 36 million communists. The working class has greatly increased its ability to rally the vast majority of the people in the struggle to isolate the reactionary aggressive monopoly circles, for new victories in the struggle for peace, democracy and socialism.

In these conditions even more vital becomes the policy of the peaceful co-existence of states with different social systems proclaimed and substantiated by V. I. Lenin. This policy answers the demands of contemporary social development and the real balance of world forces. It is in the interests of all peoples.

Creatively developing Marxism-Leninism, the Communist Party of the Soviet Union drew an important conclusion at its 20th Congress: Today war is not fatally inevitable; war can be averted. This conclusion enlisted the unanimous support of the fraternal Communist and Workers' Parties in a document of programmatic importance—in the Declaration of the Moscow conference of representatives of Communist and Workers' Parties of the socialist countries. The theses of the Moscow Declaration were reaffirmed in the communiqué of the Bucharest conference of the Marxist-Leninist parties.

A further advance of the theory of Marxism-Leninism was the conclusion of the 21st Congress of the Communist Party of the Soviet Union, which said: "Even before the complete victory of socialism on earth, given the preservation of capitalism in a part of the world, there is a real possibility of excluding world war from human society."

In drawing this conclusion our party proceeded from the fact that the fresh successes of the socialist camp would lead to the further growth of the peace forces throughout the world, while the number of countries advocating the consolidation of peace would increase. Our party took into consideration the fact that the idea of the impermissibility of war would strike ever deeper roots in the minds of the peoples, and, backed by the might of the socialist camp, they would be able to compel the bellicose circles of imperialism to abandon their plans for unleashing new wars.

The entire course of developments reaffirms the correctness of the analysis made by the communists. The socialist camp, backed by all the peace forces, has in recent years more than once cut short attempts by imperialist aggressors to engineer local wars through which imperialism threatens mankind with a new world war. This is striking evidence showing that the inception of the world socialist system and the successes of socialism have fundamentally changed the balance of power in the world in favour of socialism and the supporters of peace. Real forces have taken shape in the world in our time able to curb the imperialist aggressors. Imperialism can no longer settle at its discretion the issue of whether there will or will not be war.

Fighting for peace, the Marxist-Leninists, of course, take into consideration that the cause of war remains as long as imperialism exists. The

reactionary forces representing the interests of the capitalist monopolies might seek to unleash war. Imperialism has been and remains aggressive: its wolfish nature has not changed and will not change. That is why the socialist countries and all the peace forces must maintain the greatest vigilance and be ready to administer a crushing rebuff if the imperialists should risk starting a war.

Peace is the most cherished desire of all the peoples of the world. Men and women now have no greater desire than to avert the threat of another war of extermination.

But peace cannot be consolidated without fighting for it. That is why the pursuit by the socialist states of an active foreign policy whose general line is the principle of peaceful co-existence, the further mobilisation of all peace forces, making the peoples confident that another world war can now be averted—that is why all this is an urgent necessity of our time. Lenin said: "We must help the peoples to intervene in the issues of war and peace." Our party follows this behest of Lenin with the consistency and persistence inherent in communists.

Striving for peace, our party well remembers Lenin's directive that socialism victorious exerts the main influence on the destinies of mankind by its economic successes. And these successes can be multiplied only in conditions of peace. In peaceful economic competition with capitalism, socialism will undoubtedly gain a decisive economic victory and will ensure the peoples of its countries higher living standards than they now have. This will demonstrate even more clearly than now the superiority of our socialist system and will provide for all the peoples of the world a powerful impetus in their struggle against capitalism and for socialism.

Comrades, all of us have witnessed the resolute actions of the Soviet government in defence of peace.

The Soviet Union has fought persistently for the realisation of the proposals for general and complete disarmament which were supported last year by the United Nations General Assembly. As a result of the persistent actions of the Soviet government in the struggle for general and complete disarmament a 10-power committee was formed. We hoped that this committee would be able to clear away the obstacles which had piled up in the disarmament talks. Last January we adopted a new law on a new unilateral reduction of the Soviet armed forces by 1,200,000 men.

Our economic contacts and cultural relations with many states have been extended. We continue to render selfless aid to underdeveloped countries.

N. S. Khrushchev's tours of South-East Asia and France, as well as his visit last year to the United States, helped to spread a correct understanding of the policy of the socialist countries, to clear the international atmosphere, to expose the insidious designs of imperialism, and they created a favourable climate for a summit meeting.

But the strengthening of the cause of peace went against the grain in imperialist circles, who abhor a development of international relations which is favourable to the people. Under the pressure of monopolies, which are making enormous profits out of the arms race, the United States government adopted the path of direct provocations against our country, against the cause of peace. American air pirates intruded into the Soviet skies and Eisenhower and the American government cynically proclaimed their "right" to violate our sovereignty, allegedly for the purpose of ensuring their "security."

By sending espionage planes over our country and refusing to plead guilty honestly to these acts of brigandage, the United States government torpedoed the summit meeting. By impermissible delays, by their refusal to conduct serious negotiations on disarmament the western powers made the further participation of socialist countries in the 10-power committee impossible. The imperialists provoked a new flare-up of the " cold war " in order to give another push to the arms race, to feverish military preparations.

But such a line in international relations bodes no good for the imperialists. . . .

We offer to the western powers to conduct honest international negotiations on the outstanding questions of international relations and we consider that this is the most rational way for reducing international tension.

Some western leaders, and in particular the British Prime Minister, Mr. Macmillan, have more than once spoken in favour of such negotiations. The latest steps of the British government, however, compel us to question seriously the sincerity of Mr. Macmillan's statements about the striving of the British government to reduce international tension. Only a few days ago Mr. Macmillan announced to Parliament the conclusion of an agreement between Britain and the United States, under which the American Navy will get a base in Scotland near Glasgow, Britain's second biggest city, [sic] for submarines armed with missiles and nuclear weapons. . . .

It is worth noting that Mr. Macmillan negotiated the establishment of this base during his stay in the United States at the 15th session of the United Nations General Assembly, which has been discussing disarmament as one of the main items.

With the Americans he discussed the question of the base. And with the Soviet delegation Mr. Macmillan discussed the question of the need for negotiations to solve international problems ripe for settlement. Apparently the British government is trying to move simultaneously in two diametrically opposite directions. . . .

Comrades, of the greatest importance for the historical destinies of the peoples is the immediate abolition of the remnants of colonialism which are still strangling tens of millions of human beings. We can no longer resign ourselves to this disgrace.

The Soviet government's proposal that the United Nations should adopt a declaration on the granting of independence to colonial peoples and countries is a vital demand of our time, the voice of mankind's conscience. Some prominent leaders of imperialist states, attempting to minimise the tremendous impression produced by this Soviet proposal upon world opinion, attempting to minimise the tremendous force of attraction of the declaration for the peoples of colonial and dependent countries, allege that the declaration contains nothing but " incitement to rebellion " in the colonies.

Such a police yardstick suits only very narrow-minded and embittered persons who refuse to notice the tremendous changes which are occurring in the world and recognise only their profits, their " right " to plunder other peoples. But no such right exists. This is not a " right " but an iniquity and the peoples reject it.

By its proposals in favour of peace the Soviet government has given an impetus to the struggle for the peaceful solution of most acute international problems and has considerably widened the front of that struggle. Today people in all parts of the world see more clearly the path of the peoples to decide their own destinies.

The vigorous foreign policy of the U.S.S.R., of all the socialist countries, and the successes of the peace movement have already yielded tangible results. The imperialist policy is in the throes of a deep crisis. The moral and political isolation of American imperialism—the mainstay of the militarism and colonialism which are loathed by the peoples—is increasing each day. This is confirmed by the overthrow of the bloody Syngman Rhee régime in South Korea, the fall of the openly pro-American Bayar-Menderes régime in Turkey, the indignation which the American-Japanese military alliance aroused among the Japanese people, and the mounting tide of the national liberation movement of African peoples.

The peoples of Latin America, inspired by the example of heroic Cuba, are intensifying their struggle. All this means that the positions of imperialism continue to grow weaker while the positions of the fighters for peace, for the national independence of the peoples, for socialism, grow ever stronger.

Comrades, the most important prerequisite to ensure lasting peace on earth and new victories of the working people in the struggle against the imperialists is the unity of the countries and peoples of the great socialist camp, the unity of all Communist and Workers' Parties. Our party and our people are sparing no efforts to strengthen this unity.

Armed with Marxist-Leninist theory, communists are guided by Lenin's thesis that " only knowledge of the fundamental features of a given epoch can serve as a basis for taking into account the more detailed traits of some particular country." These remarkable words of Lenin serve as a foundation for the understanding and correct correlation of the international and national tasks of each detachment of the international communist movement. Communists are the most consistent fighters for the fundamental national interests of their peoples. At the same time they express the common interests and aims of all toiling mankind.

Loyalty to the principles of creative Marxism, the ability to understand Leninism correctly and apply it in new historical conditions, international solidarity—therein lies the great strength of the international communist and labour movement.

The fraternal cohesion of the Communist and Workers' Parties and the friendship and mutual assistance of the socialist states constitute the source of the invincibility of the countries of the socialist camp, a guarantee of their successful advance to socialism and communism.

Faithful to Marxism-Leninism, the Communist Party of the Soviet Union, our government, the working people of our country will firmly and consistently strengthen the unity and might of the socialist camp, the unity of the international communist and labour movement and will steadily pursue the Leninist policy of the peaceful co-existence of states with different social systems and strengthen the friendship of all peoples. . . .

[From text in *Soviet News* (London: Soviet Embassy), No. 4371, November 7, 1960.]

<div align="center">✳</div>

" Give Full Play to the Revolutionary Spirit of the 1957 Moscow Declarations "

The development of the situation in the past three years demonstrates that the forces of socialism have further surpassed the forces of imperialism, the forces of national liberation have further surpassed the forces of

colonialism, the forces of the people have further surpassed the forces of reaction and the forces of peace have further surpassed the forces of war. This shows that the famous dictum made by Comrade Mao Tse-tung three years ago, that " the east wind has prevailed over the west wind," is perfectly correct.

In a word, the entire situation is highly favourable to the peoples of the world and unfavourable to imperialism and all reactionaries. Any view that overestimates the strength of imperialism and underestimates the strength of the people is contrary to the Moscow Declaration and is completely incorrect. . . .

This is to say, peace can be effectively safeguarded only by incessantly strengthening the socialist camp, the national liberation movement, the people's struggles in the capitalist countries, the forces of all peace-loving people and the unity of all these forces and by waging a joint struggle. The broader and stronger this united front of the peace forces against imperialism unleashing wars and the more extensive and intensive its struggles the firmer will be the guarantee for world peace.

The might and solidarity of the countries of the socialist camp, headed by the Soviet Union, is the main force in opposing imperialism and defending world peace. At the same time, the movement for defending world peace and the revolutionary struggles of the various peoples for national liberation, democracy, freedom and socialism are inter-connected, mutually consistent and complementary to each other. The development of the liberation movement of the oppressed nations and peoples of the world and the victories of their revolutionary struggles constitute a mighty force for preventing imperialism from unleashing war and defending world peace.

After the end of the Second World War, U.S. imperialism, by using the Chiang Kai-shek reactionaries to wage a civil war, tried to wipe out the Chinese people's revolutionary force and to turn China into its colony and military base for attacking the Soviet Union and carrying out aggression against Asia. But the Chinese people, compelled to fight a patriotic revolutionary war in self-defence, finally defeated the attack of the Chiang Kai-shek reactionaries and smashed the U.S. imperialists' rabid schemes of aggression against China. The victory of the Chinese people's revolution has greatly increased the forces defending world peace. The same point is proved by the development and victories of the people's revolutionary movements in the many Asian, African and Latin American countries. Those views which oppose the revolutionary struggles of the various peoples to the struggles for defending world peace are, therefore, very wrong. . . .

The entire theory of Marxism-Leninism is in the service of the world proletariat and the revolution of the various peoples. The revolutionary spirit is the soul of Marxism-Leninism. The combination of a strict scientific spirit and high revolutionary spirit is the inherent characteristic of the Marxist-Leninist theory. If we want to uphold the theoretical positions of Marxism-Leninism and the banners of the Moscow Declaration, then we must defend and give full play to this scientific and revolutionary spirit. New historical developments and new experiences in class struggle constantly demand that we, basing ourselves on the fundamental principles and methods of Marxism-Leninism and on scientific analysis of objective things, make new summations to guide revolutionary struggles and enrich the contents of Marxism-Leninism. But, in the course of studying new situations and

new experiences, we should, under no circumstances, depart from the fundamental principles and methods of Marxism-Leninism and disregard the facts. Otherwise, it would be a fundamental violation of Marxism-Leninism.

The Moscow Declaration points to " the necessity of resolutely overcoming revision and dogmatism in the ranks of the Communist and Workers' Parties." It also clearly points out that " the main danger at present is revisionism." The characteristic of revisionism is to emasculate the revolutionary spirit of the theory of Marxism-Leninism. Imperialism and the reactionaries of various countries, in order to save themselves from their fate of decline, are always exerting ceaselessly an influence on the working class. The revisionists of different hues always make use of a certain new situation to distort and adulterate the Marxist-Leninist revolutionary theory so as to lure the working class away from the correct path of revolutionary class struggle, to meet the needs of imperialism and the reactionaries of various countries. . . .

[*People's Daily* editorial, November 21, 1960. From text released by NCNA the same day.]

" Unity under the Banner of Marxism-Leninism "

The Bucharest conference proclaimed that all the conclusions of the Declaration and the Peace Manifesto concerning the peaceful co-existence of countries with different social systems, the possibility of preventing wars in the present period, the need for the peoples to maintain vigilance with regard to the danger of war, the struggle for peace as the paramount task, and the forms of transition of different countries from capitalism to socialism can be fully applied in the present situation too.

At the July plenary meeting of the central committee of the Communist Party of the Soviet Union, our party completely and fully approved the political line and the activity of its delegation, headed by N. S. Khrushchov, at the meeting in Bucharest and also the communiqué issued by this meeting. The C.P.S.U. unanimously stated that it was true to the principles of the Declaration and the Peace Manifesto, which had been tested by experience and fully retained their force under present-day conditions.

The Communist Party of the Soviet Union has always regarded the Leninist principle of the peaceful co-existence of states with different social systems as the general line of the Soviet Union's foreign policy. This principle does not deny the struggle of classes, nor does it mean the reconciliation of socialism with capitalism. Rather, it presupposes an intensification in the struggle for the triumph of socialist ideas, for the complete victory of socialism.

This principle, advanced by V. I. Lenin and further developed in the decisions of the 20th and 21st Congresses of the C.P.S.U., the documents of other Communist and Workers' Parties, and the Declaration and the Peace Manifesto, is the only correct principle for international relations when the world is divided into two systems—the socialist and the capitalist systems.

The C.P.S.U. firmly upholds the principles of creative Marxism-Leninism. Guided by these principles it drew major theoretical conclusions and made generalisations at its 20th and 21st Congresses. . . .

[*Pravda* editorial, November 23, 1960. From text in *Soviet News* (London: Soviet Embassy), No. 4382, November 25, 1960.]

8. The 1960 Moscow Statement

The deliberations in Moscow lasted some three weeks. The delegates of 81 Communist parties had taken part, representing the vast majority of the Communist movement which, according to the final Statement, was now active in 87 countries and embraced over 36 million members. The document that emerged, signed by all, expressed essentially the Soviet views on the major points that had been in dispute, but contained a number of concessions to the Chinese. These concessions meant in effect that Peking could interpret the Statement in such a way as to permit her to continue to pursue her more intransigent line in world affairs without laying herself open to charges of breach of faith from Moscow.[22]

The first section of the Statement defines the major features of the present epoch, a question dealt with at some length in the 1957 Declaration and " Long Live Leninism! " Here the major contention of the document is that: " It is the principal characteristic of our time that the world socialist system is becoming the decisive factor in the development of society." It adds that " Whatever efforts imperialism makes it cannot stop the advance of history. . . . The complete triumph of socialism is inevitable." The corollary of these assertions is that " A new stage has begun in the development of the general crisis of capitalism."

This analysis went a great deal further than the 1957 Declaration when it was claimed only that " the world socialist system, which is growing and becoming stronger, is exerting ever greater influence upon the international situation in the interests of peace and progress and the freedom of the peoples " and that imperialism was " heading towards decline."

The discussion in " Long Live Leninism! " of the present epoch was mainly aimed at refuting the idea that the advent of nuclear weapons had changed its nature. In that article, the Chinese contended that despite the increased strength of the *bloc*, lack of vigilance and a failure to struggle against imperialism would allow imperialism to be able to do as it pleased.

The importance of these semantic differences in practice is that the expression of greater confidence in the 1960 Statement means that the

[22] According to Crankshaw, *Observer*, Feb. 19, the document was signed in the interests of unity and Liu Shao-ch'i said he disagreed with some of its provisions.

Communist *bloc* does not have to pursue its aims with as great urgency and, therefore, militancy. If the Communist *bloc* is becoming the decisive factor in world affairs, if victory is inevitable, then there is room for manoeuvre and setbacks can be accepted as temporary and minor and nothing to worry about in the long run.

This overall confidence is reflected in the particular conclusions reached in the document. Section two deals with the Communist *bloc* and asserts that:

> Today the restoration of capitalism has been made socially and economically impossible not only in the Soviet Union, but in the other socialist countries as well. The combined forces of the socialist camp reliably safeguard every socialist country against encroachments by imperialist reaction.

This can be interpreted as an assertion that even if a country like Poland seeks American aid and permits a certain westernisation of its intellectual life, this will not lead to the Americanisation of the country which the Chinese have so strongly condemned in Yugoslavia, much less to Poland being lost to the *bloc*.

Section three deals with the problem of war and peace. Here the tone and some of the language is sternly Chinese. " U.S. imperialism " had already been described as the " chief bulwark of world reaction and an international gendarme " in the first section; here it is described as the " main force of aggression and war." The optimistic and relatively mild language of the Warsaw Pact declaration has completely disappeared.

Nevertheless the theoretical analyses of the inevitability of war made by Khrushchev at the *Twentieth* and *Twenty-first* Congresses of the CPSU are both included, this being the first occasion the Chinese had subscribed to the latter. The devastation that a nuclear war would entail is spelled out in terms never used by the Chinese, who had previously expressed contempt for American nuclear weapons.[23] The " democratic and peace forces " are said to have "*no tasks more pressing* than that of safeguarding humanity against a global thermo-nuclear disaster " (emphasis added).

The confident tone of the Statement is seen when one compares the assertion in it that " the time is past when the imperialists could decide at will whether there should or should not be war " with that in " Long Live Leninism! " that " whether or not the imperialists will unleash a war is not determined by us." But the Statement does, of course, admit the possibility of war, asserting in Chinese tones that " should the imperialist maniacs start war, the peoples will sweep capitalism out of existence and bury it."

[23] See " Long Live Leninism! " above pp. 92–94.

Not unexpectedly, the Statement is somewhat ambiguous on the importance of the "national liberation movement" in preventing war. On the one hand it lists that movement as one of the forces which could help to prevent war; on the other hand, the Statement does not list *encouraging* the movement as one of the tasks when describing what the fight for peace means. This represents a definite rejection of the Chinese view as expressed by Yü Chao-li quoted on p. 81. One might argue, therefore, that all Communists accept the value to their cause of such movements as the Algerian rebellion, but they have agreed, at least on the surface, that they will not commit themselves to encouraging such movements (by, say, arms deliveries) because, presumably, such actions would increase East-West tension and so the danger of world war.

The ambiguity is increased in section four which is devoted to national liberation movements and the problems of revolution in under-developed countries. The national liberation movement is said to receive "powerful support" from the Communist movement, but whether this support is to be moral or concrete is unspecified and therefore presumably left to individual Communist parties to interpret. But the assertion that

> The existence of the world socialist system and the weakening of the positions of imperialism have provided the oppressed peoples with new opportunities of winning independence

seems to suggest that it is sufficient for the Communist *bloc* to help the national liberation movement simply by existing.

There is further ambiguity in the discussion of how national liberation movements achieve success. The Statement mentions both armed struggle and non-military methods; yet it also asserts that the colonial powers never leave of their own free will, the kind of contention which the Chinese had normally used to justify the need for violence.

This section also includes a definition of what are called "independent national democracies"—broadly speaking, successor states to colonial régimes which are acceptable to the *bloc*. Space is devoted to the problem of the "national bourgeois" leadership in those countries, and it is asserted, in keeping with Chinese beliefs, that it has a tendency to compromise more and more with domestic reaction and imperialism. Local Communist parties are said to oppose such compromises; but there is no assertion of the kind Peking would probably have liked to the effect that the Communst *bloc* should give more than moral support where, as in the U.A.R., the local Communists are imprisoned.

In fact it is explicitly stated that Communist states reject "on principle any interference in the internal affairs of young national states";

the subsequent assertion that Communist states also consider it their internationalist duty to help the peoples in strengthening their independence is designed to justify the substantial Soviet economic aid to non-Communist under-developed countries not in the Western camp.

A strict definition would appear to exclude the U.A.R. and Iraq from the list of independent national democracies though both are wooed by Moscow. But who is to do the defining, and what is the sanction to be imposed by the *bloc* on a state which drifts out of the category?

But perhaps the most important aspect of this section is an omission. There is no mention of the methods or even the need for Communist parties to *obtain power* in such countries. Clearly the Soviet view that the most important thing in the case of neutral countries is to keep them neutral won the day.

In contrast, the following section, devoted primarily to the problems of Communist parties in capitalist countries, does discuss the problem of achieving power. The possibility of " peaceful transition " without civil war is said to exist in a number of countries (another Soviet victory), though it is added that the possibility of non-peaceful transition must be borne in mind (a Chinese codicil?).

Great stress is laid on the need for united fronts with Social Democratic parties, primarily to struggle against atomic weapons and foreign bases. Significantly, Communist parties in deciding on their revolutionary tasks have to pay " due regard to the international situation " which is presumably a euphemism for the subordination of Western Communist parties' programmes to the needs of Soviet foreign policy.

The final section deals with the affairs of the Communist movement. Revisionism " remains " the main danger, but dogmatism is criticised at greater length. Significantly, the Soviet Communist Party is referred to only as the vanguard and not as the leader of the world movement.[24]

The 1960 Moscow Statement

REPRESENTATIVES of the Communist and Workers' Parties have discussed at this Meeting urgent problems of the present international situation and of the further struggle for peace, national independence, democracy and socialism.

The Meeting has shown unity of views among the participants on the issues discussed. The Communist and Workers' Parties have unanimously reaffirmed their allegiance to the Declaration and Peace Manifesto adopted in 1957. These programme documents of creative Marxism-Leninism determined the fundamental positions of the international Communist movement on the more important issues of our time and contributed in great measure toward uniting the efforts of the Communist and Workers' Parties

[24] For a discussion of the significance of this development, see above, pp. 29–32.

in the struggle to achieve common goals. They remain the banner and guide to action for the whole of the international Communist movement.

The course of events in the past three years has demonstrated the correctness of the analysis of the international situation and the outlook for world development as given in the Declaration and Peace Manifesto, and the great scientific force and effective role of creative Marxism-Leninism.

The chief result of these years is the rapid growth of the might and international influence of the world socialist system, the vigorous process of disintegration of the colonial system under the impact of the national-liberation movement, the intensification of class struggles in the capitalist world, and the continued decline and decay of the world capitalist system. The superiority of the forces of socialism over those of imperialism, of the forces of peace over those of war, is becoming ever more marked in the world arena.

Nevertheless, imperialism, which is intent on maintaining its positions, sabotages disarmament, seeks to prolong the cold war and aggravate it to the utmost, and persists in preparing a new world war. This situation demands ever closer joint efforts and resolute actions on the part of the socialist countries, the international working class, the national anti-imperialist movement, all peace-loving countries and all peace champions to prevent war and assure a peaceful life for people. It demands the further consolidation of all revolutionary forces in the fight against imperialism, for national independence and for socialism.

I

Our time, whose main content is the transition from capitalism to socialism initiated by the Great October Socialist Revolution, is a time of struggle between the two opposing social systems, a time of socialist revolutions and national-liberation revolutions, a time of the breakdown of imperialism, of the abolition of the colonial system, a time of transition of more peoples to the socialist path, of the triumph of socialism and communism on a world-wide scale.

It is the principal characteristic of our time that the world socialist system is becoming the decisive factor in the development of society.

The strength and invincibility of socialism have been demonstrated in recent decades in titanic battles between the new and old worlds. Attempts by the imperialists and their shock force—fascism—to check the course of historical development by force of arms ended in failure. Imperialism proved powerless to stop the socialist revolutions in Europe and Asia. Socialism became a world system. The imperialists tried to hamper the economic progress of the socialist countries, but their schemes were foiled. The imperialists did all in their power to preserve the system of colonial slavery, but that system is falling apart. As the world socialist system grows stronger, the international situation changes more and more in favour of the peoples fighting for independence, democracy and social progress.

Today it is the world socialist system and the forces fighting against imperialism, for a socialist transformation of society, that determine the main content, main trend and main features of the historical development of society. Whatever efforts imperialism makes, it cannot stop the advance of history. A reliable basis has been provided for further decisive victories for socialism. The complete triumph of socialism is inevitable.

The course of social development proves right Lenin's prediction that the countries of victorious socialism would influence the development of world revolution chiefly by their economic construction. Socialism has made unprecedented constructive progress in production, science and technology and in the establishment of a new, free community of people, in which their material and spiritual requirements are increasingly satisfied. The time is not far off when socialism's share of world production will be greater than that of capitalism. Capitalism will be defeated in the decisive sphere of human endeavour, the sphere of material production.

The consolidation and development of the socialist system exert an ever-increasing influence on the struggle of the peoples in the capitalist countries. By the force of its example, the world socialist system is revolutionising the thinking of the working people in the capitalist countries; it is inspiring them to fight against capitalism, and is greatly facilitating that fight. In the capitalist countries the forces fighting for peace and national independence and for the triumph of democracy and the victory of socialism are gaining in numbers and strength.

The world capitalist system is going through an intense process of disintegration and decay. Its contradictions have accelerated the development of monopoly capitalism into state-monopoly capitalism. By tightening the monopolies' grip on the life of the nation, state-monopoly capitalism closely combines the power of the monopolies with that of the state with the aim of saving the capitalist system and increasing the profits of the imperialist bourgeoisie to the utmost by exploiting the working class and plundering large sections of the population.

But no matter what methods it resorts to the monopoly bourgeoisie cannot rescue capitalism. The interests of a handful of monopolies are in irreconcilable contradiction to the interest of the entire nation. The class and national antagonisms, and the internal and external contradictions of capitalist society, have sharpened greatly. Attempts to prop the decayed pillars of capitalism by militarism are aggravating these contradictions still further.

Never has the conflict between the productive forces and relations of production in the capitalist countries been so acute. Capitalism impedes more and more the use of the achievements of modern science and technology in the interests of social progress. It turns the discoveries of human genius against mankind itself by converting them into formidable means of destructive warfare.

The instability of capitalist economy is growing. Although production in some capitalist countries is increasing to some degree or other, the contradictions of capitalism are becoming more acute on a national as well as international scale. Some capitalist countries are faced with the threat of new economic upheavals while still grappling with the consequences of the recent economic crisis. The anarchical nature of capitalist production is becoming more marked. Capitalist concentration is assuming unprecedented dimensions, and monopoly profits and superprofits are growing. Monopoly capital has greatly intensified the exploitation of the working class in new forms, above all through intensification of labour. Automation and "rationalisation" under capitalism bring the working people further calamities. Only by a stubborn struggle has the working class in some countries succeeded in winning a number of its pressing demands. In many capitalist countries, however, the standard of life is still below pre-war.

179

Despite the promises made by the bourgeoisie, full employment was provided only in some of the capitalist countries, and only temporarily. The domination of the monopolies is causing increasing harm to the interests of the broad peasant masses and large sections of the small and middle bourgeoisie. In the capitalist countries, including some of the more developed, economically underdeveloped areas still exist where the poverty of the masses is appalling, and which, moreover, continue to expand.

These facts once again refute the lies which bourgeois ideologists and revisionists spread to the effect that modern capitalism has become " people's capitalism ", that it has established a so-called " welfare state " capable of overcoming the anarchy of production and economic crises and assuring well-being for all working people.

The uneven course of development of capitalism is continuously changing the balance of forces between the imperialist countries. The narrower the sphere of imperialist domination, the stronger the antagonisms between the imperialist powers. The problem of markets has become more acute than ever. The new inter-state organisations which are established under the slogan of " integration " actually lead to increased antagonisms and struggle between the imperialist countries. They are new forms of division of the world capitalist market among the biggest capitalist combines, of penetration by stronger imperialist states of the economy of their weaker partners.

The decay of capitalism is particularly marked in the United States of America, the chief imperialist country of today. U.S. monopoly capital is clearly unable to use all the productive forces at its command. The richest of the developed capitalist countries of the world—the United States of America—has become a land of especially big chronic unemployment. Increasing under-capacity operation in industry has become permanent in that country. Despite the enormous increase in military appropriations, which is achieved at the expense of the standard of life of the working people, the rate of growth of production has been declining in the post-war years and has been barely above the growth of population. Over-production crises have become more frequent. The most developed capitalist country has become a country of the most distorted, militarised economy. More than any other capitalist country, the United States drains Asia, and especially Latin America, of their riches, holding up their progress. U.S. capitalist penetration into Africa is increasing. *U.S. imperialism has become the biggest international exploiter.*

The U.S. imperialists seek to bring many states under their control, by resorting chiefly to the policy of military blocs and economic " aid ". They violate the sovereignty of developed capitalist countries as well. The dominant monopoly bourgeoisie in the more developed capitalist countries, which has allied itself with U.S. imperialism, sacrifices the sovereignty of their countries, hoping with support from the U.S. imperialists to crush the revolutionary liberation forces, deprive the working people of democratic freedoms and impede the struggle of the masses for social progress. U.S. imperialism involves those countries in the arms race, in a policy of preparing a new war of aggression and carrying on subversive activities against socialist and neutral countries.

The pillars of the capitalist system have become so decayed that the ruling imperialist bourgeoisie in many countries can no longer resist on its own the forces of democracy and progress which are gaining in scope and strength. The imperialists form military-political alliances under U.S. leadership to

fight in common against the socialist camp and to strangle the national-liberation, working-class and socialist movements. *International developments in recent years have furnished many new proofs of the fact that U.S. imperialism is the chief bulwark of world reaction and an international gendarme, that it has become an enemy of the peoples of the whole world.*

The system of military blocs set up by the United States is being weakened both by the struggle going on between their members and as a result of the struggle which the people are waging for the abolition of these blocs. The U.S. imperialists seek to strengthen aggressive blocs, which causes increased resistance on the part of the people. The United States remains the main economic, financial and military force of modern imperialism, although its share in capitalist economy is diminishing. The British and French imperialists are making stubborn efforts to uphold their positions. The monopolies of West Germany and Japan, which have recovered their might and which are closely linked with the U.S. monopolies, are stepping up expansion. The West German monopolies, in pursuing their imperialist policy, seek more and more to exploit the underdeveloped countries.

The peoples are rising with growing determination to fight imperialism. A great struggle is getting under way between the forces of labour and capital, of democracy and reaction, of freedom and colonialism. The victory of the popular revolution in Cuba has become a splendid example for the peoples of Latin America. An anti-colonial movement for freedom and national independence is expanding irresistibly in Africa. The anti-imperialist national uprising in Iraq has been crowned with success. A powerful movement of the people against the Japanese-U.S. military alliance, for peace, democracy and national independence, is under way in Japan. Vigorous actions by the masses in Italy in defence of democracy show the militant resolve of the working people. The struggle for democracy, against the reactionary régime of personal power, is gathering momentum in France. There have been big working-class strikes in the U.S.A., Argentina, Uruguay, Chile, India, Britain, Canada, Belgium and other capitalist countries. The actions of the Negro people in the United States for their fundamental rights are assuming a mass character. There is a growing desire to unite the national forces against the fascist dictatorships in Spain and Portugal, and the democratic movement is gaining strength in Greece. Tyrannical military régimes have been overthrown in Colombia and Venezuela, a blow has been dealt to frankly pro-American puppet governments in South Korea and Turkey. A national-democratic movement, directed against the U.S. imperialists and their flunkeys, is developing in South Viet-Nam and Laos. The Indonesian people are doing away with the economic positions the imperialists still retain in that country, particularly the positions held by the Dutch colonialists. The mass movement in defence of peace is gaining ground in all continents. All this is graphic evidence that the tide of anti-imperialist, national-liberation, anti-war and class struggles is rising ever higher.

A new stage has begun in the development of the general crisis of capitalism. This is shown by the triumph of socialism in a large group of European and Asian countries embracing one-third of mankind, the powerful growth of the forces fighting for socialism throughout the world and the steady weakening of the imperialists' positions in the economic competition with socialism; the tremendous new upsurge of the national-liberation struggle and the mounting disintegration of the colonial system; the growing instability of the entire world economic system of capitalism; the sharpening

contradictions of capitalism resulting from the growth of state-monopoly capitalism and militarism; the increasing contradictions between monopolies and the interests of the nation as a whole; the curtailment of bourgeois democracy and the tendency to adopt autocratic and fascist methods of government; and a profound crisis in bourgeois politics and ideology. This stage is distinguished by the fact that it has set in not as a result of the world war, but in the conditions of competition and struggle between the two systems, an increasing change in the balance of forces in favour of socialism, and a marked aggravation of all the contradictions of imperialism. It has taken place at a time when a successful struggle by the peace-loving forces to bring about and promote peaceful coexistence has prevented the imperialists from undermining world peace by their aggressive actions, and in an atmosphere of growing struggle by the broad masses of the people for democracy, national liberation and socialism.

All the revolutionary forces are rallying against imperialist oppression and exploitation. The peoples who are building socialism and communism, the revolutionary movement of the working class in the capitalist countries, the national-liberation struggle of the oppressed peoples and the general democratic movement—these great forces of our time are merging into one powerful current that undermines and destroys the world imperialist system. The central factors of our day are the international working class and its chief creation, the world socialist system. They are an earnest of victory in the struggle for peace, democracy, national liberation, socialism and human progress.

II

A new stage has begun in the development of the world socialist system. The Soviet Union is successfully carrying on the full-scale construction of a communist society. Other countries of the socialist camp are successfully laying the foundations of socialism, and some of them have already entered the period of construction of a developed socialist society.

The socialist system as a whole has scored decisive victories. These victories signify the triumph of Marxism-Leninism; they show clearly to all the peoples who are under the domination of capital that a society based on this doctrine opens up immense opportunities for the fullest development of economy and culture, for the provision of a high standard of living and a peaceful and happy life for people.

The Soviet people, successfully carrying out the Seven-Year Economic Development Plan, are rapidly building up a material and technical basis for communism. Soviet science has ushered in what is virtually a new era in the development of world civilisation; it has initiated the exploration of outer space, furnishing impressive evidence of the economic and technical might of the socialist camp. The Soviet Union is the first country in history to be blazing a trail to communism for all mankind. It is the most striking example and most powerful bulwark for the people of the world in their struggle for peace, democratic freedoms, national independence and social progress.

The people's revolution in China dealt a crushing blow at the positions of imperialism in Asia and contributed in great measure to the balance of the world forces changing in favour of socialism. By giving a further powerful impetus to the national-liberation movement, it exerted tremendous influence on the peoples, especially those of Asia, Africa and Latin America.

The people's democratic republics of Albania, Bulgaria, Hungary, the German Democratic Republic, the Democratic Republic of Viet-Nam, China, the Korean People's Democratic Republic, Mongolia, Poland, Roumania and the Czechoslovak Socialist Republic, which, together with the great Soviet Union, form the mighty socialist camp, have within a historically short period made remarkable progress in socialist construction.

People's government in these countries has proved its unshakable solidity. Socialist relations of production predominate in the national economy; the exploitation of man by man has been abolished for ever, or is successfully being liquidated. The success of the policy of socialist industrialisation has led to a great economic upsurge in the socialist countries, which are developing their economy much faster than the capitalist countries. All these countries have established a developed industry; agrarian in the past, they have become, or are becoming, industrial-agrarian countries.

In recent years all the People's Democracies have solved, or have been successfully solving, the most difficult problem of socialist construction, that of transferring the peasantry, on a voluntary basis, from the road of small private farming to the road of large-scale co-operative farming on socialist lines. Lenin's co-operative plan has proved its great vitality both for countries where the peasant's attachment to private land ownership was a long-standing tradition and for countries that have recently put an end to feudal relations. The fraternal alliance of workers and peasants, which is led by the working class, and the maintenance and consolidation of which is, as Lenin taught, a supreme principle of the dictatorship of the proletariat, has grown stronger. In the course of socialist construction this alliance of two classes of working people, which constitutes the political foundation of the socialist system, develops continuously, and further strengthens people's rule under the leadership of the working class and promotes the socialist reorganisation of agriculture in accordance with the Leninist principle of voluntary co-operation of the peasantry.

Historic changes have taken place in the social structure of society. The classes of landlords and capitalists no longer exist in the People's Democracies. The working class has become the main force of society; its ranks are growing; its political consciousness and maturity have increased. Socialism has delivered the peasantry from age-long poverty and has made it an active force in social progress. A new, socialist intelligentsia, flesh of the flesh of the working people, is arising. All citizens have free access to knowledge and culture. Socialism has thus created not only political but material conditions for the cultural development of society, for the all-round and complete development of the gifts and abilities of man. The standard of life of the people is improving steadily thanks to economic progress.

An unbreakable alliance of the working people of all nationalities has formed and has been consolidated in multi-national socialist states. The triumph of Marxist-Leninist national policy in the socialist countries, genuine equality of nationalities, and their economic and cultural progress serve as an inspiring example for the peoples fighting against national oppression.

In the People's Democracies, socialist ideology has achieved notable successes in its struggle against bourgeois ideology. It is a long struggle that will go on until the complete emancipation of the minds of people from the survivals of bourgeois ideology.

The moral and political unity of society, which for the first time in history has come into existence and firmly established itself in the Soviet Union, is

growing now in the other socialist countries as well. This makes it possible to use the creative energy of free workers most effectively for promoting the growth of the productive forces and the prosperity of socialist society.

Socialist society is improving steadily and becoming more and more mature; day after day it gives rise to a Communist attitude to labour and other elements of the future Communist society. The methods of socialist economic management and economic planning are steadily improving. Socialist democracy continues to develop; the masses are playing an increasing role in directing economic and cultural development; certain functions of the state are being gradually transferred to public organisations.

Today the restoration of capitalism has been made socially and economically impossible not only in the Soviet Union, but in the other socialist countries as well. The combined forces of the socialist camp reliably safeguard every socialist country against encroachments by imperialist reaction. Thus the rallying of the socialist states in one camp and the growing unity and steadily increasing strength of this camp ensure complete victory for socialism within the entire system.

Thanks to the heroic effort of the working class and the peasantry and to the tremendous work of the Communist and Workers' Parties, most favourable objective opportunities have been provided in the past years for the further rapid development of the productive forces, for gaining the maximum time and achieving victory for the socialist countries in peaceful economic competition with capitalism. The Marxist-Leninist Parties heading the socialist countries consider it their duty to make proper use of these opportunities.

Having achieved major victories and withstood serious tests, the Communist Parties have gained ample and varied experience in directing socialist construction. The socialist countries and the socialist camp as a whole owe their achievements to the proper application of the general objective laws governing socialist construction, with due regard to the historical peculiarities of each country and to the interests of the entire socialist system; they owe them to the efforts of the peoples of those countries, to their close fraternal co-operation and mutual internationalist assistance, and above all, to the fraternal, internationalist assistance from the Soviet Union.

The experience of development of the socialist countries is added evidence that mutual assistance and support, and utilisation of all the advantages of unity and solidarity among the countries of the socialist camp, are a primary international condition for their achievements and successes. Imperialist, renegade and revisionist hopes of a split within the socialist camp are built on sand and doomed to failure. All the socialist countries cherish the unity of the socialist camp like the apple of their eye.

The world economic system of socialism is united by common socialist relations of production and is developing in accordance with the economic laws of socialism. Its successful development requires consistent application, in socialist construction, of the law of planned, proportionate development; encouragement of the creative initiative of the people; continuous improvement of the system of international division of labour through the co-ordination of national economic plans, specialisation and co-operation in production within the world socialist system on the basis of voluntary participation, mutual benefit and vigorous improvement of the scientific and technological standard. It requires study of collective experience; extended co-operation and fraternal mutual assistance; gradual elimination, along these lines, of

historical differences in the levels of economic development, and the provision of a material basis for a more or less simultaneous transition of all the peoples of the socialist system to communism.

Socialist construction in the various countries is a source of collective experience for the socialist camp as a whole. A thorough study of this experience by the fraternal parties, and its proper utilisation and elaboration with due regard to specific conditions and national peculiarities are an immutable law of the development of every socialist country.

In developing industrial and agricultural production in their countries at a high rate in keeping with the possibilities they have, the Communist and Workers' Parties of the socialist countries consider it their internationalist duty to make full use of all the advantages of the socialist system and the internal resources of every country to carry out, by joint effort and as speedily as possible, the historic task of surpassing the world capitalist system in over-all industrial and agricultural production and then outstrip the economically most developed capitalist countries in *per capita* output and in the standard of living. To carry out this task, it is necessary steadily to improve political and economic work, continuously to improve the methods of economic management and to run the socialist economy along scientific lines. This calls for higher productivity of labour to be achieved through continuous technical progress, economic planning, strict observance of the Leninist principle of providing material incentives and moral stimuli to work for the good of society by heightening the political consciousness of the people, and for control over the measure of labour and consumption.

To provide a material basis for the transition of the socialist countries to communism, it is indispensable to achieve a high level of production through the use of the latest techniques, electrification of the national economy, and mechanisation and automation of production, without which it is impossible to provide the abundance of consumer goods required by a communist society. On this basis, it is necessary to develop communist social relations, vigorously promote the political consciousness of the people and educate the members of the new, communist society.

The socialist camp is a social, economic and political community of free and sovereign peoples united by the close bonds of international socialist solidarity; by common interests and objectives, and following the path of socialism and communism. It is an inviolable law of the mutual relations between socialist countries strictly to adhere to the principles of Marxism-Leninism and socialist internationalism. Every country in the socialist camp is ensured genuinely equal rights and independence. Guided by the principles of complete equality, mutual advantage and comradely mutual assistance, the socialist states improve their all-round economic, political and cultural co-operation, which meets both the interests of each socialist country and those of the socialist camp as a whole.

One of the greatest achievements of the world socialist system is the practical confirmation of the Marxist-Leninist thesis that national antagonisms diminish with the decline of class antagonisms. In contrast to the laws of the capitalist system, which is characterised by antagonistic contradictions between classes, nations and states leading to armed conflicts, there are no objective causes in the nature of the socialist system for contradictions and conflicts between the peoples and states belonging to it. Its development leads to greater unity among the states and nations and to the consolidation of all the forms of co-operation between them. Under

socialism, the development of national economy, culture and statehood goes hand in hand with the strengthening and development of the entire world socialist system, and with an ever greater consolidation of the unity of nations. The interests of the socialist system as a whole and national interests are harmoniously combined. It is on this basis that the moral and political unity of all the peoples of the great socialist community has arisen and has been growing. Fraternal friendship and mutual assistance of peoples, born of the socialist system, have superseded the political isolation and national egoism typical of capitalism.

The common interests of the peoples of the socialist countries and the interests of peace and socialism demand the proper combination of the principles of socialist internationalism and socialist patriotism in politics. Every Communist Party which has become the ruling party in the state, bears historical responsibility for the destinies of both its country and the entire socialist camp.

The Declaration of 1957 points out quite correctly that undue emphasis on the role of national peculiarities and departure from the universal truth of Marxism-Leninism regarding the socialist revolution and socialist construction prejudice the common cause of socialism. The Declaration also states quite correctly that Marxism-Leninism demands creative application of the general principles of socialist revolution and socialist construction depending on the specific historical conditions in the country concerned, and does not permit of a mechanical copying of the policies and tactics of the Communist Parties of other countries. Disregard of national peculiarities may lead to the party of the proletariat being isolated from reality, from the masses, and may injure the socialist cause.

Manifestations of nationalism and national narrow-mindedness do not disappear automatically with the establishment of the socialist system. If fraternal relations and friendship between the socialist countries are to be strengthened, it is necessary that the Communist and Workers' Parties pursue a Marxist-Leninist internationalist policy, that all working people be educated in a spirit of internationalism and patriotism, and that a resolute struggle be waged to eliminate the survivals of bourgeois nationalism and chauvinism.

The Communist and Workers' Parties tirelessly educate the working people in the spirit of socialist internationalism and intolerance of all manifestations of nationalism and chauvinism. Solid unity of the Communist and Workers' Parties and of the peoples of the socialist countries, and their loyalty to the Marxist-Leninist doctrine are the main source of the strength and invincibility of each socialist country and the socialist camp as a whole.

In blazing a trail to communism, the peoples of the socialist countries are creating a prototype of a new society for all mankind. The working people of the capitalist world are following the constructive effort of the builders of socialism and communism with keen interest. This makes the Marxist-Leninist Parties and the peoples of the socialist countries accountable to the international working-class movement for the successful building of socialism and communism.

The Communist and Workers' Parties see it as their task indefatigably to strengthen the great socialist community of nations, whose international role and influence on the course of world events are growing from year to year.

The time has come when the socialist states have, by forming a world system, become an international force exerting a powerful influence on

186

world development. There are now real opportunities of solving cardinal problems of modern times in a new way, in the interests of peace, democracy and socialism.

III

The problem of war and peace is the most burning problem of our time.

War is a constant companion of capitalism. The system of exploitation of man by man and the system of extermination of man by man are two aspects of the capitalist system. Imperialism has already inflicted two devastating world wars on mankind and now threatens to plunge it into an even more terrible catastrophe. Monstrous means of mass annihilation and destruction have been developed which, if used in a new war, can cause unheard-of destruction to entire countries and reduce key centres of world industry and culture to ruins. Such a war would bring death and suffering to hundreds of millions of people, among them people in countries not involved in it. Imperialism spells grave danger to the whole of mankind.

The peoples must now be more vigilant than ever. As long as imperialism exists there will be soil for wars of aggression.

The peoples of all countries know that the danger of a new world war still persists. U.S. imperialism is the main force of aggression and war. Its policy embodies the ideology of militant reaction. The U.S. imperialists, together with the imperialists of Britain, France and West Germany, have drawn many countries into NATO, CENTO, SEATO and other military blocs under the guise of combating the "communist menace"; it has enmeshed the so-called "free world", that is, capitalist countries which depend on them, in a network of military bases spearheaded first and foremost against the socialist countries. The existence of these blocs and bases endangers universal peace and security and not only encroaches upon the sovereignty but also imperils the very life of those countries which put their territory at the disposal of the U.S. militarists.

The imperialist forces of the U.S.A., Britain and France have made a criminal deal with West-German imperialism. In West Germany militarism has been revived and the restoration is being pushed ahead of a vast regular army under the command of Hitler generals, which the U.S. imperialists are equipping with nuclear and rocket weapons and other modern means of mass annihilation, a fact which draws emphatic protests from the peace-loving peoples. Military bases are being provided for this aggressive army in France and other West-European countries. The threat to peace and the security of the European nations from West-German imperialism is increasing. The West-German revenge-seekers openly declare their intention to revise the borders established after the Second World War. Like the Hitler clique in its day, the West-German militarists are preparing war against the socialist and other countries of Europe, and strive to effect their own aggressive plans. West Berlin has been transformed into a seat of international provocation. The Bonn state has become the chief enemy of peaceful coexistence, disarmament and relaxation of tension in Europe.

The aggressive plans of the West-German imperialists must be opposed by the united might of all the peace-loving countries and nations of Europe. An especially big part in the struggle against the aggressive designs of the West-German militarists is played by the German Democratic Republic. The Meeting regards it as the duty of all the countries of the socialist camp

and of all the peace-loving peoples to defend the German Democratic Republic—the outpost of socialism in Western Europe and the true expression of the peace aspirations of the German nation.

The U.S. imperialists are also busy reviving the hotbed of war in the Far East. Trampling upon the national independence of the Japanese people and contrary to their will, they have, in collusion with the Japanese reactionary ruling circles, imposed upon Japan a new military treaty which pursues aggressive aims against the Soviet Union, the Chinese People's Republic and other peace-loving countries. The U.S. invaders have occupied the island of Taiwan, which belongs to the Chinese People's Republic, and South Korea and are interfering more and more in the affairs of South Viet-Nam; they have turned them into hotbeds of dangerous military provocations and gambles. Threatening Cuba with aggression and interfering in the affairs of the peoples of Latin America, Africa and the Middle East, the U.S. imperialists strive to create new seats of war in different parts of the world. They use such forms of regional alliance as, for example, the Organisation of American States, to retain their economic and political control and to involve the peoples of Latin America in the realisation of their aggressive schemes.

The U.S. imperialists have set up a huge war machinery and refuse to allow its reduction. The imperialists frustrate all constructive disarmament proposals by the Soviet Union and other peaceful countries. The arms race is going on. Stockpiles of nuclear weapons are becoming dangerously large. Defying protests from their own people and the peoples of other countries, particularly in the African continent, the French ruling circles are testing and manufacturing atomic weapons. The U.S. militarists are preparing to resume disastrous atomic tests; military provocations that threaten serious international conflicts continue.

The U.S. ruling circles have wrecked the Paris meeting of the Heads of Government of the four Great Powers by their policy of provocations and aggressive acts, and have set out to increase international tension and aggravate the cold war. The war menace has grown.

The imperialist provocations against peace have aroused the indignation and resistance of the peoples. U.S. imperialism has exposed itself still more and its influence in the world has sustained fresh and telling blows.

The aggressive nature of imperialism has not changed. But real forces have appeared that are capable of foiling its plans of aggression. War is not fatally inevitable. Had the imperialists been able to do what they wanted, they would already have plunged mankind into the abyss of the calamities and horrors of a new world war. But the time is past when the imperialists could decide at will whether there should or should not be war. More than once in the past years the imperialists have brought mankind to the brink of world catastrophe by starting local wars. The resolute stand of the Soviet Union, of the other socialist states and of all the peaceful forces put an end to the Anglo-Franco-Israeli intervention in Egypt, and averted a military invasion of Syria, Iraq and some other countries by the imperialists. The heroic people of Algeria continue their valiant battle for independence and freedom. The peoples of the Congo and Laos are resisting the criminal acts of the imperialists with increasing firmness. Experience shows that it is possible to combat effectively the local wars started by the imperialists, and to stamp out successfully the hotbeds of such wars.

The time has come when the attempts of the imperialist aggressors to start

a world war can be curbed. World war can be prevented by the joint efforts of the world socialist camp, the international working class, the national-liberation movement, all the countries opposing war and all peace-loving forces.

The development of international relations in our day is determined by the struggle of the two social systems—the struggle of the forces of socialism, peace and democracy against the forces of imperialism, reaction and aggression—a struggle in which the superiority of the forces of socialism, peace and democracy is becoming increasingly obvious.

For the first time in history, war is opposed by great and organised forces: the mighty Soviet Union, which now leads the world in the decisive branches of science and technology; the entire socialist camp, which has placed its great material and political might at the service of peace; a growing number of peace-loving countries of Asia, Africa and Latin America, which have a vital interest in preserving peace; the international working class and its organisations, above all the Communist Parties; the national-liberation movement of the peoples of the colonies and dependent countries; the world peace movement; and the neutral countries which want no share in the imperialist policy of war and advocate peaceful coexistence. The policy of peaceful coexistence is also favoured by a definite section of the bourgeoisie of the developed capitalist countries, which takes a sober view of the relationship of forces and of the dire consequences of a modern war. The broadest possible united front of peace supporters, fighters against the imperialist policy of aggression and war inspired by U.S. imperialism, is essential to preserve world peace. Concerted and vigorous actions of all the forces of peace can safeguard the peace and prevent a new war.

The democratic and peace forces today have no task more pressing than that of safeguarding humanity against a global thermo-nuclear disaster. The unprecedented destructive power of modern means of warfare demands that the main actions of the anti-war and peace-loving forces be directed towards preventing war. The struggle against war cannot be put off until war breaks out, for then it may prove too late for many areas of the globe and for their population to combat it. *The struggle against the threat of a new world war must be waged now and not when atom and hydrogen bombs begin to fall, and it must gain in strength from day to day. The important thing is to curb the aggressors in good time, to prevent war, and not to let it break out.*

To fight for peace today means to maintain the greatest vigilance, indefatigably to lay bare the policy of the imperialists, to keep a watchful eye on the intrigues and manoeuvres of the warmongers, arouse the righteous indignation of the peoples against those who are heading for war, organise the peace forces still better, continuously intensify mass actions for peace, and promote co-operation with all countries which have no interest in new wars. In the countries where the imperialists have established war bases, it is necessary to step up the struggle for their abolition, which is an important factor for fortifying national independence, defending sovereignty, and preventing war. The struggle of the peoples against the militarisation of their countries should be combined with the struggle against the capitalist monopolies connected with the U.S. imperialists. Today as never before, it is important to fight perseveringly in all countries to make the peace movement thrive and extend to towns and villages, factories and offices.

The peace movement is the broadest movement of our time, involving people of diverse political and religious creeds, of diverse classes of society,

who are all united by the noble urge to prevent new wars and to secure enduring peace.

Further consolidation of the world socialist system will be of prime importance in preserving durable peace. So long as there is no disarmament, the socialist countries must maintain their defence potential at an adequate level.

In the opinion of Communists the tasks which must be accomplished first of all if peace is to be safeguarded are to stop the arms race, ban nuclear weapons, their tests and production, dismantle foreign war bases and withdraw foreign troops from other countries, disband military blocs, conclude a peace treaty with Germany, turn West Berlin into a demilitarised free city, thwart the aggressive designs of the West-German revanchists, and prevent the revival of Japanese militarism.

History has placed a great responsibility for warding off a new world war first and foremost on the international working class. The imperialists plot and join forces to start a thermo-nuclear war. The international working class must close its ranks to save mankind from the disaster of a new world war. *No political, religious or other differences should be an obstacle to all the forces of the working class uniting against the war danger. The hour has struck to counter the forces of war by the mighty will and joint action of all the contingents and organisations of the world proletariat, to unite its forces to avert world war and safeguard peace.*

The Communist Parties regard the fight for peace as their prime task. They call on the working class, trade unions, co-operatives, women's and youth leagues and organisations, on all working people, irrespective of their political and religious convictions, firmly to repulse by mass struggles all acts of aggression on the part of the imperialists.

But should the imperialist maniacs start war, the peoples will sweep capitalism out of existence and bury it.

The foreign policy of the socialist countries rests on the firm foundation of the Leninist principle of peaceful coexistence and economic competition between the socialist and capitalist countries. In conditions of peace, the socialist system increasingly reveals its advantages over the capitalist system in all fields of economy, culture, science and technology. The near future will bring the forces of peace and socialism new successes. The U.S.S.R. will become the leading industrial power of the world. China will become a mighty industrial state. The socialist system will be turning out more than half the world industrial product. The peace zone will expand. The working-class movement in the capitalist countries and the national-liberation movement in the colonies and dependencies will achieve new victories. The disintegration of the colonial system will become completed. The superiority of the forces of socialism and peace will be absolute. *In these conditions a real possibility will have arisen to exclude world war from the life of society even before socialism achieves complete victory on earth, with capitalism still existing in a part of the world.* The victory of socialism all over the world will completely remove the social and national causes of wars.

The Communists of all the world uphold peaceful coexistence unanimously and consistently, and battle resolutely for the prevention of war. The Communists must work untiringly among the masses to prevent underestimation of the possibility of averting a world war, underestimation of the possibility of peaceful coexistence and, at the same time, underestimation of the danger of war.

In a world divided into two systems, the only correct and reasonable principle of international relations is the principle of peaceful coexistence of states with different social systems advanced by Lenin and further elaborated in the Moscow Declaration and the Peace Manifesto of 1957, in the decisions of the 20th and 21st Congresses of the C.P.S.U., and in the documents of other Communist and Workers' Parties.

The Five Principles jointly advanced by the Chinese People's Republic and the Republic of India, and the propositions adopted at the Bandung Conference accord with the interests of peace and the peace-loving peoples.

Peaceful coexistence of countries with different systems or destructive war —this is the alternative today. There is no other choice. Communists emphatically reject the U.S. doctrine of " cold war " and " brinkmanship ", for it is a policy leading to thermo-nuclear catastrophe. By upholding the principle of peaceful coexistence, Communists fight for the complete cessation of the cold war, disbandment of military blocs, and dismantling of military bases, for general and complete disarmament under international control, the settlement of international disputes through negotiation, respect for the equality of states and their territorial integrity, independence and sovereignty, non-interference in each other's internal affairs, extensive development of trade, cultural and scientific ties between nations.

The policy of peaceful coexistence meets the basic interests of all peoples, of all who want no new cruel wars and seek durable peace. This policy strengthens the positions of socialism, enhances the prestige and international influence of the socialist countries and promotes the prestige and influence of the Communist Parties in the capitalist countries. Peace is a loyal ally of socialism, for time is working for socialism against capitalism.

The policy of peaceful coexistence meets the basic interests of all peoples, launching vigorous action against the enemies of peace. Peaceful coexistence of states does not imply renunciation of the class struggle as the revisionists claim. The coexistence of states with different social systems is a form of class struggle between socialism and capitalism. In conditions of peaceful coexistence favourable opportunities are provided for the development of the class struggle in the capitalist countries and the national-liberation movement of the peoples of the colonial and dependent countries. In their turn, the successes of the revolutionary class and national-liberation struggle promote peaceful coexistence. The Communists consider it their duty to fortify the faith of the people in the possibility of furthering peaceful coexistence, their determination to prevent world war. They will do their utmost for the people to weaken imperialism and limit its sphere of action by an active struggle for peace, democracy and national liberation.

Peaceful coexistence of countries with different social systems does not mean conciliation of the socialist and bourgeois ideologies. On the contrary, it implies intensification of the struggle of the working class, of all the Communist Parties, for the triumph of socialist ideas. But ideological and political disputes between states must not be settled through war.

The meeting considers that the implementation of the programme for general and complete disarmament put forward by the Soviet Union would be of historic importance for the destinies of mankind. To realise this programme means to eliminate the very possibility of waging wars between countries. It is not easy to realise owing to the stubborn resistance of the imperialists. Hence it is essential to wage an active and determined struggle against the aggressive imperialist forces with the aim of carrying this

programme into practice. It is necessary to wage this struggle on an increasing scale and to strive perseveringly to achieve tangible results—the banning of the testing and manufacture of nuclear weapons, the abolition of military blocs and war bases on foreign soil and a substantial reduction of armed forces and armaments, all of which should pave the way to general disarmament. Through an active, determined struggle by the socialist and other peace-loving countries, by the international working class and the broad masses in all countries, it is possible to isolate the aggressive circles, foil the arms race and war preparations, and force the imperialists into an agreement on general disarmament.

The arms race is not a war-deterrent, nor does it make for a high degree of employment and well-being of the population. It leads to war. Only a handful of monopolies and war speculators are interested in the arms race. In the capitalist countries, the people constantly demand that military expenditures be reduced and the funds thus released be used to improve the living conditions of the masses. In each country, it is necessary to promote a broad mass movement, for the use of the funds and resources to be released through disarmament for the needs of civilian production, housing, health, public education, social security, scientific research, etc. Disarmament has now become a fighting slogan of the masses, a pressing historical necessity. By an active and resolute struggle the imperialists must be made to meet this demand of the peoples.

The Communist and Workers' Parties of the socialist countries will go on consistently pursuing the policy of peaceful coexistence of states with different social systems and doing their utmost to spare the peoples the horrors and calamities of a new war. They will display the greatest vigilance towards imperialism, vigorously strengthen the might and defensive capacity of the entire socialist camp and take every step to safeguard the security of the peoples and preserve peace.

The Communists regard it as their historical mission not only to abolish exploitation and poverty on a world scale and rule out for all time the possibility of any kind of war in the life of human society, but also to deliver mankind from the nightmare of a new world war already in our time. The Communist Parties will devote all their strength and energy to this great historical mission.

IV

National-liberation revolutions have triumphed in vast areas of the world. About forty new sovereign states have arisen in Asia and Africa in the fifteen post-war years. The victory of the Cuban revolution has powerfully stimulated the struggle of the Latin-American peoples for complete national independence. A new historical period has set in in the life of mankind: the peoples of Asia, Africa and Latin America that have won their freedom have begun to take an active part in world politics.

The complete collapse of colonialism is imminent. The breakdown of the system of colonial slavery under the impact of the national-liberation movement is a development ranking second in historic importance only to the formation of the world socialist system.

The Great October Socialist Revolution aroused the East and drew the colonial peoples into the common current of the world-wide revolutionary movement. This development was greatly facilitated by the Soviet Union's victory in the Second World War, the establishment of people's democracy

in a number of European and Asian countries, the triumph of the socialist revolution in China, and the formation of the world socialist system. The forces of world socialism contributed decisively to the struggle of the colonial and dependent peoples for liberation from imperialist oppression. The socialist system has become a reliable shield for the independent national development of the peoples who have won freedom. The national-liberation movement receives powerful support from the international working-class movement.

The face of Asia has changed radically. The colonial order is collapsing in Africa. A front of active struggle against imperialism has opened in Latin America. Hundreds of millions of people in Asia, Africa and other parts of the world have won their independence in hard-fought battles with imperialism. Communists have always recognised the progressive, revolutionary significance of national-liberation wars; they are the most active champions of national independence. The existence of the world socialist system and the weakening of the positions of imperialism have provided the oppressed peoples with new opportunities of winning independence.

The peoples of the colonial countries win their independence both through armed struggle and by non-military methods, depending on the specific conditions in the country concerned. They secure durable victory through a powerful national-liberation movement. The colonial powers never bestow freedom on the colonial peoples and never leave of their own free will the countries they are exploiting.

The United States is the mainstay of colonialism today. The imperialists, headed by the U.S.A., make desperate efforts to preserve colonial exploitation of the peoples of the former colonies by new methods and in new forms. The monopolies try to retain their hold on the levers of economic control and political influence in Asian, African and Latin American countries. These efforts are aimed at preserving their positions in the economy of the countries which have gained freedom, and at capturing new positions under the guise of economic " aid," drawing them into military blocs, implanting military dictatorships and setting up war bases there. The imperialists endeavour to emasculate and undermine the national sovereignty of the newly-free countries, to misrepresent the principle of self-determination of nations, to impose new forms of colonial domination under the spurious slogan of " inter-dependence," to put their puppets in power in these countries and bribe a section of the bourgeoisie. They resort to the poisoned weapon of national strife to undermine the young states that are not yet strong enough. They make ample use of aggressive military blocs and bilateral aggressive military alliances to achieve these ends. The imperialists' accomplices are the most reactionary sections of the local exploiting classes.

The urgent tasks of national rebirth facing the countries that have shaken off the colonial yoke cannot be effectively accomplished unless a determined struggle is waged against imperialism and the remnants of feudalism by all the patriotic forces of the nations united in a single national-democratic front. The national democratic tasks on the basis of which the progressive forces of the nation can and do unite in the countries which have won their freedom, are: the consolidation of political independence, the carrying out of agrarian reforms in the interest of the peasantry, elimination of the survivals of feudalism, the uprooting of imperialist economic domination, the restriction of foreign monopolies and their expulsion from the national economy, the creation and development of a national industry, improvement

of the living standard, the democratisation of social life, the pursuance of an independent and peaceful foreign policy, and the development of economic and cultural co-operation with the socialist and other friendly countries.

The working class, which has played an outstanding role in the fight for national liberation, demands the complete and consistent accomplishment of the tasks of the national, anti-imperialist, democratic revolution, and resists reactionary attempts to check social progress.

The solution of the peasant problem, which directly affects the interests of the vast majority of the population, is of the utmost importance to these countries. Without radical agrarian reforms it is impossible to solve the food problem and sweep away the remnants of medievalism which fetter the development of the productive forces in agriculture and industry. The creation and extension on a democratic basis of the state sector in the national economy, particularly in industry—a sector independent from foreign monopolies and gradually becoming a determining factor in the country's economy—is of great importance in these countries.

The alliance of the working class and the peasantry is the most important force in winning and defending national independence, accomplishing far-reaching democratic transformations and ensuring social progress. This alliance forms the basis of a broad national front. The extent to which the national bourgeoisie participates in the liberation struggle also depends to no small degree upon its strength and stability. A big role can be played by the national-patriotic forces, by all elements of the nation prepared to fight for national independence, against imperialism.

In present conditions, the national bourgeoisie of the colonial and dependent countries unconnected with imperialist circles, is objectively interested in the accomplishment of the principal tasks of anti-imperialist, anti-feudal revolution, and therefore can participate in the revolutionary struggle against imperialism and feudalism. In that sense it is progressive. But it is unstable; though progressive, it is inclined to compromise with imperialism and feudalism. Owing to its dual nature, the extent to which the national bourgeoisie participates in revolution differs from country to country. This depends on concrete conditions, on changes in the relationship of class forces, on the sharpness of the contradictions between imperialism, feudalism and the people, and of the contradictions between imperialism, feudalism and the national bourgeoisie.

After winning political independence the peoples seek solutions to the social problems raised by life and to the problems of reinforcing national independence. Different classes and parties offer different solutions. Which course of development to choose is the internal affair of the peoples themselves. As social contradictions grow the national bourgeoisie inclines more and more to compromising with domestic reaction and imperialism. The people, however, begin to see that the best way to abolish age-long backwardness and improve their living standard is that of non-capitalist development. Only thus can the peoples free themselves from exploitation, poverty and hunger. The working class and the broad peasant masses will play the leading part in solving this basic social problem.

In the present situation, favourable domestic and international conditions arise in many countries for the establishment of an independent national democracy, that is, a state which consistently upholds its political and economic independence, fights against imperialism and its military blocs, against military bases on its territory; a state which fights against the new

forms of colonialism and the penetration of imperialist capital; a state which rejects dictatorial and despotic methods of government; a state in which the people are ensured broad democratic rights and freedoms (freedom of speech, press, assembly, demonstrations, establishment of political parties and social organisations), the opportunity to work for the enactment of an agrarian reform and other domestic and social changes, and for participation in shaping government policy. The formation and consolidation of national democracies enables the countries concerned to make rapid social progress and play an active part in the people's struggle for peace, against the aggressive policies of the imperialist camp, for the complete abolition of colonial oppression.

The Communist Parties are working actively for a consistent completion of the anti-imperialist, anti-feudal, democratic revolution, for the establishment of national democracies, for a radical improvement in the living standard of the people. They support those actions of national governments leading to the consolidation of the gains achieved and undermining the imperialists' positions. At the same time they firmly oppose anti-democratic, anti-popular acts and those measures of the ruling circles which endanger national independence. Communists expose attempts by the reactionary section of the bourgeoisie to represent its selfish, narrow class interests as those of the entire nation. They expose the demagogic use by bourgeois politicians of socialist slogans for the same purpose. They work for a genuine democratisation of social life and rally all the progressive forces to combat despotic régimes or to curb tendencies towards setting up such régimes.

The aims of the Communists accord with the supreme interests of the nation. The reactionaries' effort to break up the national front under the slogan of "anti-communism" and isolate the Communists, the foremost contingent of the liberation movement, weakens the national movement. It is contrary to the national interests of the people and threatens the loss of national gains.

The socialist countries are true and sincere friends of the peoples fighting for liberation and of those who have thrown off the imperialist yoke. While rejecting on principle any interference in the internal affairs of young national states, they consider it their internationalist duty to help the peoples in strengthening their independence. They help and support these countries generously in achieving progress, creating a national industry, developing and consolidating the national economy and training national personnel. They co-operate with them in the struggle for world peace and against imperialist aggression.

The class-conscious workers of the colonial powers, who realised that " no nation can be free if it oppresses other nations," fought consistently for the self-determination of the nations oppressed by the imperialists. Now that these nations are taking the path of national independence, it is the internationalist duty of the workers and all democratic forces in the industrially developed capitalist countries to assist them vigorously in their struggle against the imperialists. It is their duty to assist them in their struggle for national independence and its consolidation, and in effectively solving the problems of their economic and cultural rebirth. In so doing, the workers defend the interests of the people of their own countries.

The entire course of the world history of recent decades shows the need for the complete and final abolition of the colonial system in all its forms

and manifestations. All the peoples still languishing in colonial bondage must be given every support in winning their national independence. All forms of colonial oppression must be abolished. The abolition of colonialism will also be of great importance in easing international tension and consolidating universal peace. This Meeting expresses solidarity with all the peoples of Asia, Africa, Latin America and Oceania who are carrying on an heroic struggle against imperialism. The Meeting hails the peoples of the young states of Africa who have achieved political independence—an important step towards complete emancipation. The Meeting extends heartfelt greetings and support to the heroic Algerian people fighting for freedom and national independence, and demands an immediate cessation of the aggressive war against Algeria. It indignantly condemns the inhuman system of racial persecution and tyranny in the Union of South Africa (apartheid) and urges democrats throughout the world actively to support the peoples of South Africa in their struggle for freedom and equality. The Meeting demands non-interference in the sovereign rights of the peoples of Cuba, the Congo and all the other countries that have won their freedom.

All the socialist countries and the international working-class and Communist movement recognise their duty to render the fullest moral and material assistance to the peoples fighting to free themselves from imperialist and colonial tyranny.

V

The new balance of world forces offers the Communist and Workers' Parties new opportunities of carrying out the historic tasks they face in the struggle for peace, national independence, democracy and socialism.

The Communist Parties decide on the prospects and tasks of revolution according to the concrete historical and social conditions in their respective countries and with due regard to the international situation. They are waging a selfless struggle, doing everything already in present conditions, without waiting until socialism triumphs, to defend the interests of the working class and the people, improve their living conditions and extend the democratic rights and freedoms of the people. Knowing that the brunt of the struggle for the liberation of its people from capitalist oppression rests upon it, the working class and its revolutionary vanguard will with increasing energy press forward its offensive against the domination of oppressors and exploiters in every field of political, economic and ideological activity in each country. In the process of this struggle, the people are prepared and conditions arise for decisive battles for the overthrow of capitalism, for the victory of socialist revolution.

The main blow in present conditions is directed with growing force at the capitalist monopolies, which are chiefly responsible for the arms race and which constitute the bulwark of reaction and aggression. It is directed at the whole system of state-monopoly capitalism, which defends monopoly interests.

In some non-European developed capitalist countries which are under the political, economic and military domination of U.S. imperialism, the working class and the people direct the main blow against U.S. imperialist domination, and also against monopoly capital and other domestic reactionary forces that betray the interests of the nation. In the course of this struggle all the democratic, patriotic forces of the nation come together in a united front fighting

for the victory of a revolution aimed at achieving genuine national independence and democracy, which create conditions for passing on to the tasks of socialist revolution.

The big monopolies encroach on the interests of the working class and the people in general all along the line. The exploitation of working people is gaining in intensity; so is the process in which the broad peasant masses are being ruined. At the same time, the difficulties experienced by the small and middle urban bourgeoisie are growing more acute. The oppression of the big monopolies is becoming increasingly heavier for all sections of the nation. As a result, the contradiction between the handful of monopoly capitalists and all sections of the people is now growing more pronounced, along with the sharpening of the basic class contraction of bourgeois society—that between labour and capital.

The monopolies seek to abolish, or cut down to a bare minimum, the democratic rights of the masses. The reign of open fascist terror continues in some countries. In a number of countries, fascisation is developing in new forms: dictatorial methods of government are combined with fictitious parliamentary practices, stripped of democratic content and purely formal in character. Many democratic organisations are outlawed and are compelled to go underground, while thousands of fighters for the working-class cause and champions of peace are in prison.

On behalf of all the Communists of the world, this Meeting expresses proletarian solidarity with the courageous sons and daughters of the working class and the fighters for democracy languishing behind prison bars in the U.S.A., Spain, Portugal, Japan, West Germany, Greece, Iran, Pakistan, the United Arab Republic, Jordan, Iraq, Argentina, Paraguay, the Dominican Republic, Mexico, the Union of South Africa, the Sudan and other countries. The Meeting urges launching a powerful world-wide campaign to secure the release of these champions of peace, national independence and democracy.

The working class, peasantry, intellectuals and the petty and middle urban bourgeoisie are vitally interested in the abolition of monopoly domination. Hence there are favourable conditions for rallying these forces.

Communists hold that this unity can be achieved on the basis of the struggle for peace, national independence, the protection and extension of democracy, nationalisation of the key branches of economy and democratisation of their management, the use of the entire economy for peaceful purposes in order to satisfy the needs of the population, implementation of radical agrarian reforms, improvement of the living conditions of the working people, protection of the interests of the peasantry and the small and middle urban bourgeoisie against the tyranny of the monopolies.

These measures would be an important step along the path of social progress and would meet the interests of the majority of the nation. All these measures are democratic by nature. They do not eliminate the exploitation of man by man. But if realised, they would limit the power of the monopolies, enhance the prestige and political weight of the working class in the country's affairs, help to isolate the most reactionary forces and facilitate the unification of all the progressive forces. As they participate in the fight for democratic reforms, large sections of the population come to realise the necessity of unity of action with the working class and become more active politically. It is the primary duty of the working class and its Communist vanguard to head the economic and political struggle of the people for

democratic reforms and the overthrow of the power of the monopolies, and assure its success.

Communists advocate general democratisation of the economic and social scene and of all the administrative, political and cultural organisations and institutions.

Communists regard the struggle for democracy as part of the struggle for socialism. In this struggle they continuously strengthen their bonds with the working people, increase their political consciousness, help them understand the tasks of the socialist revolution and realise the necessity of accomplishing it. This sets the Marxist-Leninist Parties completely apart from the reformists, who consider reforms within the framework of the capitalist system as the ultimate goal and deny the necessity of socialist revolution. Marxists-Leninists are firmly convinced that the peoples in the capitalist countries will in the course of their daily struggle ultimately come to understand that socialism alone is a real way out for them.

Now that more sections of the population are joining in an active class struggle, it is of the utmost importance that Communists should extend their work in trade unions and co-operatives, among the peasantry, the youth, the women, in sports organisations, and the unorganised sections of the population. There are new opportunities now to draw the younger generation into the struggle for peace and democracy, and for the great ideals of communism. Lenin's great behest—to go deeper among the masses, to work wherever there are masses, to strengthen the ties with the masses in order to lead them—must become a major task for every Communist Party.

The restoration of unity in the trade-union movement in countries where it is split, as well as on the international scale, is essential for increasing the role of the working class in political life and for the successful defence of its interests. The working people may belong to different trade unions, but they have common interests. Whenever different trade-union associations fought in common in the greatest class battles of recent years, they usually succeeded, precisely because of their unity, in winning the demands of the working people. The Communist Parties believe that there are real prerequisites for re-establishing trade-union unity, and will work perseveringly to bring it about. In those countries where no trade-union democracy exists in practice, the struggle for trade-union unity calls for continuous efforts aimed at achieving trade-union independence and recognition and observance of the trade-union rights of all working people without political or any other discrimination.

It is also essential to peace and social progress that the national and international unity of all the other mass democratic movements be restored Unity among the mass organisations may be achieved through joint action in the struggle for peace, national independence, the preservation and extension of democratic rights, the improvement of living conditions and the extension of the working people's social rights.

The decisive role in the struggle of the people of capitalist countries for the accomplishment of their tasks is played by the alliance of the working class and the working peasantry, which represents the main motive force of social revolution.

The split in the ranks of the working class, which the ruling classes, the Right-wing Social-Democratic leadership and reactionary trade-union leaders are interested to maintain on a national and international scale, remains the

principal obstacle to the achievement of the aims of the working class. Communists work resolutely to eliminate this split.

The imperialists and reactionaries in various countries resort, along with means of suppression, to methods of deception and bribery in order to divide and disrupt the solidarity of the working class. The events of the last few years have again confirmed that this division undermines the positions of the working class and is advantageous only to imperialist reaction.

Some Right-wing Social-Democratic leaders have openly adopted imperialist views, defend the capitalist system and divide the working class. Owing to their hostility to communism and their fear of the mounting influence of socialism in world affairs, they are capitulating to the reactionary, conservative forces. In some countries the Right-wing leadership has succeeded in making the Social-Democratic Parties adopt programmes in which they openly disowned Marxism, the class struggle and the traditional socialist slogans. Thereby they have again done a service to the bourgeoisie. Resistance to this policy of the Right-wing leaders is mounting in the Social-Democratic Parties. The opposition also includes a section of the Social-Democratic Party functionaries. The forces favouring joint action by the working class and other working people in the struggle for peace, democracy and social progress are growing. The overwhelming majority of the Social-Democratic Parties, particularly the workers, are friends of peace and social progress.

Communists will continue to criticise the ideological positions and Right-wing opportunist practices of the Social-Democrats. They will continue working to induce the Social-Democratic masses to adopt positions of consistent class struggle against capitalism, for the triumph of socialism. The Communists are firmly convinced that the ideological differences which exist between themselves and the Social-Democrats must not hinder exchanges of opinion on the pressing problems of the working-class movement and the joint struggle, especially against the war danger.

Communists regard Social-Democrats among the working people as their class brothers. They often work together in trade unions and other organisations, and fight jointly for the interests of the working class and the people as a whole.

The urgent interests of the working-class movement demand that the Communist and Social-Democratic Parties take joint action on a national and international scale to bring about the immediate prohibition of the manufacture, testing and use of nuclear weapons, the establishment of atom-free zones, general and complete disarmament under international control, the abolition of military bases on foreign soil and the withdrawal of foreign troops, to assist the national-liberation movement of the peoples of colonial and dependent countries, to safeguard national sovereignty, promote democracy and resist the fascist menace, improve the living standards of the working people, secure a shorter working week without wage cuts, etc. Millions of Social-Democrats and some Social-Democratic Parties have already in some form or another come out in favour of solving these problems. It is safe to say that *on overcoming the split in its ranks, on achieving unity of action of all its contingents, the working class of many capitalist countries could deliver a heavy blow to the policy of the ruling circles in the capitalist countries. It could make them stop preparing a new war, repel the offensive of monopoly capital, and have its daily vital and democratic demands met.*

In the struggle for the improvement of the living conditions of working people, the extension and preservation of their democratic rights, the achievement and defence of national independence, for peace among nations, and also in the struggle to win power and build socialism, the Communist Parties advocate co-operation with the Socialist Parties. The Communists have the great theory of Marxism-Leninism—a theory that is consistent, scientifically substantiated and borne out by life—and rich international experience in socialist construction. They are prepared to hold discussions with Social-Democrats, for they are certain that this is the best way to compare views, ideas and experience with the aim of removing deep-rooted prejudices and the division among the working people, and of establishing co-operation.

The imperialist reactionaries, who try to arouse distrust for the Communist movement and its ideology, continue to intimidate the people by alleging that the Communists need wars between states to overthrow the capitalist system and establish a socialist system. The Communist Parties emphatically reject this slander. The fact that both world wars, which were started by the imperialists, ended in socialist revolutions by no means implies that the way to social revolution is necessarily through world war, especially now that there exists a powerful world system of socialism. Marxists-Leninists have never considered that the way to social revolution lies through wars between states.

The choice of social system is the inalienable right of the people of each country. Socialist revolution cannot be imported, nor imposed from without. It is a result of the internal development of the country concerned, of the utmost sharpening of social contradictions in it. *The Communist Parties, which guide themselves by the Marxist-Leninist doctrine, have always been against the export of revolution. At the same time they fight resolutely against imperialist export of counter-revolution. They consider it their internationalist duty to call on the peoples of all countries to unite, to rally all their internal forces, to act vigorously and, relying on the might of the world socialist system, to prevent or firmly resist imperialist interference in the affairs of any people who have risen in revolution.*

The Marxist-Leninist Parties head the struggle of the working class and the working people, for the accomplishment of the socialist revolution and the establishment of the dictatorship of the proletariat in one form or another. The forms and course of development of the socialist revolution will depend on the specific balance of the class forces in the country concerned, on the organisation and maturity of the working class and its vanguard, and on the extent of the resistance put up by the ruling classes. Whatever form of dictatorship of the proletariat is established, it will always signify an extension of democracy, a transition from formal, bourgeois democracy to genuine democracy, to democracy for the working people.

The Communist Parties reaffirm the propositions put forward by the Declaration of 1957 on the forms of transition of different countries from capitalism to socialism.

The Declaration points out that the working class and its vanguard—the Marxist-Leninist Party—seek to achieve the socialist revolution by peaceful means. This would accord with the interests of the working class and the people as a whole, with the national interests of the country.

Today in a number of capitalist countries the working class, headed by its vanguard, has the opportunity, given a united working-class and popular front or other workable forms of agreement and political co-operation

between the different parties and public organisations, to unite a majority of the people, win state power without civil war and ensure the transfer of the basic means of production to the hands of the people. Relying on the majority of the people and resolutely rebuffing the opportunist elements incapable of relinquishing the policy of compromise with the capitalists and landlords, the working class can defeat the reactionary, anti-popular forces, secure a firm majority in parliament, transform parliament from an instrument serving the class interests of the bourgeoisie into an instrument serving the working people, launch an extra-parliamentary mass struggle, smash the resistance of the reactionary forces and create the necessary conditions for peaceful realisation of the socialist revolution. All this will be possible only by broad and ceaseless development of the class struggle of the workers, peasant masses and the urban middle strata against big monopoly capital, against reaction, for profound social reforms, for peace and socialism.

In the event of the exploiting classes resorting to violence against the people, the possibility of non-peaceful transition to socialism should be borne in mind. Leninism teaches, and experience confirms, that the ruling classes never relinquish power voluntarily. In this case the degree of bitterness and the forms of the class struggle will depend not so much on the proletariat as on the resistance put up by the reactionary circles to the will of the overwhelming majority of the people, on these circles using force at one or other stage of the struggle for socialism.

The actual possibility of the one or the other way of transition to socialism in each individual country depends on the concrete historical conditions.

In our time, when communism is not only the most advanced doctrine but a social system which actually exists and which has proved its superiority over capitalism, conditions are particularly favourable for expanding the influence of the Communist Parties, and vigorously exposing anti-communism—a slogan under which the capitalist class wages its struggle against the proletariat—and for winning the broadest sections of the working people for Communist ideas.

Anti-communism arose at the dawn of the working-class movement as the principal ideological weapon of the capitalist class in its struggle against the proletariat and Marxist ideology. As the class struggle grew in intensity, particularly with the formation of the world socialist system, anti-communism became more vicious and insidious. Anti-communism, which is indicative of the extreme decline of bourgeois ideology and of its deep ideological crisis, resorts to monstrous distortions of Marxist doctrine and crude slander against the socialist social system, presents Communist policies and objectives in a false light, and carries on a witch-hunt against the democratic peaceful forces and organisations.

Effectively to defend the interests of the working people, maintain peace and realise the socialist ideals of the working class, a resolute struggle must be waged against anti-communism—that poisoned weapon which the bourgeoisie uses to fence off the masses from socialism. A greater effort is required to explain the ideas of socialism to the working peoples, to educate them in a revolutionary spirit, and to develop their revolutionary class consciousness. It is necessary to show all working people the superiority of socialist society by referring to the experience of the countries of the world socialist system, demonstrating in concrete form the benefits which socialism will actually give to workers, peasants and other sections of the population in each country.

Communism assures people freedom from fear of war; it brings lasting peace, freedom from imperialist oppression and exploitation, and from unemployment and poverty. It leads to general prosperity and a high standard of living; freedom from fear of economic crises, and a rapid growth of the productive forces for the benefit of society as a whole. It frees the individual from the tyranny of the moneybag, and leads to the all-round spiritual development of man, the fullest development of talent and the unlimited scientific and cultural progress of society. All the sections of the population, with the exception of a handful of exploiters, stand to gain from the victory of the new social system, and this must be brought home to millions of people in the capitalist countries.

VI

The world Communist movement has become the most influential political force of our time, a most important factor in social progress. As it fights bitterly against imperialist reaction, for the interests of the working class and all working people, for peace, national independence, democracy and socialism, the Communist movement is making steady headway, is becoming consolidated and tempered.

There are now Communist Parties active in 87 countries of the world. Their total membership exceeds 36,000,000. This is a signal victory for Marxism-Leninism and a tremendous achievement of the working class. Like-minded Marxists are rallying in the countries which have shaken off colonial tyranny and taken the path of independent development. Communist Parties consider it their internationalist duty to promote friendship and solidarity between the working class of their countries and the working-class movement of the countries which have won their freedom in the common struggle against imperialism.

The growth of the Communist Parties and their organisational consolidation, the victories of the Communist Parties in a number of countries in the struggle against deviations, elimination of the harmful consequences of the personality cult, and the greater influence of the world Communist movement open new prospects for the successful accomplishment of the tasks facing the Communist Parties.

Marxist-Leninist Parties regard it as a law of their activity strictly to observe the Leninist standards of Party life in keeping with the principle of democratic centralism, and to cherish Party unity like the apple of their eye. They strictly adhere to the principle of Party democracy and collective leadership, for they attach, in keeping with the organisational principles of Leninism, great importance to the role of the leading party bodies in the life of the Party. They work indefatigably for the strengthening of their bonds with the Party membership and with the broad masses of the working people, and do not allow the cult of the individual, which shackles creative thought and initiative of Communists. They vigorously promote the activity of Communists, and encourage criticism and self-criticism in their ranks.

The Communist Parties have ideologically defeated the revisionists in their ranks who sought to divert them from the Marxist-Leninist path. Each Communist Party and the international Communist movement as a whole have become still stronger, ideologically and organisationally, in the struggle against revisionism, Right-wing opportunism.

The Communist Parties have unanimously condemned the Yugoslav variety of international opportunism, a variety of modern revisionist

" theories " in concentrated form. After betraying Marxism-Leninism, which they termed obsolete, the leaders of the League of Communists of Yugoslavia opposed their anti-Leninist revisionist programme to the Declaration of 1957; they set the L.C.Y. against the international Communist movement as a whole, severed their country from the socialist camp, made it dependent on so-called " aid " from U.S. and other imperialists, and thereby exposed the Yugoslav people to the danger of losing the revolutionary gains achieved through a heroic struggle. The Yugoslav revisionists carry on subversive work against the socialist camp and the world Communist movement. Under the pretext of being outside blocs, they engage in activities which prejudice the unity of all the peace-loving forces and countries. Further exposure of the leaders of Yugoslav revisionists and active struggle to safeguard the Communist movement and the working-class movement from the anti-Leninist ideas of the Yugoslav revisionists, remain an essential task of the Marxist-Leninist Parties.

The practical struggles of the working class and the entire course of social development have furnished a brilliant new proof of the great all-conquering power and vitality of Marxism-Leninism, and have thoroughly refuted all modern revisionist " theories."

The further development of the Communist and working-class movement calls as stated in the Moscow Declaration of 1957, for continuing a determined struggle on two fronts—against revisionism, which remains the main danger, and against dogmatism and sectarianism.

Revisionism, Right-wing opportunism, which mirrors bourgeois ideology in theory and practice, distorts Marxism-Leninism, robs it of its revolutionary spirit, and thereby paralyses the revolutionary will of the working class. It disarms and demobilises the workers and all working people, in their struggle against oppression by imperialists and exploiters, for peace, democracy and national-liberation, for the triumph of socialism.

Dogmatism and sectarianism in theory and practice can also become the main danger at some stage of development of individual parties, unless combated unrelentingly. They rob revolutionary parties of the ability to develop Marxism-Leninism through scientific analysis and apply it creatively according to the specific conditions. They isolate Communists from the broad masses of the working people, doom them to passive expectation or Leftist, adventurist actions in the revolutionary struggle. They prevent the Communist Parties from making a timely and correct estimate of the changing situation and of new experience and using all opportunities to bring about the victory of the working class and all democratic forces in the struggle against imperialism, reaction and the war danger. Thereby they prevent the peoples from achieving victory in their just struggle.

At a time when imperialist reaction is joining forces to fight communism it is particularly necessary to consolidate the world Communist movement. Unity and solidarity redouble the strength of our movement and provide a reliable guarantee that the great cause of communism will make victorious progress and all enemy attacks will be effectively repelled.

Communists throughout the world are united by the great doctrine of Marxism-Leninism and by the joint struggle for its realisation. The interests of the Communist movement require solidarity by every Communist Party in the observance of the estimates and conclusions on the common tasks in the struggle against imperialism, for peace, democracy and socialism, jointly reached by the fraternal Parties at their meetings.

The interests of the struggle for the working-class cause demand of each Communist Party and of the great army of Communists of all countries ever-closer unity of will and action. It is the supreme internationalist duty of every Marxist-Leninist Party to work continuously for greater unity in the world Communist movement.

A resolute defence of the unity of the world Communist movement on the principles of Marxism-Leninism and proletarian internationalism, and the prevention of any actions which may undermine that unity, are a necessary condition for victory in the struggle for national independence, democracy and peace, for the successful accomplishment of the tasks of the socialist revolution and of the building of socialism and communism. Violation of these principles would impair the forces of communism.

All the Marxist-Leninist Parties are independent and have equal rights; they shape their policies according to the specific conditions in their respective countries and in keeping with Marxist-Leninist principles, and support each other. The success of the working-class cause in any country is unthinkable without the internationalist solidarity of all Marxist-Leninist parties. Every party is responsible to the working class, to the working people of its country, to the international working-class and Communist movement as a whole.

The Communist and Workers' Parties hold meetings whenever necessary to discuss urgent problems, to share experiences, acquaint themselves with each other's views and positions, work out common views through consultations and co-ordinate joint actions in the struggle for common goals.

Whenever a Party wants to clear up questions relating to the activities of another fraternal Party, its leadership approaches the leadership of the Party concerned; if necessary, they hold meetings and consultations.

The experience and results of the meetings of representatives of the Communist Parties held in recent years, particularly the results of the two major meetings—that of November 1957 and this Meeting—show that in present-day conditions such meetings are an effective form of exchanging views and experience, enriching Marxist-Leninist theory by collective effort and elaborating a common attitude in the struggle for common objectives.

The Communist and Workers' Parties unanimously declare that the Communist Party of the Soviet Union has been, and remains, the universally recognised vanguard of the world Communist movement, being the most experienced and steeled contingent of the international Communist movement. The experience which the C.P.S.U. has gained in the struggle for the victory of the working class, in socialist construction and in the full-scale construction of communism, is of fundamental significance for the whole of the world Communist movement. The example of the C.P.S.U. and its fraternal solidarity inspire all the Communist Parties in their struggle for peace and socialism, and represent the revolutionary principles of proletarian internationalism applied in practice. The historic decisions of the 20th Congress of the C.P.S.U. are not only of great importance for the C.P.S.U. and communist construction in the U.S.S.R., but have initiated a new stage in the world Communist movement, and have promoted its development on the basis of Marxism-Leninism.

All Communist and Workers' Parties contribute to the development of the great theory of Marxism-Leninism. Mutual assistance and support in relations between all the fraternal Marxist-Leninist Parties embody the revolutionary principles of proletarian internationalism applied in practice.

Ideological issues are of especial significance today. The exploiting class tries to counteract the achievements of socialism by exerting ever greater ideological pressure on the people as it seeks to keep them in spiritual bondage to bourgeois ideology. Communists regard it as their task to launch a determined offensive on the ideological front, to work to free the people from the shackles of all types and forms of bourgeois ideology, including the pernicious influence of reformism, and to disseminate among the people progressive ideas making for social advancement, the ideas of democracy and freedom, the ideology of scientific socialism.

Historical experience shows that the survivals of capitalism in the minds of people persist over a long period even after the establishment of a socialist system. This demands extensive work by the Party for the Communist education of the people and a better Marxist-Leninist training of Party and government cadres.

Marxism-Leninism is a great integral revolutionary doctrine, the guiding light of the working class and working people of the whole world at all stages of their great battle for peace, freedom and a better life, for the establishment of the most just society, communism. Its great creative, revolutionising power lies in its unbreakable link with life, in its continuous enrichment through a comprehensive analysis of reality. On the basis of Marxism-Leninism, the community of socialist countries and the international Communist, working-class and liberation movements have achieved great historic successes, and it is only on its basis that all the tasks facing the Communist and Workers' Parties can be effectively accomplished.

The meeting sees the further consolidation of the Communist Parties on the basis of Marxism-Leninism, of proletarian internationalism, as a primary condition for the unification of all working-class, democratic and progressive forces, as a guarantee of new victories in the great struggle waged by the world Communist and working-class movement for a happy future for the whole of mankind, for the triumph of the cause of peace and socialism.

[Text as published in *World Marxist Review*, December 1960.]

9. Soviet and Chinese Interpretations of the Statement

ON the conclusion of the Moscow conference, Liu Shao-ch'i and some members of the Chinese delegation made a short good-will tour of the Soviet Union, going to Minsk and Kiev. The tour underlined the fact that the major agreement reached at the Moscow conference was on the continuing imperative need for unity between the major powers of the Communist *bloc*. Both Mr. Khrushchev in his report on the conference and the Chinese central committee in its resolution on it went out of their way to stress the strength of Sino-Soviet friendship, providing a classic case of protesting too much.[25]

Mr. Khrushchev's report was far longer and more informative than the Chinese resolution. He elaborated on a number of points on which the Russians had got their way in Moscow. He spelled out the meaning of a nuclear disaster, using estimates of casualties made by Dr. Linus Pauling which, though he did not admit this, referred to the Soviet Union as well as to America and the West. He went into greater detail than the declaration in asserting that war was unnecessary for the spread of Communism, rejecting the idea that because the First and Second World Wars led to the spread of Communism world war was an indispensable condition for Communist success. This might well have been a rejoinder to Mao's publicly expressed belief, not that world war was indispensable to the spread of Communism, but that just as the First and Second World Wars had led to the spread of Communism, so a third world war would contribute even more to its final triumph.[26]

Mr. Khrushchev's modification of the virulent anti-Americanism of the Statement has been described above.[27] Suffice it to add that his reassertion of the existence of " saner " *representatives* of the Western *ruling*

[25] Mr. Khrushchev admitted the existence of "some shortcomings and rough edges" in intra-*bloc* relations.

[26] Mao Tse-tung, "On the Correct Handling of Contradictions among the People," *Jen-min Shou-ts'e (People's Handbook), 1958* (Peking: *Ta Kung Pao*), p. 19. In the Statement, the Russians subscribed to the ritual assertion that if imperialism launched a new war it would be wiped out, but to my knowledge they have not in recent years inferred the probable results of a third world war from those of World Wars One and Two in Mao's complacent manner. Khrushchev repeated this ritual assertion but added significantly that the working class would be the first to suffer in the event of war. According to Crankshaw's account, the Chinese argued in Moscow that war was necessary: (*Observer*, February 12).

[27] See above, p. 33.

classes with whom peaceful coexistence could be agreed was a justification for negotiation with the new American administration far clearer than the Statement's admission that "a definite section of the bourgeoisie" in the West feared war; the latter analysis could be taken to refer to the people at large and not to their leaders.

The importance of Mr. Khrushchev's elaboration of the concept of wars of national liberation has also been discussed above.[28] It should be added that Mr. Khrushchev did not mention the national liberation movement when stating why world war could now be prevented, though in the section on the movement he described it as "strengthening peace." Mr. Khrushchev justifies at some length his aid to the non-Communist leaderships of newly independent countries on the grounds that combination with all possible allies "no matter if inconsistent, shaky and unstable" is essential in the anti-imperialist struggle.[29]

The Chinese resolution emphasises all the strongest anti-imperialist points in the Statement, repeating the description of America as the "world gendarme" which Khrushchev had omitted. It listed the national liberation movement as one of the forces helping to prevent war. There is no mention of "saner" representatives or even sections of the bourgeoisie. Nor does the resolution repeat Khrushchev's *Twenty-first* Congress formulation on the prevention of world war, albeit the Chinese delegation had subscribed to it in the Statement.

The conclusion to be reached on the basis of these interpretations of the Statement is that there is no *documentary* evidence so far that the Moscow conference solved the basic disagreements between Russia and China. Both sides, it seems, will interpret the Statement in accordance with their previous policy predilections rather than on the basis of a new global policy hammered out in conclave.

Khrushchev's Report on the Moscow Conference

Now that a socialist world system has taken shape and with anti-imperialist, national-liberation revolutions in full flood, it is necessary to determine the further course and perspective of world development. This cannot be done without a profound understanding of the essence, content and nature of the decisive tasks of the present epoch.

The question of the character of the epoch is not an abstract, purely theoretical question. Inseparably linked with it are the general strategy and tactics of world communism and of each communist party. . . .

The statement adopted by the meeting defines the epoch in these terms:

"Our times, the basic content of which is the transition from capitalism to socialism initiated by the great October Socialist Revolution, are times of struggle between the two opposed social systems, times of socialist revolutions and national-liberation revolutions, of the breakdown of imperialism, of the

[28] pp. 33–34.
[29] For a discussion of other aspects of Mr. Khrushchev's report, see above, pp. 33–34.

abolition of the colonial system, times of the transition of more peoples to the socialist path, of the triumph of socialism and communism on a world-wide scale."

This definition of the character of the present epoch can be regarded as an example of a creative, genuinely scientific solution of an important and responsible task. . . .

In defining the essence and character of the present epoch as a whole, it is absolutely essential that we should be clear about the main peculiarities and distinguishing features of its present stage. The post-October period, seen from the point of view of it basic motive forces, is clearly divided into two stages. One of these began with the victory of the October Revolution. It was, to use Lenin's phrase, the period of establishing and developing the national dictatorship of the proletariat, that is, the dictatorship of the proletariat within the national bounds of Russia alone.

Although right from its inception the Soviet Union began to exert a very great influence on international affairs, imperialism had largely determined the course and character of international relations. But even in those early days it proved incapable of crushing the Soviet Union, of preventing it from becoming a mighty industrial power, the bulwark of progress and civilisation a centre of attraction for all the forces fighting against imperialist oppression and fascist enslavement.

The second stage in the development of the contemporary epoch dates from the rise of the socialist world system. This was a revolutionary process of historic significance. The October Revolution broke the first link in the imperialist chain. After this the chain was broken in a number of places. In the past we used to speak about the breaking of one or more links in the imperialist chain, but at present an all-embracing chain of imperialism no longer exists. The dictatorship of the working class has emerged beyond the confines of one country and become an international force. Imperialism has lost not only the countries where socialism has triumphed, it is rapidly losing nearly all its colonies. Naturally, as a result of these blows and losses, the general crisis of capitalism has become much more acute, and the balance of force in the world has changed radically in favour of socialism.

The main distinguishing feature of our time is the fact that the socialist world system is becoming the decisive factor in the development of human society. This finds direct expression also in the sphere of international relations. In the conditions of today socialism is in a position to determine, in growing measure, the character, methods and trends of international relations. This does not mean that imperialism is an " insignificant factor " which can be ignored. Not at all. Imperialism is still very strong. It controls a powerful military machine.

Now in peacetime imperialism has created a gigantic war machine and a ramified system of military blocs and has subordinated its economy to the arms drive. The U.S. imperialists, bent on bringing the whole world under their sway, are threatening mankind with missile-nuclear war. Modern imperialism is increasingly marked by decay and parasitism. In their evaluation of the prospects of international development, Marxist-Leninists do not, and must not, have any illusions with regard to imperialism.

The facts of the barefaced provocations and aggression on the part of the imperialists are countless. There is nothing new in this. What is new is that all the imperialist probings, in addition to being conclusively exposed,

are firmly repelled, and the attempts made by the imperialists to start local wars are being thwarted.

The present balance of world forces enables the socialist camp and the other peace forces for the first time in history to set themselves the entirely realistic task of forcing the imperialists to refrain, for fear of seeing their system destroyed, from starting a world war.

In connection with the possibility of preventing a world war, I should like to deal with the prospects of the further development of the general crisis of capitalism. It is common knowledge that both the First and Second World Wars greatly influenced the rise and aggravation of the general crisis of capitalism. Can it be inferred from this that world war is an indispensable condition for the further intensification of the general crisis of capitalism? Such an inference would be absolutely wrong, because it distorts the Marxist-Leninist theory of socialist revolution and inverts the true causes of revolution. A proletarian revolution is not caused solely by military cataclysms; first and foremost it is the result of the development of the class struggle and of the internal contradictions of capitalism. . . .

Having profoundly analysed the international situation as a whole, the meeting reached a conclusion of very great theoretical and political significance, namely that " *a new stage has begun in the development of the general crisis of capitalism.*" The feature of this new stage is that it originated, not in the conditions of a world war, but in the circumstances of competition and struggle between the two systems, of the ever-growing changes in the balance of forces in favour of socialism, and of pronounced aggravation of all the contradictions of imperialism, in the circumstances when the successful struggle of the peace supporters for peaceful co-existence has prevented the imperialists from wrecking world peace by their aggressive actions, in an atmosphere of rising struggle for democracy, national liberation and socialism by the masses. All this speaks of the further aggravation of the general crisis of capitalism.

Our militant comrades in the communist parties in the capitalist countries take cognisance of this when defining their further tactical line in the struggle for the working-class cause. And we can confidently say that the immediate future harbours new successes for the combined forces of world socialism, the working class and the national-liberation movement. . . .

Prospects for the World Socialist System

The countries of the socialist world system are drawing closer to each other; their co-operation in all fields of endeavour is growing. This is a natural development. There are no insoluble contradictions between the socialist countries. The more developed and economically stronger are rendering disinterested fraternal aid to those less developed. For instance, some 500 industrial enterprises and installations have been built in the fraternal socialist countries with Soviet help. Our loans and credits to these countries amount to 7,800 million roubles in the new currency. At the same time we are bound to acknowledge that the fraternal socialist countries are aiding in the development of the Soviet economy. . . .

The consolidation of the common economic base of the socialist world system and the creation of the material base for the more or less simultaneous transition of all the peoples of the socialist system to communism will be accelerated to the extent that the internal resources of each of the countries

and the advantages of the socialist international division of labour are fully utilised; this will result in evening up the various levels of economic development. . . .

The Communist and workers' parties have correctly defined in the spirit of Marxism-Leninism and proletarian internationalism, the principles governing the relations among the socialist countries and nations. It stands to reason that some shortcomings and rough edges are bound to appear in such a momentous undertaking. But the socialist community is characterised, not by incidental shortcomings, but by the essentially international nature of socialism, by the international policy of the fraternal parties and countries and the epoch-making successes achieved thanks to this policy. As to the shortcomings, we must remove them, guided by the principles of Marxism-Leninism, of international solidarity and fraternal friendship, seeing our main aim in consolidating the socialist camp. The Soviet Union has always sacredly fulfilled its international duty, putting the interests of the unity of the socialist countries and of the international Communist movement first. Our party will steadfastly adhere to this policy. . . .

Prevention of War is the Question of Questions

Wars arose with the division of society into classes. This means that the breeding ground of war will be completely abolished only when society will no longer be divided into hostile, antagonistic classes. With the victory of the working class throughout the world, with the triumph of socialism, which will destroy all the social and national causes giving rise to wars, mankind will be able to rid itself of this dreadful scourge.

In the present conditions we must distinguish the following kinds of war: world wars, local wars, and wars of liberation or popular uprisings. This is necessary in order to work out correct tactics in regard to each.

Let us begin with the problem of *world wars*. The Communists are the most resolute opponents of world wars, as they are of wars between countries in general. Only the imperialists need these wars in order to seize foreign territories and to enslave and plunder the peoples. Prior to the rise of the socialist world camp, the working class was unable to exert a decisive influence on the decision of the question whether there would or would not be a world war. In those circumstances the finest representatives of the working class advanced the slogan of turning an imperialist war into a civil war, that is, of the working class and all working people using the situation created by the war to take power. A situation of this kind set in during the First World War, and it was used in classical fashion by Lenin and the Bolshevik Party.

In our time the conditions are different. The socialist world camp with its powerful economy and armed forces exerts an ever-growing influence on the decision of questions of war and peace. To be sure, acute contradictions and antagonisms between the imperialist countries and the urge to profit at the expense of the weaker still exist. However, the imperialists are compelled to heed the Soviet Union and the entire socialist camp, and fear to start a war between themselves. They are trying to tone down their differences. They have formed military *blocs* and have entangled many capitalist countries in them. And although these *blocs* are torn by internal conflicts, their members are united, as they themselves admit, by their hatred of communism and, naturally, by the common nature and aspirations of the imperialists.

In the conditions of today the likelihood is that there will not be wars between the capitalist, imperialist countries, although this eventuality cannot be ruled out. The imperialists are preparing war chiefly against the socialist countries, above all against the Soviet Union, the most powerful of the socialist countries. They would like to sap our might and by so doing restore the one-time rule of monopoly capital.

The task is to raise insurmountable obstacles to the unleashing of war by the imperialists. Our possibilities for putting roadblocks in the way of the warmongers are growing, so much so that we can avert a world war. It stands to reason that we cannot completely exclude the possibility of war, since imperialist countries continue to exist, but it is now much more difficult for the imperialists to start a war than was the case heretofore, prior to the rise of the powerful socialist camp. The imperialists can start a war, but they cannot do so without giving thought to the consequences.

I have had occasion to say that if even Hitler had had an inkling that his reckless gamble would end in the way it did and that he would be forced to commit suicide, then in all probability he would have thought twice before starting the war against the Soviet Union. But at that time there were but two socialist countries—the Soviet Union and the Mongolian People's Republic. Yet we smashed the aggressors, and in doing so we made use also of the contradictions between the imperialist states.

Today the situation is entirely different. At present the imperialist camp is opposed by the socialist countries, and they are a mighty force. It would be wrong to underestimate the strength of the socialist camp, its influence on world developments and, consequently, on deciding the question whether there is to be war or not. Now that there is a mighty socialist camp with powerful armed forces, the peoples can undoubtedly prevent war and thus ensure peaceful co-existence provided they rally all their forces for active struggle against the bellicose imperialists.

Local Wars

Now about *local wars*. There is much talk in the imperialist camp today about local wars, and the imperialists are even making small-calibre atomic weapons to be used in such wars. There is even a special theory on local wars. Is this mere chance? Not at all. Some of the imperialist groups fear that a world war might end in complete destruction of capitalism, and for this reason they are banking on local wars.

There have been local wars in the past and they may break out again. But the chances of starting wars even of this kind are dwindling. A small-scale imperialist war, no matter which of the imperialists starts it, may develop into a world thermonuclear and missile war. We must, therefore, fight against both world war and against local wars.

An example of a local war started by the imperialists was the aggression of Britain, France and Israel against Egypt. They wanted to strangle Egypt and intimidate the other Arab countries fighting for their independence, to scare the peoples of Asia and Africa. When we were in London, British statesmen, Mr. Eden included, spoke to us quite frankly about their desire to settle accounts with Egypt. We told them plainly: " If you start a war, you will lose it, we will not be neutral." Eventually, when the war did break out, the United Nations formally condemned it, but this did not upset the aggressors; they went ahead with their dirty business and thought they

would soon reach their goal. The Soviet Union, and the socialist camp as a whole, came to the defence of Egypt. The stern warning which the Soviet Government gave to Eden and Guy Mollet stopped the war. A local war, the gamble in Egypt failed ignominiously.

That was in 1956 when the balance of forces between the socialist and imperialist countries was not quite as favourable to us as it is now. At that time we were not as powerful as we are today. Moreover, the rulers of Britain, France and Israel banked on profiting from the difficulties that had arisen in Hungary and Poland. Representatives of the imperialist countries whispered to us, "You have your difficulties in Hungary, we have ours in Egypt, so don't meddle in our affairs." But we told the whisperers what we thought of them. We refused to shut our eyes to their knavish acts. We intervened, and we frustrated their aggression.

There you have an example of how a local war, started by the imperialists, was nipped in the bud by the intervention of the Soviet Union and the entire socialist camp.

I have said that local wars may recur. It is our task, therefore, always to be on the alert, to summon to action the forces of the socialist camp, the people of the other countries and all peace-loving forces, in order to prevent wars of aggression. If the people of all countries are united and rallied, if they fight indefatigably and combine their forces both in each country and on an international scale, wars can be prevented.

National-Liberation Wars

Now about *national-liberation wars*. Recent examples of wars of this kind are the armed struggle waged by the people of Viet Nam or the present war of the Algerian people, which is now in its seventh year.

These wars, which began as uprisings of colonial peoples against their oppressors, developed into guerrilla wars.

There will be liberation wars as long as imperialism exists, as long as colonialism exists. Wars of this kind are revolutionary wars. Such wars are not only justified, they are inevitable, for the colonialists do not freely bestow independence on the peoples. The peoples win freedom and independence only through struggle, including armed struggle.

Why was it that the U.S. imperialists, who were eager to help the French colonialists, did not venture directly to intervene in the war in Viet Nam? They did not do so because they knew that if they gave France armed assistance, Viet Nam would receive the same kind of assistance from China, the Soviet Union and the other socialist countries, and that the fighting could develop into a world war. The outcome of the war is known—North Viet Nam won.

A similar war is being waged today in Algeria. What kind of a war is it? It is an uprising of Arab people against French colonialists. It has assumed the form of a guerrilla war. The imperialists of the U.S.A. and Britain are helping their French allies with arms. Moreover, they have allowed France, a party to N.A.T.O., to transfer troops from Europe to fight against the Algerian people. The people of Algeria, too, get help from neighbouring countries and others sympathising with their love of freedom. But this is a liberation war, a war of independence waged by the people. It is a sacred war. We recognise such wars; we have helped and shall continue to help peoples fighting for their freedom.

Or take Cuba. A war was fought there too. It began as an uprising against a tyrannical régime, backed by U.S. imperialism. Batista was a puppet of the United States and the United States helped him actively. However, the U.S.A. did not directly intervene with its armed forces in the Cuban war. Led by Fidel Castro, the people of Cuba won.

Is there the likelihood of such wars recurring? Yes, there is. Are uprisings of this kind likely to recur? Yes, they are. But wars of this kind are popular uprisings. Is there the likelihood of conditions in other countries reaching the point where the cup of the popular patience overflows and they take to arms? Yes, there is such a likelihood. What is the attitude of the Marxists to such uprisings? A most favourable attitude. These uprisings cannot be identified with wars between countries, with local wars, because the insurgent people are fighting for the right of self-determination, for their social and independent national development; these uprisings are directed against the corrupt reactionary regimes, against the colonialists. The Communists support just wars of this kind wholeheartedly and without reservations and they march in the van of the peoples fighting for liberation.

Comrades, mankind has arrived at the stage in history when it is in a position to solve problems that were too much for the previous generations. This applies also to the problem of all problems, that of preventing world war.

The working class, which today rules over a vast area of the world and in time will rule over all the world, cannot allow the forces doomed by history to bring down hundreds of millions into the grave with them. For a world war in the conditions of today would be waged with missiles and nuclear weapons, that is, it would be the most destructive war in all history.

Among the H-bombs already tested there are bombs each of which is several times more powerful than all the explosives used in the Second World War and, indeed, ever since man appeared on earth. Scientists have estimated that the explosion of a single H-bomb in an industrial area would kill up to 1,500,000 outright and bring death to another 400,000 through radiation. Even a medium hydrogen bomb would be enough to wipe out a large city. According to British scientists four megaton bombs, one each for London, Birmingham, Lancashire and Yorkshire, would kill at least 20 million. According to data supplied by U.S. experts to the Senate, the anticipated casualties in the United States in twenty-four hours of nuclear war would range from 50 to 75 million people. The American physicist Linus Pauling says that the areas likely to receive powerful nuclear blows are inhabited by a total of about a thousand million people and that 500 to 750 million people would be likely to perish within sixty days of a nuclear blow. Nor would nuclear war spare the people in the countries not directly subjected to the bombing; in particular, millions would die as a result of radiation.

We know that if the imperialist madmen were to begin a world war, the peoples would wipe out capitalism. But we are resolutely opposed to war, because we are concerned for the destinies of mankind, its present and its future. We know that the first to suffer in the event of war would be the working people and their vanguard—the working class.

We remember how Lenin put the question of the destiny of the working class. Just after the revolution, when the first country of the workers and peasants found itself besieged, he said, " If we can save the working man,

save the main productive force of society—the worker—we shall get everything back, but, should we fail to save him, we are lost. . . ." (*Collected Works*, Russ. ed., Vol. 29, pp. 334–335.)

There exists in the world today, not just one country of workers and peasants, but a whole system of socialist countries. It is our duty to safeguard peace and ensure the peaceful development of this grand creation of the international working class, to protect the peoples of all countries from a new war of annihilation. The victory of socialism on a world scale, inevitable by virtue of the laws of history, is no longer far off. War between countries is not needed for this victory.

A sober consideration of what a nuclear war implies is indispensable if we are to pursue a consistent policy of averting war and of mobilising the masses for the purpose of doing so. For the realisation by the masses of what a nuclear war means strengthens their resolve to fight against war. It is necessary, therefore, to warn the masses about the deadly consequences of a new world war and arouse their righteous wrath against those who are plotting this crime. The possibility of averting war is not a gift from heaven. Peace cannot be had by request. It can be secured only by an active, purposeful struggle. That is why we have been waging this struggle, and will continue to do so. . . .

Peaceful Coexistence

The policy of peaceful co-existence is, then, as far as its social content is concerned, a form of intense economic, political and ideological struggle between the proletariat and the aggressive forces of imperialism in the world arena.

The struggle against imperialism can succeed only if its aggressive actions are firmly resisted. Scolding will not halt the imperialist adventurers. There is only one way in which they can be curbed: steady strengthening of the economic, political and military power of the socialist countries, vigorous consolidation and reinforcement of the world revolutionary movement, mobilisation of the people for the struggle to avert war. . . .

When we call for a world without arms and without wars, we take into account, of course, that in the conditions of today, with two differing world social systems, there are forces in the imperialist camp, and fairly strong forces at that, who not only refuse to support this call, but who are waging a struggle against it.

The question of the struggle for communism is a class question. In the case of the struggle for peace, this is a question the solution of which can unite not only the working class, the peasantry and the petty bourgeoisie, but also that part of the bourgeoisie which sees the real danger of a thermonuclear war. . . .

Two trends can be observed in the policy of the capitalist camp in relation to the socialist countries—one bellicose and aggressive, the other moderate and sober. Lenin pointed to the need of establishing contacts with those circles of the bourgeoisie which gravitate towards pacifism, "be it even of the palest hue" (*Collected Works*, Russ. ed., Vol. 33, p. 236). In the struggle for peace, he said, we should not overlook also the saner representatives of the bourgeoisie.

The soundness of these words is confirmed by current events as well. Fear for the future of capitalism haunts the ruling classes of the imperialist

camp. The more reactionary circles are displaying a growing nervousness and tendency towards reckless practices and aggression, by means of which they hope to mend their fences. At the same time, there are also among the ruling circles of these countries those who know the danger of a new war to capitalism. Hence the two trends: one leaning towards war, the other towards accepting, in one way or another, the idea of peaceful co-existence.

The socialist countries take both of these trends into account in their policy. They work for negotiations and agreements with the capitalist countries on the basis of constructive proposals and promote personal contact between statesmen of the socialist and capitalist countries. Every opportunity should be used as before to expose the cold-war men, those who want to keep up the arms drive, and to convince the masses that the socialist countries really mean what they say in working to safeguard world peace. . . .

Abolition of Colonialism and the Newly-Independent Countries

We were glad to welcome at the Moscow meeting representatives from the fraternal Communist parties of the Asian, African and Latin American countries, staunch fighters for the independence and free development of the peoples. Today there are Communist parties in more than fifty countries of those continents. This has extended the sphere of influence of the Communist movement, making it truly world-wide. . . .

Lenin saw that task in encouraging the revolutionary urge of the working masses for activity and organisation irrespective of the level they had attained, in using Communist theory in the specific conditions of their countries, in merging with the proletarians of other countries in common struggle (*Collected Works*, Russ. Ed., Vol. 30, pp. 137–138).

This task had not yet been realised anywhere when Lenin first set it, and there was no book to tell how it should be carried out. The Communist parties in the countries which are now fighting for national independence or which have already won it, are in an incomparably more favourable position, for there is now a vast store of experience in applying Marxist-Leninist theory in the conditions of countries and areas which capitalism had doomed to age-long backwardness.

This experience gained by the world Communist movement is a great treasure-house for all Communists. Obviously, only the Party operating in the country concerned can make proper use of this experience and correctly shape the policy to be pursued.

These parties are concentrating on the main point of how best to approach their own peoples, how to convince the masses that they cannot win a better future unless they fight against imperialism and the forces of internal reaction, and how to strengthen international solidarity with the socialist countries, with the communist vanguard of the working people of the world.

The renovation of the world on the principles of freedom, democracy and socialism, in which we are now participating, is a great historical process in which different revolutionary and democratic movements unite and co-operate, with socialist revolutions exerting the determining influence. The success of the national-liberation movement, due in large measure to the victories of socialism, in turn strengthen the international positions of socialism in the struggle against imperialism. It is this truly Leninist concept of the historical processes that forms the basis of the Communist parties and

socialist countries, a policy aimed at strengthening the close alliance with those people fighting for independence or who have already won it. . . .

The imperialist powers, above all the United States, are doing their utmost to harness the countries that have cast off the colonial yoke to their system and thereby strengthen the positions of world capitalism, to infuse it, as bourgeois ideologists put it, with fresh blood, to rejuvenate and consolidate it. If we look the facts in the face, we shall have to admit that the imperialists have powerful economic levers with which to exert pressure on the newly-independent countries. They still succeed in enmeshing some of the politically-independent countries in the web of economic dependence. Now that it is no longer possible to establish outright colonial régimes, the imperialists resort to disguised forms and methods of enslaving and plundering the countries that have attained freedom. At the same time, the colonial powers back the internal reactionaries in all these countries; they impose on them puppet dictatorial régimes and involve them in aggressive *blocs*. Although there are sharp contradictions between the imperialist countries, they often take joint action against the national-liberation movement.

But if we take account of all the factors shaping the destinies of the peoples that have shaken off colonial rule, we will see that in the final analysis the trends of social progress opposing imperialism are bound to prevail.

But these matters are resolved in bitter struggle within each country. The statement of the meeting contains important propositions on the basic issues of the national-liberation movement. It defines the tasks of the Communist parties and their attitude to the various classes and social groups. In expressing the identity of views of the Marxist-Leninist parties, the statement calls for the maximum utilisation of the revolutionary possibilities of the various classes and social strata and for drawing all allies, no matter if inconsistent, shaky and unstable, into the struggle against imperialism.

The Communists are revolutionaries and it would be a bad thing if they failed to discern the new opportunities, to find the best ways and the best means of reaching the goal. Special note should be taken of the idea set forth in the statement about the formation of national democratic states. The statement outlines the main characteristics of these states and their tasks. It should be stressed that in view of the great variety of conditions in those countries where the peoples, having achieved independence, are now moulding their own way of life, a variety of ways of solving the tasks of social progress is bound to emerge.

The correct application of Marxist-Leninist theory in the newly-independent countries consists precisely in seeking the forms that take cognisance of the peculiarities of the economic, political and cultural life of the peoples to unite all the sound forces of the nation, to ensure the leading role of the working class in the national front, in the struggle completely to eradicate the roots of imperialism and the remnants of feudalism, and to clear the way for the ultimate advance towards socialism.

Today, when imperialist reaction is striving to foist the policy of anti-communism on the young independent states, it is most important to give a truthful explanation of the Communist views and ideals. Communists support the general democratic measures of the national governments. At the same time, they explain to the masses that these measures are far from being socialist.

The aspirations of the peoples now smashing the fetters of colonialism

are particularly appreciated and understood best of all by the working people of the socialist countries, by the Communists of the whole world. Our world outlook, the interests of all working people for which we are fighting, impel us to do our best to ensure that the peoples take the right road to progress, to the flowering of their material and spiritual forces. We, by means of our policy, must strengthen the confidence of the peoples in the socialist countries.

The aid extended by the U.S.S.R. and the other socialist states to the countries which have won independence has but one aim—to help strengthen the position of these countries in the struggle against imperialism, to further the development of their national economy and improve the life of their people. Noting that the working class of the advanced countries is vitally interested in " ensuring the independence " of the colonial countries " in the shortest possible period," Engels wrote: " One thing is indisputable: the victorious proletariat cannot impose happiness on another nation without undermining thereby its own victory " (K. Marx and F. Engels, *Works*, Russ. ed., Vol. 27, pp. 238, 239).

The international duty of the victorious working class consists in helping the peoples of the economically underdeveloped countries to smash the last links in the chains of colonial slavery, in rendering them all-round aid in their struggle against imperialism, for the right to self-determination and independent development. However, it does not follow that socialist aid exerts no influence on the prospects of the further development of newly-independent countries.

The Soviet Union has been and is the sincere friend of the colonial peoples; it has always championed their rights, interests and strivings for independence. We shall continue to strengthen and develop our economic and cultural co-operation with countries which have become independent.

The Soviet Union submitted to the Fifteenth Session of the U.N. General Assembly the declaration for granting independence to colonial countries and peoples.

As a result of the bitter political struggle which raged round this proposal both within and without the U.N., the General Assembly adopted the declaration. The basic point in the Soviet Declaration—the need for abolishing colonialism in all its forms and manifestations rapidly and for good—was in the main reflected in the resolution adopted by the United Nations. This was a victory for the progressive forces and all the socialist countries, which are defending the cause of freedom and independent national development of peoples firmly and consistently. . . .

The peoples of the socialist countries, the Communists and progressives all over the world see their duty in abolishing the last remnants of the colonial system of imperialism, in supporting the peoples now liberating themselves from the colonial powers and in helping them to realise their ideals of liberation. . . .

Some Ideological Questions of the Communist Movement

For us Soviet Communists, sons of the October Revolution, recognition of the necessity of the revolutionary transformation of capitalist society into socialist society is axiomatic. The road to socialism lies through the proletarian revolution and the dictatorship of the proletariat. As regards the forms of the transition to socialism, these, as pointed out by the Twentieth

Congress of the C.P.S.U., will become more and more varied. This does not necessarily mean that the transition to socialism will everywhere and in all cases be associated with armed uprising and civil war. Marxism-Leninism starts from the premise that the forms of the transition to socialism may be peaceful and non-peaceful. It is in the interests of the working class, of the masses, that the revolution be carried out in a peaceful way. But in the event of the ruling classes resisting the revolution with violence and refusing to submit to the will of the people, the proletariat will be obliged to crush their resistance and launch a resolute civil war.

We are convinced that with the growth of the might of the socialist world system and the better organisation of the working class in the capitalist countries, increasingly favourable conditions for socialist revolutions will arise. The transition to socialism in countries with developed parliamentary traditions may be effected by utilising parliament and in other countries by utilising institutions conforming to their national traditions. In this case it is a question of using the parliamentary form and not the bourgeois parliament as such in order to place it at the service of the people, and to fill it with new meaning. Thus, it will not be a matter of electoral combinations or simply skirmishes round the polls. The reformists indulge in this sort of thing. Such combinations are alien to us Communists. For us the rallying and consolidation of the revolutionary forces of the working class and of all working people, and the launching of mass revolutionary action are an absolute condition for winning a stable majority in parliament. To win a majority in parliament and transform it into an organ of the people's power, given a powerful revolutionary movement in the country, means smashing the military-bureaucratic machine of the bourgeoisie and setting up a new, proletarian people's state in parliamentary form.

It is quite obvious that in those countries where capitalism is still strong and still commands a huge military and police apparatus, the transition to socialism will inevitably take place in conditions of sharp class struggle. The political leadership of the working class, headed by the Communist vanguard, is the decisive condition no matter what the forms of transition to socialism are. . . .

The struggle against revisionism, against any deviation from Leninism, is as important as ever. It is a struggle aimed at strengthening the socialist camp, at consistently applying the principles of Marxism-Leninism. . . .

The Communist movement faces yet another danger—dogmatism and sectarianism. At present, when all forces must be united to fight imperialism, prevent war and end the omnipotence of the monopolies, dogmatism and sectarianism can do great harm to our cause. Leninism is uncompromising towards dogmatism. Lenin wrote: " . . . It is necessary to grasp the indisputable truth that the Marxist should study life as it is, the precise facts of *reality*, and should not cling to the theory of yesterday which, like any theory, at best can but indicate the basic, the general factors, and can but *draw close* to an understanding of the complexities of life " (*Collected Works*, Russ. ed., Vol. 24, p. 26).

Dogmatism nourishes a sectarian bigotry, which hampers the unity of the working class and of all progressive forces with the Communist parties. Dogmatism and sectarianism are irreconcilably at variance with the creative development of revolutionary theory and its creative application, they lead to the isolation of Communists from the masses of the working people, doom

them to passive anticipation or to reckless ultra-leftism in the revolutionary struggle, prevent them from utilising all the opportunities in the interests of the victory of the working class and of all the democratic forces.

The statement stresses that the Communist parties will continue to wage a resolute struggle on two fronts—against revisionism, which is still the main danger, and against dogmatism and sectarianism. Dogmatism and sectarianism may also become the main danger at one or another stage in the development of the various parties unless a consistent struggle is waged against them. . . .

Soviet Leadership of the Communist Camp

It should be noted that at the meeting the delegation of the CPSU expressed its point of view concerning the formula that the Soviet Union stands at the head of the socialist camp and the CPSU at the head of the Communist movement. The delegation declared that this formula was regarded above all as high appreciation of the services rendered by our Party, founded by Lenin, and expressed its heartfelt gratitude to all the fraternal parties for it. Our Party, reared by Lenin, has always seen its first duty in fulfilling its international obligations to the working class of the world. The delegation assured the meeting that the CPSU would continue to hold high the banner of proletarian internationalism and would spare no effort in carrying out its international duties.

Nevertheless the CPSU delegation proposed that that formula be not included in the statement or other documents of the Communist movement.

As to the principles of relations between the fraternal parties, the CPSU very definitely expressed its views on this matter at its Twenty-First Congress. From the rostrum of the Congress, we declared to the whole world that in the Communist movement, as in the socialist camp, there has always been complete equality and solidarity of all the Communist and Workers' parties and socialist countries. The Communist Party of the Soviet Union does not lead other parties. There are no " superior " and " subordinate " parties in the Communist movement. All the Communist parties are equal and independent, all are responsible for the destiny of the Communist movement, for its setbacks and victories. Every Communist and Workers' Party is responsible to the working class, to the working people of its country, to the entire international working-class and Communist movement.

The role of the Soviet Union does not lie in its leading the other socialist countries, but in its being the first to blaze the trail to socialism, in its being the most powerful country in the socialist world system, in its having accumulated vast positive experience in building socialism, and being the first to embark on the full-scale building of communism. It is stressed in the statement that the Communist Party of the Soviet Union has been and remains the universally recognised vanguard of the world Communist movement, being its most experienced and steeled contingent.

At the present time, when there is a large group of socialist countries each facing its own specific tasks, when there are eighty-seven Communist and Workers' parties each with its own tasks, it is impossible to lead all the socialist countries and Communist parties from any single centre. It is both impossible and unnecessary. Tempered Marxist-Leninist cadres capable of leading their parties, their countries, have grown up in the Communist parties.

And, indeed, it is well known that the CPSU does not issue directives to other parties. The fact that we will be called " the head," spells no advantages for our Party or the other parties. Just the reverse. It only creates difficulties.

As is seen from the statement, the fraternal parties agreed with the reasons stated by our delegation. The question may arise: will not our international solidarity be weakened by the fact that this proposition is not written down in the statement? No, it will not. At present there are no rules regulating relations between parties, but we have a common Marxist-Leninist ideology, and loyalty to this ideology is the main condition of our solidarity and unity. It is essential that we guide ourselves consistently by the directions of Marx, Engels and Lenin, that we persistently put into practice the principles of Marxism-Leninism. The international solidarity of the Communist movement will then constantly increase. . . .

Inasmuch as in the socialist countries conditions differ from country to country, it is only natural that each Communist Party applies Marxist-Leninist theory in keeping with the conditions obtaining in its country. For this reason, we must show understanding for this urge of the fraternal parties, which should know the conditions and features of their countries best. . . .

Naturally, one must not inflate the importance of these distinctive features, exaggerate them and overlook the basic general line of socialist construction charted in the doctrine of Marx and Lenin. We have always firmly championed the purity of the great teaching of Marxism-Leninism and the basic principles for its realisation, and will continue to do so.

Representatives of the Communist and Workers' parties exchanged opinions on questions of the current international situation and discussed the pressing problems of the Communist and working-class movement, or, as comrades put it figuratively at the meeting, we set our watches. Indeed, the socialist countries and the Communist parties need to set the time. When someone's watch is fast or slow, it is adjusted, so as to show the right time. The Communist movement, too, needs to set the time, so that our formidable army marches in step and advances with confident stride towards communism. Putting it figuratively Marxism-Leninism, the jointly prepared documents of international Communist meetings, are our time-piece.

Now that all the Communist and Workers' parties have adopted unanimous decisions at the meeting, each Party will strictly and undeviatingly abide by these decisions in everything it does. . . .

The unity of every Communist Party, the unity of all the Communist parties, is what makes up the integral world Communist movement, which is aimed at achieving our common goal, victory for communism throughout the world. The main thing that is required of all the Communist and Workers' parties today, is perseveringly to strengthen to the utmost the unity and cohesion of their ranks. . . .

Our Party will do everything to make the socialist camp and the world Communist front still stronger.

The Communist Party of the Soviet Union is firmly determined to strengthen unity and friendship with all the fraternal parties of the socialist countries, with the Marxist-Leninist parties of all the world. In this connection I want to emphasise our invariable effort to strengthen bonds of fraternal friendship with the Communist Party of China, with the great Chinese people. In its relations with the Communist Party of China our

Party always proceeds from the premise that the friendship of our two great peoples, the unity of our two parties, the biggest parties in the international Communist movement, are of exceptional importance in the struggle for the triumph of our common cause. Our Party has always exerted and will continue to exert every effort to strengthen this great friendship. We have one common goal with People's China, with the Chinese Communists, as with the Communists of all countries—safeguarding peace and the building of communism; common interests—the happiness and wellbeing of the working people: and a firm common basis of principle—Marxism-Leninism. . . .

[At a meeting of party organisations of the Higher Party School, the Academy of Social Sciences, and the Institute of Marxism-Leninism, January 6, 1961. From text in *World Marxist Review*, No. 1, 1961.]

Chinese Communist Party Resolution on the Moscow Conference

The ninth plenary session of the Eighth Central Committee of the Communist Party of China, after hearing a report by Comrade Teng Hsiao-p'ing on the meeting of representatives of Communist and Workers' Parties held in November 1960, expressed satisfaction with the work of the Chinese Communist Party delegation headed by Comrade Liu Shao-ch'i. . . .

The achievements of this meeting have greatly inspired the people of the world, who are striving for world peace, national liberation, democracy and socialism, have dealt heavy blows at the imperialists headed by the United States of America, the reactionaries of all countries and the Yugoslav revisionist clique, and have strengthened the solidarity of the socialist camp and the international communist movement on the new basis. The statement of this meeting reiterated that the 1957 Moscow Declaration and peace manifesto were the fighting banners and guides to action for the whole international communist movement; it enriched the 1957 documents by its correct analysis of the international situation during the past three years and of a series of important problems confronting the international communist movement. The Communist Party of China, always unswervingly upholding Marxism-Leninism and the principle of proletarian internationalism, will defend the statement of this meeting, just as it has defended the Moscow Declaration of 1957, and will resolutely strive for the realization of the common tasks set forth by this document.

As the statement says, our time is a time of struggle between two opposing social systems, a time of socialist revolutions and national-liberation revolutions, a time of the breakdown of imperialism, of the abolition of the colonial system, a time of transition of more peoples to the socialist path, of the triumph of socialism and communism on a world-wide scale. The doom of imperialism and the triumph of socialism are inevitable. The course of social development has once again testified to the great vitality of Marxism-Leninism and has thoroughly refuted all modern revisionist " theories " against Marxism-Leninism.

At present, there is a new upsurge in the struggle of the people thoughout the world against imperialism, for world peace, national liberation, democracy and socialism. The powerful socialist camp is becoming the decisive factor in the development of human society. The rise of the national democratic revolutions is a great development second only to the formation of the world socialist system. The mass political and economic struggles

waged by the peoples in the developed capitalist countries against oppression by domestic and foreign monopoly capital have been gaining momentum. All these forces have merged into a giant torrent battering the world imperialist system. The general crisis of capitalism has reached a new stage of development. The forces of peace have surpassed the forces of war. The progressive forces have surpassed the reactionary forces. The forces of socialism have surpassed the forces of imperialism. A bright prospect for the cause of peace, national liberation, democracy and socialism is unfolding before the people of the world.

The present situation imperatively demands that peoples all over the world further unite and wage an unremitting struggle against the policies of aggression and war of the imperialists headed by the United States. The United States, the chief imperialist country of our time, being the biggest international exploiter, the world gendarme, the chief bulwark of world reaction and modern colonialism and the main force of aggression and war of our time, is the main enemy of the peoples of the whole world. U.S. imperialism, together with other imperialist countries and the reactionaries of all countries, has formed all kinds of military and political alliances and is carrying out with increased intensity criminal activities to oppose the socialist camp and to strangle the national-liberation movement, the revolutionary movement of the working class and democratic movements in general. As a result of its persistence in this reactionary policy, U.S. imperialism has landed itself in unprecedented isolation. With the peoples of the world persevering in a resolute struggle against the forces of reaction and aggression headed by the United States, the peace, national-liberation, democratic and socialist movements are sure to win ever greater victories. Revolution is the affair of the peoples themselves in the various countries. The communists have always been against the export of revolution. They also resolutely oppose imperialist export of counter-revolution, against imperialist interference in the internal affairs of the people of various countries who have risen in revolution. The Communist Party of China and the Chinese people will, as in the past, make unremitting efforts in close unity with the fraternal parties and the revolutionary peoples of various countries to further the cause of the peoples of the world against imperialism and for world peace, national-liberation, democracy and socialism. They deem it their internationalist obligation to support the struggles of oppressed nations and oppressed peoples against imperialism.

The defence of world peace, the realization of peaceful co-existence and peaceful competition among countries of different social systems and the prevention of the new world war which is now being planned by the imperialists constitute the most pressing tasks for the peoples of the world. The imperialists headed by the United States are stubbornly persisting in a " cold war " policy leading to the catastrophe of nuclear war, intensifying the arming of the militarist forces of West Germany and Japan and fanatically engaging in armaments expansion and war preparations. Facts have proved that the aggressive nature of imperialism has not changed. As long as imperialism exists there will be soil for wars of aggression. The danger is not yet over that imperialism will launch a new and unprecedentedly destructive world war. It is more imperative than ever that the peoples should be especially vigilant. However, owing to the fundamental change in the international balance of class forces, a new world war can be

prevented by the joint efforts of the powerful forces of our era—the socialist camp, the international working class, the national-liberation movement and all peace-loving countries and peoples. Peace can be effectively safeguarded provided there is reliance on the struggle of the masses of the people and provided a broad united front is established and expanded against the policies of aggression and war of the imperialists headed by the United States. Marxist-Leninists have never held that the way to socialist revolution necessarily lies through wars between states. The socialist countries have always persisted in the policy of peaceful co-existence and peaceful competition with the capitalist countries, advocated the settlement of international disputes through negotiation, advocated disarmament, the banning of nuclear weapons, the disbandment of military *blocs*, the dismantling of military bases in foreign territory, and the prevention of the revival of the militarist forces in West Germany and Japan. The peace proposals put forward by the socialist countries, and first of all by the Soviet Union, have won warm endorsement and support from people the world over. The Communist Party and the people of China have always regarded the safeguarding of world peace, the realization of peaceful co-existence and the prevention of ₃nother world war as their most urgent tasks in the international struggle. During the past year, our country concluded treaties of friendship and mutual non-aggression or treaties of peace and friendship with Burma, Nepal, Afghanistan, Guinea and Cambodia, a boundary treaty with Burma, an agreement on the boundary question with Nepal and an arrangement for the implementation of the treaty concerning the question of dual nationality with Indonesia. The conclusion of these treaties, this agreement and this arrangement has borne out the inexhaustible vitality of the five principles of peaceful co-existence and has made important contributions to the cause of safeguarding world peace. In the future, we shall continue to stand by the other socialist countries and all peace-loving countries and peoples in tenacious struggles to defend world peace and prevent world war.

The solidarity of the socialist camp and of the international communist movement is the most important guarantee for victory in the struggle of all peoples for world peace, national liberation, democracy and socialism. This great solidarity is forged by common ideals and the common cause and has been developed and consolidated in the common struggle against the common enemy. It is based on Marxism-Leninism and the principle of proletarian internationalism. The Communist Party of China, in accordance with the principle of proletarian internationalism, has consistently striven to safeguard this great solidarity.

The socialist countries carry on political, economic and cultural co-operation in accordance with the principles of complete equality, mutual respect for independence and sovereignty, mutual non-interference in internal affairs, mutual benefit and comradely mutual assistance. The Communist Parties of all countries are independent and equal and at the same time, in the spirit of proletarian internationalism, they must adhere to the common stand on the struggle against imperialism and for peace, national liberation, democracy and socialism as jointly adopted at meetings of the fraternal parties and must unite as one and support each other in their common cause. The statement of this meeting pointed out that the Communist and Workers' Parties should hold meetings whenever necessary to discuss urgent problems, acquaint themselves with each other's views and positions, work out common

views through consultations and co-ordinate joint actions in the struggle for common goals. This is entirely necessary for the strengthening of solidarity and for victory in the common cause.

The great Marxist-Leninist teachings are the unshakable ideological foundation of the solidarity of the socialist camp and the unity of the international communist movement. In order to safeguard the purity of Marxism-Leninism and its creative application and development, it is necessary firmly to combat revisionism which mirrors bourgeois ideology and departs from and betrays Marxism-Leninism, and especially to combat Yugoslav revisionism. Modern revisionism is still the main danger for the international communist movement. At the same time, the tendencies of dogmatism and sectarianism, which are divorced from reality and from the masses, must also be opposed. The plenary session of the Central Committee of the Communist Party of China held that it is of particular importance at present to continue to carry out the principle of integrating the universal truth of Marxism-Leninism with the specific practice of China's revolution and construction, and to raise the level of Marxism-Leninism of the cadres of the Party and the state.

The unity between China and the Soviet Union and between the Chinese and the Soviet Parties is of particularly great significance. In the international communist movement, the great Communist Party of the Soviet Union is the vanguard with the longest history and richest experience. The great Soviet Union is the most advanced and most powerful country in the socialist camp. The Communist Party of China has consistently striven to maintain and strengthen the unity between the Chinese and the Soviet Parties and between the two countries, holding that this is in the fundamental interests of the peoples of China and the Soviet Union and also of the peoples of the whole world. The imperialists will never succeed in their hopeless scheme to split the unity between the Chinese and the Soviet Parties and between the two countries. . . .

[Adopted January 18. NCNA, January 20, 1961.]

10. Appendices : "Inside" Reports of the Dispute

The Chinese Position

IF West Bengal's Harekrishna Konar is to be believed, he has been chosen by the Chinese to lead the attack on the Soviet positions in the Communist Party of India. He is reported to have told the Calcutta District Party Council last week how Kerala's Damodaran was snubbed by the Chinese and he himself had long interviews with important leaders. Damodaran and Konar had gone to Hanoi as CPI's fraternal delegates to the Vietnamese Lao Dang Party Conference.

Damodaran's fault was that he stuck to General Secretary Ajoy Ghosh's instructions to keep away from the Chinese and to tell them, if they took the initiative in fraternising, what the CPI feels about the Chinese general political line and particularly about the Chinese attitude towards India.

Chinese views. Konar told the Calcutta District Council that so far, Indian Communists knew only the Soviet point of view but now he was in a position to place the Chinese point of view before them and he considered it his duty to do so even if it amounted to a technical breach of Party forms. He said, the Chinese told him that their differences with the Soviet Party started soon after Stalin's death. They did not like the Soviet leadership's handling of the Beria case. The way the Soviet leadership went about denigrating Stalin was "obnoxious." The Soviet attitude towards Yugoslav revisionism was "cringing" and one of giving concessions. On every occasion the Chinese pointed out the mistakes of the Russians to them but the latter paid no heed. At the time of the Twentieth Congress they did not take account of the Chinese criticism of their "distortions of Marxism." Even at the time of the Hungarian "counter-revolution" the Soviet attitude was "vacillating" and Khrushchev was on the point of withdrawing Soviet armies. It was with great difficulty that the Chinese succeeded in "persuading" the Soviet leaders to take a "firm line" and "go to the defence of Hungarian revolution."

The Chinese complained that even at the time of the Moscow (1957) Conference the Soviet Leaders did not take a firm attitude and were prepared to give more concessions to the Yugoslavs. The Soviet leaders were of the view that revisionism was no longer the main enemy and that under the changed circumstances fire had to be concentrated against dogmatism; it was because the Russians themselves were taking revisionist positions. The Chinese told them, " If you do not fight revisionism we will have to take up the battle single-handed against all distortions of Marxism." It was only then that the Russians agreed to accept the Chinese amendments to the draft declaration on behalf of 12 parties. The Yugoslavs refused to sign the amended declaration. But later the Soviet leaders too went back upon the Declaration.

Complaining bitterly about the unfriendly attitude of the Soviet leaders since then the Chinese held that almost all the Russian technicians had been withdrawn from China even before their term of contract had ended. The Soviet leaders did not like the "political education" of the technicians arranged by the Chinese Party as a gesture of its fraternal feelings for the Russians, the Soviet leaders considered it an interference with their inner-Party affairs—an echo, according to the Chinese, of the complaint of Tito against Stalin in 1948. The Chinese also told Konar that while the American Embassy in Moscow was allowed to bring out its journal in Russian, the paper published by the Chinese was closed down on the plea that it sought to propagate ideas in conflict with the official Soviet line.

Cold War. Coming to the issues round which the Soviet-Chinese controversy centres, the Chinese said that the alternative to peaceful co-existence was not war; it was cold war. By putting forward the thesis that war would break out if the policy of peaceful co-existence was given up, the Soviet leaders, according to the Chinese, were trying to create a scare among the people and deaden the edge of anti-imperialist and anti-war struggles of the people of capitalist and colonial countries. By insisting that peaceful co-existence was possible the Soviet leaders were sowing illusions about imperialism. The Chinese also dismissed the possibility of peaceful transition to socialism. They believe that the Soviet line of peaceful co-existence and peaceful transition arose out of a wrong understanding of the nature of imperialism and the role of working class.

About the approach to the bourgeoisie and the governments of the newly liberated countries, the Chinese said that capitalism in Asia was weak in relation to imperialism and was bound to line up with the latter, whatever might be the attitude adopted by it (capitalism in the newly liberated countries of Asia) earlier as a result of the pressure of the people. There was a swing towards the Right in the government of these countries.

China and India. The Chinese estimate of India is that the Government and Jawaharlal Nehru were now leaning more on imperialism and coming out in their "true reactionary colours in domestic policies." The Chinese assured the Indian listener that they had no intention of crossing the MacMahon Line. Soviet and Indian party leaders should have no fears on this account. According to the Chinese the Government of India came to know of the Ladakh incident from its spies or from Soviet reports and began to make much noise about it. Even if the Ladakh incident had not taken place the Indian government would have cooked up some other issue so that it could divert the attention of the people from its shift in foreign policy and also from its reactionary home policy. . . .

[Report carried in the Indian news magazine *Link*, October 16, 1960.]

The Soviet Position

The Chinese Party has been accused of not accepting the ideas embodied in the 18-Parties Rome Declaration and the 12-Parties Moscow Declaration. The differences seem to have begun soon after the Soviet Party Congress when the Chinese began criticism of the common understanding arrived at between the fraternal delegations of different parties to the Congress. Earlier, in the days of Stalin also, the Chinese had criticised certain Soviet policies but the criticism at that time had acted as a "corrective" while now they

took up positions basically opposed to those accepted at international conferences. (Long quotations from the Chinese publication " Long Live Leninism " have been given to show how the Chinese went back upon the declarations and statements they had signed along with other parties.) Moreover, the Chinese resented Soviet criticism of some of their policies such as their Tibet policy, Communes and " Leap Forward " and considered such criticism " unfriendly."

Among the " unfriendly " acts of the Chinese listed is interference in the internal affairs of two East European Parties. Soviet political instructors sent to work among Soviet citizens in China were not allowed to function and attempts were made to subvert the political allegiance of Soviet Communists in China; it was only then that Soviet technicians were withdrawn. The Chinese periodical published from Moscow was stopped for printing articles distorting and attacking Soviet positions; but it was stopped only after the Soviet periodical published from Peking had been closed down. The gravest charges against the Chinese, however, are those which relate to the activities of the Chinese representatives on international mass organisations like the World Federation of Trade Unions, the Women's Organisation and the Peace Movement. The Chinese are accused of attempts to break the unity of these " non-party " mass organisations and to convert them into purely communist organisations contrary to the accepted policy of other Communist Parties. The Chinese who have withdrawn their representative from the World Peace Movement's headquarters wanted Peace Partisans not merely to campaign against the danger of war but also participate in anti-imperialist and anti-capitalist mass actions. . . .

[*Link*, October 30, 1960.]

227

PRAEGER PAPERBACKS

THE SINO-SOVIET DISPUTE

Documented and analyzed by

G. F. HUDSON, RICHARD LOWENTHAL,

and RODERICK MacFARQUHAR

After six years of apparent harmony in the Sino-Soviet partnership, the Chinese began to take an increasingly "hard" ideological line, clashing with the Soviets on such issues as Titoism, the inevitability of war, and Soviet leadership of the bloc. The extent of the Moscow-Peking dispute became public knowledge in early 1960; and the dispute itself was dramatically resolved—temporarily, at least—at the Moscow conference of eighty-one Communist parties in November, 1960.

The object of this book, originally prepared as a special issue of *The China Quarterly*, is to document and analyze the dispute and to assess the current status of Sino-Soviet relations. All the pertinent documents are here: Khrushchev's "secret speech"; editorials from *Pravda* and the Chinese *People's Daily;* the Chinese attack on Soviet diplomacy at the World Federation of Trade Unions meeting in Peking; Khrushchev's speech, P'eng Chen's reply, and the official communiqué of the Bucharest conference; the 1960 Moscow statement and Soviet and Chinese comments on it.

The editors provide authoritative interpretation of these documents. In his Introduction, Mr. Hudson details the background to the dispute. Mr. Lowenthal analyzes the course of the dispute during 1960, dealing with the major points raised by the documents. Mr. MacFarquhar clarifies the economic issues that affect Sino-Soviet relations, and he comments on each group of documents, describing the arguments and delineating the crucial passages. The result is an up-to-date and penetrating study of the reality and durability of the Moscow-Peking alliance.

THE EDITORS: G. F. Hudson is Director of the Centre for Far Eastern Studies at St. Antony's College, Oxford.

Richard Lowenthal, for many years a foreign-affairs commentator for *The Observer* (London), is now Professor of International Relations at the Free University in West Berlin.

Roderick MacFarquhar, Editor of *The China Quarterly,* writes on Chinese and Asian affairs for the London *Daily Telegraph.*

FREDERICK A. PRAEGER, *Publisher*
64 UNIVERSITY PLACE, NEW YORK 3, N.Y.